Italian painting

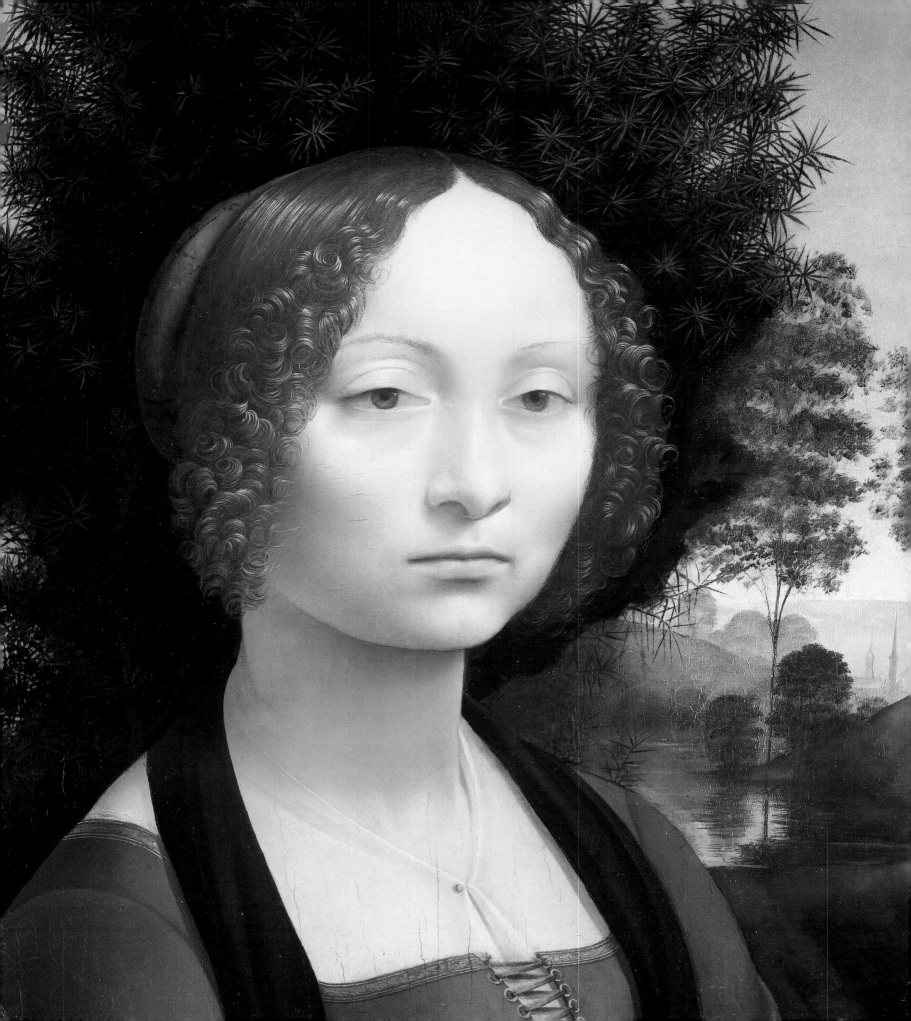

ITALIAN PAINTING

Artists and their masterpieces throughout the ages

KÖNEMANN

Contents

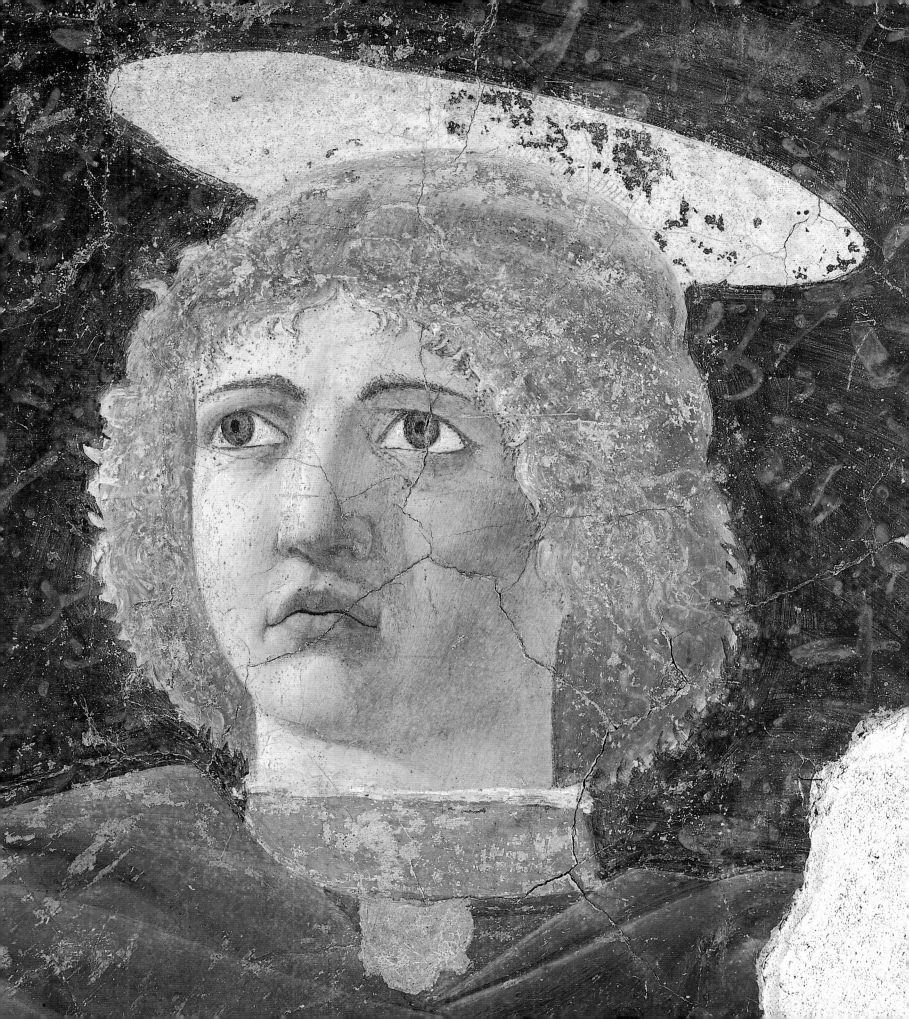

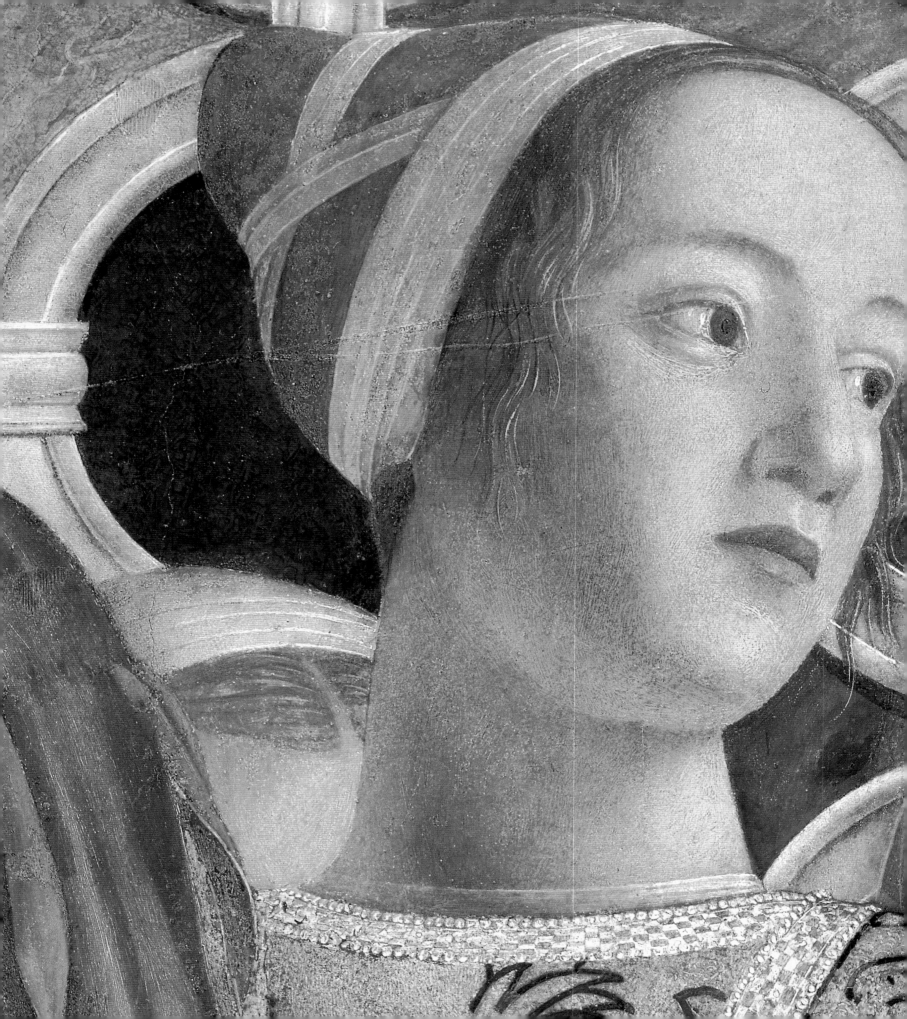

The job of choosing five hundred masterpieces from seven centuries of painting is both thrilling and devastating. Names, places and images spring to mind conjuring up ideas, emotions and memories. One never wants to "cast aside" one painting and single out another. For every choice made there is automatically an equivalent rejection. It is often hard to live with this because for each painting selected another could have been chosen.

Any anthology, even one as vast as this, can only give a partial idea of the richness of Italian painting. So when faced with a bottomless well to draw from, we decided to lay down some ground rules.

Firstly, we have attempted to give a clear idea of the "common language" shared by Italian painting throughout the ages. We decided that this would be our thread. Unlike other European nations, Italy only became a unified state in the second half of the nineteenth century. Before, its ever-changing map was made up of local or foreign-held fiefdoms. Despite this, Italian art possesses a strong sense of togetherness. This is in part due to the way the great artists traveled from place to place, so there was a never-ending circulation of ideas and models of painting.

One of the factors that forges the common identity of Italian painting is precisely the quantity of sources and the variety of schools. Our selection of artists and works is therefore aimed at underlining the substantial coherence of Italian art. The coherence stemmed from cross-fertilization between different strands and from the individual creativity of the artists. In all parts of the peninsula, painting produced an extraordinarily free range of significant forms of expression which continued down the centuries.

It was this observation which indeed dictated our third criterion for choosing which works to include. Everyone knows that the "capitals" of Italian art are Rome, Florence and Venice. What makes Italian art different, however, is the capillary spread of wonderful works of art everywhere in the country. Beyond this, for four centuries Italian masterpieces have been exported. This led directly to the establishment and growth of the major museums abroad. So in Italy itself not only are masterpieces concentrated in a handful of key cities, but there is also a typical pattern of what virtually amounts to museums whose contents are "spread" across a hundred or so historical sites of varying size. As in the past, many major Italian works of art are now abroad. We have tried to reflect this situation in the geographical spread of images chosen.

Of course, we cannot overlook a number of works which for centuries have been regarded as the yardstick against which European art was measured. These works have entered the collective imagination and are traditionally the Mecca of cultural tourism. Nevertheless, neither can we ignore the fact that aesthetic experience belongs to the sphere of the irrational. For this reason we have made minor concessions to the individual taste of those of us making the selection of artists and masterpieces. As these are personal choices, they are highly questionable. Anyone leafing through this book is bound to be surprised, both with regard to what is in it and with regard to what has been left out. But this is what is so wonderful about art. It offers us the comfort of great certainty, serene and safe reference points and, at the same time, allows space to fantasy and to individual sensitivity.

The 14th Century

Giotto
*Incontro di Gioacchino e Anna alla Porta
Aurea*/The Meeting at the Golden Gate
1304–06
Padua, Cappella degli Scrovegni

At the start of the fourteenth century Dante started a legend that has lasted to this day. In his *Divina Commedia* he wrote, "credette Cimabue de la pintura/tener lo campo; ed or ha Giotto il grido/sì che la fama di colui è oscura" [Cimabue was believed to hold the field in painting; but now Giotto has eclipsed him and the other's fame has faded]. Giorgio Vasari took up this idea in his *Vite* [Lives of the Great Painters] of 1550 and for centuries people have repeated the tale that Cimabue was the grandfather of all Italian painting. He is said to have founded the Florentine school which, at the start of the Trecento (fourteenth century), taught Italy the language of painting, just as it undoubtedly did with its literature. But this tells only half the story of what was really happening in Italian painting at the time. It encourages the not-always-justified idea that Tuscan art was always better than art in other regions of Italy. It also neglects major artists working in the thirteenth century. Having said all this, even today it can provide useful insight into the origins of the "Grand Tradition" of Italian painting.

Above all, it underlines that the real turning point in Italian painting came with the transition from rigidly stylized Byzantine art, which changed hardly at all over the centuries, to an art which observed and interpreted reality in constantly changing ways. At the same time artists began rediscovering the long-vanished but still potent art of classical antiquity. The static, hierarchical, mystical imagery of Byzantium gave way to a new dynamic vision clearly expressed in Giotto's frescos. As the fourteenth-century painter Cennino Cennini wrote, Giotto translated art from "Greek (Byzantine) to Latin (Italian)." The clarity of Dante and Boccaccio's "common tongue" (Tuscan Italian) mirrored by the direct eloquence of characters painted by Giotto or Ambrogio Lorenzetti. The exception to this development was Venice, the most Byzantine of all Italian cities. The still eastern style of mosaics in St. Mark's was echoed in Venetian painting despite the fact that in 1304 Giotto painted the Cappella degli Scrovegni in neighboring Padua.

The people Giotto painted are real men and women whose social roles can be clearly seen. In his scenes of daily life in town or country, we can almost touch the physical spaces they inhabit. As it developed in the fourteenth century, the greatest achievement of Italian art was this emphasis on the full humanity of individuals, living in history and in the actual world. These were the first stirrings of an intellectual movement that within a century would blossom into the full Renaissance.

Another thing that emerged during the first half of the fourteenth century was the phenomenon of the local school. In the preceding centuries art had looked mainly to non-local models, such as Byzantine or Ottonian (German) art. This meant that styles could easily spread from one region to another. But from the fourteenth century onwards the various regions, and indeed often individual cities, began to express their newly gained political independence through their own typical schools of art. These were highly individual and distinct from each other although still containing common references. The variety of these local schools was balanced by the way many famous artists traveled widely, spreading their art and ideas. Giotto, who was from Florence, left his mark on Assisi, Rome, Padua, Milan, and Naples. Simone Martini from Siena traveled to Naples and Avignon. Roman-born Pietro Cavallini also worked in both Naples and Assisi. Such travels gave rise to close artistic ties which at least partly balanced local artistic independence. Frequently painting became the proud means by which a city's public events were proclaimed and celebrated. The social and political life of a city such a Siena was reflected in its painting and the city liked what it saw. One feast day, a stirring procession of citizens accompanied the new painting of the *Madonna in Maestà* from the studio of its painter Duccio to the Cathedral. A few years later the City Council, vying with the Cathedral, commissioned Simone Martini to paint a fresco on a similar subject for the Palazzo Pubblico. In the Sala dei Nove, Ambrogio Lorenzetti painted the fascinating allegories of *Good and Bad Government* – a political manifesto in the form of an artis-

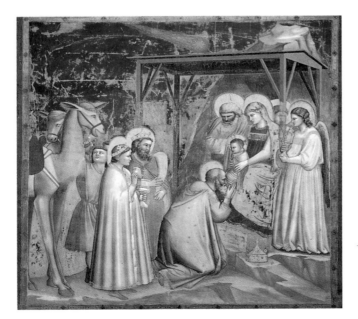

Giotto
Adorazione dei Magi/
The Adoration of the Magi
Padua, Cappella degli Scrovegni.

tic masterpiece. Even the tax registers (locally known as "biccherne") were exquisitely decorated with painted frontispieces.

Siena and Florence were the cities – both wealthy and bitter rivals – in which the debate about painting was at its liveliest. However, the place where all of the major artists in the late thirteenth and the first half of the fourteenth centuries actually met was in Assisi at the Basilica of S. Francesco, the greatest artistic project of the age in Europe. The two Gothic churches of the basilica are built on top of each other. Every available space – walls, ceilings, vaults, transepts, side chapels and galleries – is covered in painting. Not all of the painters have been identified and critics still argue even about the most famous frescos, especially the large scenes of the life of St. Francis in the Upper Church, traditionally considered to be Giotto's first major work. At Assisi generations of artists followed each other on the scaffolding. The best of the Roman school was there (Filippo Rusuti, Jacopo Torriti, and perhaps even Pietro Cavallini), as were Cimabue and Giotto from Florence and all the great Sienese painters (Duccio, the Lorenzetti brothers, Simone Martini). The work in Assisi became in effect a laboratory in which the art of the fourteenth century was developed. On one hand we have Giotto's stern but human solemnity. On the other, we see the elegant lines of Simone Martini, a friend of Petrarch strongly attracted to pure, almost ethereal ideals of beauty and poetry. Simone was the precursor of and model for the International Gothic style of painting that soon found favor in courts around Europe.

The social and cultural progress of the fourteenth century was abruptly interrupted in the middle decades. Three years of famine were followed by the terrible scourge of the Black Death (1348). Europe was devastated and Italy was hit especially hard. The newly rediscovered interest in exploring reality started by Giotto was dropped in the second half of the century and art in some ways stagnated, but only for a time. In fact, the greater certainty and independence shown by Italian art may be connected to the generally healthy political and economic situation of the day. During the first half of the fourteenth century, after centuries of wars between supporters of the Papacy (the Guelfs) and those of the Emperor (the Ghibellines), many Italian states and cities benefited from local administrative stability. This coincided with the growing strength of the ruling dynasties (for instance, the Visconti in Milan or Angevin in Naples) or with stable oligarchic governments in the republics of Florence and Venice. A strong merchant and commercial class developed in the main cities. Paintings in Giotto's style, which rapidly spread through many

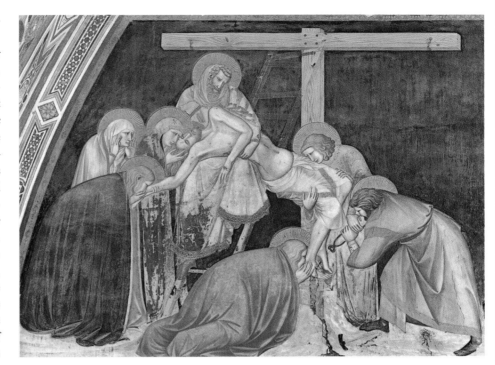

regions owing to the painter's travels, provide images of that cultural and economic certainty. We can see the reflection of the new attitudes and outlook of men satisfied with their own knowledge and interpretation of their times and surroundings. The people that Giotto painted were real men and women with their accompanying anxieties and hopes, wonder and emotion. They are painted often life-sized and fully three-dimensional.

Painting at this troubled stage, in the wake of the Black Death, divided into two specific directions. In Tuscany an austere, admonitory image came back into fashion. Divine power was seen dominating the human sphere, setting its limits and judging its destiny. The severe foreheads we see in Orcagna's painting looked once again for inspiration to the solemn, other-wordly hierarchy of Byzantine art. On the other hand, the International Gothic style preferred by many courts favored luxurious images preciously refined down to the finest detail. Reality was replaced by romantic fables and chivalrous poetry. In the second half of the fourteenth century, the celebration of noble families through the symbolic use of heraldry became an inspiration for some refined and fantastically inventive paintings and illustrated manuscripts. From this strand the Lombard school was to emerge.

Pietro Lorenzetti
Deposizione dalla Croce/Descent from the Cross
Assisi, St. Francis, Lower Church.

Cimabue
Madonna col Bambino in
trono e due angeli/
Madonna and Child
Enthroned with Two Angels

*c. 1300, wood panel, Bologna,
Santa Maria dei Servi.*

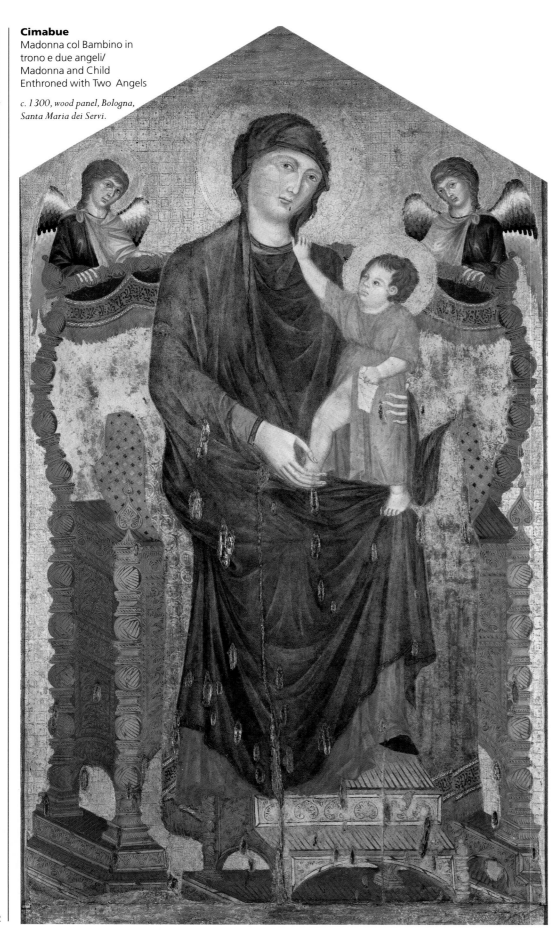

Cimabue

*Cenni di Pepo, active between 1272 and
1302*

Cimabue's work had a decisive effect on
the early development of Italian art.
Tradition, inspired by Dante's reference
to him, regards his monumental
compositions as marking the real
foundation of the Florentine school, his
work challenging the style and rules of
Byzantine painting. His relationship
with Giotto is the subject of one of the
oldest and most famous legends in the
history of art. After probably spending
some time in Rome (1272), Cimabue
started the huge task of painting a series
of frescos in the basilica at Assisi.
Despite the erosion of the centuries
(and recent earthquake damage), works
like the *Crucifixion* in the Upper Church
reveal a style which already had a well-
defined, dramatic quality. The power of
Cimabue's painting can be seen from his
panel paintings of the *Madonna in Maestà*
(in the Louvre, the Uffizi, and in
Bologna in which the supple power of
the painting grows progressively
greater). This can also be seen in the
panel paintings depicting the terror of
the crucifixion (the best known of these
was that from S. Croce in Florence,
destroyed in the 1966 flood) and in his
cartoons made for the mosaics in the
Baptistery in Florence and for Pisa
cathedral.

Pietro Cavallini

*active in Rome and Naples between 1273
and 1308*

The Roman school of the second half of
the thirteenth century was also crucial
to the development of Giotto's work
and Italian painting in general. Critical
recognition of this has come late but is
growing steadily. Pietro Cavallini is the
outstanding artist of his school,
especially with regard to his innovative
use of color and light. In Rome he
painted frescos (the most important of
which is the *Last Judgment* in S. Cecilia in
the Trastevere district) and designed
mosaics (*Life of the Virgin* in S. Maria,
again in Trastevere, dating from 1291).
The painter also worked for some time
at the court in Naples where we still
have his frescos in the cathedral as well
as in S. Maria Donna regina and S.
Domenico. Opinion still differs on
whether he worked on the Franciscan
basilica in Assisi and the Sancta
Sanctorum in Rome (the Chapel of St.
Lawrence in the Lateran Palace).

Pietro Cavallini
Giudizio Finale/The Last Judgment

c. 1293, fresco, Rome, S. Cecilia in Trastevere.

Despite being damaged, this image of Christ sitting in judgment surrounded by the angelic hosts reveals Pietro Cavallini's sense of monumental power. The measured frontal view comes from the Byzantine tradition while the warm tones of the colors and the play of the light are definitely new.

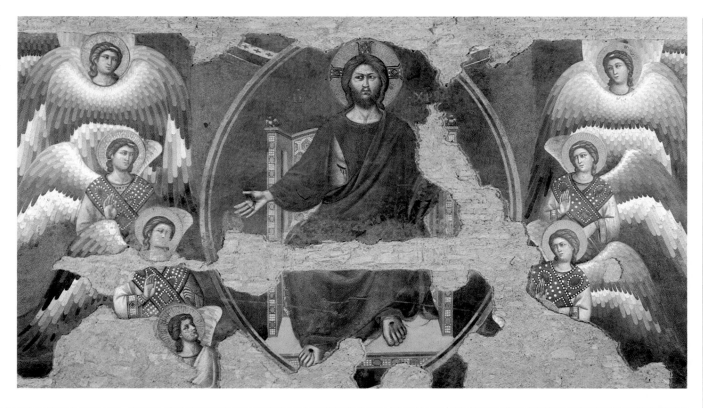

Pietro Cavallini
Crocifissione/Crucifixion

c. 1308, fresco, Naples, S. Domenico Maggiore.

13

Giotto di Bondone

Vespignano c. 1267–Florence 1337

A key figure for the whole of Western art, Giotto rivaled his fellow Florentine as well as with contemporary Dante in his richness of emotional expression and radical innovations. His stays in Padua, Rimini, Milan, and Naples produced local schools of artists, called the "Giotteschi." Traditionally, Giotto was Cimabue's pupil. His training was completed, however, when he got to know the Roman school while working in Assisi with other artists. Critical argument still rages over whether Giotto's early days as an artist were spent working on the fresco scaffolds in Assisi's Upper Church painting the famous cycle of the *Life of St. Francis* catastrophically damaged in the 1997 earthquakes. In 1304 Giotto went to Padua where he undoubtedly painted the frescos in the Capella degli Scrovegni. These, with their powerful humanity were to become the template for centuries of Italian painting. His human figures possess a real physical presence. They are set against natural backgrounds or fully three-dimensional architectural settings. This realistic trend continued in his later work. Among his paintings in Florence, we still have the two frescoed chapels (Bardi and Peruzzi) in the church of S. Croce which were not finished until after 1320. In his later years Giotto also worked in Naples, Rome, and Milan.

On the previous page
Giotto
Omaggio di un
semplice/Homage
of a Simple Man

*1295–1300, fresco, Assisi,
St. Francis, Upper Church.*

This is one of the scenes
from the youth of St.

Francis, solidly based on
reality. In the main square
of Assisi, a man throws
down his own cloak as St.
Francis goes by. The Roman
temple once dedicated to
Minerva and the Palazzo
Communale can both still
be seen exactly as in the
fresco.

Giotto
Predica davanti a Onorio
III/Sermon Before
Honorius III

*1295–1300, fresco, Assisi,
St. Francis, Upper Church.*

As he experimented with
depicting space, Giotto's
knowledge increased. In

this fresco he painted a
three-dimensional "box"
representing the hall. He
then emphasized the space
by cleverly arranging the
architectural elements and
human figures within it.
This gives the figures
volume, defined in space by
the depth of the regular

geometrical solids. Like all
the scenes from the St.
Francis cycle, this has not
escaped heavy-handed
restoration work in the past
and is now in a desperately
damaged state after the
1997 earthquakes.

15

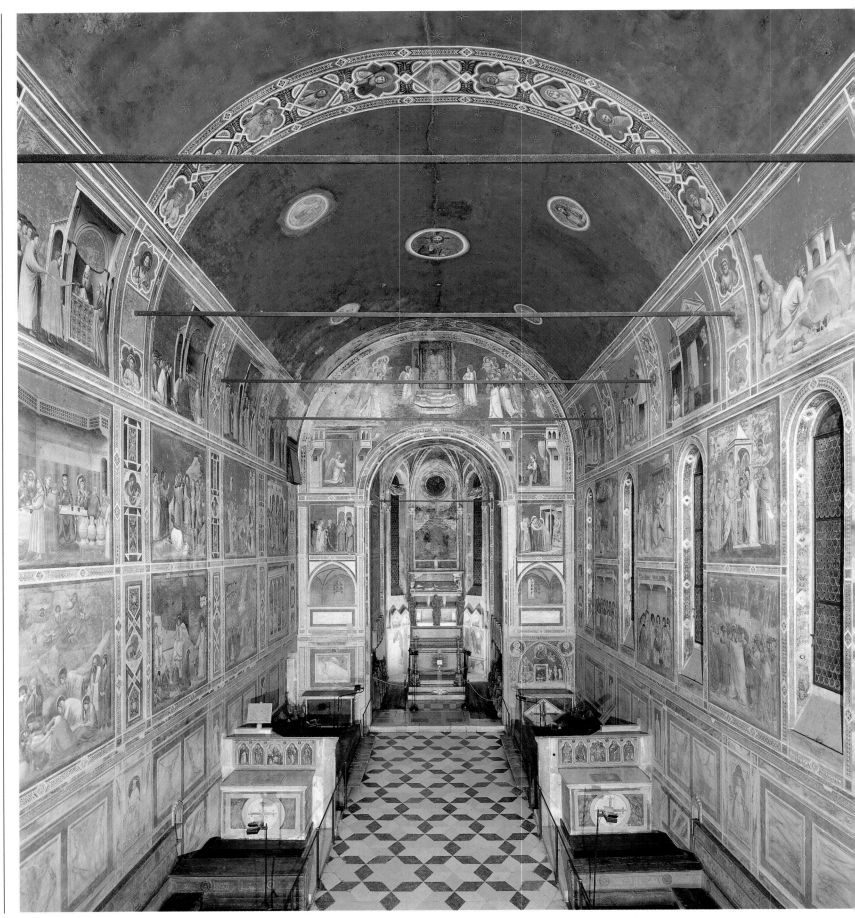

On the facing page
Giotto
Veduta dell'interno verso l'abside/View of the Interior Toward the Apse

1304–06, fresco, Padua, Capella degli Scrovegni.

Enrico Scrovegni built the chapel in expiation of his father's sins of usury. The chapel is quite small and very simple in structure, perhaps at Giotto's own suggestion. At the bottom, false marble skirting has grisailles (painted in grayish tones) images of Vices and Virtues. Along the walls and around the chancel arch three successive tiers show *Scenes from the Lives of Joachim and Anne, the Virgin and Christ*. There are also roundels showing the Evangelists and the Doctors of the Church. The work is completed by a scene showing *The Last Judgment*. The fine state of preservation of these frescos enables us to appreciate Giotto's innovations in regard to his depth of vision and his portrayal of real human emotions.

Giotto
Sogno di Gioacchino/
Joachim's Dream

1304–06, fresco, Padua, Capella degli Scrovegni.

Giotto's tendency to depict human figures almost as geometrical shapes is demonstrated by the way the sleeping figure of Joachim seems contained as if within a cube. The stillness of the scene is broken by the liveliness of the sheep. Here Giotto was perhaps inspired by his legendary youth as a Tuscan shepherd boy.

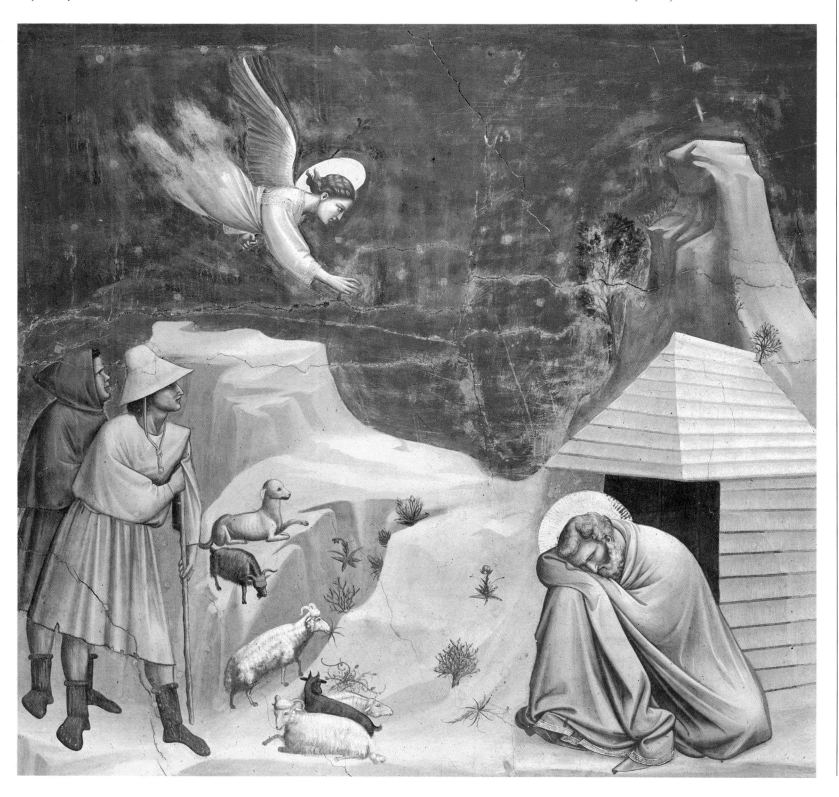

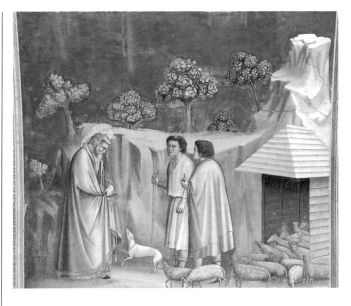

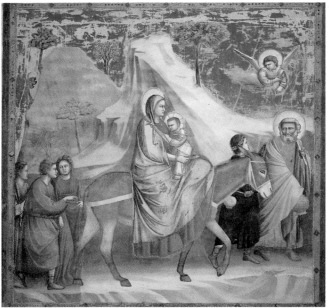

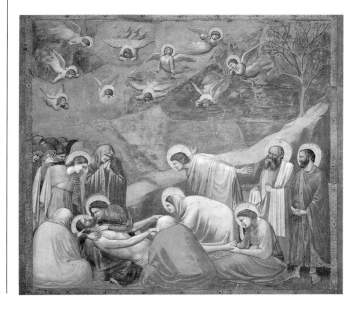

Giotto

Gioacchino si ritira tra i pastori/Joachim Taking Refuge among the Shepherds; Fuga in Egitto/ Flight into Egypt; Compianto su Cristo morto/Lamentation; Incontro di Gioacchino e Anna alla Porta Aurea/ Meeting at the Golden Gate; Bacio di Giuda/ The Kiss of Judas

all 1304–06, frescos, Padua, Capella degli Scrovegni.

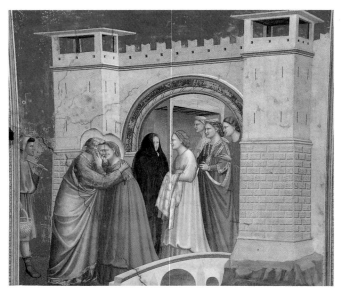

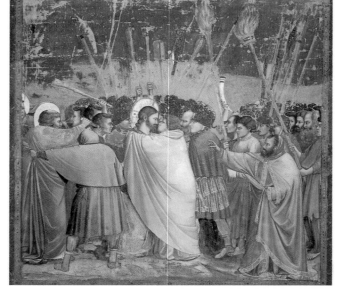

The chronological sequence of the scenes in the Scrovegni [Arena] Chapel starts at the bottom of the left-hand wall, upper order, with the story of the Virgin's parents. Giotto reintroduced to Western art human feelings and gestures that had been absent for nearly a thousand years. *The Arrest of Christ in the Garden of Olives* is the biggest crowd scene even though it is structured around the two immobile heads of Judas and Christ. Judas' gesture of betrayal can be compared to the affectionate and shy embrace between Joachim and Anne on the same wall. The *Lamentation* reveals many of the most radical experiments that Giotto carried out in Padua. These included the use of countryside as an element in the composition, shown in bleak winter and not merely as a neutral background. Attention focuses on portraying human feelings with a wide-ranging narrative approach which included figures seen from behind. The angels are also shown in an agony of grief, circling above. Finally, the way Giotto arranged scenic elements to give them depth is fully developed here. The two Marys seen from behind, the body of Christ, and the figure of the Virgin give the impression of three levels leading the viewer toward the interior of the picture.

Giotto
Gesù davanti a Caifa/
Christ Before Caiphus

*1304–06, fresco, Padua,
Capella degli Scrovegni.*

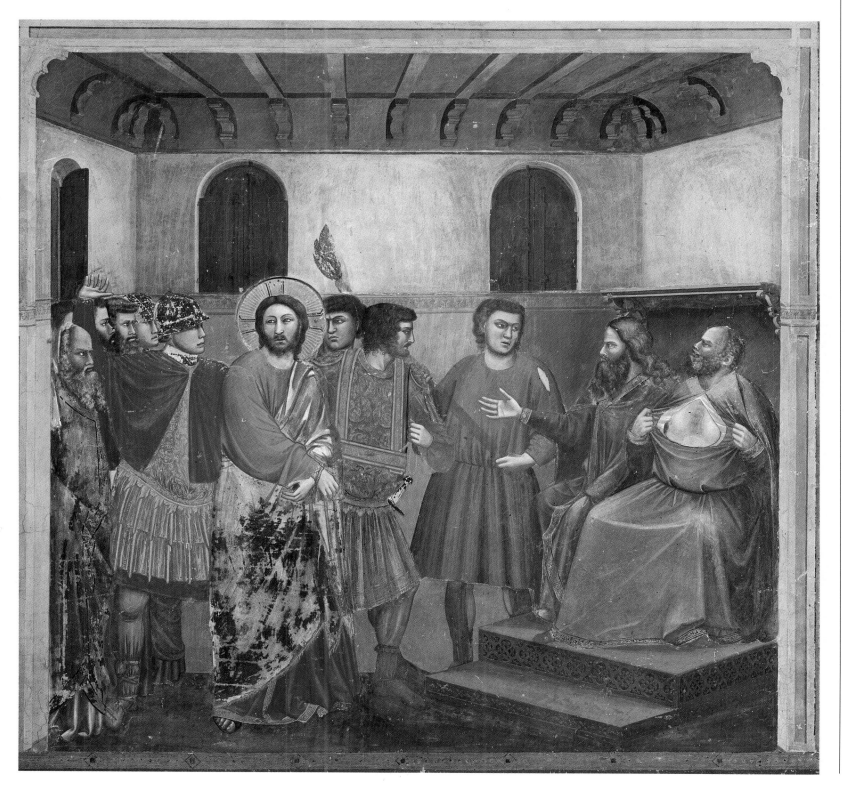

Giotto
Madonna in trono
(Pala d'Ognissanti)/
Madonna Enthroned
(All Saints' Altarpiece)

*1306–11, wood panel,
Florence, Uffizi.*

This composition, which
has recently been restored,
adheres to the Tuscan
tradition of Virgins painted
against a gold background
on a pentagonal panel. The
physically solid presence of
the Madonna and Child,
deliberately framed by
regular geometrical solids,
stands out against the
Gothic throne which
appears by contrast flimsily
elegant. The sense of
perspective given by the
pierced seat breaks
completely with the
massive thrones seen in the
Maestà painted by Duccio
and Cimabue. Finally, the
gestures of the pair of
kneeling angels holding
vases of flowers are highly
original.

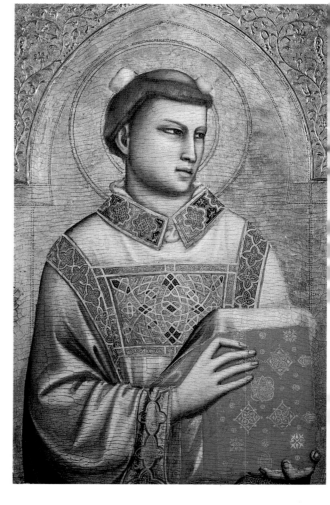

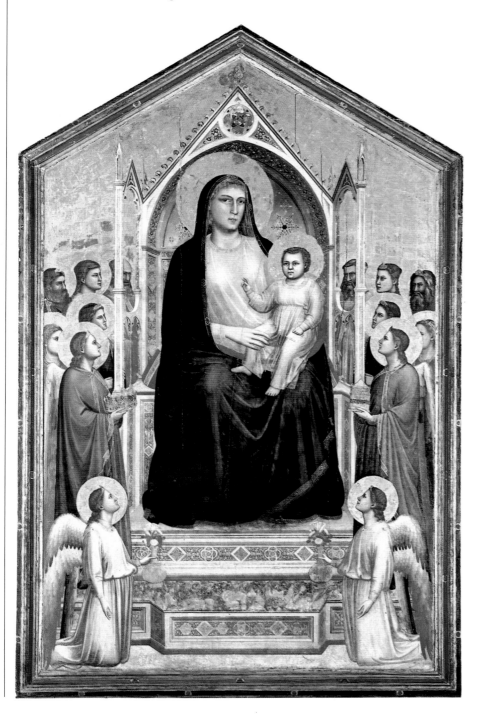

Giotto
Santo Stefano/St. Stephen

*1320–25, wood panel,
Florence, Horne Museum.*

This wood panel is in good
condition. It was originally
part of a polyptych which is
now scattered among the
collections of several
museums. The central panel
was the *Madonna* currently
in the National Gallery of
Art in Washington. *St.
Stephen* is one of the works
in which Giotto paid close
attention to the
transparency of the colors.
They were applied with
extremely delicate
brushstrokes which, as in
many of his later works,
reveals Giotto's own
awareness of the
increasingly fashionable
International Gothic style.

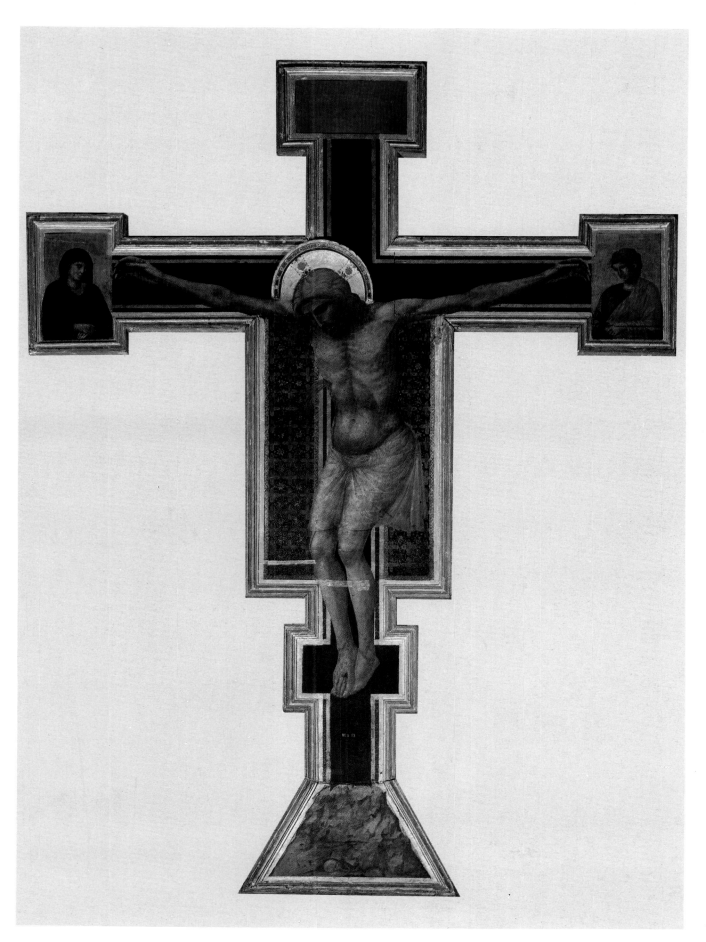

Giotto
Crocifisso/Crucifix

1290/1300, wood panel, Florence, S. Maria Novella, Sacristy.

This, probably Giotto's earliest surviving work, is the largest and most ambitious of the shaped panels of Christ on the cross painted by Giotto. Although his limited anatomical knowledge prevented him attaining the realism of his later crucifixes (in Padua and Rimini), Giotto's break with Byzantine tradition is already clear. This can be seen from the natural pose, the sense of real weight in the way Christ's body so painfully hangs, the basic simplicity of the loin-cloth, and the realism of the two feet fixed with a single nail.

On the following page, top
Giotto
Polittico Stefaneschi/
Stefaneschi Polyptych
(front)

c. 1330, wood panel, Rome, Vatican Gallery.

Painted for the high altar in Old St. Peter's, this is the best preserved of Giotto's Roman paintings. It was commissioned by Cardinal Jacopo Caetani Stefaneschi who is portrayed on one side of the Polyptych, itself painted on both sides. The growing influence of the International Gothic is again evident in the detail.

On the following page, bottom
Giotto and assistants
Polittico Baroncelli/
Baroncelli Polyptych

1334, wood panel, Florence, Santa Croce, Baroncelli Chapel.

Both the tightly packed hosts of angels praising the Virgin and the huge figures in the central panel indicate that considerable assistance was needed for this work. Giotto no longer worked with a few individual assistants, but now had a well-organized studio. We are beginning to identify a number of Giotto's own relations and well-known artists.

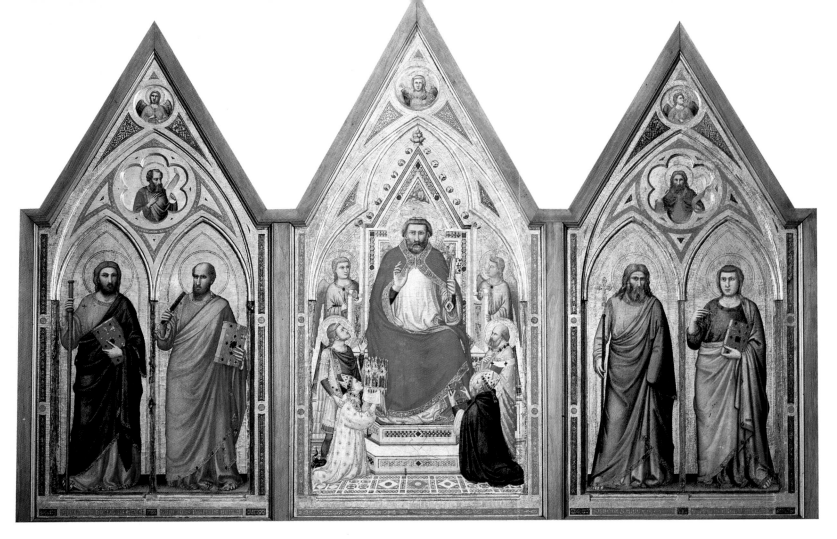

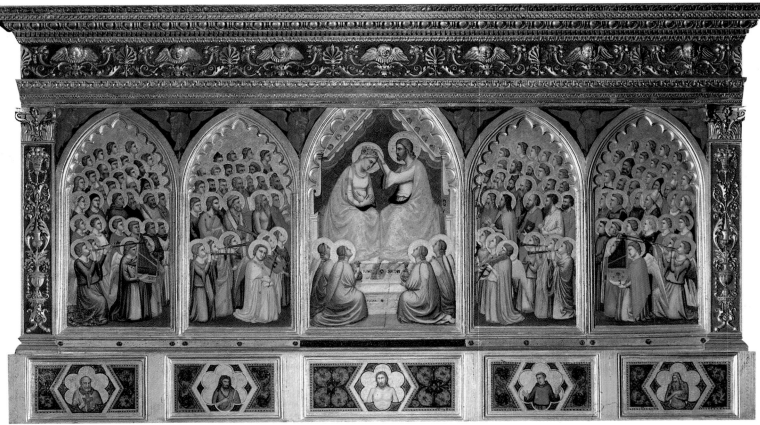

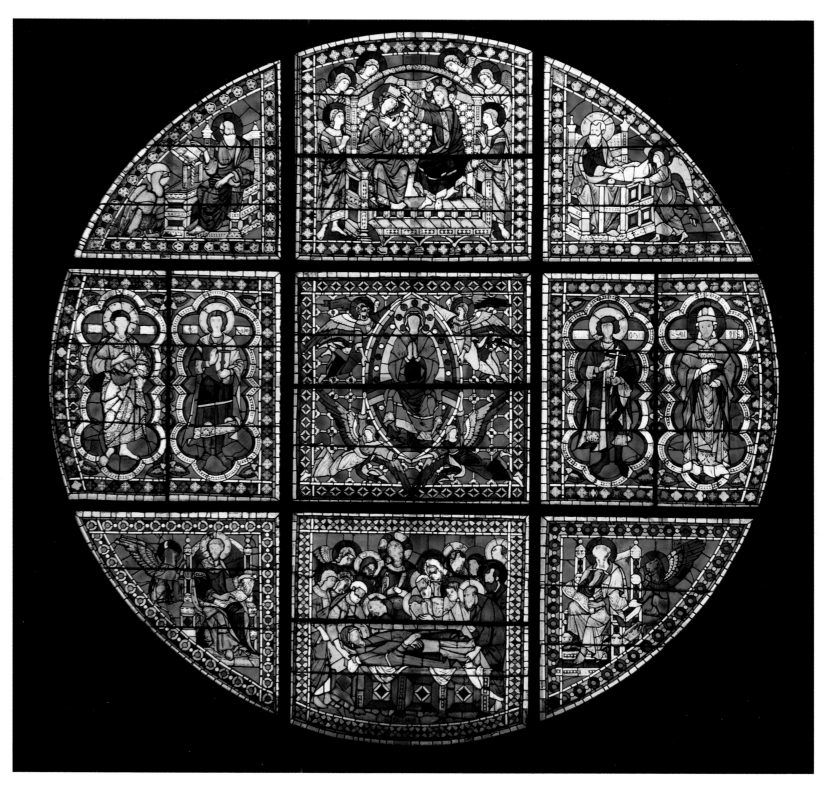

Duccio di Buoninsegna

Siena, c. 1260–1318

The great age of the Sienese School started with Duccio. At the beginning of the fourteenth century Siena was vying with its neighbor, Florence, for political and artistic supremacy in central Italy. A faithful follower of Byzantine painting, Duccio managed to give to his traditionally painted figures fresh humanity and life with his new-found sensitivity to color and line. While his paintings may seem rooted in the Byzantine tradition, we can discern the first signs of the International Gothic art that was to influence Simone Martini and the Lorenzetti brothers.

The most important features of Duccio's work were his supple draughtsmanship and use of clear colors. This was apparent in the *Madonna Rucellai* in the Uffizi (1285) and in the round choir window for Siena cathedral (1288). Although as a young man Duccio probably worked in Assisi, he spent virtually his entire life in Siena. Nonetheless, it appears that he was aware of the new ideas in Florentine art. The delicate Virgins now in Perugia, London, and also Siena provide wonderful examples of Duccio's poetic rendering of feeling. They preceded his masterpiece which encapsulated both his own work and the very spirit of an age in transition. This is the splendid *Maestà* he painted for Siena cathedral, now in the Museo dell'Opera.

Duccio di Buoninsegna
Vetrata con Storie di Maria/Window Showing the Life of Mary
c.1287–88, stained-glass, Siena Cathedral.

This is the oldest and the most important surviving example of Italian stained glass. The technique was widespread across northern Europe, especially in France, but is rare in Italy.

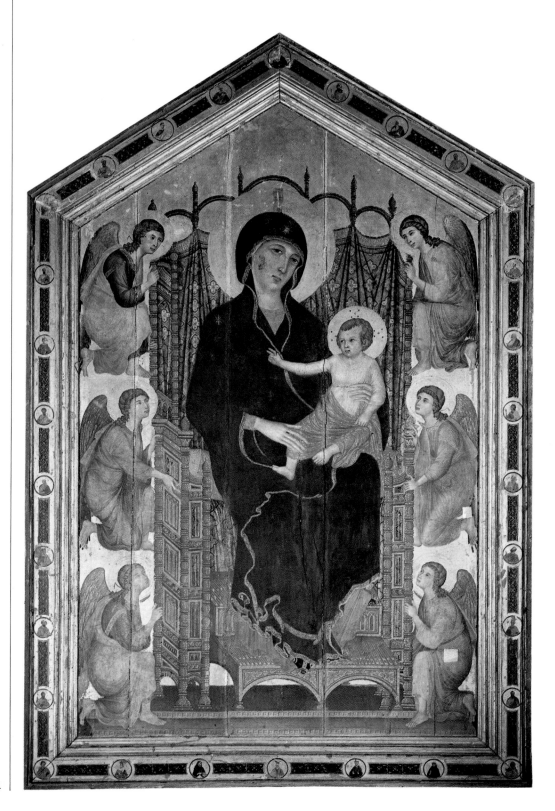

Duccio di Buoninsegna
Madonna Rucellai/Rucellai Madonna

c.1285, wood panel, Florence, Uffizi.

This altarpiece was once attributed to Cimabue but is, in fact, typical of the young Duccio's output. Working within the limits of Byzantine tradition, he created images fascinating for their insubstantial quality that seem held together by magic. The Virgin's robes fall almost sinuously, foreshadowing the elegance of Gothic painting.

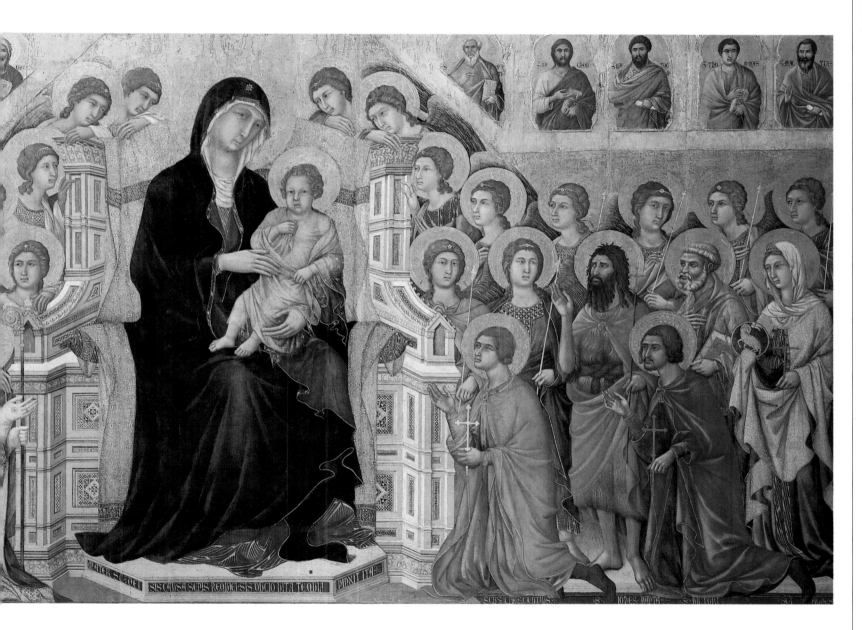

Duccio di Buoninsegna
Maestà (front)

1308–11, wood panel, Siena, Cathedral Museum.

The celebrated masterpiece that the inhabitants of Siena carried in procession from Duccio's studio to the High Altar in the Cathedral, the *Maestà* is a very large and complex picture. Over the years, the original frame and some other parts have been lost, but the main body of the picture is substantially preserved. The front shows a large image of the enthroned Virgin which is still based on Byzantine models. The patron saint of Siena is surrounded by wondering, dreamy angels looking toward her. Set square in the center is the massive marble block with decorations that remind us of the Cosmati work found in many Roman mosaics. The inscription around the base of the throne contains two prayers. The Virgin is being asked to grant peace to Siena and glory to Duccio who has painted the scene.

25

Duccio di Buoninsegna
Maestà (back): Cristo davanti ad Anna e il Diniego di Pietro/Christ Before Anne and Peter's Denial

1308–11, wood panel, Siena, Museo dell'Opera del Duomo.

On the back of the *Maestà* there are scenes from the *Passion of Christ*. Like the front, all of it is in Siena's Museo dell'Opera del Duomo. The museum also contains a few panels from the double altar step showing *Scenes from the Life of Christ and the Virgin* although this was partially broken up and the paintings have been scattered among a number of museums. The scenes from the Passion faithfully follow the accounts of the Gospels. The episodes are laid out in a regular pattern and are painted with a notable elegance. This picture is almost an exception in that it fills a double space. By introducing this clever architectural refinement, Duccio manages to connect the two episodes (the judgment of Christ and Peter's denial) and so emphasizes the work's underlying narrative unity.

Duccio di Buoninsegna
Maestà (back):
Deposizione dalla
Croce/Deposition

*1308–11, wood panel, Siena,
Museo dell'Opera del Duomo.*

Although Duccio's starting
point was the iconographic
tradition of Byzantine
art, on the back of his
altarpieces he always
managed to include details
filled with poetic
sweetness. The painter
endows even the most
tragic episodes with an
almost classical grace.

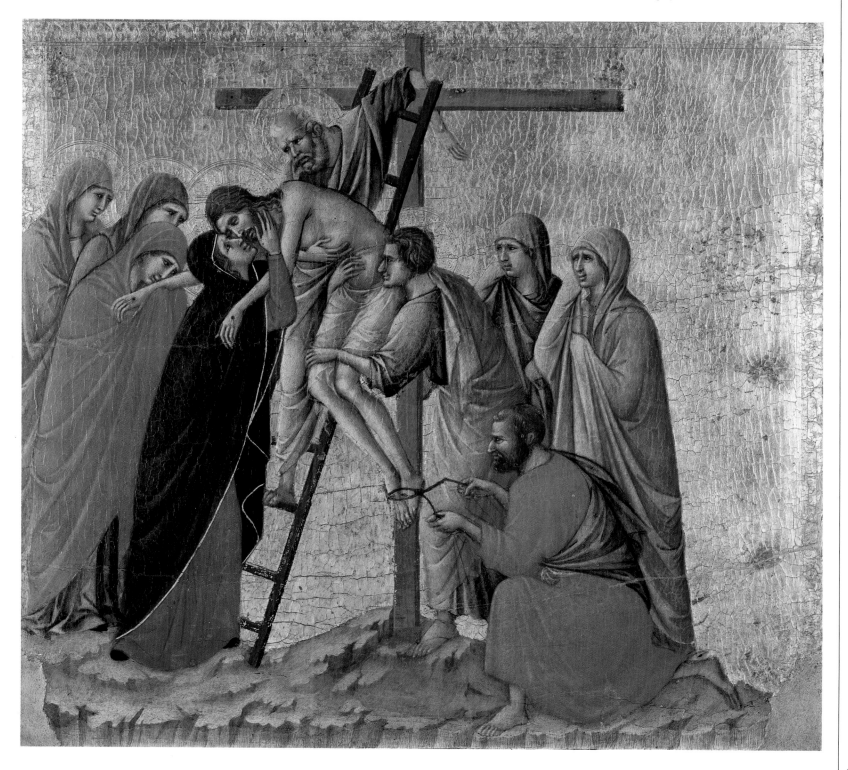

Simone Martini

Siena c. 1284–Avignon 1344

Simone Martini was a seductively refined artist of international importance. His genius lay in anticipating the developments that produced the courtly style of the International Gothic. If the parallel between Giotto and Dante can appear forced, the association of Simone Martini's name with Petrarch is historically and stylistically relevant. Both, the painter and poet, spent long periods in Avignon, and there is an obvious connection between the erotic imagery of Petrarch's poetry and the lyrical sweetness of Simone Martini's painting. The 1317 *Maestà* in Siena's Palazzo Pubblico shows Simone's art as already mature. Immediately after finishing this first masterpiece, he went to Naples. In 1320 he painted the great polyptychs of Orvieto and Pisa, followed by the *Life of St. Martin* in the Lower Church in Assisi. This was his greatest achievement as a creator of narrative scenes. There has recently been controversy over the attribution of the famous *Guidoriccio da Fogliano at the Siege of Montemassi* (1328). Simone Martini balanced realistically solid individual detail against a fabulous background, in *The Annunciation* (1333, Florence, Uffizi), one of the masterpieces of fourteenth-century Italian painting. Simone Martini spent his last years in Avignon, to which the popes had moved. Thanks chiefly to his work there, Avignon became a major center of International Gothic art.

Simone Martini
Maestà

1317, fresco, Siena, Palazzo Pubblico.

This monumental composition marked Simone Martini's debut on the Sienese art scene. Painted a few years after Duccio's *Maestà*, the young artist has reworked the famous image in a delicately Gothic style. He creates an image of the Virgin seated on a throne under a canopy held aloft by saints and decorated patriotically in the black and white colors of Siena.

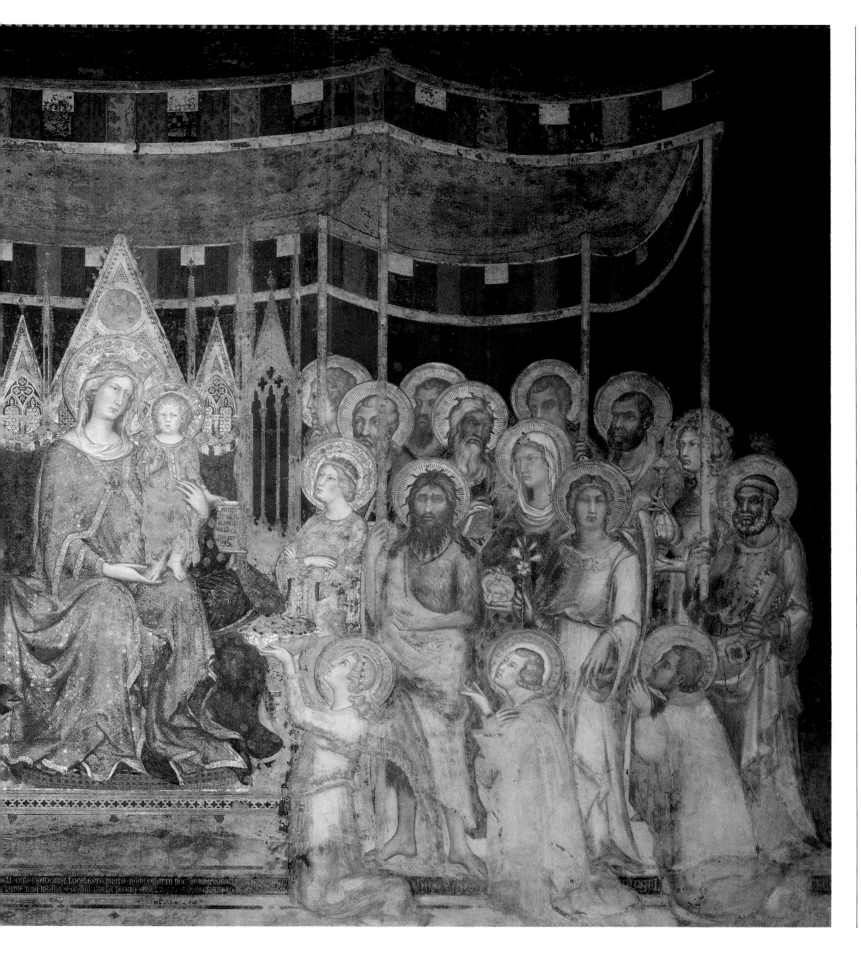

Simone Martini
San Ludovico di Tolosa
incorona Roberto
d'Angiò/St. Louis of
Toulouse Crowning
Robert of Anjou

*1317, wood panel, Naples,
Museo di Capodimonte.*

Simone is considered a
founding father of the
International Gothic style
which became so popular in
royal courts, and this large
Neapolitan panel can be
seen as his prototype. It
introduces a sumptuous
combination of heraldic
elements (the gilded
French fleur-de-lys around
the frame) and ornamental
brilliance. The materials
used are of great intrinsic
value and yet there is a
realistic narrative drive in
the small episodes shown
on the predella. What is
striking is the sophisticated
and extremely elegant way
in which the artist has
controlled his outlines,
handled the capricious folds
of the robes, and given
precise, clear definition to
the contours of the faces
and hands.

Simone Martini
Annunciazione/
Annunciation

*1333, wood panel, Florence,
Uffizi.*

This is Simone's masterpiece
and perhaps the greatest
work of the International
Gothic. Unlike his fellow
Sienese artists, Pietro and
Ambrogio Lorenzetti,
Simone did not bother with
the architecture of his
backgrounds nor experiment
with perspective. Instead, a
sea of gold surrounds the
aristocratic profiles of the
two main characters, while
a vase of lilies in the center
adds an extra touch of
elegance. Birds' wings,
leaves, draperies, and more
lilies decorate the work,
almost obscuring the
relationship between an
elegant, imploring Gabriel
and an exquisite, reluctant
Mary.

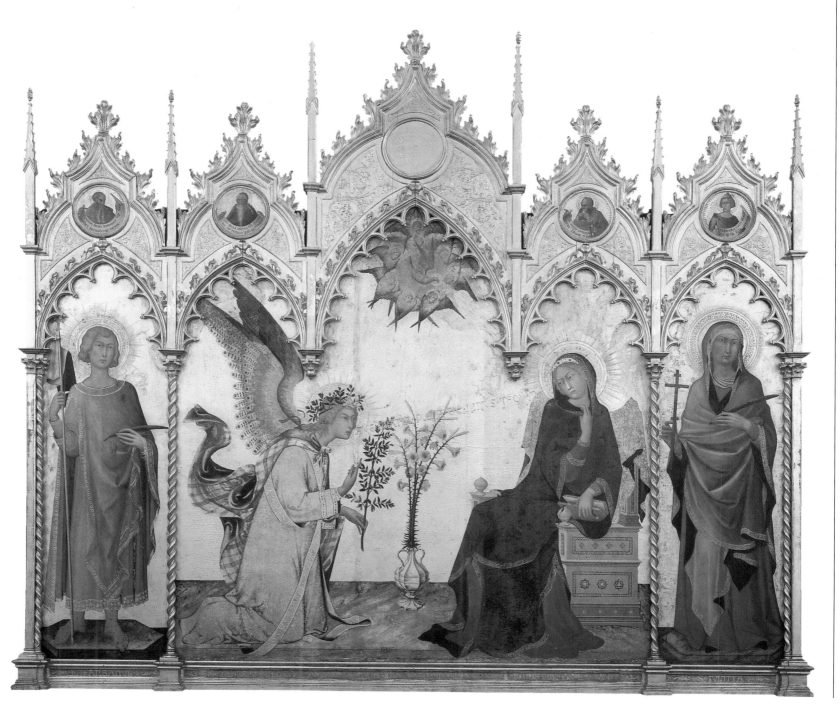

Pietro Lorenzetti

Siena, c. 1280–1348

Little is known of the life of Pietro Lorenzetti, but he was probably Ambrogio's elder brother and, like him, influenced by Duccio. However, the two brothers usually worked independently. Pietro painted ambitious fresco cycles and polyptychs – not just for his native Siena – which represent the more monumental and dramatic side of Sienese art. His early work (such as *Madonna and Child* in the Cortona Museo Diocesano) reveals a precocious and intelligent interest in Giotto's output. This resulted in solemn figures clearly defined in space. He became established thanks to the well-preserved *Polyptych* (1320) in Pieve of Arezzo. During the 1320s he went on to receive commissions from important patrons. His frescos of the *Stories of the Passion* and the *Virgin of the Sunsets* in the left transept of the Lower Church in Assisi (1324-25) are of striking complexity. The same is true of the frescos he painted immediately afterwards for the Sienese church of St. Francis. These works and the wood panels he painted in the same period are imbued with a noble and severe sense of composure. He started effectively to place groups of people against three-dimensional backgrounds and developed this further during the following decade (*Humilitas Altarpiece*, Florence, Uffizi; *Madonna Enthroned*, Siena, Pinacoteca Nazionale). Even though his scenes tend to be austere and symmetrical (unlike his brother Ambrogio's pleasant narrative vein), Pietro always included realistic details of clothing and objects. He was also able to capture the way people look at each other. He usually concentrated a lot of description and animation into the altar step (predella), such as the enchanting episode depicted in the Carmelite predella now in the Siena Pinacoteca Nazionale. It was only toward the end of his career that Pietro developed his considerable narrative powers which were delicately and tenderly expressed in one of his masterpieces, a triptych dedicated to the *Nativity of the Virgin* (1342, Siena, Museo dell'Opera del Duomo).

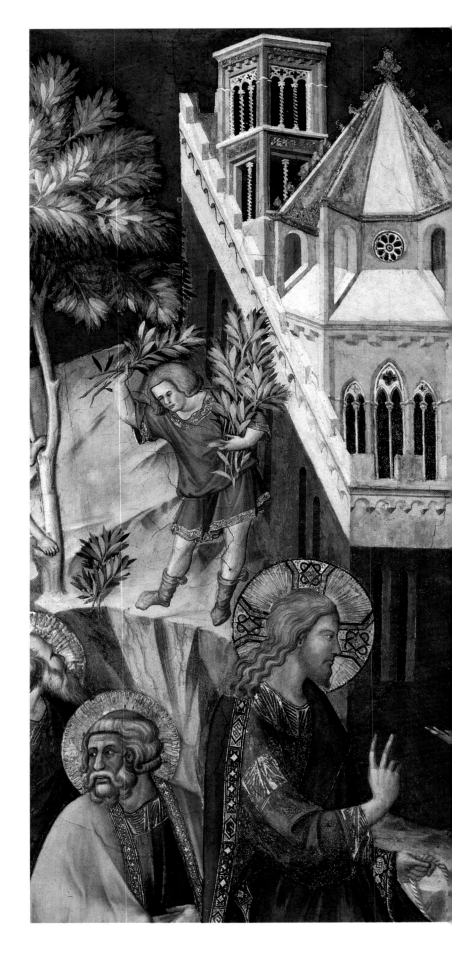

Pietro Lorenzetti

Ingresso di Cristo in Gerusalemme/Entry of Christ into Jerusalem

detail, c. 1320, fresco, Assisi, St. Francis, Lower Church.

Pietro Lorenzetti's frescos in Assisi can be seen as Siena's answer to Giotto's art. His debt to Duccio is especially clear in both the characters' faces and their gestures, but is set against his own highly complex and ambitious architectural backgrounds.

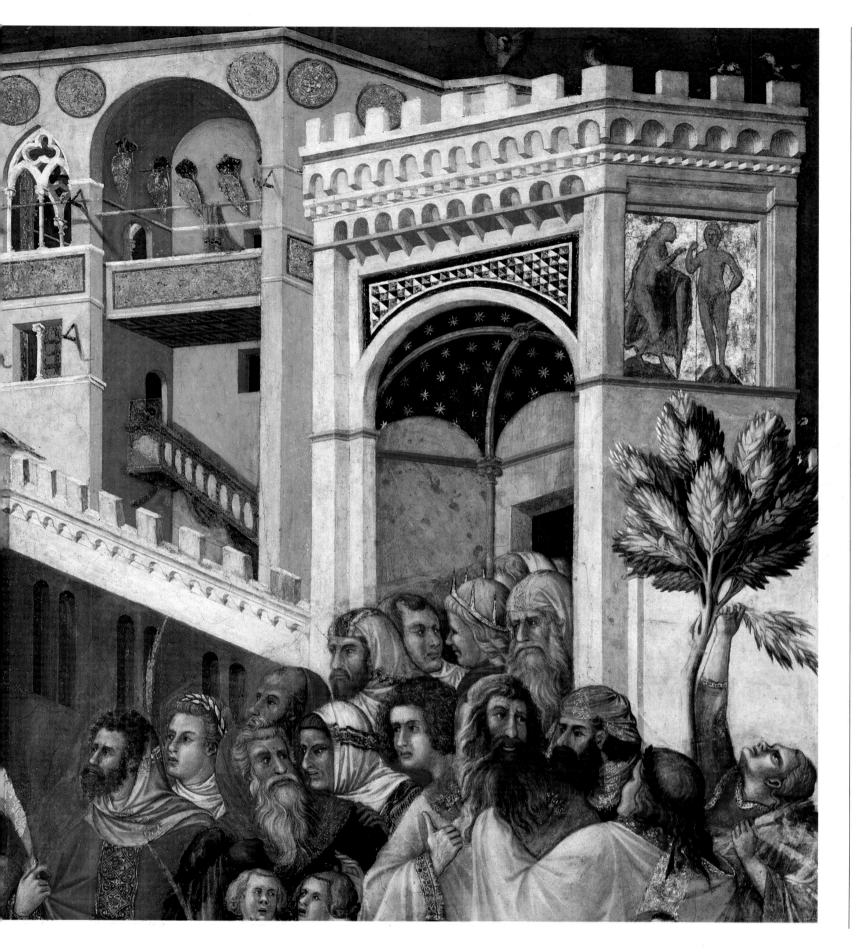

Pietro Lorenzetti
Polittico/Polyptych

*1320, wood panel, Arezzo,
Pieve di S. Maria.*

This has fortunately been
preserved in its entirety and
is still in its original setting.
It is a fine example of a
fourteenth-century
polyptych which centers
around the image of the
Virgin and Child. The size
of the figures shown in the
various tiers gradually gets
smaller. The influence of
Giotto is here less obvious
than Duccio.

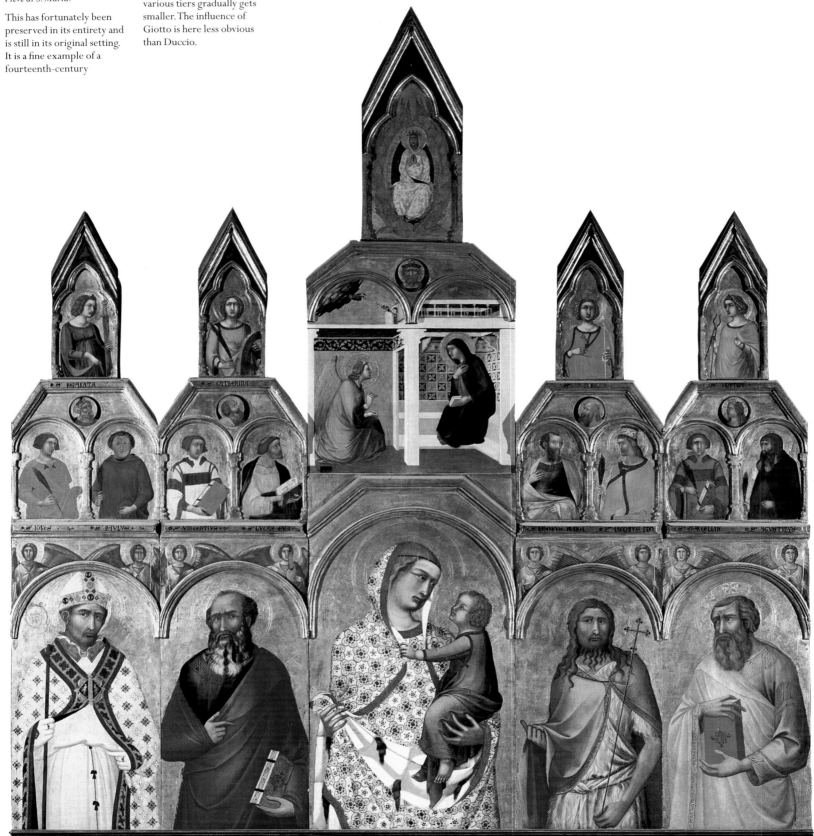

Pietro Lorenzetti
Nascita della Vergine/The Birth of the Virgin

1342, wood panel, Siena, Museo dell' Opera del Decomo.

In this late work Pietro was definitely moving toward depicting everyday reality with some attempt at capturing perspective. The continuity between the spaces (for instance, the ceilings or St. Anne's bed) becomes more important than the apparent divisions in the triptych. The way the characters move and the feelings they show reveal a truth that is both moving and touching.

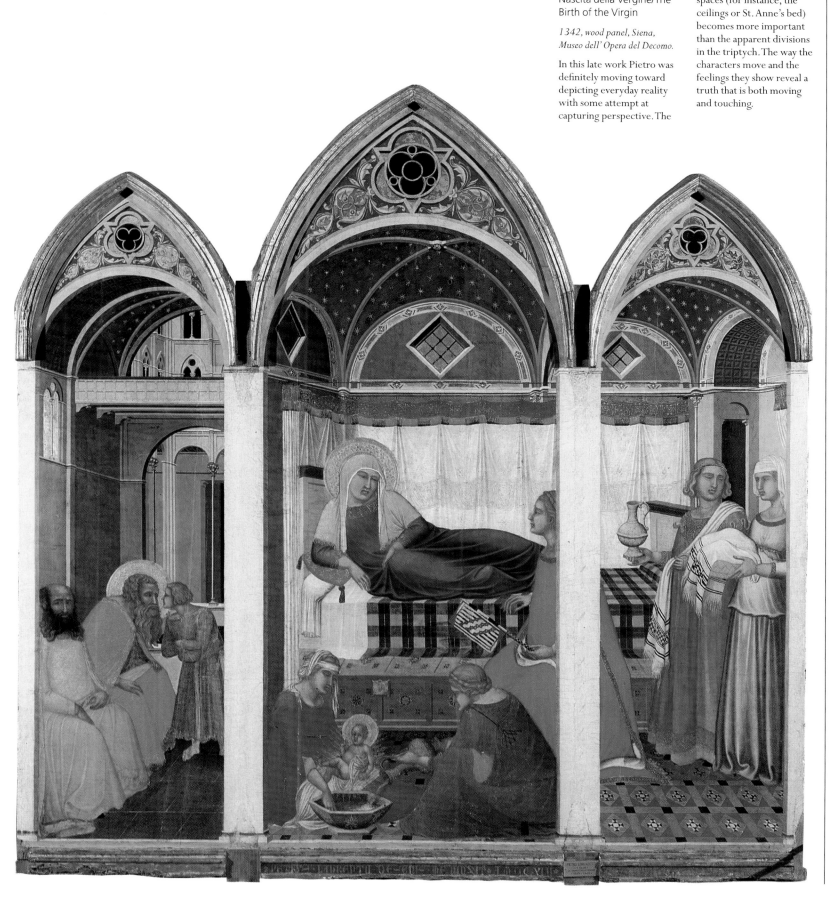

Ambrogio Lorenzetti

Siena, active between 1319 and 1348

It is not uncommon to find two brothers whose careers run at times together but who are really quite different in style. The Lorenzetti brothers provide a classic example: Pietro's robust solemnity is countered by Ambrogio's cheerful amusement with all aspects of life which enabled him to turn reality into fable and, vice versa, to give concrete, tangible form to divine characters or abstruse political allegories. In both cases, the brothers' artistic progress started with Duccio. They pursued separate paths, Ambrogio being notably more of an innovator, only linking up again in the 1340s. They then shared the same terrible fate, both probably dying from the Black Death in 1348. Although he always remained one of the finest representatives of Sienese art, Ambrogio Lorenzetti established crucial contacts with Giotto and artistic circles in Florence where he probably lived between 1319–27. His early work was fairly static in depicting gesture, even though his use of expression was already observant. During the 1320s Ambrogio's confidence grew until he was ready to produce monumental works (*Maestà*, Massa Marittima, Palazzo Comunale) for particularly complex environments (*Presentation at the Temple*, Florence, Uffizi), as well as scenes with a dynamic content (frescos in the church of St. Francis in Siena and in the S. Galgano Chapel at Montesiepi). Alongside these, there are also lesser but nonetheless charming works such as the *Madonna of the Milk* in the Archbishop's Palace in Siena. The masterpieces that sum up his achievements are the allegories *Good and Bad Government* in the Siena Palazzo Pubblico (1337–39). They depict scenes from everyday life, crammed with incidents and yet newly naturalistic in his treatment of architecture.

Ambrogio Lorenzetti
Effetti del Buon Governo in città e nel contado/
Good Government

detail, 1337–40, fresco, Siena, Palazzo Pubblico, Sala dei Nove.

This is perhaps the most famous and impressive image of a medieval city ever painted. The towering cityscape forms the backdrop to the swarming activity of its citizens, from builders on the roofs to merchants, a school teacher and the group of girls dancing happily in the foreground. This panorama of a whole society was truly original.

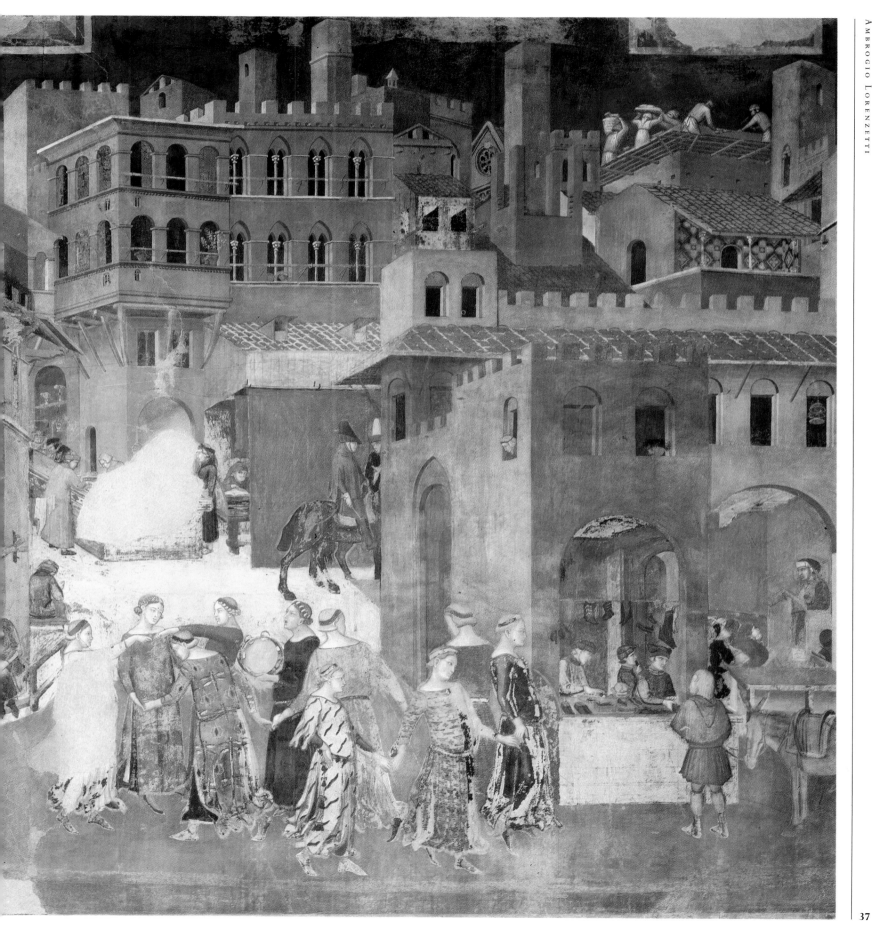

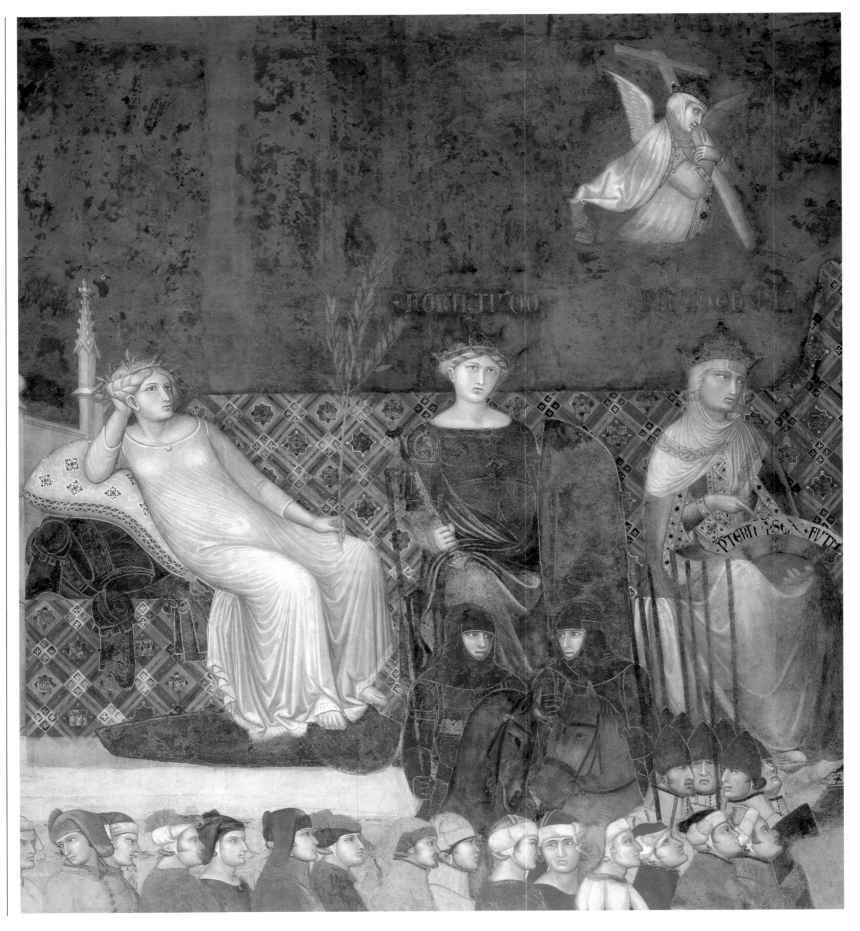

Ambrogio Lorenzetti
Allegoria del Buon
Governo/Allegory of
Good Government

*detail, 1337–40, fresco,
Siena, Palazzo Pubblico,
Sala dei Nove.*

An allegorical composition
fills the lower part of the
walls of the chamber. It
symbolically shows the
citizenry trustingly
gathered around a paternal
and reassuring image of
Good Government flanked
by the figures of the
Virtues. Ambrogio has
managed to turn a political,
if celebratory, image into a
living and breathing picture
of real people. Even the
symbolic figures seem alive
and believable. The figure of
Peace is particularly
fascinating as she reclines
languidly on the left.

Ambrogio Lorenzetti
Annunciazione/
Annunciation

*1344, wood panel, Siena,
Pinacoteca Nazionale.*

In this late and highly
finished work, Ambrogio
abandons his usual earthy
depiction of realistic and
human detail in favor of
emphasizing the almost
Gothic elegance of the two
characters. They face each
other across a floor that is,
however, painted in
rigorous perspective.

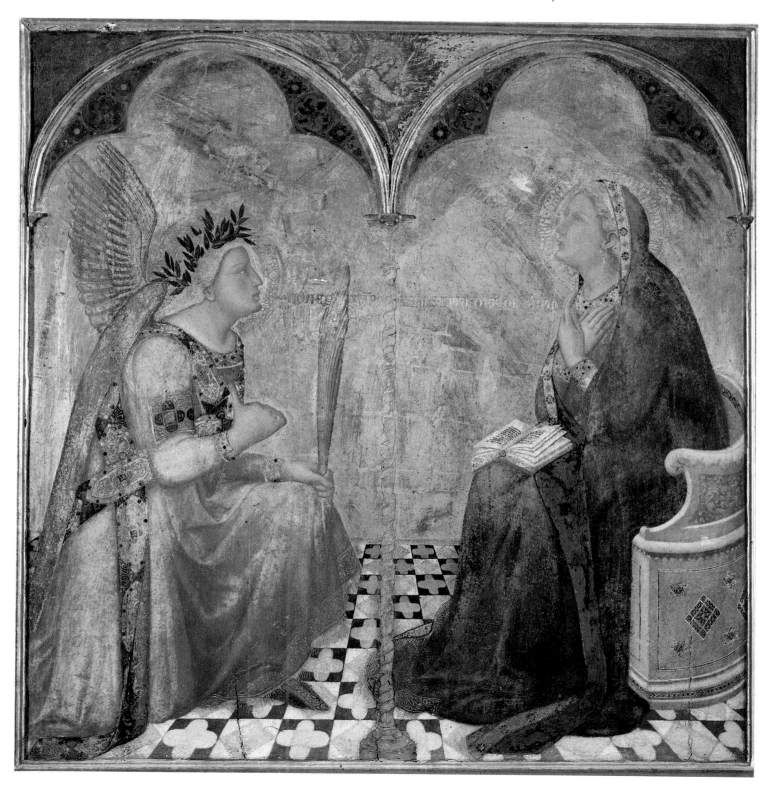

Vitale da Bologna
Vitale di Aimo de' Cavalli, active from 1330, died before 1361

A major artist of the minor fourteenth-century Emilian school, Vitale da Bologna absorbed and adapted a range of influences. He combined the narrative skill of the Rimini school with the refinement of the Sienese and Giotto's nobility. On a general level, he possessed the expressive and dynamic realism of Bolognese painters and illuminators. Most of Vitale's work was carried out in Bologna itself toward the middle of the century (*Madonna of the Teeth*, 1345; *Polyptych* in the church of S. Salvatore, 1353; frescos in S. Maria dei Servi, 1355). Vitale also made a number of significant journeys to Pomposa and Udine where, with the assistance of a well-equipped studio, he painted a number of fresco cycles. A minor masterpiece is his *St. George and the Dragon* now in the Bologna Pinacoteca Nazionale. In this work his attempt to portray action and expression leads to the forced contortion of the horse. There has been heated critical debate over the frescos removed from the church at Mezzaratti, now also in the Bologna Pinacoteca Nazionale. They can be regarded as an important monument to the Emilian school in which Vitale interacted with other painters.

Vitale da Bologna
Madonna col Bambino (Madonna dei denti)/
Virgin and Child (Madonna of the Teeth)

1345, wood panel, Bologna, Museo Davia-Bargellini.

The lively nature of the Bolognese paintings of the fourteenth century is easily perceived in the narrative scenes of fresco cycles (nearly all of which, however, are in a poor state of conservation) and in the illuminated miniatures. Vitale managed to convey this nature in his images, not through the action, but through the looks and gestures of his characters. To this he adds a whole range of highly decorative elements and an expressively rich use of color.

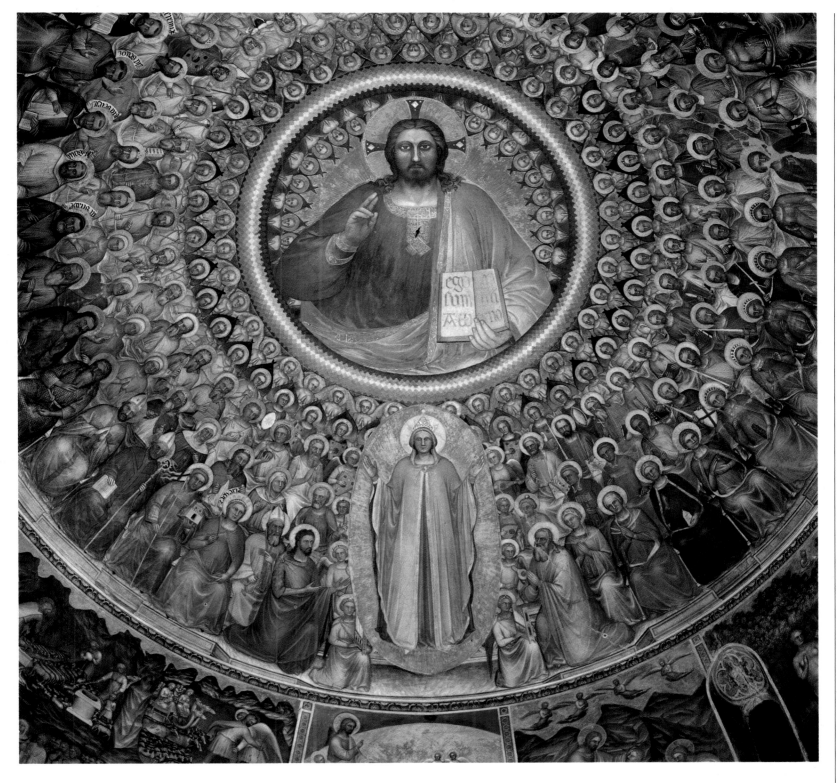

Giusto de' Menabuoi

active in the second half of the fourteenth century in Lombardy and Padua – Padua, 1391

There are still many things we do not know about the life and works of this important artist. It is possible that he left Tuscany for northern Italy to escape the plague in 1348. Toward the middle of the century we find him in Milan, which escaped the first wave of the Plague and was still reverberating from Giotto's stay there. In his frescos for Viboldone Abbey, Giusto took up Giotto's legacy. In turn these frescos were immediately seized upon as an example for the local school. So it was that Giusto became the link in the chain joining the solemnity of Giotto's lesson to the narrative spirit of Lombard and Venetian art. Due to the frescos he painted for the Paduan church of the Eremitani, in 1370 he was made a Paduan citizen. He left important works in the town, such as the frescos in the Baptistery (1376) and in the Belludi Chapel of the Basilica del Santo (1382). He also became a source of inspiration for Altichiero.

Giusto de' Menabuoi
Paradiso/Paradise

1375–76, fresco, Padua, Battistero.

41

Altichiero

Verona c.1330, active in Verona and Padua from 1369 to 1384

Altichiero was one of the outstanding artists of Venetian painting in the second half of the fourteenth century. He can be considered as the founding-father of the Veronese Gothic school, delighting in elaborate naturalistic details, although he was influenced by Giotto's work at Padua. Confirmed facts about the artists are few. He was active in Verona in 1369. Ten years later he was recorded in Padua when he was paid for the S. Felice Chapel frescos in the Basilica del Santo. In his two most important fresco cycles (S. Felice Chapel in the Basilica del Santo and the Oratory of S. Giorgio, both in Padua, 1379 and 1384), Altichiero worked together with Avanzo. The artist's hand can be identified in the design of the natural or architectural backgrounds. Altichiero alone was responsible for the votive frescos in the Cavalli Chapel in S. Anastasia in Verona and in the church of the Eremitani in Padua.

Altichiero
Presentazione della famiglia Cavalli alla Vergine e al Bambino/ Virgin Being Worshipped by Members of the Cavalli Family

c. 1370, fresco, Verona, S. Anastasia, Cavalli Chapel.

Partially ruined by the insertion of a canopied tomb in about 1390, the fresco is the collective votive offering of the Cavalli family from Verona. The men of the family, in armor, are before the Virgin. The family's patron saints accompany the faithful and their nonchalant movements contrast wonderfully with the stiff votive posture of the kneeling knights. The setting is also splendid, showing an imaginary fourteenth-century palace complete with galleries and pavilions.

On the opposite page
Altichiero
Decollazione di san Giorgio/Execution of St. George

c. 1380, fresco, Padua, Oratory of S. Giorgio.

Frescos showing scenes from the life of St. George decorate the walls of the chapel built by the Lupi family, who were counts of Soragna, in the sacristy of the Basilica del Santo. Once more Altichiero worked together with Avanzo, a Paduan painter with whom some years earlier he had painted the frescos in the St. Felice Chapel in the right transept of the Basilica del Santo. Here Altichiero shows most interestingly the influence of Giotto in the solidity of his groups of figures posed in large natural spaces. He achieves brilliant results with this technique, softened by Gothic details. In addition to this, the Veronese painter took pains to portray everyday feelings. Notice the way the father takes his son away from the scene of the macabre torture.

The 15th Century

Masolino da Panicale

La guarigione dello zoppo e la risurrezione di Tabita/The Healing of the Lame Man and the Raising of Tabitha

Detail, 1424–25, Florence, S. Maria del Carmine, Brancacci Chapel

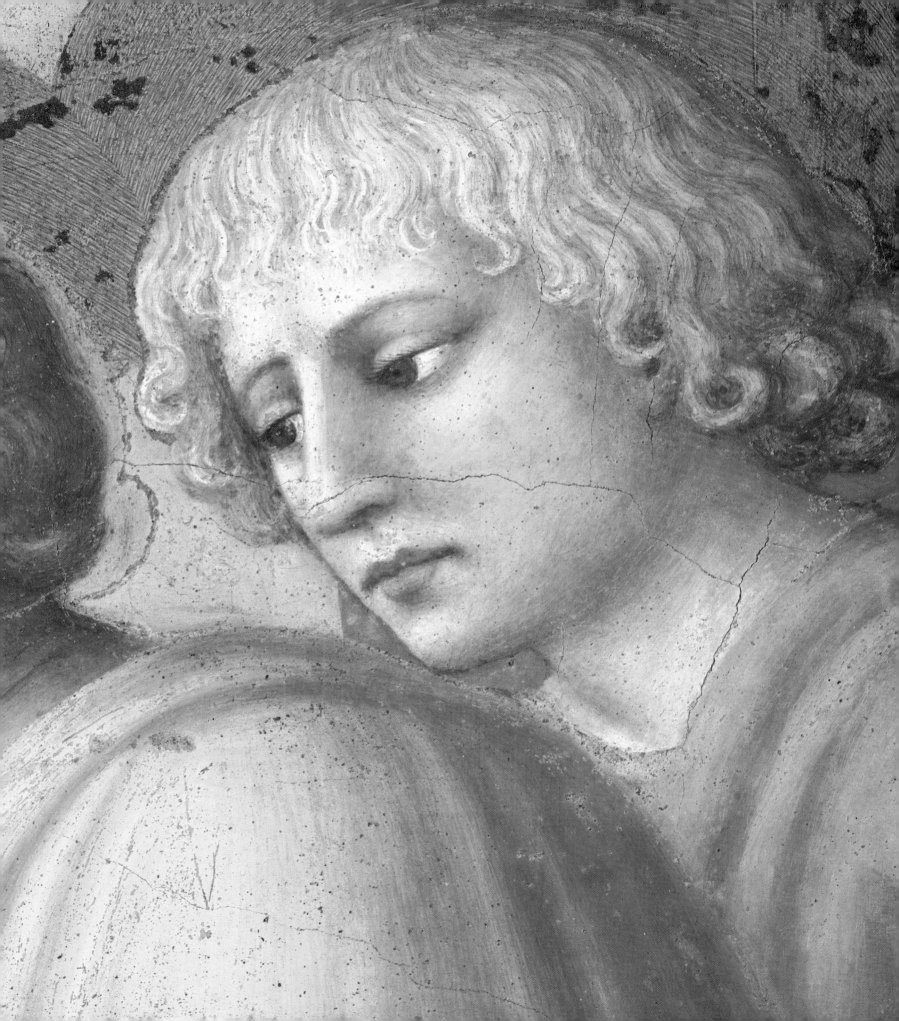

Gentile da Fabriano
*Polittico di Valleromita:
Maddalena/Val Romita
Polyptych: Mary Magdalene,*
c. 1400–10, wood panel,
Milan, Brera.

Masaccio's classical nobility, Piero della Francesca's elegant geometry, Fra Angelico's enchanting purity, Botticelli's wistfully gracious allegories, Mantegna's hard-edged monumentality: these are among the most famous images of the Quattrocento (fifteenth century) in Italy. They all use the solemn yet cheerful language of the Renaissance, with its deliberate rediscovery of classical Greek and Roman art and culture. Whether in the tranquility of private studies, in the lecture halls of universities, or in the most fashionable courts, artists and writers created one of the deepest and longest-lasting cultural transformations that the world has ever seen. Without lessening their intense religious feelings (and it was a deeply religious age), the fifteenth-century artists broke loose from medieval shackles. They turned their attention out to the natural world, so often rejected by medieval men, and took an active role as responsible players in the world and its history. Christopher Columbus' undertaking can be seen almost as the symbolic seal on a century that felt no fear of the unknown and embraced discovery. But, significantly, Columbus was not trying to discover a new world but to find a new way to an old one, that of Asia. So, too, did most Quattrocento scholars and artists attempt to rediscover the lost world of Antiquity. In triumphantly doing so, they created an utterly new world.

It is difficult to avoid the clichéd but fascinating comparison between Lorenzo the Magnificent's Florence or the splendid court of Federico da Montefeltro in Urbino with classical Athens at its zenith under Pericles in the fifth century B.C. The first Greek Humanism, with its belief "Man is the measure of all things" is the key to the Renaissance, a civilization which also placed human beings at the center of the universe and which exalted culture and art. This was achieved through the creativity of architects, painters, and sculptors who applied an ideal of perfect geometry to the correct "imitation" of nature. It was also made possible by the passionate and indeed courageous patronage of dukes, bishops, republics, and cities, prepared to back radical commissions.

If we look at Italian civilization in the fifteenth century, we see something thrilling, not only because of the intellectual attempts to rediscover the classical world. Indeed, the greatest fascination of the early Renaissance lies in its variety and the continuous contrast between very different forms of expression. This artistic and cultural plurality was encouraged by the complex political structure in Italy, split between countless city states and principalities. This diversity assumes particular significance when we take into account the vital role of enlightened patrons in the

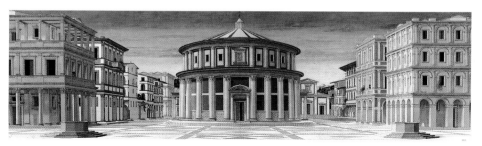

Piero della Francesca (?)
*Veduta di città ideale/
Perspective View of an Ideal
City*, c. 1475, wood panel,
Urbino, Galleria Nazionale
delle Marche.

Piero della Francesca
Flagellazione/The Flagellation
1450–60, wood panel,
Urbino, Galleria Nazionale
delle Marche.

Sandro Botticelli
*Venere e Marte/
Venus and Mars*, 1483,
wood panel,
London, National Gallery.

fifteenth century. Their awareness of the "political" role of the image shaped and conditioned expressive choices and specific iconographies. The republics of Venice and Florence, among others, emphasized the part that all citizens had to play in government and administration (even though, in fact, in both cities aristocratic oligarchies held power). In other centers great and small, the courts of the local princes were experiencing their moments of greatest splendor. Just after the middle of the century, the Peace of Lodi (1454) confirmed the dominance of five main states (the duchy of Milan, the republics of Venice and Florence, the Papacy in Rome, and the Kingdom of Naples). But smaller states could still hold the balance between their bigger neighbors and so had potential importance.

Fifteenth-century painting in Italy witnessed the flowering of numerous local schools. Each was capable of coming up with fresh, innovative ideas thanks to their relative freedom of expression and the open dialogue with other cities. In this way, a relationship grew up between centers and outlying districts which provided the impetus for all the most important moments of Italian painting. In concrete terms, this can be seen in the rich, widespread presence of works of art right across the country. No other century gives such a clear picture of the underlying characteristics of Italian painting and by which it can be identified. The belief in the intrinsic dignity of human beings led to harmonious spaces, based upon mathematical laws, into which all figures seem to fit perfectly. Italian painting in the fifteenth century above all breathes the air of superbly well-calculated proportion. No one aspect of a painting dominates the others, every part is in relationship to the whole. Even violent expressions and feelings seem to be portrayed with controlled composure. The "waning of the Middle Ages" merges almost imperceptibly with the dawn of modern humanity.

Trying to condense the main lines of the history of painting, we can hazard the sweeping statement that the first years of the century's art seems covered in the gold, gems, and precious flowers of International Gothic. Gentile da Fabriano is the most elegant of those who worked in this vein. He is also someone who reminds us of how frequently fifteenth-century painters traveled. This, combined with the influx of foreign works and artists, meant that comparisons and modernization were part of a continuous process. By checking the dates, we can understand how frenetic the pace of innovation must have been. In 1423 Gentile da Fabriano painted his masterpiece (*Adoration of the Magi* for S. Trinita) in Florence. The following year Masolino and Masaccio started work on the frescos in the Brancacci Chapel at S. Maria

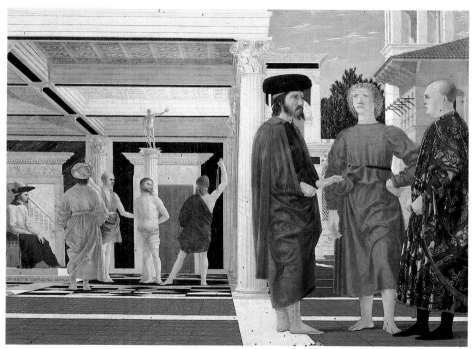

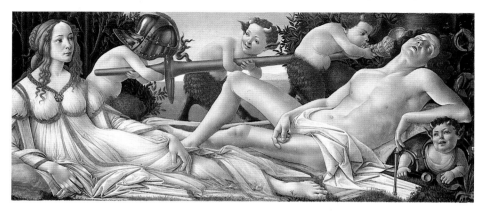

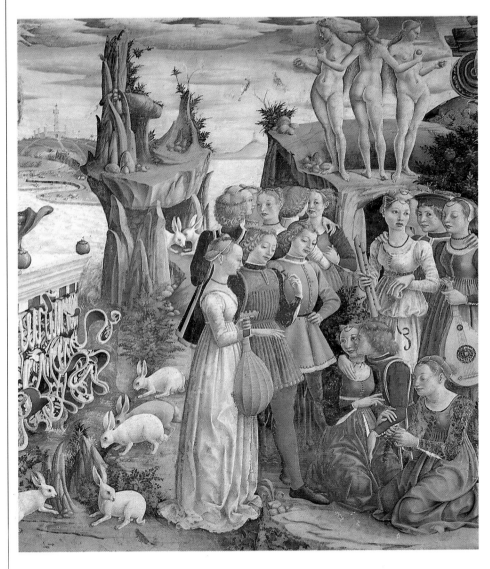

Francesco del Cossa
*Trionfo di Venere/Triumph
of Venus*,
detail, 1469–70, fresco,
Ferrara, Palazzo Schifanoia,
Salone dei Mesi.

del Carmine, situated on the other side of the Arno. Only a few months and a few hundred yards separate the most splendid flowering of International Gothic and the revolutionary, unadorned, terse exaltation of the human figure that Masaccio created.

In Florence, Masaccio's radicalism (at much the same time as Donatello was transforming sculpture and Brunelleschi modernizing architecture) swiftly molded the vocabulary of a new generation of young artists. From the 1430s onwards, painters such as Fra Angelico, Paolo Uccello, and Filippo Lippi searched for a personal compromise between Masaccio's cogent, neo-Giottesque austerity and the still widespread taste for rich and complex images. One major innovation can be noticed at once. Gold backgrounds disappeared and were replaced by sweeping landscapes or realistic architectural backdrops. Similarly, the polyptych was replaced by the "tabula quadra" [square picture] as a single altarpiece in which all the characters were involved in the same scene. An excellent example of the new formula applied to the *Sacra Conversazione* is Domenico Veneziano's *Altarpiece of St. Lucy of the Magnolias* which is outstanding for its nobility.

Meanwhile, courts in southern and northern Italy alike were exploring the contrasts with art from northern Europe, in particular Flemish and Provençal painting. This comparison between Italian masters and the influx of work from north of the Alps was typical of the last period of Gothic art in Naples and Milan. However, it bore different results in the two cities. Pisanello, one of the greatest painters of the day, traveled constantly between Verona, Mantua, Ferrara, Venice, Milan, Rome, and Naples. Such movement encouraged the transition of taste in the splendid aristocratic courts away from International Gothic toward the Renaissance rediscovery of ancient art. While in Florence painters in the early fifteenth century concentrated above all on the human figure and on the quest for an "ideal city," fashioned in clear and pure architectural forms, in some courts artists still depicted plants and animals, customs and landscapes, feelings and relationships with highly detailed, intricate craftsmanship. In fact, this type of courtly art complemented the Tuscan artists' work in defining the rules of three-dimensional vision, which could sometimes become almost too cerebral. It took the truly universal genius of Leonardo da Vinci to bring the two strands together at the end of the century. On the other hand, Florence itself was not entirely resistant to the charms of an art rich in detail and narrative content, as shown by Benozzo Gozzoli's fresco of the *The Journey of the Magi* for the private chapel in the Medici Palace.

In northern Italy, a complete understanding of the rules of perspective was reached when Donatello worked for a time in

Padua. By 1450 this Venetian city had become the most advanced northern center of new creative ideas, although this advance depended on visiting Tuscan masters as much as the young, talented northern painters working in Padua. This led to an explosion in differing local styles. An example of this is the odd and highly original painting turned out in Ferrara by Cosmè Tura and Francesco del Cossa (whose frescos in Palazzo Schifanoia provide a fascinating testimony of their work). Another is the highly decorative refinement of Carlo Crivelli's work in the Marches. Above all, this was the period that gave us the archeologically accurate but highly dramatic genius of Andrea Mantegna. The Bridal Chamber in Mantua marks a new era in the style of Italian courts. Gone is all gorgeous late-Gothic love of ornament. Instead we have solemn and highly intellectual Renaissance images. The most complete example of a Renaissance court, however, was the Ducal Palace built by Federico da Montefeltro in the small city of Urbino. With visionary patronage, the Duke brought men of letters, Renaissances, architects, and painters from all parts of Italy to Urbino. Each made his contribution to an international dialogue on art on the highest level, but the outstanding figure in Urbino was surely Piero della Francesca. He produced works, such as the *Montefeltro Altarpiece* now in the Brera Gallery in Milan, that are unsurpassable models of how form and color can be blended into mathematical perspective. But, perhaps unsurprisingly, his austere geometrical art was not widely popular.

By the 1470s knowledge of perspective and how to paint a three-dimensional image had almost certainly penetrated every corner of Italy. Although the manner differed from place to place, by this date a revolution in painting had already taken place. In Florence, this was the age of Botticelli. Thanks both to the Medicis'

Domenico Ghirlandaio
Nascita di Maria/Nativity of the Virgin,
1486–90, fresco, Florence, S. Maria Novella, choir.

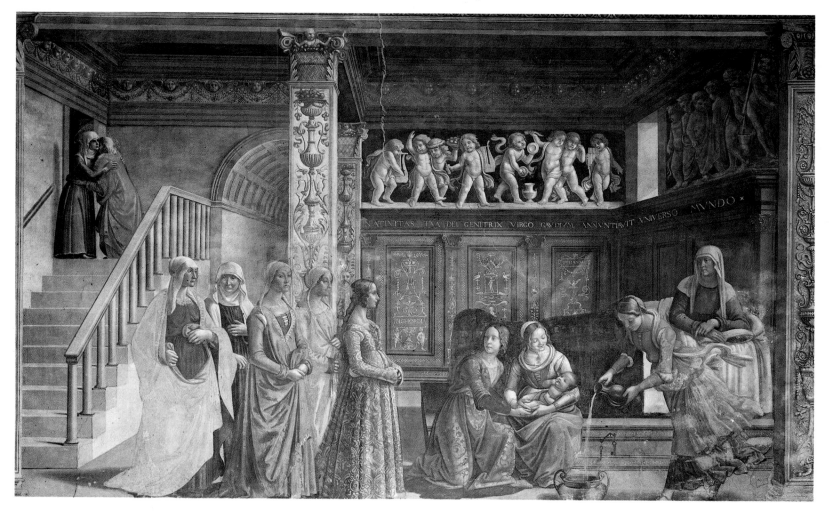

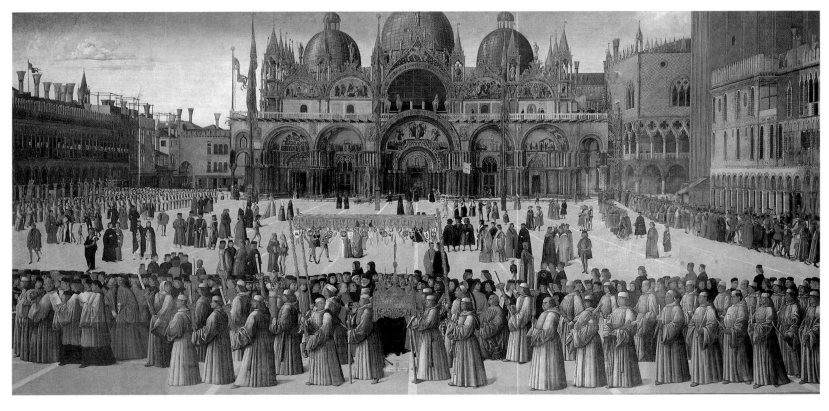

Gentile Bellini
Processione in piazza San Marco/Procession in Piazza San Marco,
1496, canvas, Venice, Gallerie dell'Accademia.

support and the sophisticated philosophical and esthetic Neoplatonism of their circle, Botticelli produced huge pagan allegories, such as *Spring* and the *Birth of Venus* marked by powerful, elegant but clear design, not without a Gothic grace. These masterpieces epitomize the Golden Age of Lorenzo the Magnificent. In 1475, Antonello da Messina arrived in Venice, fresh from contacts both with Flemish painting, which had pioneered the use of oil paints, and the work of Piero della Francesca. Thanks to Antonello's time in the city of the lagoons, the Venetian school abandoned the last vestiges of Byzantine art and Gothic tradition and began their own new, long-lasting and distinctive Renaissance. The main artist in this phase was Giovanni Bellini, who laid the foundations of Venetian painting and shaped its essence. Giovanni Bellini can, in fact, be credited with being the first artist to depict fully all the subtleties of atmospheric light and shadow. At first his example was only taken up partially by Vivarini and Carpaccio, not being developed in full until the start of the following century through Giorgione and Titian's early work.

A true Renaissance school of art also grew up in Milan under the Sforza dukes, thanks initially to the work of Vincenzo Foppa and Bramante, but they were soon eclipsed by Leonardo da Vinci who, arriving in 1481, effectively created the Milanese School. After a long period of crisis, when the Popes were either absent or far too busy with political problems to act as art patrons, Rome also began to reclaim its role as a great cultural center. Pope Sextus IV built the Sistine Chapel which was decorated around 1480 by artists such as Botticelli, Ghirlandaio, Perugino. This represented one of the triumphs of sophisticated but elegant Quattrocento painting, devoid of all harshness. Perugino's sweet and very urbane style was extremely popular throughout Italy. It was from this high plateau of artistic excellence that Raphael would soon soar.

There are two other important factors to bear in mind. The first concerns the technical developments that took place in painting and in the equipment artists used. At the start of the fifteenth century, monumental painting fell exclusively into one of two categories: frescos or wood panels. There was a marked preference for polyptychs on a gold background, framed in richly carved surrounds. These were the most widespread type of late-Gothic painting. The progressive growth in the acceptance of the view that art should imitate reality led to gold backgrounds being replaced by landscapes and to the fragmented device of the polyp-

tych being abandoned in favor of large single pictures. An ever-growing number of patrons, many of whom commissioned work that was no longer exclusively religious in nature, welcomed even further developments. Equally important after the middle of the century, and thanks mainly to Antonello da Messina, the use of oil as the preferred medium began to gain favor throughout Italy. Within two generations it had replaced traditional color techniques using tempera (made of egg yolk, quick drying and so ideal for fresco work but less capable of expressing atmosphere). Oil initially was used for small-scale works such as portraits, but was later used for altarpieces too. Some artists like Botticelli at times worked in a mixture of the two mediums.

The second factor concerns the role of the artist in society. In the previous century, some masters such as Giotto had already begun to raise the status of artists, but in the early fifteenth century the social rank of painters remained fairly low, on a par with specialized craftsmen. Painting was considered one of the "mechanical arts" in which manual dexterity was the most important consideration. The mechanical arts were contrasted unfavorably with the liberal arts which were based on writing and the intellect. Artists' studios across Europe in the fifteenth century were more like workshops or factories than libraries. They turned out not only paintings, but many other products: decorated furniture, costumes, heraldic shields, the trappings for public holidays, flags and so on. But in Italy the way that artists increasingly took part in the cultural and philosophical debate (Leon Battista Alberti and Piero della Francesca being two typical examples) led to major social developments which had almost no parallel in other countries.

During the Renaissance, Italian painters became intellectuals, taking part in dialogues with their patrons and with men of letters. They did not merely carry out a work but also claimed the right to discuss its underlying ideas. This should be borne in mind when we consider the perennial greatness and importance of a century in which art above all else contributed to giving humanity a new horizon, and perspectives hitherto undreamed of. The ideals of fifteenth-century humanism, seen from a distance of five hundred years, may appear Utopian. Its premises of universal harmony and the restoration of a civilization governed by serene, rational thought were only partially achieved even at the zenith of the Renaissance. Nevertheless, through its marvelous accomplishments, it left to humanity one of the few periods in art that has lastingly exalted the human spirit.

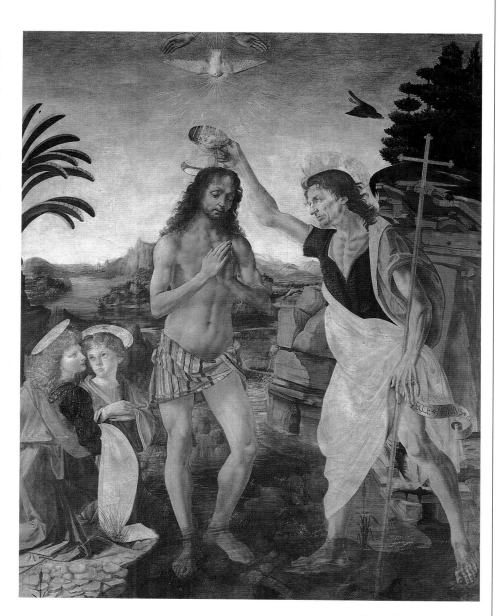

Andrea Verrocchio and Leonardo da Vinci
Battesimo di Cristo/Baptism of Christ,
c. 1472–75, wood panel, Florence, Uffizi.

Madonna col Bambino e santi Nicola e Caterina/ Virgin and Child with St. Nicholas and St. Catherine

c. 1405, wood panel, Berlin, Staatliche Museen zu Berlin-Preussischer Kulturbesitz.

This is an important example of Gentile's early work. In particular it reveals the Sienese and Lombard elements in his training. The painting has all the beautiful characteristics of late International Gothic art: the use of precious materials on a splendid gold background, attention to natural details (the flowering grass), sinuous lines, graceful expressions and gestures. St. Nicholas was the patron saint of the person who commissioned the work. He is seen kneeling in prayer and the Child lifts his hand in blessing in his direction. A charming Gothic detail is the musical angels who perch like birds in the leaves of the trees.

Gentile da Fabriano

Fabriano, 1370/80–Rome, 1427

This master from the Marches was the major Italian figure in the International Gothic style. He was, in fact, the most sought-after and famous artist in Italy during the first quarter of the fifteenth century. This can be seen from his travels to the great cities (Venice, Florence, Rome) where culture was caught between Gothic and the first Renaissance experiments. It can also be deduced from the large number of pupils he attracted, including Pisanello, Jacopo Bellini, and Fra Angelico, his greatest heir. While we do not know his exact date of birth, in his artistic make-up there is not only a basic Umbrian-Marches undercurrent, but also an influence of Rimini and Lombardy. A typical example of his early work is the *Polyptych of the Coronation of the Virgin*. This was painted in the first decade of the Quattrocento for a convent at Val Romita, near Fabriano. It is now in the Brera Gallery in Milan. In 1408, Gentile was called to Venice to paint some frescos (unfortunately destroyed) in the Doge's Palace. After a spell in Brescia, in 1419 the painter settled in Florence where the generation of Donatello, Ghilberti, and Brunelleschi were working. Gentile da Fabriano's work is stylish and elegant, making much use of gold backgrounds and countless precious details. His great technical skill hints at a new interest in classical sculpture. In 1423 he produced his best-known work, the monumental *Adoration of the Magi* for the Strozzi Chapel in S. Trinita and now in the Uffizi. This was followed in 1425 by the *Quaratesi Polyptych* (now broken up and in various museums). After stays in Siena and Orvieto (where he painted the fresco of the *Virgin and Child* in the cathedral) in January 1427 he moved to Rome. Here he started the ambitious fresco decoration of the central nave of the basilica of S. John Lateran which remained unfinished when he died in August that year.

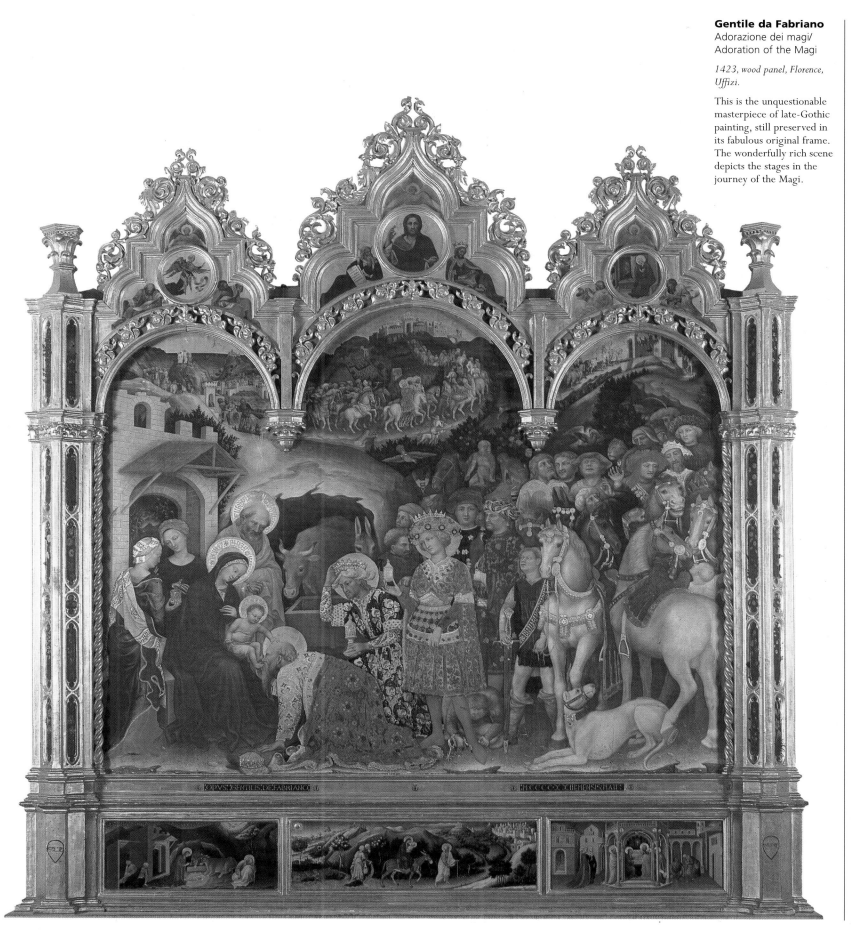

Gentile da Fabriano
Adorazione dei magi/
Adoration of the Magi

1423, wood panel, Florence, Uffizi.

This is the unquestionable masterpiece of late-Gothic painting, still preserved in its fabulous original frame. The wonderfully rich scene depicts the stages in the journey of the Magi.

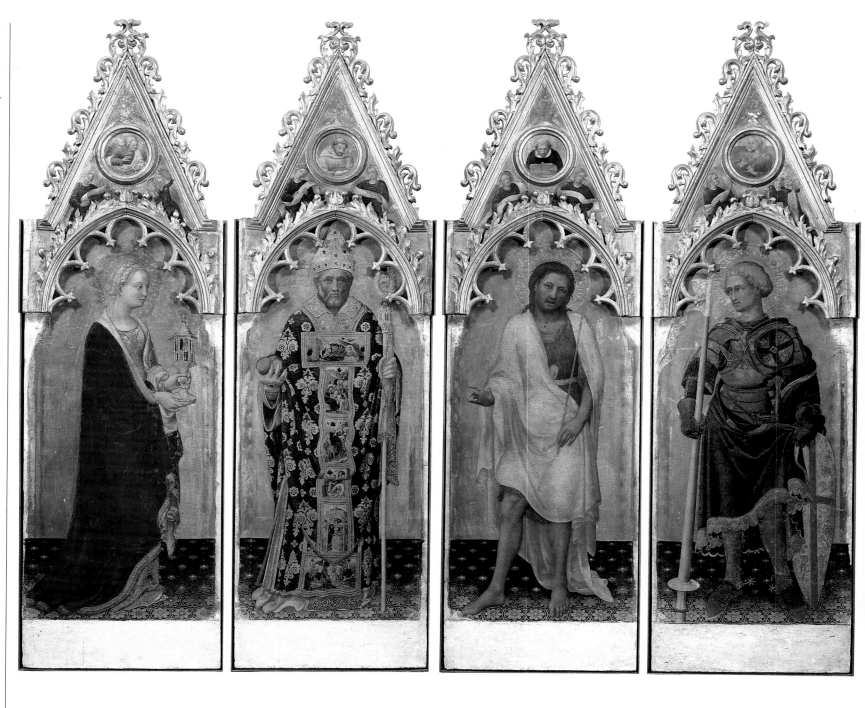

Gentile da Fabriano
Santa Maria Maddalena, San Nicola da Bari, San Giovanni Battista, San Giorgio/St. Mary Magdalene, St. Nicholas of Bari, St. John the Baptist, St. George

1425, wood panels, Florence, Uffizi

The four saints made up the side panels to the *Quaratesi Polyptych* painted for the Florentine church of S. Niccolò Soprarno. The *Virgin and Child*, which used to be in the center of the composition, is now in the National Gallery in London. The altar steps showing the *Scenes from the Life of St. Nicholas of Bari* are split between the Vatican Gallery in Rome and the National Gallery in Washington. Despite the fragmentation of the work (unfortunately a far too common fate for many fourteenth- and fifteenth-century polyptychs which were removed from their frames, split into pieces, and sold on the art market), the solid figures of these saints demonstrate the way Gentile da Fabriano's painting developed during the time he spent in Florence. Without jeopardizing the grace of his lines or the richness of his materials, the painter seems aware of the strides being made in art at around that time by Masolino and Masaccio. The flowering grass of his early work is here replaced by a tiled floor. Each figure is treated with a solemn human and monumental characterization. He achieved this by a more rigorous definition of the volume the figures occupy in real space. But overall it remains thoroughly Gothic in its atmosphere.

Masolino da Panicale

Tommaso di Cristofano Fini, Panicale in Valdelsa, 1383–Florence, 1440

Masolino was a pupil of Ghilberti and, according to one tradition, Masaccio's teacher. His major works can be found from Florence to Lombardy, Umbria to Rome. Masolino managed to combine the decorative and fantastic tastes of late-Gothic art with the conquest of perspective. His scenes are imbued with warm light and delicate colors. Masolino made his appearance at the start of the 1420s with works in both Florence and Empoli. In 1424 the *Virgin and Child with St. Anne* (Uffizi) marked the start of his partnership with Masaccio which culminated in the Brancacci Chapel in S. Maria del Carmine. In 1425 he broke off his work in Florence and left for Hungary in the train of Cardinal Branda Castiglione. In 1428 the Cardinal invited him to Rome to paint the frescoes in the private chapel of the church of S. Clement's. The frescos were dedicated to the *Scenes from the Life of St. Catherine of Alexandria*. Some of his panel paintings also date from his Roman years. In 1432, on the other hand, he produced a delightful fresco of the *Madonna and Child* for the church of S. Fortunato in Todi in central Italy. Cardinal Castiglione summoned him again in 1435, this time to Castiglione Olona in Lombardy. Together with other major Tuscan artists he painted the frescos in the Collegiate choir, some of the rooms in the Cardinal's palace and, most importantly, a spectacular section of the Baptistery.

Masolino da Panicale
Banchetto di Erode/
Herod's Banquet

1435, fresco, Castiglione Olona (Varese), Baptistery.

Long porticos of truly classical purity connect the three separate episodes. The descriptive details still seems rooted in the late-Gothic style, but the monumental scale of his work is already inspired by Renaissance classicism.

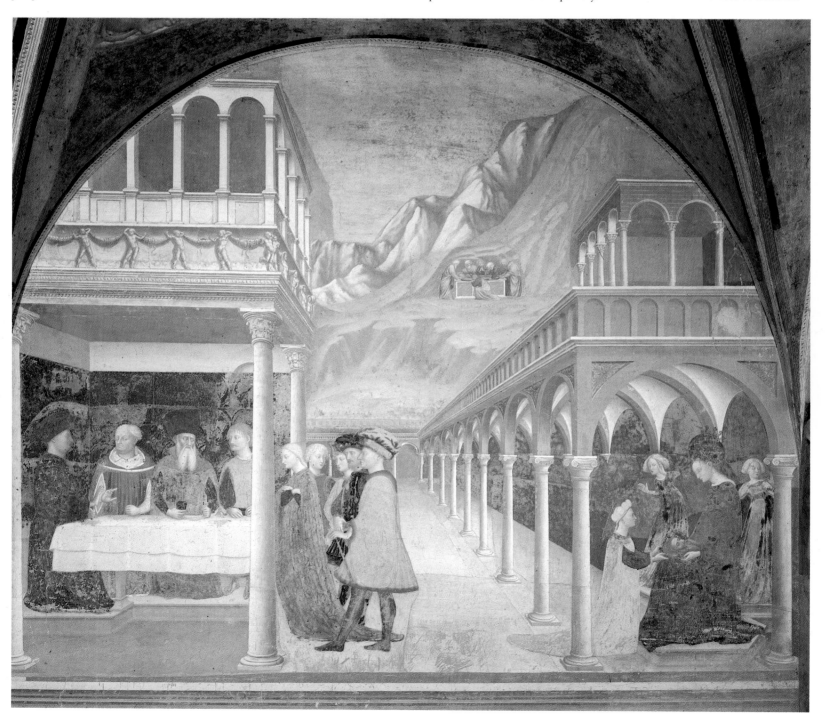

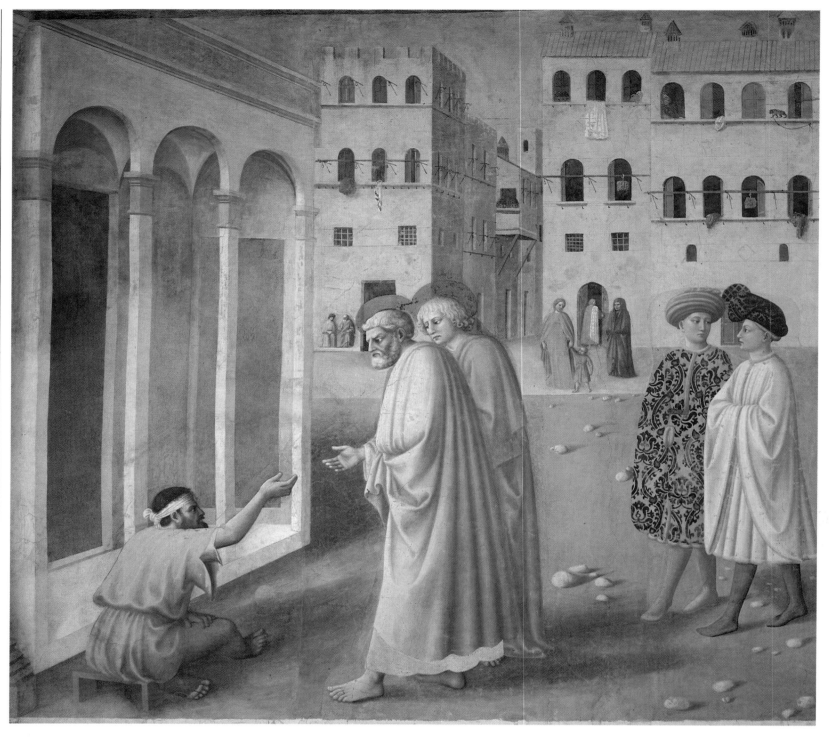

Masolino da Panicale
San Pietro risana uno storpio/St. Peter Heals a Cripple

1424–25, fresco, Florence, S. Maria del Carmine, Brancacci Chapel.

This fresco cycle was painted when Masolino was working with Masaccio. Masolino was probably responsible for the more tranquil scenes where the narrative proceeds without emotional upheaval. The delicate expressions, measured gestures, and costume details are set against the backdrop of Florence of his day, providing a reliable historical document. A technical comparison between the styles of the two artists is provided by the two likenesses of Adam and Eve that are symmetrically depicted on either side of the entrance to the chapel. Masolino sets his two nudes against the intense green of the garden. They embody an innocent purity depicted with the vigor of classical sculpture. Even though we can still find a few concessions to late-Gothic fantasy (the devilish serpent with a woman's head), Adam and Eve before sin appear in the spring of life and possess a chaste, truly Renaissance composure.

Opposite, Masaccio dramatically expressed the sense of a human and divine tragedy through their brutal fall from the state of grace in which Masolino's Adam and Eve found themselves. Masaccio's couple have larger, tougher feet to walk the world, they are utterly despairing, their strongly classical nudity no longer admirable but shameful. This underlines the dreadful contrast between Masolino's verdant garden and the cruel desert that Masaccio depicts outside the gates of Eden.

Masolino da Panicale
Adamo e Eva nell'Eden/ Adam and Eve in Eden

Masaccio
Adamo e Eva cacciati dal Paradiso/The Expulsion of Adam and Eve from Paradise

1424–25, fresco, Florence, S. Maria del Carmine, Brancacci Chapel (both illustrations).

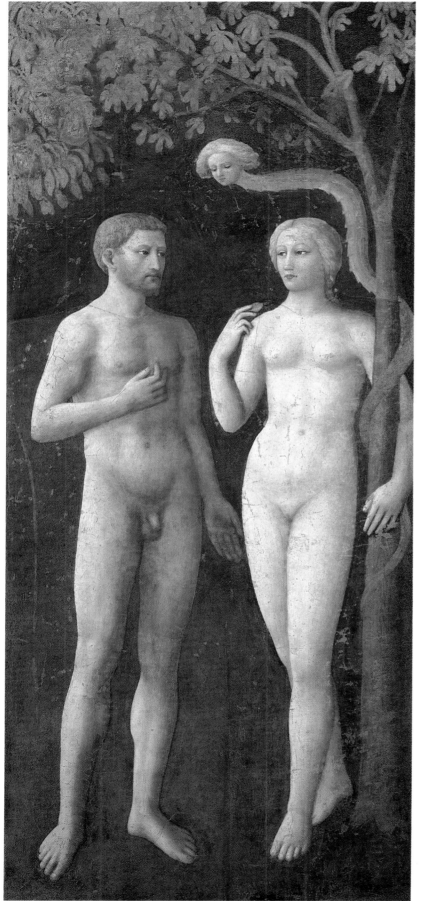
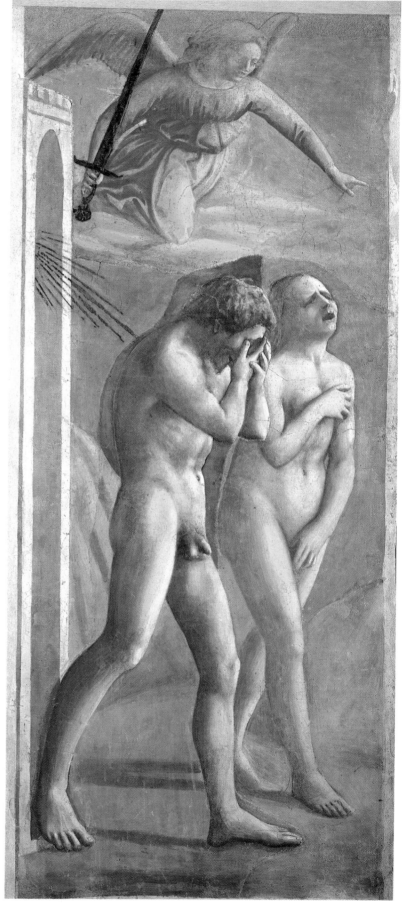

Masaccio

Tommaso di Giovanni Cassai, San Giovanni Valdamo, 1401–Rome, 1428

Although Masaccio died at the age of only 27, he is one of the greatest revolutionaries in the history of art. In a mere a handful of works he showed himself Giotto's true heir and proved an inspiration to later Renaissance artists, including Leonardo and Michelangelo. His first known work (dated 1422) is the *Triptych* in the church of S. Giovenale at Cascia di Reggello. Although an immature work, it already reveals his rejection of Gothic grace in favor of realistic, weighty, bulky figures. In 1424 he probably worked with Masolino on the *Virgin and Child with St. Anne* now in the Uffizi. Here Masaccio's quest for a new plastic realism is explicit in the way his figures occupy true depth in the picture. Still with Masolino, Masaccio went on to paint the fresco cycle for the Brancacci Chapel in Florence, recently restored. Masaccio's own art emerged clearly here, his new mastery of perspective being used to portray grave, noble, often suffering human beings in a real world. In 1426 he painted a polyptych for the church of the Carmelitani in Pisa. The solemnly majestic fresco of the *Trinity* in the Florentine church of S. Maria Novella, dates from 1426–27. In late 1427 Masaccio left for Rome, where he died a few months later.

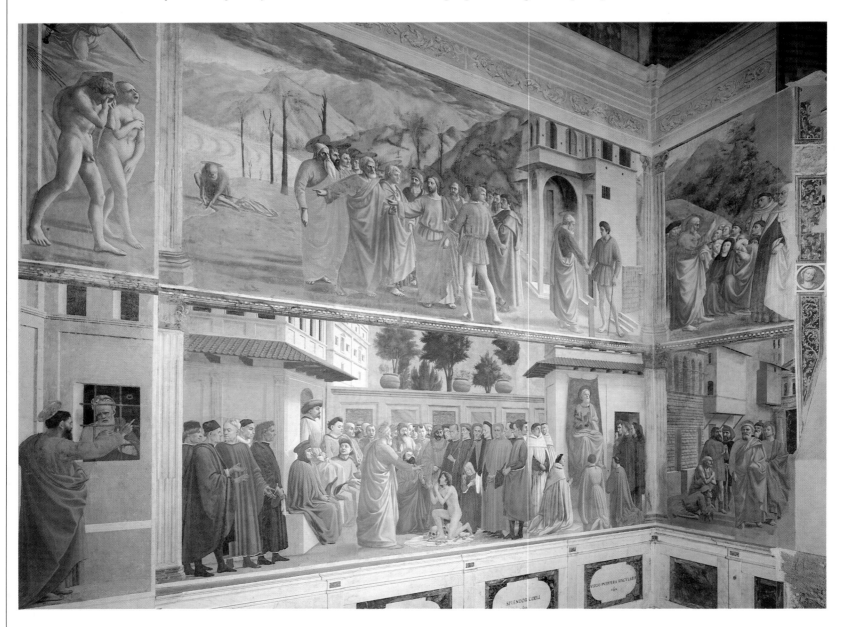

Masolino da Panicale, Masaccio, and Filippino Lippi
General View of the Left Wall of the Brancacci Chapel

1424-25, fresco, Florence, S. Maria del Carmine, Brancacci Chapel.

The Brancacci Chapel is a milestone in Italian art and for this reason it calls for special attention. The scenes dealing with the life and miracles of St. Peter mark the real start of the new Renaissance approach to painting in the way they develop and explore perspective. Recent restoration work has allowed the original brightness of the colors to be seen once more. The relationship between Masolino and Masaccio cannot be written off as "early" and "later" stages in the evolution of art, for they influenced each other. However, no one can miss the difference between Masolino's elegant narrative (very obvious in the *St. Peter's Sermon* at the top of the back wall and in the large upper scene on the right wall) and Masaccio's dramatic and solemnly statuesque style. This reaches its zenith in the solemn *Gathering of Men* around Christ in the *Tribute Money* (above, top). The frescos, which remained unfinished for several decades, were completed by Filippino Lippi in about 1480.

Masolino da Panicale, Masaccio and Filippino Lippi
General View of the Right Wall of the Brancacci Chapel

1424–25, fresco, Florence, S. Maria del Carmine, Brancacci Chapel.

The lower portion of the wall showing St. Peter's upside-down crucifixion is by Filippino Lippi. The upper scene is by Masolino with help from Masaccio on the townscape. Masaccio painted the two pictures that can be seen one above the other on the back wall.

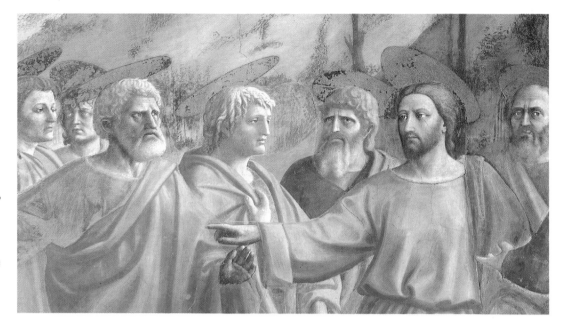

Masaccio
Il pagamento del tributo/ The Tribute Money

detail, c. 1425, fresco, Florence, S. Maria del Carmine, Brancacci Chapel.

In this, the most famous of the scenes, Christ tells St. Peter to pay taxes to the emperor. Here, Masaccio concentrates great expressive tension in the large group of people through their eloquent gestures and almost immobile stance which exalt the statuesque nobility of their figures.

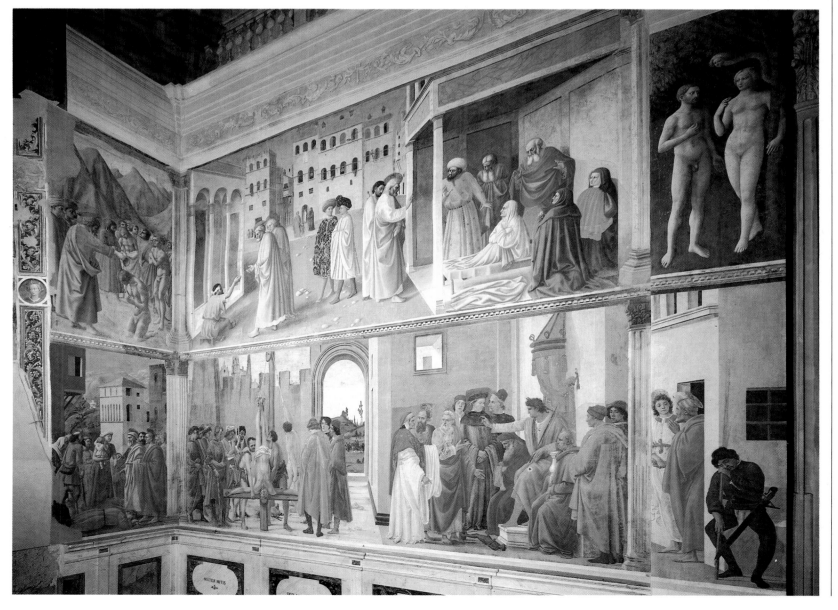

59

Masolino da Panicale and Masaccio
Madonna col Bambino e sant'Anna/Virgin and Child with St. Anne

c. 1424–25, wood panel, Florence, Uffizi.

This is thought to be the joint work of Masolino and Masaccio. Masolino's work stands out for its delicate draughtsmanship in the elegant angels and surrounds, while in the austerely monumental figure of St. Anne. Masaccio reveals the tremendous geometrical rigor and weight of his art.

Masaccio
Crocifissione/Crucifixion

1425–26, wood panel, Naples, Museo di Capodimonte.

This was originally the cyma of the Pisa *Polyptych* which has since been scattered among various museums. Masaccio painted over an earlier version and added the dramatic figure of Mary Magdalene standing at the foot of the Cross. Above Christ's head we see the symbolic figure of the pelican which sacrifices itself for its young.

Masaccio
Trittico di san Giovenale/ S. Giovenale Triptych

1422, wood panel, Cascia di Reggello (Florence), parish church of S. Pietro.

Masaccio
Madonna in trono/
Madonna Enthroned

*1426–27, wood panel,
London, National Gallery.*

Central panel of the Pisa
Polyptych. It is a good
example of his research
into large geometric forms.

Masaccio
Trinità/Trinity

*c. 1426–28, fresco, Florence,
S. Maria Novella.*

The fresco gives the illusion
of a side chapel built deep
in the side wall of the
church. Two supplicants are
kneeling in adoration of the
Trinity. The Virgin and St.
John are also turning in the
same direction. On the
lower portion, underneath
a false (painted) altar, a
skeleton symbolizes Death.
The extraordinarily fine
architectural background
was inspired by
Brunelleschi's work.

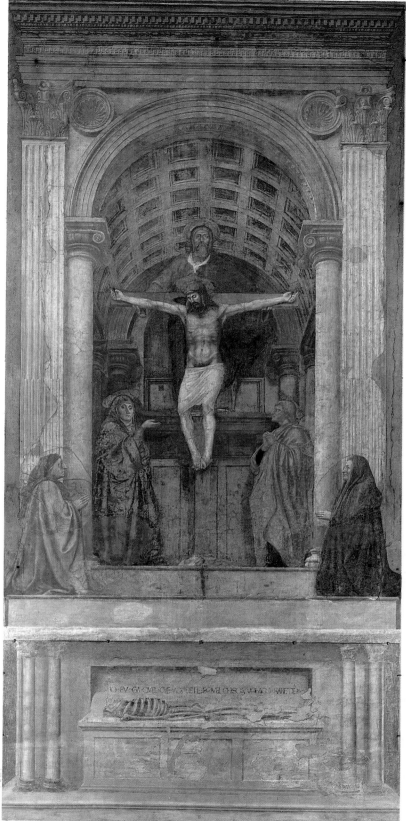

Paolo Uccello

Paolo di Dono, Florence, 1397–1475

Uccello is central to the story of the exploration of perspective. But he also not only painted fascinating pictures of heroic and chivalrous subjects but also carried out detailed mathematical research to often extraordinary effect.

He may have trained with the sculptor Ghiberti, although never a sculptor himself, and just after 1420 painted *Stories of Genesis* in the Green Cloisters in S. Maria Novella. In 1425 he moved to Venice where he helped decorate St. Mark's with mosaics. Returning to Florence, in 1436 he painted the huge fresco for the *Equestrian Monument to Sir John Hawkwood*, the English

mercenary soldier, in S. Maria del Fiore, showing his obsession with perspective. In the cathedral he later decorated the back of the clock and designed windows for the drum of the dome. Three wood panels depicting the *Battle of San Romano* were commissioned by the Medici. During the 1440s he painted frescos for the cloisters of S. Miniato al Monte, for

the cathedral at Prato and the *Life of Noah* in the Chiostro Verde of S. Maria Novella. In 1465 he was working for Federico da Montefeltro, he produced the altar step depicting the *Profanation of the Host* in the Ducal Palace in Urbino. Uccello died in poverty in 1475.

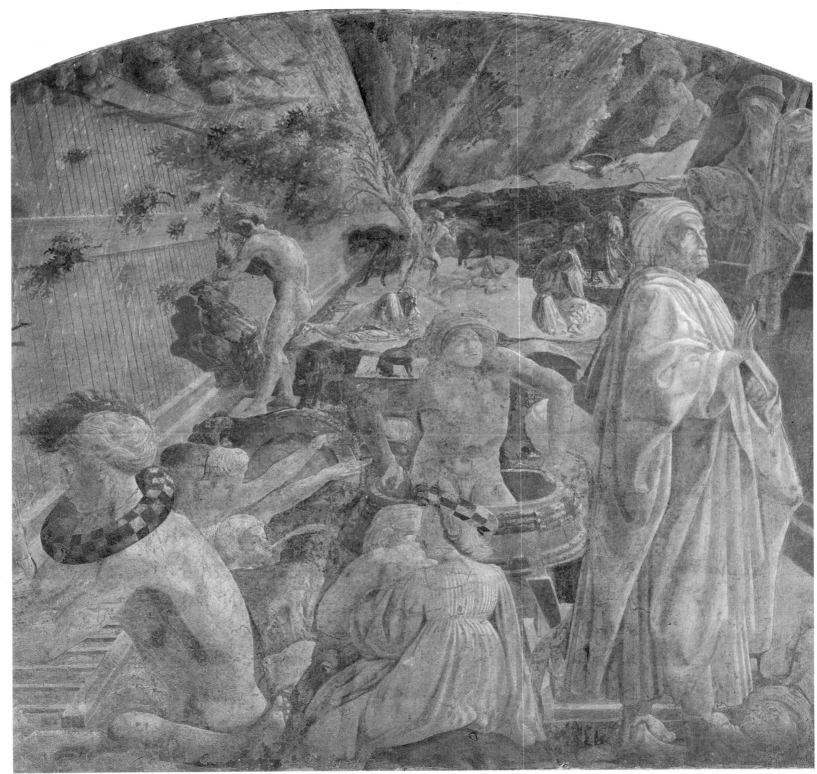

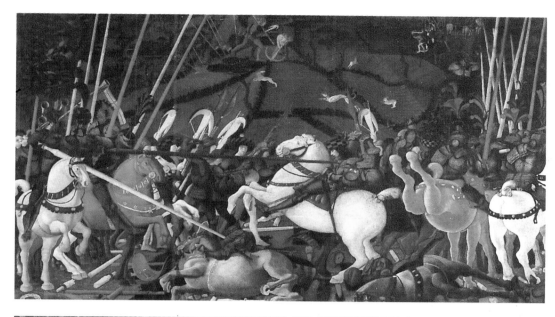

Paolo Uccello
Tre momenti della Battaglia di San Romano/ Three Incidents from the Battle of San Romano

c. 1456, wood panels, Florence, Uffizi; Paris, Louvre; London, National Gallery.

The date in which these three famous panels were painted is disputed. What is certain is that they were originally all in the Medici Palace where they made a prestigious wall decoration for one of the rooms. The story of the battle, which was won by Florentine forces in 1432, is told in three distinct episodes which combine to form a single spectacular narrative. Uccello's obsession with displaying his mastery of perspective (such as the long white and red lances or the exceptional horses that have rolled over on the ground) and the dramatic nature of the clash between the knights combine with his almost magical story telling. This is underpinned by the use of unreal colors and light as if describing some fabulous tale of chivalrous adventure. In each of the scenes someone is wearing a "mazzocchi," the huge multi-faceted headgear that Paolo Uccello often included in his pictures due to the specific difficulty of painting it in proper perspective.

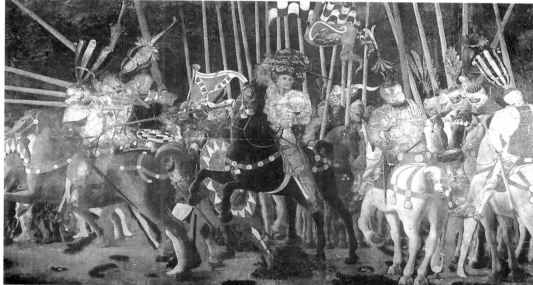

On the opposite page
Paolo Uccello
Diluvio Universale/The Flood

detail, c. 1450, fresco, Florence, S. Maria Novella, Chiostro Verde.

This giddy virtuoso masterpiece shows humanity terrified by the Flood. Men and women, battered by the wind, seek shelter in all manner of ways. On the right, a calm Noah examines the steep hull of the Ark. In the narrow central corridor we see people's attempts to escape the floodwaters. One man lowers himself into a barrel, others hang on to trees. The woman in the middle and the man in the foreground to the left respectively wear a checked hat and a collar. Here Uccello is showing off his mastery of perspective and the classical nude. The characteristic greenish hue, which has given its name to the cloisters of the Dominican convent, was used in this and other Biblical scenes painted by Paolo Uccello and his studio.

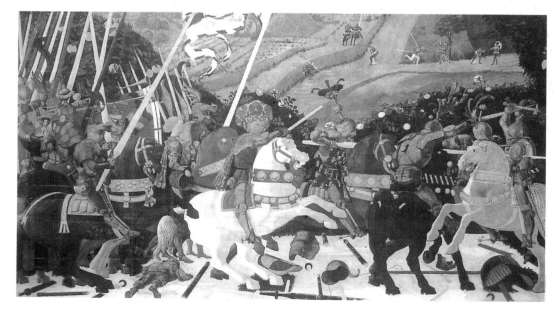

Fra Angelico
Sacra Conversazione
(Madonna delle Ombre)/
Sacra Conversazione
(Madonna of the
Shadows)

*c. 1450, fresco, Florence,
Convento di S. Marco.*

Painted in the corridor off

which the brethren's cells
open, this fresco was one
of Fra Angelico's last works
in S. Marco's Dominican
Monastery. There is almost
a metaphysical feel to the
frozen gestures, the deep
gazes, and the strong and
boldly-applied colors. This
sensation is boosted by

the power of the side-
lighting which in turn is
emphasized by the long
shadows cast by the
classical capitals. These are
reminiscent of architecture
by Michelozzo. This fresco
is the painter's ultimate
achievement of wonderful
synthesis between his

mystical inspiration and the
effective application of
recent breakthroughs in
Renaissance painting.

On the opposite page
Fra Angelico
Annunciazione/
Annunciation

*c. 1430, wood panel,
S. Giovanni Valdarno (Arezzo),
Santuario of S. Maria delle
Grazie.*

Now that it has been so

successfully restored, this
large composition is today
appreciated as one of the
painter's masterpieces.
Angelico returned time
after time to his favorite
theme of the angel
bringing the news and the
devout Mary in a posture
of humble acceptance.

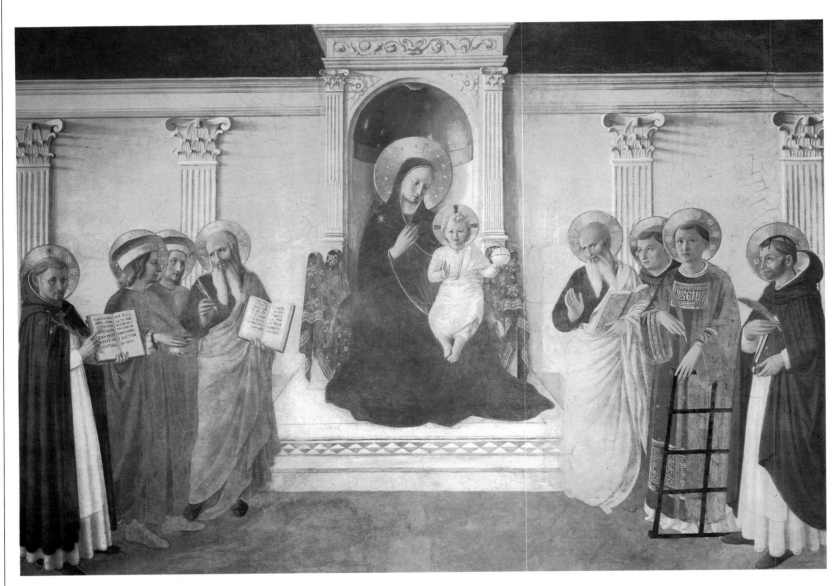

Fra Angelico

*Brother Giovanni da Fiesole, Vicchio di
Mugelo, c. 1395–Rome, 1455*

The enchantment of his painting, his
life of retreat spent within the walls
of Dominican monasteries, and his
mystical inspiration, make Angelico's
art the most touching of any produced
in the early Renaissance. But to say this
conjures up only a heavenly image
which does no justice to the painter's
true greatness. Angelico managed to

soften the austerity of the new science
of perspective due to the way he used
soft yet clear colors to express his
religious feelings. During the 1420s,
Angelico learned his art in Florence.
His first works were influenced by
Gentile da Fabriano but he also
absorbed the lessons of Giotto's and
Masaccio's art, to combine Gothic
sweetness with Renaissance realism.
The result of this artistic fusion was
The Flax Dressers' Tabernacle (1433) now
in the Museo di S. Marco in Florence.
In the fifteenth century, however, it

was a Dominican monastery where
Angelico long lived. There, between
1439–42 he frescoed the murals in the
Chapter Room, the cloister galleries,
the corridors, and the cells of the
brethren and in so doing established
his own school. His panel paintings
combine a sound understanding of
linear perspective and a delicacy of
scene and color, being a great
influence on the art of Domenico
Veneziano and Piero della Francesca's
early work. In 1446, Fra Angelico and
his excellent assistants, such as

Benozzo Gozzoli, went to the Vatican
to paint the frescos in Nicholas IV's
Chapel, which are more typical of
their time. In 1447 he started
decorating the S. Brizio Chapel in
Orvieto Cathedral (taken up again half
a century later by Luca Signorelli).
After 1450 he painted the last frescoes
in S. Marco. He was called back to
Rome in 1453 where he died two
years later.

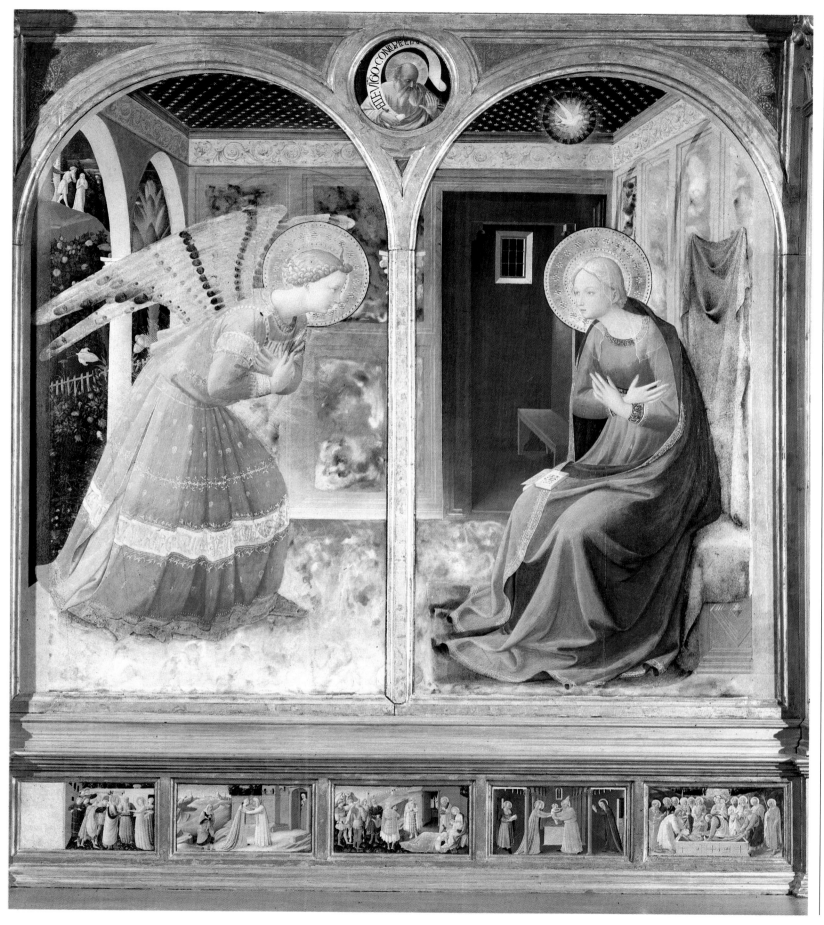

Fra Angelico
Pala di Annalena/The Annalena Altarpiece

1434, wood panel, Florence, Convento di S. Marco.

Originally in the Convento di S. Vincenzo in Annalena, this is one of the artist's early *Sacre Conversazioni*. In fact, Angelico seems to be holding himself back a little in this work. The floor and even more so the Virgin's throne are unquestionably part of the new culture of perspective. In the background, however, the portico is screened by a sumptuous gold brocade curtain. The nobility of the saints' figures and the robust geometrical block that contains the Virgin, place Angelico firmly as a follower of Masaccio. But Angelico's work is softened by the way he captures tender feelings and sweet prayer. The two characters dressed in red to the right of the group are the doctors' saints Cosma and Damiano who were also the Medici family's patron saints. It is for this reason that they figure so frequently in Florentine painting.

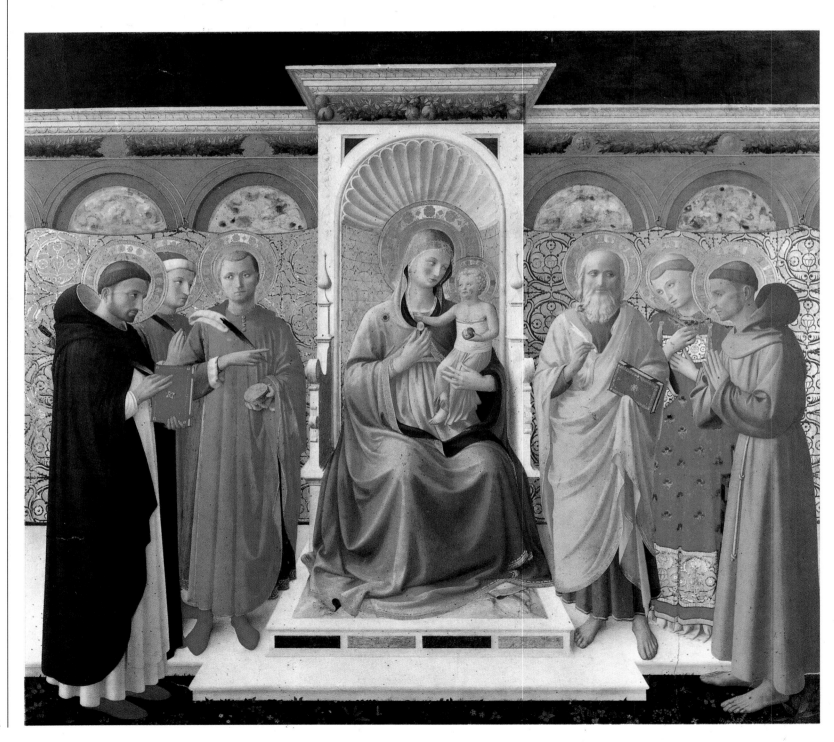

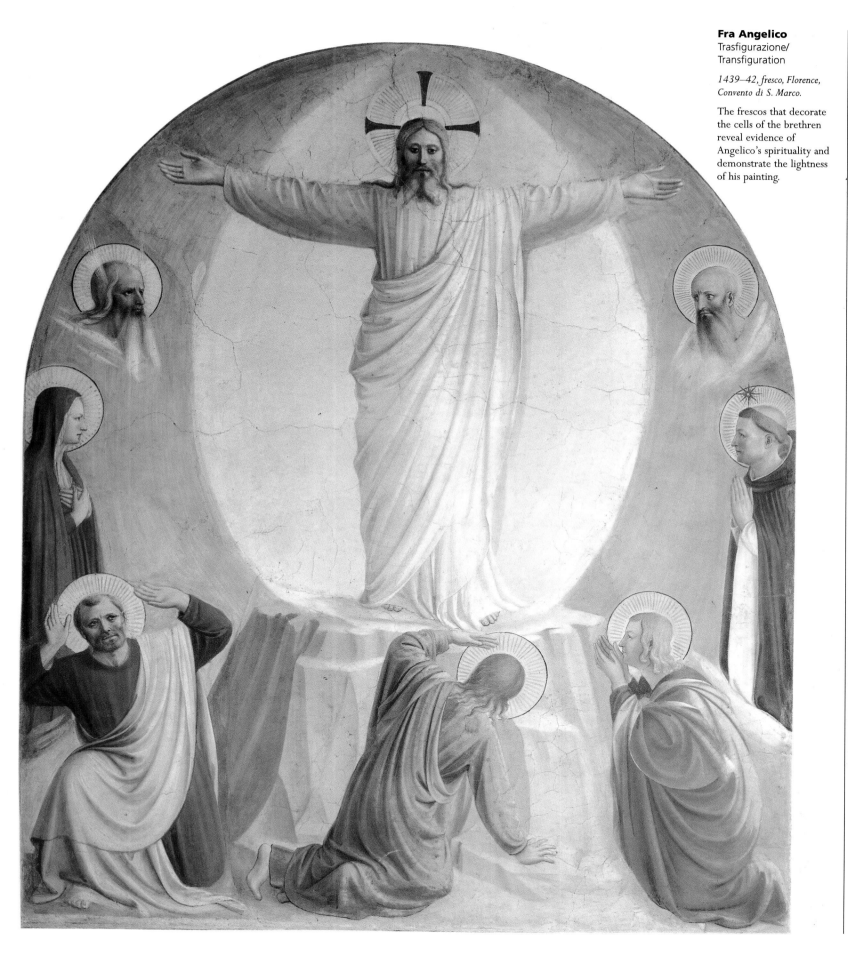

Fra Angelico
Trasfigurazione/
Transfiguration

*1439–42, fresco, Florence,
Convento di S. Marco.*

The frescos that decorate
the cells of the brethren
reveal evidence of
Angelico's spirituality and
demonstrate the lightness
of his painting.

Domenico Veneziano

Domenico di Bartolomeo, Venice, c. 1410–Florence, 1461

Domenico Veneziano's complex and rich artistic background, learning his craft between Rome and Florence, gave him a composite style that was very personal. His surviving work dates mainly from the middle decades of his life when he was working in Florence. Of his outstanding works, we should mention the *Adoration of the Magi* (Berlin, Staatliche Museen/ Preussischer Kulturbesitz). This was painted just before he started the frescos (now almost completely vanished) in the church of S. Egido in Florence on which he worked together with Andrea del Castagno and Piero della Francesca. In 1447 Domenico Veneziano completed his masterpiece *Altarpiece of St. Lucy of the Magnolias* (Florence, Uffizi). It was this work that definitively marked an end to the use of polyptychs as altar paintings.

Domenico Veneziano
Pala di Santa Lucia de' Magnoli/Altarpiece of St. Lucy of the Magnolias

1445–47, wood panel, Florence, Uffizi.

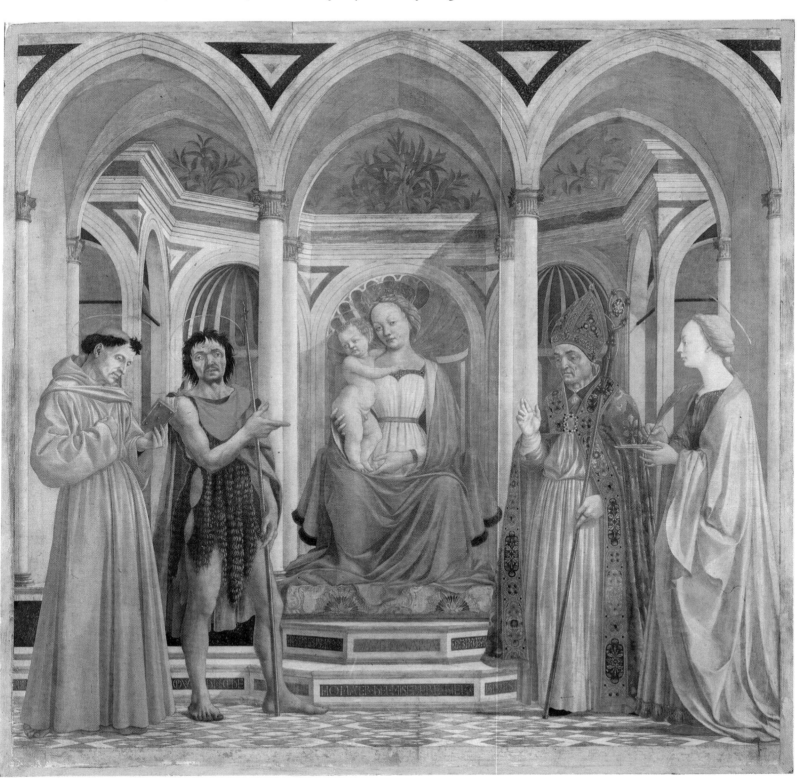

Piero della Francesca

Arezzo, 1416/17–92

Piero was an artist of fundamental importance to the Renaissance in Europe. With great lucidity, he finally established the geometrical rules upon which perspective is based. He then created a style combining monumental grandeur and mathematical rigor with limpidly beautiful use of color and light. He worked in Florence under Domenico Veneziano but his career was based in the provinces (Sansepolcro, Arezzo, Rimini, Urbino, Perugia). In turn, this had a determining role in the birth of vital local schools of painting. After a few works painted in the small town of his birth, in about 1450 Piero traveled to Ferrara and Rimini where he was much inspired by seeing Flemish art and above all by Alberti's buildings in Rimini. The classic proportions and the mathematically worked-out sense of space of the architect are at the heart of the wonderful cycle of frescos dealing with *Stories of the Cross* that Piero began in 1452 for the choir of the church of St. Francis in Arezzo. The monumental solemn beauty of the Arezzo frescos was followed by other works such as the *Polyptych* now in the Umbrian National Gallery in Perugia and the *Augustine Polyptych*. During the 1460s the artist painted some of his greatest masterpieces for the Duke of Urbino. These include the *Flagellation of Christ* and the *Senigallia Madonna*. There was also a twin portrait of Federico da Montefeltro and his wife Battista Sforza (Florence, Uffizi), the *Nativity* (London, National Gallery), and above all the incomparable *Montefeltro Altarpiece*. This last work is often considered the painting that epitomizes the noblest aspirations of the Quattrocento. Piero reputedly lost his sight in old age, restricting himself to writing tracts on painting and mathematics.

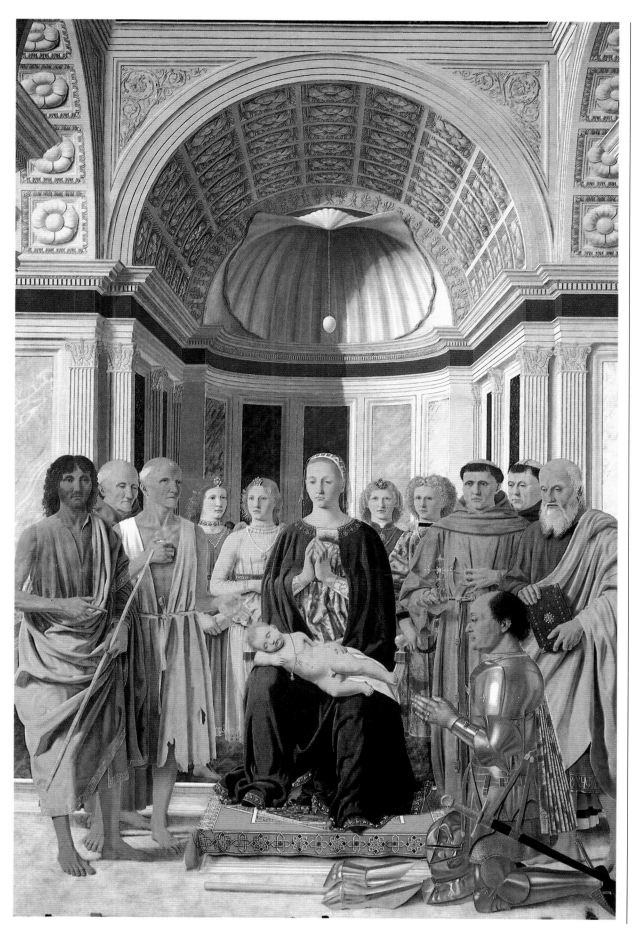

Piero della Francesca
Pala Montefeltro/
Montefeltro Altarpiece

1472–74, wood panel, Milan, Brera.

With perfect architecture, lucid colors, and quiet human feeling, this is one of the supreme achievements of Renaissance art.

Piero della Francesca

Storie della Vera Croce: L'adorazione del sacro legno e l'incontro di Salomone con la regina di Saba; Battaglia di Eraclio e Cosroe/Legend of the True Cross: Adoration of the True Cross and the Queen of Sheba Meeting with Solomon; the Battle of Heraclius and Chosroes c.1455–60, fresco, Arezzo, S. Francesco.

The frescos that Piero painted in the choir of the Arezzo church are perfect examples of his conception of proportion, order, and composition. The story itself was inspired by the thirteenth-century *Golden Legend*. It tells the complicated tale of the wood used in the Cross, starting with the death of Adam and going through to the known Emperor Constantine. The painter ignored the chronological sequences of the scenes in favor of a structured rhythm and clear symmetry between the walls. He alternates moments of great ritual solemnity with confused battles, passages of contemplation with lively narrative scenes. The whole cycle is imprinted with the artist's extraordinary mental powers. The greatness of Piero della Francesca lies in the way that, within this intellectual rigor, he was able to create vibrant emotions of tenderness or of terror. Human feeling does not dent the geometrical purity of his forms, but rather warms it and endows it with a vivid spirit. The scene in which the Queen of Sheba embraces Solomon borrows from the group of apostles in Masaccio's *Tribute Money*. But Piero develops it on a far greater, more monumental scale and sets it against an unquestionably classical architectural backdrop. The cycle has been undergoing restoration work and at time of writing is only partially visible.

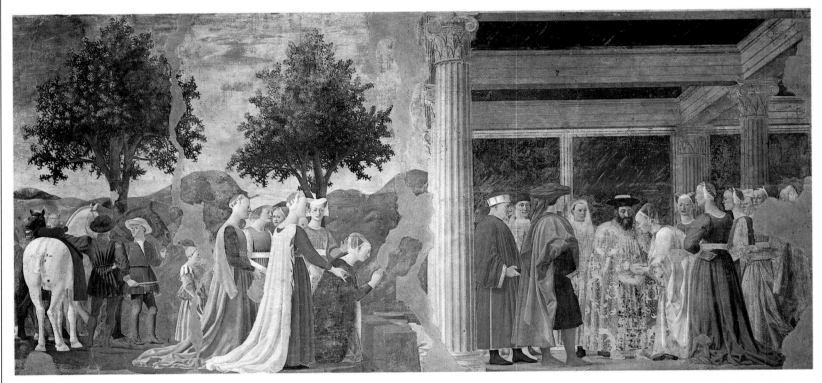

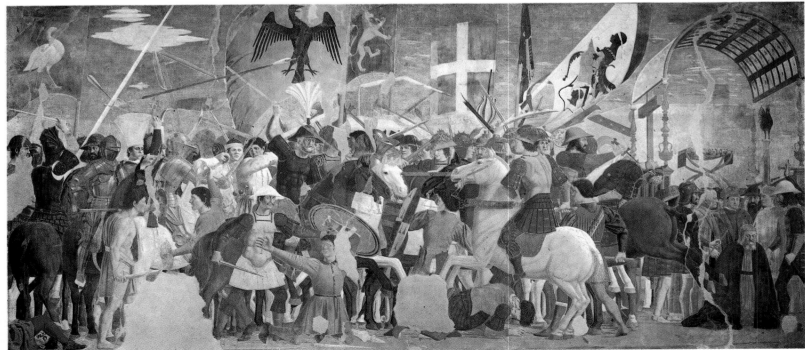

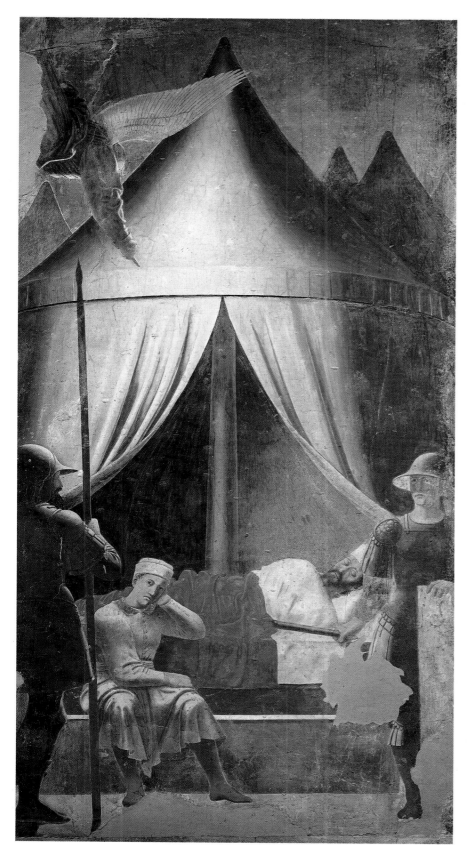

Piero della Francesca
Storie della Vera Croce:
Sogno di Costantino/
Legend of the True Cross:
Constantine's Dream

*c. 1457–58, fresco, Arezzo,
S. Francesco.*

Piero della Francesca
Santa Maria Maddalena/
St. Mary Magdalene

*c. 1460, fresco, Arezzo,
cathedral.*

On the opposite page
Piero della Francesca
Resurrezione/
The Resurrection

*1463, fresco, Sansepolcro,
Pinacoteca Comunale.*

The museum is housed in one of Sansepolcro's palaces, on one wall of which is this majestic scene, rich in both mystical and civic symbolic meanings. The figure of the risen Christ is shown with the banner of Sansepolcro, the little town where the painter was born. The solemn moment when Christ rises from the tomb is depicted with an austere grandeur. Both human history and nature seem divided into two: on the left is a wintry landscape, arid and lifeless, while the other is flourishing, spring like and alive, as Christ returns from the dead to waken all nature and humanity.

Piero della Francesca
Annunciazione/Annunciation (cyma from the St. Anthony Polyptych)

c. 1470, wood panel, Perugia, Galleria Nazionale dell'Umbria.

Originally the topmost part of the large *Polyptych* that Piero painted for the Perugian convent of S. Antonio alle Monache, this painting is a stunning demonstration of how perfectly the artist could handle perspective. This is evident not just in the way he painted the architecture of the colonnade rushing away from us but includes the sophisticated manner in which he painted light and shade. The effect almost amounts to trompe l'œil.

Piero della Francesca
Urbino Diptych (front): Portraits of Battista Sforza and Federico da Montefeltro

1465–70, wood panels, Florence, Uffizi.

The Duke and Duchess stand out against the background of the Montefeltro hills, which is continued across the rear of the two wood panels showing allegorically the triumphs of the lords of Urbino. Piero's mastery of depth and volume, as he daringly places the Duke above what should be a cliff top overlooking the distant river is brilliantly displayed. The Duke is painted without grandeur but with a quiet humanity, unusually in profile (he had lost one eye). The brushwork is executed with painstaking detail, showing perhaps the influence of Flemish art.

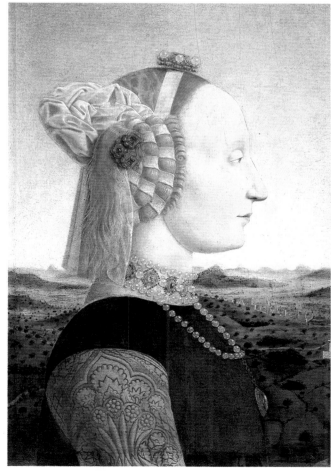

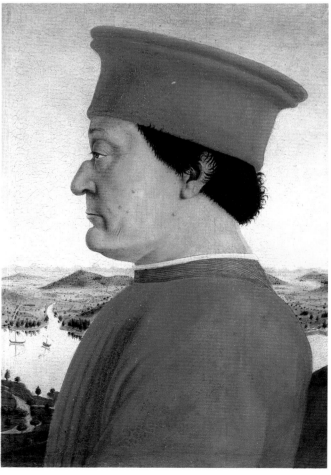

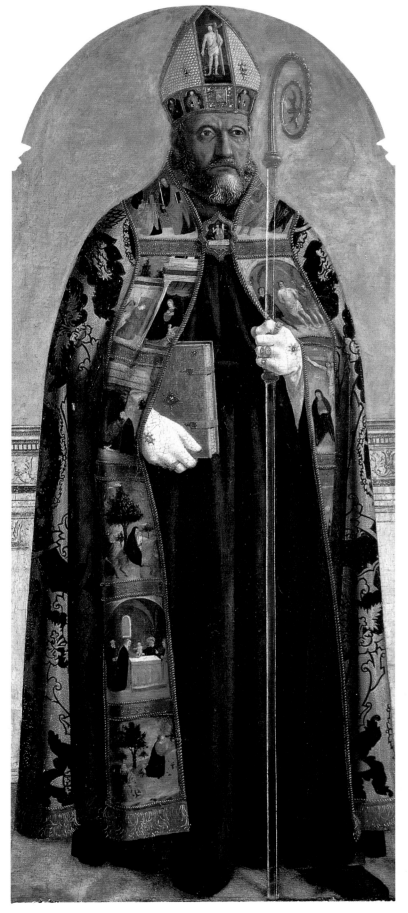
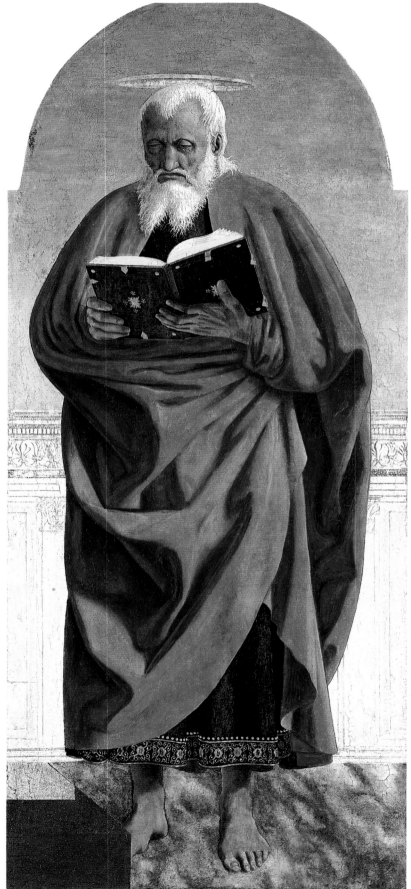

On the opposite page
Piero della Francesca
Sant'Agostino; San
Giovanni Evangelista/St.
Augustine; St. John the
Evangelist

*c. 1465, wood panels, Lisbon,
Museu Nacional de Arte
Antiga; New York, Frick
Collection.*

The *Polyptych* from the high
altar in the church of S.
Augustine in Sansepolcro is
one of the finest works
from Piero's artistic
maturity. Unfortunately it
was broken up and in the
last century the panels
were scattered. Apart from
the smaller panels on the

altar step, we still have the
weighty figures of the four
saints on the side panels (in
addition to the two shown
here, there are also *St.
Michael the Archangel* in the
National Gallery in
London and *St. Nicholas of
Tolentino* in the Poldi
Pezzoli Museum in Milan).

The central panel showing
the *Virgin Enthroned* has,
however, been lost. The
noble concentration of
expression, the forms of
the saints, surrounded by a
space filled with clear blue
light, mark perhaps one of
the supreme achievements
of Renaissance art.

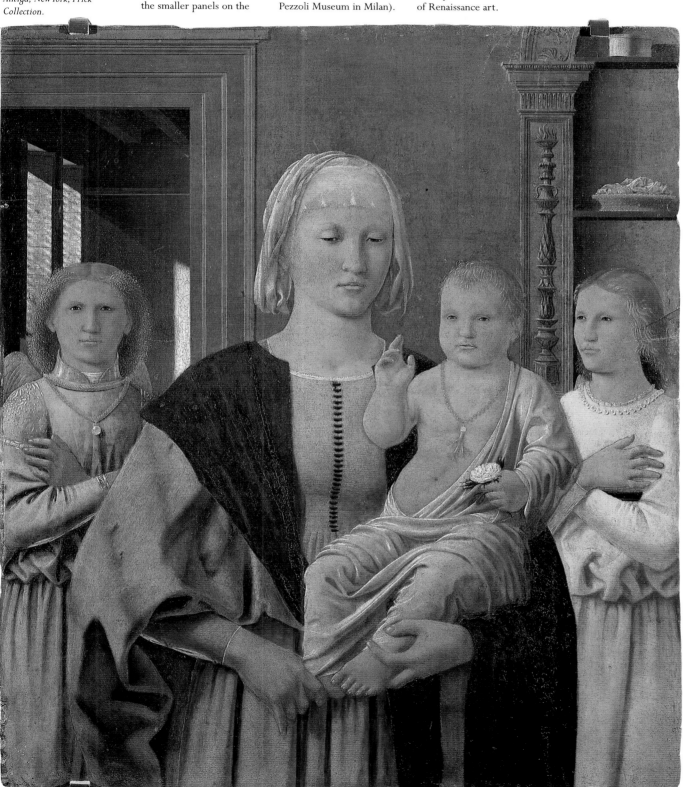

Piero della Francesca
Madonna col Bambino
benedicente e due angeli
(Madonna di Senigallia)/
Virgin with Child Giving
His Blessing and Two
Angels (The Senigallia
Madonna)

*c. 1470, wood panel, Urbino,
Galleria Nazionale delle
Marche.*

This wonderfully elegant,
accomplished painting is
the fruit of Piero's long
relationship with the court
in Urbino, whose
architecture must have
inspired Piero's
background. The panel
synthesizes some aspects of
Flemish art (accuracy of
detail, minute attention to
the way the light falls,
descriptive sense of reality)
and the noble vision of the
Italian Renaissance most
marked in the serene
symmetry and the
geometrical logic of the
painting. Once again this
picture emphasizes Piero's
search for simple volumes
(a pyramid for the Virgin,
two cylinders drawn along
the upright lines of the
door posts for the angels).
Here, however, he dwells
with infinite patience and
delicacy on the tiniest
detail, such as the
transparent quality of the
light falling through the
window panes and even its
reflection on fingernails,
jewels, veils and the collars
worn by the characters.

Pisanello

Antonio Pisano, Verona (?), c. 1395–
Mantua (?), 1455

Pisanello was one of the foremost exponents of the courtly splendors of the International Gothic style in Italy, with a sometimes ironic, sometimes romantic view of the world. Because so many of his major works have been lost, today we only have an incomplete knowledge of this artist who played a fundamental role in the early part of the Quattrocento. However, the few paintings we have are supplemented by many excellent drawings and his renowned medals. The son of a Pisan merchant (hence his nickname), the painter trained in the Veneto, first in Verona and then in Venice where he worked on frescos alongside Gentile da Fabriano (1418-20). Pisanello then followed Gentile to Florence in about 1423 and absorbed the latest Gothic influences. In Verona during the 1420s Pisanello's career took off. He painted the *Madonna with a Quail* (Museo di Castelvecchio) and the *Annunciation* for the Brenzoni Monument in S. Fermo (c. 1426). After Gentile da Fabriano's death (1427), Pisanello was called to Rome to complete the frescos in St. John in the Lateran, which were later destroyed during the Baroque period. From the 1430s onwards, Pisanello was active in courts of several princes. In the Ducal Palace in Mantua he painted murals of courtly scenes. In Ferrara he portrayed people from the Este court (*Lionello d'Este*, Bergamo, Accademia Carrara; an unidentified *Princess*, Paris Louvre). In Rimini he produced medals for Novello Malatesta. His most important work is a fresco showing *St. George and the Dragon* in the church of S. Anastasia in Verona (1436–38). Following this masterpiece, Pisanello concentrated mainly on producing exquisitely elegant commemorative medals for the rulers of northern courts and for King Alfonso of Aragon, to whose court in Naples he moved in about 1450. After the middle of the century, the triumph of Renaissance classical art throughout Italy led to a rapid decline in Pisanello's fame and after his death he was almost forgotten.

Pisanello
Madonna della quaglia/
Madonna with a Quail

1420–22, wood panel, Verona,
Museo di Castelvecchio.

Pisanello

**Partenza di san Giorgio/
St. George and the
Princess of Trebizond**

*detail, 1436–38, fresco,
Verona, S. Anastasia.*

The scene is divided into two contrasting parts. On one side we see a desolate and dragon-wasted land, with corpses hanging from the gallows and menacing dark cliffs rising steeply. On the other side, a Gothic city's fantastically ornate skyline forms the background to the main scene. Pisanello shows the moment when St. George, watched by the princess, mounts his horse to set out against the monster. The Princess comes from the tiny Greek kingdom of Trebizond on the Black Sea – a land both exotically distant and highly suitable, for St. George was in origin a Greek saint who fought pagans, and Christian Trebizond was being threatened by the Muslim Turks. His departure is a moment filled with poignant tension, for the saint does not look at all confident of victory. (Trebizond would indeed soon fall to the Turks.) The fresco was worked out in meticulous detail but Pisanello never lost sight of the overall composition. He studied each detail with extraordinary precision and was at pains to reproduce reality exactly, with the animals, the lords and ladies, even the macabre detail of the men hanging from the gallows. But the true magic of Pisanello's painting lies in his capacity to bring his characters to life above all through their inner spiritual frailty.

Cosmè Tura

Ferrara, c. 1430–95

Tura was the first, most original, and best-known artist of the Ferrara school, introducing to the Este city a strange and totally original style. In Padua in the 1450s, the young Tura came into contact with Squarcione's circle and Mantegna who was at the beginning of his own career. These encounters produced the sculptural quality of his often tortuous art. On his return to Ferrara, Tura became court painter to the d'Este family and never left the city again. He was also in charge of decorating the Este residences which included frescos in the Salone dei Mesi in the Schifanoia Palace.

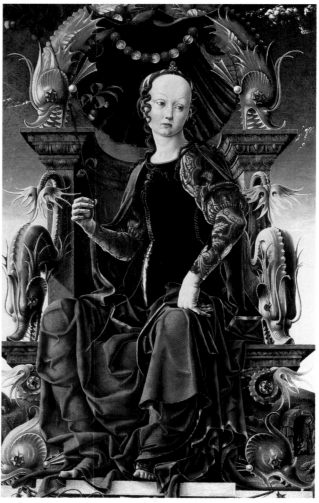

Cosmè Tura
Madonna in trono/
Virgin Enthroned

1474, wood panel, London, National Gallery.

This was the central part of the *Roverella Altarpiece* (a polyptych now in various museums) and is a work of strange beauty. Tura had to paint the scene in a steep vertical format. To suit this he invented an unusual throne with steps, decorated with Hebrew inscriptions and crowned by a richly carved summit.

Cosmè Tura
Primavera/Spring

c. 1460, wood panel, London, National Gallery.

The title traditionally given to this painting has nothing to do with the identity of the mysterious and fascinating figure seated on a throne decorated with sharp-edged copper dolphins. The picture probably shows one of the Muses painted to decorate the Este study at Belfiore.

On the opposite page
Cosmè Tura
San Giorgio e il drago/St. George and the Dragon

1469, wood panel, Ferrara, della cathedrale.

The dramatic way in which the gestures are fixed, the unreal atmosphere created by the golden sky, and the exasperated grimaces on the faces of all the main characters, including the horse, make this painting one of the most original of the whole Italian Renaissance.

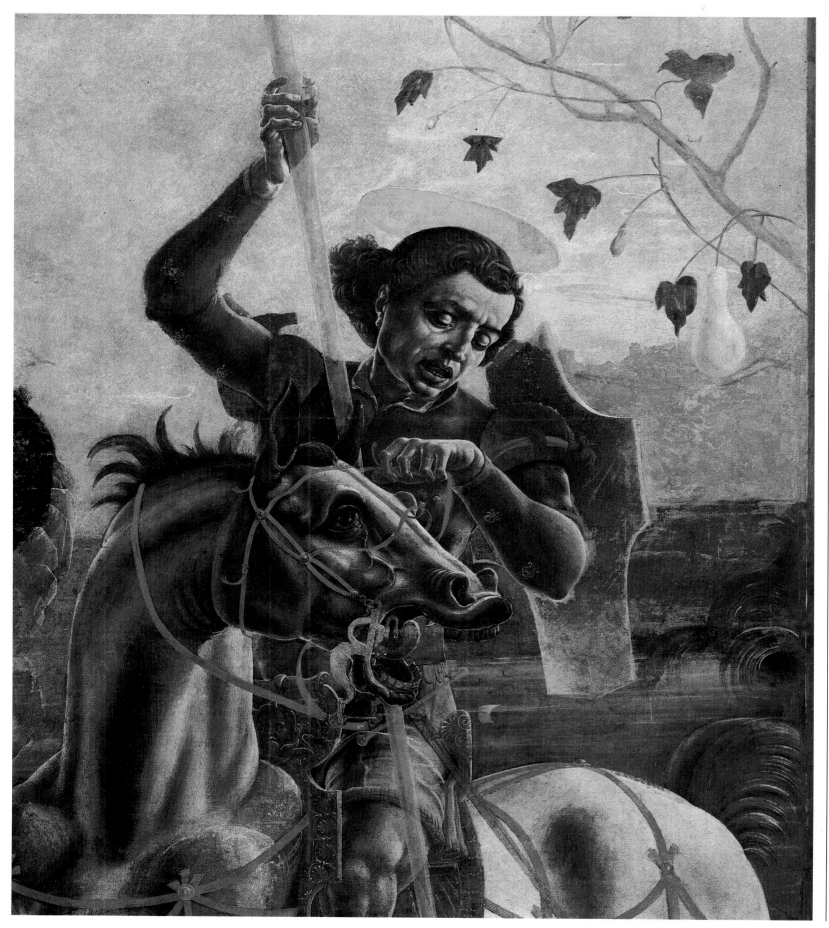

Francesco del Cossa

Ferrara, c. 1436–77/78

Cosmè Tura's assistant and partner in Ferrara, Cossa diluted his master's harshness in his own more genial style of painting. His masterpieces are the allegories of the Months that he painted for the salon in the Schifanoia Palace in Ferrara (c. 1470). Here he combined mythological scenes and astrological references with episodes from contemporary life of the Duke, the city, and the countryside. Dissatisfied with the remuneration he was receiving, Cossa left Ferrara and just after 1470 settled in Bologna. There he painted major altarpieces (*Merchants' Altarpiece*, Bologna, Galleria Nazionale; *Annunciation*, Dresden, Gemäldegalerie) and for the church of S. Petronio he produced the ambitious *Grifoni Polyptych*. The plastic energy of his characters extends to Cosssa's detailed landscapes and architectural backdrops as well.

Francesco del Cossa
San Pietro; San Giovanni Battista/St. Peter; St. John the Baptist

c. 1473, wood panels, Milan, Brera.

These were the side panels to the *Polyptych*.

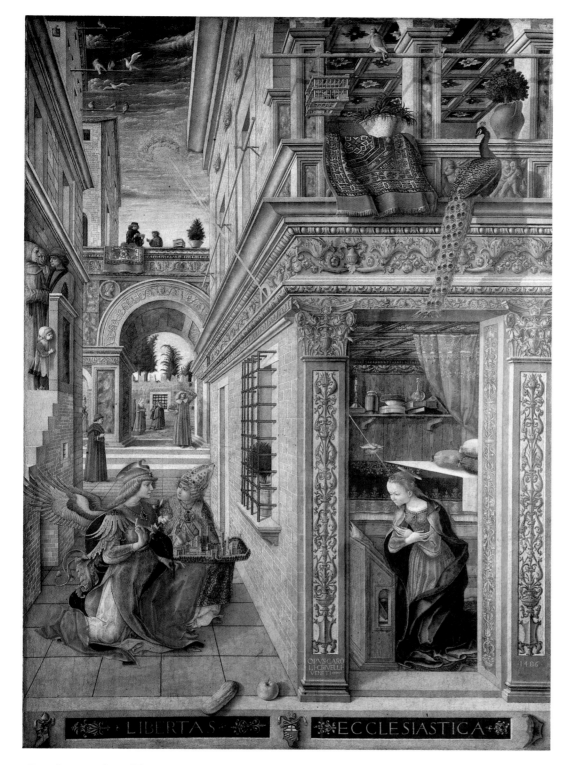

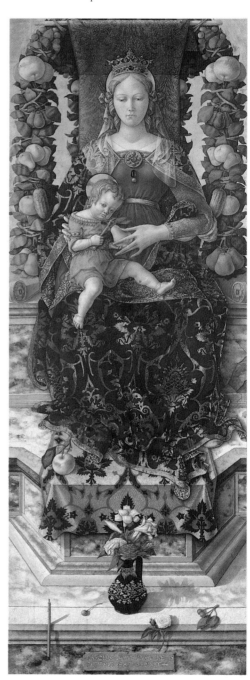

Carlo Crivelli
Madonna della candeletta/Madonna of the Taper

c. 1490, wood panel, Milan, Brera.

This was the central piece of a dismantled polyptych. It takes its name from the slender candle in the bottom left of the picture.

On the following page
Carlo Crivelli
Santa Caterina d'Alessandria, san Pietro e la Maddalena/ St. Catherine of Alexandria, St. Peter, and Mary Magdalene

c. 1475, wood panels, Montefiore dell'Aso (Ascoli Piceno), S. Lucia.

Carlo Crivelli

Venice, c. 1430/35 – the Marches, 1494/95

Crivelli was born in Venice and received his early training in the Vivarini studio before moving to Padua. The young Crivelli experienced misfortunes which led him first to Istria (1459) and then to the Marches where he lived from 1468 until he died. In the provinces Crivelli's creativity flourished best and he became one of the most individual Italian artists in the second half of the Quattrocento. He was obviously familiar with the most advanced perspective and classical monumental art. However, in his hands this was dressed in splendid and exuberant ornamental trapping. He even reintroduced the old gold background.

Carlo Crivelli
Annunciazione/ Annunciation

1486, wood panel, London, National Gallery.

Perhaps his greatest masterpiece, this panel was painted for Ascoli Piceno as can be seen from the presence of St. Emidio.

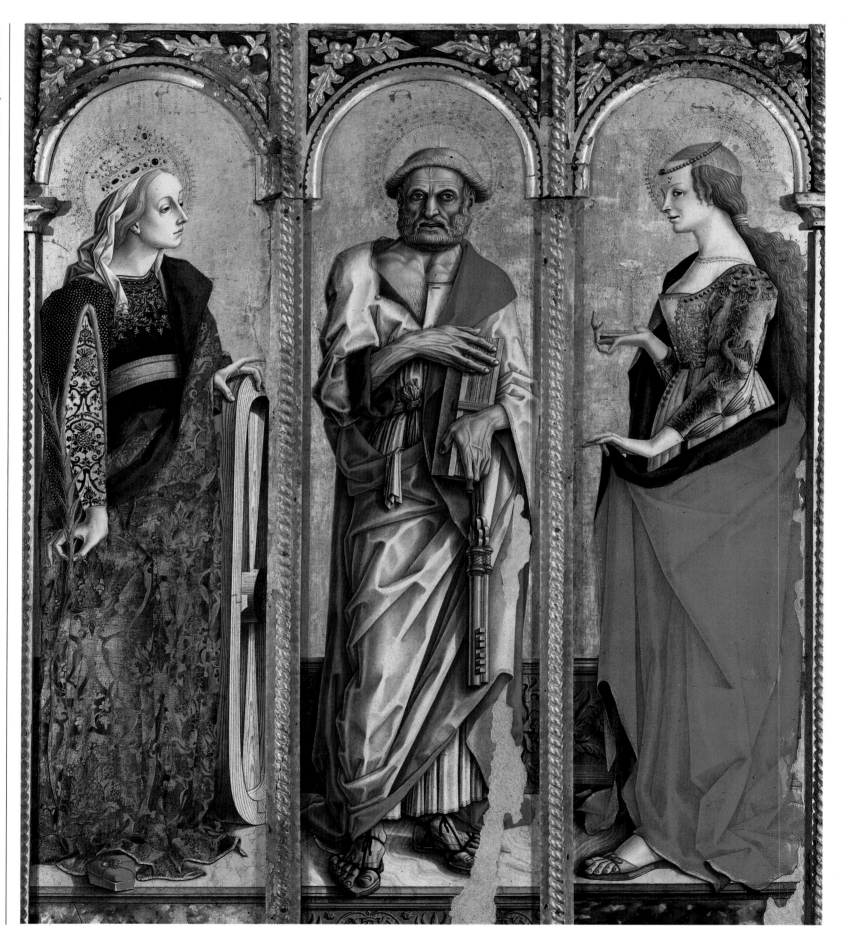

Andrea Mantegna

Isola di Carturo, Padua, 1431–Mantua, 1506

A leading figure in the development of Renaissance painting in northern Italy, Mantegna transformed painting through his ambitious but tormented and marmoreal interpretation of classical art. He studied in Padua under Francesco Squarcione but also knew of Donatello. At a very early age Mantegna made his debut with frescos for the church of the Eremitani in Padua about 1450. The *Triptych* that he painted for the Veronese church of S. Zeno (1458) reveals clearly the character of his art. The figures possess a solemn monumental quality and are remarkably faithful to antique statues. Throughout Mantegna's art both classical architecture and perspective were continuously explored. It was then that Mantegna's working relationship with his brother-in-law Giovanni Bellini began, which was vitally important to the development of the Renaissance in Venice. In 1460 Mantegna became court painter to the Gonzaga family. After that he only left Mantua for occasional trips to Tuscany and Rome. His masterpiece in Mantua is the famous decorative scheme for the *Bridal Chamber* in the Duke's Palace (c. 1474), a revolutionary project carried out with virtuoso skill in illusionistic perspective. Mantegna, a keen student of archeology, never flagged in attempts to create an art that could rival that of the Ancients. His passion for classical subjects is demonstrated by the nine large paintings of *The Triumph of Caesar* (1480, Hampton Court, Royal Collection). The loftily intellectual tone of such compositions can also be seen in altarpieces such as the *Madonna of the Victory* (1495; Paris, Louvre). In 1487 Mantegna started the elegant decorative work in the studiolo of Isabella Gonzaga. Mantegna himself painted two pieces on mythological subjects, both now in the Louvre. In his last years, he also experimented with engraving.

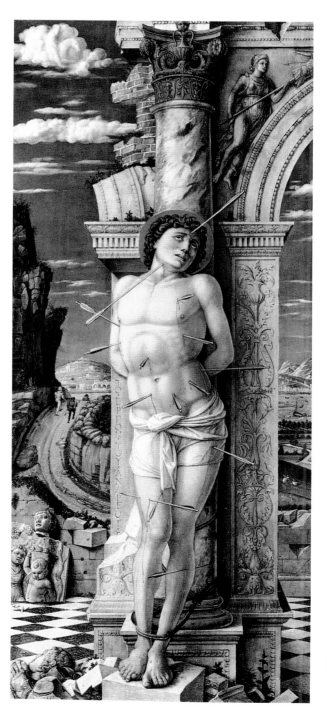

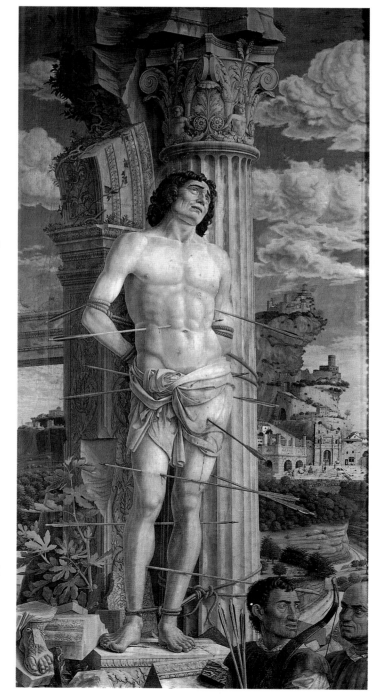

On the left
Andrea Mantegna
St. Sebastian

c. 1459, wood panel, Vienna, Kunsthistorisches Museum.

On the right
St. Sebastian

1480, canvas, Paris, Louvre.

These two paintings on an identical subject belong respectively to Mantegna's early and later periods. A comparison between them reveals the constants in his work as well as developments in his style. Mantegna's classical taste is already fully fledged in the small panel now in Vienna. Notice that in true Renaissance fashion the painting is obsessed with recreating classical antiquity. Here Mantegna's view of antiquity is one of devoted admiration. He dwells on the clean lines of the surfaces and is painstakingly accurate in his reproduction of architectural detail. He is also at pains to portray the martyr in an elegant pose. By the time the large canvas of *St. Sebastian* in the Louvre was painted, Mantegna's understanding had clearly grown. Every detail expresses genuine human emotion, from the brutish faces of the archers to the Saint's long-suffering looks. By now the artist had complete control of anatomical detail. The crumbling ruins in the foreground and the incomplete buildings in the background reveal a vision of a lost civilization that cannot be rebuilt.

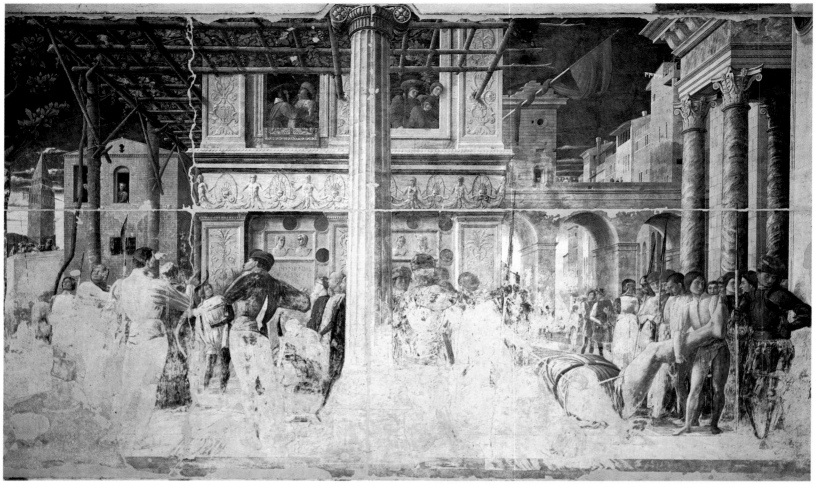

Andrea Mantegna
Martirio e trasporto del corpo di san Cristoforo (Storie di san Giacomo e di san Cristoforo)/ Martyrdom of St. Christopher and the Transport of his Body (Lives of St. James and St. Christopher)

1457, fresco, Padua, Church of the Eremitani, Orvetari Chapel.

The Orvetari Chapel was almost completely destroyed by bombing in 1944. In the scenes that are still visible (shown here) we can see the young Mantegna's interest both in architectural perspective and in the classical world. In the *Martyrdom of St. Christopher* the central building is surrounded by a pergola shown in perspective. In the lower part of the building we can see Roman memorial stones.

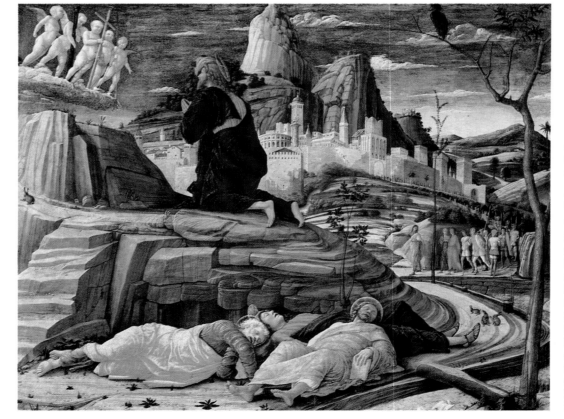

Andrea Mantegna
Orazione nell'orto/The Agony in the Garden

1455, wood panel, London, National Gallery.

This was Mantegna's first landscape. The harsh, rocky, and steep scenery is broken up by strongly-defined lines which are the hallmark of the way Mantegna handled figures. Every part of the scene, including the clouds, has a hard, almost metallic, quality. This panel directly inspired the very similar composition by Mantegna's brother-in-law, Giovanni Bellini.

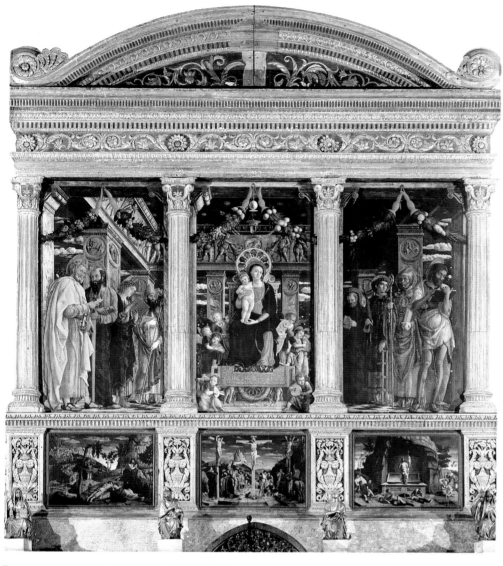

Andrea Mantegna
Polittico di San Zeno/
St. Zeno Polyptych

*1457–59, wood panel, Verona,
S. Zeno.*

At the bottom of the page
Predella (altar step) with
the Crucifixion

Paris, Louvre.

The way the large main
scene was structured
revolutionized the whole
concept of altarpieces in
northern Italy. The frame
still hints at the divisions of
a triptych. In fact the three
panels form a single
picture thus creating an
architectural setting
complete with pillars into
which the groups of figures
fit symmetrically.

Andrea Mantegna
San Giorgio/St. George

*1467, wood panel, Venice,
Gallerie dell'Accademia.*

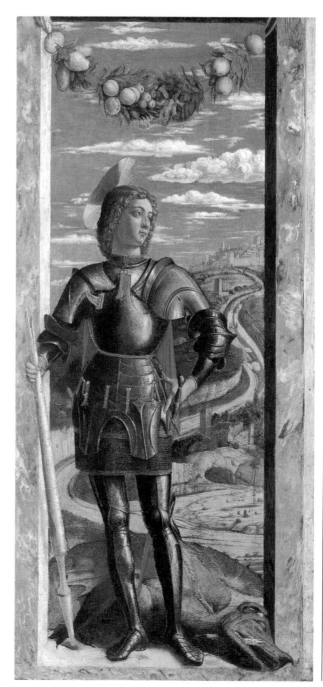

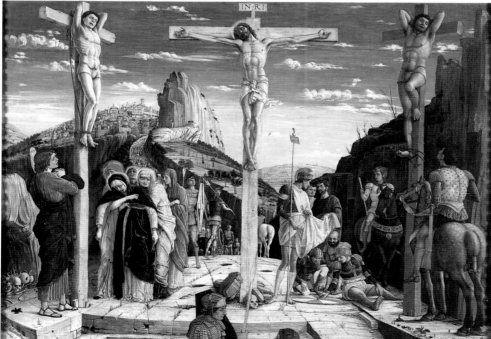

Andrea Mantegna
Veduta della parete occidentale e della parete settentrionale/ View of the West and North Walls

1465–74, dry mural, Mantua, Palazzo Ducale, Bridal Chamber.

The decoration of the so-called "Bridal Chamber" is among the most famous secular paintings of any Italian Renaissance court and a masterpiece of trompe l'œil (illusory art). The precious details of late-Gothic give way to large-scale scenes. These are underpinned by a strong sense of perspective combined with the accurate reproduction of nature. With this work Mantegna reached full artistic maturity. The documents of the day refer to the room as the "camera picta" [painted chamber], and Mantegna designed it as a single unit. Two walls are covered by a false curtain held back to reveal members of the Gonzaga family. The entrance wall is broken by pillars painted with classical motifs behind which we see a landscape full of Roman monuments. Against this background we have the *Marquess Ludovico Greeting his Son Cardinal Francesco Gonzaga*. Accompanying the figures are a splendid train of pages with horses in decorative bridles and pure-bred dogs. The next wall shows *The Gonzaga Court*. Here Mantegna reveals his talents as a portrait painter. He varied his style to capture the fresh cheeks of the young girls, the stern faces of the older people, and the dwarf's smile.

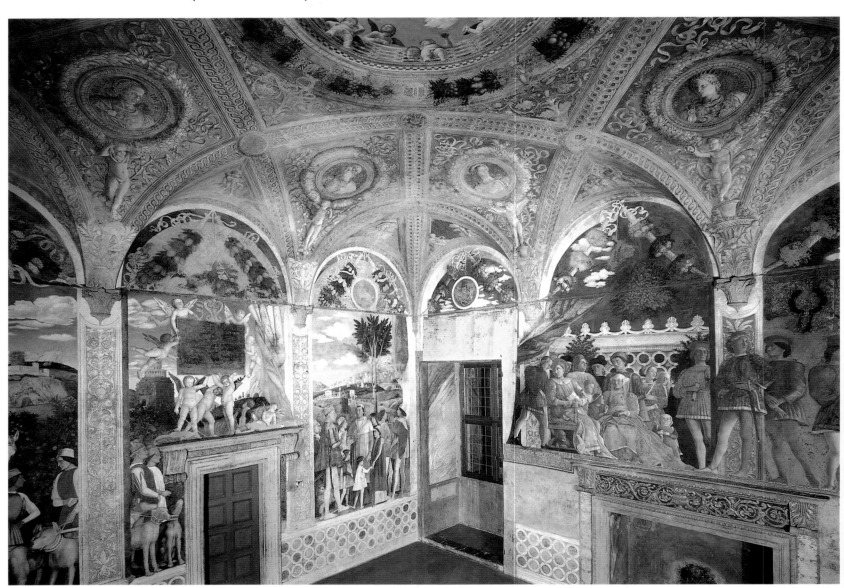

On the opposite page
Andrea Mantegna
Oculo con putti e dame affacciati/Roundel with Putti and Ladies Looking Down, detail of ceiling

1465–74, fresco, Mantua, Palazzo Ducale, Bridal Chamber.

The famous circular roundel is set in the chiaroscuro coffers of the ceiling painted with classical motifs. Over a balcony from which people and animals peer down at us, a giddy perspective opens up toward the sky. This use of trompe l'œil was to be an example for future generations, in particular for Correggio and beyond him for later painters such as Tiepolo.

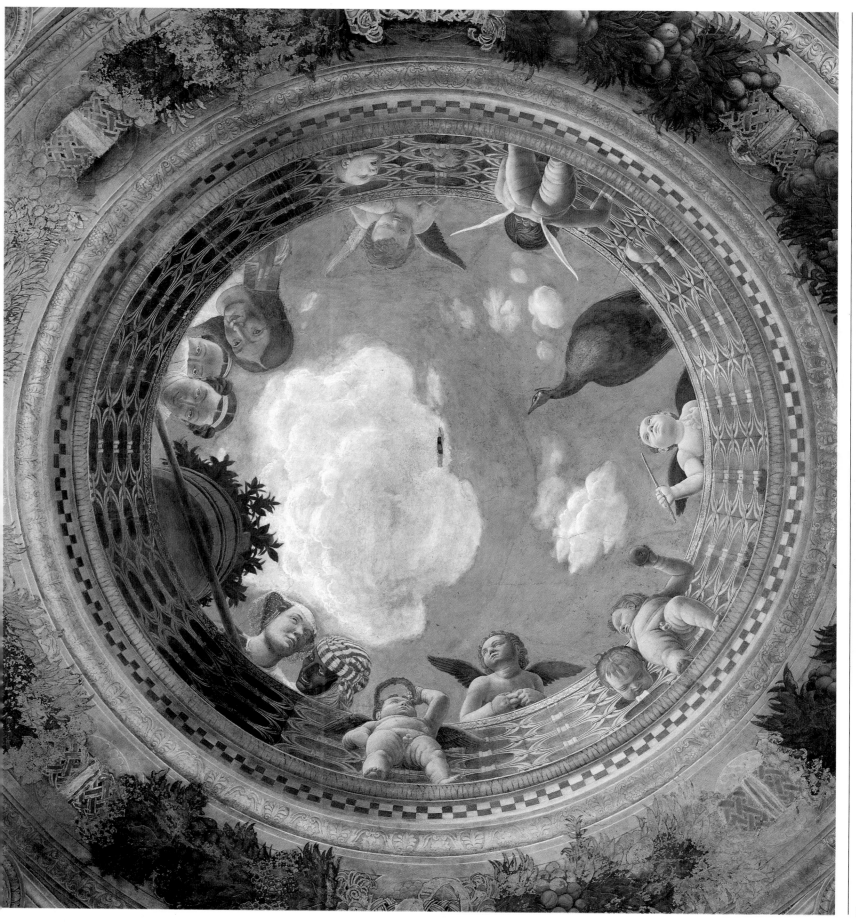

Andrea Mantegna
Il Parnaso/Parnassus

1497, canvas, Paris, Louvre.

This was the first painting that Isabella d'Este, Marchioness of Mantua, ordered to decorate her private study. The iconographic program was drawn up by the court's resident man of letters, Paride Ceresara. It proved particularly congenial to Mantegna as it gave him the opportunity of showing off in elegant detail his huge knowledge of classical antiquity and mythology. He reworked the stories in the cultured Renaissance terms. In the center of the picture the nine Muses dance to a cithara played by Apollo. On the right the god Mercury is leading the winged horse Pegasus. On the knoll, behind the Muses, Venus and Mars are embracing while Cupid taunts Vulcan, Venus' husband.

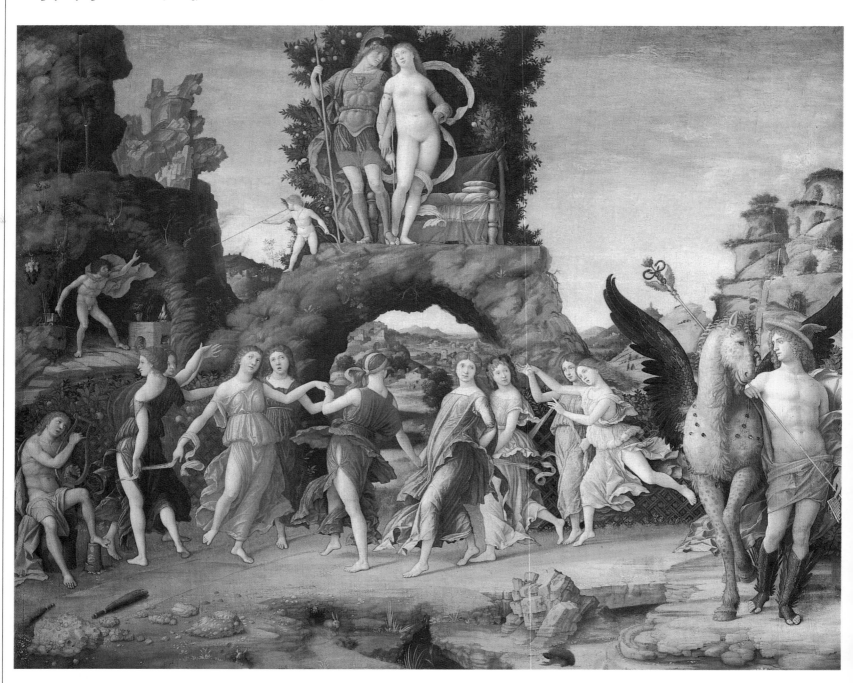

Andrea Mantegna
Cristo Morto/Dead Christ

c. 1500, canvas, Milan, Brera.

This canvas is of uncertain date but is thought to be one of the master's late works, hinting at his own forthcoming death. It was mentioned in the inventory of household goods that Mantegna's son drew up on his father's death. It was meant to be placed at the foot of the painter's tomb in the chapel set aside for him in the church of S. Andrea in Mantua. The dull light of the laying-out chapel gives the picture a dirty gray color that reduces everything to its bare essentials. Mantegna dramatically foreshortens the body of Christ, watched over by the Virgin and other mourners. Their faces peer from the shadows like tragic masks.

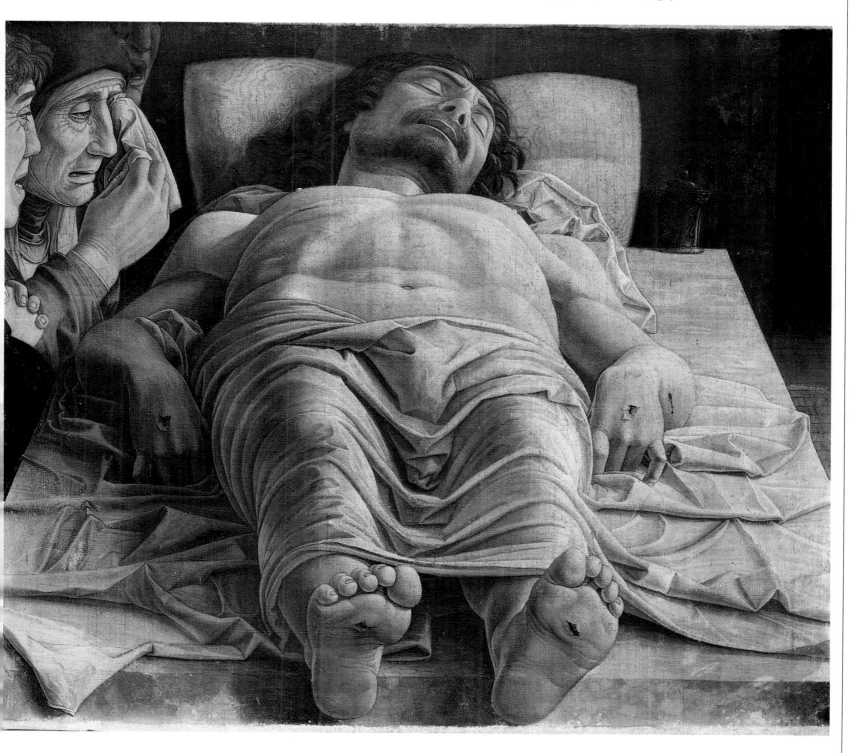

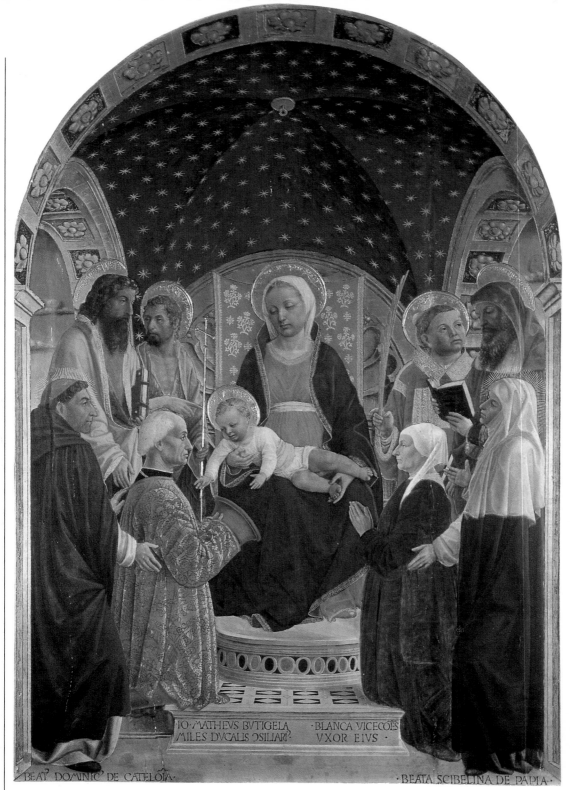

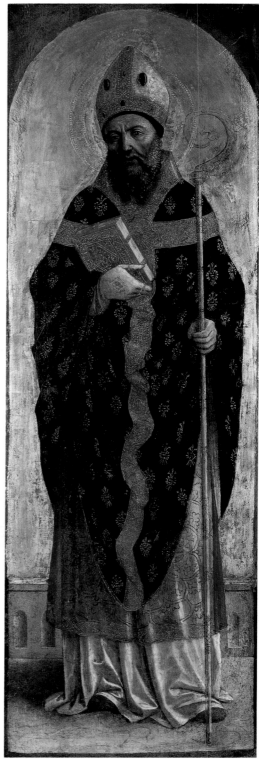

Vincenzo Foppa

Orzinuovi (Brescia), 1427/30–Brescia, 1515/16

Foppa and Mantegna studied together in Padua and Foppa went on to become the first important Renaissance painter in Lombardy. Working in a Milan still dominated by International Gothic, Foppa painted the frescos in the Portinari Chapel in S. Eustorgio (1468). His panel paintings and altarpieces reveal his knowledge of perspective and a melancholy seen in the delicate use of chiaroscuro. Apart from his work in Milan, Foppa was active in Pavia and in Liguria and molded painting throughout north-western Lombardy. His style, influenced by Mantegna, combines grace and realism.

Vincenzo Foppa
Bottigella Altarpiece

*Pavia, Musei Civici,
Malaspina Pinacoteca,
c. 1480–84, wood panel.*

Vincenzo Foppa
St. Augustine

*c. 1465–70, wood panel,
Milan, Sforza Castle,
Civiche Raccolte d'Arte.*

Together with a matching panel of St. Theodore, this was originally part of a polyptych in the church of the Carmine in Pavia. The refined way in which he painted the saint's canonical dress brings to mind Provençal and Flemish painting.

Vincenzo Foppa
Madonna del libro/
Madonna of the Book

*1460–68, wood panel, Milan,
Sforza Castle, Ciriche Raccolte
d'Arte.*

This is a wonderfully
delicate early work. The
small panel can be read
almost as an experimental
exercise, produced by an
artist at the very start of
his career. The geometrical
frame is defined with
precision and is enlivened
by a beaded garland of the
type used by Mantegna.
Foppa is tentative but full
of poetry in the way he
portrays the Virgin and
Child, who, unusually, is
dressed in a Roman-style
singlet – another
borrowing from Mantegna,
as is the Roman lettering
in the surround. In the
painting emotion is
controlled, gesture is
lightly drawn, tones are
dull, flesh has a silvery-
gray quality. This is all part
of Foppa's constant
attention to the quiet
reality of everyday life.
Foppa's human realism was
to become the basis upon
which Lombard painting
developed.

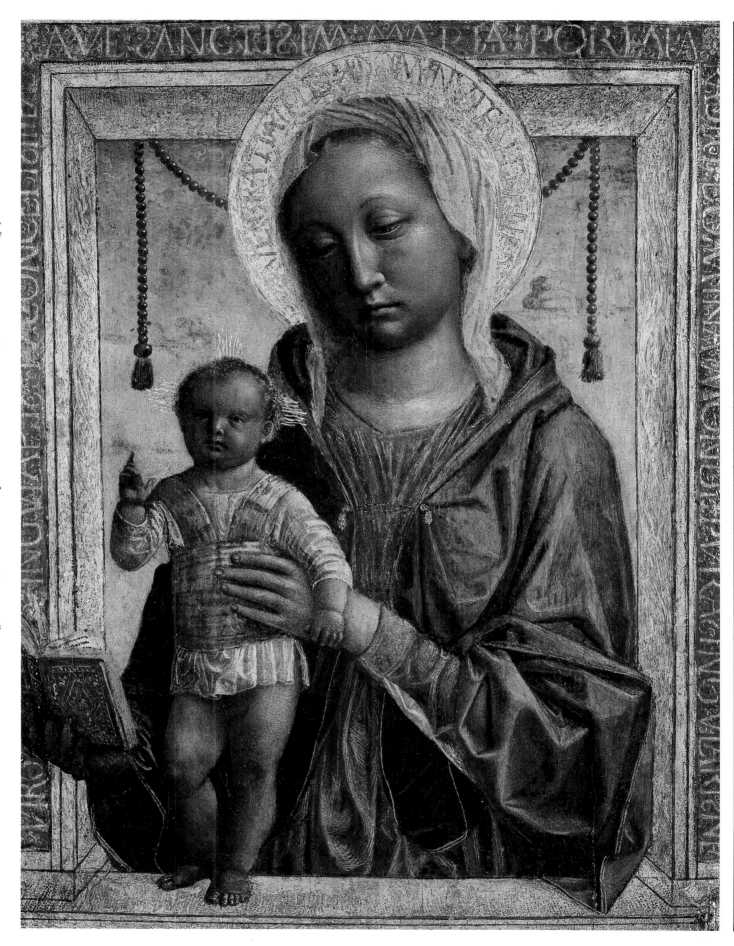

91

Antonello da Messina

Messina, c. 1430–79

If we want to understand the international interaction of painting in the mid fifteenth century then we must look at the vital role played by Antonello da Messina. His career leads from his learning from Flemish painters, through vital contacts with Piero della Francesca, and on to the crucial role he played in the development of the Venetian school both by helping to introduce oil painting to the city and, as a development from this, to model forms by using light in subtle gradations of tone, rather than by hard line. He was trained in the cosmopolitan environment of Naples of the 1450s where he encountered Flemish art. From his earliest work, Antonello combined Flemish attention to detail with an Italian sense of geometric space. His own development was extremely rapid as can be seen from a succession of new versions of the Crucifixion that he produced (Antwerp and London). The high point of his career was his stay in Venice between 1474—76, when he produced works of enormous power, such as the *S. Cassiano Altarpiece* (fragments in the Kunsthistorisches Museum in Vienna) and his extraordinary *St. Sebastian* (Dresden, Gemäldegalerie).

Antonello da Messina
Rittrato d'uomo/Portrait of a Man (Trivulzio Portrait)

1476, wood panel, Turin, Museo Civico.

Antonello was one of the best portrait painters of the fifteenth century. He abandoned the regulation profile pose and turned the sitter's bust and head three-quarters on, facing out of the shadow into the light. The painter brought a strikingly vivid realism to his subject, whose identity is not known.

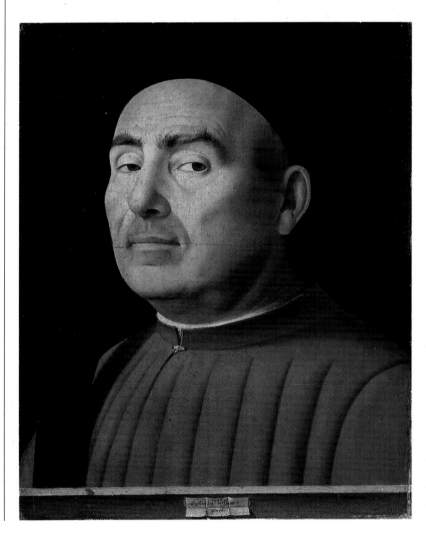

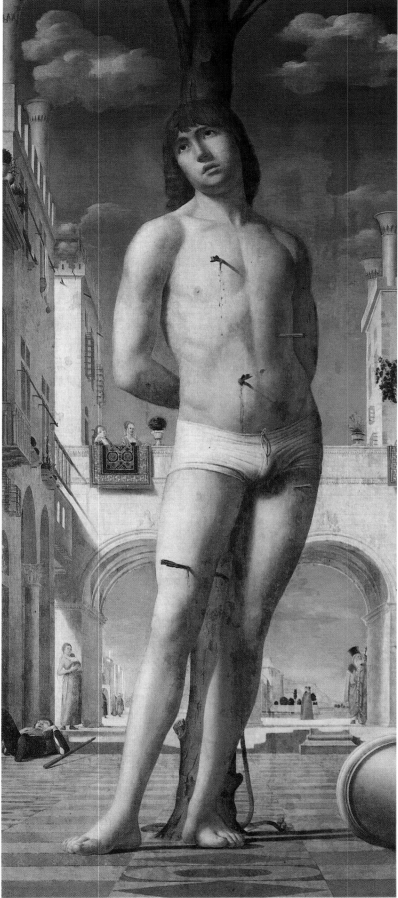

*On the preceding page
On the right*

Antonello da Messina
San Sebastiano/
St. Sebastian

*c. 1475–76, wood panel,
Dresden, Gemäldegalerie.*

The fine figure of the martyr-saint was originally part of a cycle of paintings that the artist executed during his stay in Venice. The young St. Sebastian, modeled as if within the geometrical shape of a cylinder, stands at the center of a wonderful cityscape, with receding buildings and figures underlining the depth of perspective. The view of the ideal urban setting is warmed by an all-embracing sense of atmospheric light. This can be seen in the shadows cast by the arrows piercing the martyr's flesh. It was through works like this, painted in the then revolutionary medium of oil, that Antonello decisively influenced Venetian painting.

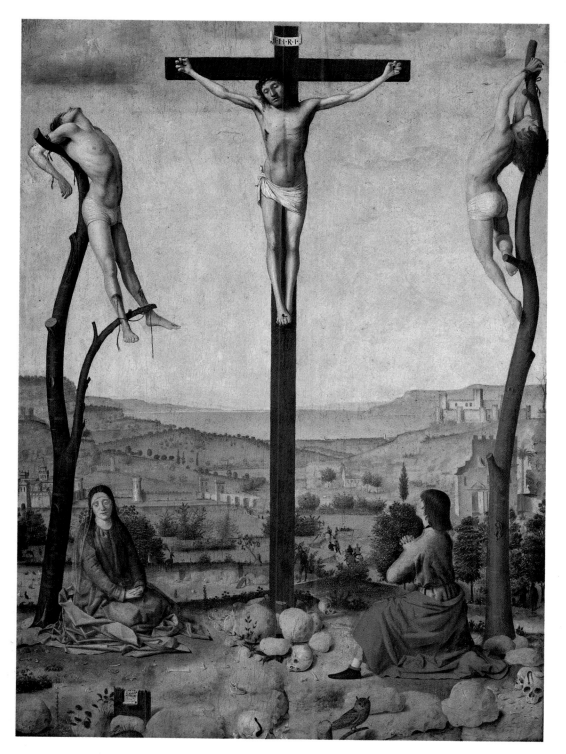

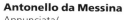

Antonello da Messina
Annunciata/
The Annunciation

*c. 1474, wood panel, Palermo,
Galleria Nazionale.*

This must be the best known of all the Sicilian painter's works. He manages to evoke feelings of candor, modesty and emotional involvement even though the Virgin's gesture and expression are very restrained. Here Antonello gives his own highly personal interpretation of Piero della Francesca's geometrical rigor which he amplifies by using oil paint to intensify color and volume.

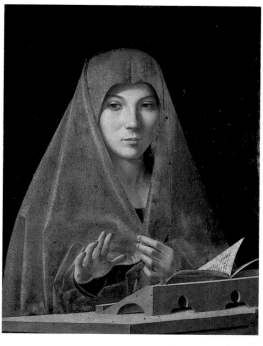

Antonello da Messina
Crocifissione/
Crucifixion

*c. 1475–76, wood panel,
Antwerp, Musée des Beaux Arts.*

This is the most complex and dramatic of Antonello's repeated variations on the theme of the Crucifixion. His description of the landscape is accurate down to the very last detail. This contrasts effectively with the emptiness of the sky against which the three crucified men are seen. Christ's painful composure on the smooth wooden cross is underlined by the contorted and twisted bodies of the two thieves, lashed to gnarled tree trunks.

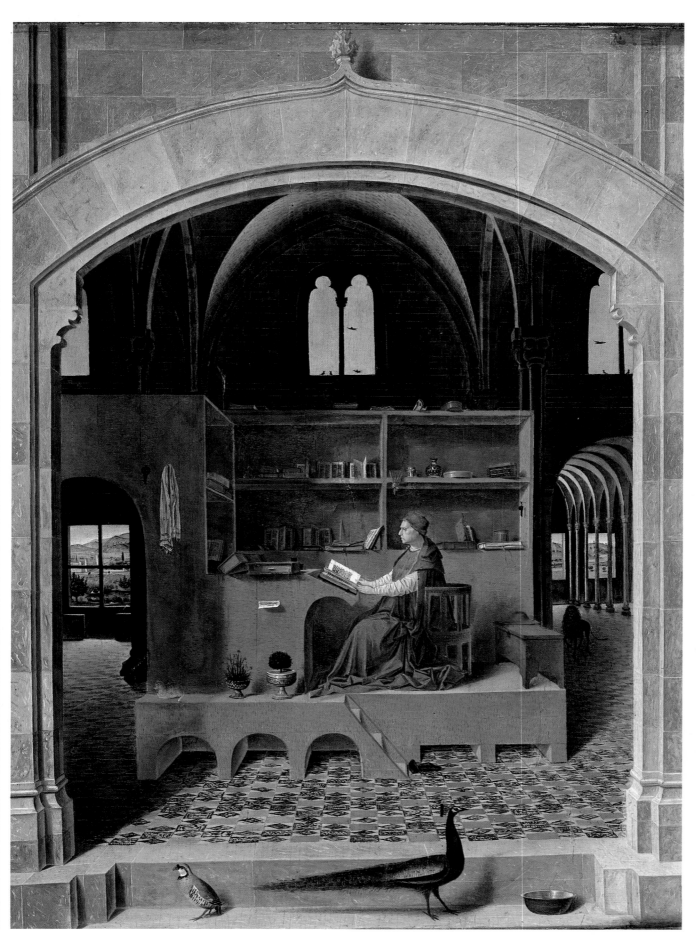

Antonello da Messina
San Gerolamo nello studio/St. Jerome in his Study

c. 1474—75, wood panel, London, National Gallery.

As a memorable example of Antonello's mastery of Italian perspective combining triumphantly with Flemish attention to detail, this picture holds a special place in the history of Italian painting of the fifteenth century. It is no coincidence that in the past it was attributed to the great Flemish master Van Eyck. Around the saint who is concentrating on his studies, Antonello creates a little world of objects, animals, plants, and architecture of every description, including a lion (the Saint's emblem) stepping light-footedly along the corridor on the right. The fascination exerted by the masterpiece is increased by the way that light floods in from various apertures, the natural world pushes up to the windows at the back of the building, while the world of learning reverberates from the pages of the books. It is typical of Antonello (and of Italian art in general, but not of Flemish art) that even where it is small in scale, the painting manages to retain a sense of monumental grandeur.

Gentile Bellini

Venice, c. 1430–1507

Gentile Bellini is famous as a painter of portraits and cityscapes, partly because these are his only surviving works. It is to him that we owe probably the first accurate views of Venice teeming with life. For a long time he and his brother

Giovanni worked as pupils and assistants to their father Jacopo. Gentile's independent career took off during the 1460s when he received public recognition for his *Portrait of St. Lorenzo Giustiniani* (1465, Venice, Accademia). This was painted in profile and possessed characteristic graphic qualities. Following this work, in 1466 he was given official commissions by

the Republic. He was also invited to travel to Constantinople (Istanbul) to undertake a mission that was diplomatic as much as artistic in nature (*Portrait of Sultan Mehmet II*, London, National Gallery). On several occasions, Gentile also worked decorating institutional buildings. In 1496 he started work on a group of huge canvases of narrative scenes for

the Scuola di S. Giovanni Evangelista, now in the Accademia. They are crowded with faithful and lively descriptions of the city. For the Scuola di S. Marco he painted the huge *Preaching of St. Mark in Alexandria* (Milan, Brera).

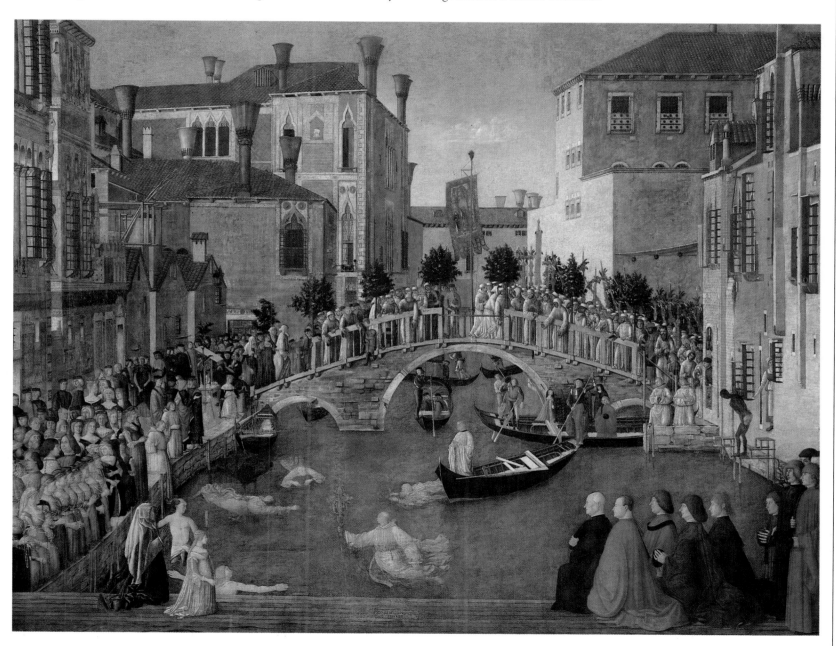

Gentile Bellini
Miracolo della croce/The Miracle of the True Cross

1496–1500, canvas, Venice, Gallerie dell'Accademia.

This large canvas was commissioned by the rich and powerful Scuola di S.

Giovanni Evangelista in the context of a series of scenes dedicated to the cult of a precious fragment believed to be a relic of the Cross. The scene shows how the relic was found again after it had fallen into a canal. Gentile Bellini used the

opportunity to give his witty sense of narrative free range. The realistic setting was a city scene in the Venice of his day. The lively tone of the descriptive episodes (look at the figure of the black man who is about to dive off a small

jetty on the right) and the enchantment of the architectural views offset the rather static gestures and the repetitive poses of the individual characters.

Giovanni Bellini
Venice, 1433 (?)–1516

Gentile's (presumedly) younger brother and, like him, a pupil of their father Jacopo, Giovanni Bellini was the greatest reformer, almost the founder, of Venetian painting. The impetus to abandon his Gothic heritage was the strongly classical art of his brother-in-law Andrea Mantegna. This is why Giovanni Bellini's early works are directly inspired by similar compositions by Mantegna. But Bellini's subtle attention to capturing light and natural atmosphere was different. Antonello da Messina's arrival in Venice introduced him to the regular use of oil paint. Giovanni tried thereafter to achieve subtle and soft effects of light even when working on large-scale compositions. From 1483, he was the official painter to the Republic and ran an efficient studio where Giorgione and Titian trained. He produced numerous versions of his favorite theme of the Virgin and Child, as well as portraits and altarpieces. In the first years of the sixteenth century Bellini was influenced by Giorgione's radical achievements, and at the end of his life he also painted secular themes, such as *The Feast of the Gods* (1514) in the National Gallery in Washington and the dreamy *Young Woman doing her Hair* (Vienna, Kunsthistorisches Museum).

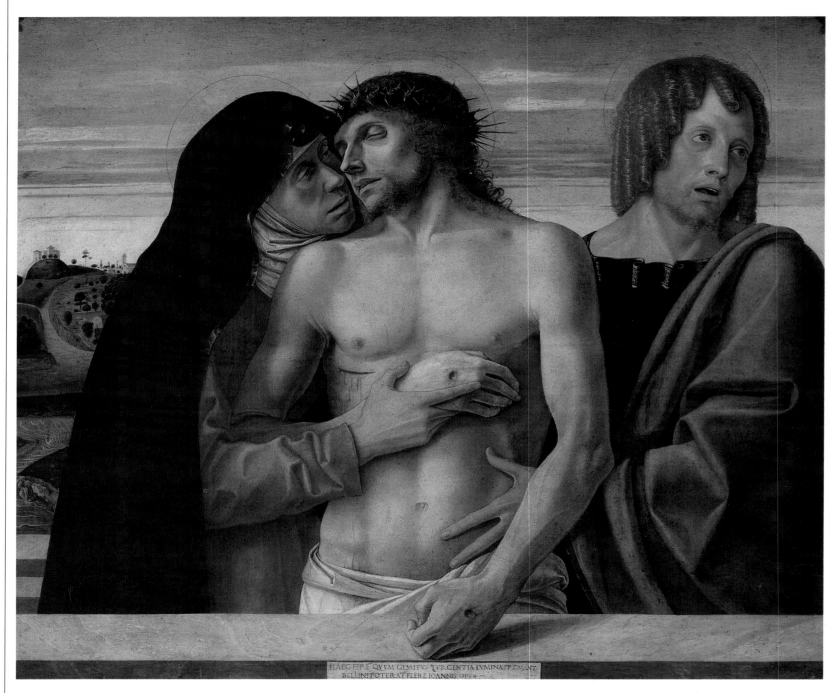

Giovanni Bellini
Pietà

c. 1465, wood panel, Milan, Brera.

This picture marks a decisive step towards the acquisition of his own, unmistakable style. His borrowings from Mantegna (the three large figures turned toward the spectator but separated by a marble slab) had by now been assimilated into Bellini's own way of defining light.

Giovanni Bellini
Polittico di san Vincenzo Ferreri/Polyptych of S. Vincenzo Ferreri

c. 1464–68, wood panel,

Venice, SS. Giovanni e Paolo.

The large Polyptych, which is still in its original frame, celebrated the recent canonization of the Dominican saint Vincenzo Ferreri. The work is of great complexity and was probably painted during the 1470s.

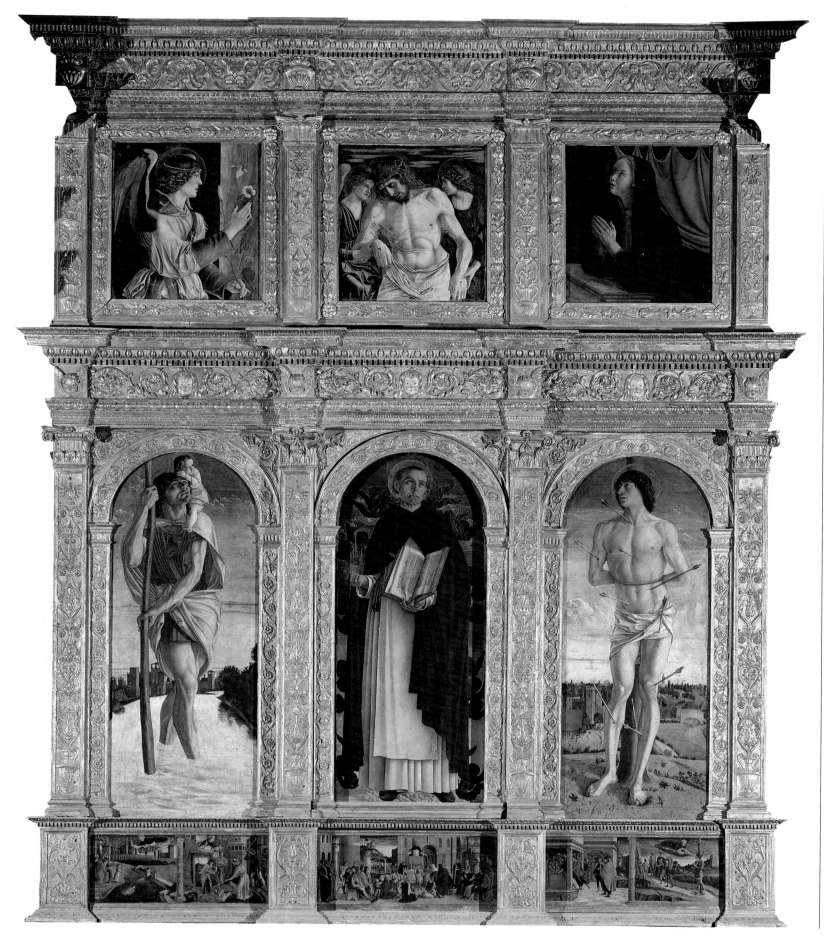

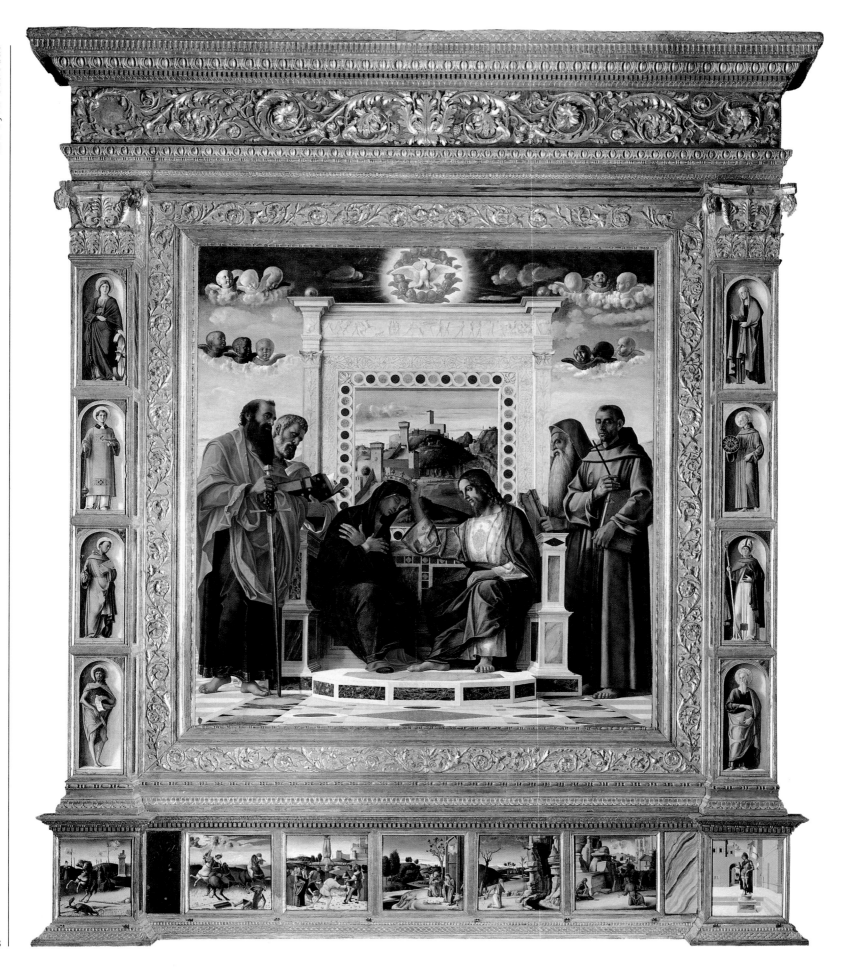

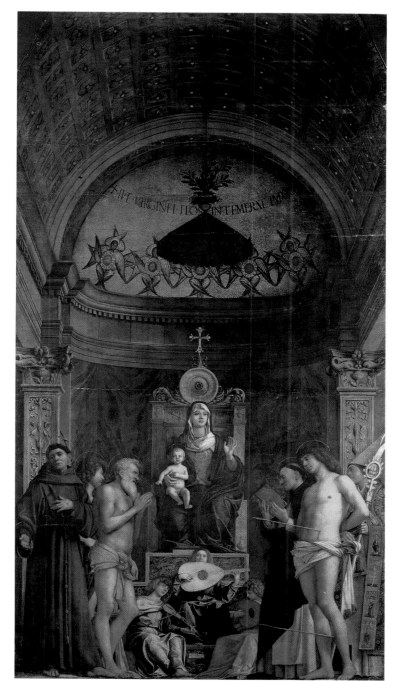

Giovanni Bellini
Pala di san Giobbe/The St. Giobbe Altarpiece

1487, wood panel, Venice, Accademia.

One of the painter's mature works, this shows the influence of altarpieces by Antonello da Messina in its Renaissance architecture but reinterpreted in the new Venetian manner he himself was creating. Bellini's perfect understanding of the rules of perspective is softened by the way he interprets light. The mosaic apse behind the figures diffuses light to various parts of the picture. His mastery of the nude form is also strikingly Renaissance in style.

Giovanni Bellini
I santi Cristoforo, Gerolamo e Ludovico/ St. Christopher, St. Jerome, and St. Louis

1513, wood panel, Venice, S. Giovanni Crisostomo.

This was Giovanni Bellini's last major religious composition. It is freely structured and has already shed all reference to the traditional manner of composition used in the fifteenth century.

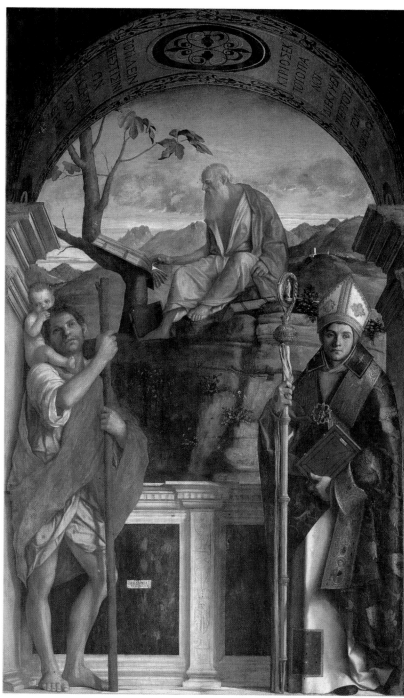

On the opposite page
Giovanni Bellini
Incoronazione della Vergine (Pala Pesaro)/ Coronation of the Virgin (Pesaro Altarpiece)

c. 1471–74, wood panels, Pesaro, Museo Civico.

Splendidly preserved (including its original frame), this ambitious composition dates from the early 1470s. In the main scene Giovanni Bellini demonstrates his mastery of solemn grandeur. It is impeccable in the way he applies precise geometric principles (which can be seen in the floor and in the architectural elements of the throne on which Christ is placing a crown on the Virgin's head). These principles, however, are made to blend with the surrounding countryside. Through a frame made by the throne behind the characters, Bellini depicts the real panorama of the coastal hills between Romagna and the Marches including Gradara castle.

Giovanni Bellini
Trittico dei Frari/
Frari Triptych

*1488, wood panels, Venice,
S. Maria Gloriosa dei Frari,
Sacristy.*

Beautifully preserved, the
Triptych reaffirms Bellini's
interpretation of central
Italian Renaissance art but
alters it by a poetic use of
light.

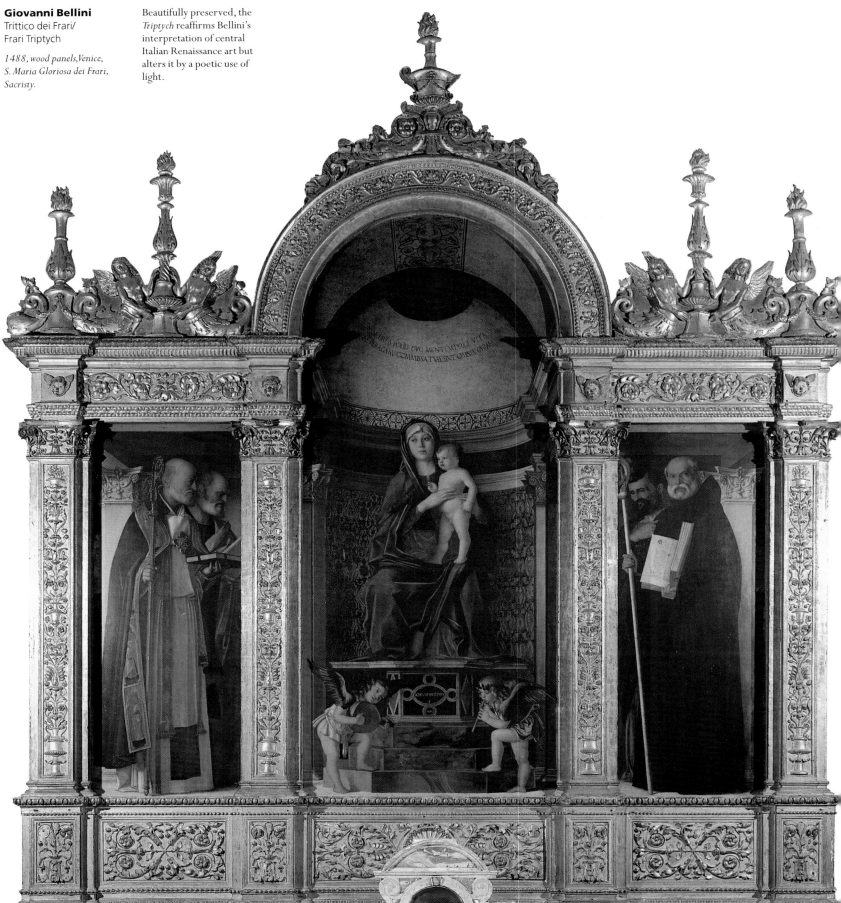

Giovanni Bellini
Pietà

*c. 1505, wood panel, Venice,
Gallerie dell'Accademia.*

Although over 70 years
old when he painted this,
Bellini was still eager to
experiment stylistically. In
this dramatic work he was
experimenting with "mood
painting" (painting the
picture with pure color
almost unaided by a
preliminary drawing). In
the background we can see
the main buildings of
Vicenza depicted against
the Alps.

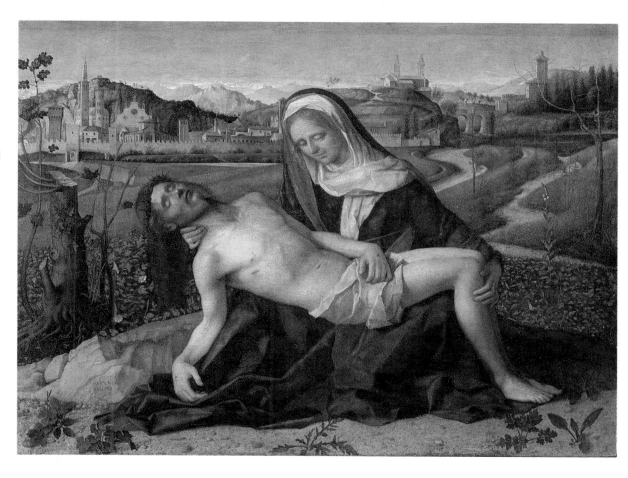

Giovanni Bellini
Madonna col Bambino tra
le sante Caterina e
Maddalena/Virgin and
Child between St.
Catherine and St. Mary
Magdalene

*c.1500, wood panel, Venice,
Gallerie dell'Accademia.*

A typically gentle, peaceful
painting.

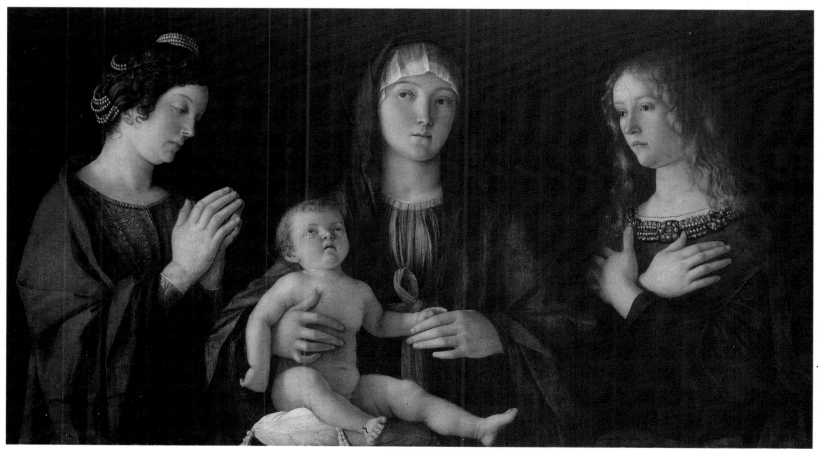

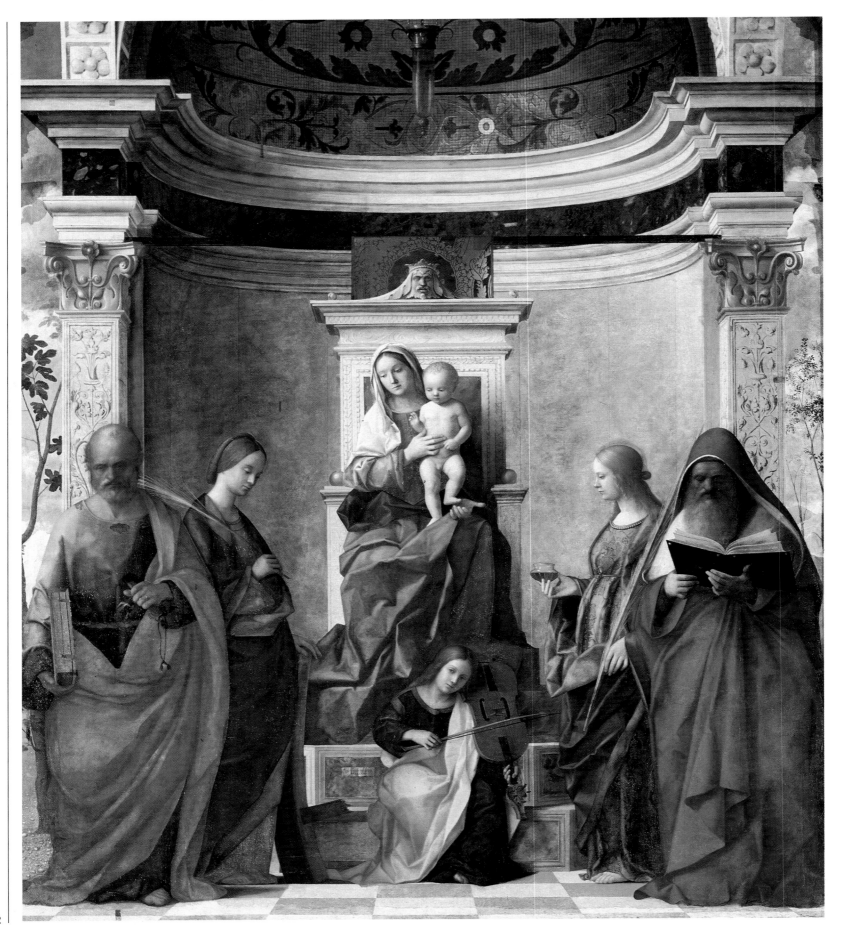

On the opposite page
Giovanni Bellini
Sacra Conversazione

1505, wood panel, Vicenza, S. Zaccaria.

The painting was part of the original altar. It provided a new interpretation of the Renaissance altarpiece. The architecture is "open" at the sides to allow light to circulate freely from the landscape beyond. By inventing this way of using space, Giovanni Bellini was able to modernize the Renaissance model of the Sacra Conversazione. The group is placed in the apse of a church, giving heavy chiaroscuro contrasts.

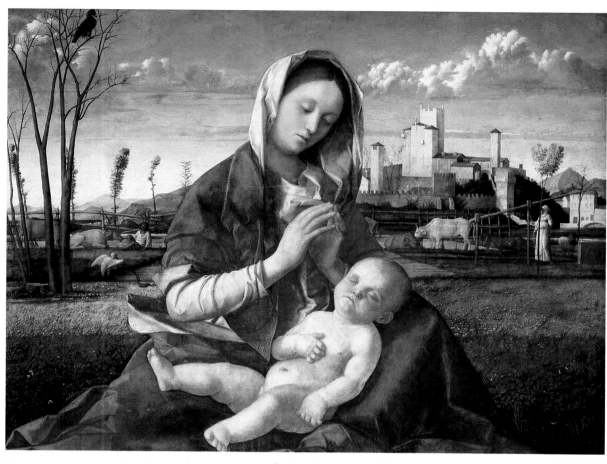

Giovanni Bellini
Madonna del prato/
Madonna of the Meadow

c. 1505, wood panel, London, National Gallery.

The figures are no longer placed in front of a landscape but realistically set within it, adding to its beauty.

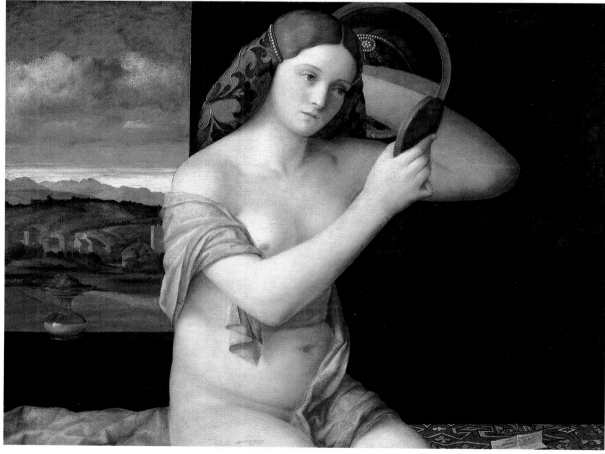

Giovanni Bellini
Giovane alla Specchio/
Young Woman Holding a Mirror

1515, canvas, Vienna, Kunsthistorisches Museum.

Painted the year before his death, this picture provides ultimate proof of Giovanni Bellini's unflagging inventiveness. This, his first and only large female nude, shows his continuing adoption of the latest Renaissance ideas from central Italy, but again transformed by his distinctive art. She is just touched by the light from the distant mountains and possesses a chaste, sweet purity.

Antonio Vivarini

Venice, c. 1418–76/84

Head of a family of artists involved in the transition from Gothic to Renaissance, Antonio Vivarini is remembered for his ambitious, archaic, ornate polyptychs set in flowery golden frames. He often produced these in partnership with his brother-in-law, the painter Giovanni d'Alemagna (their relationship was so close artistically that it is almost impossible to distinguish their separate hands). They were assisted by highly skilled cabinet makers. When he opened his studio in Venice in the 1440s, Vivarini still looked to Byzantine models. He was, however, aware of the fabulous ornament of International Gothic. He immediately received important commissions, such as the triptych that is still housed in S. Zaccaria and the *Triptych of Charity* now in the Accademia. The fame of the Vivarinis' "Murano" studio, which rivaled that of the Bellinis, spread beyond Venice. In 1447 Antonio joined the guild of Paduan painters. Working with Giovanni d'Alemagna he started the decoration of the Orvetari Chapel in the church of the Eremitani. This was left unfinished when his brother-in-law died (1450) and was later finished by Mantegna, then at the start of his career, who soon influenced Vivarini. Vivarini then produced the Bologna polyptych. In the 1460s he painted the *Praglia Polyptych* (now in the Brera Gallery in Milan) and, most importantly, the *St. Anthony Abbot Polyptych* in the Vatican Gallery (1464). After this, Antonio appears to have retired from painting.

Antonio and Bartolomeo Vivarini
Polittico della Certosa/
Charter House Polyptych

c. 1450–60, wood panels, Bologna, Pinacoteca Nazionale.

The dazzling gilding on the frames and the panel backgrounds reflects the Gothic culture found in Antonio Vivarini's workshop. The energetic individuality of some of the figures, however, provides the clue to the presence of Antonio's younger brother Bartolomeo.

On the opposite page
Antonio Vivarini
Polittico di sant'Antonio Abate/St. Anthony Abbot Polyptych

1464, wood panels, Rome, Vatican Gallery.

Even in his more sophisticated work,

Antonio Vivarini remained faithful to the devotional scheme of the polyptych with a painted sculpture on a gold background with a rich Gothic surround. This work can be compared to Cima da Conegliano's *Polyptych* illustrated on page 110.

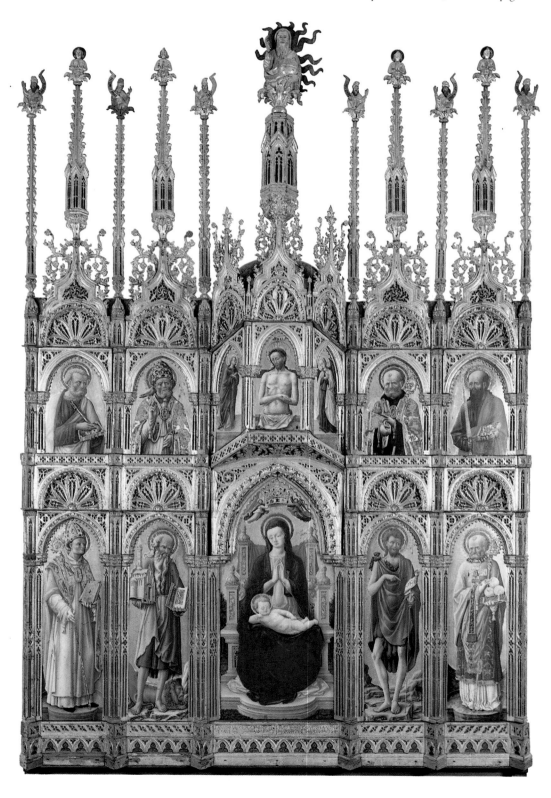

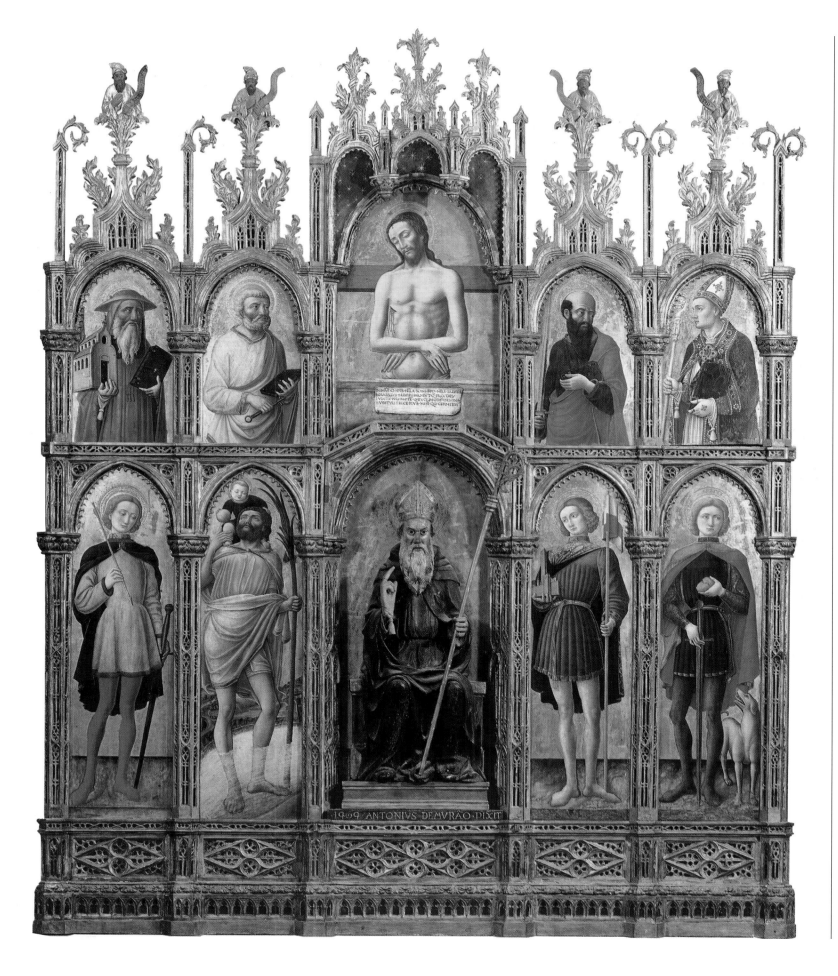

Bartolomeo Vivarini

Venice, c. 1430–after 1491

Younger than his brother Antonio by about 12 years, Bartolomeo worked for a long time as an assistant in the family studio. His temperament drew him toward the more modern, classically-inspired style of Mantegna. This can be discerned early on in the parts he painted in the *Bologna Polyptych* (1450) and also in the later Arbe and Osimo polyptychs. After Antonio retired from the scene in the 1460s, Bartolomeo was able to develop his own style fully. This consisted of blocked and statuesque poses, clear light, graphic surrounds, and unwavering purity. A good example of this is the *Sacra Conversazione* in the Capodimonte Gallery in Naples (1465). He then went on to produce a long series of altarpieces and polyptychs for Venetian churches. Some of these have remained in their original locations (S. Zanipolo, S. Giovanni in Bragora, S. Eufemia) while others are now housed in the Accademia or in other museums. When Giovanni Bellini rose to be the official painter of the Venetian Republic (1483), Bartolomeo's style soon seemed old-fashioned. Nevertheless, the painter's success continued with works produced for Bergamo and elsewhere on the Venetian mainland.

Bartolomeo Vivarini
Trittico di san Martino (San Giovanni Battista, san Martino e il povero e san Sebastiano)/St. Martin Triptych (St. John the Baptist, St. Martin and the Poor Man, and St. Sebastian)

1491, wood panels, Bergamo, Carrara Accademia.

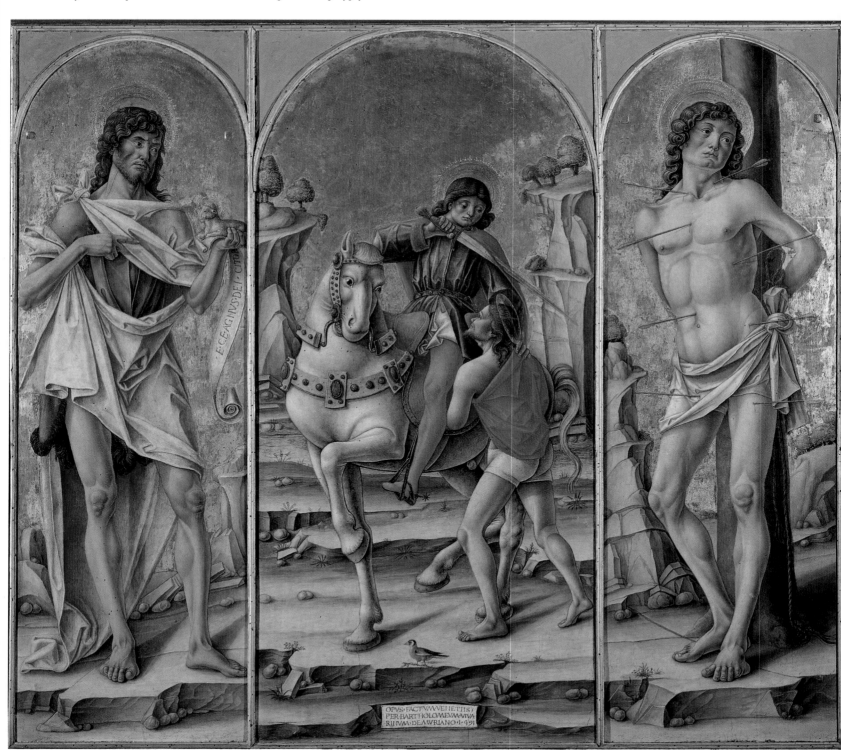

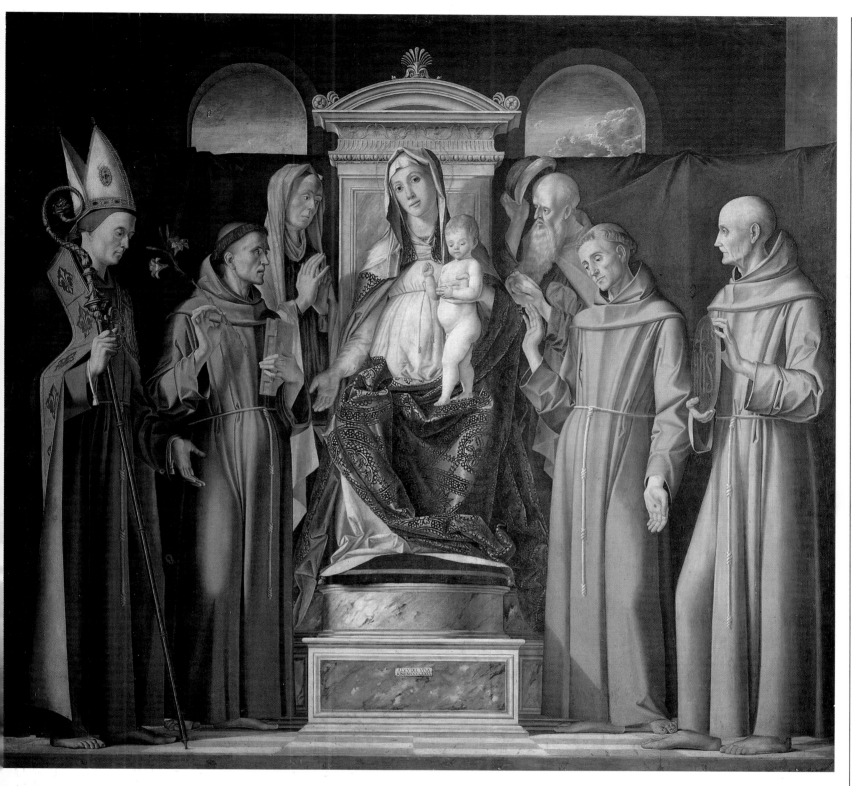

Alvise Vivarini

Venice, 1442/53–1503/05

Antonio's son and for many years
assistant to his uncle Bartolomeo, Alvise
understood the need to update the
family tradition by taking into account
the new ideas introduced by Giovanni
Bellini and Antonello da Messina. This is

amply demonstrated in the *Sacra
Conversazione* in the Accademia in Venice
(1480). The graphic clarity and steady
light of the Vivarini studio is combined
with a monumental and perspective
vision that gives a unified concept of
space. The success of Alvise's artistic
repositioning is proved by the numerous
Virgins in the Bellini mold that he
turned out as well as the number of

altarpieces that still remain in Venice
(although two of particular interest are
now in the Staatliche Museen
Preussischer Kulturbesitz in Berlin).
There are also a lot of interesting virile
portraits which reveal his great
admiration for Antonello. Toward the
end of his career Alvise produced a work
of great commitment, the *St. Ambrose
Altarpiece* for the church of the Frari.

Alvise Vivarini
Sacra Conversazione

*1480, wood panel, Venice,
Accademia.*

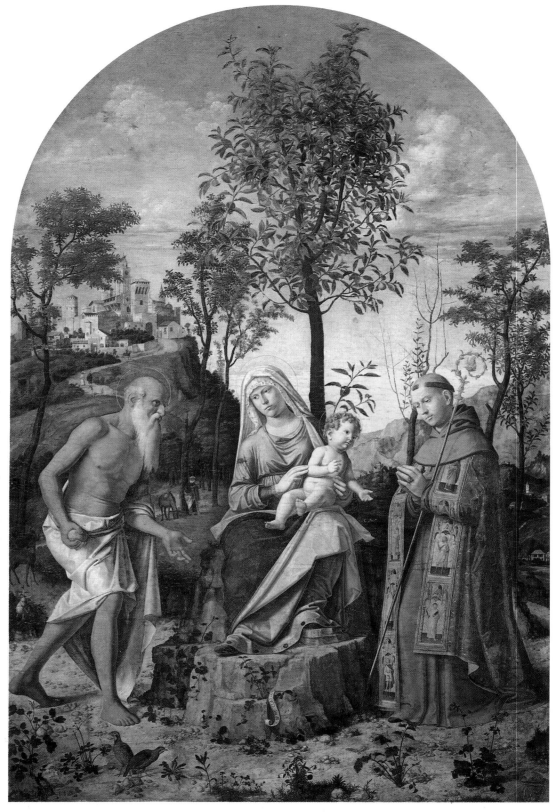

Cima da Conegliano

Giovanni Battista Cima, Conegliano (Treviso), 1459/60–1517/18

An elegant exponent of Venetian painting, sometimes called "the poor man's Bellini," from his earliest work (such as the *Olera Polyptych*), Cima demonstrated an individual style. This had been developed by careful study of many artists. In about 1490 he moved to Venice (where he stayed without a break until 1516). He was particularly interested in Antonello da Messina's work. Cima's best work included a number of Virgins and huge, dazzling altarpieces. These were painted with perfect clarity and a light that is almost northern. He took enormous care over the accuracy of detail and nature, producing peaceful imagines of the Venetian countryside and hills. *The Madonna with the Orange Tree*, Venice, Accademia; *St. John the Baptist and Saints*, Venice, S. Maria dell'Orto; *Baptism of Christ*, Venice, S. Giovanni in Bragora; *Sacra Conversazione*, Conegliano Cathedral. Even after Giorgione arrived on the scene and Titian began working, Cima did not convert to their way of painting but rather remained faithful to his well-defined reading of descriptive detail. But he did turn to secular subjects *Endymion Asleep*, Parma, National Gallery. The gentle rhythms of his compositions and his much-loved natural backgrounds grew even more tranquil.

On the opposite page
Cima da Conegliano
Risanamento di Aniano/
The Healing of Anianus

1497–99, wood panel, Berlin, Staatliche Museen Preussischer Kulturbesitz.

Originally in the church of the Crociferi in Venice, this is the most important example of Cima's religious painting. It can withstand comparison with the large narrative canvasses painted in the same period by Carpaccio and Gentile Bellini. Unlike these specialist painters, however, Cima stuck doggedly to his tranquil style. The soft light shows up the architectural details with great clarity.

Cima da Conegliano
Madonna dell'arancio/The Madonna with the Orange Tree

c. 1495–97, wood panel, Venice, Accademia.

On his arrival from the provinces, Cima claimed his place as a major painter of the Venetian school. This was above all thanks to his large, tranquil altarpieces. Their hallmarks were the use of light to illuminate the landscape, the composure of gesture and the clarity of the contours. Within a few years this style, which has similarities to north European painting, was overtaken by the growing popularity of tonally subtle painting shown in the works of Giovanni Bellini and Giorgione.

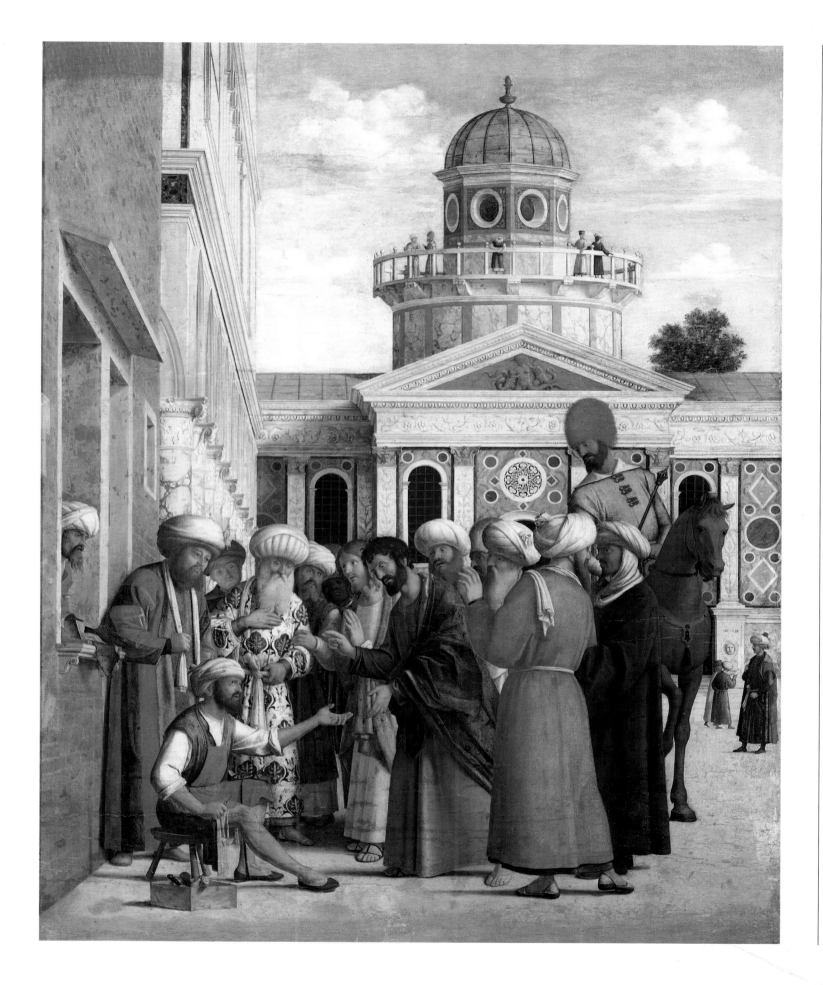

Cima da Conegliano
Politttico di Olera/
Olera Polyptych

*c. 1486–88, wood panels,
Olera (Bergamo), Parish
Church of S. Bartolomeo.*

Perfectly preserved in its
original surround, this is an
example of the rigorous yet
delicate style of the young
painter before he moved to
Venice. The use of the old-
fashioned type of gilded
polyptych surrounding a
wooden statue of the patron
saint indicates his own
provincial location in a
small, rather backward
town in the mountain
valleys.

Vittore Carpaccio

Venice, c. 1455/60–1525/26

The most famous and fascinating works by Carpaccio come from his stupendous cycle of huge canvasses on the subjects of St. George and St. Ursula. These reveal the painter's unusual ability to compose vast narrative scenes with crowds of main characters and onlookers against detailed urban backdrops. Even when the town portrayed is not Venice, the canvasses still evoke the magical fascination of the city. Carpaccio's activities in his early years are not easy to piece together. In 1490, however, he began the cycle of *The Legend of St. Ursula* (Venice, Accademia). This took him several years to complete and contains remarkable evidence of his stylistic development. By the end he had achieved a perfect balance between anecdotal action, architectural perspectives, soft light, bright colors, and a wealth of descriptive detail. The canvasses painted between 1502–07 for the Scuola di S. Giorgio degli Schiavoni (still in situ) reach the same level. The later cycles painted for the merchants from Venetian ports in Albania and S. Stefano, scattered between various Italian and foreign museums, seem less powerful. However, he achieved great emotional drama in the resplendent altar paintings produced in the first decade of the Cinquecento. They seem to ignore or reject the soft-toned paintings of Giovanni Bellini and Giorgione (*The Presentation at the Temple*, Venice, Accademia; *Meditation on the Passion*, Berlin, Staatliche Museen/ Preussischer Kulturbesitz). Carpaccio also received a number of official commissions (*The Lion of St. Mark* in the Doge's Palace), but after his altarpiece for the church of S. Vitale, his Venetian career foundered, partly because by then Titian dominated the scene. Carpaccio ended his career back in the provinces (Bergamo, Cadore, Istria) where his now out-dated style still attracted admirers. He was rediscovered in the nineteenth century and now ranks second only to Giovanni Bellini among Venetian fifteenth-century artists.

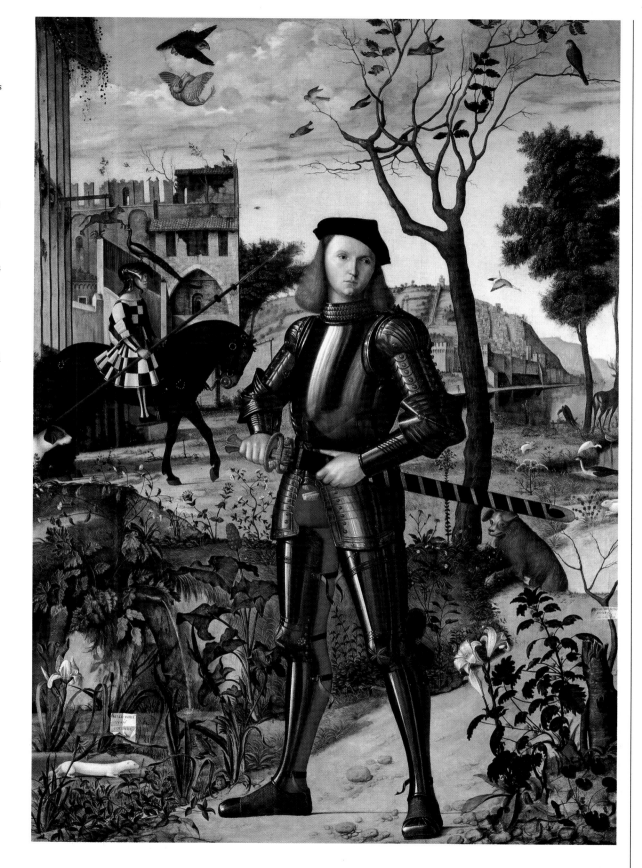

On the preceding page
Vittore Carpaccio
Giovane Cavaliere/
Young Knight

*1510, canvas, Madrid,
Fundación Colección
Thyssen-Bornemisza.*

Although Carpaccio achieved considerable fame as a portrait painter, this picture is probably the best portrait he painted. It could almost symbolize the end of the age of chivalry. Heraldic devices and other details have led to the extremely plausible theory that the knight depicted is in fact Francesco Maria della Rovere, the future Duke of Urbino. There is no denying that the painting is still imbued with a fifteenth-century artistic sense, and that the flowers, animals, and details of armor and architecture are all reproduced with loving detail. Nevertheless, Carpaccio shows a number of signs of artistic originality, starting with his very unusual decision to paint his subject full-length.

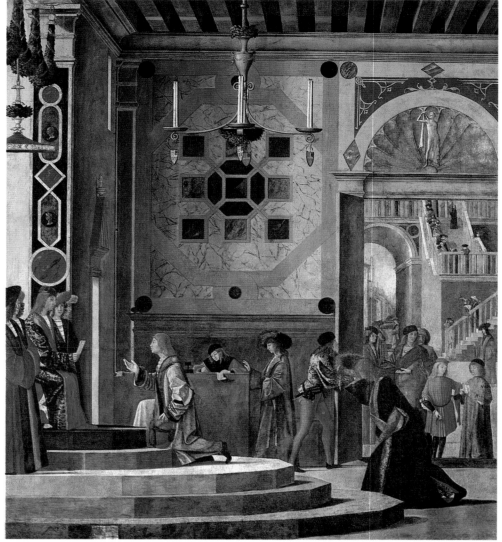

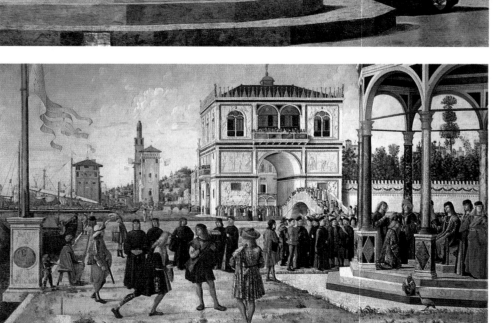

Vittore Carpaccio
Partenza degli
Ambasciatori/Departure
of the Ambassadors

Ritorno degli
Ambasciatori/Return of
the Ambassadors

*1495, canvasses, Venice,
Gallerie dell'Accademia.*

The cycle painted for the School of Sant'Orsola is Carpaccio's most famous undertaking. Although the cycle is preserved in its original condition, it is no longer in its original setting (which is still extant next to the church of SS. Giovanni e Paolo). The probable influences on his formative years (Gentile Bellini's narrative sense, Antonello da Messina's use of space, Alvise Vivarini's exact use of light, and the Ferrara school's precise graphics) appear to give way to a more confident and personal style. Employing marvelous colors and details, Carpaccio balances reality and fantasy with an underlying sense of space that is truly classical. He creates the impression of a fabulous world, a fairy-tale Venice where the romantic and sad tale of the beautiful Princess Ursula is set.

Vittore Carpaccio
Storie di sant'Orsola:
Sogno di sant'Orsola/The
Legend of St. Ursula: The
Dream of St. Ursula

*1495, canvas, Venice, Gallerie
dell'Accademia.*

This is a most fascinating
demonstration of
Carpaccio's versatility.
The scenes range from
measured courtly dignity to
this touching and intimate
episode. At dawn, an angel
bearing the palm of
martyrdom enters the
room in which Ursula is
sleeping. He brings her
a dream about her
approaching death. The
objects and furnishings
which surround the sweetly
sleeping saint are all
reproduced with loving and
touching care. They provide
a reliable inventory of the
interior of rich Venetian
houses at the end of the
fifteenth century.

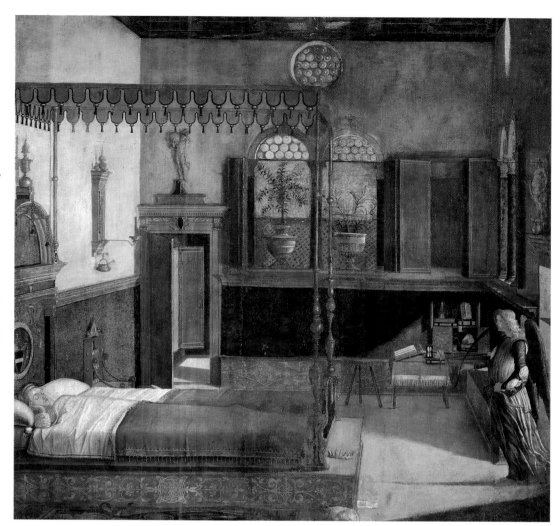

Vittore Carpaccio
Storie di sant'Orsola: Il re
di Bretagna accoglie gli
Ambasciatori inglesi/The
Legend of St. Ursula: The
Arrival of the English
Ambassadors

*1495, canvas, Venice, Gallerie
dell'Accademia.*

By combining the
geometrical rigor of
Renaissance perspective
with his own supremely
imaginative conceptions,
Carpaccio has constructed
a scene rich in architectural
splendors and colors. The
English ambassadors are
delivering a letter which
requests the hand of
Princess Ursula in marriage
to the crown prince of
England. On the right of the
painting, Ursula informs her
father of her conditions for
accepting the marriage. Her
old nurse, seated at the foot
of the stairs, seems to have a
presentiment about Ursula's
impending martyrdom. This
painting, too, contains much
valuable documentary
evidence of the times.

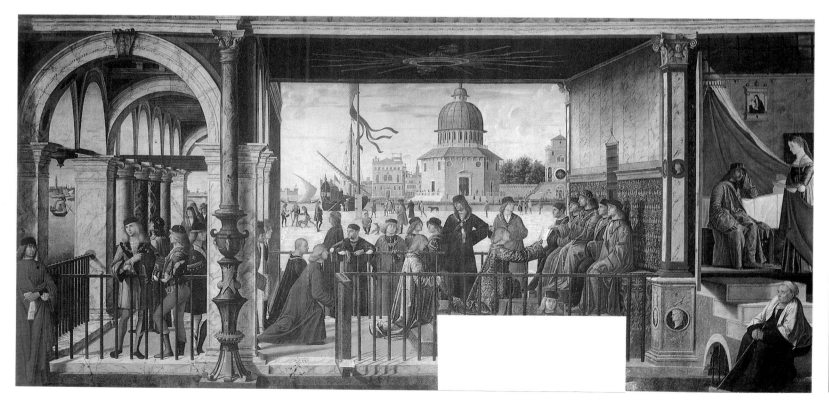

Vittore Carpaccio
Storie della Vergine: Annunciazione/Life of the Virgin: Annunciation

1504, canvas, Venice, Ca' d'Oro, Galleria Giorgio Franchetti.

The Venetian merchants living in ports in Albania, who were rivals to those from Dalmatia, commissioned a cycle of canvasses from Carpaccio when he was working for the Dalmatians at the Scuola degli Schiavoni. Carpaccio delegated most of the Albanian work to his pupils and studio assistants.

The resulting drop in quality is clear. The canvasses in the cycle, which were almost square in format, depicted episodes from the Virgin's life. They were painted between 1502–08. The cycle was subsequently broken up and scattered.

On the opposite page
Vittore Carpaccio
Storie di san Gerolamo: Visione di sant'Agostino/ Life of St. Jerome: Vision of St. Augustine

1502–04, canvas, Venice, Scuola di San Giorgio degli Schiavoni.

The cycle of large canvasses painted for the School of San Giorgio degli Schiavoni is the only group of Carpaccio's large canvasses to remain in its original location. The School was used as a meeting place for Dalmatians living in Venice and was dedicated to saints Jerome, George and Trifone. For this reason the canvasses, painted between 1502–07, follow episodes from the lives of all three patron saints. This scene comes from the cycle dedicated to St. Jerome. It commemorates him appearing to St. Augustine

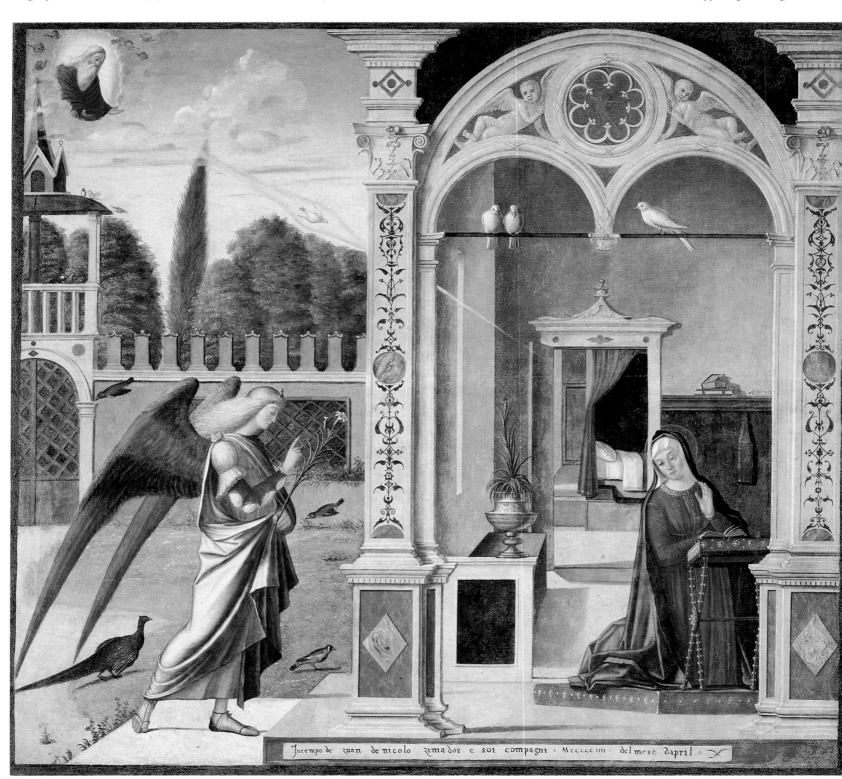

in the form of a ray of light. As if to show what he could do when he wanted to, Carpaccio has based the whole painting around the archeologically very correct classical alcove at the end, revealing his complete mastery of perspective. Not only St. Augustine, but his little hairy dog and even the objects in his study seem suspended in a moment of deeply intense mysticism. The light is basically natural everyday light. It is soft and penetrating, it warms and delineates all the scientific and astronomical equipment that surrounds St. Augustine. The result is an extremely vivid and realistic image of the study of a Renaissance scholar, rather than a saint.

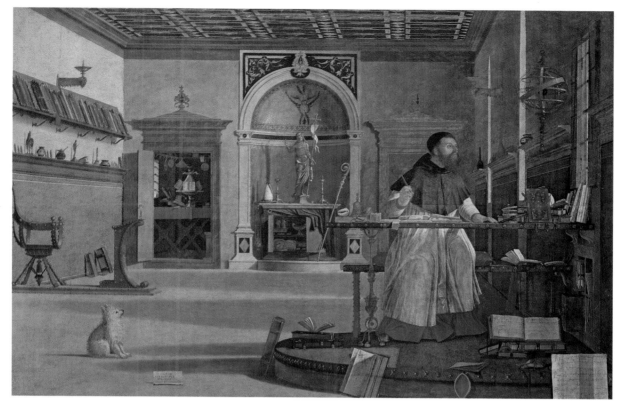

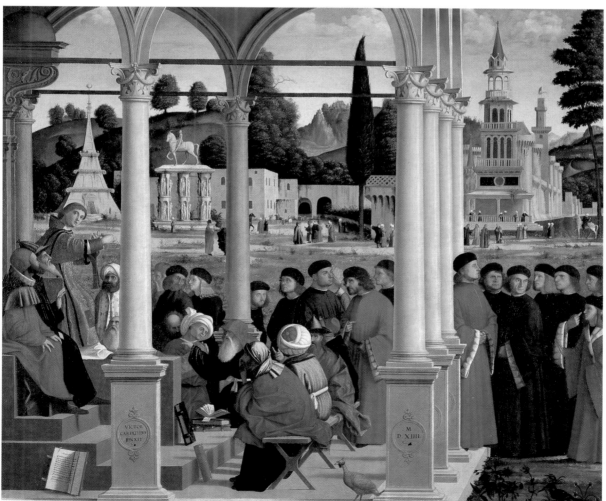

Vittore Carpaccio
Storie di santo Stefano: Disputa di santo Stefano/ Life of St. Stephen: St. Stephen Disputing

1514, canvas, Milan, Brera.

This is part of a cycle painted for the Scuola di Santo Stefano which has been scattered between various museums. Carpaccio produced the canvasses during the 1510s, apparently with little help from assistants. This makes the cycle the best text through which to study Carpaccio's development in his last period. Thanks to the penetrating clarity of the light and brilliant architectural fantasy, mingling classical and oriental elements, the episode now in Milan is certainly the best of the cycle. Eastern scholars mix with the brothers of the School as they listen to St. Stephen's sermon.

Bramante

*Donato D'Angelo, Fermignano (Pesaro),
1444–Rome, 1514*

Bramante was the greatest architect of
the High Renaissance. From the Milan
of the Sforzas to the Rome of Pope
Julius II he proved a splendid and
original interpreter of classical
antiquity in increasingly monumental
and daring forms. However, his debut
was made as a painter when he arrived
in Milan in about 1480. Although he did
produce a number of architectural
works at this time (S. Maria presso S.
Satiro, S. Maria delle Grazie, cloisters
of S. Ambrogio), it was his painting,
especially his use of trompe l'œil and
the rigorous monumentality of the
figures in solemn spatial contexts that
influenced the Lombard school. The
Brera Gallery houses the repositioned
frescos of *Men-at-Arms* and the wood
panel *Christ at the Column*. This is the
only panel that can definitely be
attributed to Bramante. The Sforza
Castle contains his symbolic fresco
Argus which he painted together with
Bramantino. Bramante left Milan after
the fall of Ludovico Sforza (il Moro)
and settled in Rome in 1499. Here
he started his extraordinary
reinterpretation of antiquity (the small
temple next to S. Pietro in Montorio
left a deep impression on the artists of
his own day, including Raphael). Within
a few years he had become the most
important architect at the papal court.
For Pope Julius II he undertook the
overall redesign of the Vatican Palaces
around the Belvedere courtyard. From
1506 onwards he did fundamental work
on rebuilding St. Peter's which was
later to be carried on by Michelangelo.

Bramante
Cristo alla colonna/Christ
at the Column

*c. 1490, wood panel, Milan,
Brera.*

This was painted for the
Chiaravalle abbey. Christ's
torso, carved like a column,
is a fine example of the
geometrical monumentality
that was Bramante's
inspiration not only as an
architect but also as a painter.
Through the window we can
see a landscape with many
watercourses. Light glints
realistically on Christ's curly
hair. Both of these features
can be related to similar
work by Leonardo during his
stay in Milan.

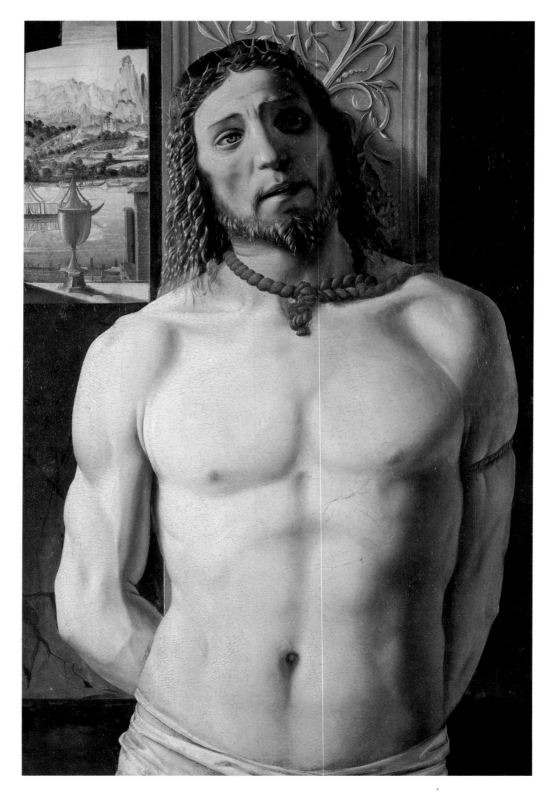

Bramantino

Bartolomeo Suardi, Milan, c. 1465–1530

In a Milan dominated by Leonardo's influence, Bramantino's rejection of the Tuscan master's style appears controversial. His own training was gained in Lombardy and Ferrara where Bramantino developed a rigorous incisive style under the influence of Bramante, whose name he copied. His compositions are full of intense symbolic meanings and, thanks to Bramante, they attained monumental proportions through imposing architectural backgrounds. During the first decade of the fifteenth century Bramantino emerged as the most important Milanese artist. For governor Gian Giacomo Trivulzio he produced the sketches for twelve *Tapestries of the Months* (Milan, Sforza Castle), masterpieces of Italian textile art. The tapestries were designed for the funeral chapel annexed to the church of S. Nazaro in Milan. During a trip to Rome (1508) Bramantino's cultural outlook was updated and his subsequent work was characterized by frozen and austere classical forms.

Bramantino
Adorazione dei Magi/
Adoration of the Magi

c. 1490, wood panel, London, National Gallery.

The characters are fixed in ritual poses, frozen in an atmosphere of ancient symbolism.

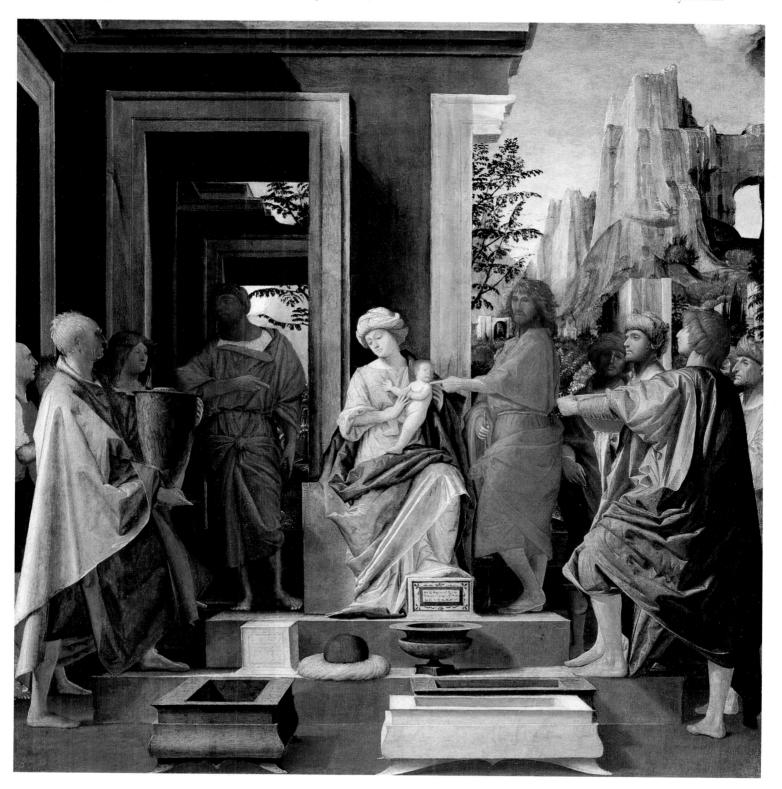

Benozzo Gozzoli

Benozzo di Lese (Florence), c. 1421–Pistoia, 1497

Benozzo Gozzoli is famous for only one work but that is one of the most delightful in the whole Renaissance. Originally trained as a goldsmith, he was Fra Angelico's assistant in Rome. In 1450 he was in Montefalco in Umbria where he left frescos in the churches of S. Fortunato and S. Francesco. After revisiting Rome in 1458 he received the most important commission of his career: to decorate the private chapel in the Medici Palace in Florence. The subject chosen was the *Journey of the Magi* which he used to portray various members of the Medici family, with its young princes handsomely, even flamboyantly dressed and all set against a wonderful landscape, creating a fairy tale of the Renaissance. Between 1464 and 1466 Gozzoli was located in San Gimignano where he painted the frescos in the collegiate church and in S. Agostino.

Benozzo Gozzoli
General View of the Journey of the Magi

1458–60, fresco, Florence, Medici Riccardi Palazzo, chapel.

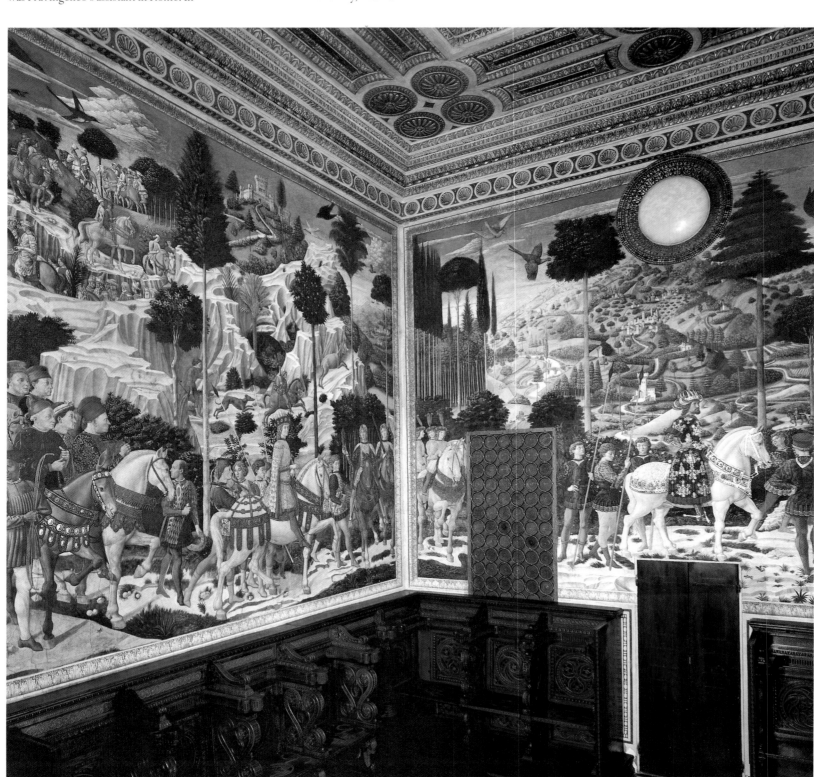

Melozzo da Forlì

Melozzo di Giuliano degli Ambrogi, Forlì, 1438–94

Renowned in his own lifetime for his great skill in perspective and illusionism, as a painter Melozzo da Forlì played a very significant role in the development of Renaissance painting in central and eastern Italy, from the Marches to Rome. His early work was in Forlì and was indebted to Piero della Francesca. In 1469 he was in Rome where he produced a sacerdotal banner which is still in the church of S. Marco. In the 1470s he was very busy at the cosmopolitan court of Urbino, where he designed a private study and the library for Federico da Montefeltro. He returned to Rome in 1475, this time to carry out prestigious commissions. Honored by Sextus IV with the position of *pictor papalis* [official Vatican painter], between 1475–77 he painted the fresco decorations in the Apostolic Library. All that remains is a noble commemorative scene which is now in the Vatican Gallery. He was then employed by Giuliano della Rovere (the future pope Julius II) to work on refurbishing the church of SS. Apostoli. He painted the frescos in the apse showing the Redeemer and a concert of angels. Various fragments of this ambitious composition can still be seen in the Quirinal Palace and the Vatican Gallery. In about 1484, and by now backed up by his own efficient studio, Melozzo was in Loreto to paint the murals for the Treasury Chapel at the sanctuary. Nothing remains of his later work which was carried out between Forlì, Rome, and Ancona. In 1944 his frescos in the church of S. Biagio in Forlì were also destroyed by bombs.

Melozzo da Forlì
Sisto IV nomina il Platina prefetto della Biblioteca Vaticana/Sextus IV Appointing Platina Prefect of the Vatican Library

1477, fresco (detached), Rome, Vatican Gallery.

This courtly scene of great nobility provides a quintessential image of fifteenth-century culture, not least because it demonstrates the relationship between the literary and artistic worlds, both nurtured by great patrons. Encapsulated in a space with perfect perspective which owes its rhythm to the theories of Leon Battista Alberti, the occasion depicted is not without solemnity. This is confirmed by the long epigraph with its perfect Latin characters. Pope Sextus IV (who built the Sistine Chapel) is founding the Vatican Library, putting a famous Renaissance scholar in charge of it. The calm, noble seriousness of the characters recall the style of Piero della Francesca.

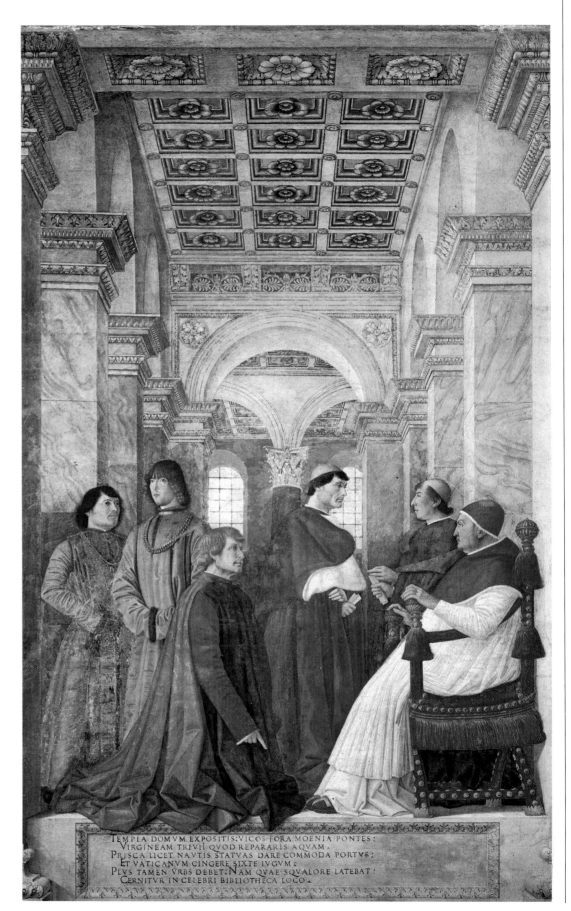

Fra Filippo Lippi

Florence, c. 1406–Spoleto, 1469

Filippo Lippi was an artist of vital importance to the development of Florentine painting, forming a link between Masaccio, whose pupil he probably was, and Botticelli. He first appeared on the artistic scene at the start of the 1430s. Among his early works are the frescos in the Carmine Friary where some years earlier he had taken his vows as a monk. In 1434 he visited Padua, but his art was moving in another direction, becoming more linear and filled with decorative motifs – thin fluttering draperies, brocades. Filippo began his monumental work *Coronation of the Virgin* (Uffizi). This was surrounded by numerous altarpieces which used Domenico Veneziano's rules of perspective. But they are all characterized by the delicacy and detail which touched even Leonardo. In 1452 Lippi moved to Prato where he painted what may be his masterpiece, the frescos in the cathedral choir as well as other works. His long stay in Prato has to be viewed in the light of the scandal which broke over his relationship with the nun Lucrezia Buti, by whom he fathered Filippino. Back in Florence once more, Filippo received prestigious commissions, such as the *Nativity* for the Magi Chapel in the Medici Palace, now in Berlin. It was after receiving another Medici commission that Filippo started his last work, the frescos in the choir of Spoleto cathedral.

Filippo Lippi
Incoronazione della Vergine/Coronation of the Virgin

detail, 1466–69, fresco, Spoleto (Perugia), Cathedral.

The frescos telling the *Life of the Virgin* in the conch of Spoleto cathedral apse were the last and most ambitious of Filippo Lippi's works. They remained incomplete at his death but were finished a couple of months later, in December 1469, by his son Filippino who was still very young at the time. The priestly grandeur of the images are drafted with graphic clarity.

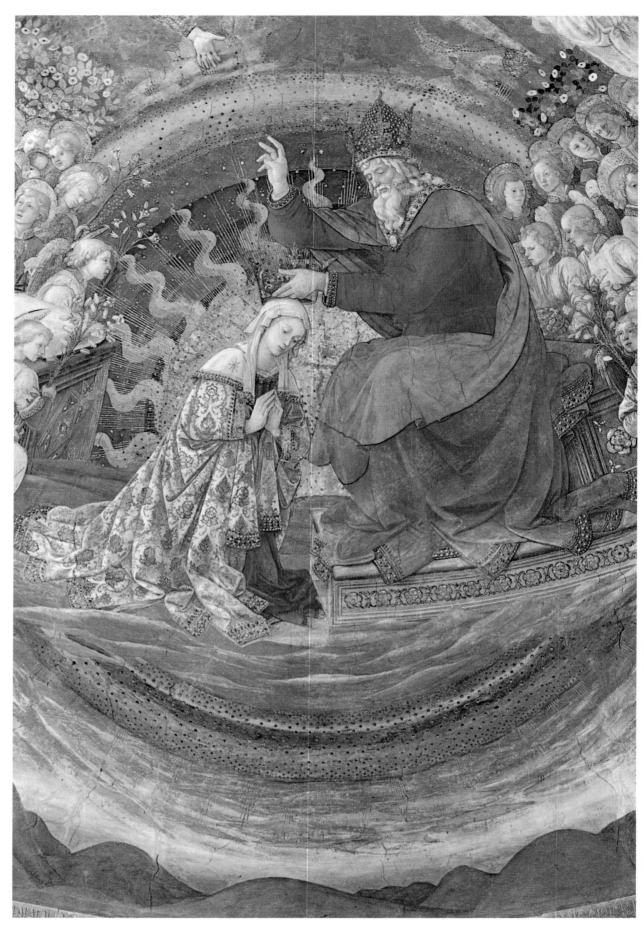

Filippo Lippi
Annunciazione/
Annunciation

c. 1442, wood panel, Florence, S. Lorenzo.

Painted for the Martelli Chapel in the transept of Brunelleschi's church, this altarpiece fits perfectly into the artistic climate of Medici Florence. Its clear command of perspective is spelled out by shadow and light. This reveals the well-proportioned relationship between buildings, figures, and natural features. It also underlines the volumes and the rigorous axial line of the painting, emphasized by the central pillar. All of these elements are typical of the Quattrocento in central Italy. The glass phial in the foreground and its contents almost seem trompe-l'œil. This is proof of his illusionistic ability. While Gabriel and the Virgin seem almost ritually immobilized, the two angels on the left give the impression that they are really taking part in something that is very much alive.

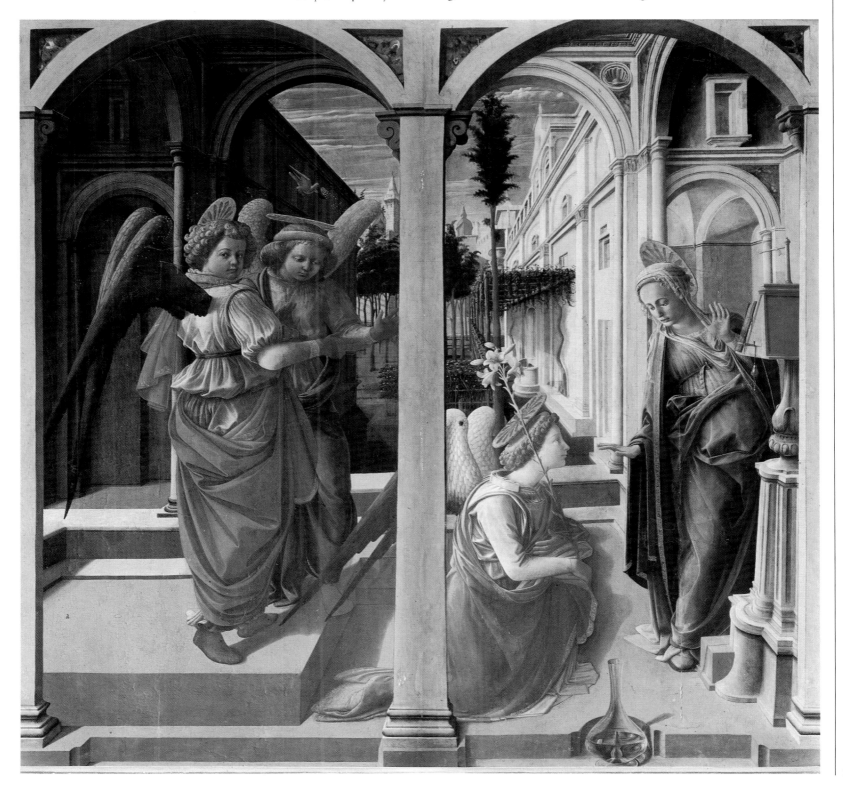

Sandro Botticelli

Alessandro Filipepi, Florence, 1445–1510

Botticelli's great pictures in the Uffizi, especially his world-famous pagan allegories, have come to epitomize the spirit of Florence under Lorenzo the Magnificent. Botticelli himself is seen as the artist who portrayed one of the high moments in art and culture. But we would have a limited understanding of Botticelli's œuvre if we only looked at the masterpieces he produced for the Medici. His long artistic career, in fact, covers the climax of the fifteenth-century Renaissance, to which he contributed so much, and continues into the High Renaissance. In 1464 he probably became Filippo Lippi's pupil and he certainly absorbed from Lippi the almost Gothic love of graceful ornament which was to be a keynote of his mature art. The young Botticelli practised his skills on the subject of the Virgin and Child of which he produced numerous versions. In 1470 his *Fortitude* completed a group of allegorical figures by Piero Pollaiolo (Florence, Uffizi). Two years later he joined the guild of Florentine painters with his own pupil Filippino Lippi. Soon after he was taken up by members of the ruling Medici family, painting portraits of them. He also produced notable religious paintings, such as the *Adoration of the Magi* (1475, Uffizi) and *Spring* (1477–80), the first in his cycle of pagan allegories that also included the *Birth of Venus* and *Pallas and the Centaur*. Now at the height of his fame and the pinnacle of his career, he was called to Rome in 1482 to paint three frescos for the Sistine Chapel. Back in Florence once more, he produced a series of altarpieces. He also began to specialize in the difficult tondo (round) format. The death of Lorenzo in 1492 marked the end of an era. Savonarola's apocalyptic sermons may have caused Botticelli to rethink his art. In his last period, he produced works of tortured spirituality, such as the two versions of the *Deposition* in Berlin and *Mystic Nativity* (1501, London, National Gallery), which also belong to this period.

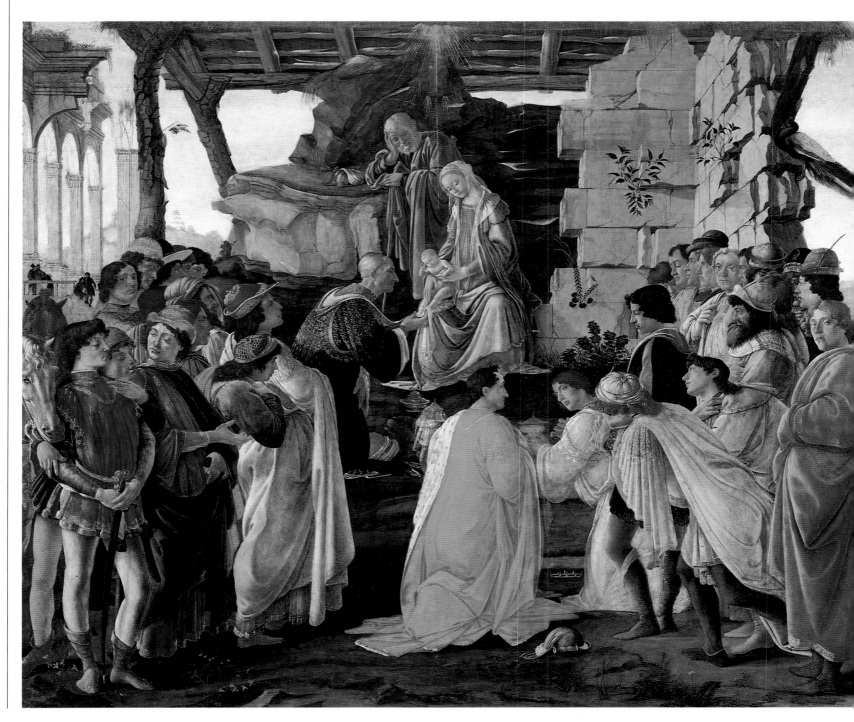

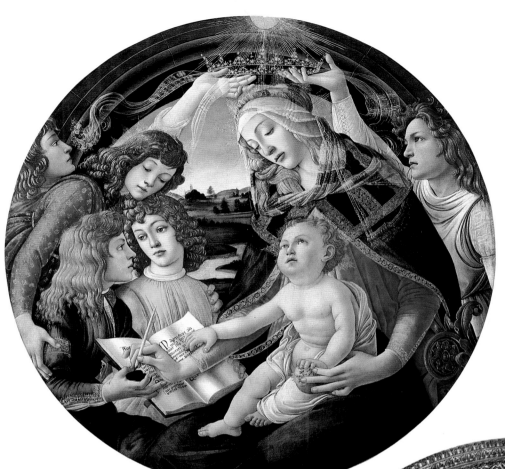

Sandro Botticelli
Madonna del Magnificat/
The Madonna of the
Magnificat

*c. 1487, wood panel, Florence,
Uffizi.*

The round tondo format is
typically Florentine and
brings out the stylized and
the graceful quality of
Botticelli's painting. The
two Uffizi panels deform
the images, respectively
simulating the effect of a
convex and a concave
mirror. One of Botticelli's
most popular works, this
was thought by the critic
John Aldington Symonds to
be his best.

Sandro Botticelli
Madonna della
melagrana/The Madonna
of the Pomegranate

*1487, wood panel, Florence,
Uffizi.*

On the opposite page
Sandro Botticelli
Adorazione dei Magi/
Adoration of the Magi

*1475, wood panel, Florence,
Uffizi.*

Botticelli included portraits
of members of the Medici
court in this devotional
work, a common practice
at the time. Cosimo de'
Medici, the real founder of
the dynasty, is kneeling
before the Virgin. Piero,
who is dressed in red, and
Giovanni are on his right in
the center of the picture.
On the left, in the Magi's
train, we find the poet
Angelo Poliziano (the man
asking the youth to move
over), the philosopher Pico
della Mirandola (who is
bowing), perhaps Lorenzo
the Magnificent in white
and Giuliano (in black next
to Giovanni). The elderly
patron is dressed in blue
and on the extreme right of
the picture, wearing a
yellow cloak, we perhaps
see the painter himself.

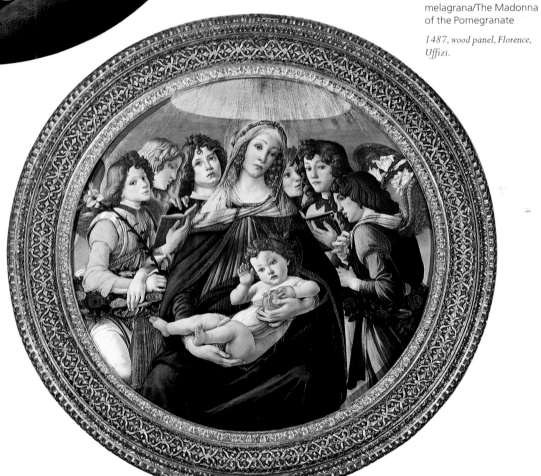

123

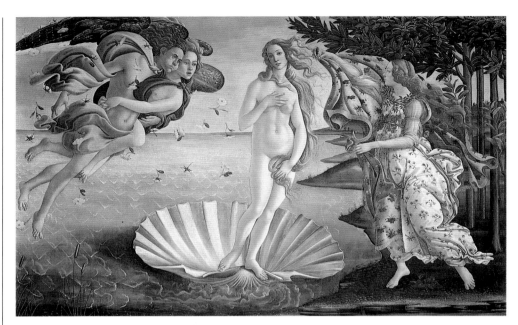

Sandro Botticelli
La Nascita di Venere/
Birth of Venus

*1484–86, wood panel,
Florence, Uffizi*

La primavera/Spring

*1475–82, wood panel,
Florence, Uffizi.*

Botticelli painted his large
pagan allegories probably
taking advice from the poet
Poliziano as well as the
Neoplatonist philosopher
Marsilio Ficino. The
masterpieces have come to
symbolize the Florentine
golden age under Lorenzo
the Magnificent in the 1470s
and 1480s, for whose circle
they were painted. Part of a
generation of painters grown
bored with Masaccio's
austere realism, Botticelli
introduced an element of
Gothic elegance and
wistfulness, which adds to
the romantic appeal of this
pagan theme. The figures in
Spring especially lack the
solidity of much earlier
Quattrocento art, and the
background recalls a Gothic
tapestry. By giving a form to
current neo-pagan literary
and philosophical ideas
through his exceptionally
limpid color and impeccably
clear draughtsmanship,
Botticelli perhaps
unwittingly brought about a
revolution in art. His Venus
was the first large-scale
female nude in Western art
for a thousand years.

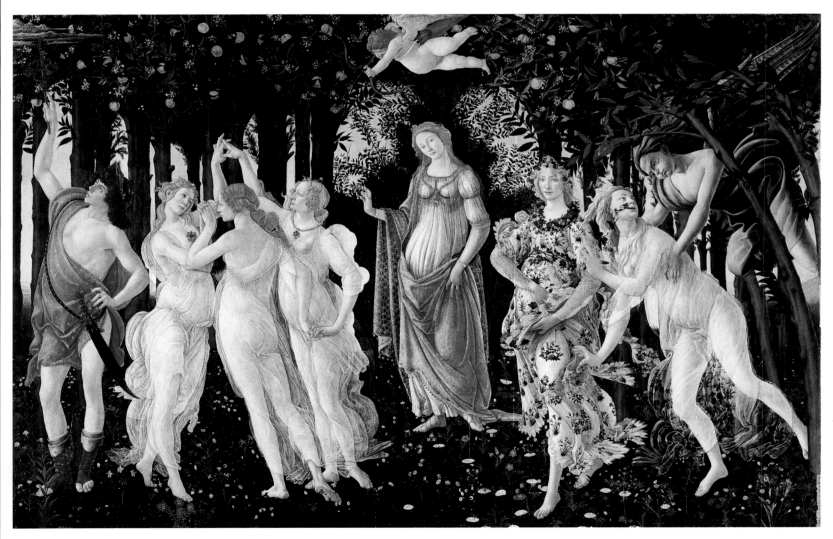

Sandro Botticelli
Madonna del libro/
Madonna of the Book

*1480, wood panel, Florence,
Uffizi.*

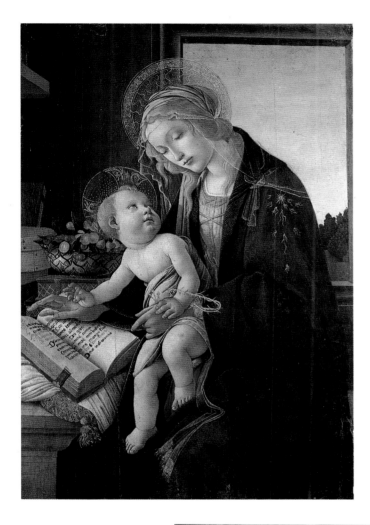

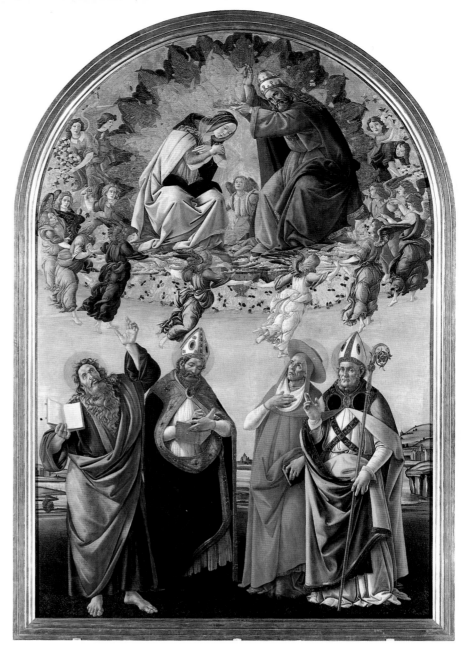

Sandro Botticelli
Incoronazione della
Vergine con i santi
Giovanni Evangelista,
Agostino, Gerolamo ed
Eligio/The Coronation of
the Virgin with St. John
the Evangelist, St.
Augustine, St. Jerome,
and St. Eligio

*1490–93, wood panel,
Florence, Uffizi.*

Sandro Botticelli
Compianto sul Cristo
morto/Lamentation

*1489–92, wood panel,
Munich, Alte Pinakothek.*

Sandro Botticelli
Punizione di Core, Datan e Abiron/The Punishment of Korah, Dathan, and Abiram

1482, Rome, Vatican, Sistine Chapel.

Botticelli played a major role in decorating the side walls of the Sistine Chapel. In the scenes that tell the story of Moses, he introduced a new way of recreating classical antiquity due to his own observations of Rome's archeological monuments. The figures are extremely elegant, the colors particularly clear but what perhaps Botticelli lacked here was a sense of narrative unity.

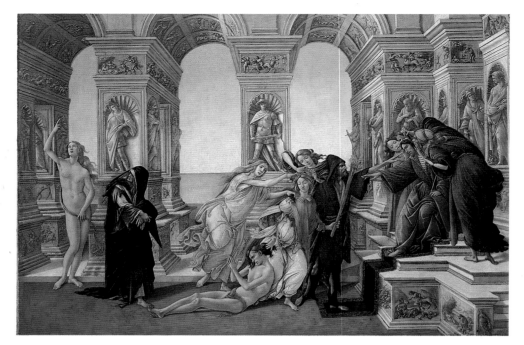

Sandro Botticelli
Calunnia/The Calumny of Apelles

1495, wood panel, Florence, Uffizi.

After the death of Lorenzo the Magnificent, partly due to Savonarola's fanatical sermons and the troubled political situation, Botticelli entered a phase of deep introspection. His painting became more nervous and angular even when, as in this instance, he gives a new intellectual interpretation to classical ideas. In fact the picture is an attempt to translate a literary description of a lost work by the Greek painter Apelles.

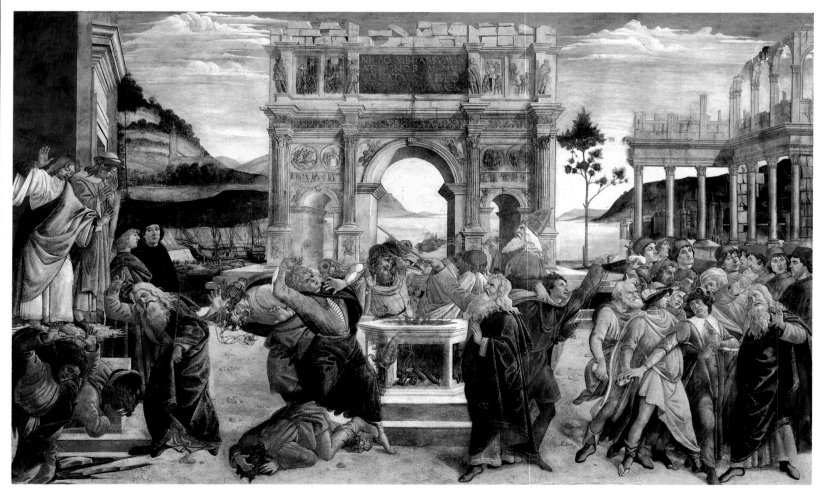

Domenico Ghirlandaio
Esequie di santa Fina/
The Funeral of St. Fina

*1475, fresco, San Gimignano,
Collegiata.*

Domenico Ghirlandaio

*Domenico di Tommaso Bigordi, Florence
1449–94*

The most prolific member of a large family of artists, Domenico was at his best carrying out broad-ranging fresco cycles. It was these that deservedly earned him Vasari's epithet "pronto, presto e facile" – ready, quick and easy. The painter's own nickname of Ghirlandaio derived from his love of including ornamental garlands in his pictures. After studying under Verrocchio with Perugino, he was able to branch out on his own in the 1460s thanks to the patronage of the Vespucci family, for whom he produced various works for the Florentine church of Ognissanti and painted a fresco of the *Last Supper* for the monastery attached to the church. In 1475 he went to San Gimignano to paint the frescos of *The Life of St. Fina* in the Collegiate church. In 1481 he traveled to Rome to paint frescos for the Sistine Chapel. The prestige of this job led to many commissions on his return to Florence including the decoration of the Sala dei Gigli in Palazzo Vecchio (1483), frescos and an altarpiece for the Sassetti Chapel in S. Trinita (1485) and frescos in the Tornabuoni Chapel in S. Maria Novella. This last work was finished in 1490 by his large and busy studio which counted Michelangelo among its pupils.

127

Perugino

Pietro Vannucci, Città della Pieve (Perugia), c. 1450–Fontignano, Perugia, 1524

Sought after by aristocratic and ecclesiastic patrons from all over Italy and capable of coordinating a huge output, Pietro Perugino created a real fashion for his elegant and slightly vague style. He deliberately shied away from exploring expression too deeply. He preferred dreamy poses wrapped in the sweetness of unified color. He probably studied under Verrocchio in Florence and soon became famous. In 1481 Pope Sextus IV summoned him to Rome to decorate the walls of the Sistine Chapel alongside Botticelli, and for the next two decades he was in great demand, with a busy studio producing gentle, pious, often sentimental religious works. Some of his most important work was produced around 1490, including *The Vision of St. Bernard* (Munich, Alte Pinakothek) and the *Deposition* (Florence, Galleria Palatina). After about 1505, he seems to have retired to Perugia, perhaps finding the atmosphere in Florence too competitive for his elegant but now repetitive art. But he maintained his prestigious links with the Duchy of Milan and the Gonzaga family. His most famous pupil was Raphael, whose famous serenity was perhaps derived from Perugino's art.

Perugino
Madonna in trono col Bambino e due sante/
Madonna Enthroned with Child and two Saints

c. 1480, wood panel, Paris, Louvre.

Perugino
Consegna delle chiavi/ Christ Giving the Keys to St. Peter

1480–81, fresco, Rome Vatican, Sistine Chapel.

This famous masterpiece marks the beginning of the central phase of Perugino's career. Pope Sextus IV called him to Rome in 1481 along with Ghirlandaio and Botticelli. Perugino painted three large scenes on the side walls of the chapel. He was also the author of the composition on the back wall (later destroyed by Michelangelo to make way for his *Last Judgment*) and of a few portraits of some of the early popes at the top of the room. The composition shown here stands out for the importance of its symbolic meaning. It shows Christ investing the first pope (St. Peter), blessing his role as future pontiff, and underlining his authority as the Vicar of Christ. The scene is set in the place where the conclaves were held. From the compositional viewpoint, it contains a number of important new features including the wide-angled architectural and natural surrounds contained within a paved church square criss-crossed with lines to stress the perspective effect. The work's many borrowings from classical antiquity (the two triumphal arches) combine with the Renaissance model church with its central layout in the form of a Greek cross, then considered the ideal.

On the following page
Perugino
Portrait of Francesco delle Opere

1494, wood panel, Florence, Uffizi.

This is the masterpiece of Perugino's infrequent but always accomplished portraits. There is a strong sense of harmony as the spreading panorama (perhaps a view of Lake Trasimeno) gives the bust, the hands and the face of the sitter emerge an unusual vigor. Here the old lesson about volume that the young Perugino learnt as Piero della Francesca's pupil comes to the fore once again. But now it is accompanied by a new, fresh sensitivity to gradations of light.

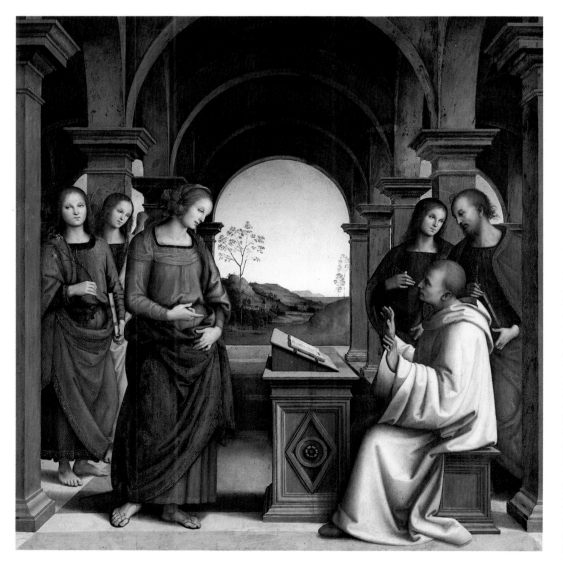

Perugino
Visione di san Bernardo/The Vision of St. Bernard

wood panel, Munich, Alte Pinakothek.

Originally painted for the Florentine church of S. Spirito (for which Perugino also designed the window on the front elevation) this is one of the painter's most heartfelt works. The very nature of the mystic apparition justifies both the way the scene appears to be suspended in time and its contemplative tone. This was heightened by Perugino's novel use of light and color. The severe, dark architecture of the bare pillars contrasts with the distant, serene view of the countryside. The saint's white cassock contrasts with the colored garb of the angels and the Virgin. Perugino's figure of the Virgin was used as a model by Raphael for his *The Betrothal of the Virgin* which is now in the Brera.

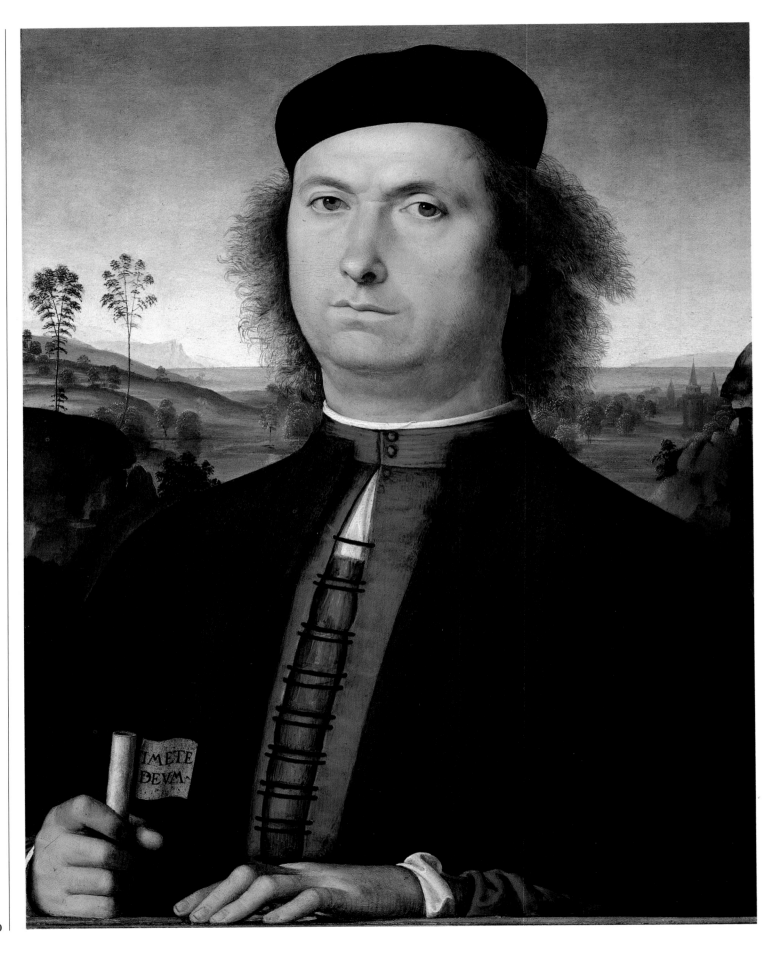

Pinturicchio

Bernardino di Betto, Perugia,
c. 1454–Siena, 1513

A fascinating master of large-scale decoration, Pinturicchio produced some of the best ornamental ideas in Umbria and Rome during the whole Renaissance. He was still young when he joined Perugino's studio where he rose to be his assistant, learning Perugino's sweetness of style though not his subtle use of light. In this capacity, he worked initially on the *Life of St. Bernardino* (1473, Perugia, Galleria Nazionale dell'Umbria) and then on the prestigious project for the Sistine Chapel (1481). After that Pinturicchio's own career took off and he continued to

alternate between Perugia and Rome. These include frescos in S. Maria d'Aracoeli, S. Maria del Popolo and, most importantly, in the apartments of Pope Alexander VI in the Vatican (1492–95). The work in Rome provides the proof of how up-to-date Pinturicchio was in his interpretation of mural decoration. He used the antique repertory with genius to stunning effect. Back in Umbria, Pinturicchio painted altarpieces and frescos. But Pinturicchio's masterpiece remains the splendidly colorful frescos that cover the walls of the Piccolomini Library in Siena cathedral (1505).

Pinturicchio
Annunciazione/ Annunciation

1501, fresco, Spello (Perugia),
S. Maria Maggiore, Baglioni
Chapel.

This enchanting scene has rightly become a symbol of the grace and elegance of Umbrian art at its best in the fifteenth century. As was his usual custom, Pinturicchio did not concentrate on the main figures in the scene. Even though they are pleasing to the eye, they do not possess much intensity. What he was really interested in was

depicting a host of exuberant and fantastic descriptive details, especially elaborate architecture. After his long stay in Rome, Pinturicchio came back with the very latest ideas. These translated naturally into his well-drafted and deep perspective. They can also be seen in the variety of classical references that appear in his ornamental repertory. To the right of the scene Pinturicchio included his own self-portrait in the form of a little picture on the wall.

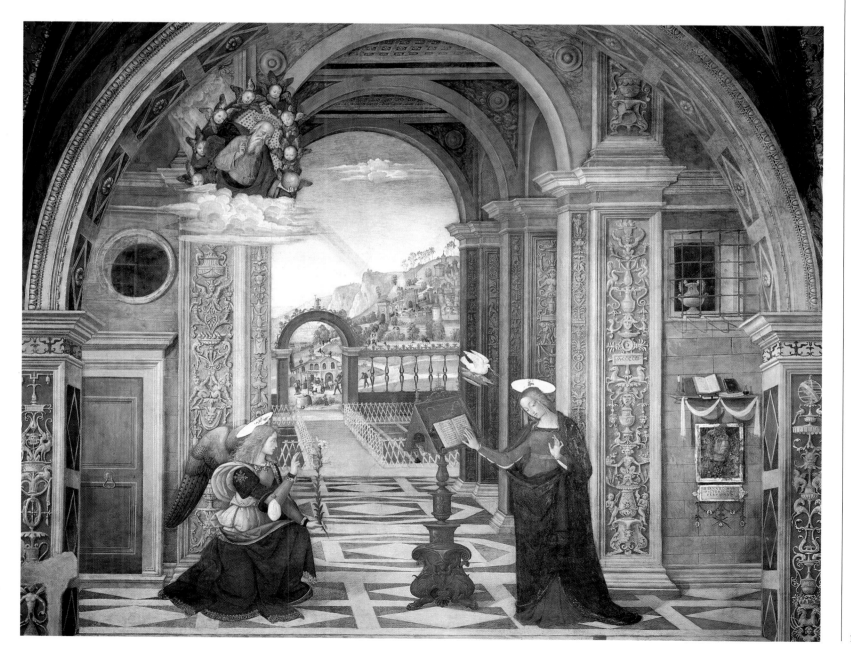

Francesco di Giorgio Martini and "Fiduciario di Francesco"
Annunciazione/
Annunciation

1470, wood panel, Siena, Pinacoteca Nazionale.

This highly unusual painting was the last of the artist's youthful output. The playful gestures of the two characters are emphasized by the abundant folds of the drapery. On the other hand, the perspective of the scene is expressively deformed in order to create a dramatic touch.

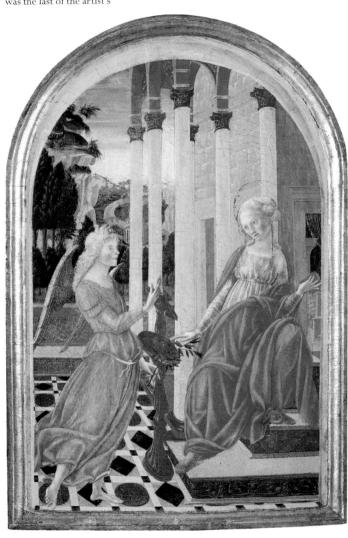

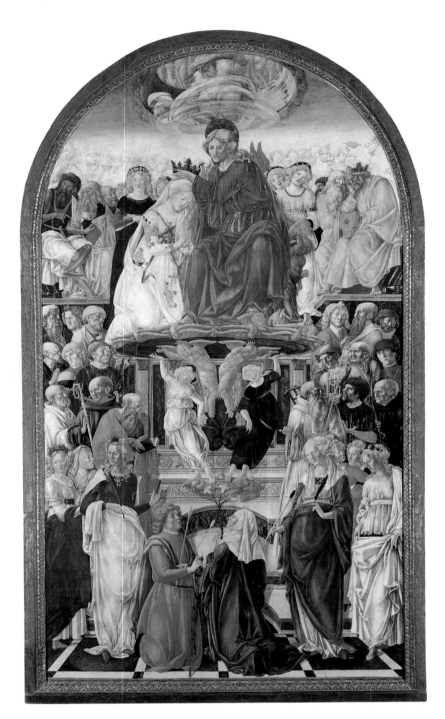

Francesco di Giorgio Martini

Siena, 1439–1501

The multifaceted and often brilliant range of work undertaken by Francesco di Giorgio is typical of the eclectic nature of artists in the Age of Humanism. Architect, sculptor, military engineer, inventor, and technologist, second only to his friend Leonardo da Vinci, di Giorgio only occasionally turned his attention to painting. Despite this, the role he played was of pivotal importance to the development of Sienese art in the late Quattrocento. It is true, however, the artist's training and early career were connected to painting. He was a pupil of Vecchietta and worked alongside Neroccio. After a few miniatures and paintings for furniture, Francesco di Giorgio started to undertake bigger-scale projects from 1470. His expressive graphic style, full of unusual ideas, is nicely encapsulated in the two altarpieces *The Coronation of the Virgin* and *Nativity*, both of which date from around 1475 and are in the National Gallery in Siena. In 1477 he was summoned to Urbino to work as the principal architect at the court of Federico da Montefeltro. Apart from his contributions to the Ducal Palace in Urbino, Francesco di Giorgio also designed and built several noteworthy castles and fortifications. Among his other architectural masterpieces dating from the 1480s are the church of S. Maria del Calcinaio near Cortona and the Ducal Palace in Gubbio. In 1489 he went back to Siena where he sculpted the bronze angels for the cathedral's high altar. He also started painting again but almost immediately left for Milan and then on to Naples, but later returned to settle in his native town. It is to his second period of Sienese painting that we owe his frescos in S. Agostino and the outstanding altarpiece of the *Nativity* which was originally in the church of S. Domenico but is now in the Siena Pinacoteca Nazionale.

On the opposite page
Francesco di Giorgio Martini

Incoronazione della Vergine/The Coronation of the Virgin

1472, wood panel, Siena, Pinacoteca Nazionale.

Painted for the Abbey at Monteoliveto Maggiore, this large and crowded altarpiece was Francesco di Giorgio's most ambitious undertaking in his work as a painter. About 40 characters, each one visually identifiable thanks to the artist's careful graphic research, crowd into the main scene. Christ is crowning the Virgin on a strange podium which is held up by angels. Above them, di Giorgio uses steep perspective to include a whirlwind image of God the Father.

Francesco di Giorgio Martini

Natività/Nativity

1485–90, wood panel, Siena, S. Domenico.

This beautiful altarpiece is completed by a lunette attributed to Matteo di Giovanni and has altar steps painted by Bernardino Fungai. As such it sums up the Sienese school in the late fifteenth century. After his years in Urbino working as an architect, Francesco di Giorgio took up painting once more. The evolution in his style compared to his earlier work is obvious. The artist had by now fully mastered the depiction of space. The figures are scattered, paired into couples whose movements counterbalance each other. Colors are carefully juxtaposed. The grandiose ruined arch that dominates the scene showed Francesco di Giorgio's love of the classical world which he depicted with the deft strokes of an architectural drawing.

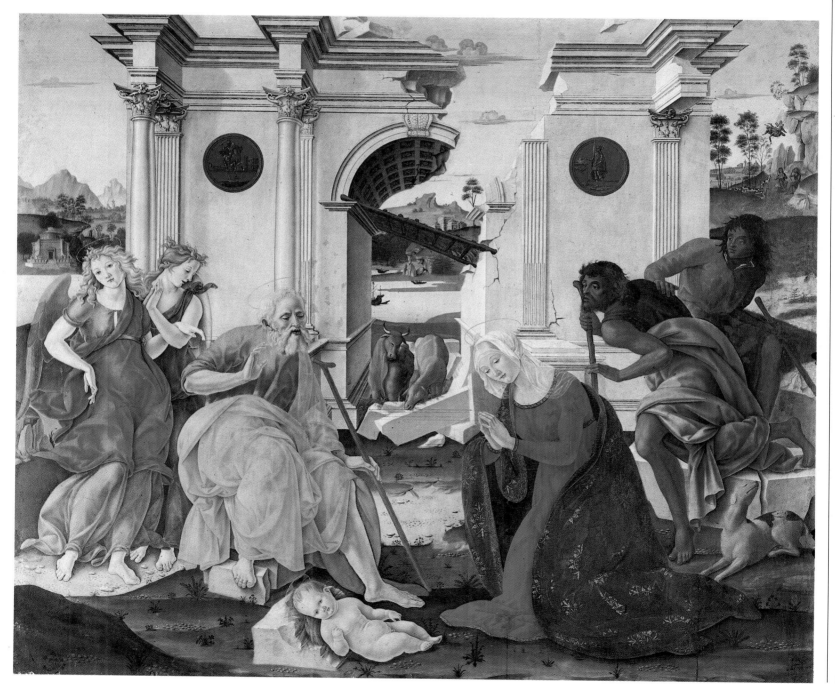

Filippino Lippi

Prato, c. 1457–Florence, 1504

If his birth proved embarrassing for his parents, Fra Filippo Lippi and Sister Lucrezia Buti, who were both in holy orders, Filippino certainly compensated for this by being a true infant prodigy. He assisted his father from a tender age and had only just turned 12 when Filippo died. Nevertheless, Filippino was able to complete the frescos in Spoleto cathedral. Straight afterwards he went on to assist Botticelli during what was destined to be a fruitful period in his early work. The two painters worked very closely but Filippino developed a more robust use of line and form than his master. Filippino's first certain works are characterized by an uneasy sweetness and a sinuous rhythm to his draughtsmanship over which he still retained total control. This can be seen in his first major work, completing the frescos started by Masaccio and Masolino in the Brancacci Chapel (c. 1484/85). It is also apparent in the *Otto de Pratica Altarpiece* for the Palazzo Vecchio (now in the Uffizi), in the *Vision of St. Bernard* (1486, Badia, Florence), in the *Nerli Altarpiece* for S. Spirito (c. 1488) and in the start he made on the frescos in the Strozzi Chapel in S. Maria Novella which were only finished in 1502. Thanks to Lorenzo the Magnificent's intervention, Filippino was called to Rome in 1488 to paint the frescos in the Carafa Chapel in S. Maria sopra Minerva. Struck by recent archeological discoveries, Filippino worked on antique ornamental motifs. Back in Florence, the painter was one of the first and most lucid to respond to the crisis in art caused by the death of Lorenzo the Magnificent and Savonarola's sermons. His painting became bizarre, fantastical and tend increasingly to seem hallucinatory in a highly inventive way. Among his last works are the *Deposition* (Florence, Accademia) which was completed by Perugino.

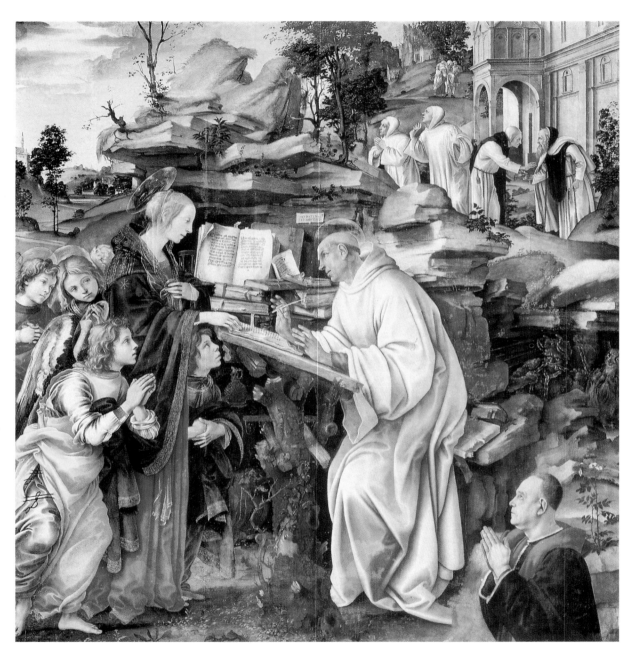

Filippino Lippi
Apparizione della Madonna a san Bernardo/ The Apparition of the Virgin to St. Bernard

c. 1486, wood panel, Florence, Badia.

Painted at a time when Filippino was fully committed to finishing Masaccio and Masolino's frescos in the Brancacci Chapel, this dazzling altarpiece is one of the unquestioned masterpieces of Tuscan painting produced towards the end of the fifteenth century. Filippino rivaled the Flemish masters in his perfect depiction of detail and the vivacity of his colors. However, this work shows the first signs of the sense of unease and melancholy that appear to gnaw at the souls of Filippino's characters.

Filippino Lippi

Storie di san Filippo: San Filippo esorcizza nel tempio di Hieropoli/Life of St. Philip: St. Philip Exorcising in the Temple of Hieropolis

1487–1502, fresco, Florence, S. Maria Novella, Strozzi Chapel.

Even in their chronology, the dramatic frescos in the Strozzi Chapel mark the end of an era. The balance and harmony upon which all of Florentine Humanism had been centered were now broken. The rhetorical gestures, the charged expressions, the unreal colors, but above all the ambiguity between architecture and figures, already belonged to a new age. The calm certainties of the fifteenth century were disappearing, giving way to the more troubled, questioning details common during the sixteenth century.

The eccentric altar in the painting deserves a note to itself. At the foot of the altar steps crouches the dragon that the saint is exorcizing. The composed and measured perspectives that Tuscan painters preferred almost to the end of the fifteenth century, their regular architecture and classical rhythm are here abandoned in favor of an eclectic and deliberately confused rag-bag of architectural motifs. These are bizarrely interwoven in a way that breaks every rule. The overall effect is one of instability that also infects the groups of characters. There is a sense of unending clash between sculpture, reliefs, votive offerings, colored statues, and lifelike details. We are seeing nothing less than the air of tension that followed the death of Lorenzo the Magnificent.

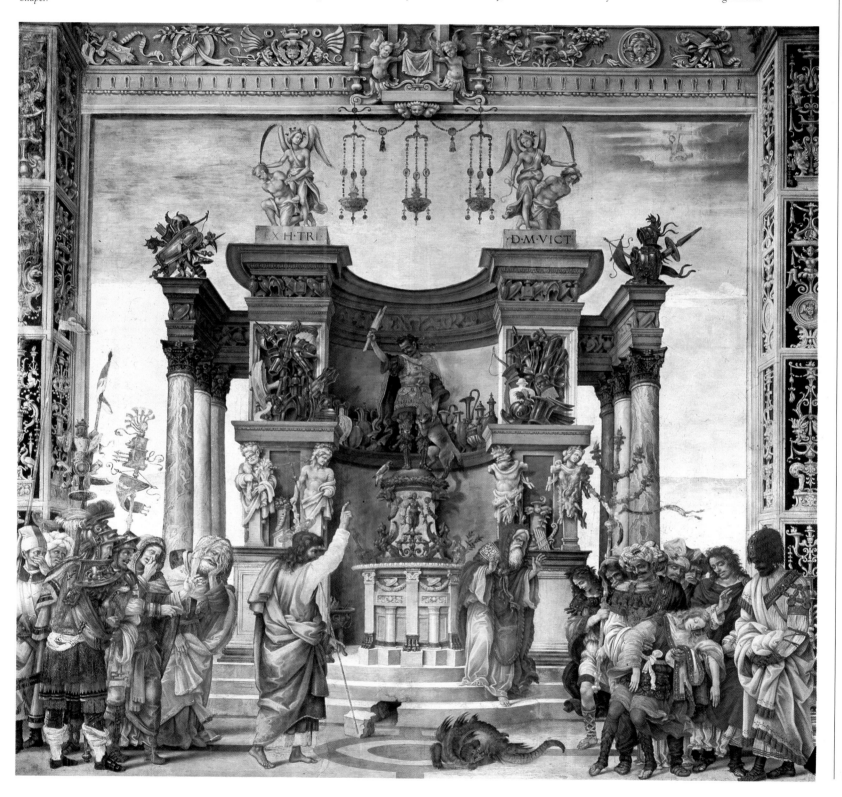

Luca Signorelli
Crocifissione/Crucifixion

c. 1500, fresco, Morra, church of S. Crescentino.

The solid structure of this group of people and horsemen is the legacy of Signorelli's time with Piero della Francesca. It is also typical of the kind of work Signorelli produced not only in the great capitals of art, such as Florence and Rome, but also in minor provincial centers in Umbria and Tuscany. Apart from his famous altarpieces and fresco cycles that were particularly grandiose and complex in nature, Signorelli's work of this time can be found in small places, especially in the area around Perugia.

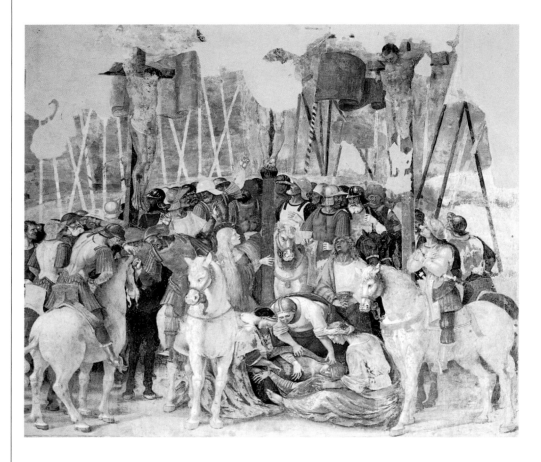

Luca Signorelli

Cortona, c. 1445–1523

Signorelli garnered and interpreted the most up-to-date, expressive stimuli from all Tuscan painting. He alternated between periods spent at the very heart of the cultural developments of his day (in the courts of Lorenzo the Magnificent in Florence and Federico da Montefeltro in Urbino) and long stays in minor centers. He was reputedly a pupil of Piero della Francesca then working in Arezzo, after which he worked with the Pollaiolo brothers in Florence but his own style did not mature until he went to Urbino. Here, among other works, he painted the *Flagellation of Christ*, now in Milan. In 1482 he was in Rome where he assisted Perugino on his Sistine Chapel frescos. After this close contact with Perugino, Signorelli's style softened.

This can be seen in the frescos he painted for the sacristy of the Loreto Sanctuary and his *St. Onofrio Altarpiece* for Perugia cathedral (1484). He then moved to Florence where he became a minor painter in Medici circles. During this period he produced the panels now in the Uffizi, including a tondo of the *Madonna and Child*. Following Lorenzo's death in 1492, the painter chose to leave Florence to tackle two large fresco cycles. One was on the subject of the *Life of St. Benedict* in the abbey cloisters at Monteoliveto Maggiore (1496–98). The other was the awe-inspiring *Apocalypse* for the S. Brizio Chapel in Orvieto cathedral (1499–1504). Luca Signorelli spent nearly the whole of his last twenty years in the provinces, between Cortona and Città di Castello.

Luca Signorelli
Giudizio finale: i dannati/
The Last Judgment:
The Damned

1499–1502, fresco, Orvieto, Cathedral, S. Brizio Chapel.

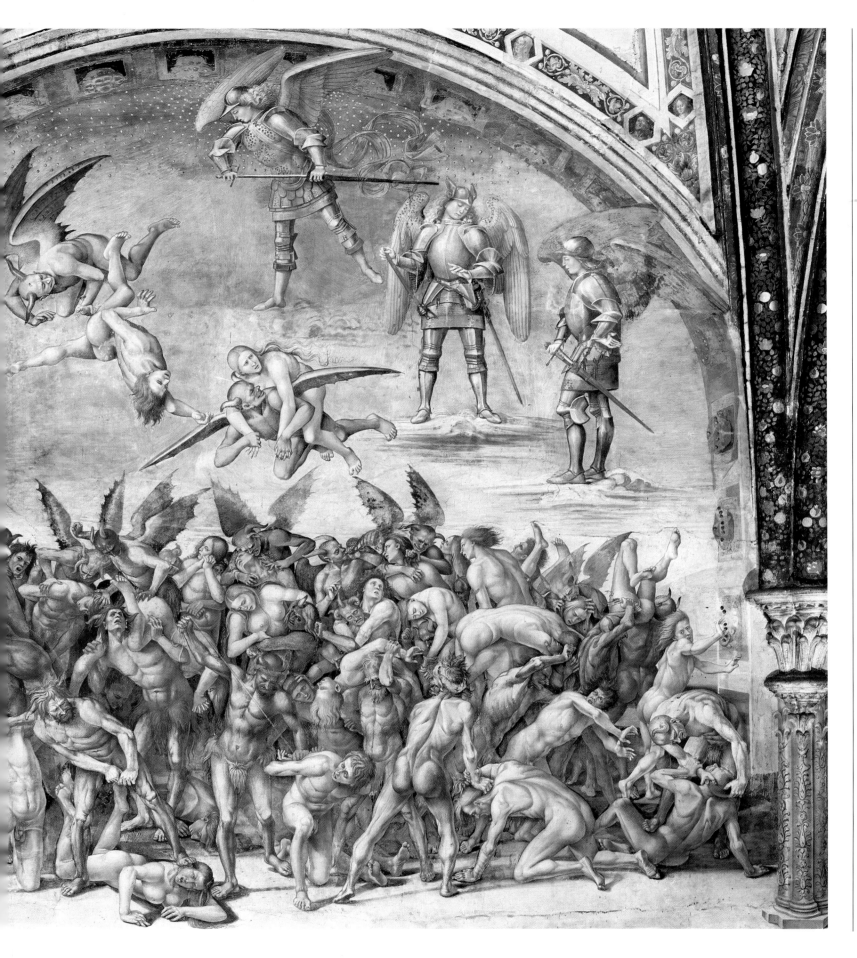

The 16th Century

Raphael
La Scuola di Atene/The School of Athens

Detail, 1509, Rome, Vatican, Papal
Rooms, Stanza della Segnatura

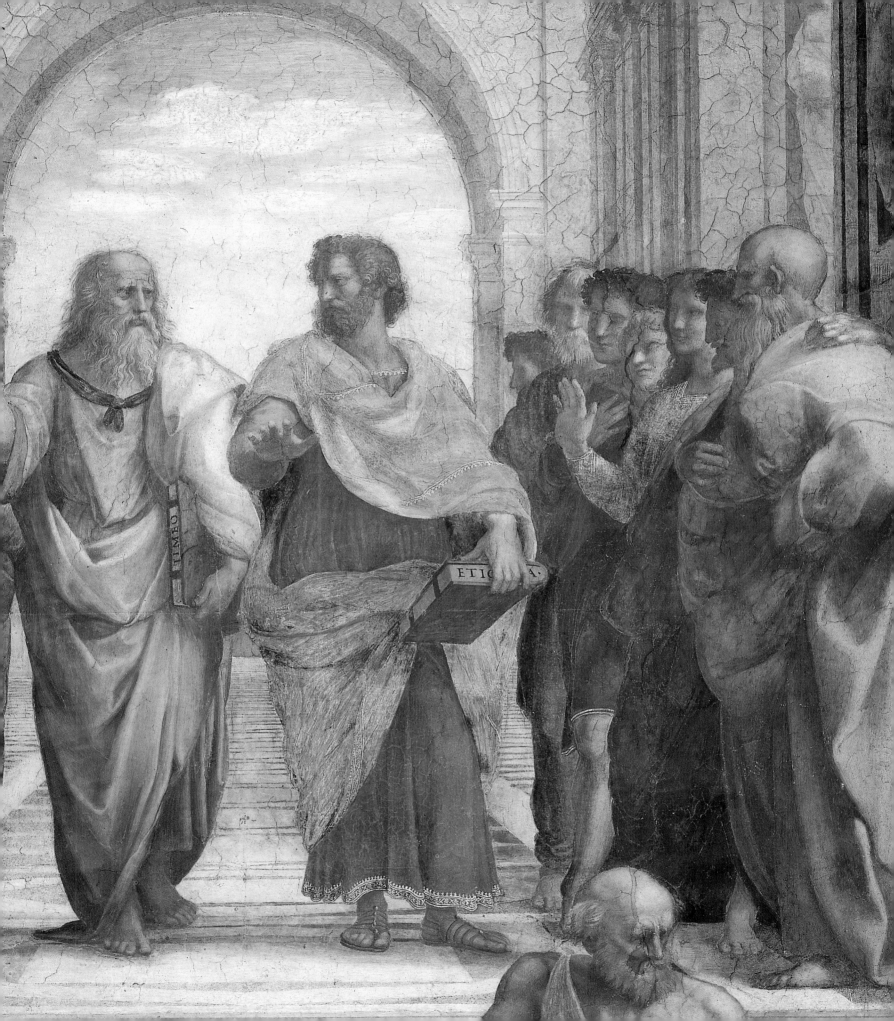

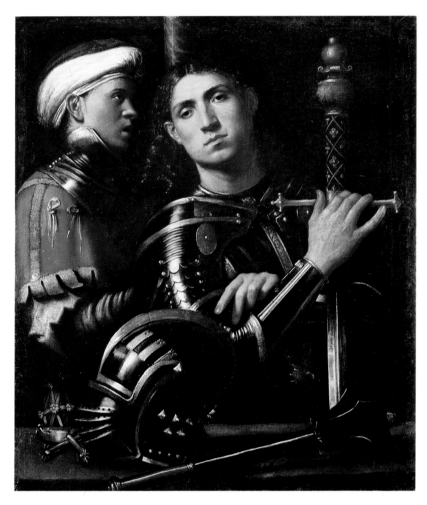

Giorgione
Ritratto di gentiluomo in armatura/Portrait of a Gentleman in Armor,
c. 1510, canvas, Florence, Uffizi.

Fifteenth-century Renaissance art can be seen as a reflection of a calm and stable epoch in search of harmony. The often grandiose and dramatic art of the Cinquecento (sixteenth century) symbolizes a different century, one torn by wars, troubled by profound doubts and shaken by new religious movements. While some nation states (Spain, France, England) consolidated themselves, new routes were opened up by overseas discoveries and whole new worlds were discovered. Meanwhile Martin Luther's Reformation tore central Europe apart, the Ottoman Empire of Turkey continued its advance up to the gates of Vienna and the plague recurred again and again. These were events that shook the Continent politically, economically, and culturally, and changed Europe for ever. It is no coincidence that historians often classify the fifteenth century as part of the Middle Ages, whereas the sixteenth century is considered the beginning of the Modern Age. In Italy there could no longer be any doubt that foreign powers were there to stay (the whole of the South as well as the former Duchy of Milan fell under Spanish rule and only Venice retained a real independence). At the same time, the old-established patterns of trade across the Mediterranean seemed threatened by new ocean routes to the East, although this threat was slow to materialize.

But the century opened splendidly. Its first twenty years are known as the High Renaissance, when Leonardo, Raphael, Michelangelo, and Titian — bitter rivals but ones who constantly exchanged ideas — produced unprecedented masterpieces, fulfilling the ideals pursued by artists since Giotto two centuries earlier. Italian art as a whole reached heights that have never been surpassed, and was confirmed as by far the richest, most varied, and influential school in Europe. However, Italy's increasingly troubled political situation (it was the chief battle ground for the constantly clashing armies of France, Spain, and Germany up to 1559) meant that both artists and their works sometimes went abroad, lured by rich monarchs. They took with them the latest in Italian Renaissance art which spread throughout Europe. Leonardo moved to France where he died, so bringing the High Renaissance to a still medieval country. Other, lesser painters such as Rosso Fiorentino and Primaticcio followed, founding the Fontainebleau school of painting. Great rulers such as the Emperor Charles V and his son Philip II became Titian's main patrons, partly supplanting the old-established families of small Italian courts. At the same time there were already the first signs of the economic and historical decline that would undermine Italian art in the very long run, although the Seicento (seventeenth century) saw another golden age in the arts.

Titian
*Gli Andrii/Bacchanal of
the Andrians*,
1518–19, canvas, Madrid,
Prado.

Titian
Pietà,
1576, canvas, Venice,
Accademia.

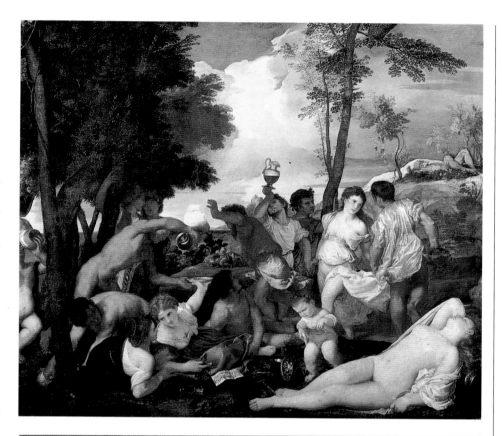

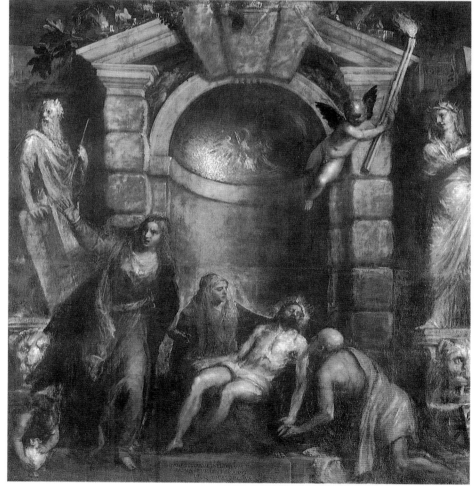

The Cinquecento was also a century of self-portraits. The great Italian masters had already acquired the same high cultural status enjoyed by Renaissance scholars, and were no longer regarded as menial craftsmen. Their interest in self-portraiture (the cheapest type of portraiture, after all) partly reflects their new-found status. Leonardo drew his own aging self in the wrinkled and meditative psychological self-portrait in his Merlin-like drawing done in extreme old age. At the apex of the High Renaissance, Raphael's self-portrait depicts him at ease among scholars and philosophers in "The School of Athens." Decades later, utterly disillusioned with history and life, Michelangelo produced his self-portrait as St. Bartholomew, a ragged old beggar with flayed skin in his *Last Judgment* in the Sistine Chapel. The Mannerist painter Parmigianino turned his *Self-portrait in a Convex Mirror* into a prodigious virtuoso exercise. Titian's great series of self-portraits show a painter physically growing older but whose understanding grew ever more vigorous — an artist ready to meet eternity with paintbrush in hand.

Without simplifying art history too much, we can say that in the sixteenth century major changes occurred about every two decades. Each change was, often deliberately, part of the process of constant renewal, for artists were still keen to experiment in any way they possibly could, untrammelled by the past. Each period contained an abundance and variety of art forms without parallel in any other century of art history, save perhaps our own. Up to 1520 the High Renaissance sparkled with the splendor of its Golden Age. From 1520 to 1540 new religious doubts and questionings on the destiny of man opened the way to new concepts in painting which later culminated in Michelangelo's *Last Judgment*. From 1540 to 1560 a dichotomy emerged between the hyper-sophisticated Mannerism of Tuscany and Rome and the sensual depiction of reality of the Venetian and Lombard schools. Between 1560 and 1580 Titian, Tintoretto, and Veronese brought Venetian painting to a triumphant and dramatic climax. The last twenty years of the century were, by comparison, years of relative stagnation artistically until Caravaggio rediscovered the natural world with his revolutionary realism and the Carracci dynasty revitalized the classical tradition. Michelangelo and Titian were both particularly long-lived. If we compare the two great masters' early work with that of their old age, we are instantly struck by the chasm between the generally sunnily optimistic art of the early sixteenth century and the often work tortured of the second half.

Among the key events shaping much of the cultural pattern of the first half of the Cinquecento, some occurred before the turn

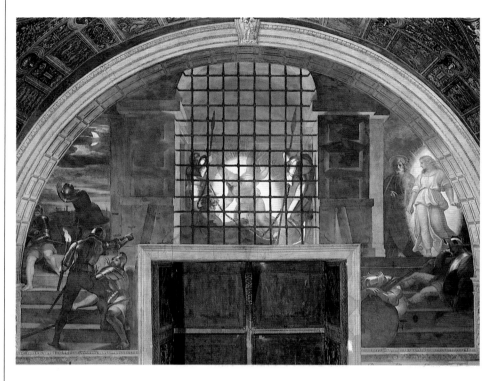

Raphael
Liberazione di san Pietro dal carcere/Deliverance of St. Peter from Prison,
1513, fresco, Rome, Vatican, Stanza di Eliodoro.

of the century. In 1492 Christopher Columbus had inadvertently discovered a new continent. This spelled the end of the old map of the world, which the fifteenth century had shared with Antiquity. The Earth was found to be bigger than the supposedly omniscient Greek philosophers had ever guessed. Also Florence, capital of the early Renaissance, was in turmoil after the death of Lorenzo the Magnificent in 1492, terrified by the admonitory sermons of Fra Savonarola. Although four years later the Dominican monk was burned at the stake, his condemnation of the vanities of pleasure-seeking and paganism shook the conscience of many, including artists. The charming style in which some painters had worked throughout their long careers (Botticelli, Perugino) was now found inadequate.

In the first years of the sixteenth century, Florence was again the center of artistic excitement, as Leonardo and Michelangelo competed to decorate the walls of the Palazzo Vecchio with huge battle scenes, which impressed all contemporaries, including the young Raphael. At the same time Michelangelo carved his *David,* the supreme emblem of High Renaissance heroism. But it was Rome which was to be the real center of Cinquecento art, as the popes began their grandiose project of rebuilding St. Peter's. Michelangelo was summoned there in 1505 to build Pope Julius II's tomb – a gigantic project never to be finished. Instead, in

1508 he began decorating the ceiling of the Sistine Chapel with his back-breaking and breathtaking masterpiece, the fresco cycle of *The Creation,* where the fall from the Garden of Eden is portrayed with passionate intensity. The same year saw Raphael start work on another part of the work of the Vatican, the Stanza della Segnatura, where he created an enchanted equilibrium. In contrast to the grandiose power to be found in Michelangelo, the frescos in the Stanze di Raffaello (or Raphael Rooms as they are now often known), show a combination of majestic grandeur with sweet gracefulness which seemed to incarnate the ideals of the High Renaissance. Plato (a portrait probably of Leonardo) and Aristotle dispute in the fresco *The School of Athens* as though they were members of the papal court – a court which sometimes felt itself more pagan Greek than Christian, but where pagan and Christian thought united in general harmony. What united both Michelangelo's and Raphael's art was their immense, supremely assured, grandeur.

The change in style and generation, however, was not felt only in central Italy. Milan was being fought over by the French and the Spanish when Leonardo returned to put his own seal on the local school. In Venice the narrative and analytical tradition of Carpaccio and Gentile Bellini was replaced, first by the melancholy, poetic dreamy sweetness of Giorgione and then by Titian's first explosions of color which characterize *The Assumption* on the high altar of the Venetian church of the Frari. These new leaders of art were quickly surrounded by schools, assistants, and lesser imitators. They were also supported by a lively output of writings and treatises on art. These theoretical essays (which culminated in the famous *Lives of the Most Excellent Artists from Cimabue to Michelangelo* published by Giorgio Vasari in 1550) began to uncover an ever-more marked contrast between the supremacy of draughtsmanship venerated in Florence and Rome and the rich, dramatic love and use of color that the Venetians adored. At the same time a few painters who lived highly individual lives, such as Lorenzo Lotto, raised the question of whether other, more personalized, ways of painting might not be possible.

Raphael's death (1520) coincided with the rapid growth of the Lutheran schism which the highly cultured, peace-loving Pope Leo X (Lorenzo the Magnificent's son) could not halt. A few years later the Eternal City was dealt a seemingly mortal blow by the Sack of Rome (1527), and the High Renaissance was finally over, except for some artists in Venice. In such a changed world, painters perceived the urgent need to rethink the forms and rules of their art. The most thoroughgoing proposals came out of Florence where Pontormo and Rosso Fiorentino started by studying and

Correggio
Danae,
1531–32, canvas, Rome,
Galleria Borghese.

Giovan Gerolamo Savoldo
*Pala dei due eremiti/
Altarpiece with Two Hermits*,
detail, 1520, wood panel,
Venice, Gallerie
dell'Accademia.

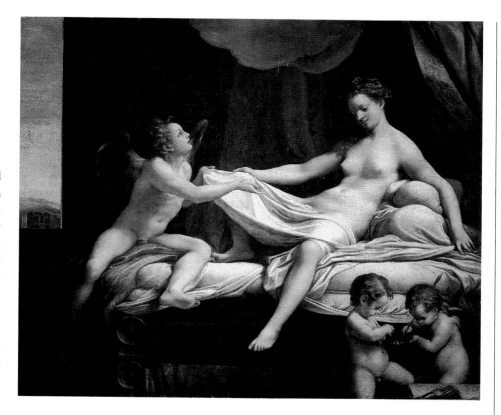

faithfully emulating the works of Michelangelo and Raphael and ended by violently distorting such traditional forms. Their frozen figures flaunted wildly contorted poses and nervously melodramatic expressions, far removed from Raphael's serenity. A new movement was born: Mannerism. During the course of the century this was to become the dominant artistic current in central Italy and, through the export of works of art and of artists themselves, much of Europe. In northern Italy, however, they had different ideas. At about the same time, that is to say around 1520, provincial artists began working on large-scale decorative projects. These were much appreciated by the public. Instead of the tormented estheticism of the Tuscan Mannerists these moving works blended all the elements together in harmony. The frescos painted by Gaudenzio Ferrari at Varallo, by Pordenone in Cremona and above all by Correggio in Parma provide a daring foretaste of the most thrilling compositions of Baroque art.

There is no doubt, however, that in their respective cities of Rome and Venice it was Michelangelo and Titian who determined how art developed. After almost 30 years Michelangelo returned to the Sistine Chapel to paint *The Last Judgment*, the final and most terrible epic in the history of the human race. By then, Titian was the international artist par excellence. He painted a host of memorable portraits which captured the faces and characteristics of the most powerful people in Europe. In 1545 the two great artists, by then both growing old, met in Rome and failed to agree. Both had been commissioned by the Farnese Pope Paul III, who also called the Council of Trent at the start of the Counter-Reformation.

The work of this huge religious council was closely linked to the more strictly political tasks demanded by the Emperor Charles V and the Diet of Augsburg, which Titian also attended while painting the Emperor. From the middle of the century, the end of over 30 years of conflict in Germany between Catholics and Protestants meant that the way religious images had long been used needed to be reassessed. As had happened two centuries earlier after the Black Death of 1348, the century divided almost into two halves. On the one hand, and especially in Florence and Rome, Mannerism became ever-more sophisticated and intellectual, striving toward the artificial creation of a new painting and celebrating the rule of often despotic dukes. Bronzino's portraits are a perfect example of this, but they were nonetheless outdone by the bizarreness of some the richest and most fanciful foreign collectors, such as the Hapsburg Emperor Rudolf II who was Arcimboldo's patron. On the other hand, in the smaller centers, such as Brescia, Bergamo and the Marches,

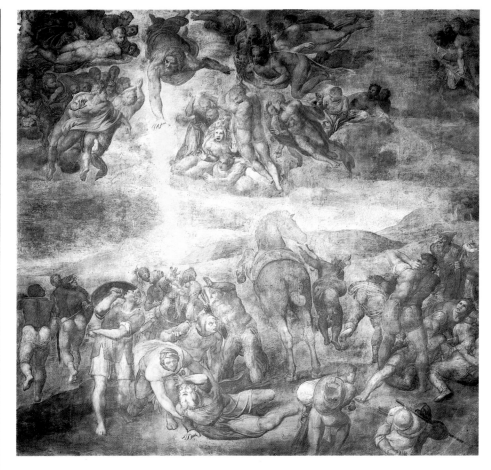

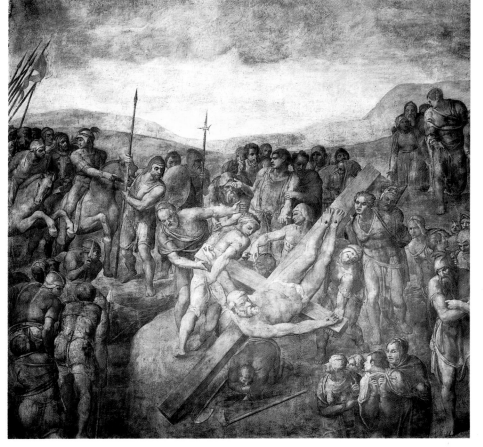

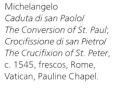

Michelangelo
Caduta di san Paolo/
The Conversion of St. Paul;
Crocifissione di san Pietro/
The Crucifixion of St. Peter,
c. 1545, frescos, Rome,
Vatican, Pauline Chapel.

there was a rediscovery of the human dimension in direct touch with reality. Here we have forerunners of Caravaggio's radical realism and of the return of simple treatments of religious subjects.

The expansion of the Ottoman Empire in the eastern Mediterranean posed a real threat to Venice whose island empire was being continually attacked. Not even victory in the Battle of Lepanto (1571) removed the ever-present Turkish danger. Despite this, in the sixteenth century as a whole Venice put on a glittering display, building classically-inspired palaces, churches, libraries, and villas designed by Sansovino and Palladio. It also boasted a glittering list of magnificent painters. Titian had embarked on a solitary and wonderful adventure. In his extreme old age he painted some of the most striking images ever produced in art, works so unfinished and evanescent that they move almost toward abstraction. These were not the works which made him famous but they appeal to us now more than ever. Generally, the Venetian school produced artists who were at ease in any situation, always willing and able to take on decorative cycles of enormous size. In the 1560s and 1570s artistic activity in Venice reached levels of the very highest creativity. You can choose the sunlit, sumptuous, spectacular scenes created by Paolo Veronese, where no touch of religious controversy and doubt is permitted to darken scenes of frankly pagan sensuality – but a sensuality transmuted by the power of art to a higher plane. Or you can choose the intensely spiritual, highly dramatic canvases of Tintoretto, which rival Michelangelo's greatest works, or turn to Jacopo Bassano's marvelously realistic views of peasant life in the mountains.

By the close of the century, however, the great stream of fresh geniuses seemed to have dried up. One after another the greatest painters had died: Michelangelo in 1564, Titian in 1576, Veronese in 1588, and Tintoretto in 1594. A new generation of artists would have to make its mark on a very different artistic landscape. It would also have to stand up to ever fiercer international competition from new schools of painting, themselves often originally inspired by Italy. Little by little, Italy was destined to lose its central position in the world of European art, although for centuries to come it would remain a place of artistic pilgrimage. In the seventeenth century artists as different as Rubens and Poussin would visit Italy, and Poussin, the founder of French classicism, would choose to spend his life in Rome. Even so, the last years of the century saw Italian art adrift and directionless. The narrow puritanism of the early Counter-Reformation, with its distrust of all exuberance and artistic independence, had blighted

Paolo Veronese
Cristo nell'orto/Christ in the Garden,
1581, canvas, Milan, Brera.

Leonardo
San Giovanni Battista/St. John the Baptist,
1516, wood panel, Paris, Louvre.

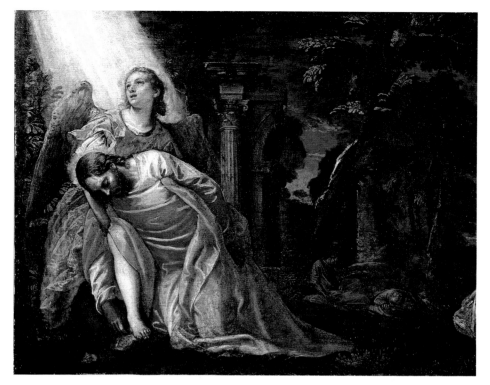

even the art of Venice. The most luminous period of Italian art and culture therefore closed on a note of muted tragedy. This is all the more striking because it came after such an extraordinary era of the human spirit.

The adventurous path pursued by Renaissance man was first trodden in the proud city of Florence by Dante and Giotto. They set out to claim a new role for humanity to play in the world ("fatti non foste a viver come bruti/ ma per seguir virtute e conoscenza" ["you were not made to live like savages/ but to follow virtue and knowledge"]). Over the generations the Renaissance had taken on a scale and depth that could not possibly have been foreseen at the start. At its zenith, it produced a unique generation of the greatest masters, all of them born between the middle and the end of the fifteenth century. It was in the centuries of the Renaissance that our own modern way of living in the world was first hinted at and shaped. With that came our modern ability to relate to our own history and destiny, our way of interpreting the present as a link in the chain between a passionately-studied past and a future that we can face with equanimity. With the Renaissance came also a new awareness of the world of the ancient Greeks and Romans and with that a slowly achieved awareness – quite lacking in the Middle Ages – that such a world was over and past. The Renaissance also gave us a new taste for beauty, a new love of nature, and a new passion for life and for art. This, more than the individual masterpieces of even the greatest painters, is the true inheritance of the Renaissance. It is undoubtedly something for Italy to be proud of, but it also has produced an abundance of works of art, many of them of the highest quality, that are difficult to preserve and to keep intact for the world.

In its dying days the Renaissance gave way to a new attitude toward man, nature, the mysteries of the cosmos, and the divine mystery. This was the generation of Caravaggio and Galileo. Each in his own way built a telescope to look fearlessly into the depths of the soul or into the dark of the night. They looked toward a humanity and a universe which, a century earlier, Leonardo had more joyously been the first to explore.

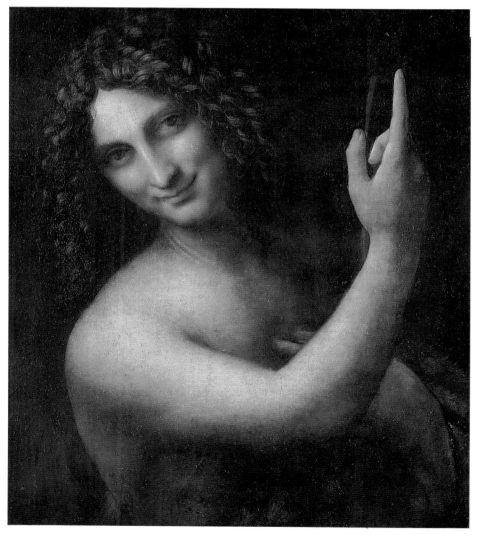

Leonardo da Vinci

Vinci (Florence), 1452–Cloux near Amboise, 1519

Leonardo da Vinci epitomizes the High Renaissance. He was a restless, multi-faceted character, dissatisfied by his results, alternating between art and science but seldom capable of finishing anything. This makes his œuvre the most frustrating of the great Renaissance artists. Painting (and especially drawing) provided the base from which he threw himself into disparate activities. Leonardo was an inventor, musician, architect, sculptor, painter, hydraulic and military engineer, town planner, botanist, and astronomer. He received his training in Florence during the 1460s; traditionally his first work being the angel in *The Baptism of Christ* in the Uffizi, combining languor and intensity in a way that was to typify his art. He was one of the first Florentine artists to paint mainly in oils, which allowed him subtly to model forms through light and shade rather than clear-cut lines. His striking talent for portraiture became apparent, as with *Ginevra Benci* in Washington, and with it his interest in expressing human psychology through subtle gradations of expression, fusing them with atmospheric landscapes. This was first seen in his *Annunciation* (Uffizi). His decision to leave Florence for Milan c. 1481 was surprising, Milan not then being a noted artistic center, but he swiftly became the Sforza court's master not only of art but also of courtly ceremonies and military defense. During his long stay in Milan, he produced works of paramount importance, such as *The Virgin of the Rocks* (Paris, Louvre), *Last Supper,* and fascinating studies of human faces (Windsor, Royal Collection). When Milan fell to the invading French in 1499, Leonardo returned to Florence where, with his younger rival Michelangelo, he painted (now lost) frescos in the Palazzo Vecchio and started work on the *Mona Lisa*. Both works were to have immense influence on later artists. Leonardo kept hundreds of drawings, notes and studies. Back in Milan again he worked on *The Madonna and St. Anne*, Paris, Louvre, where he left a decisive mark on the local school. He finally accepted an invitation from King François I in 1516 and settled in France, where he painted his last, enigmatic work *St. John the Baptist*, Paris, Louvre.

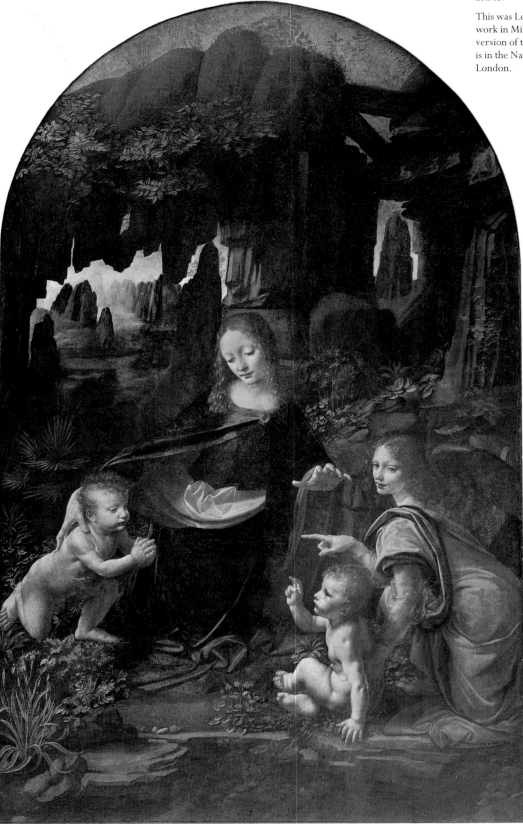

Leonardo da Vinci
Vergine delle rocce/
The Virgin of the Rocks

c. 1483–90, wood panel transferred onto canvas, Paris, Louvre.

This was Leonardo's first work in Milan. His second version of the same subject is in the National Gallery in London.

Leonardo da Vinci
Ultima Cena/The Last Supper

detail, 1495–97, tempera and oil over two preparatory layers, Milan, S. Maria delle Grazie, refectory.

This masterpiece was commissioned by the Duke of Milan, Ludovico Sforza (il Moro). Despite its very poor condition it is still astoundingly expressive and tremendously moving. Leonardo completely ignored the traditional approach, choosing instead to depict the moment in which Christ tells the Apostles that he is about to be betrayed. As dismay spreads among them, the artist wonderfully captures their feelings. Leonardo's analysis of gesture and expression is superb. He deliberately used what looks like the sign language of the deaf in order to express feeling. Trying to capture every little detail with perfect accuracy, he experimented with an oil-based alternative to the traditional fresco technique which forced him to apply the paint quite rapidly. Unfortunately, the method of fixing the color to the wall that Leonardo tried out proved inadequate. The mural was already in need of restoration only a few years after it was first completed. For centuries restoration work followed trial, followed further restoration work. The room itself was lived in during the Napoleonic occupation and was badly damaged by bombing in 1943. Recent, painstakingly slow restoration has brought to light what still remains of the original painting and in particular has revealed details that had been covered by repainting.

Leonardo da Vinci
Ritratto di musico/Portrait of a Musician

1485–90, wood panel, Milan, Pinacoteca Ambrosiana.

This is Leonardo's only panel painting left in Milan and is one of his earliest surviving portraits. It is obvious that the sitter is a musician from the score he is holding in his right hand. He is probably Franchino Gaffurio, the chapel master at Milan cathedral and a prominent treatise-writer. The intelligent, inspired face emerges from the dark background with all the three-dimensionally plastic force of a sculpture. His golden curls are painted with the meticulous care normally only found in miniature painting. His red hat and his clothes were probably painted by Leonardo's pupils.

On the opposite page
Leonardo da Vinci
Annunciazione/ The Annunciation

c. 1474, wood panel, Florence, Uffizi.

This rare, early work underlines not only the similarities but also the differences between Leonardo and mainstream Florentine art, which at the time was dominated by the rising star of Botticelli. A few details, such as the lectern that is not fully in perspective or the screen of trees at the end of the garden, are still in the older style of idealized fifteenth-century gardens. Similarly, the elegance of the gestures and the folds of the drapery can be related to tastes of Botticelli and Perugino. In contrast, however, the mistily atmospheric landscape in the center of the background and the way Leonardo has delighted in painting with scientific accuracy flowers and grasses already give a clear indication of the way his painting would develop in the future.

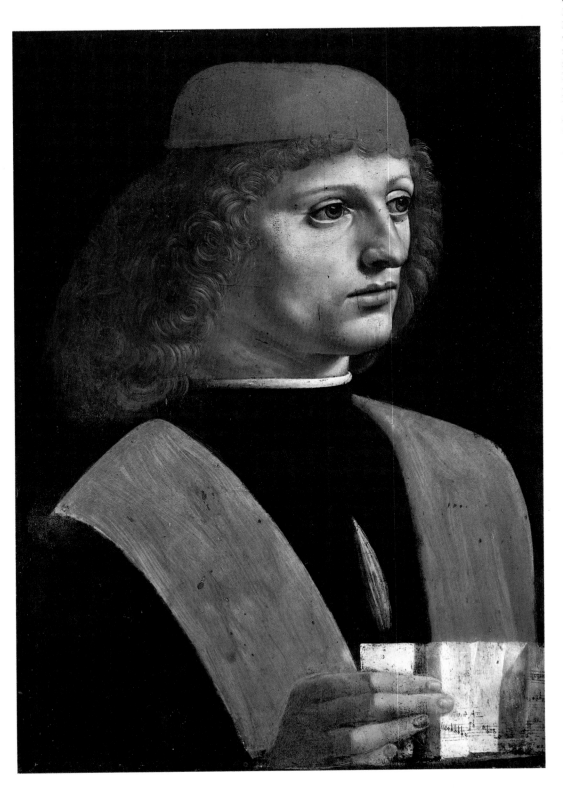

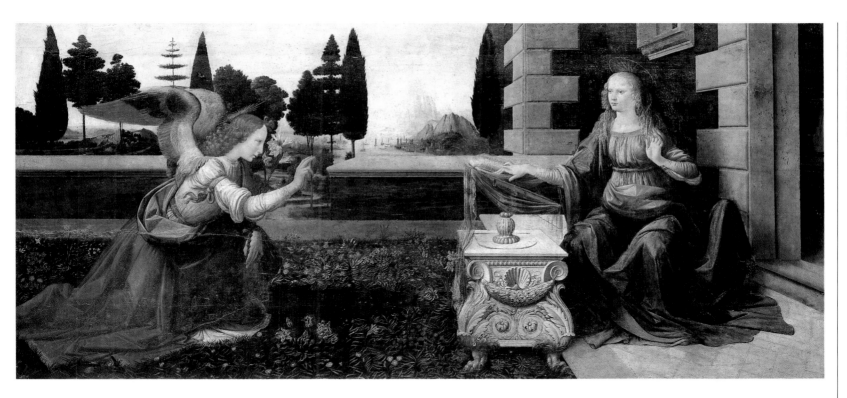

Leonardo da Vinci
La dama con l'ermellino/
Lady with an Ermine

c. 1490, wood panel, Krakow, Czartoryksi Muzeum.

The movement of this beautiful girl turning slowly from the shadow into the light is mirrored by the small animal (ermine or white weasel) she is holding. The sitter is generally assumed to be Cecilia Gallerani, the aristocratic lover of Ludovico Sforza.

Leonardo da Vinci
Ritratto di dama (La Belle Ferronière)/Portrait of a Lady (La Belle Ferronière)

c. 1495–99, wood panel, Paris, Louvre.

It is very probable that this enigmatic and highly intelligent young lady was also a noblewoman at the Milanese court. It is even possible that this is another portrait of Cecilia Gallerani seen in the Krakow painting. Both are superb examples of Leonardo's genius as a portrait painter.

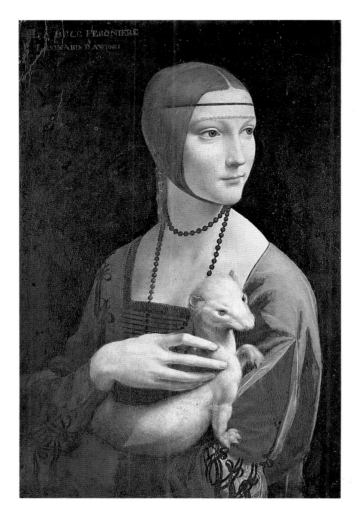

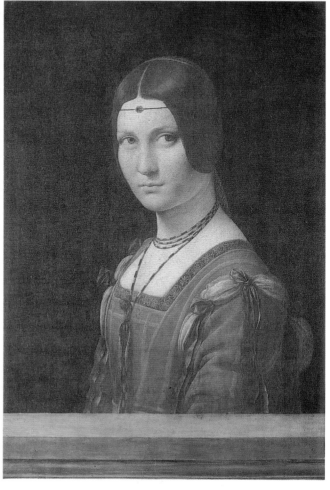

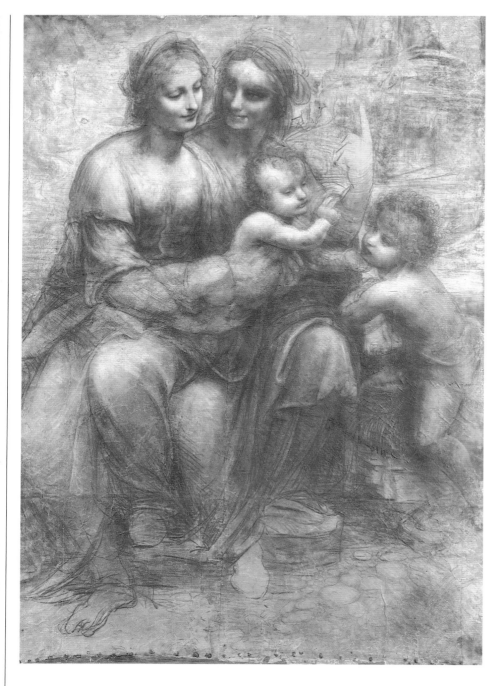

Leonardo da Vinci
Sant'Anna, la Vergine, il Bambino e san Giovannino/The Virgin and Child with St. Anne and the Infant St. John

1499–1508(?), a sfumato cartoon in charcoal, tempera, and white lead on paper, London, National Gallery.

This is a full-size cartoon (preparatory drawing) for *The Virgin and Child with St. Anne.* It shows how Leonardo's drawing shaped and underlay all his painting, for he was arguably the greatest draughtsman who has ever lived. Leonardo was in the habit of studying all his subjects to the point of obsession. Apart from portraits, it was rare that he considered any one version of a painting to be definitive. He felt that he had the right to keep his paintings in a perennially unfinished state, something which annoyed patrons kept waiting for years. Failing to finish his works, he would go back and rework them. Sometimes he even started all over again. One only has to compare the cartoon to the final painting to see just how much Leonardo changed the structure of the drawing and the individual characters. The cartoon reveals the power of Leonardo da Vinci's drawing. This stemmed from the way he balanced two opposing aspects in his art: clarity of line, typically Tuscan, and shadowy chiaroscuro, which he himself had pioneered.

Leonardo da Vinci
Sant'Anna, la Vergine e il Bambino con l'agnello/The Virgin and Child with St. Anne and a Lamb

c. 1510–13, wood panel, Paris, Louvre.

The three holy characters smile with a mysterious sweetness amid a setting of trees, rocks and water. Behind them rise fantastic yet minutely observed mountains. This beautiful yet weird landscape should be viewed bearing in mind the scientific and artistic research in the Alps that Leonardo undertook during his second stay in Milan.

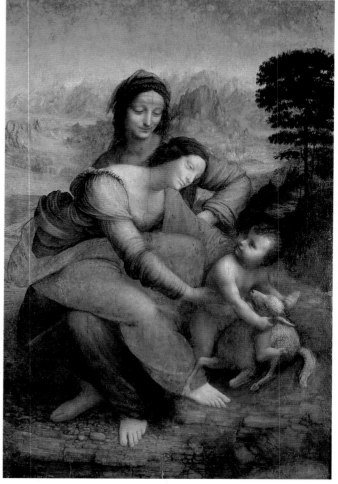

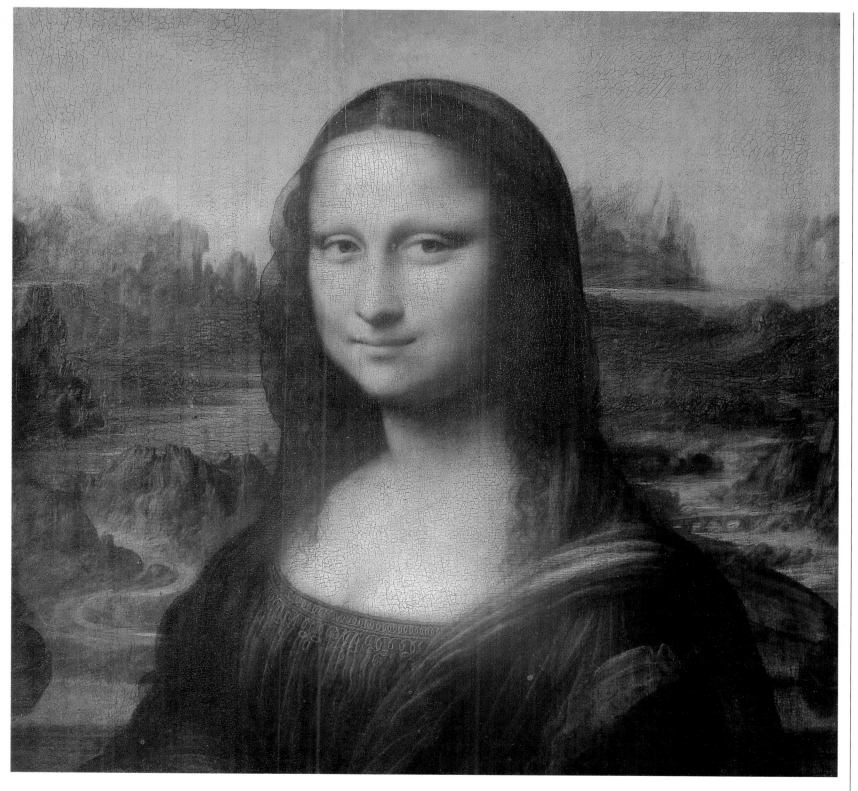

Leonardo da Vinci
Mona Lisa (La Gioconda)

detail, 1503/06–13, wood panel, Paris, Louvre.

The *Mona Lisa* (literally, Lady Lisa) is so famous that we can no longer look at it impartially as just a mere painting. It is now part of our collective imagination and for centuries it has been a cult object, either to worship or desecrate. The ineffable smile was a recurrent and disturbing feature of all of Leonardo's later work. He started this portrait in Florence and continued to work on it during his second Milanese period. He then took it with him to France where he continued intermittently to work at it. The portrait contains all the intellectual studies and emotional tensions of the artist's last years. In particular, we can see his search for expression, his attitude to landscape, the wintry atmosphere and the way the contours merge imperceptibly into the background through the use of chiaroscuro. It is possible to read into this haunting work any amount of speculation about Leonardo's own beliefs in the cosmos, God, and humanity, so endlessly ambiguous is the Mona Lisa's smile.

151

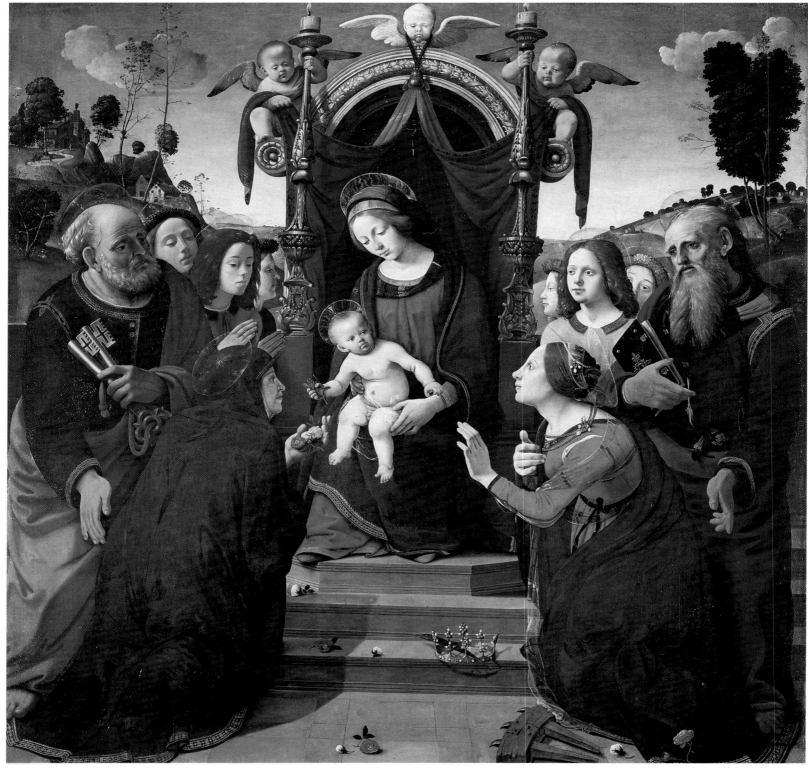

Piero di Cosimo

Florence, 1461/62–1521

Piero di Cosimo's individuality makes him exceptional even in an age when artists had unprecedented freedom. According to Vasari's biography, he was a noted eccentric, living off hard-boiled eggs and hating the sound of church bells. He took his surname from the painter Cosimo Rosselli, whose pupil he had been and who he helped in decorating the Sistine Chapel. Following this debut, Piero's career progressed slowly, but his style changed. He was influenced by Leonardo and by Luca Signorelli and Filippino Lippi. He excelled at painting animals with a sympathy rare in his age.

The remarkable mythological scenes about early mankind he painted in the last decade of the fifteenth century were possibly based on Boccaccio's ideas. At the start of the sixteenth century Piero's style became even more eccentric.

Piero di Cosimo
Madonna col Bambino, angeli e santi/Madonna and Child with Saints and Angels

1493, wood panel, Florence, Museo dello Spedale degli Innocenti.

Fra Bartolomeo

Bartolomeo di Paolo del Fattorino,
Savignano (Prato), 1472–Florence, 1517

Bartolomeo was a fellow pupil of Piero di Cosimo in Cosimo Rosselli's studio. After Savonarola started preaching, however, he went through a religious crisis. In 1500 gave up painting to take holy orders. In 1504 he returned to art, starting a workshop inside S. Marco's Monastery where he produced his *Vision of St. Bernard*. Along with Raphael, he emerged as one of the leading younger artists who used Leonardo's subtle manner of conveying atmosphere and fused it with a new drama. In 1508 he traveled to Venice, where his use of color became warmer and more substantial, and his new Tuscan art was a vital influence on the young Titian. Subsequent developments included increasing the mystical power of the sacred characters.

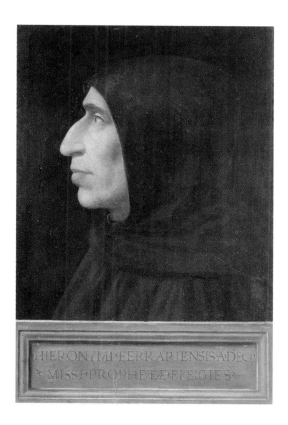

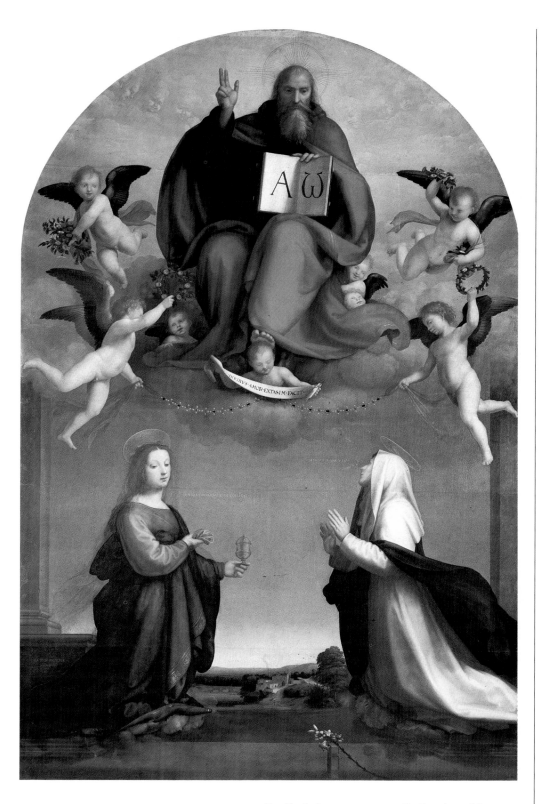

Fra Bartolomeo
Portrait of Girolamo Savonarola

1517(?), wood panel, Florence, Museo di S. Marco.

As a Dominican friar, for many years Fra Bartolomeo worked in the same monastery that Fra Angelico had decorated with frescos and where Savonarola had been the Prior. This portrait was part of the posthumous rehabilitation of the fiery preacher. It presents an image full of ascetic rigor and stern determination.

Fra Bartolomeo
Dio Padre in gloria tra le sante Maria Maddalena e Caterina da Siena/God the Father in Glory with St. Mary Magdalene and St. Catherine of Siena

1509, wood panel, Lucca, Pinacoteca.

Fra Bartolomeo's huge altarpieces had a completely new feel to them. They balanced heartfelt dramatic religious emotions with a delicate feel for light and color, comparable to pictures then being painted by Raphael.

Raphael
Madonna col Bambino e
san Giovannino
(Madonna della seggiola)/
Madonna and Child with
the Infant St. John

*1513, wood panel, Florence,
Pitti Palace, Galleria Palatina.*

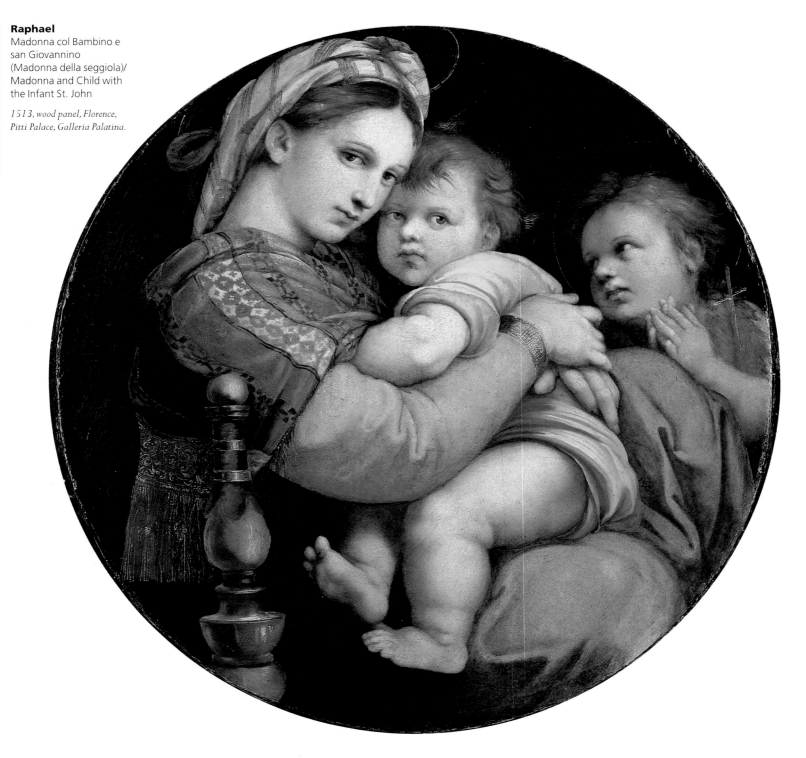

Raphael
(Raffaello Sanzio) Urbino, 1483–Rome, 1520

Raphael epitomized in both his life and
his art the ideals of the High Renaissance.
Son of the painter and writer Giovanni
Santi, he was an infant prodigy. His talent
developed so precociously that he was
just eleven years old when he took over
the family studio on his father's death. By
the time he was 16 he was acclaimed as a
master in his own right. His roots lay in
the art of Urbino, influenced by Piero

dalla Francesca. In about 1500, Raphael
probably worked with Perugino, but his
relationship with Perugino was not that
of pupil but of a sometimes critical
colleague. An example of this is *The
Marriage of the Virgin*, Milan, Brera, in
which Raphael reworked Perugino's
original idea. This ability to assimilate
ideas from other artists marked Raphael's
Florentine period (1504–08). Influenced
by Michelangelo as well as Leonardo, he
attained a wonderful balance between
their grandeur and sophistication and his

own typical sweetness of expression,
seen in a number of memorable
Madonnas. With his painting of *The
Entombment* (Rome, Galleria Borghese),
Raphael revealed his superb dramatic
powers in a fully classical style. In 1508
Pope Julius II summoned him to Rome
to paint frescos in his private Vatican
apartments. The cycle was started in the
Stanza della Segnatura (1508–11) and
then in the Stanza di Eliodoro
(1511–13). The majestically harmonious
scenes set against sublimely symmetrical

backgrounds influenced European art for
centuries with their visions of classical
dignity, grandeur, and serenity. When
Leo X became pope, Raphael supervised
further decorative programs and painted
superb portraits of the pope and his
court. Raphael was by then the most
famous artist in Italy, living like a prince.
His art began to change, foreshadowing
the elegant contortions of the
Mannerists, but his early death sadly
cut it short.

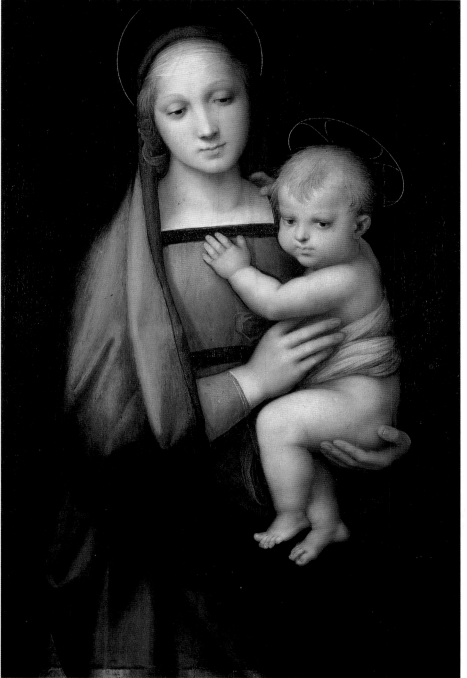

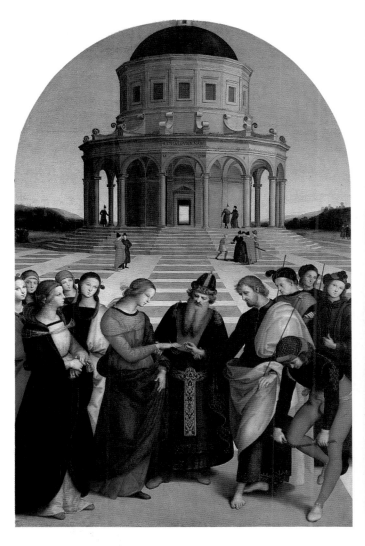

Raphael
Sposalizio della Vergine/ The Betrothal of the Virgin

1504, wood panel, Milan, Brera.

Raphael was just 21 years old when he produced this masterpiece for Città di Castello. It provides a majestic yet touching conclusion to the painter's youthful output. His relationship with Perugino is clear from both the overall layout and the individual details or figures. But the young Raphael has surpassed his master in the perfectly lucid way he deals with the architectural and natural spaces. Extending them around the exquisitely proportioned temple which, like Perugino's, is a perfect circle, a shape loved by the Renaissance.

Raphael
Madonna del Granduca/ Madonna of the Grand Duke

1506, wood panel, Florence, Pitti Palace, Galleria Palatina.

The title by which this Madonna is known derives from Ferdinand III, the Grand Duke of Tuscany, who purchased it in 1799 and refused to be parted from it for the rest of his life. The figures emerge with great delicacy from the dark background. The fact that our viewpoint is just slightly lower than theirs endows the picture with a sense of tranquil monumentality. It is typical of Raphael's Florentine period and contains references to Leonardo's work.

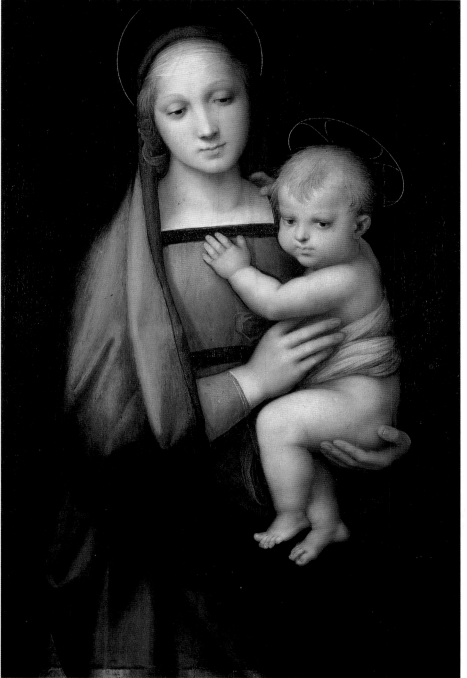

Raphael
Trasporto di Cristo al sepolcro/The Entombment

1508, wood panel, Rome, Galleria Borghese.

The painting was really a commemoration of a dramatic crime of the time, namely the brutal murder of a young member of the Baglioni family in Perugia. The work was commissioned by the dead man's mother with the dual purpose of commemorating the slaughter of an innocent and the anguish of a mother. Raphael composed the painting around these two separate themes, although he juxtaposed the two groups of figures. The tense expressions, eloquent gestures, and quotations from classical art recall Michelangelo (especially the lifeless body of Christ and the figure on the right twisting round to support the Madonna). These elements combined to make the picture almost Raphael's manifesto of artistic maturity and power. It was mainly on the strength of this painting that Raphael was summoned to Rome.

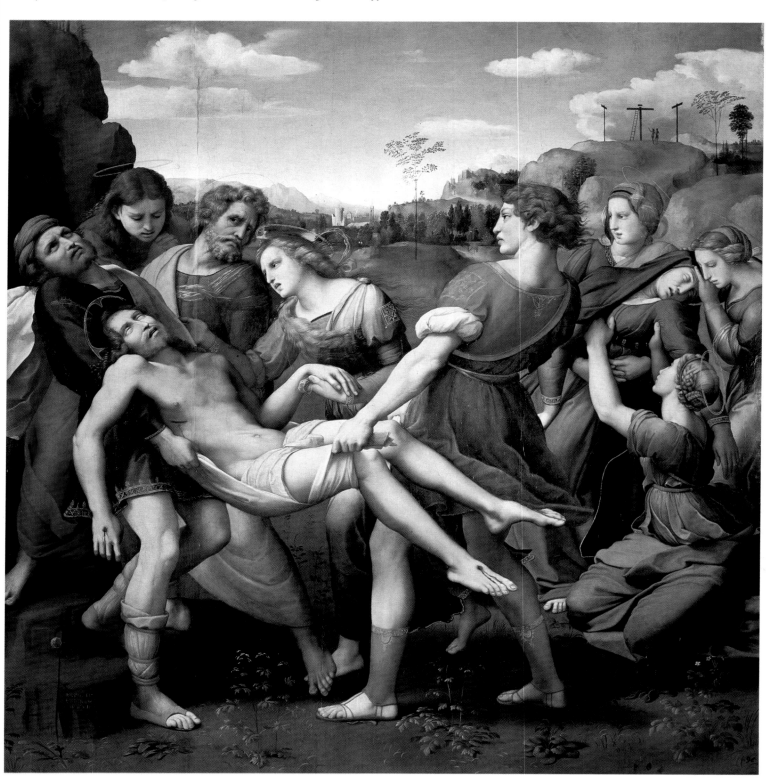

Raphael
Madonna del Belvedere/
Madonna of the Meadow

*1506, wood panel, Vienna,
Kunsthistorisches Museum.*

During his Florentine
period, Raphael produced
a number of delicate
variations on the theme of
the Madonna in a landscape
with the Child and the
infant St. John. Other
equally enchanting versions
can be found in Florence,
Paris, Edinburgh, and
Washington.

Raphael
Madonna di Foligno/
Madonna of Foligno

*1511–12, wood panel, Rome,
Vatican Gallery.*

Despite having both the
appearance and dimensions
of an altarpiece, this was in
fact a votive offering made
by the Papal Chamberlain,
Sigismondo de Conti, for
his escape from danger
when a meteorite fell on his
house (shown in the
background of the scene).

Raphael
Madonna Sistina/
The Sistine Madonna

*1515–16, canvas, Dresden,
Gemäldegalerie.*

This late work was painted
for the church of S. Sisto in
Piacenza. Set in the apse, it
gave the illusion of being a
window opening onto the
sky, with curtains drawn
back and a ledge on which
the two famous cherubs are
leaning. Its combination of
quiet grandeur and fragile
humanity is unique.

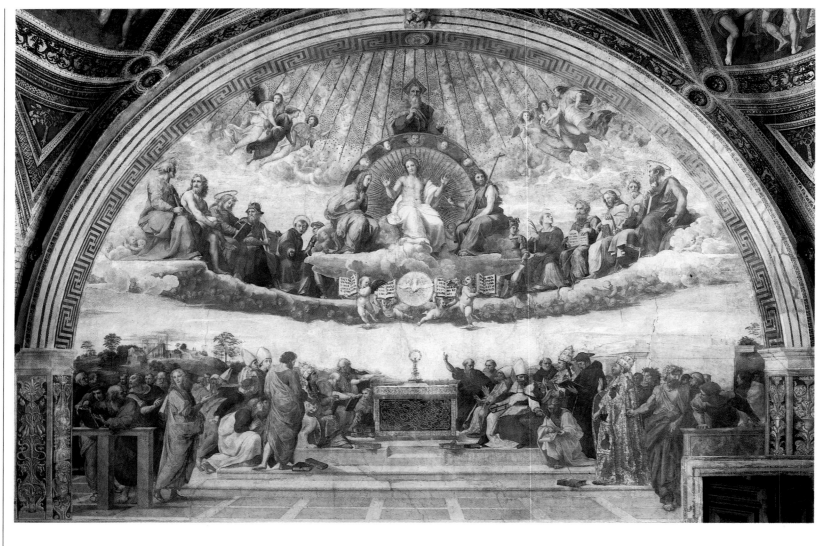

Raphael
Disputa del Sacramento/
Disputation

*1508–09, fresco, Rome,
Vatican, Papal Rooms and the
Stanza della Segnatura.*

The first fresco Raphael
painted to decorate Pope
Julius II's apartment in the
Vatican was this huge
lunette in what was
originally the pope's private
library. In this example
Theology is symbolized by a
double semicircle of
characters arranged in two
tiers, one divine and one
earthly. Raphael manages to
combine grandeur and
gracefulness in a seemingly
effortless manner.

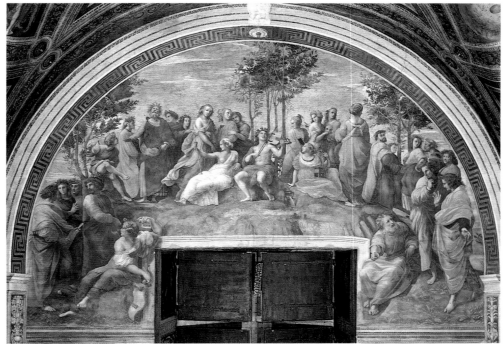

Raphael
Il Parnaso/Parnassus

*1509–10, fresco, Rome,
Vatican, Papal Rooms and the
Stanza della Segnatura.*

The wall dedicated to
Poetry presented the added
problem of containing a
window. Raphael made
clever use of its presence by
painting the summit of
Mount Parnassus over the
top of it. Apollo is playing
the cithara, accompanied by
nine Muses and the most
famous ancient and
contemporary poets, from
Homer to Ludovico
Ariosto.

Raphael
Quattro scene bibliche/ Four Biblical Scenes

1511, fresco, Rome, Vatican, Papal Rooms and the Stanza di Eliodoro.

As you move from the first room into the next (called the Heliodorus Room for the subject of the most eye-catching fresco), it is obvious that Raphael was employing new and highly original ideas. Compared to the Stanza della Segnatura, his style here is more dramatic and powerful and less contemplative and serene. The ceiling, where he was probably assisted by Baldassarre Peruzzi, gives the impression of four triangular canvasses strung up by long cords held in place by rings. The stories from the Old Testament are painted using a technique that resembles tapestry.

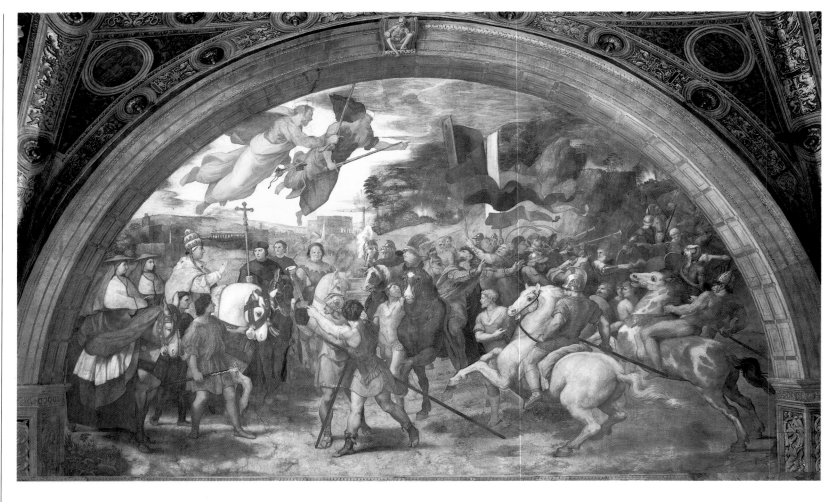

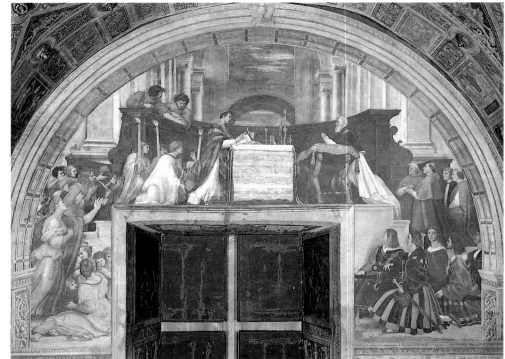

Raphael
Incontro di Attila e Leone Magno sul fiume Mincio/ The Meeting of Attila and Leo the Great at the River Mincio

1513, fresco, Rome, Vatican, Papal Rooms and the Stanza di Eliodoro.

The second room is more political in character than the first. This episode which shows the pope's successful and peaceful intervention was requested by the Julius II's peace-loving successor Leo X. Son of Lorenzo the Magnificent, Leo X pursued a policy of reconciliation between warring states. He commissioned this painting as a means of emphasizing the alternative to endless wars: papal diplomacy, which had saved Rome from the Huns in 451. The stronger colors and more frenzied action point to Michelangelo's influence again on Raphael.

Raphael
La Messa di Bolsena/ The Mass at Bolsena

1512, fresco, Rome, Vatican, Papal Rooms and the Stanza di Eliodoro.

The miracle of blood issuing from the Host during a mass celebrated at Bolsena dated back to the thirteenth century. But Raphael brought it up to date by including Pope Julius II (on the right) with his multi-colored train of cardinals, prelates, and Swiss guards.

Raphael
Portrait of Agnolo Doni

*1506–07, wood panel,
Florence, Pitti Palace.*

This is typical of Raphael's early portraits painted during his Florentine period. This work combines Perugino's refined accuracy with Leonardo's intensity of expression and a touch of almost Flemish realism in the way Raphael paints the Agnolo's face, which he may have derived from looking at Ghirlandaio. Agnolo Doni was a Florentine gentleman employed in public service. He is shown in an informal pose with remarkably lifelike eyes.

Raphael
Portrait of a Lady
(La Velata/The Veiled Lady)

*1516, canvas, Florence, Pitti
Palace, Galleria Palatina.*

Some of Raphael's female portraits have given rise to imaginative stories about their depicting girls whom Raphael loved. What is really of interest, however, is the way Raphael painted them. Here the way the light falls on the folds of the sleeve in the foreground is quite exceptional. The melting softness of the colors is balanced by the geometry of her almost pyramidal shape, both aspects helping to enhance her apparent vulnerability.

Raphael
Portrait of Baldassare
Castiglione

c. 1515, canvas, Paris, Louvre.

Castiglione was the renowned author of *The Courtier*, a handbook prescribing courtly manners, and a great friend of Raphael. We immediately get an impression of this familiarity thanks to the way Castiglione's eyes look intelligently, yet not altogether happily, out at us. With extraordinary skill, Raphael here rivals both Leonardo and Titian in their greatest portraits with his subtle characterization and rich colors. This ranks as one of the greatest portraits in Western art.

161

Giulio Romano

Giulio Pippi, Rome, 1492/1499–Mantua, 1546

Guilio Romano was a noted architect as well as one of the first painters of the emerging Mannerist school. As Raphael's chief pupil, all of his training and early work was done in Raphael's studio before he became his master's right-hand man. In this capacity he oversaw some of the most important decorative cycles, such as the Vatican rooms and loggias, the Farnesina Palace and Villa Madama. A supple plastic quality and a preference for metallic colors mark his *Martyrdom of St. Stephen*, Genoa, S. Stefano, or *The Madonna of the Cat*, Naples, Capodimonte. In these works we can also discern a tendency toward distorted, rhetorical gestures and expressions that are the hallmark of early Mannerists. When Raphael died (1520), Giulio Romano took over the studio and successfully completed the work in hand, the Constantine Room in the Vatican, which required considerable expertise. In 1524 he moved to Mantua. From then until his death Giulio dominated the art of the Gonzaga's highly civilized Renaissance court. For the Gonzagas he designed extraordinary fresco cycles and ambitious building projects such as the Palazzo Tè, Mantua Cathedral, and the Abbey of S. Benedetto Po. He also undertook the renovation of ancient buildings, with new apartments in the Ducal Palace, and designed cartoons for tapestries and elaborate jewelry. Many Gonzaga residences have since been damaged or demolished so much has been lost. Of what survives, his most complex enterprise is the design and decoration of the Palazzo Tè. Begun in 1526, this is one of the first true Mannerist buildings which flouted the rules of classical architecture. Each room contained new and original, even bizarre, decorative ideas. In the Sala de' Giganti, his illusionistic masterpiece, the whole room is painted from floor to ceiling to give the impression of giants hurling down rocks.

Giulio Romano
General View of the Cupid and Psyche Room

c. 1526–28, fresco, Mantua, Palazzo Tè.

When he decorated the Gonzaga's residence outside the city, Giulio let loose his riotous fantasy, creating surprises in every room. Classical scenes flow freely into one another around the walls while the ceiling is divided into separate sections. He delighted in playing with illusions of false perspective and light, so that figures seem to step or jump out of all the scenes, which illustrate ancient myths.

Michelangelo Buonarroti

Caprese (Arezzo), 1475–Rome, 1564

Sculptor, architect, poet and engineer, and only rather reluctantly a painter, Michelangelo ranks with Leonardo as the supreme example of Renaissance

Man. But, while Leonardo served only his own genius, Michelangelo served the Church first and last. When young, Michelangelo was attracted by the Neoplatonism then fashionable, but even then his art was more Christian than pagan. Before 1500 he had sculpted memorable masterpieces in marble, a *Bacchus* and *Pietà*. During the first years of the 1500s he painted

frequently in Florence, where he and Leonardo competed on frescos (now lost) for the Palazzo Vecchio. He also painted the *Doni Tondo*. Summoned to Rome to work on the Sistine Chapel, he triumphantly and almost unassisted completed this daunting task between 1508–12. It made him the most famous painter in Europe, but he gave up painting for over 20 years,

concentrating on sculpture and architecture. He took up his brushes again in the 1530s for the huge task of painting *The Last Judgment* in the Sistine Chapel. In his later years, his thoughts about death produced his last two carvings of the *Pietà*.

Michelangelo
Sacra famiglia con san Giovannino (Tondo Doni)/ Holy Family with the Infant St. John (Doni Tondo)

1503–04, wood panel, Florence, Uffizi.

On the opposite page
Michelangelo
Ignudo/Nude Youth

detail, 1508–12, fresco, Rome, Vatican, Sistine Chapel, ceiling.

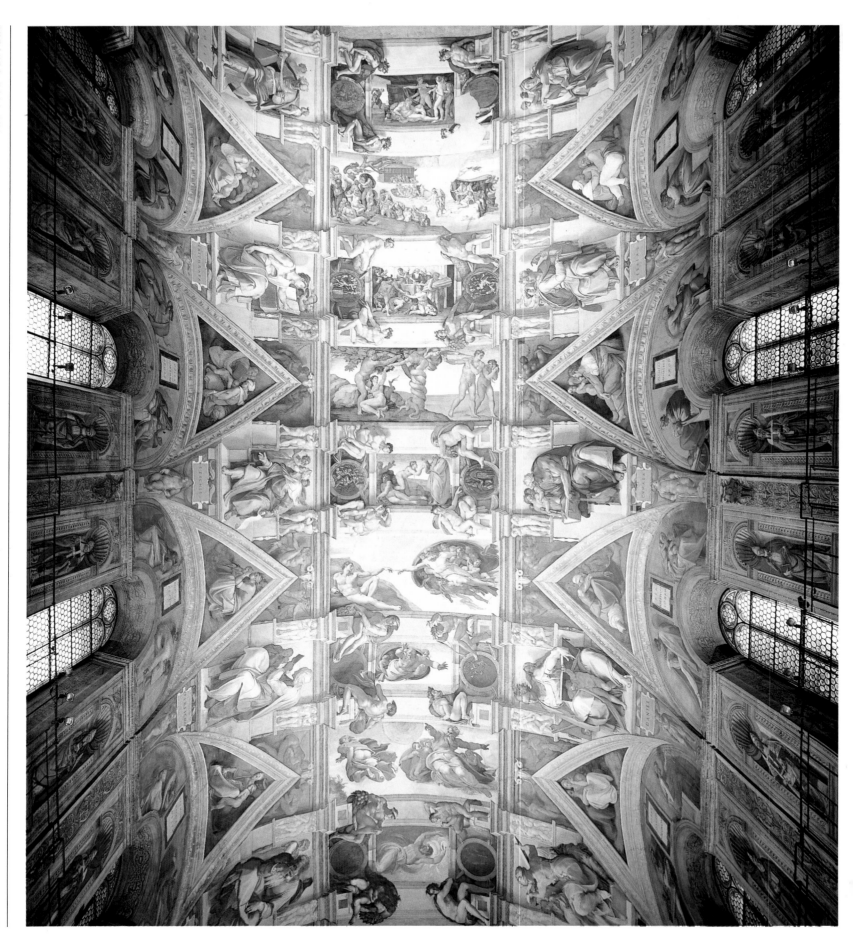

Michelangelo
Storie della Genesi/
Scenes from Genesis

*1508–12, fresco, Rome,
Vatican, Sistine Chapel,
ceiling.*

The iconographic program of the ceiling of the Sistine Chapel has the Creation as its central climax. Around this Michelangelo placed a sequence of monumental figures of Old Testament Prophets and pagan Sibyls and then, in the lunettes around the windows, he showed Christ's forerunners. Stories of the Book of Genesis from the fall of Man (through Original Sin) to his first salvation (through Noah's Ark) provide the historical premises for the path to Redemption. The program was later altered when on the back wall (where Perugino had painted frescos) Michelangelo added *The Last Judgment*. In the central section Michelangelo painted a series of nine Biblical scenes, alternating larger pictures with smaller episodes. At the corners between them he inserted beautiful nude youths (the Ignudi), who have no biblical justification but may be symbols of ideal beauty. At the end toward the back wall, we find the *Separation of Light from Darkness* and the *Sacrifice of Noah*, after the solemn episodes depicting the Creation. The scene of the *Creation of Adam* shows the virile contact between the hurtling figure of God the Father, full of divine energy, and the athletic figure of the first Man, rising from the clay. This has become one of the symbols of the Renaissance. Michelangelo finished painting the ceiling of the Sistine Chapel when he was 37. It transformed both his own career and also the Renaissance. Recently restored, it is quite often considered the summit of Western art.

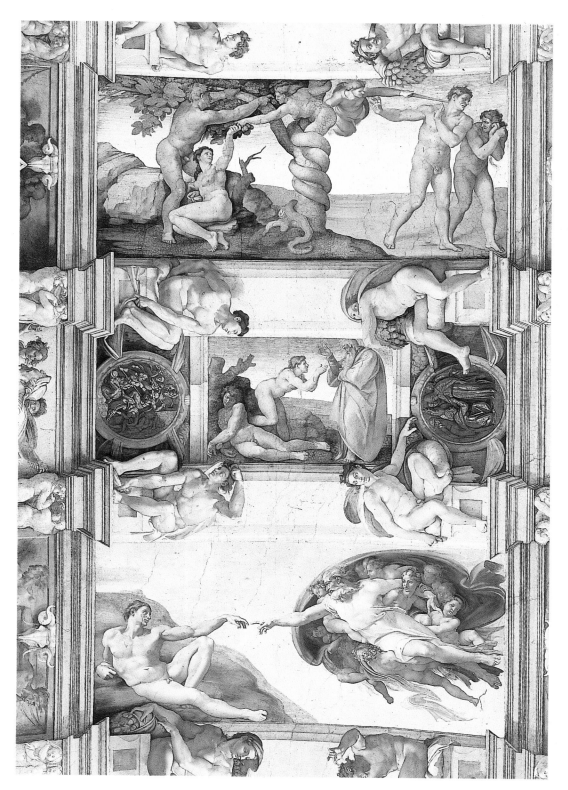

Michelangelo
Storie della Genesi:
Peccato Originale e
Cacciata dall'Eden;
Creazione di Eva;
Creazione di Adamo/
Stories from the Book of
Genesis, detail, from top
to bottom: Original Sin
and the Expulsion from
Paradise; The Creation of
Eve; The Creation of
Adam

*1508–12, fresco, Rome,
Vatican, Sistine Chapel,
ceiling.*

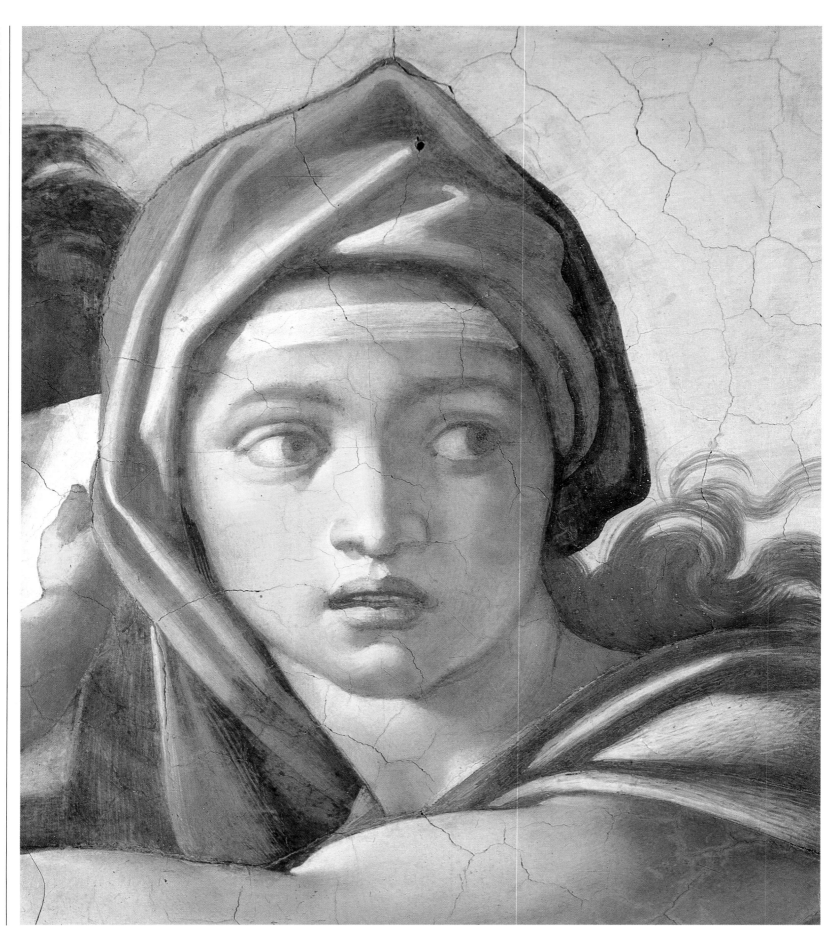

On the opposite page
Michelangelo
La Sibilla Delfica/
The Delphic Sibyl

*1508–12, fresco, Rome,
Vatican, Sistine Chapel,
ceiling.*

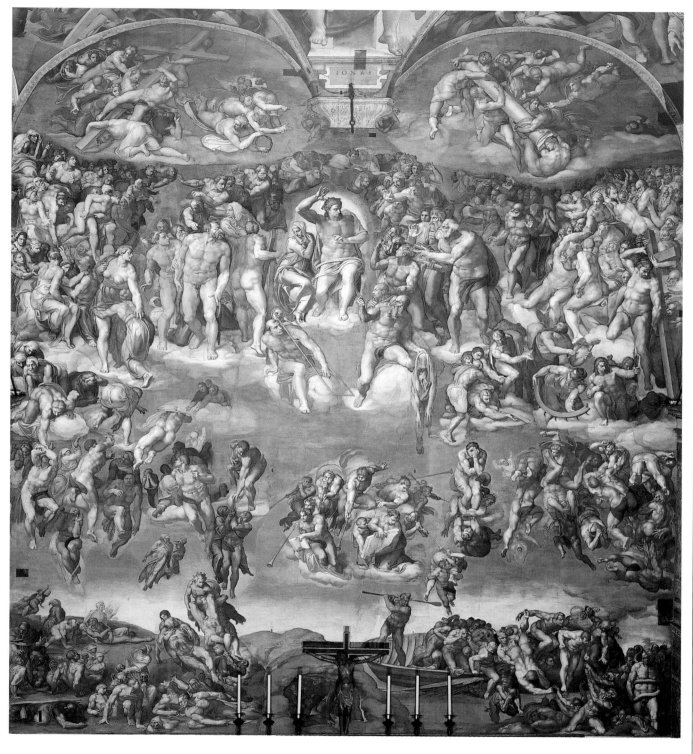

Michelangelo
Giudizio Universale/
The Last Judgment

*1536–41, fresco, Rome, Vatican,
Sistine Chapel, back wall.*

The fresco is the terrible
summary, if not obituary, of
the Renaissance, whose
optimistic humanism had
been ruined by the Sack of
Rome and religious schism.

Michelangelo's *Day of Wrath*
is one of the most tortured
and dramatic creations in
art, but its moral and poetic
meaning surpasses mere
history of art, for it should
be seen as a pivotal work in
the whole culture of Europe.
Such comments are even
more justified now that we
have seen the results of the
recent massive restoration

work. This has removed
some of the "braghettoni"
(veils and cloths painted over
the private parts of the
nudes) which had been
added in 1564 due to the
new puritanism of the
Counter-Reformation. It
also removed later touch-ups
and grayish discoloration.
The clarity of the mural has
now reemerged with

astounding freshness. We see
the tragedy of mankind
crushed by divine wrath.
The whole work is full of
indescribable energy. Until
then, traditional iconography
had shown the Last
Judgment arranged in an
orderly fashion in successive
tiers, starting with the figure
of Christ. Michelangelo
conceived it as a single

explosion projecting the
whole image toward us at
once. The lunettes contain
angelic hosts with the
instruments of the Passion.
Amid the assembled saints
below them, even the
Madonna seems to be
cowering in fear at Christ.
Among the saints we can
pick out the imposing figures
of Peter and Paul while St.

Bartholomew is actually a
tormented self-portrait of
Michelangelo. Underneath
these figures, angels are
blowing trumpets to call the
dead back to life. All around
a battle rages between angels
and demons for the
possession of human souls.

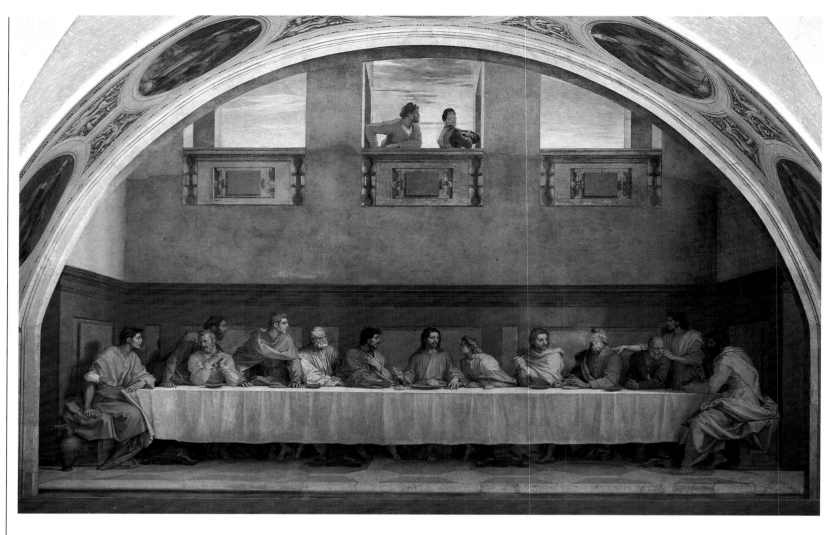

Andrea del Sarto

Andrea d'Agnolo, Florence, 1486–1531

Andrea del Sarto was the careful custodian of the serene Florentine tradition of the late fifteenth century. He cleverly modernized what he inherited, giving it broader dimensions but without ever moving toward the stylistic daring of the early Mannerists. A number of them, however, were his pupils. Andrea trained under Piero di Cosimo. He opened his own studio in Florence in 1508 and was immediately commissioned to paint an important fresco cycle in the small Voti cloister at the Santissima Annunziata. During a trip to Rome he came into contact with Raphael and with the works of Michelangelo and Sansovino. After his return he started on the grisailles decorations in the Chiostro dello Scalzo which proved to be of fundamental importance to Florentine drawing in the early sixteenth century. By then he was the leading painter in Florence. His *Madonna of the Harpies* (Florence, Uffizi) was painted in 1517 shortly before he

followed Leonardo's path to France just ahead of Rosso Fiorentino. He did not stay long and during the 1520s his style became ever more intensely devotional. He also did a lot of important research into the use of color. In this period he produced his masterpiece *The Last Supper of San Salvi*. In it, the conversation between Christ and his disciples is set against a realistic background with three large windows opening onto the sky.

Andrea del Sarto
Ultima Cena/
The Last Supper

1519, fresco, Florence, Monastery of S. Salvi.

This was the final great version of the Last Supper painted in Florence during the Renaissance. Reference to Leonardo's work produced a supremely elegant composition, full of expression but without

undue excitement. During the siege of Florence in 1529, Spanish troops who were billeted nearby spared the *Last Supper of San Salvi* because of its beauty.

Andrea del Sarto
Storie del Battista:
Battesimo di Cristo/
Life of John the Baptist:
the Baptism of Christ

c. 1507–13, fresco, Florence, Chiostro dello Scalzo.

The grisaille technique used in this cycle reveals Andrea del Sarto's genius as a draughtsman. For many years it was considered such an excellent example that it was imitated and copied as part of a painter's training.

Andrea del Sarto
Madonna della scala/
Madonna on the Stairs

c. 1522, canvas, Madrid, Prado.

This is a fine example of del Sarto's monumental style after 1520. From the time it was first painted, it was used as a classic example of composition and expression. Indeed it was considered in academic circles to be an excellent model and was copied many times over the years. Andrea del Sarto occupies a position half way between the by then out-dated certainties of the fifteenth-century Humanism and the elegantly expressed tensions that were emerging in Mannerism. Del Sarto's figures are gracefully posed but free of anatomical strain. The structure of the group freely reinvented the traditional triangular format of the fifteenth-century *Sacra Conversazione*. The soft light, muted colors and slight *sfumato* (subtle blending of tones) of the contours show that he was still relatively up-to-date as a painter. Indeed, at the start of the sixteenth century his place was firmly in the mainstream of artistic debate about the directions painting should be taking, although his views did not prevail.

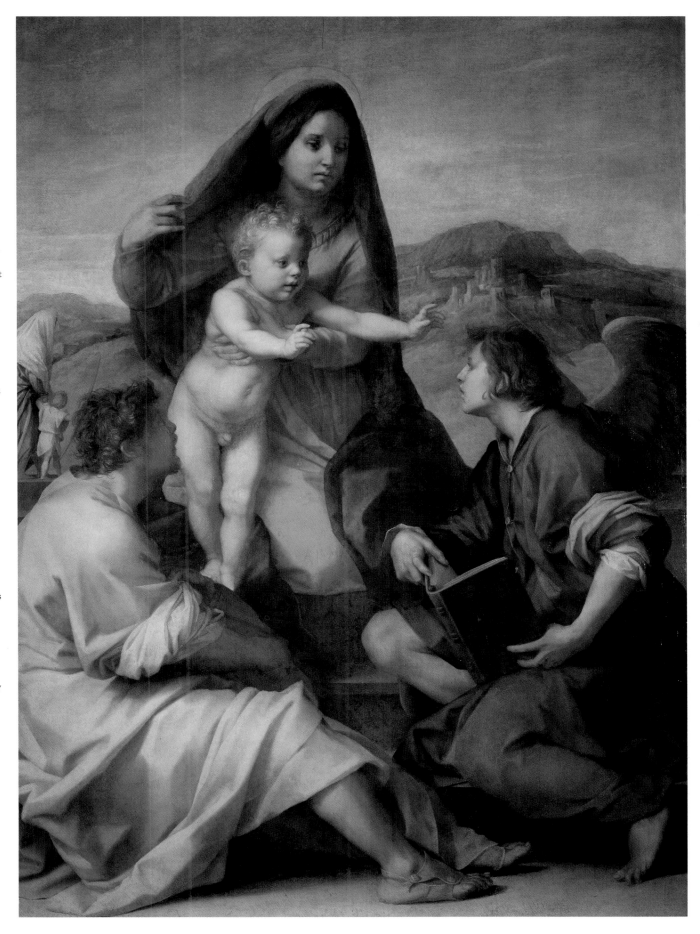

Domenico Beccafumi

Domenico di Giacomo di Pace, Montaperti (Siena), c. 1486–Siena, 1551

Beccafumi was the most important artist in Siena during the first half of the sixteenth century and, with Sodoma, the city's last artist of more than local importance. For almost 40 years he worked ceaselessly in his native city, absorbing the latest styles. Beccafumi was well informed about the artistic experiments of Leonardo and was also aware of Fra Bartolomeo and of Raphael and Michelangelo's Vatican frescos. Beccafumi's first work was the *Trinity Triptych* (1513, Siena, Pinacoteca Nazionale). This was followed by his robust *St. Paul* in the Cathedral Museum and his frescos in the S. Bernardino Oratory (1518), both in Siena. In 1519 he started the program of narrative designs for a floor in the cathedral, a task which took over 30 years. While all of Beccafumi's work was done in Siena, we can detect a variety of influences in his oeuvre, including Mannerism. These fed his search for fantastic effects, visions of radiant light and iridescent color combining together in spectacular compositions. In 1536 he painted some panels for Pisa cathedral, followed by the frescos in the choir of Siena cathedral; he also made eight bronze angels for the choir. In his last years, Beccafumi's monumental altarpieces alternated with more delicately intimate compositions.

Domenico Beccafumi
San Michele scaccia gli angeli ribelli/St. Michael Casts Out the Rebel Angels

c. 1525, wood panel, Siena, Pinacoteca Nazionale.

This spectacular and grandiloquent painting was produced during the period Beccafumi was closest to Michelangelo (to see this, look at the dramatic nudes at the bottom of the picture). As always, Beccafumi reinvented his subject in a visionary manner, full of burning light.

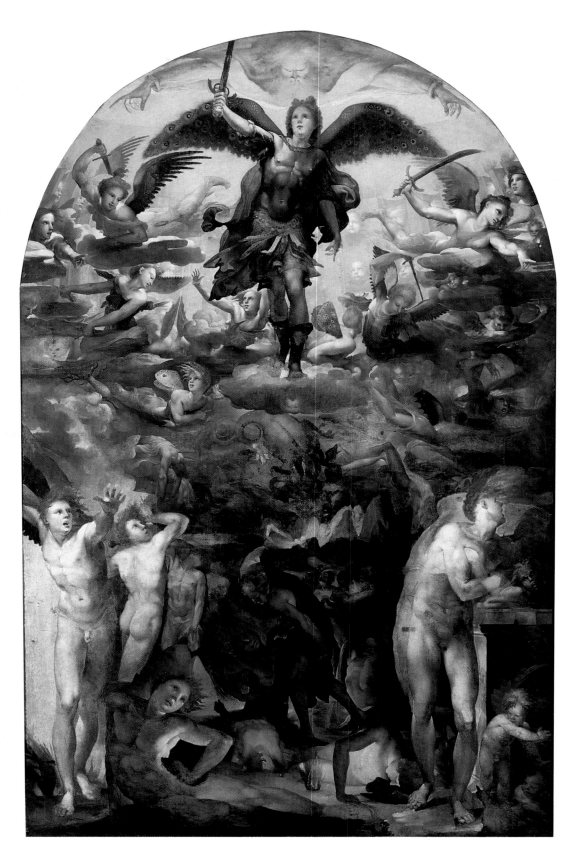

Domenico Beccafumi
Annunciazione/
The Annunciation

c. 1545, wood panel, Sarteano (Siena), SS. Martino, and Vittorio.

In the closing years of his career, Beccafumi tended to rein in his more extravagant ideas and also went back to painting calmer compositions that create a sense of silent intimacy. However, he never gave up his unmistakable and extraordinarily rich use of color nor his love of grading the tone in his pictures from parts that were brilliantly bathed in warm light through to very dark areas.

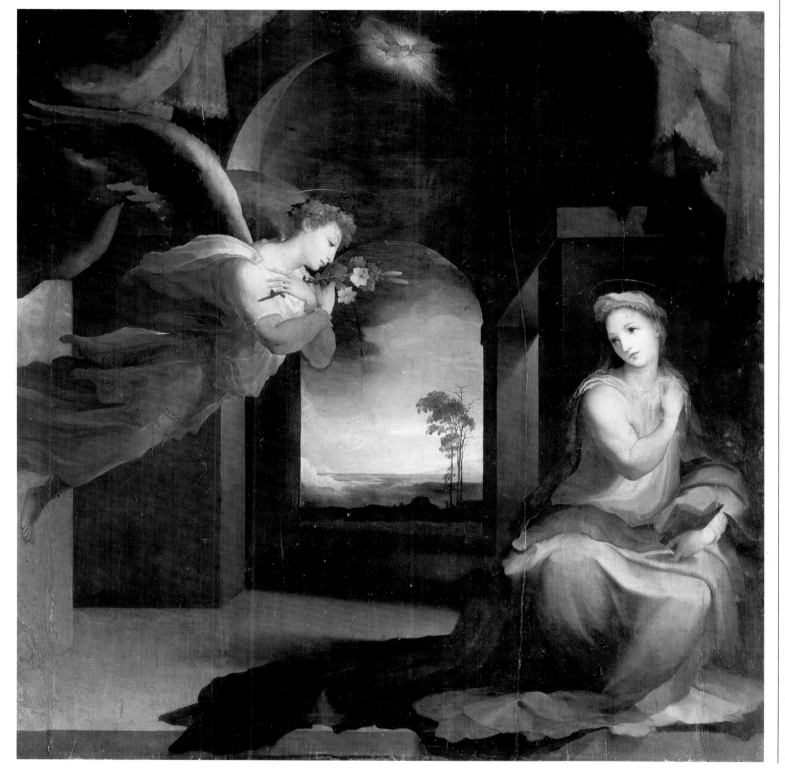

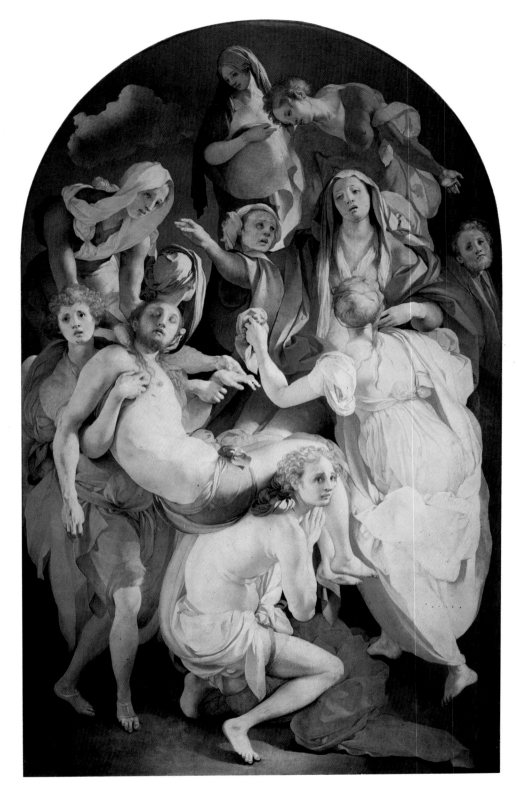

Pontormo
Deposizione di Cristo/
Deposition

*1525–29, wood panel,
Florence, S. Felicita, Capponi
Chapel.*

This altarpiece was the most revolutionary and innovative painted in Florence at the time and can be considered as the manifesto of the vanguard of Mannerism. The regular symmetry of High Renaissance painting is shattered. The composition is deliberately ambiguous and lacks any stable reference point of either architecture or perspective. The gestures and lines of the characters are often melodramatic, while their bodies are almost grotesquely distorted, especially that of Christ, and appear to be restlessly gyrating in an undefined space. The cold, cutting light makes the colors assume livid and utmost unreal hues.

Pontormo

*Jacopo Carucci, Pontorme (Florence),
1494–Florence, 1557*

As an artist Pontormo was tormented and dissatisfied, but extraordinarily gifted and daring. He was also prone to bouts of depression. He was one of the painters primarily responsible for changing Florentine painting from the High Renaissance to Mannerism. After training with several artists, including Leonardo, Pontormo ended up as a pupil of Andrea del Sarto. He made his debut with the frescos for the SS. Annunziata. He was soon attracted to Michelangelo and to prints from the North European schools, especially those of Albrecht Dürer. It was not long before he achieved great fame himself and around 1520 he started to receive official commissions. The frescos in the Charter House at Galluzzo, painted between 1523–25, and the decoration of the Capponi Chapel in S. Felicita (1525–26) provide clear dates for the start of his search for new ways of expression that bordered on the neurotic. After the siege of Florence in 1529, Pontormo retreated increasingly into his own world. During the last years of his life he was involved in a huge fresco scheme for S. Lorenzo, Florence, which was totally destroyed in the eighteenth century. His inherent melancholy and neurosis increased in these final years, as revealed in his own diaries.

Pontormo
Visitazione/Visitation

*c. 1528–29, wood panel,
Carmignano (Florence), parish
church of S. Michele.*

This disturbing masterpiece
originating from the early
years of Mannerism shows
a monumental scene
depicted in a frozen fashion
against the background of a
roughly painted, funereally
gloomy town. The almost
metaphysical allusion is
underlined by the "doubling
up" of the two women who
are seen simultaneously
from the front and in profile
while the color of their
dresses is symmetrically
reversed.

On the following pages
Pontormo
Lunetta con Vertunno e
Pomona/Lunette with
Vortumnus and Pomona

*1519–21, fresco, Poggio a
Caiano, Villa Medici.*

Pontormo's early success
was crowned by the official
commissions he received
from the Medici court. This
lunette was painted using
only an almost frantic series
of sketches as outline. It
alludes to the richness and
happiness of the harvest
season, but the way it does
so is most unusual. The
characters, unusually
individualistic for such a
work, are shown at various
heights in front of a wall
above which sprout long
and slender fern-like
shoots. Note the unusually
realistic portrayal of the
male nude on the left.

Rosso Fiorentino

Giovan Battista di Jacopo, Florence, 1495–Fontainebleau (Paris), 1540

Rosso Fiorentino was the principal artist connected with the first and more adventurous period of Florentine Mannerism. He trained, along with Pontormo, in Andrea del Sarto's studio and made his debut working with them on the frescos in the small Voti cloisters in SS. Annunziata. The tormented story of his *Assumption* (1513–17), which he deliberately damaged, demonstrated early on that Rosso would become a controversial and polemical painter. His characters often had odd, almost diabolic, physiognomies ("with a cruel and desperate air" according to Vasari) which left his patrons a little perplexed. His *Deposition* in Volterra (1521) is a good example of the violent and disconcertingly aggressive way he deformed figures as well as colors. Developments in his style happened astonishingly fast. Within the space of a few years during which he continued to produce major works, his style moved away its from Florentine background to absorb the latest of Michelangelo's work. Rosso's art from this period is comparable to Parmigiano. After the Sack of Rome (1527), he started to travel. His style fluctuated wildly – sometimes intense, even demonic, sometimes more elegant and sweet, more in keeping with the official nature of his commissions. In 1530 he moved to Paris and was commissioned by François I to decorate an imposing gallery in his château at Fontainebleau (1532–37). This, along with Primaticcio's work in the château, formed the basis of the highly influential Mannerist School of Fontainebleau, which dominated French taste for three generations.

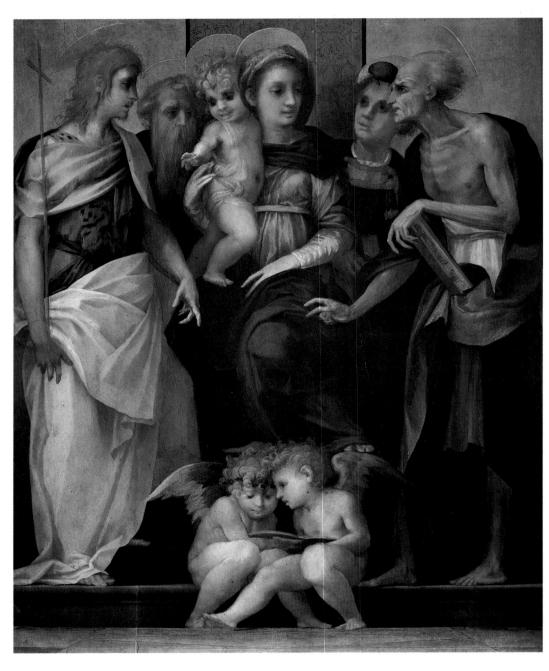

Rosso Fiorentino
Madonna col Bambino e quattro santi/Madonna and Child with Four Saints

1518, wood panel, Florence, Uffizi.

A neurotic, even deformed stylization that at times verges on the grotesque is the most immediate characteristic of Rosso Fiorentino's paintings, and can be glimpsed already in this picture. Most notably, the restlessness of the whole work contradicts a High Renaissance ideal: that of serene majesty. This accentuates the expressive dynamism of his compositions, whose colors and tones seem burnt or lividly overstated. The almost infernal aspect of some of the characters has given rise to a number of sometimes wild hypotheses about the painter's far-from-happy psychology (he comitted suicide).

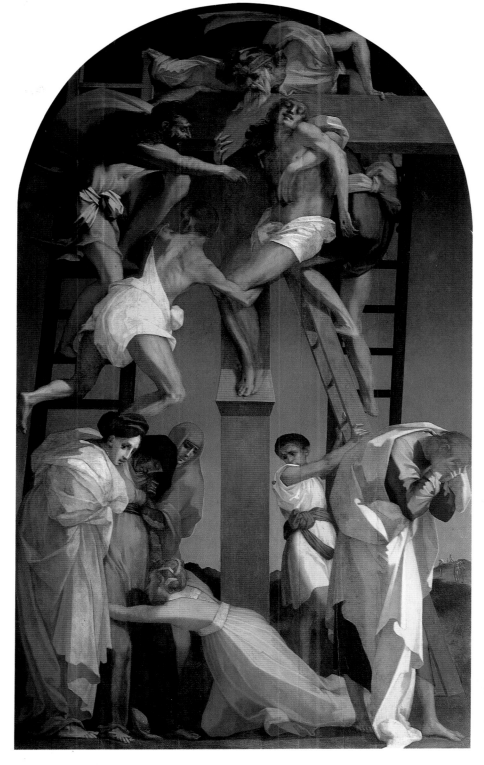

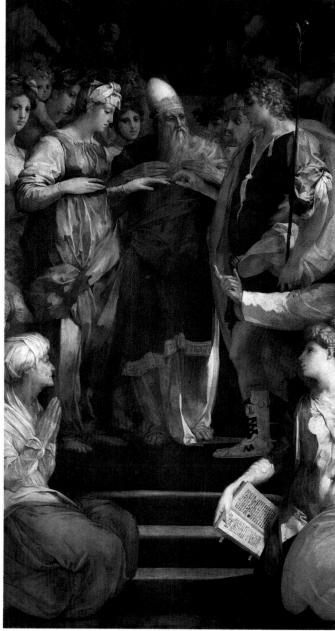

Rosso Fiorentino
Deposizione dalla Croce/
Descent from the Cross

*1521, wood panel, Volterra,
Picture Gallery.*

This is without question
one of the most disturbing
pictures of the sixteenth
century. The composition
has a complex and forced
structure. It is charged with
emotional intensity, the
characters are frozen in
dramatic gestures and the
unnatural colors are applied
in compact and harshly
defined blocks. The sky is
particularly impressive, its
vibrant yet oppressive hue
seeming as if a lead weight
were pushing down on the
scene. The three ladders
that appear to be leaning on
the ultra-smooth cross are,
in fact, no more than a trick
of Rosso's compositional
technique, since closer
examination reveals that
their positions are actually
quite impossible.

Rosso Fiorentino
Sposalizio della Vergine/
The Marriage of the Virgin

*detail, 1523, wood panel,
Florence, S. Lorenzo.*

179

Giorgione

Castelfranco Veneto (Treviso),
c. 1477/78–Venice, 1510

The lack of biographical facts on Giorgione has given rise to many legends about this poetic master. Despite dying so young, probably of the plague, he changed the course of Venetian painting. The key to Giorgione's art lies in his new method of painting landscapes, and especially the way he magically conveys light and atmosphere. To obtain this effect Giorgione minimized the importance of line drawing and concentrated on subtle chromatic transitions. His style tended to subordinate the supposed subject to dreamy or mysterious evocations of mood. He applied his novel technique to religious paintings (*The Castelfranco Madonna*), but it was most effective in poetic or allegorical works. Sucha as *The Three Philosophers* in Vienna or *The Tempest* in Venice, both endlessly mysterious pictures. When commissioned in 1508 to paint the frescos on the façade of the Fondaco dei Tedeschi in Venice, Giorgione had an even younger Titian as a colleague and the two developed an artistic partnership so close that at times it is impossible to be certain which man painted what. Giorgione was one of the most influential painters in Western art, and one of the most imitated.

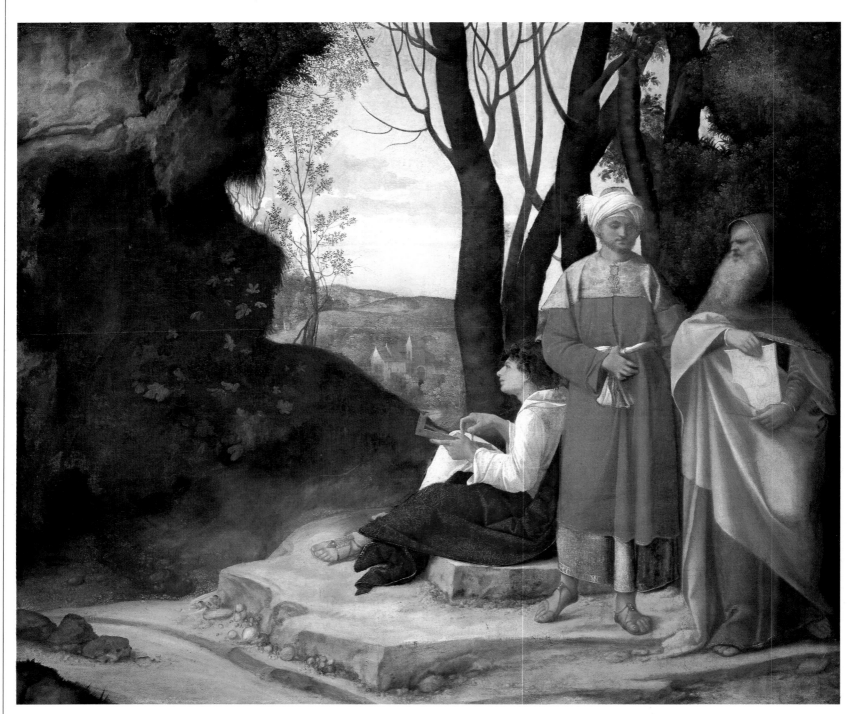

On the opposite page
Giorgione
I tre filosofi/The Three Philosophers

c. 1505/08, canvas, Vienna, Kunsthistorisches Museum.

This canvas was painted at the mid point of Giorgione's brief stylistic development. The colors are fresh and lively but are subtly blended with the atmospheric light. Among the many theories about this work is the suggestion that the *Three Philosophers* could be astronomers, or even the Magi waiting for the star to appear, or alternatively they could represent three schools of philosophy: the new Renaissance (on the left), the Eastern, in the turban, and the third the ancient Greek. The young philosopher on the left is often thought to be a self-portrait of the artist.

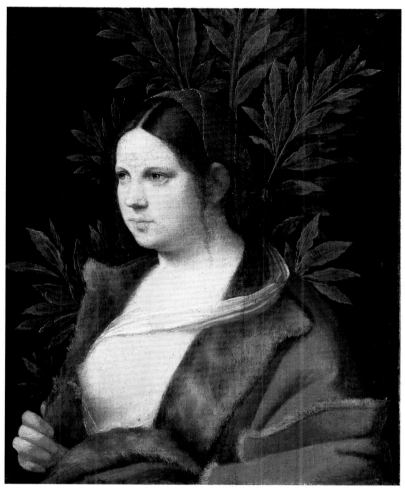

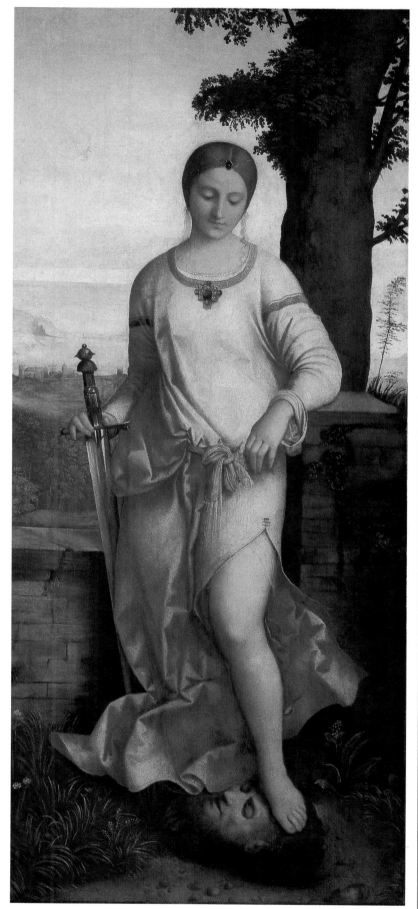

Giorgione
Ritratto femminile/ Portrait of a Woman (Laura)

1506, canvas on a wood panel, Vienna, Kunsthistorisches Museum.

Writing on the back of this picture allows us to date it exactly, uniquely among Giorgione's works. The name of the girl (who was probably the same model he used later in *The Tempest*) has been deduced from the laurel leaves used as background decoration. According to those writing at the time, Giorgione was the first to paint this type of half busts of women with such successfully gentle eroticism. Laura has exposed one breast but the atmosphere remains more dreamlike than licentious. Titian among many other artists later took up the genre.

Giorgione
Giuditta/Judith

c. 1503, wood panel, St. Petersburg, Hermitage.

A comparison between this picture and old engravings of it proves that the sides of the panel have been cut down. The gentle sunset in the background, painted by Giorgione, shows his early attempts at using radiant light for his new technique of painting mood, not subject matter. Any violence linked to the supposed subject (Judith decapitating Holofernes) is completely absent.

Giorgione
Adorazione dei pastori/
Adoration of the
Shepherds

*c. 1504, wood panel,
Washington, National Gallery.*

This painting comes from a
transitional moment in
Giorgione's paintings.

There is also a replica with
slight variations in the
Kunsthistorisches Museum
in Vienna. The figures are
still rather stiff and, like
the general layout of the
landscape, strongly
reminiscent of Giovanni
Bellini's *Transfiguration*. But
the landscape itself shows

signs of the new *sfumato*
technique pioneered by
Leonardo, which allowed
Giorgione to soften
contours and make the
distant blue mountains
merge mistily with the sky.
The effect overall is highly
atmospheric, even quite
romantic. This makes the

landscape no longer merely
a pleasing background, but
an important part of the
whole picture.

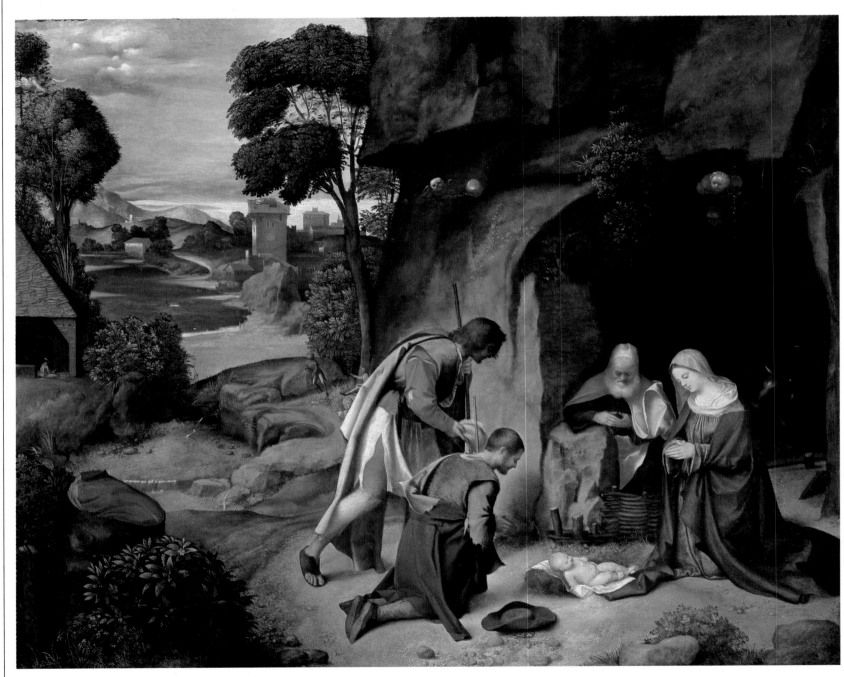

On the opposite page
Giorgione
Tempesta/The Tempest

*c. 1506, canvas, Venice,
Accademia.*

This is one of only a handful

of paintings by Giorgione
for which we have some
documentary sources, but
it has proved impossible to
determine the subject
matter. In 1569 it was listed
in the belongings of the

Vendramin family under
the title *Mercury and Isis*, in
which case the man should
be Mercury. But x-rays have
revealed that his figure has
been painted over that of an
old woman. This hardly

matters, however, for the
unquestioned focus of the
painting is the mysterious
landscape itself, all blue
and green with the white
lightning cracking above it.
Here Giorgione moved

away from the clear
definition of background
architecture and vegetation
found in his early work. The
blend of colors used is now
much richer and far more
subtle, creating a dreamy

mood in which humanity
and landscape almost seem
to become one.

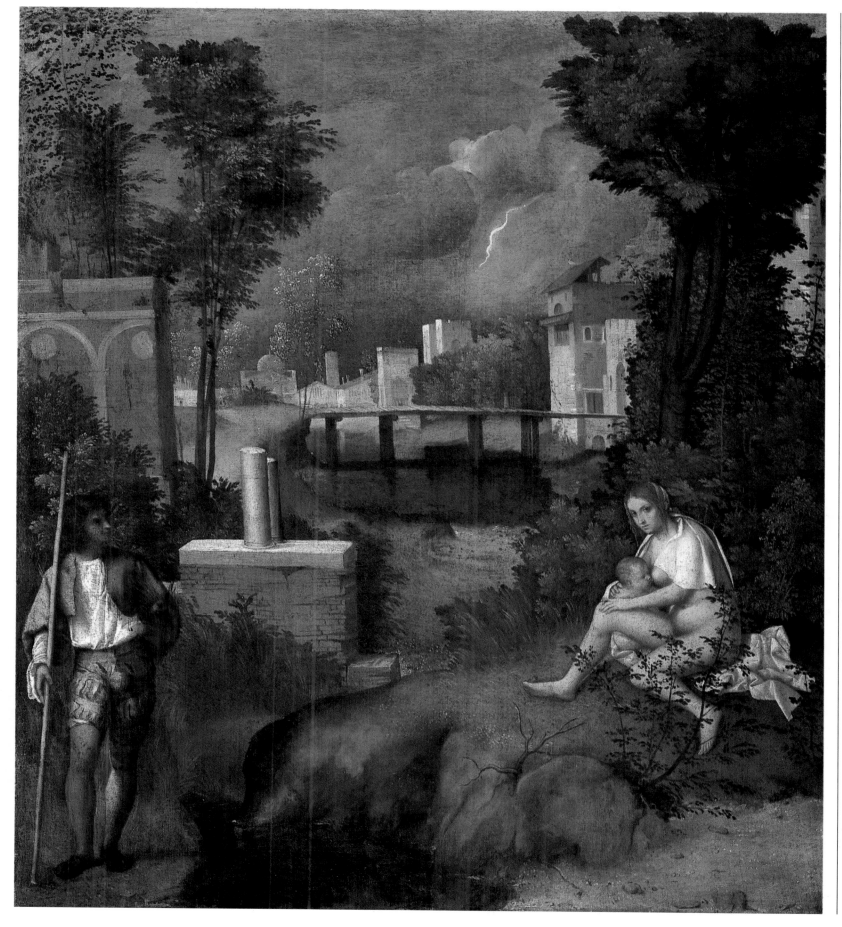

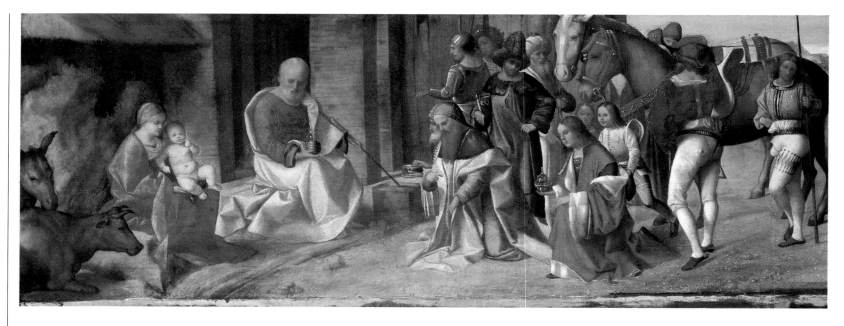

Above

Giorgione
Adorazione dei Magi/The Adoration of the Magi

c. 1502/04, wood panel, London, National Gallery.

Giorgione used the elongated format of this picture to divide the subject into two distinct scenes. This is underlined by the brick wall in the middle. On the left, the Holy Family is enveloped in a tranquil half-light. On the other side the Magi's train, which includes pages in showy costume, is in full light. This is an early and not fully authenticated work.

Below

Giorgione
Venere dormiente/Sleeping Venus (Dresden Venus)

c. 1510, canvas, Dresden, Gemäldegalerie.

The nude body of the sleeping girl seems to echo the soft contours of the hills and become almost part of the tranquil, fertile countryside. In no way does this image attempt to convey the overt eroticism of Venus. The extremely classical shape of the girl, which has been derived from antique sculptures, shows a new development in Giorgione's art.

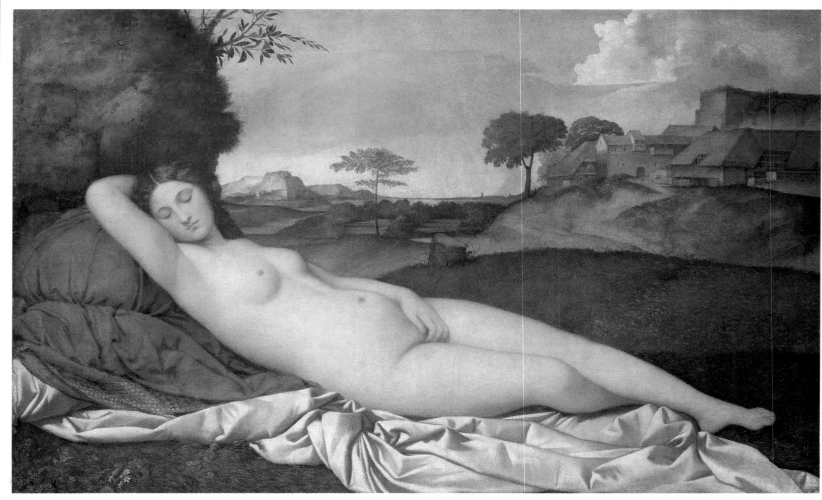

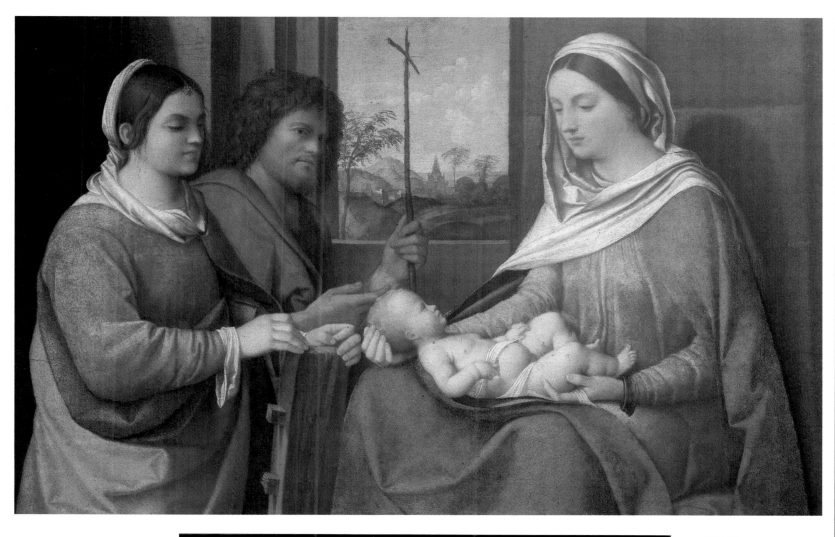

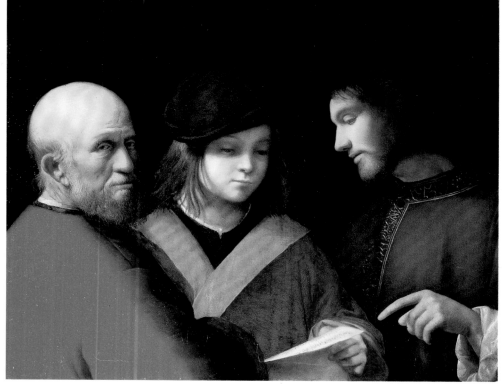

Giorgione
Tre età dell'uomo
(Concerto)/The Three
Ages of Man (The
Concert)

*c. 1510, Florence, Pitti Palace,
Galleria Palatina.*

This painting is typical of
the allegories produced by
Giorgione and his followers
or imitators. It is possible
that more than one person
painted it. But even if it is
not all Giorgione's own
work, the subtle play of
light and atmosphere of
quiet thought are typical of
him. It was one of his last
signed paintings, possibly
finished just before he died
of plague in summer 1510.

Giorgione
Sacra Conversazione

*c. 1505, wood panel, Venice,
Gallerie dell'Accademia.*

With the sole exception of
The Castelfranco Madonna, all
of Giorgione's religious
subjects were probably
painted for private chapels
or for collectors, including
this small panel. The
peaceful way the figures are
arranged in a space which is
softly lit is typical of the
most intimate vein of
Giorgione's middle period.
Some scholars think that
the young Sebastiano del
Piombo helped finish this
particular painting.

Palma the Elder

Jacopo Negretti, Serina (Bergamo), c. 1480 – Venice, 1528

Palma was typical exponent of a group of painters coming from the mainland Venetian territories. He represents the easy-going strand in the rapid evolution of Venetian painting. His nickname "il Vecchio" (the Elder) was added to distinguish him from his great-nephew Jacopo Palma "il Giovane" (the Younger), a prominent Venetian artist of the late Renaissance. Although originally from Bergamo, Palma moved to Venice in 1510 where he concentrated on two distinct types of work: altarpieces for churches in Venice and the Veneto region and, quite separately, very marketable pieces portraying seductive young women, usually voluptuous blondes, sometimes in mythological guise. The hallmarks of his painting are diffused light, serenity, richly luxurious colors, and an atmosphere of calm splendor, reflecting the influence of early Titian. The gentle sensuality of these half-length portraits of women (such as *The Girls Bathing*, in the Kunsthistorisches Museum in Vienna) is echoed in his religious painting which often includes sweet female figures, for instance the *St. Barbara Polyptych* (1522–24, Venice, S. Maria Formosa) or *The Adoration of the Magi* (Milan, Brera).

Jacopo Palma the Elder

Sacra Conversazione

1521, wood panel, Vicenza, S. Stefano.

Altarpieces by Palma the Elder were hugely popular in Venice and its mainland territories. Their success was more than justified by the encompassing, luminous beauty of the overall composition combined with the fascination of the individual characters. Although he incorporated the most up-to-date trends of the Venetian school (such as the use of rich color that owes a lot to Titian, the vast and romantic landscapes, and the wonderful play of light on cloaks and armor), Palma the Elder nevertheless revealed his own distinctive style in the smooth sensuality of his women.

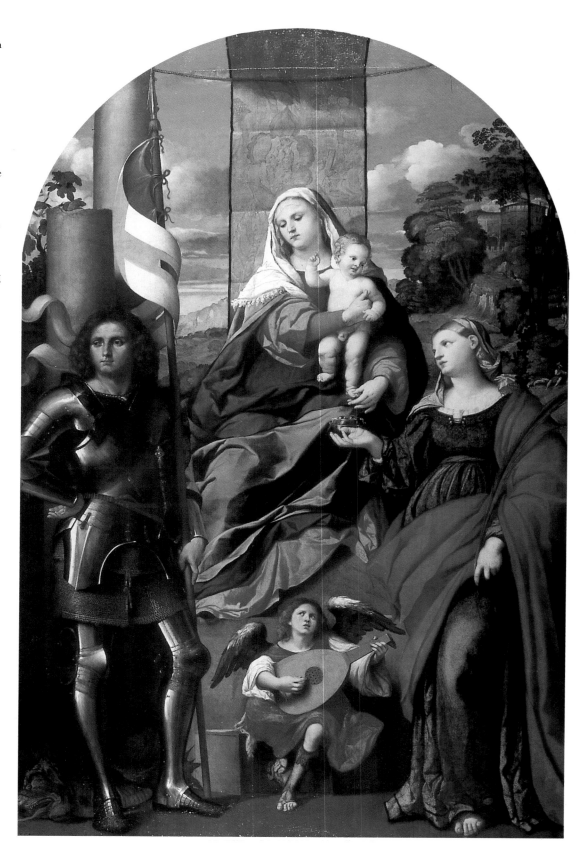

Jacopo Palma the Elder
Assunzione della
Vergine/Assumption

*1512, wood panel, Venice,
Gallerie dell'Accademia.*

This ordered and tranquil
composition is bathed in a
warm, golden light and
contains an appealing and
harmonious range of colors,
elegant gestures, and
controlled expressions. It
can be contrasted to Titian's
diametrically different
handling of the same
subject (see page 190).
Nothing could make it
clearer that, compared to
the avant-garde of the
Venetian school, Palma the
Elder clung to a serene and
reflective position that was
intrinsically still anchored
to turn-of-the-century
peacefulness.

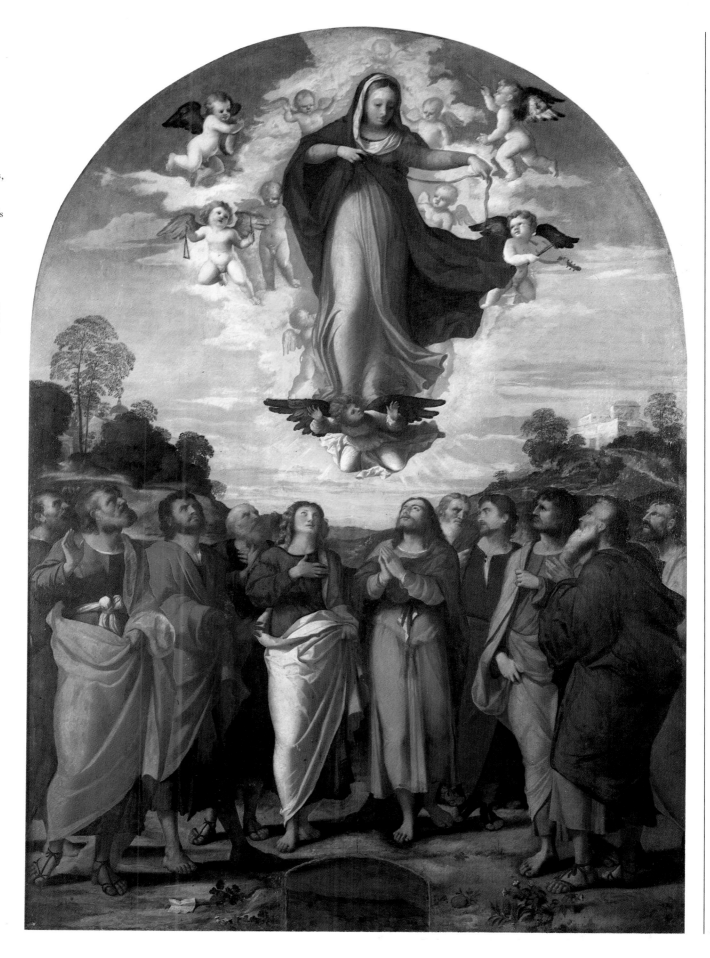

Sebastiano del Piombo

Sebastiano Luciani, Venice, c. 1485–Rome, 1547

Sebastiano was a fascinating and important figure in the art worlds of two capitals (Venice and Rome). He was in contact with all the major artists of the first half of the sixteenth century, including Giorgione, with whom he probably trained, Titian, Raphael, and Michelangelo, and his own personal and robustly attractive style grew from them. He produced his first work in about 1510 (an organ screen now in the Gallerie dell'Accademia and the altarpiece in S. Giovanni Crisostomo). These proved to be masterpieces of Venetian painting in its moment of transition between Giorgione's soft harmony and Titian's dynamic style. It was presumably Titian's meteoric rise that made Sebastiano leave for Rome in 1511 where he had been invited to work alongside Raphael on the Farnesina frescos. He soon reconciled Venetian color with the creative research undertaken by painters of the Roman school, and particularly by Michelangelo with whom Sebastiano became firm friends – reputedly after quarrelling with Raphael. Thanks to his *Pietà* which is now in Viterbo and the paintings for the Borgherini Chapel in S. Pietro in Montorio, by about 1516 Sebastiano had become the artist who put Michelangelo's ideas into pictorial form. Michelangelo even provided the drawings for his huge altarpiece of *The Resurrection of Lazzarus*, 1519 (London, National Gallery), that was painted to compete with Raphael's *Transfiguration*. After Raphael's death, Sebastiano became the most important painter in Rome, as is shown by the numerous official portraits he produced for the court of Pope Clement VII. Sebastiano remained in Rome even after the Sack (1527) and in 1531 was rewarded with the post of "officio del Piombo" (Keeper of the Seals) hence his nickname, a highly-paid ecclesiastic sinecure. After this his output of paintings fell off.

Sebastiano del Piombo
Ritratto di donna detta "Dorotea"/Portrait of a Young Woman called "Dorotea"

1513, wood panel, Berlin, Staatliche Museen Preussischer Kulturbesitz.

This is a superb example of Sebastiano's Venetian training combining with the monumentalism he was learning in Rome. With extreme sensitivity he depicts the dying light of the countryside at sunset, showing it spilling into the foreground until it is lost in the fluffy fur. On the other hand, the way he structures the strong and sculpted physical presence of the young girl already reflects the figurative influence of Rome derived from Raphael and Michelangelo, to both of whom Sebastiano was soon to be compared.

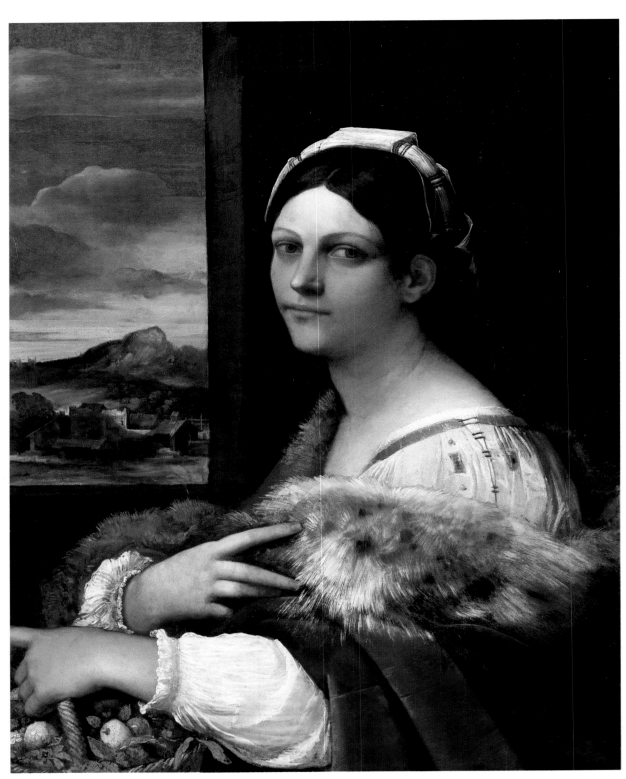

Sebastiano del Piombo

San Ludovico da Tolosa; San Romualdo/St. Louis of Toulouse; St. Romuald

1510, canvases, Venice, Gallerie dell'Accademia.

Together with a further two panels (showing saints Rocco and Sebastian), these canvases formed an organ screen for the church of S. Bartolomeo in the Rialto district of Venice. This was the most important work produced by the young painter in Venice and provides the clearest demonstration of his close contact with Giorgione. Like Giorgione's frescos on the façade of the Fondaco dei Tedeschi, the elegant figures of the saints stand calmly in the welcoming recesses of gilded niches, bathed in soft and warm light. Compared to Titian's vigorous boldness, Sebastiano del Piombo's manner remained much more concentrated and contemplative. It is almost as if he was only willing to work within the peace of the architectural setting, never to challenge it.

Titian
(Tiziano Vecellio)
Pieve di Cadore (Belluno), 1483/88–Venice, 1576

Indisputably the greatest painter of the Venetian school, Titian's long life can be seen as an endless train of successes and honors. In reality he is the supreme example of an artist constantly researching and inexhaustibly renewing his art. Titian's career covers almost a century of Renaissance art, starting at its High Renaissance zenith and ending in its dramatic dissolution in his last works. Titian was originally Bellini's pupil but moved to Giorgione's studio, becoming his collaborator on the Fondaco dei Tedeschi and completing some canvases like *The Sleeping Venus*. By the time he had started work on the *Assumption* of the Frari in 1516, he was recognized as the greatest painter in Venice and Giovanni Bellini's successor as the Republic's official painter. This was chiefly thanks to his richness of color and the dynamism of his compositions. In 1518 he began painting a series of brilliant mythological works for Alfonso d'Este, Duke of Ferrara. This marked the beginning of his paintings for such courts. Titian's fame as a painter was mainly due to the immense vitality of his portraits. In the 1530s, perhaps due to his wife's death, Titian's colors became more subdued and his style less dramatic. Around 1540 he became aware of new developments in Mannerism. Partly because of this, partly for family reasons (he was trying to get his son Pomponio a church post) he traveled to Rome in 1545–46, where he had a famous argument with Michelangelo. The two great masters had utterly opposing visions of art: Michelangelo put drawing at the center of his art, Titian opted mainly for color but he had long ago assimilated Michelangelo's monumental forms. After two trips to Germany in the train of Emperor Charles V, from 1551 Titian's œuvre divides into two. On the one hand he produced his last, terrifying altarpieces (*The Martyrdom of St. Lawrence*, Church of the Gesuiti; *Pietà*, now in the Accademia). On the other, he painted his *Poesie* (poems) for Philip II of Spain, mythological scenes which seem tragic mirrors of the human condition. Gradually his colors became darker, thicker and heavier and he seemed not to finish his works. In his last works he no longer used brushes to apply paint, but rubbed it on directly with his fingers.

Titian
Assunta/Assumption

1516–18, wood panel, Venice, S. Maria Gloriosa dei Frari.

The enormous altarpiece is sited over the high altar in the Franciscan church in the Gothic style. It marks the start of Titian's dominance of Venetian art, combining the dynamic vigor of the Roman High Renaissance with a Venetian love of rich, splendid colors. The Virgin soars up to God the Father in heaven amid a blaze of gold. When finished, it was the largest altarpiece ever painted in the city, and the first designed to be seen from a single viewpoint. When unveiled it provoked differing reactions. Ordinary people were enthusiastic; those who had commissioned it were puzzled by the rough appearance of the Apostles. Fellow painters reacted hostilely, for they were not yet ready for Titian's radically new way of painting, so different from Bellini's or Giorgone's gentler art. Within a short time, however, the painting became a touchstone for the whole Venetian school.

On the opposite page
Titian
Miracolo del neonato/The Miracle of the New-Born Infant

1511, fresco, Padua, Scuola del Santo.

The three Paduan frescos showing the miracles of St. Anthony were Titian's first important independent work. He became one of the most influential painters in Venice.

Titian
Madonna in trono e santi con la famiglia Pesaro (Pala Pesaro)/The Madonna and Child Enthroned with Saints and the Pesaro Family (The Pesaro Altarpiece)

1522–26, canvas, Venice, S. Maria Gloriosa dei Frari.

In contrast to the traditional layout, Titian has moved his Madonna over to the right. Titian's assured use of classical architecture – with the two great pillars soaring past the human figures and even clouds into the blue heavens – is combined with the vividness which he painted the Pesaro family in all their different generations, joining heaven and earth in his art. For centuries *The Pesaro Altarpiece* was the archetype for Venetian altarpieces, from Veronese to Sebastiano Ricci.

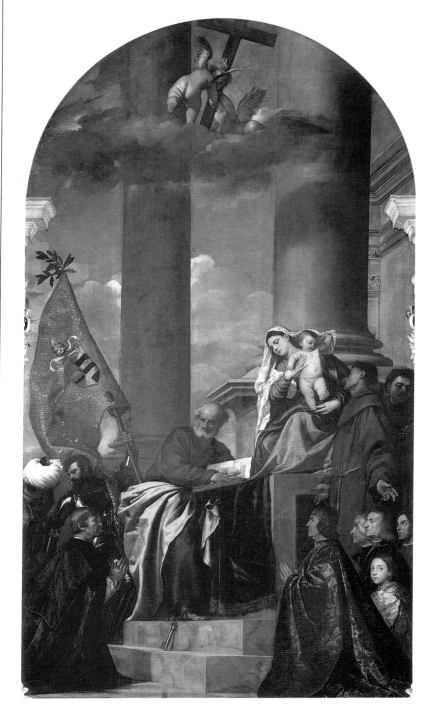

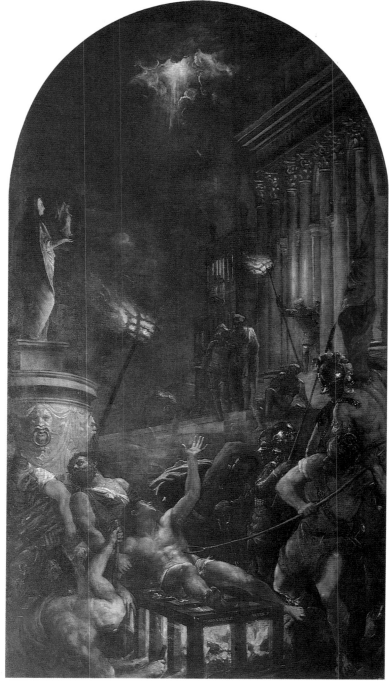

Titian
Martirio di san Lorenzo/ Martyrdom of St. Lawrence

1548–49, wood panel transferred onto canvas, Venice, church of the Gesuiti.

Titian abandoned the last of High Renaissance tradition when he created this composition which pushed back the very limits of artistic expression. The painting was inspired by the artist's dramatic research into light. The dark of the night is lit up by a violent source of light inside the scene. The picture has incredible emotional power.

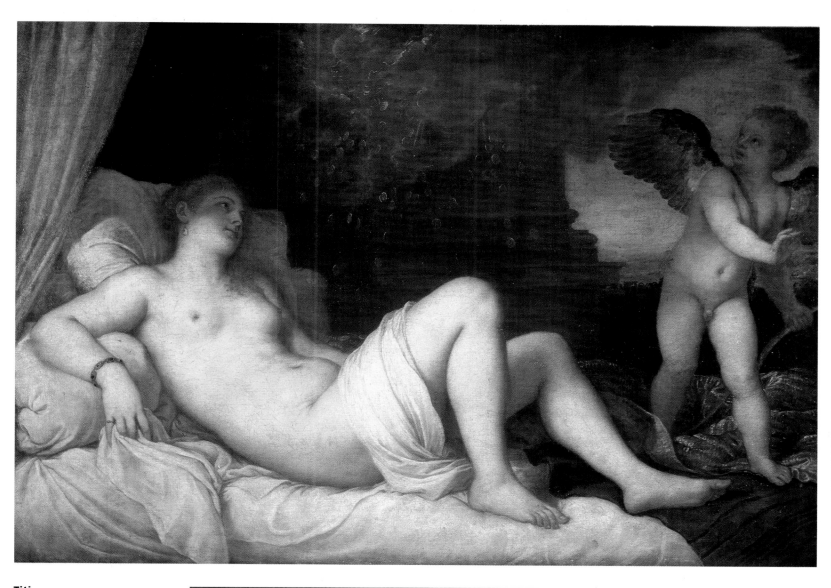

Titian
Danae

1545, canvas, Naples, Museo di Capodimonte.

The canvas, which was started in Venice and finished in Rome, was Titian's personal gift to the cultured Cardinal Alessandro Farnese, nephew (probably son) of Pope Paul III, who had sponsored the painter's trip to Rome. When it was still at the sketch stage, Monsignor Della Casa described it to Cardinal Farnese in the following words, "una nuda che vi faria venire il diavolo addosso" ["a female nude who would fill you with the devil"]. The influence of Titian recently seeing ancient Roman sculptures is evident in the very classical nudes.

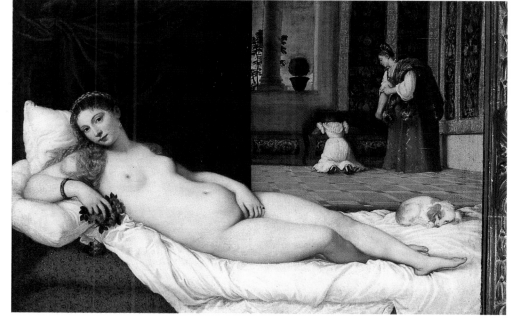

Titian
Venere di Urbino/Venus of Urbino

1538, canvas, Florence, Uffizi.

Commissioned by Guidobaldo della Rovere, lord of Urbino, this picture marks a decisive advance on previous depictions of Venus (though this may in fact just be a portrait of Guidobaldo's mistress). The serene sense of contemplation found in *The Dresden Venus* (see page 184) has been replaced by an alluring sensuality, emphasized by her bracelet and the luxury of her bedroom. The goddess looks seductively out directly at the viewer as she reclines on her bed.

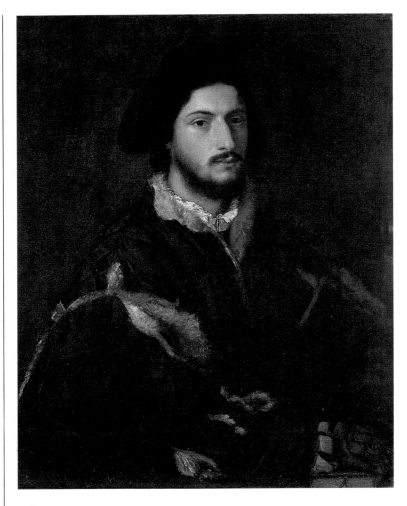

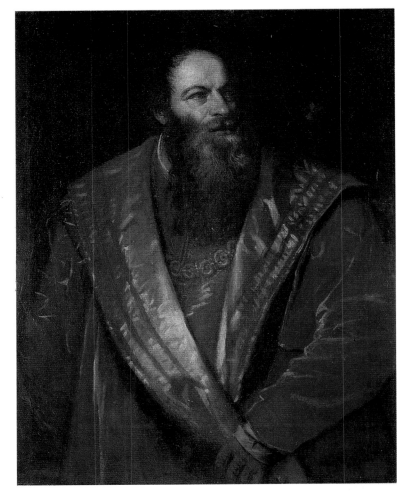

Titian
Portrait of Vincenzo Mosti

c. 1520, wood panel transferred onto canvas, Florence, Pitti Palace, Galleria Palatina.

The sitter was an official at the Este court whom Titian painted during one of his numerous long stays in Ferrara. When the painting was transferred from panel to canvas it did not damage the balance of varying tones of gray which underlay the refined play of light and color in this picture, nor its firm pyramidal structure. The dignified vivacity with which Titian has portrayed Mosti explains why he soon became the most popular portraitist in Europe.

Titian
Portrait of Pietro Aretino

1545, canvas, Florence, Pitti Palace, Galleria Palatina.

This was a private portrait that Titian painted just before leaving for Rome. It is the tangible proof the strong bond of friendship and close professional relationship he had with the Tuscan writer, "the world's first journalist." But the portrait was so new in its rough style that when Aretino received it he thought it was "piuttosto abbozzato che non finito" ["rather more of a sketch than a finished painting"]. Titian was, in fact, experimenting with the technique that would characterize the last period of his art. Outlines were no longer carefully defined and sweeping brushstrokes were applied apparently in haste.

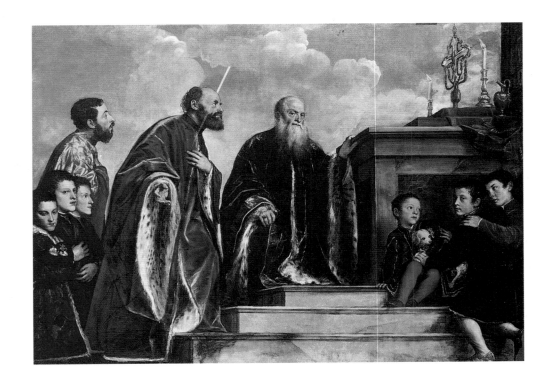

Titian
Votive Portrait of the Vendramin Family

1543–47, canvas, London, National Gallery.

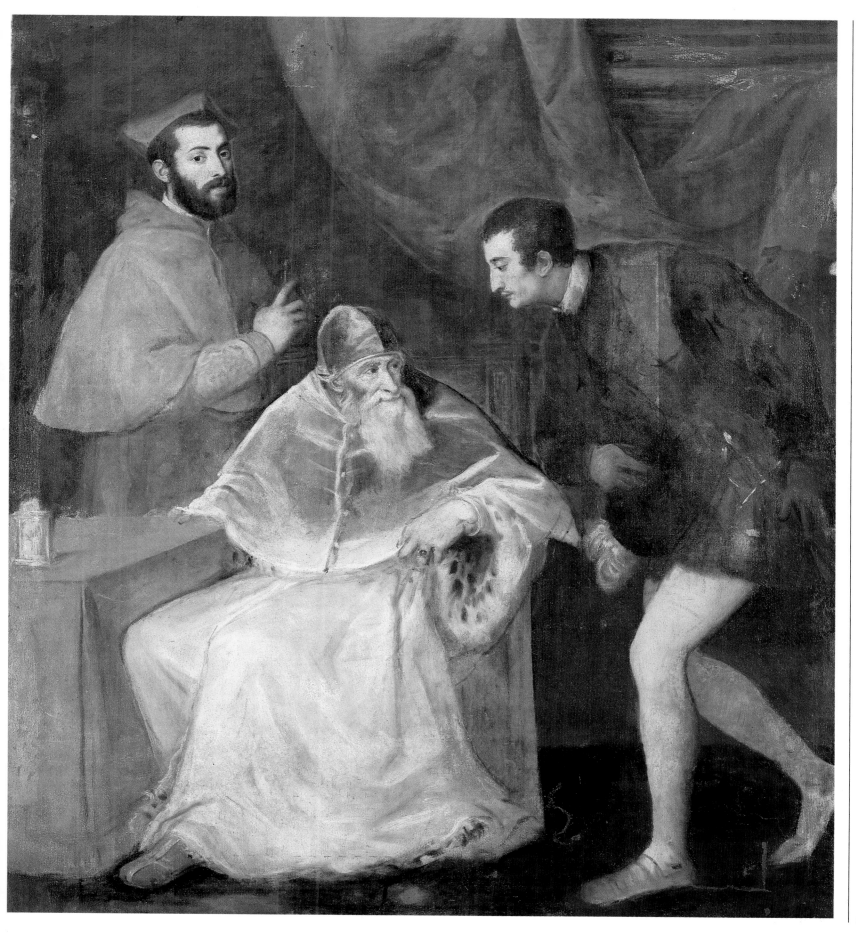

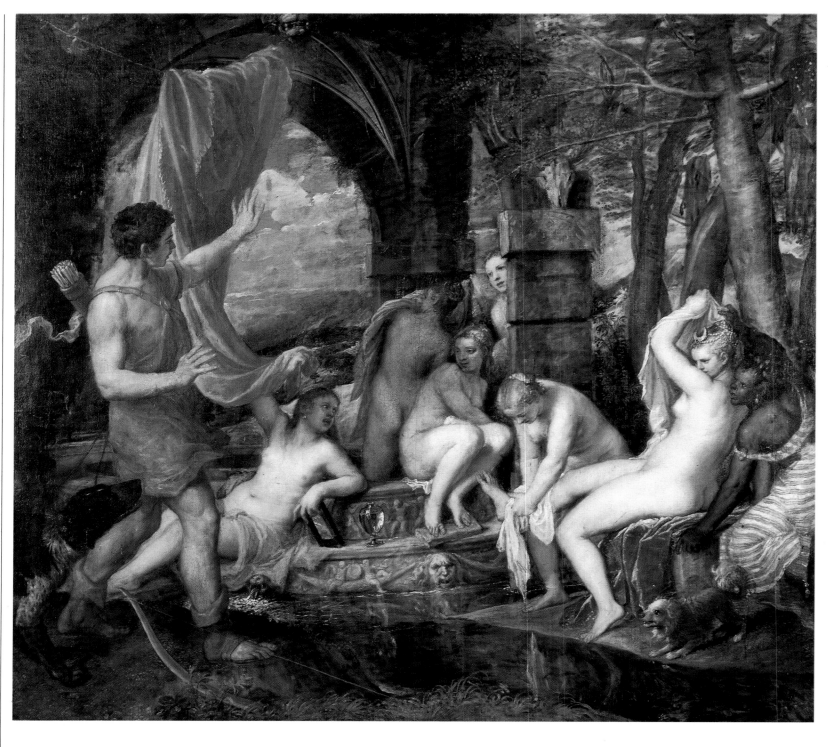

On the preceding page
Titian
Portrait of Farnese Pope
Paul III with his Nephews

*1546, canvas, Naples,
Museo di Capodimonte.*

Inspired by Raphael's
portrait of Leo X, Titian
portrays the pope with his
nephews Alessandro and
Ottavio. The boney old
pope may be shrunk and

decrepit but he still is
giving his obsequious
"nephew" (almost certainly
his son) Ottavio an
extremely shrewd look.
The rapid and sketchy
technique, with details left
unfinished, adds to the
impression of the
suffocating atmosphere of
court intrigue. The shady
furtiveness of the two
nephews and the foxiness of

the old pope are so
brilliantly revealed that
Titian must have realized
the pope would never
accept the portrait, for he
abandoned it uncompleted
on leaving Rome. His
colors are richer and
thicker than ever with
shades of red dominating
the picture. According to
Titian's own maxim,
anyone who wants to be a

painter needs to master
three colors, white, red,
and black and "averli in
man" ["be able to handle
them"].

Titian
Diana e Atteone/Diana
and Actaeon

*1558, canvas, Edinburgh,
National Gallery of Scotland.*

This was part of a cycle of
great mythological works
which Titian called *Poesie*
(poems) and painted for
Philip II of Spain, his last
great patron. As he moved
from maturity into old age,

Titian's work did not lose
its taste for vivid color or
precious detail. On the
contrary, his work became
richer as he developed a
manner of applying paint
thickly to canvasses full of
movement and life. But
there is a note of autumnal
darkness, even sadness,
about the canvas which
reveals his own darkening
thought.

Lorenzo Lotto

Venice, c. 1480–Loreto, 1556/57

Lotto's troubled life is often contrasted with Titian's success. After training in Venice, reputedly in Bellini's studio, Lotto's first youthful success came in Treviso and the Marches during the opening decade of the century. Then came a disastrous stay in Rome, after which he took refuge in Bergamo where, between 1513–25, he painted altarpieces, portraits, and fresco cycles. These stood out for their fine Renaissance composition but there is an unease about them, which suggests a neurotic personality. He went back to Venice in 1526 but was unable to get much local patronage. Poverty forced him out of Venice and he went back to live in the Marches. In his last years, his painting became hesitant and uncertain and he reputedly went blind. Already an old man, he took vows as a lay-brother and entered the Sanctuary of the Santa Casa in Loreto where he seems to have achieved serenity before he died.

Lorenzo Lotto
Santa Lucia davanti al giudice/St. Lucy Before the Judge

1532, wood panel, Jesi (Ancona), Pinacoteca Comunale.

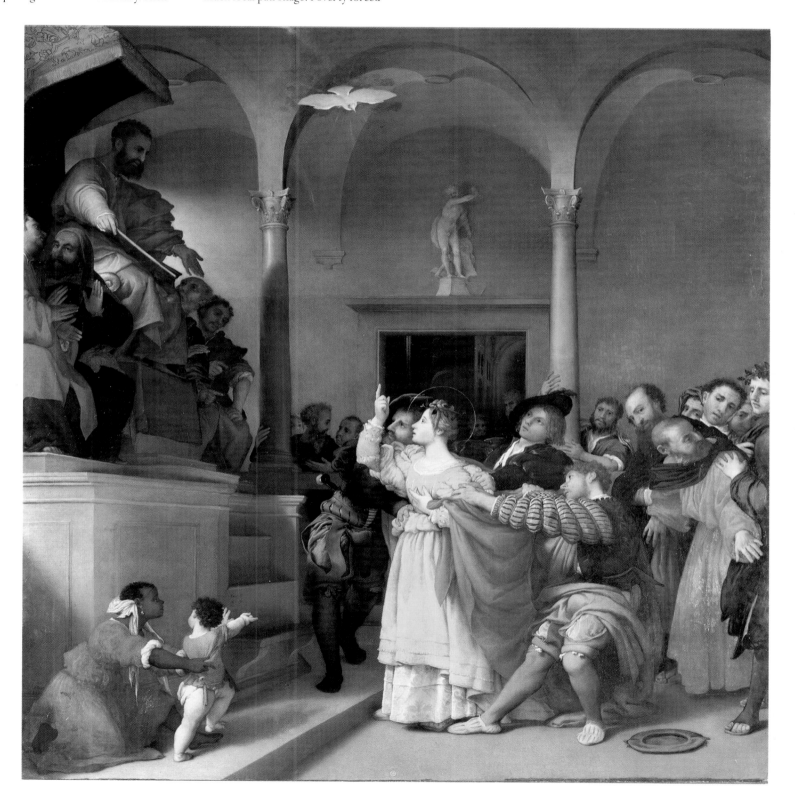

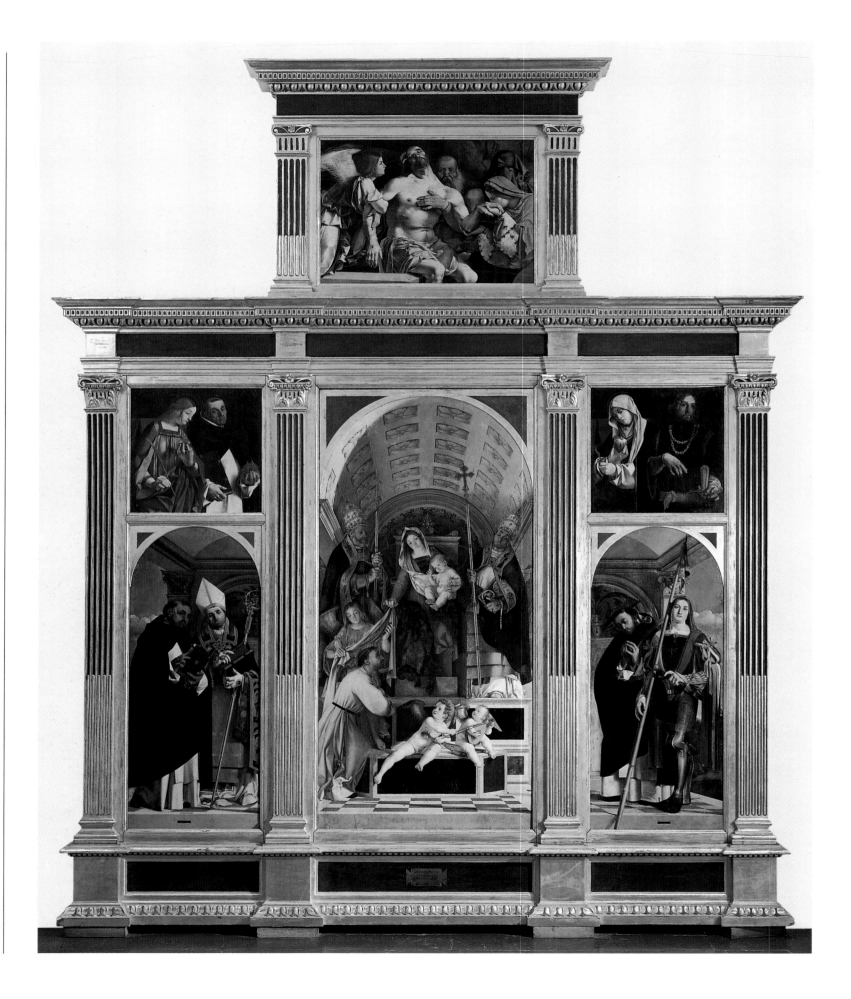

On the opposite page
Lorenzo Lotto
Polittico di san Domenico/
St. Dominic Polyptych

*1506—08, wood panel,
Recanati (Macerata),
Pinacoteca Comunale.*

Although not in its original
frame, this important early
polyptych has at least been
kept together in Recanati.
The work was painted
before Lotto's journey to
Rome. It stands out for its
rather melancholic air of
thoughtful meditation in
both the central scene and
the side panels. In contrast,
the *Pietà* at the top is full of
dark mystery. Motifs from
northern Europe are found
in the figures of the saints,
including the descriptive
use of light and the clothes
worn, but the overall
symmetrical construction
demonstrates how aware
Lorenzo Lotto already was
of central Italian High
Renaissance art.

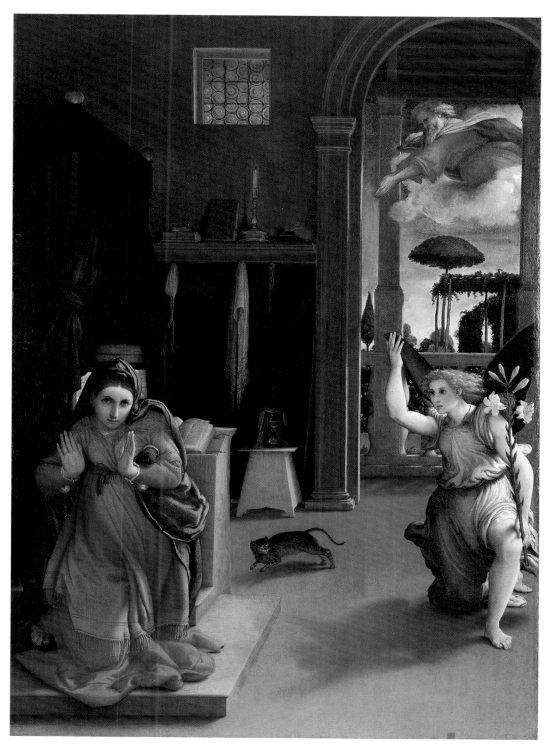

Lorenzo Lotto
Annunciazione/
The Annunciation

*c. 1527, canvas, Recanati
(Macerata), Pinacoteca
Comunale.*

Lotto's contacts with the
Marches started when he
was young and provided a
constant thread throughout
his life. He had already gone
back to Venice when he
painted this unsettling and
highly original version of a
subject seen thousands of
times in the history of art. A
tremor of fear runs through
the whole scene, startling
the defenseless, fragile
Virgin and the terrified cat
which, with its back
arched, flees the from the
manic-looking angel. The
objects in the room are all
carefully depicted, almost
as though Lotto wanted to
underline the contrast
between the quiet flow of
ordinary life and the
upheaval caused by the
angel's appearance.

Lorenzo Lotto
Ritratto di giovane con lucerna/Portrait of a Young Man with a Lamp, also known as Portrait of a Young Man against a White Curtain

c. 1506, wood panel, Vienna, Kunsthistorisches Museum.

A lamp is in the top right-hand corner of the picture, half-hidden behind the sumptuous background brocade. This is in sharp contrast with the severe black clothes worn by the young man. Lotto conveys the sitter's mood of psychological unrest with exceptional vigor and penetration.

Lorenzo Lotto
Ritratto di gentildonna in veste di Lucrezia/Portrait of a Lady dressed as Lucretia

c. 1533, wood panel, London, National Gallery.

Lorenzo Lotto
Ritratto di giovane con libro/Portrait of a Young Man with a Book

c. 1526, wood panel, Milan, Sforza Castle, Civiche Raccolte d'Arte.

This small portrait is one of Lotto's most accomplished and disturbing works. The brushwork is meticulous to the point of absolute perfection. The way the sitter cocks his head to look out of the frame means that his penetrating glance meets the viewer's eyes straight on. This, in turn, makes the young man appear both obsessively present and "inafferabile come un pesce veduto in una boccia di cristallo" ["as unreachable as a fish seen through a glass bowl"] (A. Banti).

Lorenzo Lotto
Angelo annunciante/The
Angel of the Annunciation

*c.1530, canvas, Jesi,
Pinacoteca Comunale.*

Together with the
Annunciation in the same
museum, this canvas was part
of a now-dismantled altar.

Lorenzo Lotto
Pala di san Bernardino/San
Bernardino Altarpiece

*1521, wood panel, Bergamo,
S. Bernardino in Pignolo.*

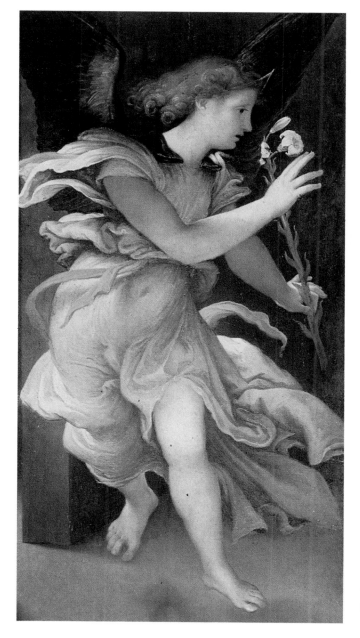

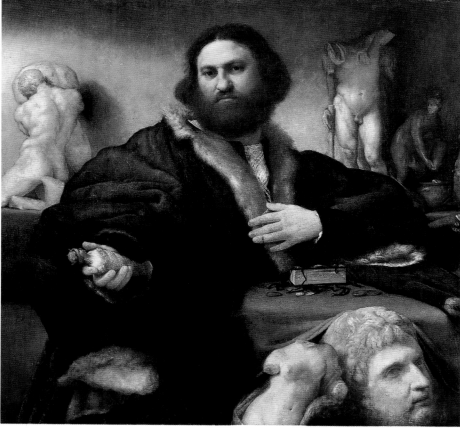

Lorenzo Lotto
Ritratto di Andrea Odoni/
Portrait of Andrea Odoni

*c.1527, canvas, Hampton
Court, Royal Collection.*

The figure of the collector
of antiquities slowly fills
the whole space which is

cluttered with relics of an
illustrious but fragmentary
past. The light is toned
down and the deliberate
way Lotto paints the
marbles slightly out of
focus gives the portrait a
noble but melancholic feel.

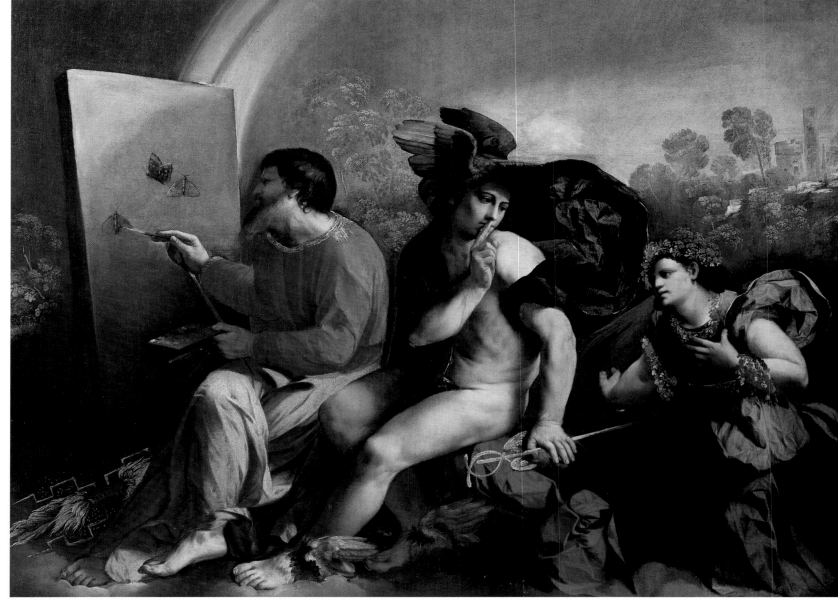

Dosso Dossi
Giove pittore di farfalle,
Mercurio e la Virtù/Jupiter
Painting Butterflies,
Mercury and Virtue

*c. 1522–24, canvas, Vienna,
Kunsthistorisches Museum.*

Dosso Dossi

*Giovanni di Niccolò Luteri, between Mantua
and Ferrara, c. 1490–Ferrara, 1542*

We do not know exactly either where or when Dosso was born. He was to become the outstanding painter in the Ferrara school of the whole sixteenth century. In its timing and thought, his work was in perfect harmony with that of Ludovico Ariosto, who was then the court poet to the Este family. Dosso's early training brought him into close contact with Giorgione's circles. In about 1510 he was in Mantua and from 1514 he became court painter in Ferrara. He was called almost immediately to work alongside Bellini and Titian on the decorative mythological scheme for Alfonso d'Este. Thanks to frequent travels (mainly to Venice but also to Florence and Rome), Dosso stayed in constant contact with what was going on in the world of painting and his style evolved at the same pace as most of sixteenth-century art. In the long years he worked for the Este family he produced both altarpieces (sometimes in collaboration with Garofalo, such as the grandiose *Polyptych* now in the Ferrara National Gallery) and noteworthy decorative cycles on pagan literary or mythological themes. Dosso's main stylistic reference is Venetian art, and he long continued Giorgione's romantic landscape style. But he quotes from Ferrara's own tradition, as well as possessing his own narrative vein close to Ariosto's poetry. The frescos in the Villa Imperiale in Pesaro and Buonconsiglio Castle in Trento were painted in collaboration with his brother Battista in about 1530.

Dosso Dossi
Circe

c.1522–24, canvas, Rome, Galleria Borghese.

The identification of this mysterious figure with the enchantress from the *Odyssey* is doubtful. However, this does not diminish the fascination of the luxurious image. The painting is redolent with the colors and luminous atmosphere of Venetian art which here join with the Ferrara school's inexhaustible search for esoteric and literary seduction.

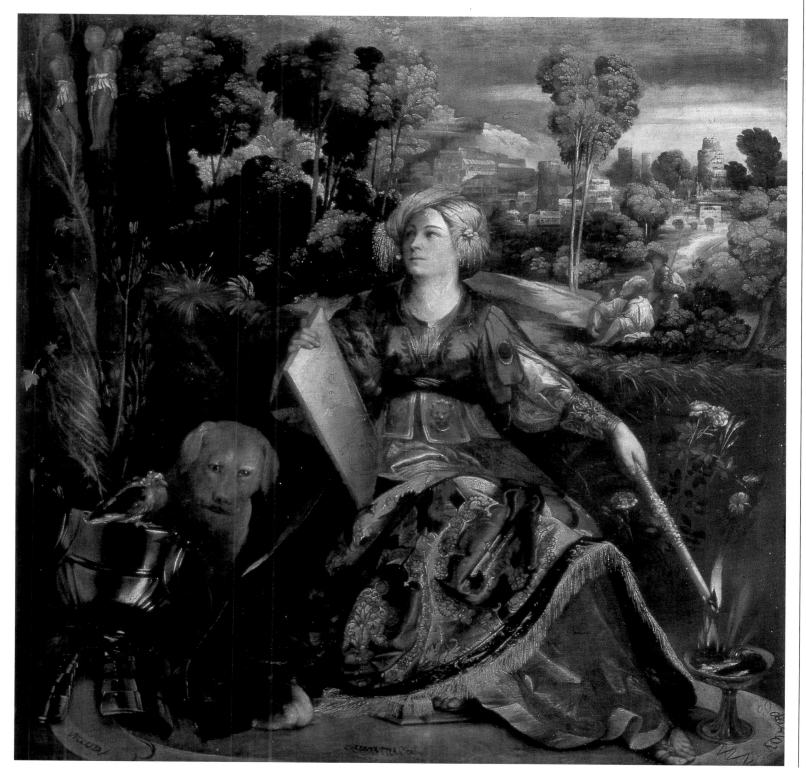

Correggio

Antonio Allegri, Correggio (Parma),
c. 1489–1534

In the quiet backwater of Parma Correggio worked away and developed a highly personal form of Renaissance art. Both Mantegna and Lorenzo Costa may have influenced him but Correggio's style was fluid, luminous, and deliberately appealing. Correggio's art was also astoundingly daring in the way he used perspective. In this regard, it almost looked forward to Baroque painting. He trained in Mantua during Mantegna's last years of life, a period in which Raphael's sweet style first became known through prints and engravings. To these elements Correggio added his own distinctive use of *sfumato* to soften his art and a deliberate, almost sentimental elegance, as well as influences from Leonardo and the Venetian school. We can trace these influences from Correggio's early work right through to the first large-scale commission he undertook in Parma, namely the Abbess' Room in the convent of S. Paolo (1519). The originality of Correggio's pictorial ideas was always tempered by his refined taste for expression and color. All of this came together brilliantly in his cycle for the church of S. John the Evangelist in Parma. He started painting the frescos in the dome (1520–21) before moving on to the other parts of the church where he was helped by his pupils. During the 1520s he produced a series of altarpieces that were spectacular in conception. Gestures blend into each other, expressions are all smiles, the colors all enticing. Particularly noteworthy are *The Adoration of the Shepherds* (1522, Dresden, Gemäldegalerie), and the *Madonna and St. Jerome* (1523, Parma, National Gallery). His masterpiece, summing up his life's work, is *The Assumption* in the dome of Parma Cathedral. It is vertiginous and illusionistic in its use of perspective yet soft in execution. In his last years of life, Correggio went back to work for the Gonzaga family, producing two canvasses for the private study of Isabella (now in the Louvre) and the cycle of the *Loves of Jupiter*.

Correggio
Madonna di san Giorgio/
Madonna of St. George

c. 1530, wood panel, Dresden,
Gemäldegalerie.

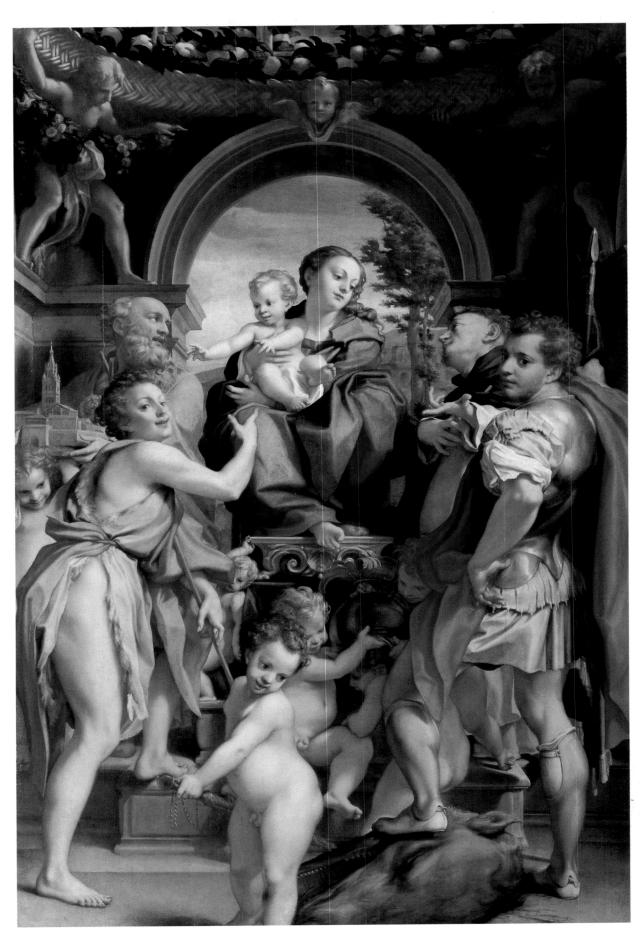

Correggio
Veduta d'insieme della camera della Badessa/ General View of the Abbess' Room

c. 1519, fresco, Parma, Convent of S. Paolo.

This extraordinary chamber, which is a perfect example of Renaissance style, remained secret for centuries. It was, in fact, considered unbecoming for a nun to receive guests in what was considered to be an intensely pagan room, dominated by the figure of Diana (over the mantelpiece) and transformed magically into a pergola thanks to the illusionistic frescos on the ceiling which draw their inspiration from Mantegna and Leonardo. Most people find the grisailles lunettes around the top of the walls wonderful but somehow slightly disturbing. They give the illusion of very soft classical sculptures caressed in radiant light, resting on false capitals with rams' heads between which Correggio has slung fabric bands holding ritual objects. All in all, this is an incredible piece of trompe l'œil and a worthy successor to Mantegna' art.

Correggio
Madonna di san Gerolamo/Madonna and St. Jerome

1523, wood panel, Parma, Galleria Nazionale.

This is perhaps Correggio's most famous altarpiece. Works like this make us understand the painter's true originality. He was capable of completely renewing the structure on which the composition and feeling of the Renaissance altarpiece had hitherto been based. In doing so, however, the painter never turned to the newly fashionable distorted ways of Mannerism. Correggio's starting point was Leonardo (obvious in the Madonna's face and, above all, the way the *sfumato* blends the outlines). To this he added his own distinctive sweetness of expression, repose, and serene Christian faith. His splendid choice of colors, which tend towards softly golden tones, almost anticipates certain aspects of Baroque painting, yet again reconfirming Correggio as its true if surprising forerunner.

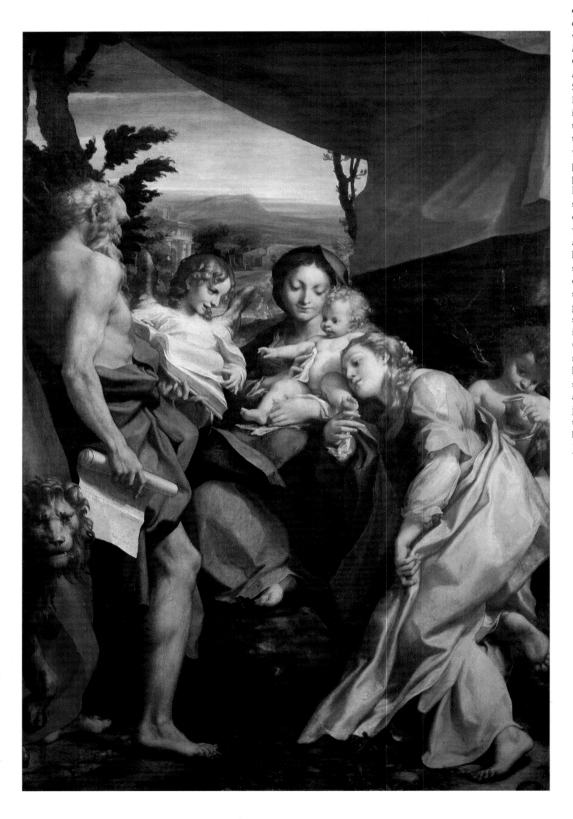

On the opposite page
Correggio
Ratto di Ganimede/ Abduction of Ganymede; Giove e Io/Jupiter and Io

c.1531, canvas, Vienna, Kunsthistorisches Museum.

The two paintings are part of Correggio's exceptional cycle on the *Loves of Jupiter* which also includes the *Danae* in the Borghese Gallery in Rome and the *Leda and the Swan* in the Staatliche Museen Preussischer Kulturbesitz in Berlin. Taken together, this cycle forms the apex of the mythological-erotic vein of Renaissance painting. It also contains passages of the sweetest loving abandon. In this sense, the most extraordinary scene is where Jupiter, disguised as a cloud, embraces and kisses the nymph Io who swoons away. The soft divine cloud really does seem able to enfold the girl's shapely body and squeeze her in a soft, irresistible embrace. Correggio's elegance, manners, and sense of humor ensure that such scenes always shy firmly away from cheap eroticism, just as he softly obscures the real fate of the boy being taken off to serve Jupiter.

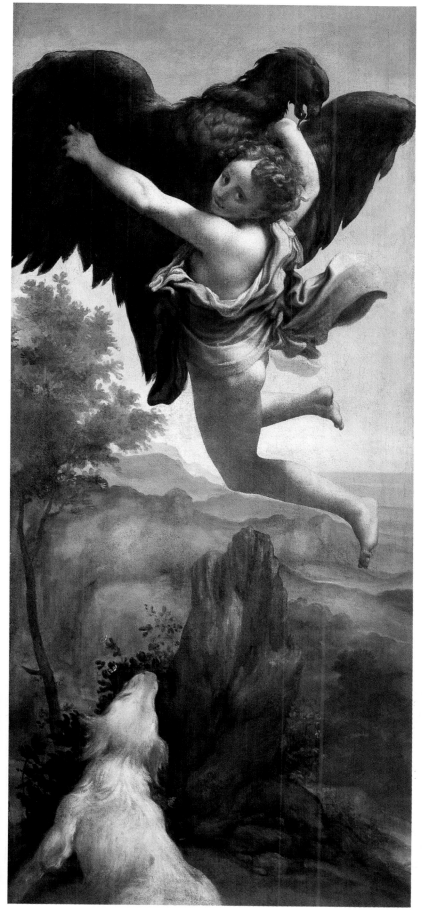

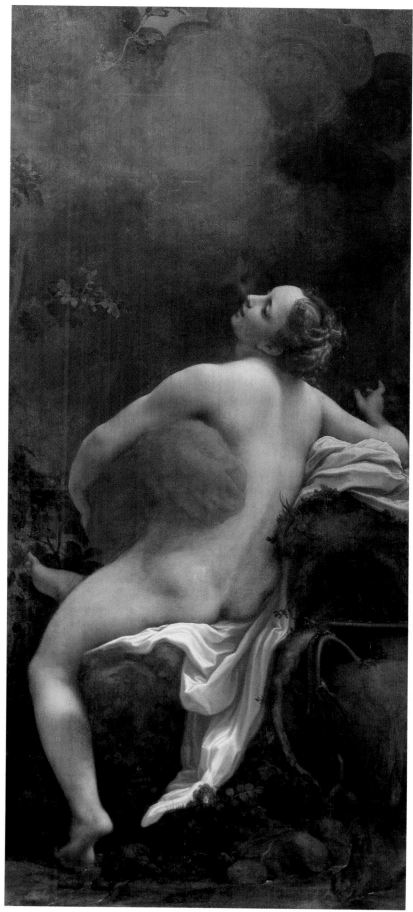

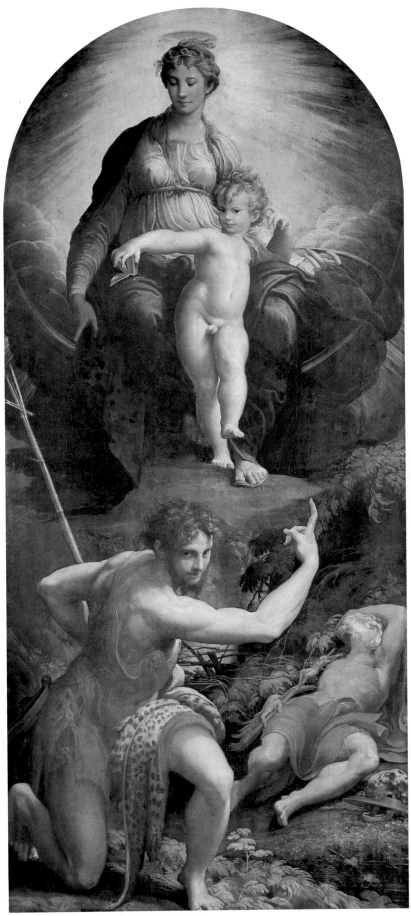

Parmigianino

Francesco Mazzola, Parma,
1503–Casalmaggiore, 1540

Unnaturalistic, icy, and intellectual, Parmigianino is the stylistic opposite to Correggio. Their coexistence in the same town made Parma in the 1520s one of the chief centers of sixteenth-century art. Parmigianino's talent developed at a precocious age and he quickly rivaled Correggio, whom he admired, by putting himself forward as the exponent of Mannerism. When only 20 he produced his first major work, *Diana Bathing*, for the castle of Sanvitate at Fontanellato. In 1524 he went to Rome where he was deeply influenced by Michelangelo's and Raphael's works. This stay gave rise to a number of portraits and religious pictures heavily influenced by the Mannerists. After the Sack of Rome in 1527 he spent a few years in Bologna only to return to Parma in 1531. He then painted the frescos known as *The Madonna of the Palisade* showing an extremely refined and stylized form of Mannerism. His output in this period was marked by an unnatural lengthening of figures in snake-like poses. One example of this is his unfinished *Madonna with the Long Neck* in the Uffizi. In the last years of his short life, Parmigianino reputedly retired from painting to concentrate on alchemy.

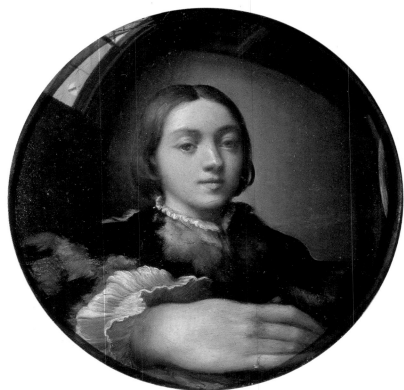

Parmigianino
Autoritratto in uno specchio convesso/Self-Portrait in a Convex Mirror

c. 1524, wood panel, Vienna, Kunsthistorisches Museum.

This famous painting was nothing less than a virtuoso tour-de-force. It simulated the way in which the face, hand and the whole room are distorted when they are reflected in a convex mirror. Parmigianino took this picture to Rome to use it as a calling card that demonstrated his talent.

Parmigianino
Visione di san Gerolamo/
Vision of St. Jerome

1526–27, wood panel,
London, National Gallery.

Painted during his stay in Rome, the way in which the bodies are strongly contorted shows Parmigianino's own interpretation of Mannerism. For him this was a striking yet ambiguous way of impressing the viewer.

Parmigianino
Portrait of a Young Woman known as Antea

1524–27, canvas, Naples, Museo di Capodimonte.

The highly finished way in which this portrait was painted produces an effect almost of magical hyper-realism. It was this quality that made Parmigianino an excellent and fascinating portrait-painter. The faces of his sitters often shows expressions of doubt, tension, or suppressed emotion which ooze out of their often icy immobility.

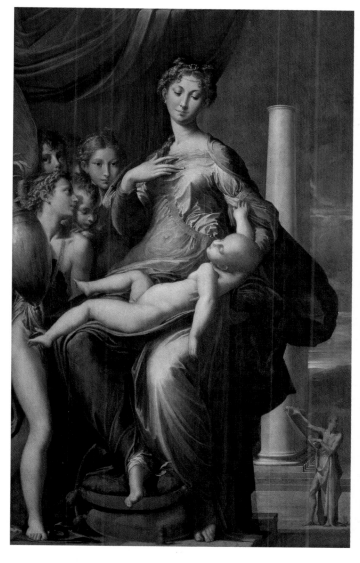

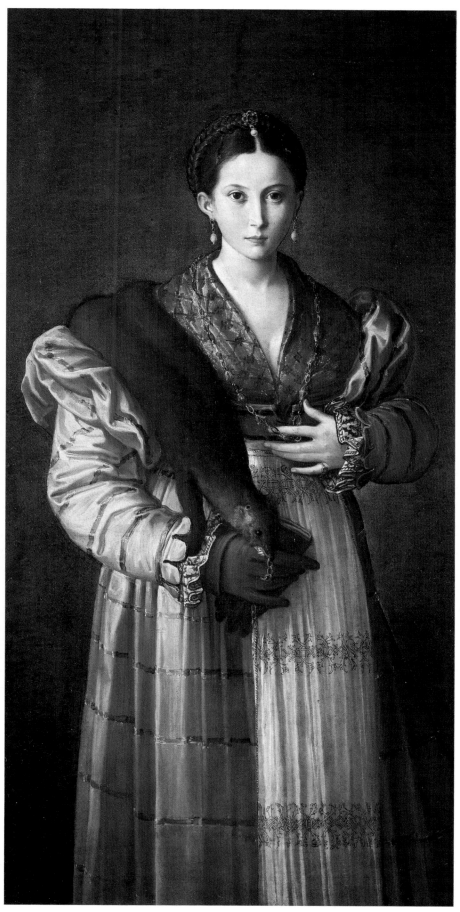

Parmigianino
Madonna col Bambino, angeli e san Girolamo (Madonna dal collo lungo)/Madonna and Child with Angel and St. Jerome (Madonna with the Long Neck)

1534–35, wood panel, Florence, Uffizi.

Despite the time it took to paint and the difficulty of the work itself, this celebrated painting remained unfinished. It is the masterpiece of Parmigianino's œuvre and epitomizes his own hyper-sophisticated version of Mannerism. The figures, which are portrayed with an unnatural but flexible elegance, stretch anatomical likelihood to its limit. Limbs are unnaturally lengthened while mysterious symbols endow the scene with its esoteric but mysterious dimension.

Gaudenzio Ferrari

Valduggia (Vercelli), 1475/80–Milan, 1546

Gaudenzio was an original and powerful artist, unduly neglected because much of his work is inaccessible. Influenced by Leonardo, his eclectic talents allowed him to incorporate the latest ideas. At the Sanctuary of Sacro Monte the fusion between landscape, architecture, painting and sculpture turned the sanctuary chapels near Varallo into a total work of art. His own artistic background was the Lombard school but there was also an element of Perugino in his art. Gaudenzio's first mature work was a large dividing wall for S. Maria delle Grazie at Varallo (1513) followed by two Sacro Monte chapels' works: *The Adoration of the Shepherds* and *Calvary*. Here Gaudenzio produced both sculptures and frescos, harmoniously blending the elements. He managed to repeat this in later works, such as the frescos and altarpiece in S. Cristoforo in Vercelli (1529–34), and in some late paintings that he produced in Milan.

Gaudenzio Ferrari
Polittico di Novara/
Novara Polyptych

*1514–21, wood panels,
Novara, S. Gaudenzio.*

This monumental altar includes many parts that were exquisitely drawn and delicately expressed.

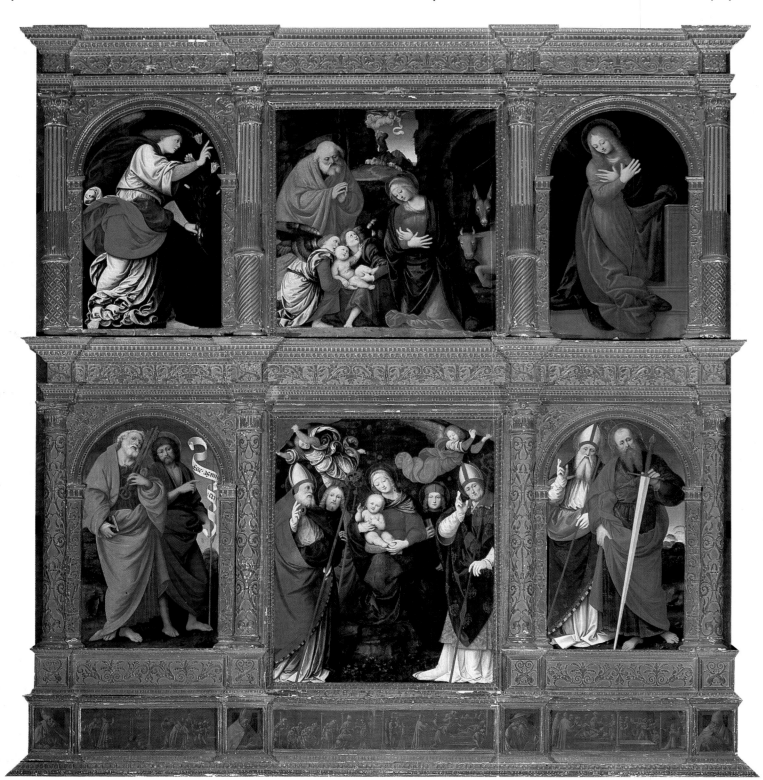

Gaudenzio Ferrari
Crocifissione/Crucifixion

1513, fresco, Varallo Sesia (Vercelli), S. Maria delle Grazie.

This is the central scene from the large dividing wall of the convent church, located at the start of the road leading to the Sacro Monte at Varallo. The overall structure of the monumental composition (which comprises a sequence of pictures showing episodes from the life and passion of Christ) is very much in the Lombard-Piedmontese tradition of frescoed dividing walls. Nevertheless, in every scene Gaudenzio tried out emotionally-charged compositional ideas or new methods of painting perspective and light. It was here that he did the groundwork for the Sacro Monte chapels where *The Scenes from the Passion of Christ* achieved both overwhelming popular appeal and artistic nobility. *The Crucifixion* is an excellent example of how Gaudenzio was able to mix traditional features (the helmets, coats of armor, and bridles which are shown in relief) with novel figurative allusions from Perugino to Leonardo. The whole thing is underpinned by Gaudenzio's narrative and dramatic power which pulls all the characters into a single, engulfing wave of feeling. Following the church's advice in the *Devotio Moderna*, Gaudenzio sets all the gospel episodes in his own day. At the foot of the Cross, to the right, we can see two people from Varallo accompanied by a boisterous dog and sweet women with babies in their arms. These sunny, everyday, images contrast sharply with the ugly, caricatured faces of the soldiers who are playing dice for Christ's clothes.

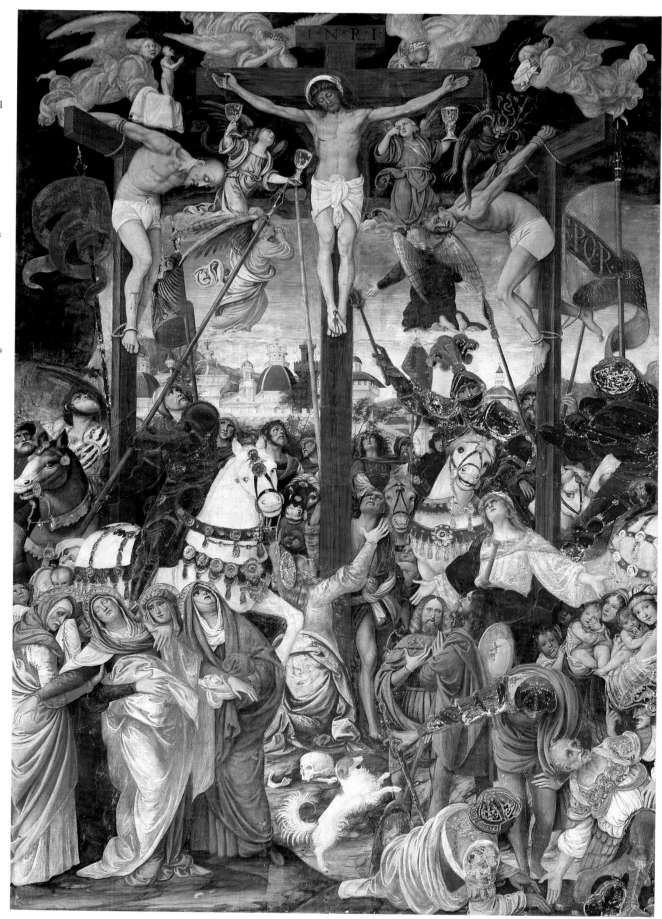

Pordenone

*Giovanni Antonio de' Sacchis, Pordenone,
c. 1483–Ferrara, 1539*

Named for the north Italian town where he was born, Pordenone is too often written off as a weird provincial rival to Titian. After training with an unknown master, Pordenone produced his first works in Friuli soon after 1510. These show the influence of Giorgione and Titian mingling with that of German woodcuts, especially Dürer's prints, and Mantegna's illusionism. During a trip to Rome he saw the work of Michelangelo and Raphael, which added solidity to his art. Later, he absorbed certain Mannerist influences. After painting illusionistic frescos for the Malchiostro Chapel in Treviso cathedral – a first for Venetian art – Pordenone began painting the frescos on the inner façade and the main nave of Cremona cathedral (1520–22) which show his gift for depicting bizarre groups of figures in melodramatic situations. This gift was confirmed in the doors he created for the Spilimbergo organ. After a brief period in Venice, in 1530 he went to work in Emiliao. Bolstered by new stimuli learned from Correggio and Parmigianino, Pordenone tackled the Venetian art world again, becoming for a moment a real rival to Titian. He died in Ferrara, where he had gone to design tapestries for the Duke.

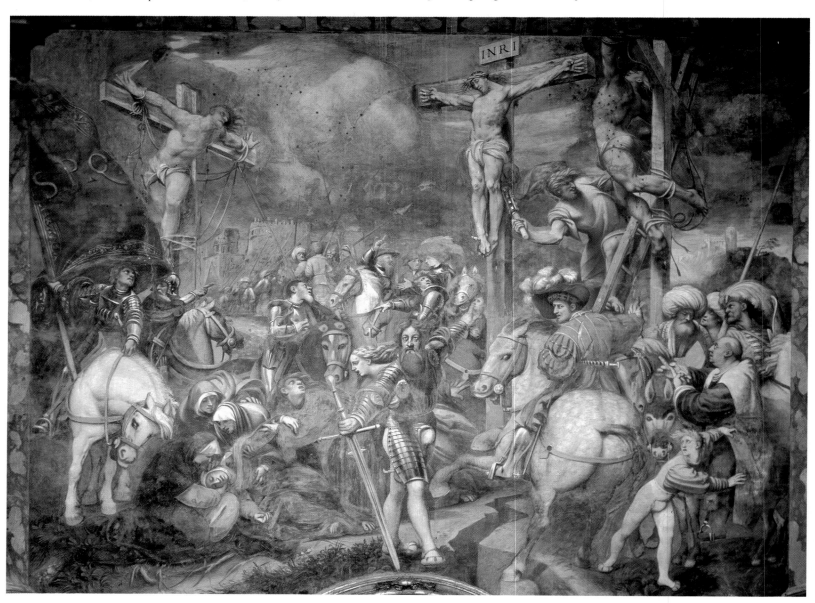

Pordenone
Crocifissione/Crucifixion

1520–22, fresco, Cremona, cathedral.

Located on the inner façade of the cathedral, this is the most impressive of the murals of the *Passion of Christ* that were the contribution of Pordenone to the large-scale decorative cycle painted by various artists in Cremona cathedral. The ample space offered by the Romanesque building allowed Pordenone to give free rein to his violent, dramatic, and highly-charged theatrical vein. The composition has the air of a painterly whirlwind and was much appreciated by the public.

It was a fundamental departure from the traditional way that Calvary had previously been shown. The muggy, storm-laden atmosphere conjures up amazing effects of light. The three crosses are arranged in an asymmetrical fashion and are viewed from an angle. The crowd mills around uncomfortably and the dramatically foreshortened horses have an almost demonic look about them. The entire composition focuses around the tall mercenary at the center. When he took over the job of painting the frescos in the cathedral of Cremona from Romanino, Pordenone revolutionized the local school.

Pordenone
Madonna in trono e santi/Madonna and Child Enthroned with Saints

c. 1525, Susegana (Treviso), parish church.

Pordenone's enormous artistic freedom compared to the main Venetian school is beautifully expressed in this altarpiece. The traditional layout of the scene is subverted by the asymmetrical architectural backdrop behind the group. It is also upset by the uneasy but effective way that each member of the group is gesticulating.

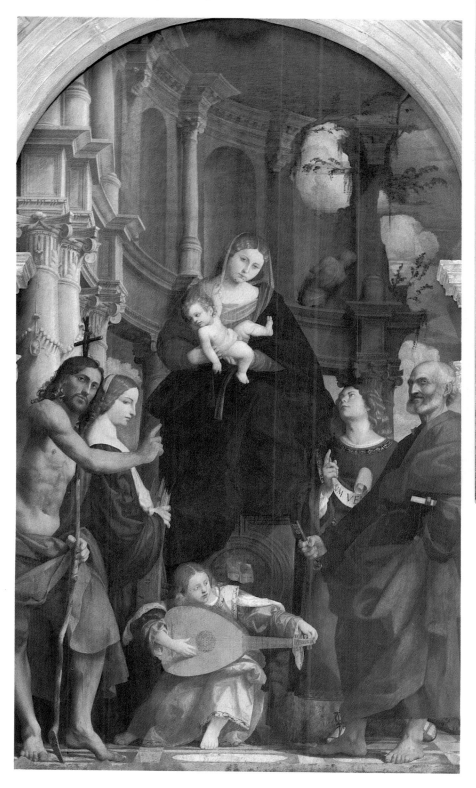

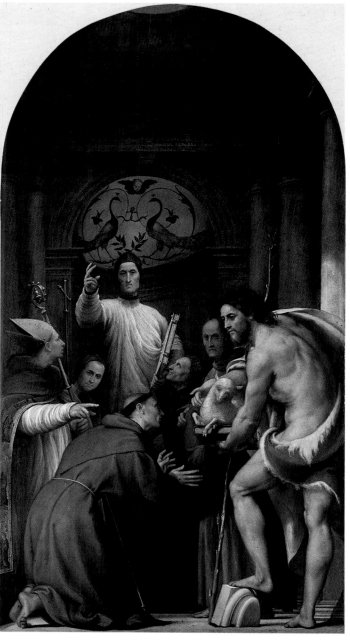

Pordenone
Pala di san Lorenzo Giustiniani/St. Lorenzo Giustiniani Altarpiece

detail, 1532, canvas, Venice, Gallerie dell'Accademia.

This was the most important altarpiece that Pordenone painted in Venice, where surprisingly little of his work survives. It can be read almost as his manifesto. The painter started from a premise familiar to Venetian tradition (the group of figures against the background of an apse decorated with gold mosaics which is reminiscent of Giovanni Bellini). However, his muscular poses and the way the figures relate to each other make full use of the vocabulary of Mannerism. The deadened tones and the almost foggy quality of the light were a direct challenge to Titian's strong rich colors.

213

Gerolamo Romanino

Brescia, c. 1484/87–1562

Romanino was the principal Renaissance painter in Brescia. His own training had been gained partly in Milan, partly in Venice. The influence of Titian had a strong and immediate effect on his art. This can be seen in both the large Paduan altarpiece (1513) and no less in the grandiose *Sacra Conversazione* that he painted for the church of S. Francesco in Brescia (1517). From 1517–19 he worked on the decorative cycle in Cremona cathedral, where he was later replaced by Pordenone. Between 1521–24 he painted a cycle of canvases for the Chapel of the Santissimo Sacramento in the church of S. Giovanni Evangelista in Brescia. The cycle was characterized by a solid, human, and sometimes even bitter brand of realism. This was followed by a series of altarpieces and frescos in Brescia and the surrounding area, always typically drawn from real life. In 1531 Romanino went to Trento to paint murals in Buonconsiglio castle. After this aristocratic commission was completed, he painted a group of frescos in the Valcamonica area in which his powers of expression almost changed into caricature. Romanino was tireless in his creation of evocative images and he found more and more work in Brescia, Verona, Modena, and a string of smaller towns. As he matured, the visionary and grandiose sense he brought to his scenes gradually increased.

Gerolamo Romanino
La paga agli operai/
Paying the Workers

1531–32, fresco, Trento, Buonconsiglio Castle, Garden Staircase.

Buonconsiglio castle was a grand Renaissance palace built by the ambitious Archbishop Bernardo Cles. How to decorate its elegant residential quarters was a brain-teaser that Romanino had to solve. He managed to convey an atmosphere of sumptuous richness through his frescos without compromising his trademark of a muscular — almost brutal — sense of reality.

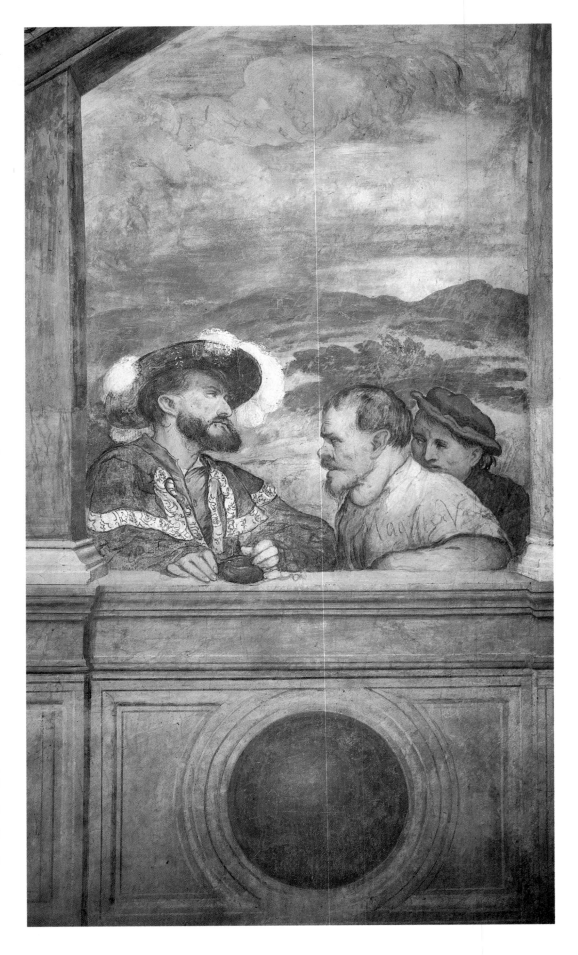

Gerolamo Romanino
S. Giustina Altarpiece

1514, wood panel, Padua, Museo Civico.

Romanino painted this splendid altarpiece when he was still quite young. It is preserved in its entirety and in its original frame. It provides early proof of the interest that Romanino would nurture in Titian's first paintings. The full and clear richness of Titianesque colors was to remain a constant of Romanino's œuvre. To this he also brought his own search for a highly concrete reality.

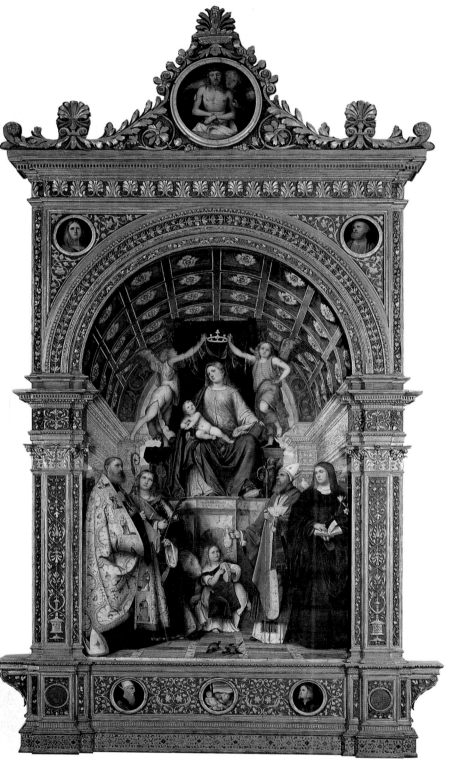

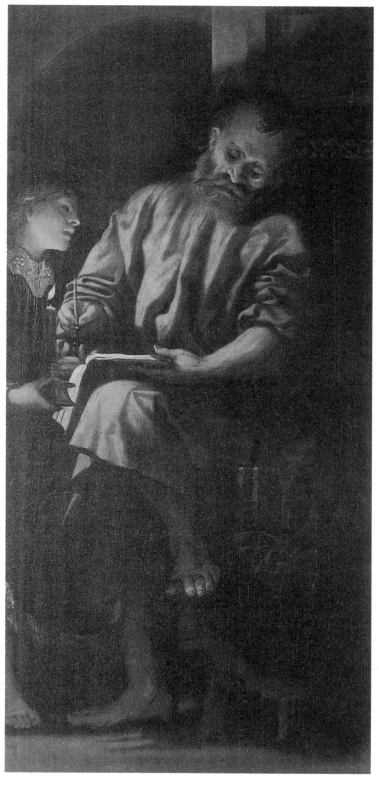

Gerolamo Romanino
San Matteo e l'angelo/St. Matthew and the Angel

1521–24, canvas, Brescia, church of S. Giovanni Evangelista, Chapel of the Sacrament.

Romanino's love of realism reached its height in his dense night scenes. Art critics sometimes see in these the forerunners of Caravaggio's radical painting.

215

Giovan Gerolamo Savoldo

Brescia, 1480/85–c. 1548

Savoldo was the most accomplished of sixteenth-century Brescian painters. He carefully studied the effects of light and reflections in a way that was most unusual for the time. Even though Savoldo spent much of his artistic career in Venice, he is considered to be part of the Brescia school. One reason for this is that many of his patrons were from his native city, but it is also because of his links to the current of realism and acute psychological portrayal. This could be found both in Renaissance Brescia, exemplified by Romanino, and Bergamo, as seen in Lotto and later Moroni. Savoldo may have begun working in Florence, where he is first documented, but he was working in Venice by around 1520. His œuvre was wide-ranging. He painted altarpieces (including the grandiose one now in the Brera in Milan), portraits, and religious paintings for private collectors. He often replicated these in a number of different versions, such as the beautiful *Mary Magdalene* or *The Rest on the Flight to Egypt*. During the 1520s Savoldo's painting was brightened by glowing light, vivid colors, and silvery effects, often using the device of a reflection in a mirror. In the following decade, his light grew duller as he became interested in more delicate and smoky landscapes and intimate pictures with a poetic melancholy tone. Good examples of this type of painting can be seen in the Pinacoteca Tosio-Martinengo in Brescia and include Romanino's *Portrait of a Flautist* and his best version of the *Adoration of the Shepherds*.

Giovan Gerolamo Savoldo

Tobiolo e l'angelo/Tobias and the Angel

c. 1527, canvas, Rome, Borghese Galleria.

During the first ten years that he worked in Venice, Savoldo developed his own extremely sensitive response to Titian's use of color and light. He translated this into sparkling vibrations. But he never lost his mainland sense of realism which is the hallmark of all his work.

Giovan Gerolamo Savoldo

Adorazione dei pastori/ Adoration of the Shepherds

c. 1540, wood panel, Brescia, Pinacoteca Tosio-Martinengo.

This is a fine example of Savoldo's mature work. He painted various versions of the same ever-popular subject, but the Brescia painting is the most concentrated and convincing. It reveals Savoldo's appealing poetic sentiment which is demonstrated through the simple and direct gestures of the characters, fully expressing their humanity. The light is subtle and the details build up an impressive feeling of realism. Savoldo's true forte was for night scenes like this, which let him give his liking for unusual light effects full play. Particularly noteworthy is the contrast of the dark background and the brilliantly yet softly illuminated figures in the foreground.

Paolo Veronese

Paolo Caliari, Verona, 1528–Venice, 1588

Paolo Veronese was one of the greatest Renaissance artists in Venice, along with Tintoretto dominating the city's art in the generation after Titian. He was also one of the world's most brilliant decorative painters. His luminous palette seems to portray Venice in its Golden Age as a radiant, happy republic. In fact, the times were darkened by defeats in war and outbreaks of plague. This hardly troubled Veronese, who loved to turn any subject into a sunny, happy pageant. Almost everything he painted – pagan tales, obscure allegories, altarpieces, even solemn Biblical stories – became an excuse to express his love of life and of painting. After training in his native Verona, Veronese soon established his own distinctive style, with such success that by 1553 he was in Venice working in the Doge's Palace. From then on, Veronese was one of Venice's main official artists. His paintings were both lucid and grandiose, relying on classical architectural backgrounds and strikingly rich colors. However, the resplendent *Last Supper* he painted in 1573 attracted the attention of the Inquisition, who objected to its "buffoons, drunkards, dwarfs." Claiming artistic license, Veronese simply changed the title to *Feast in the House of Levi*. In the 1560s he produced decorative masterpieces for the Villa Barbaro at Maser, which brilliantly harmonize with the architecture of Andrea Palladio: sunny frescos, delighting in beauty, youth, and the harvest. In the 1560s he produced a series of shimmering paintings for Venetian churches. In his later years his art sobered a little and grew more reflective but even more elegant, and showed signs of genuine religious feeling. His state commissions now involved the rebuilding and redecoration of the Doge's Palace.

Veronese

Trionfo di Venezia/
Triumph of Venice

detail, 1583, canvas, Venice, Doge's Palace, Sala del Maggior Consiglio.

Set into the ceiling of the great chamber where the Venetian patricians (oligarchs) met, the oval picture celebrates the glory of Venice, reminding the world that it was still wealthy and strong despite the recent loss of Cyprus to the Turks and an outbreak of plague. Veronese again created exuberant scenes, with solidly fleshed allegorical ladies supported on clouds as they salute the equally solid personification of the Republic. The background architecture is typically grandiloquent.

On the opposite page
Veronese
Marte e Venere incatenati da Amore/Mars and Venus

c. 1580, canvas, New York, Metropolitan Museum.

Veronese may originally have painted this delightful canvas for Rudolf II's famous collection of art and natural curiosities which the Habsburg emperor assembled in Prague. The way in which the picture was painted, with the rich but darkly colored background, the overall atmosphere of heaviness, and a certain underlying melancholy are typical of his later works, which were relatively muted in tone.

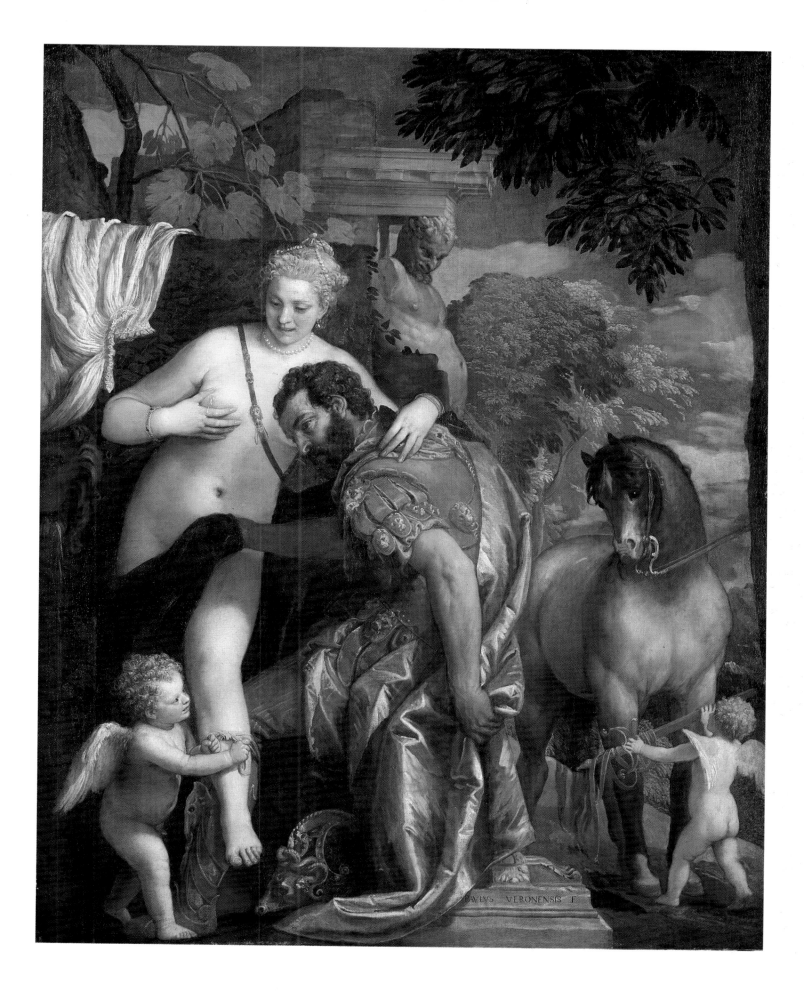

Veronese
Decorations in the Rooms on the Piano Nobile

detail, c. 1560, frescos, Maser, (Treviso), Villa Barbaro, Sala dell'Olimpo.

The fresco cycle that Veronese painted for the villa Palladio built for the brothers Marcantonio and Daniele Barbaro is one of Veronese's personal high points but also marks a zenith in Renaissance art as a whole. The luminous structure of Palladio's villa gave Veronese the chance to work in large, spacious, and logically-arranged rooms.

The subjects shown in the frescos follow a complex iconographic program (very probably devised by the Barbaro brothers themselves as they were both highly cultured Renaissance humanists). Veronese, however, managed to transform even the most obscure allegory into tangible, credible, and joyful figures. The general design of the murals was meant to celebrate the joys of family life and rural pursuits. But his subject-matter (cleverly depicted as he used the same landscapes that could be seen through the large windows) was merely a pretext. Endless visual puns and amazing architectural trompe l'œil – especially the two women below – are intermixed with resplendent male and female figures. In nearly all cases, Veronese created figures full of happiness and beauty. Veronese's color is transparent and the light is very clear. These were the effects that artists in the eighteenth century, in particular Ricci and Tiepolo, would seek to emulate.

Veronese
Bimbetta che si affaccia/ Little Girl Peeping Out

c. 1560, fresco, Maser (Treviso), Villa Barbaro.

This is perhaps the most charming detail of the entire cycle. The smiling little girl peeps round a half-open false door in the middle of the villa.

Veronese
La Musica/Music

1556–57, canvas, Venice, Libreria Marciana.

This is another composition set in a ceiling and was therefore subject to a specific viewpoint. Veronese secured the commission after a competition with another six painters of his own generation, and was awarded a prize of a gold medal which was presented by Titian, whose art he so greatly admired. Of the three canvasses painted for the ceiling in the Libreria Marciana, *Music* is the best known thanks to its wonderful compositional balance and the deep richness of the color, comparable to that used 30 or 40 years earlier by the young Titian.

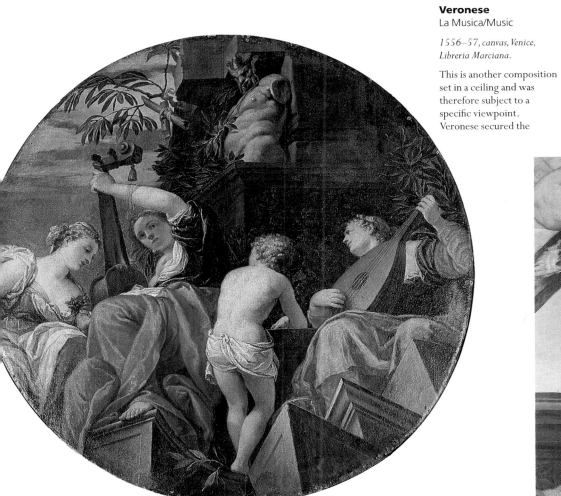

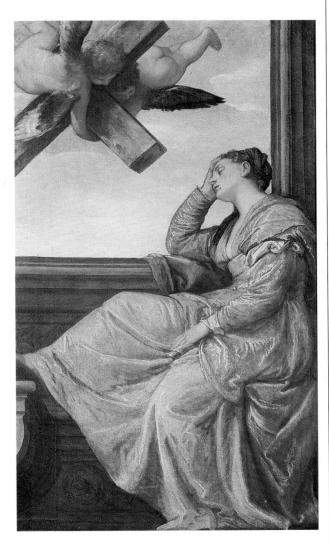

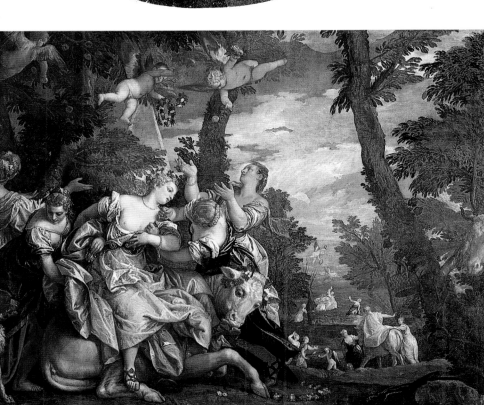

Veronese
Ratto di Europa/The Rape of Europa

c. 1580, Venice, Doge's Palace, Sala dell'Anticollegio.

This popular subject could become, in the hands of Titian, a terrifying scene of abduction. Typically, however, Veronese has treated the theme playfully and joyfully, although there is an obvious melancholic note underlying the overall glamor which is typical of his later art.

Veronese
Sogno di sant'Elena/ St. Helena: Vision of the Cross

c. 1570, canvas, London, National Gallery.

It was rare for Veronese to concentrate on a single figure. Here, St. Helena dreams of the Cross in front of an open window. The color is applied in super-imposed fine layers of color. This picture is one of Veronese's most delicate and moving works.

Veronese
L santi Antonio, Cornelio
e Cipriano/Saints
Anthony, Cornelius,
and Cyprian
c. 1567, canvas, Milan, Brera.

Even though he was
working within a traditional
layout, Veronese managed
to make the picture more
a light-hearted social
encounter than one filled
with religion. Everything
seems magnificent in an
interior that is lined with
precious marbles and
glittering gold.

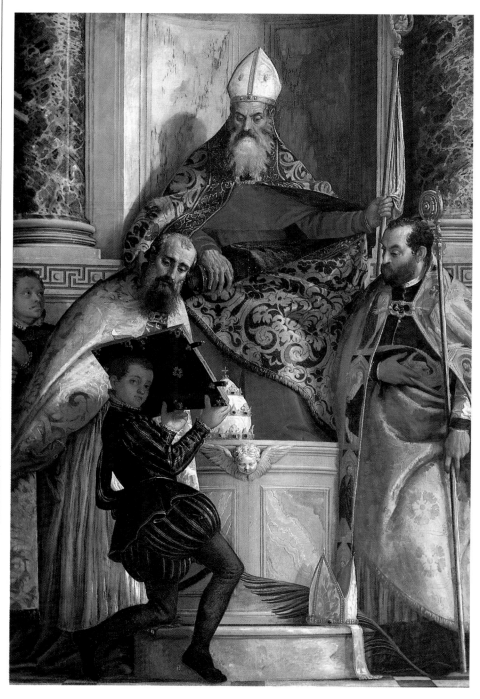

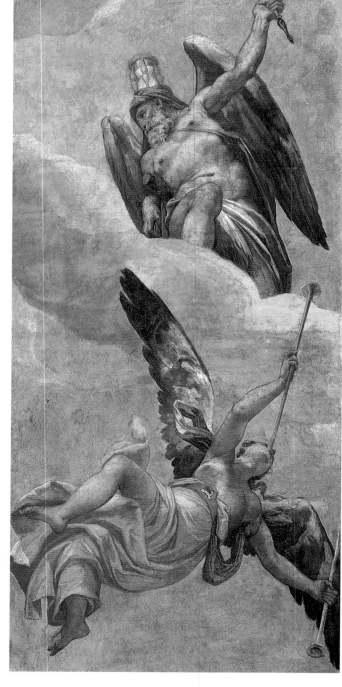

Veronese
Il Tempo e la Fama/
Time and Fame

*1551, fresco removed from the
wall, Castelfranco Veneto,
cathedral.*

This is the largest fragment
of what remains of the
frescos in Villa Soranzo
painted by Veronese and
Zelotti in 1551. They were
destroyed after they started
to come away from the wall
in 1818. It was Veronese's
first attempt at decorative
frescos on allegorical
subjects. He showed that
he already had many
immensely fresh and
inventive ideas about
composition coupled with a
markedly virtuoso use of
perspective. The wonderful
clarity of the light and the
monumental solidity of the
figures reveal that his chief
cultural inspiration at this
stage was the work of
Michelangelo and Raphael.

Veronese
Giunone versa i suoi doni su Venezia/Juno Bestowing her Gifts on Venice

1553–54, canvas, Venice, Doge's Palace, Sala del Consiglio dei Dieci.

This was one of the first ceiling decorations he painted in the Doge's Palace. He was only 25 when asked to decorate the ceiling in some of the meeting rooms.

Veronese
Aracne o la Dialettica/Arachne or Dialectics

1575–77, canvas, Venice, Doge's Palace, Sala del Collegio.

Veronese
Venere e Adone/Venus and Adonis

c. 1580, canvas, Madrid, Prado.

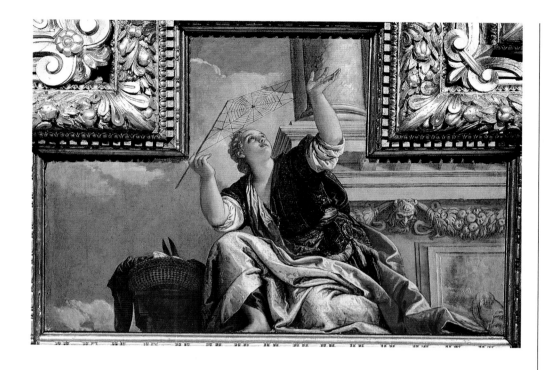

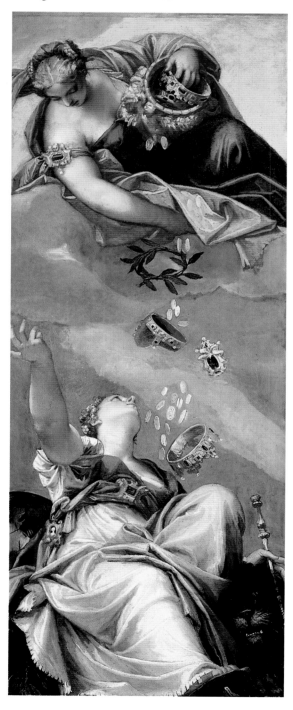

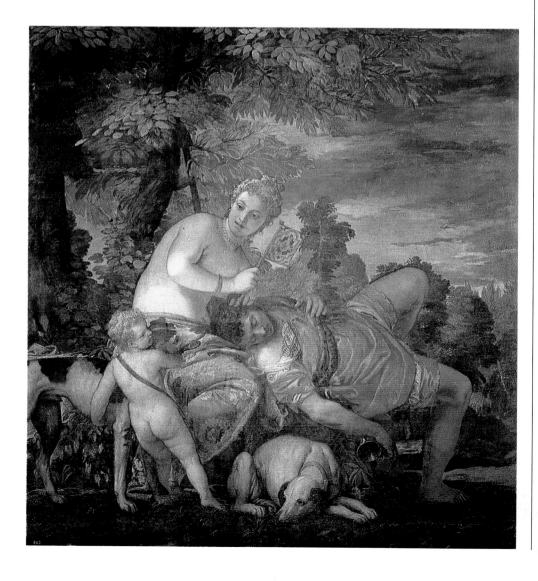

Tintoretto

Jacopo Robusti, Venice, 1519–94

Tintoretto was the last grand figure of Venetian Renaissance art. After his death, art in the Republic shrank to repetitive copies, chiefly of him. Tintoretto claimed to have been a pupil of Titian but Bordenone was a more likely master. No work can be ascribed to him before 1545, although he was already his own master. He burst onto the Venetian art scene with his spectacular *The Miracle of St. Mark* (1548, Venice, Accademia). He was hailed as a rival to Titian, and claimed to unite "the color of Titian with the drawing of Michelangelo," although in fact he was not much like either, being much more melodramatic in his art. Tintoretto certainly retained a Venetian love of color and light, but added grandiose gestures, muscular bodies, and amazing viewpoints in the fashion of the Mannerists. During the 1550s Tintoretto produced both mythological and religious scenes marked by fluid brushwork and very contorted poses. He was never daunted by tasks of colossal proportions and in 1564 started decorating the huge Scuola di San Rocco. In many respects, this work contains the story of his own development. From grandiloquent and crowded scenes, he moved on to intensely moving compositions until he reached the final, astoundingly visionary images in the rooms on the ground floor. Assisted by his own studio, which included his daughter Marietta, Tintoretto produced dozens of altarpieces for Venetian churches. From 1575 onward, he was also engaged in redecorating the Doge's Palace which he left off at the unfinished canvas of *Paradiso* in the Sala del Maggior Consiglio. By this time Titian and Veronese had died and Tintoretto was also old. His last works, including *The Last Supper* in S. Giorgio Maggiore, were markedly mystical, showing almost disembodied spirits soaring through the air. He had a great influence on El Greco.

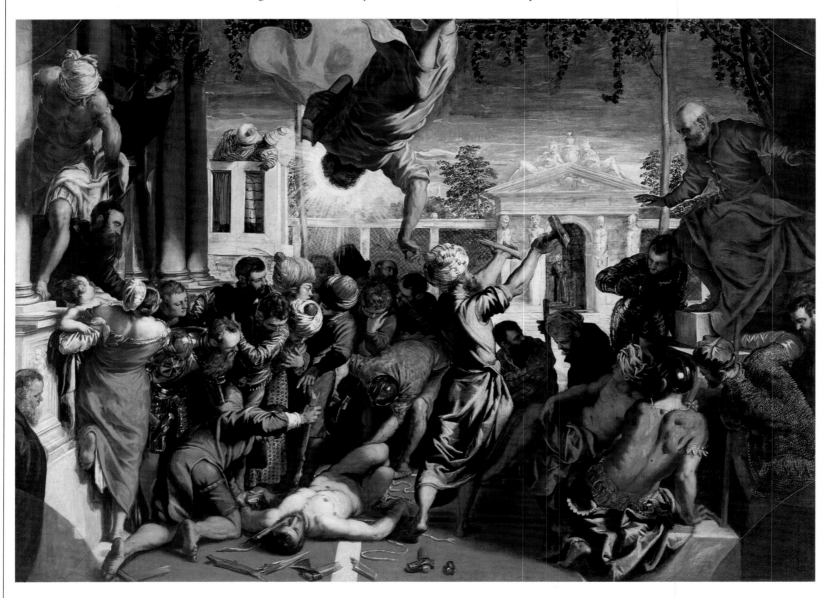

Tintoretto
Miracolo dello schiavo/
The Miracle of the Slave

1548, canvas, Venice, Accademia.

Pietro Aretino, Titian's literary friend, was among the many who greeted this huge canvas with much enthusiasm. It had been painted as part of the decorative program in the Scuola di San Marco (a religious fraternity, not a school). With it, aged 30, Tintoretto established his place as the leading artist of the new generation. But his work started some heated debate, with Titian reputedly being shocked. The dramatic and grandiose tone of the scene, its exaggerated foreshortening, the discrepancy between the detailed immediate naturalism and the unreal atmosphere of the miracle, were unprecedented in Venetian art, although the rich colors and the noble Renaissance architecture in the background were typically Venetian. Even though he claimed to stick to his twin reference points of Michelangelo and Titian, by now Tintoretto was in the process of discovering his own unmistakable, creative style.

Tintoretto
Cristo davanti a Pilato/
Christ Before Pilate

*1565–67, canvas, Venice,
Scuola di San Rocco, Sala
dell'Albergo.*

Tintoretto was not above
resorting to distinctly
dubious tricks to get the
better of his competitors.
He won the vital
commission for decorating
the Sala dell'Albergo, the
start of work in the Scuola
di san Rocco which was to
last for 23 years, by
sneaking into the room and
painting his specimen work
complete and in situ the
night before, while his
rivals could show only
rough sketches. The
brethren were of course
dazzled by his finished work
and awarded him the
contract. The walls of the
vast room are covered in
huge canvases showing the
Passion. The scenes were
arranged in a free order,
reflecting his own artistic
aims as much as the
Scuola's. Sincere and
intense devotion was
coupled with Tintoretto's
desire to push innovation
and his own talent to their
limits. In this picture the
figure of Christ appears
luminously frail and almost
disembodiedly spiritual
against the opulently
gleaming marble pillars
flanking Pilate's throne.

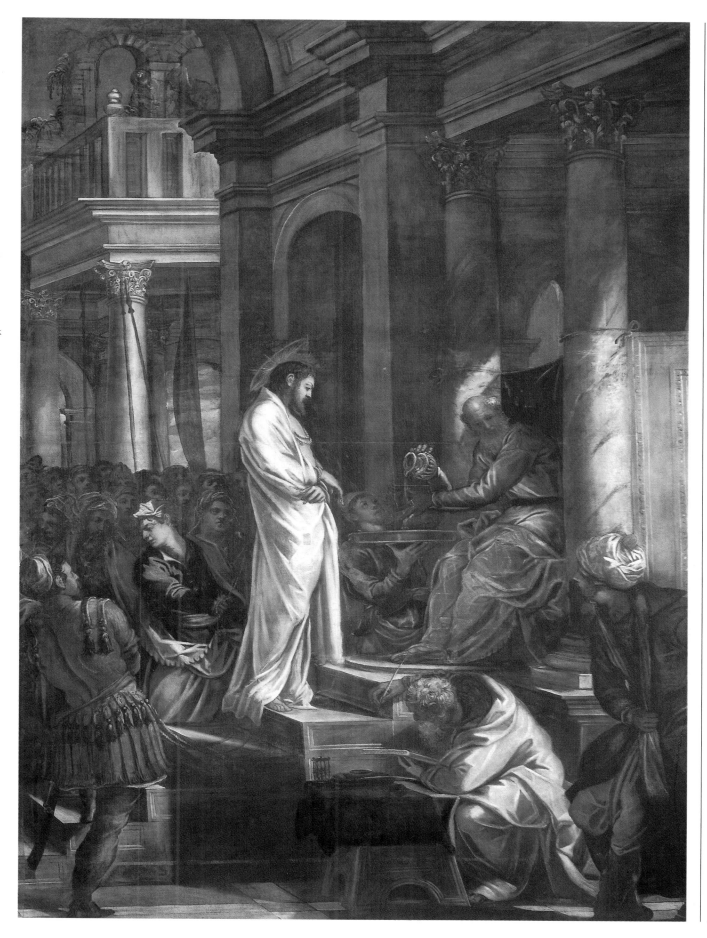

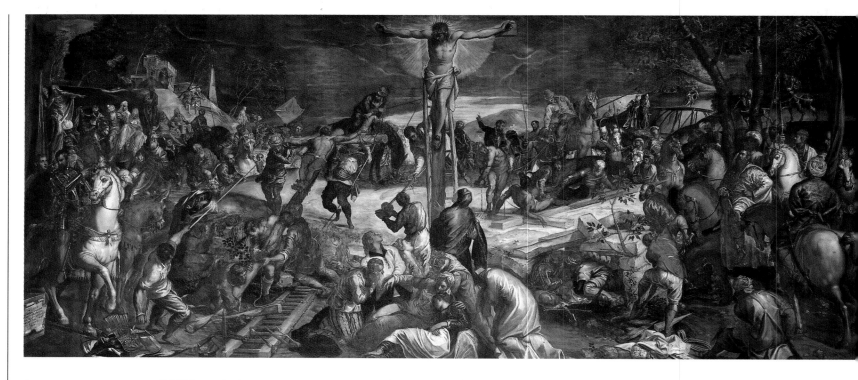

Tintoretto
Ritrovamento del corpo di san Marco/The Finding of the Body of St. Mark

1562–66, canvas, Milan, Brera.

Tintoretto was again commissioned by Tommaso Rangone, the Guardian Grande, or head of the Scuola, to do more paintings in the Scuola di San Marco. The new cycle consisted of three large canvasses (the first and third are *The Removal of The Body of St. Mark* and *The Miracle of the Saracen*, both in the Accademia). They represent a high point in Tintoretto's work. His penchant for unusual perspectives and dramatic positioning of characters are the key to his art. He secretly built wooden sets which he used to study and test his scenes, adding tiny wax and rag figures and experimenting with strange lighting effects. In the center of this canvas we can see the patron kneeling next to the body of St. Mark whose gigantic ghost stands on the left. St. Mark, as the patron saint of Venice, was a popular subject and this illustrates a true story.

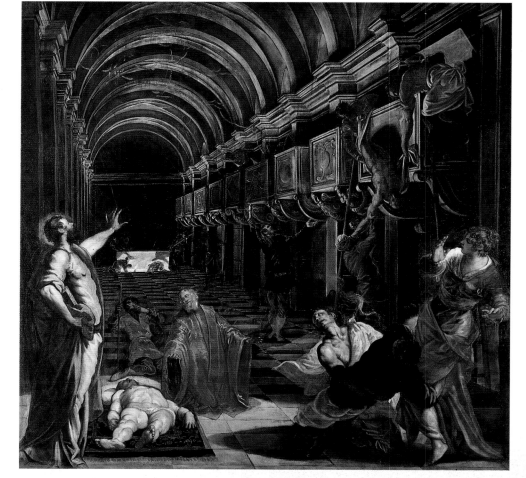

Tintoretto
Crocifissione/Crucifixion

1565–67, canvas, Venice, Scuola di San Rocco, Sala dell'Albergo.

This huge Crucifixion demonstrates Tintoretto's extraordinary ability to handle immense undertakings. It is the largest and perhaps most imposing of all the works in San Rocco, filled with an army of figures all vividly painted and all contributing to the general drama. The cunningly planted diagonals (one of them running up the cross of one of the thieves which is being raised) lead the spectator's eye up to the isolated figure of Christ on the Cross, right at the center of the work, so uniting the action. The officers of the Scuola, who used to sit directly beneath this giant canvas, must surely have been overwhelmed by its majesty. Copying the work has often been used as a training exercise for young painters so they could learn to combine the coherence of the whole with the vastly varied descriptive detail.

Tintoretto
Filosofo/Philosopher

1570, canvas, Venice, Libreria Marciana.

This was one of a series of 12 images of thinkers, five painted by Tintoretto, that were placed along the walls of the reading room of Sansovino's fine new library. For once, he was not asked to produce a narrative scene crowded with drama and people. In these expressive canvasses, Tintoretto effectively showed his ability to concentrate his virtuoso style and light effects onto a single figure.

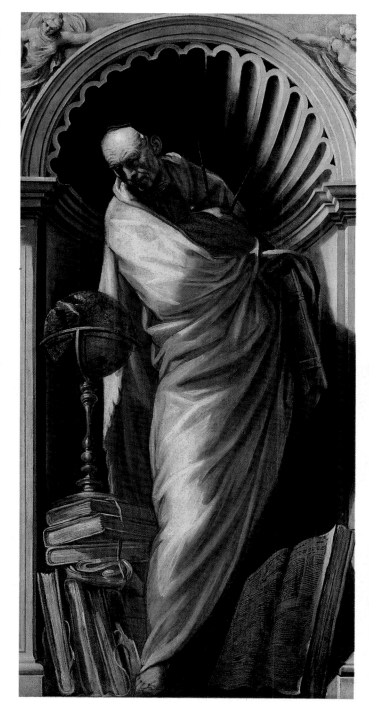

On the preceding page
Tintoretto
Santa Maria Egiziaca/
St. Mary of Egypt

1583–88, canvas, Venice,
Scuola di San Rocco, ground
floor room.

This is one of Tintoretto's
eight large canvasses in the
ground floor room of the
Scuola di San Rocco. In this
series of works, his art
moves onto new poetic
heights, especially obvious
in his remarkable treatment
of the landscape and the
gentle, almost tranquil way
in which he shows St. Mary,
a former prostitute who
went into the desert to
repent. Tintoretto was
personally committed to
this particular task, leaving
most of the really even
more prestigious work of
finishing paintings for the
Doge's Palace to his pupils.
It was most often when he
painted landscape scenes
that Tintoretto found the
gentle note sometimes
missing in his œuvre. The
natural elements – trees,
water, animals – are all
bathed in a radiant but
vibrant light, gleaming
strangely as if covered in
phosphorus. This gives
them an inner intensity,
almost as if revealing their
own souls. In this respect,
St. Mary of Egypt has
almost been considered
a forerunner of the
developments that would
dominate seventeenth-
century painting.

On the following page
Tintoretto
Adorazione dei pastori/
Adoration of the
Shepherds

1577–78, canvas, Venice,
Scuola di San Rocco, upper
room.

Tintoretto considerably
extended the far more
modest program he was
initially asked to undertake.
He threw himself into the
work with typical
enthusiasm and a desire to
create radically new
decorative schemes for the
main salon of the School.
The common thread in the
biblical scenes on the
ceiling is the way the Old
Testament foreshadows the
sacrifice of the Eucharist.
The paintings were
designed to be viewed from
below and highlight
Tintoretto's genius for
finding new, remarkably
effective, points of view.
The canvases on the walls
are linked in theme to those
on the ceiling but show
scenes from the New
Testament. This set
Tintoretto a tricky problem
because these canvases
were unfortunately set
between the windows
where there was little light.
Nevertheless, he managed
to make these limitations
work to the advantage of his
paintings by including a
large number of plays on
light and other evocative
ideas.

Tintoretto
Ultima Cena/The Last
Supper

1592–94, canvas, Venice,
S. Giorgio Maggiore.

Tintoretto's final works
were done for the apse of
the spacious church of S.
Giorgio which had recently
been built to Palladio's
design. Yet again Tintoretto
divided his compositions
into contrasting groups of
figures. This was used to
painful effect in The

Deposition. The Last Supper
contains Tintoretto's final
attempt to push his use of
lighting to its bounds. In this
case, he provides light from
two distinct sources. The
ambiguous way the painting
shifts between reality and
miracle produces a moment
of great poetry and deep
mysticism. This is further
heightened by the
evanescent figures of the
angels floating in the gloom
above the scene of *The Last*
Supper.

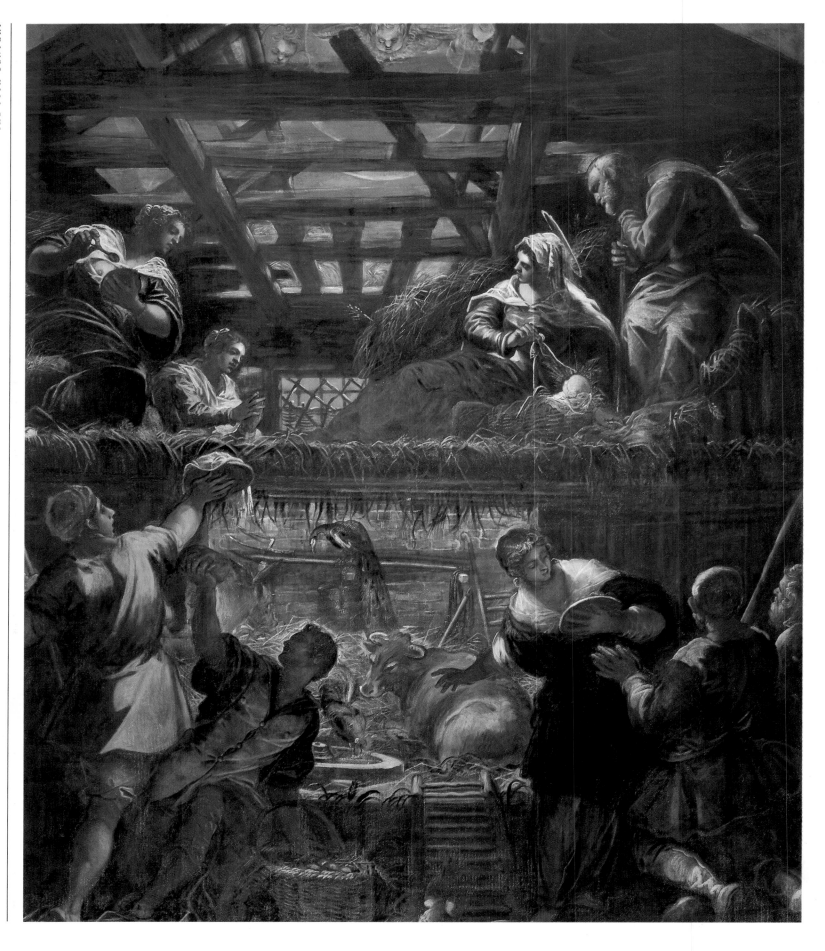

Jacopo Bassano

Jacopo da Ponte, Bassano (Vicenza),
1510/15–92

Jacopo was a powerful provincial painter at the end of the Venetian Renaissance and himself came from a numerous family of Bassano painters. Even though most of his career was spent in small or middle-sized towns on the mainland, he always remained alert to the latest developments in art and won some renown in Venice itself. He also had the ability to devise new ideas for compositions that possessed great force of expression. Trained in his father's studio, Jacopo broke away from the local popular and devotional tradition by studying prints by Raphael and developments in Mannerism. During the 1540s his painting was experimental, the anatomy of his characters was forced and their postures unnatural. This phase proved crucial in the development of his own very personal style which was capable of assimilating new ideas and translating them into an art with enormous communicative power. Jacopo Bassano's popular realism was underpinned by his exceptional use of light and characterized by the lifelike quality of the people and details, especially the animals, in his pictures. Over the years his oeuvre became increasingly grand and dramatic, starting with a series of altarpieces (in Bassano, Treviso, Padua, and Belluno) whose production dates from the 1550s through to the end of his career. His four painter sons increasingly contributed to his output, carrying on his studio after his death.

Jacopo Bassano
San Valentino battezza santa Lucilla/St. Valentine Baptizing St. Lucilla

c.1575, canvas, Bassano del Grappa, Museo Civico.

An extraordinary burst of light bounces off the characters, casting silky reflections on the robes and making the gold glimmer. The painter produced this masterpiece when he was well into his middle age. It gives us tremendous insight into his enormously innovative power which fell between popular realism and magical effects. It is astounding to think Jacopo Bassano was able to produce paintings of this stature when he was so removed from the major centers of art.

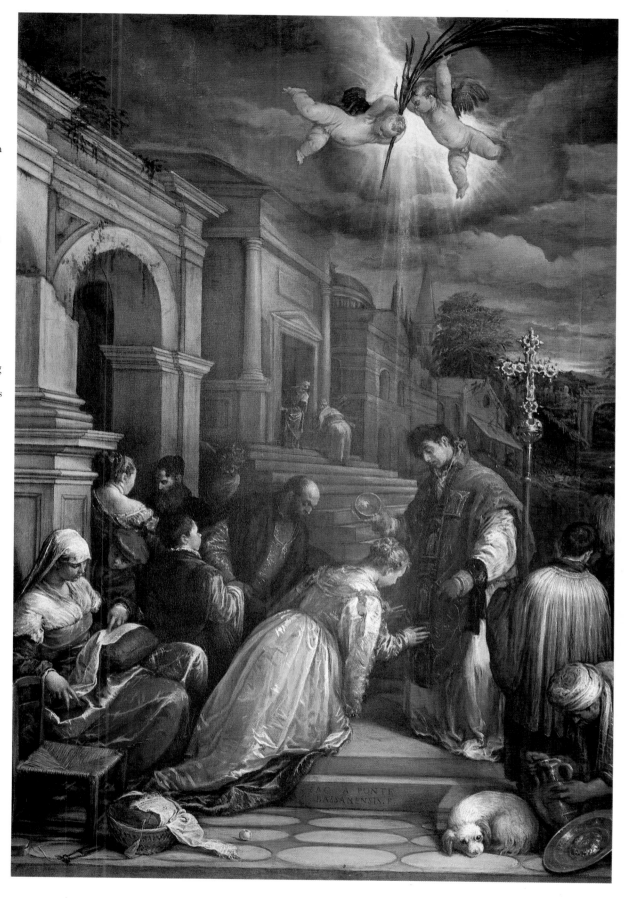

Jacopo Bassano
Il Paradiso terrestre/The
Earthly Paradise

*c. 1570–75, canvas, Rome
Galleria Doria Pamphili.*

Even though Jacopo
Bassano chose to remain in
his native town, his fame
spread quickly among
collectors thanks to
paintings into which he
poured his genuine love
of nature, animals, light,
and the colors of the
countryside.

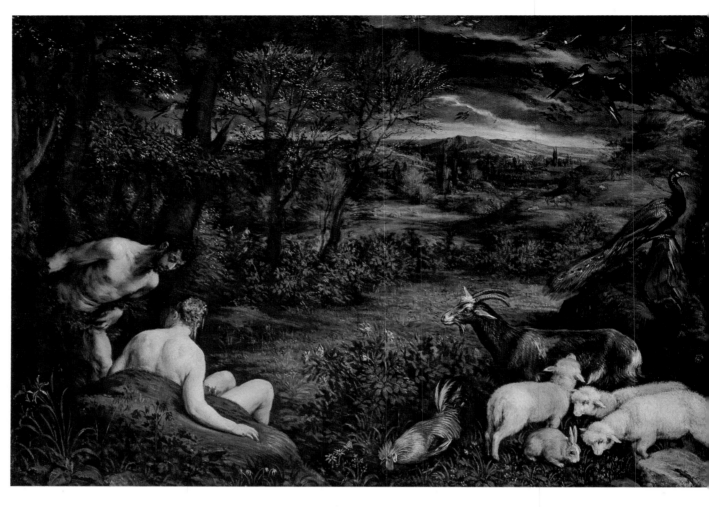

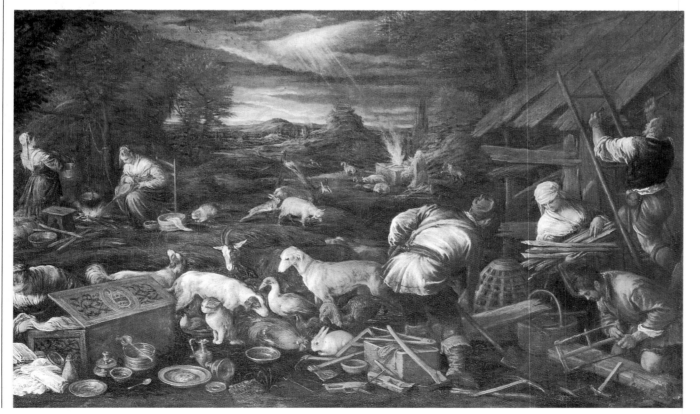

Jacopo Bassano
Sacrificio di Noè/
Noah's Sacrifice

*c. 1574, canvas, Potsdam,
Staatliche Schlösser und
Gärten Potsdam-Sanssouci.*

This work is typical of
Bassano's mature painting.
The painter uses the biblical
episode of Noah coming
out of the ark to paint yet
again a huge number of
animals. This type of
composition, where the
subject is obviously only an
excuse for painting the
countryside and nature,
especially animals, was a
huge success in the art
market of the day. Jacopo
Bassano and his sons
continued to produce many
such scenes.

Giovan Battista Moroni

Albino (Bergamo), 1520/24–Albino, 1578

Moroni was one of the greatest, albeit the shyest, portrait painters of the sixteenth century. Recent critical work has highlighted his abundant production of religious painting and altarpieces which developed the ideas originated by Renaissance painters of the Brescia school. Nevertheless, the expressive power of his portraits is sufficient to classify Moroni as a specialist. After serving his apprenticeship with Moretto in Brescia, Giovan Battista Moroni spent nearly all his career in and around Bergamo, where he continued Lotto's tradition. The only deviance to this were two periods spent in Trento (1548 and 1551) when the Council of Trent was in session. On both occasions Moroni painted a number of works (including the *Altarpiece of the Doctors of the Church* for the church of S. Maria Maggiore). It was during his stays in Trento that he also made contact with the Madruzzo family and with Titian. From the 1550s onwards, in fact, Moroni was often commissioned as an alternative portraitist to Titian. A whole stream of provincial lords and ladies took it in turns to sit for him. The result is a series of portraits of people full of dignified humanity and concrete in every sense. Heroism is not in their vocabulary, but they are all well grounded in everyday life. His religious paintings are rarer, but we should at least mention *The Last Supper* in the parish church at Romano in Lombardy.

Giovan Battista Moroni

Il cavaliere in rosa/
The Gentleman in Pink
(Gian Gerolamo Grumelli)

1560, canvas, Bergamo, Collezione conti Morosini.

Moroni's style was already mature when he painted this splendid picture which summarizes his qualities as a portrait-painter. There is an intense truthfulness about the face of the sitter whose clothing and environment are littered with symbolic allusions. Moroni's sense of light and color can neatly be linked to the Bergamo tradition established by Lorenzo Lotto but perhaps even more to the Brescia school.

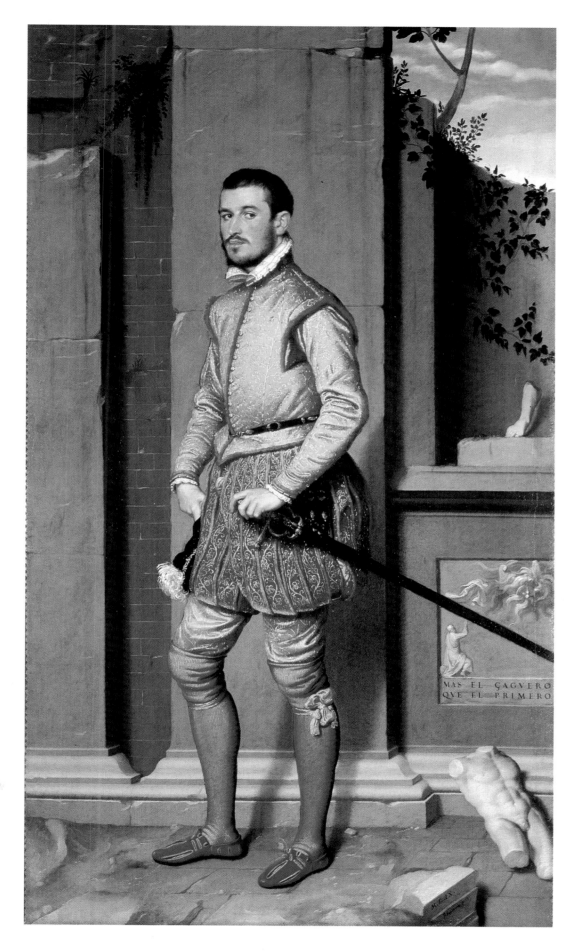

Giuseppe Arcimboldi

Milan, 1527–93

In the middle of the sixteenth century Arcimboldo made a normal debut with youthful works including designs for windows and tapestries respectively in Milan and Monza cathedrals and frescos for the cathedral of Como. None of these gave any inkling of the bizarre originality he would soon develop. In 1562 he was summoned to the Imperial court in Prague and almost immediately his original and grotesque fantasy was unleashed. He composed portraits and allegories by superimposing a variety of objects. Arcimboldo's style has been so often imitated over the centuries that it is sometimes difficult to make exact attributions. He has been seen by some as the forerunner of Surrealism in our own century, but, more to the point, he should be seen in his own context at the end of the Renaissance. This was a time when people (collectors and scientists alike) were beginning to pay more attention to nature. Arcimboldo really created the fantastic image of the court in Prague, creating costumes, set designs, and decorations. Emperor Rudolf II set him the task of researching and buying works of art and natural curiosities, as well as giving him countless commissions for paintings. In 1587 Arcimboldo went back to Milan but stayed in contact with the Emperor. Towards the end of his life, he sent the Emperor the idiosyncratic portrait of him in the guise of the Greek god Vortumnus.

Giuseppe Arcimboldo
L'Inverno/Winter

1563, canvas, Vienna, Kunsthistorisches Museum.

The painting is part of a cycle dedicated to the four seasons. Each one is symbolically represented by a startling and evocative juxtaposition of fruits and objects typical of that time of the year. Arcimboldo found this subject particularly congenial and often painted groups of pictures on a theme. Not only did he paint the four seasons, but also the four elements (Earth, Air, Water, and Fire).

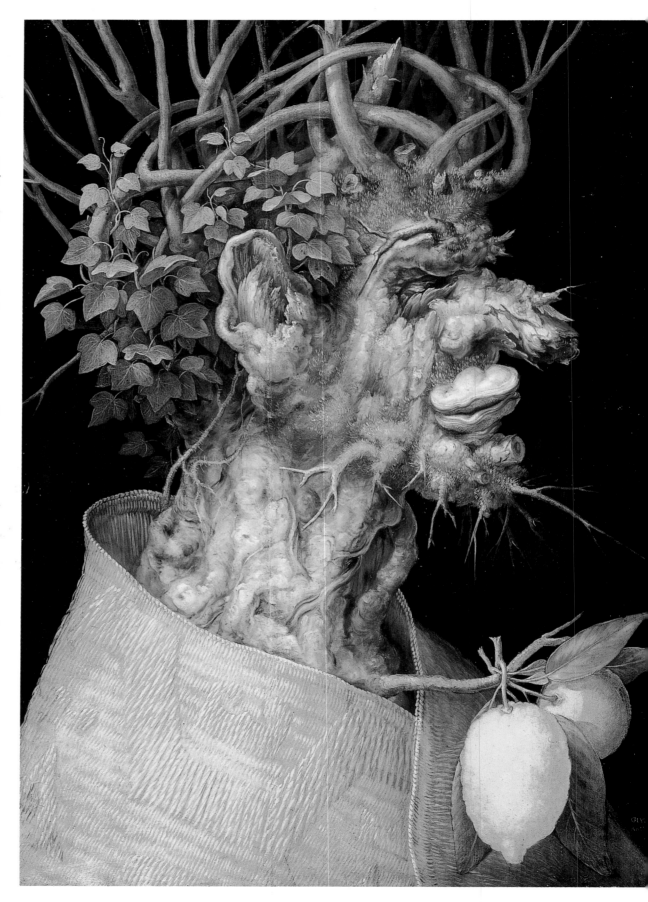

Giuseppe Arcimboldo
Vertumno/Vortumnus

1591, canvas, (suburban)
Stockholm, Skoklosters Slott.

There is no mistaking this masterpiece of fantasy and virtuoso imagination by Arcimboldo. The mythical Vortumnus, god of harvests and abundance, is in fact a bizarre portrait of the Habsburg Emperor Rudolf II. In the sixteenth century the emperor's cosmopolitan court in Prague became a center of international art, where Arcimboldo moved in the refined and exclusive circles of late European Mannerism. His painting might appear almost irreverent, but in fact is the manifestation of his eager search for new ideas and his exploration of different ways of expression. (It also gives quite a good impression of the Emperor.) This led him to break the usual rules in order to provoke uncensored reactions and emotions. The paintings and objects contained in Rudolf of Habsburg's *Wunderkammer* (room of wonders) were unfortunately scattered after a Swedish army sacked Prague during the Thirty Years' War (1618–48).

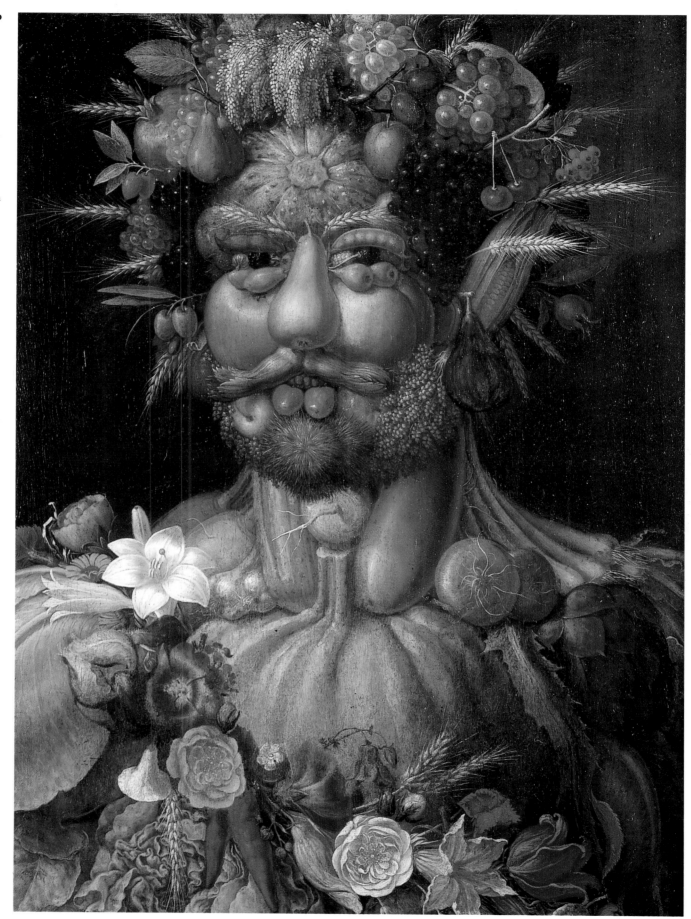

Francesco Salviati

*Francesco de' Rossi, Florence,
c. 1509–Rome, 1563*

The painter adopted his surname as a tribute to Cardinal Giovanni Salviati, his first patron in Rome. Although Salviati trained in Florence under Andrea del Sarto, nearly all his career was spent in Rome where he was the champion of the second generation of Mannerism. By this stage, Mannerism had lost the subversive impact of its early days and had become the artistic mainstream throughout central Italy. Salviati pushed Mannerist artificiality to levels of the highest elegance. He was meticulous in his use of classical quotations, over the friezes that framed his pictures and over the anatomy of his figures which was inspired by Michelangelo. His cold, clear light emphasizes his line drawing technique and carefully avoids natural effects of light. The result of all this is a sophisticated abstraction and virtuosity. Salviati worked in all the Mannerist decorative centers in Rome, such as the oratories at Gonfalone and S. Giovanni Decollato, the monastery of S. Salvatore at Lauro and Palazzo Sacchetti. His journeys to Venice (1539–41) and France (1555–57) were very important to the spread of Mannerism as was his long stay in Florence (1543–49). Here he was honored in various ways and also painted the frescos in the sala dell'Udienza in Palazzo Vecchio.

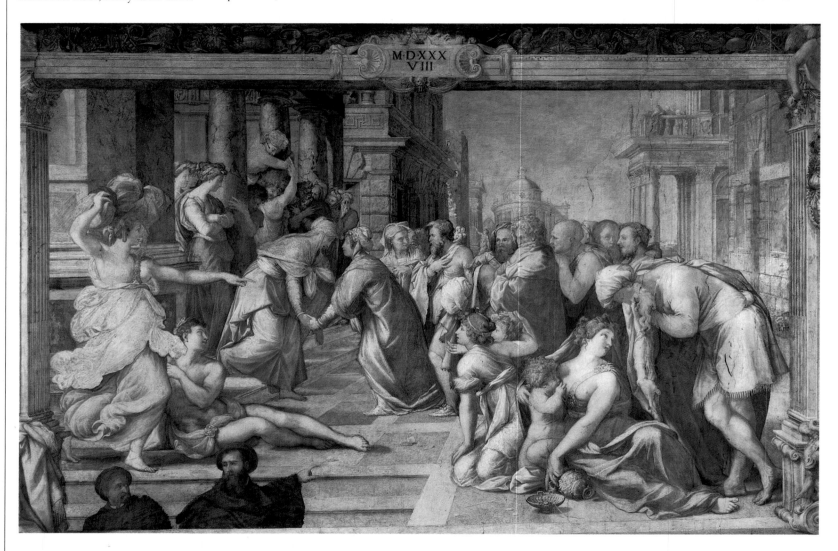

Francesco Salviati
Visitazione/The Visitation

1538, fresco, Rome, Oratory of S. Giovanni Decollato.

This is a quintessential work of second generation Mannerism. It effectively demonstrates the key role that Salviati played in the evolution of the style in Rome. The oratory was decorated at various times by many other artists who were important in the second quarter of the sixteenth century. Salviati's painting can be viewed as a vast repertory of motifs not only in regard to the architectural backgrounds but (and above all) for the poses of the individual figures. He glacially interprets subjects and characters taken from classical antiquity. He also used judicious quotations from Raphael, especially his later works such as the Stanza dell'Incendio at Borgo. Salviati's draughtsmanship was impeccably perfect. He could conjure up new spaces merely by painting two characters entering a scene. Overall, however, the greatest impression he leaves is that of intellectual control over image and result. There is a strong overall sense of unreality connected particularly to the coldness of his colors.

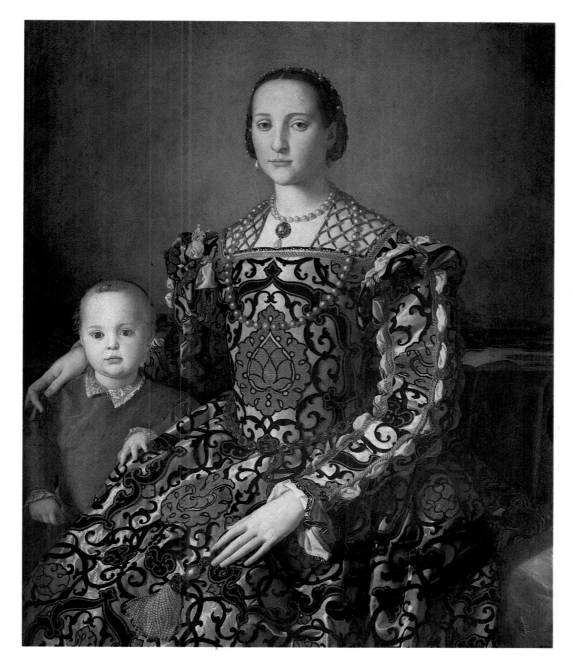

Bronzino
Thitraldo di Eleonora da Toledo/Portrait of Eleonora da Toledo

Florence, Uffizi.

The firm and glocial way that Bronzino draws outline and detail makes his portraits quite unmistakable. At the same time they possess an almost arrogant grandeur. This leads to a sense of immobile and timeless refinement which is particularly noticeable in his portraits of the Grand Duke's family. Archeological work in the tomb of Eleonora, the wife of Francesco I de' Medici, has revealed fragments of the dress worn in this portrait.

Bronzino

Agnolo di Cosimo di Mariano Tori, Florence, 1503–72

Bronzino was the best portrayer of the frozen, rigid etiquette of the Grand Duke's court in Florence. His career is interwoven with the history of Mannerism on which he left his own mark. He happily established himself as the official painter of the Grand Duchy and as the enigmatic stylist of a small circle of cultured aristocrats. Bronzino was first Pontormo's pupil and then for many years his close assistant. With his master he took part in many important

jobs in Florence in the 1520s (frescos in the Galluzzo Charter House and decorating the Capponi Chapel in S. Felicita). In 1530 he was summoned to the della Rovere court in the Marches and it was there that he began to paint portraits. It was not long before his outstanding talent in this direction became clear and he started to develop his own style, quite distinct from that of Pontormo. In fact, in addition to his master's almost maniacal insistence on accurate drawing, Bronzino added his own very personal use of color which he applied in a clear and compact fashion that almost gave the effect of varnish. By about 1540 he had

undoubtedly become the darling of the Medici court and Florentine aristocracy, not least thanks to his literary talents, for he was also poet. He alternated his production of smooth, almost crystalline portraits, with noteworthy decorative schemes, such as the frescos in the Medici villas, the redecoration of the private apartments in the Palazzo Vecchio or designing tapestries for the Grand Duke. From 1560 onward, he produced more religious paintings for altars in the major Florentine churches. These reveal his limits as a painter.

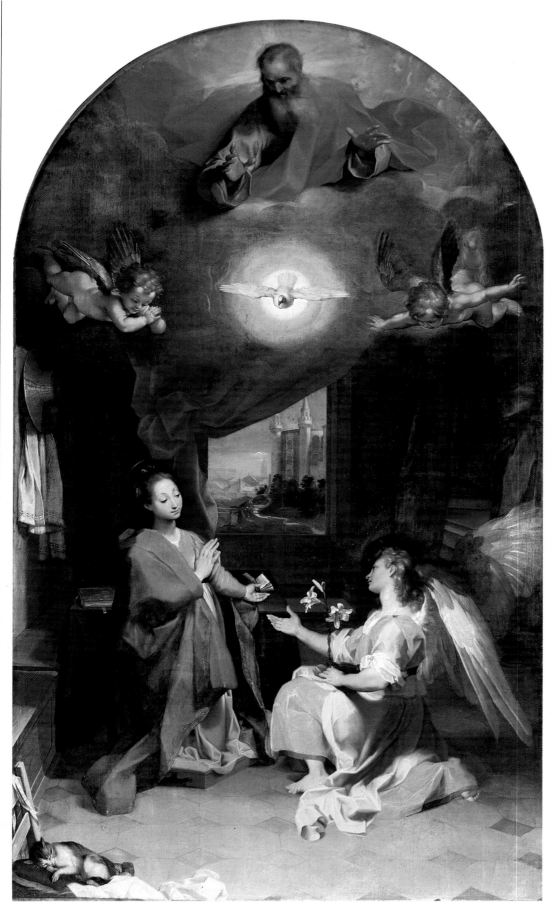

Federico Barocci

Urbino, 1535–1612

It is not only his dates that make Federico Barocci a suitable candidate with which to close the history of Italian Renaissance painting. Born in the Marches, Barocci acted as the linchpin that joined the great masters of the sixteenth century with the new art, from Carracci to Guido Reni, that was to emerge in the next century. Barocci trained in his native Urbino with its incredible artistic legacy. He seems to have been particularly conscious of Raphael's contribution to his own style. From his earliest work he incorporated Correggio's sunny grace enriched with his personal and warm taste for Venetian color. After an unhappy stay in Rome he returned to Urbino for good (1565). The fact that he was not in the center of the cultural world did not stop Barocci from wielding decisive influence, thanks also to the way that he stuck exactly to the Counter-Reformation's tenets on religious art drawn up at the Council of Trent. His compositions had a simple and direct fluidity and included touching details from everyday life. This did not, however, stop him from attempting more ambitious compositions from time to time, such as *The Deposition* in Perugia cathedral, 1569; *The Virgin of the People* (Florence, Uffizi, 1576–79); *The Martyrdom of St. Vitale* (Milan, Brera, 1583). In these paintings we can see how he gradually tried to introduce a feeling of wider space. In his later works, Barocci's spirituality and contemplative nature emerged more clearly, pointing decisively toward the beginnings of the Baroque.

Federico Barocci

Annunciazione/
Annunciation

1592–96, canvas, Perugia, S. Maria degli Angeli, Coli-Pontani Chapel.

Barocci's altarpieces reveal his precise and rapid response to the instructions issued by the Council of Trent on religious art. The Mannerists may have had a refined intellectual quality but they were too often abstruse. Mannerism was now definitely swept aside.

In its place came simple images with an obvious flow to them, free of mysteries or complications. Sacred episodes were set in the context of everyday reality. This can be seen from the way Barocci includes the Ducal Palace at Urbino in the background and fills the picture with descriptive detail, including the sleeping cat in the foreground. The figures' sweetness of expression is a direct reference to Correggio.

Federico Barocci

Riposo durante la fuga in
Egitto/Rest on the Flight
into Egypt

*1570–75 (?), canvas, Rome,
Vatican Gallery.*

Even in his smaller
canvasses which were
painted for private chapels
or collectors, Barocci
abandoned the often cold
calligraphy of the
Mannerists. Instead, he
favored delicate images,
rosy colors, soft light, and
landscape settings. This did
not mean that Barocci was
not also a refined painter.
Indeed, in a painting like
this the way that the
gestures and looks of the
characters link to each
other shows that he studied
his compositions carefully.
But what he did not do was
to show off cleverness for
its own sake. The way that
he accurately describes a
number of details (the
fruits, the metal objects, or
the items in the bottom left
corner) foreshadow the
imminent developments
that would give rise to the
new (for Italy) genre of still
lives. This is yet another
confirmation of Barocci's
key role in a time of
transition.

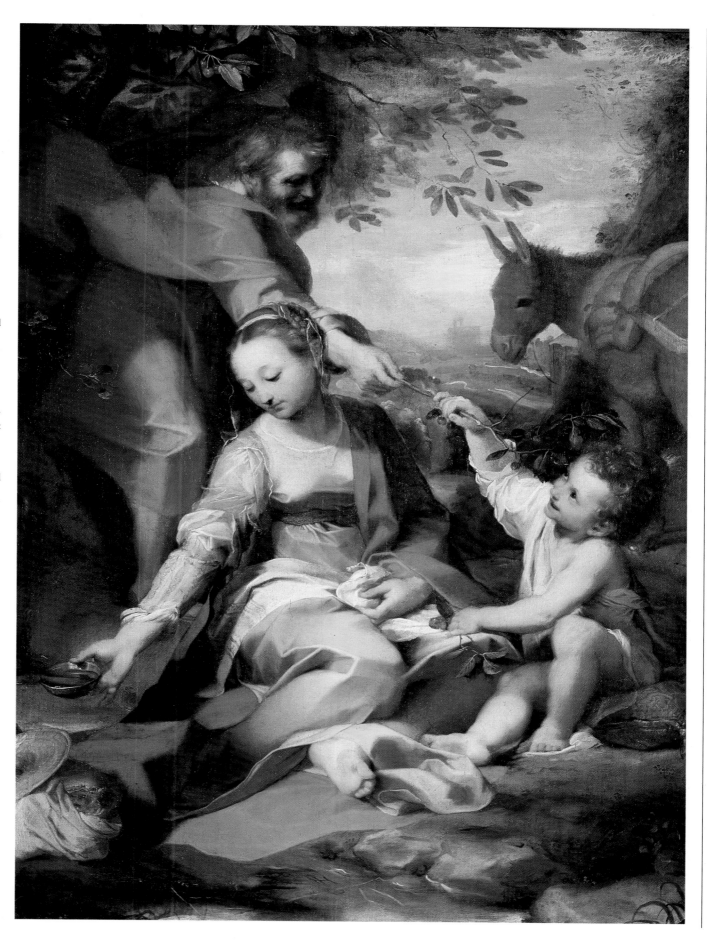

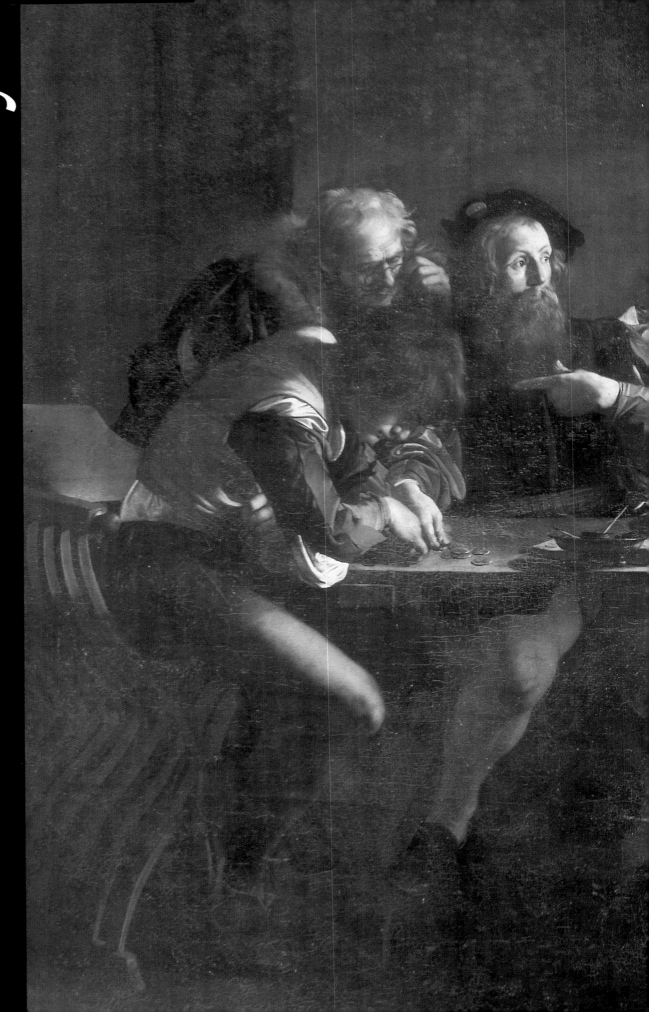

The 17th Century

Caravaggio
Vocazione di san Matteo/The Calling of St. Matthew

1599–1600, Rome, S. Luigi dei Francesi
Contarelli Chapel

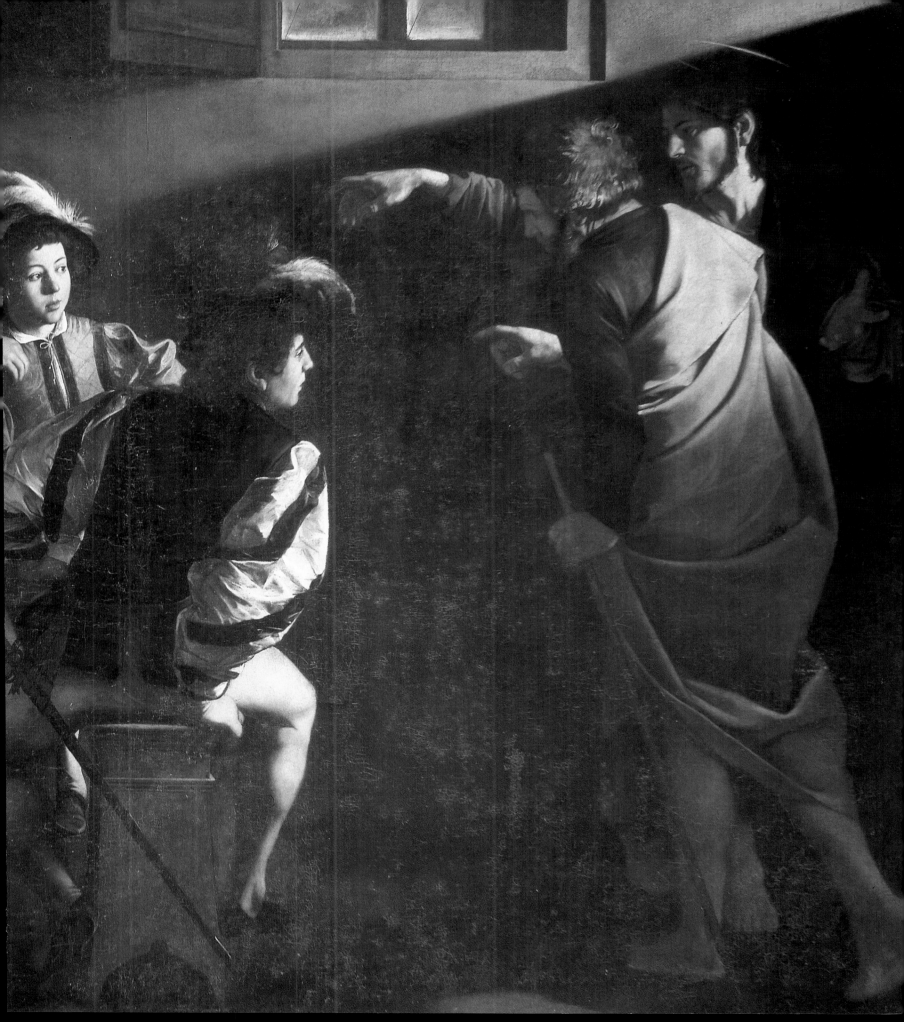

Caravaggio
Le sette opere di misericordia/
The Seven Works of Mercy,
1606/1607, canvas, Naples,
Pio Monte della Misericordia
(in storage at the Gallerie di
Capodimonte.

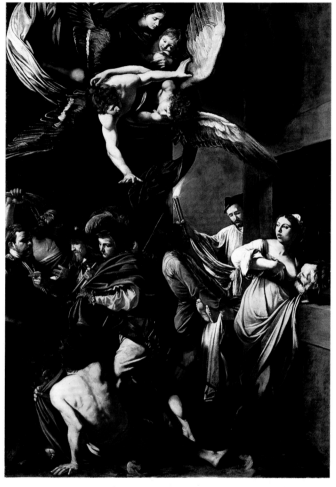

Annibale Carracci
Mangiafagioli/Bean Eater,
1584, canvas, Rome, Galleria
Colonna.

F or a long time the seventeenth century has been one of
the least loved in Italian history. Even today the term
Baroque is sometimes used in a derogatory sense (for
instance to mock the way someone talks or a style in
decoration). It is synonymous with being over the top, superflu-
ous, florid, or downright useless. Proud buildings and even whole
city centers throughout Italy have been scorned for being
"Baroque" in the harshest way. This has happened from northern
Piedmont to southernmost Sicily precisely because of the wide-
spread prejudice and lack of esteem for the Baroque. The main
classical thrust of Italian culture prefers almost to edit out the
seventeenth century. A small example will easily illustrate this:
while even people who have not studied any art can probably give
you the names of a fair number of Renaissance artists, the only
name most people can ever remember from the seventeenth cen-
tury is that of Caravaggio. It is only fairly recently that opinion has
begun to shift and the seventeenth century's long period as an
outcast has come to an end. Restoration work, literary rediscov-
eries and more open minds have all contributed to a fresh appre-
ciation of at least some of the great works produced by a century
often in turmoil, shaken by doubts and always on the cusp
between splendid tragedy and comic festivity. In short, the seven-
teenth century was far from useless. On the contrary, it was full
of passion and humanity expressed by artists with great tempera-
ments and enormous personalities.

We can to some extent justify the way that the seventeenth
century has been written off by recalling a few historical facts. At
the time Italy was going through not only an economic and politi-
cal crisis but a cultural one too. The crises were not caused by a
dramatic sequence of events (like the Thirty Years' War that tore
Germany apart between 1618 and 1648), but were rather the
result of a slow, unstoppable decline. Little by little Italy slipped
away toward the margins of Western history and culture. During
the second half of the century in particular, Italian intellectuals
seemed almost bewildered by this new and unpalatable state of
affairs. The leading role that Italy had played in Europe for over
two centuries had been lost to other countries. It is no coinci-
dence that in several other countries the seventeenth century is
remembered as a "golden age:" England produced Shakespeare
among many other writers and intellectuals; Holland was enjoy-
ing the most enthralling chapter in its artistic history with mas-
ters such as Rembrandt and Vermeer; in Spain the literary heights
scaled by Cervantes and Calderòn de la Barca were equaled by
achievements in painting from El Greco to Vélasquez; in France
the rebirth of royal grandeur culminated at the court of the Sun

Annibale Carracci
*Resurrezione di Cristo/
The Resurrection*,
detail, 1593, canvas, Paris,
Louvre.

King in Versailles. Compared to this exuberance, the figurative arts in Italy certainly still had vitality but of a somewhat limited kind. What happened to Galileo, the greatest Italian scientist of the seventeenth century, can appear symptomatic.

Venice and Florence, the resplendent capitals of the Renaissance, were both very dull in the visual arts, although Venice boasted a series of great musicians. Rome, on the other hand, was brilliant. Unquestionably, throughout this century the Eternal City was a source of cultural trends that then spread across Europe. But this did not happen simply because of contemporary Italian artists working in Rome. It was also because Rome contained both antique and Renaissance masterpieces which attracted foreign artists to Italy. They considered that a journey to Rome was a crucial and irreplaceable esthetic experience. The decades before and after 1600 were in fact a time when art changed completely. There was a widespread feeling that something was needed to stir up the now stagnant waters of Mannerism. At the Council of Trent, the Counter-Reformation had called for a new type of religious art, less artificial and speaking more directly to worshippers' hearts and souls. At first this had led to repressive limitations of artistic freedom, but as the Catholic Church regained its vigor and self-confidence after the shock of the Reformation, it began to demand an art radically revitalized and suitably exultant for the Church. Arriving from

the foggy towns of northern Italy, Annibale Carracci and Caravaggio revolutionized painting from the roots upwards. Their presence underlines Rome's role as an open post-Renaissance workshop. Carracci eclectically reworked the strands of classical art, Caravaggio seized on reality just as it looked at the time. Their results appear to be pulling in opposite directions. However, both were born of the common need to to come up with a wholly new way of painting that spoke directly to the viewer's heart and imagination. It was these two painters working in parallel that gave rise to the main currents of seventeenth-century art in Italy. These in turn opened the doors to new independent genres. Annibale Carracci is the lyrical forerunner of idealized landscape painting. Caravaggio perfectly interpreted and elegantly executed the idea of the still life in his intensely powerful, poetic masterpiece *Basket of Fruit* now in the Pinacoteca Ambrosiana in Milan. Both artists died young and in unfortunate circumstances (Annibale Carracci died "of melancholy" in 1609; Caravaggio died in anguished exile in 1610). Their followers and imitators split into two sharply contrasting schools. The Emilians, led by Guido Reni, Domenichino, and Albani, who had studied in the Carracci family Academy, were exponents of an elegant and sophisticated classical style. The less-organized but far livelier bunch of Caravaggisti sought in various ways to recapture their master's dramatic power, among them Gentileschi, Serodine, and

Manfredi. A new factor was added to the artistic mix in Rome by the arrival of Pieter Paul Rubens, the young but already exuberant Flemish painter, whose expansive, fleshy brushwork paid homage to Titian's use of color. He found intelligent followers in Italy, especially among painters who came into direct and prolonged contact with either Rubens or his work, such as Strozzi in Genoa and Fetti in Mantua.

Naples was a case on its own. It was still the most populous city in Europe and in the seventeenth century its artistic school was highly original and productive. This was initially inspired by Caravaggio's repeated visits to the city but was developed throughout the century by a constant stream of important painters. The debate between the classical and the Caravaggist schools can also be traced through the history of the alternating fortunes in the collectability of the two strands. It was resolved in around 1630 when a third current emerged. This was openly Baroque.

The man who more than anyone else directed artistic taste in seventeenth-century Rome was Gian Lorenzo Bernini. Unsurpassable as a sculptor, architect, and town planner, occasionally he also turned his talents to painting, writing plays, and acting. He possessed the dynamic personality to reshape radically the artistic image of a whole city and century. He was soon joined by other artists. Pietro da Cortona possessed overwhelming talent and was given the prominent task of translating Bernini's ideas into splendid pictorial decorations in Rome and Florence. This was the beginning of a long season of large-scale decorations on ceilings and domes. It went on to include the perspective magic wrought by Father Pozzo and ran right through most of the century, almost up to Tiepolo's day.

Compared to the preceding centuries, the independence and originality of local schools in different regions or cities seemed to fade. The artistic ideals of Caravaggio or the Carracci family

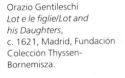

Orazio Gentileschi
Lot e le figlie/Lot and his Daughters,
c. 1621, Madrid, Fundación Colección Thyssen-Bornemisza.

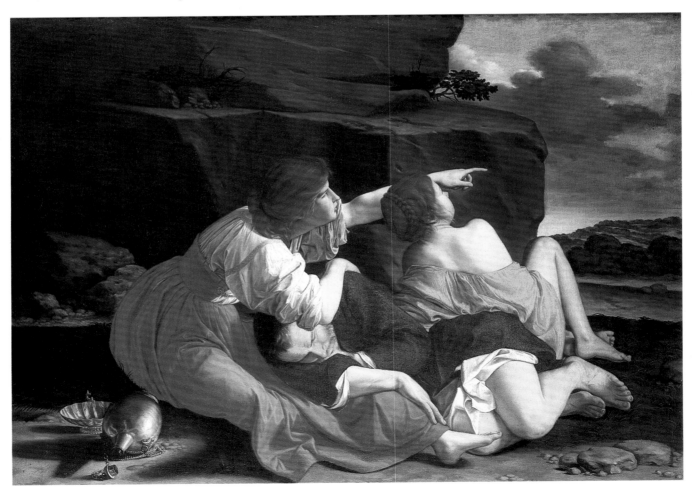

Domenico Fetti
David,
c. 1620, canvas, Venice,
Gallerie dell'Accademia.

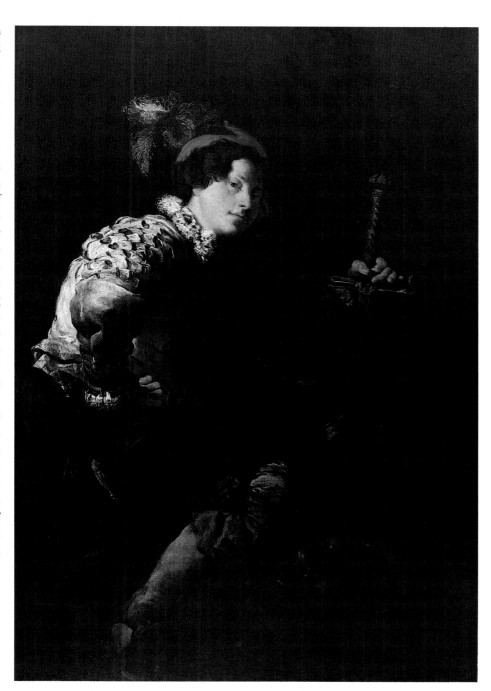

spread almost simultaneously across the whole country. This was partly due to the fact that nearly every important painter visited Rome regularly. Despite this, in the seventeenth century the historical vitality of the Italian regions still produced numerous and beautiful reminders of its existence. Just to take a single, noteworthy case, we should recall that under Spanish domination Lombardy produced St. Charles Borromeo and his cousin Federico Borromeo. There is no doubting the authentic greatness of their religious genius which gave rise to a school of painting that alternated between rapt mystical ecstasy and peaceful meditations on reality. But even accepting this, during the second half of the century the climate of creative tension slackened generally. Right into their old age Pietro da Cortona and, above all, Bernini kept large-scale, spectacular Baroque art alive in Rome. Even so, the climate of innovation, so tangible at the start of the century, was by then only a memory. The drive to renew completely figurative art came out of the imaginative and talented Neapolitan school. Extrovert Luca Giordano's long foreign trips led to a taste for painting that was freer, quicker, and more virtuoso in style. Giordano's fresh and nervous brushstrokes played a determining role in lightening the increasingly heavy style of painting in the second half of the seventeenth century. His example would shortly be taken up by the talented artists who created the wonderful rebirth of Venetian art in the eighteenth century.

Finally, one area that was very little explored in Italy was that of genre painting (landscapes, scenes of everyday life, still life). In contrast, this was already a successful part of Flemish and Dutch art. But those placing commissions among the old Italian aristocratic families or the prelates of the church considered these inferior subjects. They were only collected by a few intelligent connoisseurs. But it was precisely among the subdued voices of the genre painters, in particular still life painters, that we are able to find snatches of moving, truly intense, poetry in Italian seventeenth-century art.

Ludovico Carracci

Bologna, 1555–1619

Ludovico was by temperament a fairly shy person who never found real success, unlike his cousin Annibale. Apart from traveling when young in the course of his studies and a brief and rather unpleasant stay in Rome, he spent all his life in the cosy atmosphere of Bologna, where most of his work still remains. He nevertheless has to be recognized as the first painter systematically to abandon the late Mannerist style in favor of a new kind of moral and devotional style of painting. By interpreting the suggestions made by Cardinal Paleotti, who had a special interest in the reform of religious art, Ludovico Carracci took an early lead in its renewal. This was arrived at by reassessing nature exactly as it is, even when it appears plain or uninteresting, but without ever resorting to the cerebral ploys used by the last of the Mannerists. To achieve his aim, as well as painting, Ludovico placed great emphasis on teaching. In the 1580s, he and his two cousins Annibale and Agostino opened their "Accademia dei Desiderosi" [The Academy of those who wish to make Progress]. This was later renamed "Academia degli Incamminati" [The Academy of those who are making Progress] but later still was known simply as the Carracci Academy. This was responsible for shaping a whole generation of Emilian painters. Proof of how united the group was came when the three Carracci cousins together painted the frescos in Palazzo Fava. The simplicity of their compositions recalls Federico Barocci's style while the sweetness of their expression is reminiscent of Correggio. Ludovico's own sensitivity derived from his deep knowledge of Venetian painting. His style was composed of delicate gestures, bashful looks, and a good deal of narrative drama. Especially in his medium to small pictures this readily became lyrical poetry. Among his most important works we should mention his youthful *Annunciation* and his noble *Madonna dei Bargellini* (both in the Pinacoteca Nazionale in Bologna). Later on he painted the frescos in the cloisters of S. Michele in Bosco, near Bologna (1604). After his cousins' deaths he produced some large and rather sad compositions, such as *The Funeral of the Madonna* in the Parma Galleria Nazionale and the fresco of the *Annunciation* on the triumphal arch in the Metropolitan church of S. Pietro in Bologna, finished the year he died.

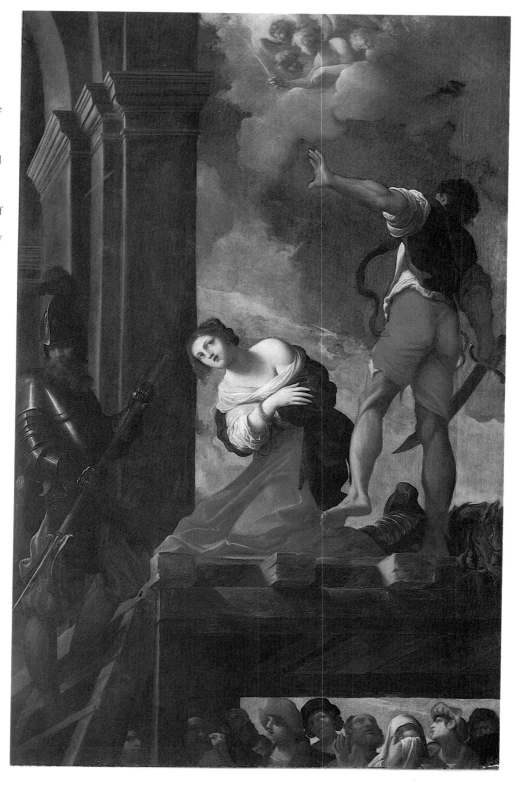

Ludovico Carracci
Martirio di santa Margherita/The Martyrdom of St. Margaret

1616, canvas, Mantua, S. Maurizio, Cappella di Santa Margherita.

The perfect way in which all the formal components of this altarpiece are balanced shows how deeply Ludovico Carracci reformed religious painting. He used both intelligence and sensitivity in the way he implemented the Counter-Reformation dictates laid down by the Council of Trent. Ludovico tried to stick to simplicity and persuasion. The saint baring her neck for the executioner is a model of Christian virtues. These are exalted through her luminous beauty which contrasts with the brutality of the soldier to the left and the executioner himself (two figures which contain references to Titian, something so often found in Ludovico's work). The faithful looking at this picture are able to identify with the spectators below the scaffold and thus feel they are present at the scene rather than outsiders to it.

Ludovico, Agostino, and Annibale Carracci
Storie di Giasone/The Stories of Jason

detail, 1584, fresco, Bologna, Palazzo Fava.

The three Carracci cousins were always proud of the fact that the fascinating frieze that surrounds this room in Palazzo Fava was a team effort. They refused to identify which part each one had painted. Recent critical attempts have tried to distinguish Ludovico's contributions from those of his younger cousins Agostino and Annibale. At the same time these studies have emphasized the value of the way the three artists collaborated on this work. The Carracci cousins' idea of an Academy should not be seen as a reactionary move or merely the wish to perpetuate rigid classical models. It should rather be viewed as a cultured and dynamic relationship with tradition. With this in mind, it is much easier to appreciate the variety of quotations and the richness of motifs found in Palazzo Fava. Above all, however, we perceive a sense of hidden, wintry melancholy, a feeling almost of crepuscular poetry that can most probably be attributed to Ludovico's own sensibility.

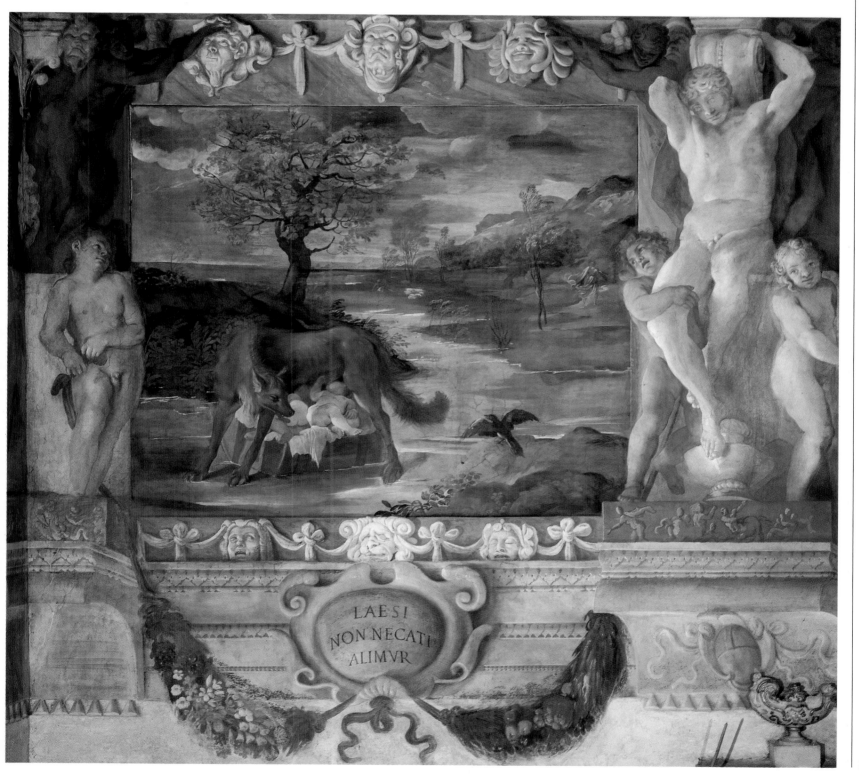

LAESI
NON NECATI
ALIMVR

Annibale Carracci

Bologna, 1560–Rome, 1609

It seems likely that Annibale and his brother Agostino both trained in their cousin Ludovico Carracci's studio. The three certainly worked together on a number of occasions but it was soon apparent that Annibale was the real genius among them, with the potential to become one of the greatest reformers in the history of painting. From his debut with a *Crucifixion*, Bologna, S. Maria della Carità, 1583, Annibale looked determined to reject the aridly cerebral and cold formulas of the Mannerists. This return to more direct and forthright painting was also seen in his original choice of subjects, such as butcher's shops or ordinary people eating. Well-spent study tours around 1585 allowed Annibale to master the Renaissance Grand Manner of Titian and Correggio, especially their use of color, but he rediscovered it in a modernized way. The foundation of the "Accademia dei Desiderosi" was of paramount importance to art as it signaled their belief that classical contemporary painting could still be taught. All the Carracci stressed the importance of drawing from life (all three were brilliant graphic artists), which was to be a hallmark of the Bolognese School they founded. In about 1595 both the Academy and the Carracci cousins' activity physically moved to Rome. This was in official recognition of the movement of artistic

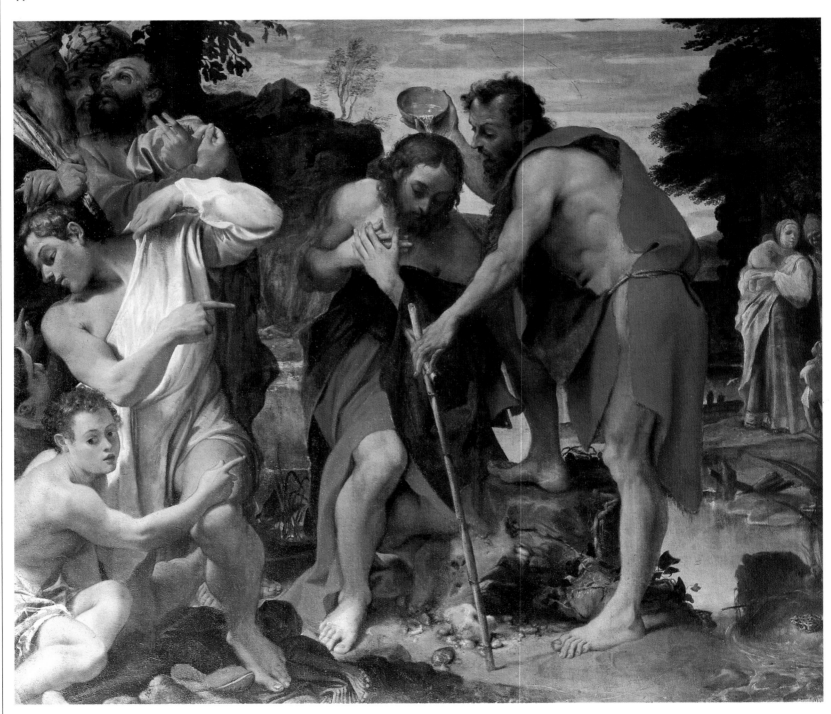

reform they had started and then taken right to the very heart of artistic debate. Thanks chiefly to them, Rome became the leading center of the latest ideas and experiments in art in the seventeenth century. On the surface, some of these ideas seemed to be going in opposite directions, but underneath, everything sprang from the need for a natural and humanist way of painting, whether with Caravaggio's radical realism or Annibale Carracci's renovated classical style. During his years in Rome, Annibale was an enthusiastic exponent of a cleansed classical art. He paid tribute to it in the amazing ceiling that he spent the last years of his life painting in the Palazzo Farnese. On this, and also on the large landscape lunettes in the Galleria Doria Pamphili, Annibale was helped by young assistants, nearly all from Emilia, who subsequently established the classical style there that proved to be so successful. Annibale Carracci's reputation as an "academic artist" and the fact that for over three centuries he has been regarded as a paradigm of classical style, has meant that for too long we have overlooked his no less fascinating handling of nature, evident in his *Landscape with the Flight into Egypt*. But the melancholy which can be glimpsed in that landscape, whose symmetry almost anticipates Poussin's, overwhelmed Annibale as a man and he stopped painting toward the end of his life. Fortunately, his true place in art has been recognized by recent critical works.

Annibale Carracci
Sposalizio mistico di santa Caterina/The Mystic Marriage of St. Catherine

1585–87, canvas, Naples, Gallerie di Capodimonte.

This picture was once in the Farnese collection. The scene's elegant if almost overpowering sweetness is directly derived from Correggio. This can clearly be seen from the saint's downcast but slightly smiling eyes. The dark background emphasizes the softness of the light coming in from one side.

On the opposite page
Annibale Carracci
Battesimo di Cristo/ The Baptism of Christ

1584, canvas, Bologna, S. Gregorio.

Annibale Carracci's religious compositions are almost always set in wide spaces enhanced by luminous and deep landscapes. The figures are invariably in classical poses but these do not seem at all forced or unnatural.

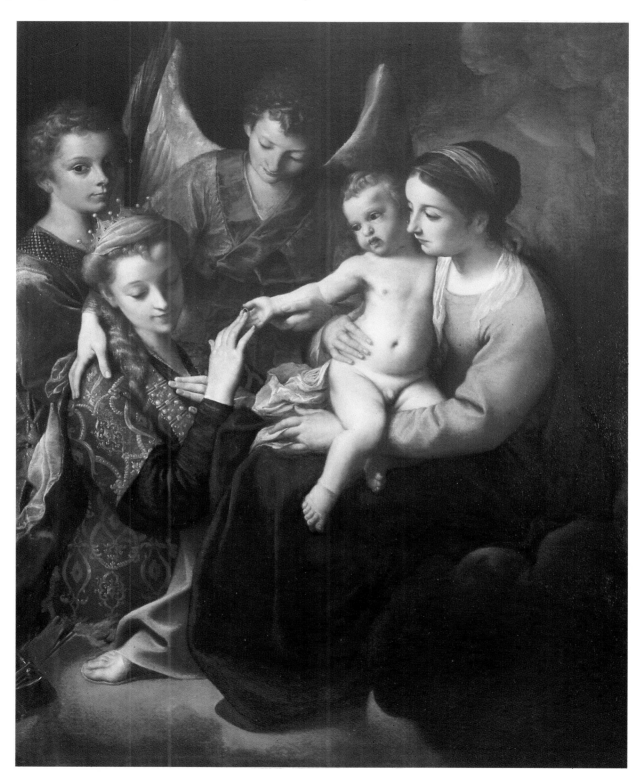

249

Annibale Carracci
Paesaggio con la fuga in
Egitto/Landscape with the
Flight into Egypt

*1604, canvas, Rome, Galleria
Doria Pamphili.*

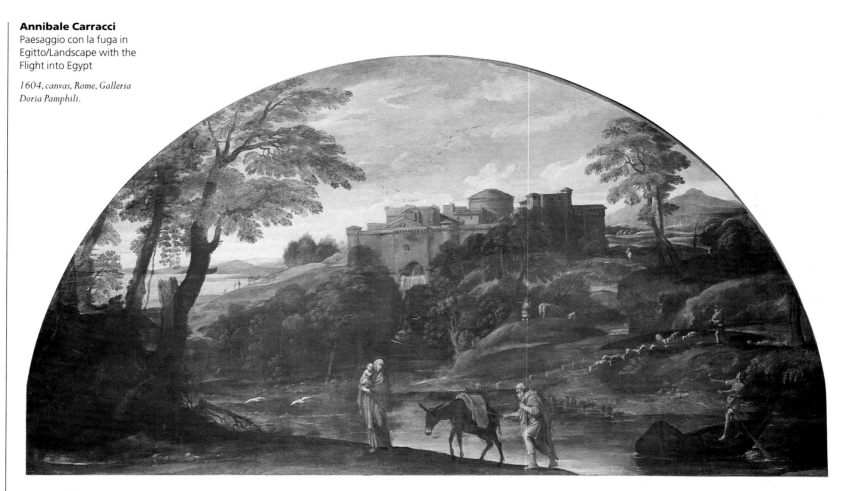

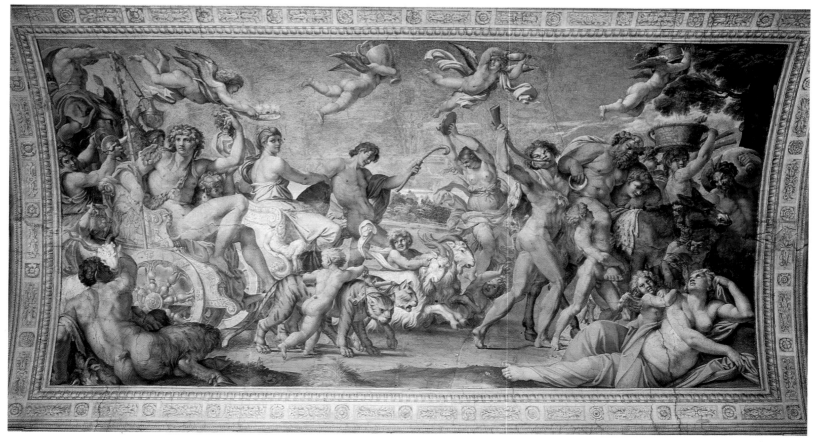

Annibale Carracci
Trionfo di Bacco e
Arianna/ Triumph of
Bacchus and Ariadne

Opposite page, bottom
Omaggio a Diana/
Homage to Diana

*1597–1602, frescos, Rome,
Palazzo Farnese.*

The huge ceiling in the
reception room of Palazzo
Farnese, painted just as the
seventeenth century was
beginning, was part of a
great cycle of decorative
paintings on the theme *The
Loves of the Gods*, which
Carracci painted for
Cardinal Odoardo Farnese.
They are his undoubted
masterpieces and were
tremendously influential,
for two centuries ranking
with Michelangelo's work
in the Sistine Chapel and
Raphael's frescos in the
Vatican as the supreme
examples of Western
painting. Generations of
young painters were set to
copy it. During the
protracted period it took to
complete the frescos, the
Palazzo Farnese cycle
became a test bed for the
Carraccis' revitalized
classicism. Annibale
Carracci transformed the
reception room into a
shining collection of
classical pictures. In fact,
the decoration was not
intended to be a single
scene, but imitated a
collection of framed
paintings surrounding the
main scene. This was the
*Triumph of Bacchus and
Ariadne* which fills the
center of the ceiling. The
individual pictures are
painted with a smiling,
serene sense of classical
antiquity revisited and
reinterpreted through the
art of Raphael,
Michelangelo, Titian and
Correggio. Many of the
separate currents that had
flowed through the
Renaissance came together
here. They gave life to a new
sort of art which was
characterized by the
supremacy of resplendent
and light-hearted
decoration, filled with
color and movement.

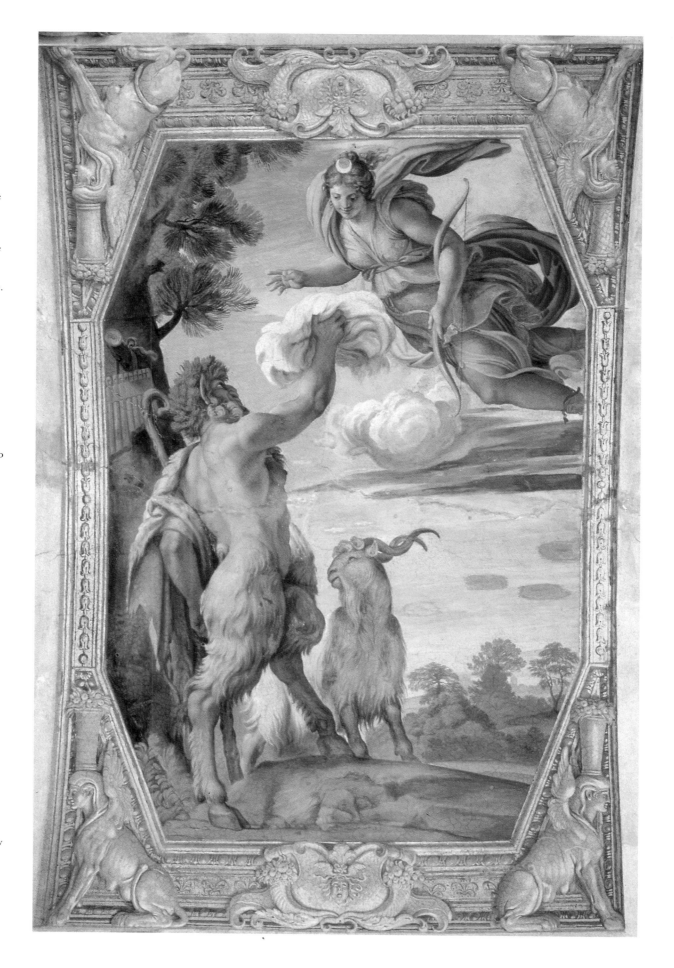

Caravaggio

Michelangelo Merisi, Milan, 1571–Porto Ercole (Grosseto), 1610

In Caravaggio's career, his often violent character became entwined inextricably with his genius. This is why the Lombard painter later became the prototype of the "accursed artist." At the time his ideas were so disturbing that patrons often failed to understand or appreciate them for Caravaggio was one of the greatest revolutionaries in all art. Caravaggio trained in Lombardy where his direct approach to art made him the suitable heir to the local tradition of realism. In about 1590 he moved to Rome where he worked with Cavalier d'Arpino. Caravaggio specialized in painting flowers and fruit and so gave rise to the Italian still life genre. His early paintings were of medium size and showed subjects taken from everyday life: scenes and people captured in the streets (tricksters, shop-boys, gypsies, players) of the poor quarters which he frequented himself. His exceptionally accomplished technique was used to create images with overpowering impact and seeming psychological truth. They were worlds apart from the coldly intellectual quality of the last Mannerists. Success was not slow in coming and Caravaggio became the darling of rich and cultured patrons. In 1600 he painted the St. Matthew canvases for the church of S. Luigi dei Francesi in Rome. This was a milestone not only in his own career but also in religious art in general. Thanks to his powerful way of using light, the scenes in these and subsequent canvases are filled with dramatic tension. Following them, he was commissioned to do a series of large altarpieces for Roman churches (S. Maria del Popolo, S. Agostino). His ideas were so daring and innovative that they left the patrons rather bewildered and some works were rejected, such as *Death of the Virgin* now in the Louvre. In 1606, after he had killed a man in a brawl over a bet, only the worst of many episodes of violence, Caravaggio was forced to flee Rome. His first stay in Naples left an indelible mark on the local school. He then sailed to Malta where he initially was welcomed, painting *The Beheading of St. John the Baptist* in Valletta cathedral. Soon, however, he landed in jail. He fled to Sicily where his painting became even more dramatic. In this period, his realism was tinged with visionary touches. His second stay in Naples (1609–10) ended up with someone else wounded and Caravaggio on the run once more. Before he could settle down, he died.

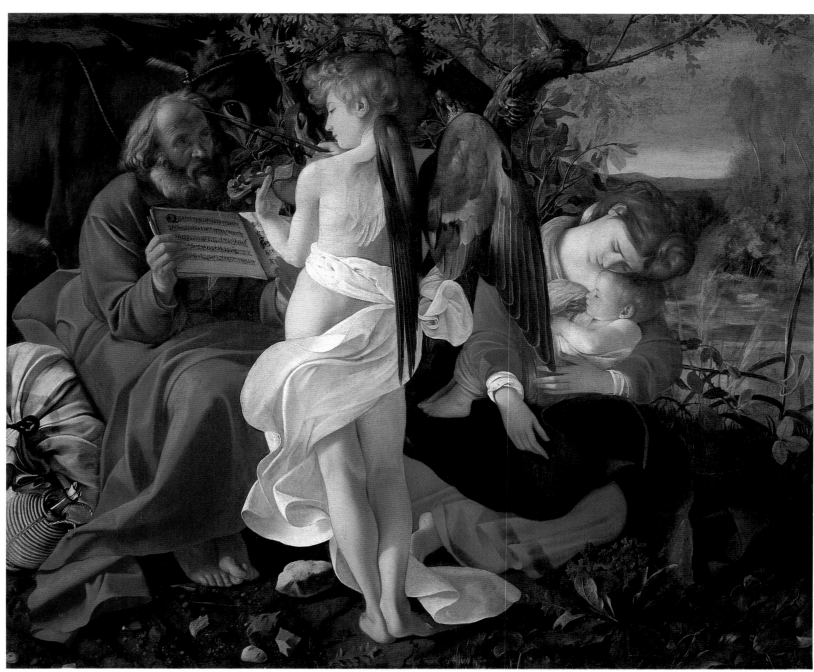

On the opposite page

Caravaggio
Riposo durante la fuga in Egitto/Rest on the Flight into Egypt

1594–96, canvas, Rome, Galleria Doria Pamphili.

This marks the high point of Caravaggio's youthful output and seems to contain a final tribute to the Lombard tradition of realism. The diffused softness of the light, the countryside, and the extraordinarily elegant angel playing the viola combine to create an atmosphere of a rural idyll. In his handling of sacred characters, Caravaggio used the same natural realism to be found in his secular painting.

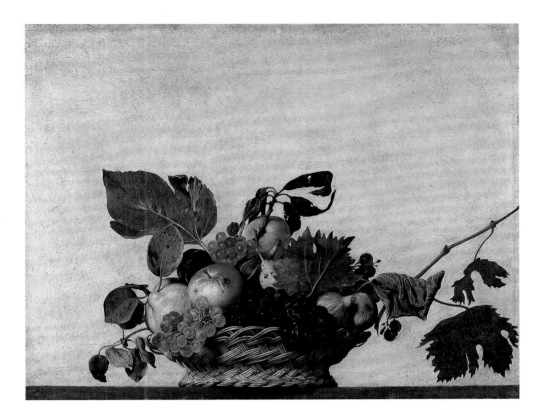

Caravaggio
Canestro di frutta/Basket of Fruit

1596, canvas, Milan, Pinacoteca Ambrosiana.

The painting is also known by the title *Wicker Basket* which was how Cardinal Federico Borromeo described it when Cardinal del Monte gave it to him. Painting such baskets started and closed the genre of still life for Caravaggio. In fact, for the very first time just a bare basket with a few bits of fruit was elevated to the status of absolute protagonist in a work of art. It was no longer an "object," but the "subject" of the work.

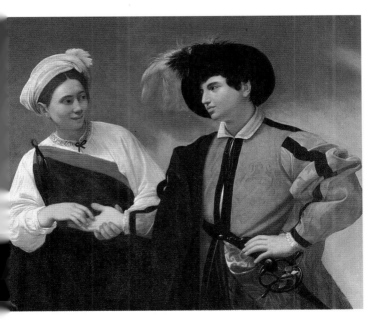

Caravaggio
La buona ventura/The Fortune Teller

c. 1594, canvas, Rome, Pinacoteca Capitolina.

According to his seventeenth-century biographer Bellori, to paint this picture Caravaggio stopped a gypsy woman who happened to be going down the street. He took her to his lodgings where he painted her portrait as though she were telling the fortune of an adventurer.

Caravaggio
Giovane con un cesto di frutta/Boy with a Basket of Fruit

1593–94, canvas, Rome, Galleria Borghese.

This is part of an important group of Caravaggio's early works depicting common people found in the little streets and taverns in the area around the Piazza Navona.

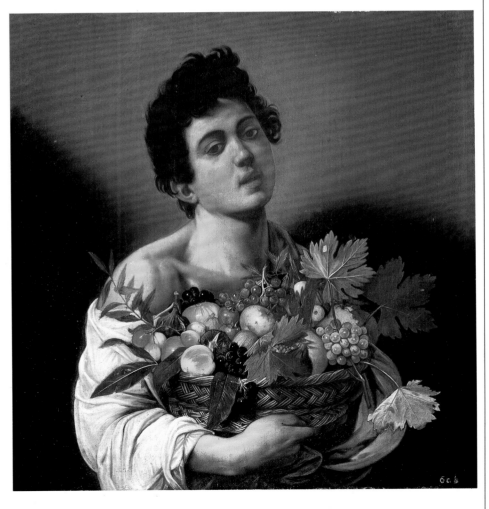

Caravaggio
Santa Caterina
d'Alessandria/
St. Catherine of
Alexandria

*1597, canvas, Madrid,
Fundación Colección Thyssen-
Bornemisza.*

This picture is typical of a
very specific moment in
Caravaggio's artistic
progress and used the same
model that is seen in his
Judith and Holofernes (see
p. 256). In this phase
Caravaggio moved on from
his early genre paintings
and commenced the

monumental undertaking
of producing altarpieces for
Roman churches. The
figures are beautifully
modeled by the light and
emerge powerfully from
the background. Objects
are shown with such
realism as if to be made
from their original materials.

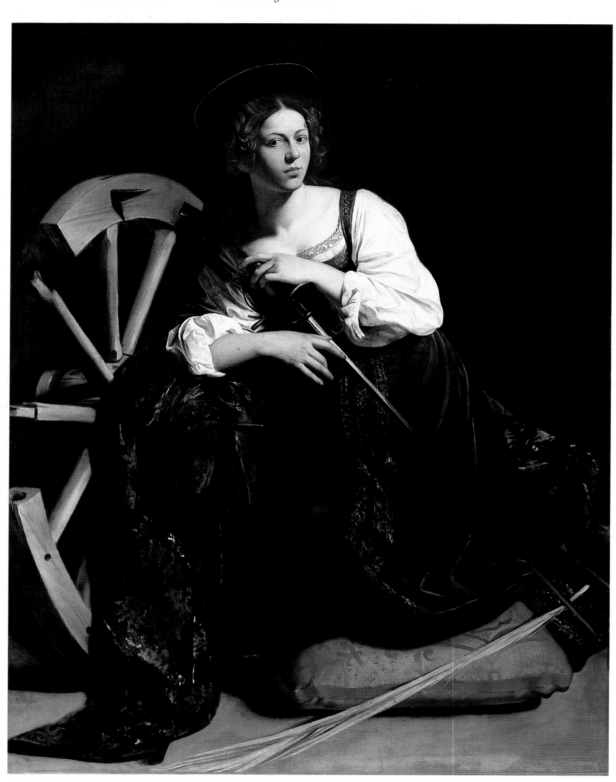

On the opposite page
Caravaggio
Sacrificio di Isacco/
The Sacrifice of Isaac

*c. 1603, canvas, Florence,
Uffizi.*

This is the best known
version of the dramatic
Biblical episode. Isaac's face
twisted in terror and his
crying are unforgettable
details. It is far removed
from pious or academic
renderings of the story.
This detail alone provides
the key to the bursting
expressive power of
Caravaggio's painting
which constantly touched
upon the most earthy and
uncomfortable aspects
of reality.

Opposite page, bottom left
Caravaggio
Sacrificio di Isacco/
The Sacrifice of Isaac

*1598–99, canvas, Princeton
(New Jersey), Johnson
Collection.*

Bottom right
Caravaggio
Stigmate di san Francesco/
St. Francis' Stigmata

*1594–95, canvas, Hartford
(Connecticut), Wadsworth
Athenaeum.*

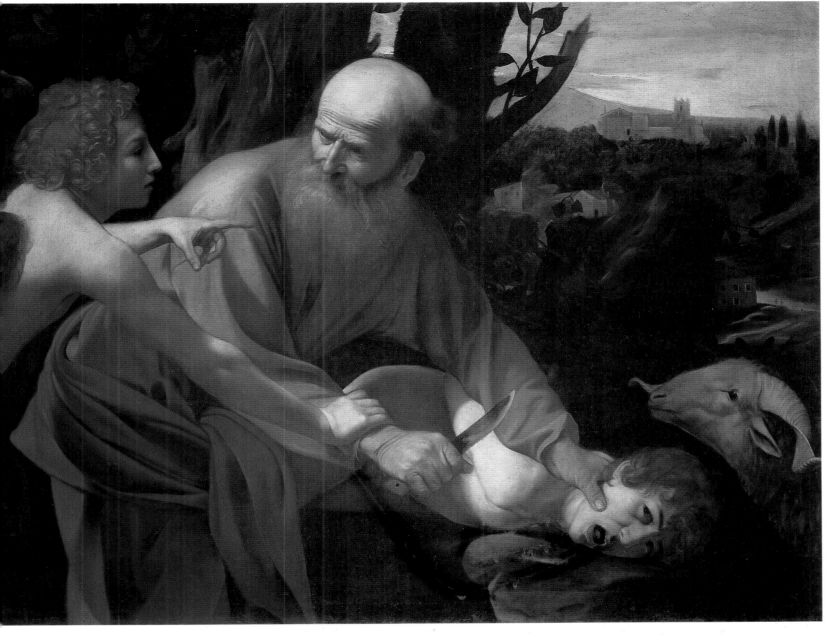

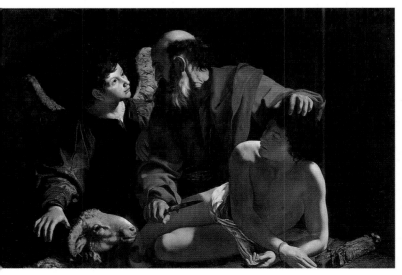

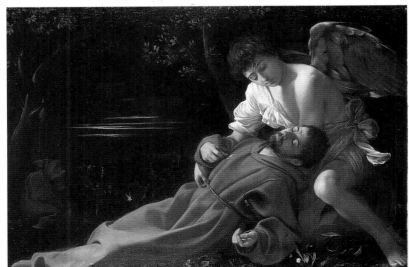

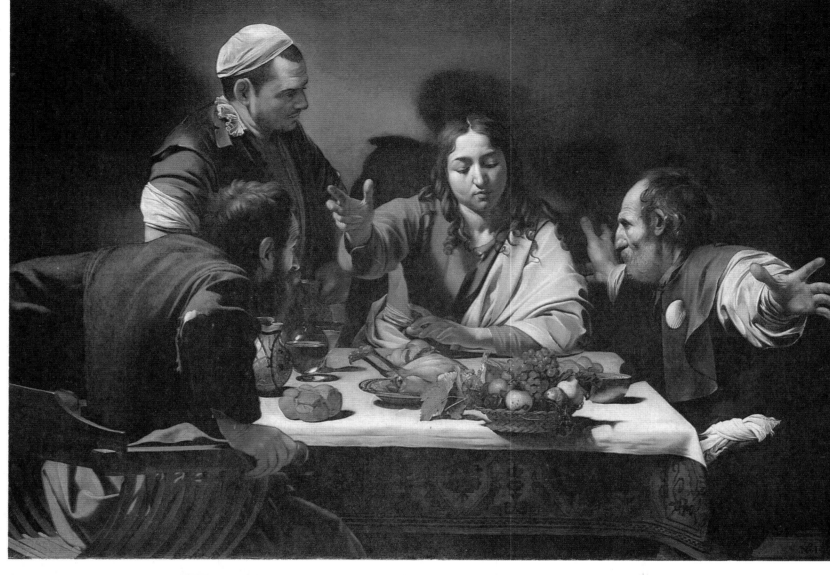

Caravaggio
Cena in Emmaus/
The Supper at Emmaus

*1596–98, canvas, London,
National Gallery.*

This is the first version of
the Gospel story that
Caravaggio painted twice,
at very different points in
his career. In this one,
dating from the end of his
youth, the part played by
still life on the table
remains important. Light is
already beginning to slant
in from a quite different
angle, giving the viewer
a real sensation of the
physical presence of the
people in the picture.

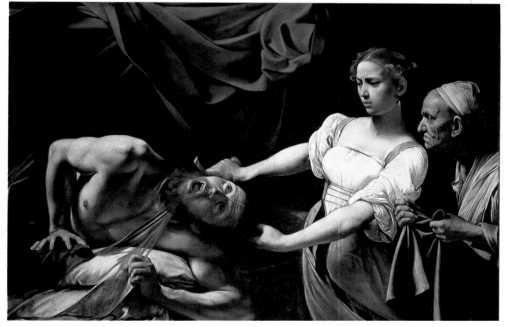

Caravaggio
Giuditta e Oloferne/
Judith and Holofernes

*1595–96, canvas, Rome,
Galleria Nazionale d'Arte
Antica.*

This spectacular and
dramatic scene comes from
a quite separate group of
paintings, all produced at
the start of Caravaggio's
connection with Cardinal
del Monte. The figures
possess an extraordinary
clarity verging on three-
dimensional hardness. A
specific and steady source
of light illuminates the most
macabre details. The theme
of heads being cut off and
gushing blood recurs
throughout Caravaggio's
work and was effectively a
leitmotif of his career.

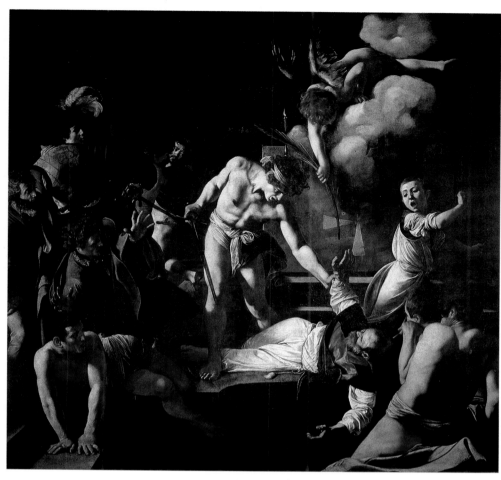

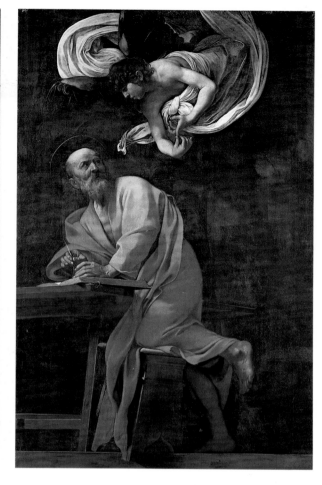

Caravaggio

Martirio di san Matteo/
The Martyrdom of St.
Matthew; Vocazione di
san Matteo/The Calling of
St. Matthew; San Matteo
e l'angelo/St. Matthew
and the Angel

*1599–1602, canvases, Rome,
San Luigi dei Francesi,
Contarelli Chapel.*

The cycle in S. Luigi dei
Francesi was the largest and
the most homogeneous
commission that he ever
undertook. *The Martyrdom*
is the busiest and most
dynamic scene which
centers around a killer
rushing in to slay the
wounded saint. Caravaggio
used groups of people
looking on in horror to
depict a whole sequence of
very human emotions which
culminate in the choir boy
running off screaming. As
well as references to Raphael
and Leonardo, Caravaggio
also probably included his
own self-portrait – he is the
man with a short beard half-

hidden in the shadows at the
back of the picture, just to
the left of the hired assassin.
The Calling is brought to life
by the new and moving way
that Caravaggio used light.
It is no longer suffused
throughout the picture, but
has direction and purpose.
Christ is on the right, half-
hidden by Peter, turning
toward Matthew seated at a
table surrounded by other
tax collectors. This set up a
play of contrasting poses and
extraordinarily fine details.
The composition manages
to convey a strong sense of
moral tension which was
copied by his followers as
the basis for similar pictures.
This *St. Matthew and the Angel*
was Caravaggio's second
version. The first had been
turned down because the
image it presented of St.
Matthew lacked the
requisite decorum.
Nevertheless the still
informal posture of the saint
indicates a marked degree of
indifference to his patrons'
complaints.

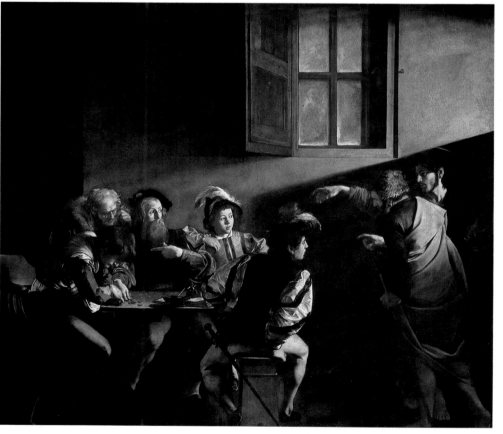

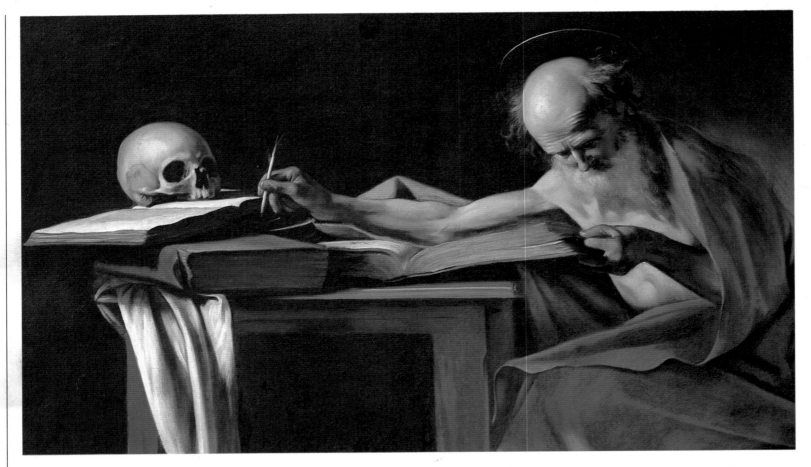

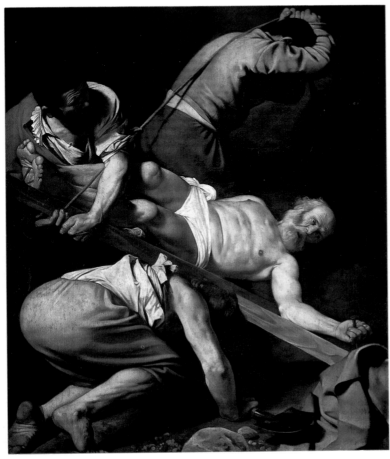

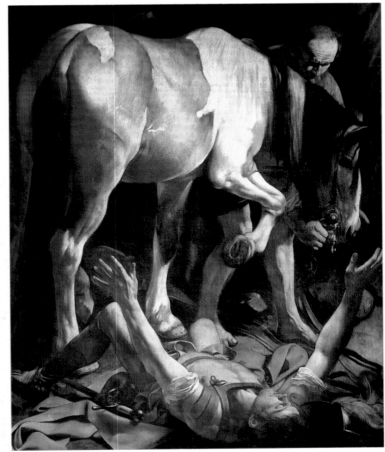

Opposite page, top
Caravaggio
San Gerolamo/
St. Jerome

1606, canvas, Rome, Galleria Borghese.

Opposite page, bottom
Caravaggio
Crocifissione di san Pietro/
The Crucifixion of St.
Peter; Caduta di san
Paolo/The Conversion of
St. Paul

*1600–01, canvases, Rome,
S. Maria del Popolo, Cerasi
Chapel.*

The two canvases from the Cerasi Chapel were painted immediately after the cycle for S. Luigi dei Francesi and were indeed the ideal follow-up. For his *Crucifixion of St. Peter*, Caravaggio has used starkly contrasted light and dark to help concentrate the viewer's gaze on a handful of figures who are the true protagonists of the action. The sense of humanity and intense participation that he created was extended to include the executioners. The men are not shown as characters acting in a brutal or cruel fashion, but rather as ordinary people who have a job to do. In *The Conversion of St. Paul* Caravaggio's radically free interpretation of religious themes reached new heights. St. Paul is not blinded by the light out on the road to Damascus, but is inside a half-darkened stable filled with the dappled flanks of the huge horse, and his blinding is witnessed only by a single stable hand emerging from the gloom. The silence and the solitude increase the fascination of the scene. In the contract drawn up for the two Cerasi Chapel canvases, Caravaggio is referred to as "egregius in urbe pictor" (outstanding painter of the city). Despite his often wild behavior Caravaggio, who was not yet 30, was already at the peak of his fame.

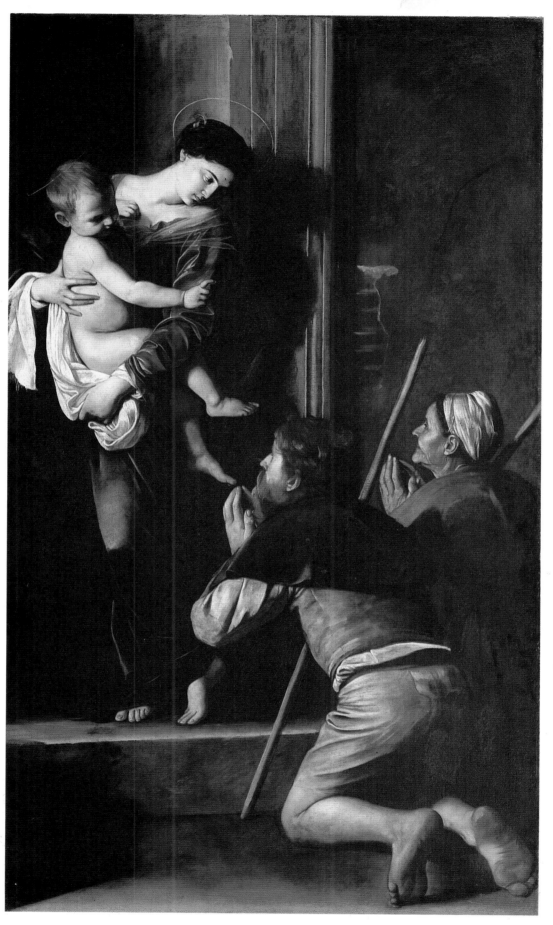

Caravaggio
Madonna dei pellegrini/
The Madonna of the
Pilgrims

*1603–05, canvas, Rome,
S. Agostino.*

The altar is dedicated to the Madonna of Loreto but Caravaggio only just touches on the traditional form of devotion to her. Instead, his Madonna is standing at the front door of an ordinary house. Caravaggio showed that Mary, too, was an ordinary woman, which is far removed from traditional iconography. In front of her we see the two people who have almost usurped the role of protagonists in the painting. They are poor pilgrims dressed in grimy rags and showing the viewer a close-up of their sore and dirty feet. This highly realistic detail caused an outcry among his contemporaries.

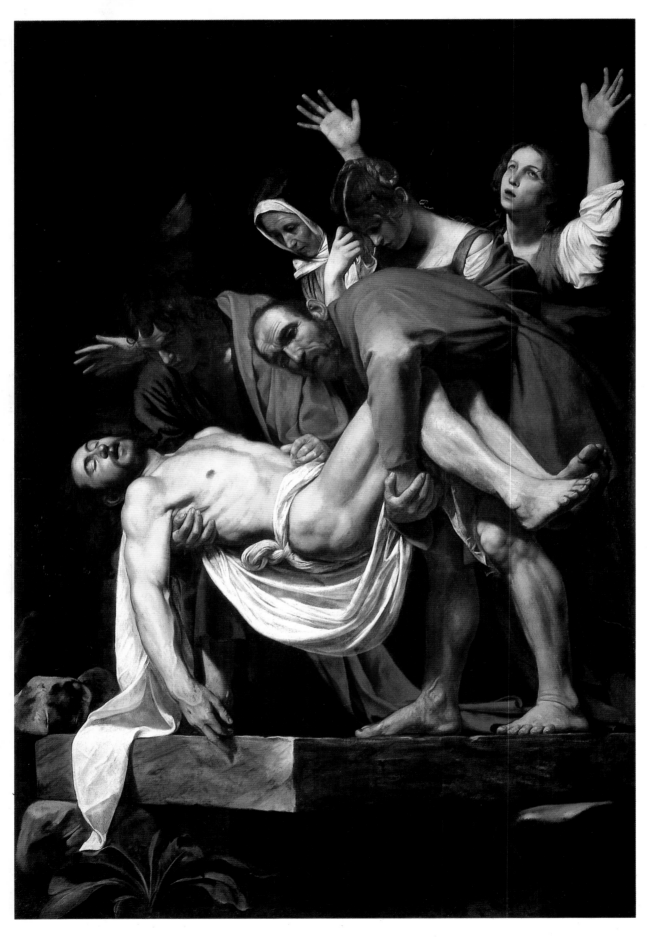

Caravaggio
Deposizione nel sepolcro/
Deposition

*1602–04, canvas, Rome,
Vatican Gallery.*

Painted for S. Maria in
Vallicella, this canvas is
often thought of as a kind
of classical interlude in
Caravaggio's final years in
Rome. It is quite evident
that he was trying to depict
a sculpted group worthy of
Michelangelo. The gestures
are blocked out in an
expressive manner and he
uses light to sculpt the
figures. On the other hand,
Caravaggio had not wholly
abandoned his powers of
realism, as can be seen from
the corner of the jutting
stone or Nicodemus' legs.

Caravaggio
Morte della Vergine/
The Death of the Virgin

1606, canvas, Paris, Louvre.

This was the last canvas he
painted in Rome. It was
commissioned for S. Maria
della Scala but the
Carmelites turned it
down because it lacked
"decorum." They also
suspected that the model
Caravaggio used for the
Virgin was a prostitute who
had drowned in the Tiber.
The Gonzaga family bought
it and it was later acquired
for the collection of Charles
I of England before finally
going to France.
Dominated by the blood-
red drape overhead, the
scene is one of utter misery
and touching grief. The
weeping apostles gather
around Mary's bed,
underlined by the diagonal
line of light filtering from
left to right. The final touch
is the hunched figure of
Mary Magdalene.

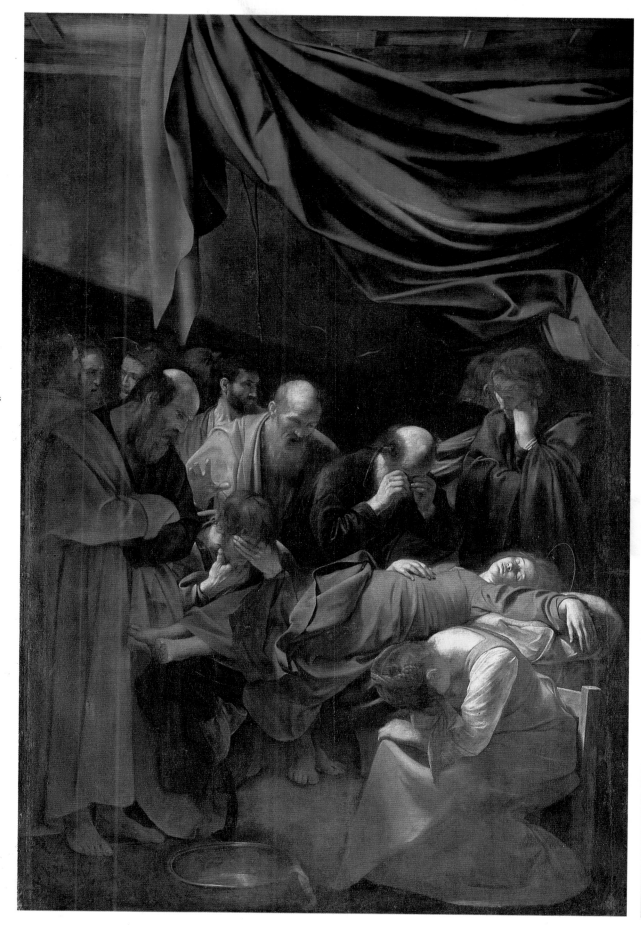

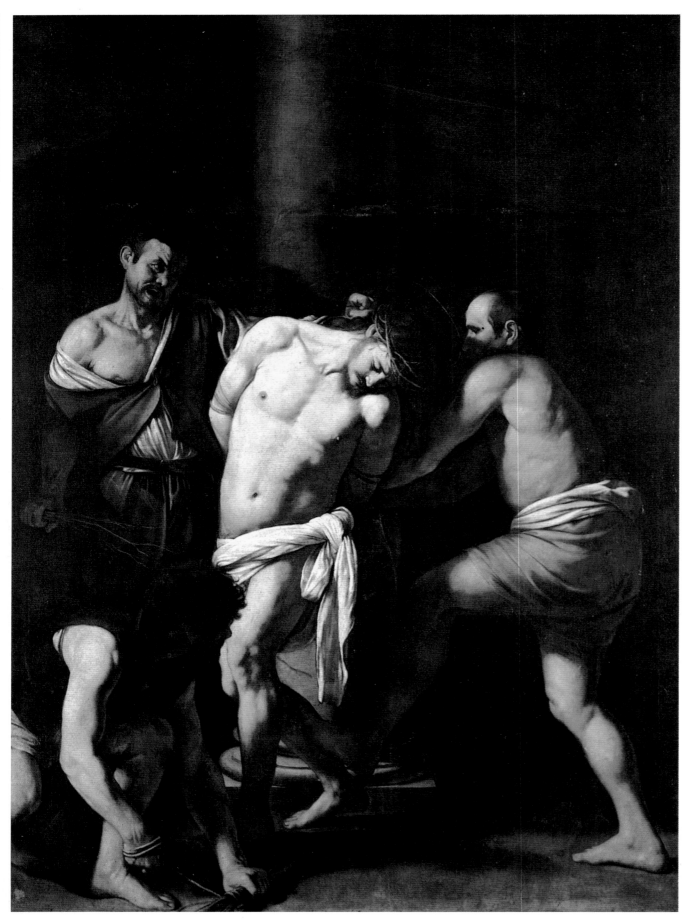

Caravaggio
Flagellazione di Cristo/
Flagellation of Christ

*1606–07, canvas, Naples,
Museo di Capodimonte.*

Recently-discovered
documents suggest that the
canvas was painted during
Caravaggio's first stay in
Naples. In fact the tragic
bitterness of unrelenting
torment, the deep shadows
reaching out to touch the
figures, and the overall
atmosphere of tragedy are
all typical of Caravaggio's
last period.

Caravaggio
Ritratto di cavaliere di Malta/Portrait of a Knight of Malta

c. 1608, canvas, Florence, Pitti Palace, Galleria Palatina.

This may be a portrait of the Grand Master Olaf de Wignacourt who first welcomed the exiled Caravaggio to Malta and made him a member of the noble order of the Knights of St. John. Once he discovered that Caravaggio was on the run from justice, however, he had him imprisoned and publicly withdrew all the privileges that he had previously bestowed.

Caravaggio
Decollazione del Battista/ The Beheading of John the Baptist

1608, canvas, Valletta (Malta), S. John's.

This was Caravaggio's largest and only signed painting (his name is traced in the blood spurting out of St. John's truncated neck). The evolution of his art was about to enter its final phase. He was still on the run but nurtured the hope of being able to go back to Rome. By this time he had stopped using vivid colors and abandoned the sparkling details of his youth. He now began to concentrate on the use of space. In the huge Maltese canvas he grouped all the characters on the left while the whole of the right-hand side was filled with the blank prison wall. This gives the episode the chilling impression of a merciless execution carried out just before dawn.

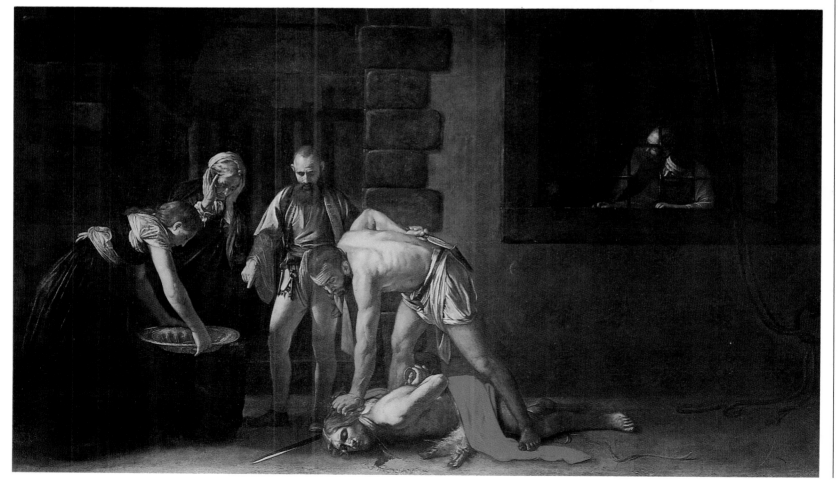

Guido Reni

Bologna, 1575–1642

Guido Reni was a quintessentially classical academic but he was also one of the most elegant painters in the annals of art history. He was constantly seeking an absolute, rarefied perfection which he measured against classical Antiquity and Raphael. Because of this, over the years the Bolognese painter has been in and out of fashion, depending on the tastes of the times. The eighteenth century loved him, the nineteenth century, persuaded by the violent criticism of John Ruskin, hated him. But even his detractors cannot deny the exceptional technical quality of his work nor the clarity of his supremely assured and harmonious brushwork. He joined the Carracci Academy when he was 20. His studies were rounded off by a trip to Rome in about 1600. From that moment on, antique and recent Roman art became his ideals. He admired Raphael unconditionally. He did, however, come to terms with Caravaggio's naturalism in a group of youthful works such as *The Crucifixion of St. Peter* in the Vatican Gallery, 1604, where the use of chiaroscuro provided enormous energy. He alternated between living in his native Bologna and visits to Rome. After Annibale Carracci's death (1609) he became the leader of the classical school of Emilian painters. His adhesion to this school can be seen in the frescos he painted in Rome in about 1610 in the Quirinal Palace, the Vatican, and various churches. They were inspired by the return to classical taste and culminated in *Aurora* in Palazzo Ludovisi which has almost mimetic qualities. The large altarpieces he painted in Bologna – *The Massacre of the Innocents* and *Pietà dei Mendicanti* both in the Bologna Pinacoteca Nazionale – mark the triumph of design, the ability to control and channel feelings, gestures, expressions, drawing, and color into a single, eloquent, and faultless form. Guido Reni's success was underlined by the important commissions he received. They included the cycle of *The Labors of Hercules* (1617–21) that he painted for the Duke of Mantua and which are now in the Louvre. He exalted the clarity of light, the perfection of the body, and lively color. Toward the end of his life, Reni modified his style. His paintings became so airy as to seem insubstantial and were almost completely monochrome. He also used long, flowing brushstrokes and conveyed an atmosphere laden with intense melancholy.

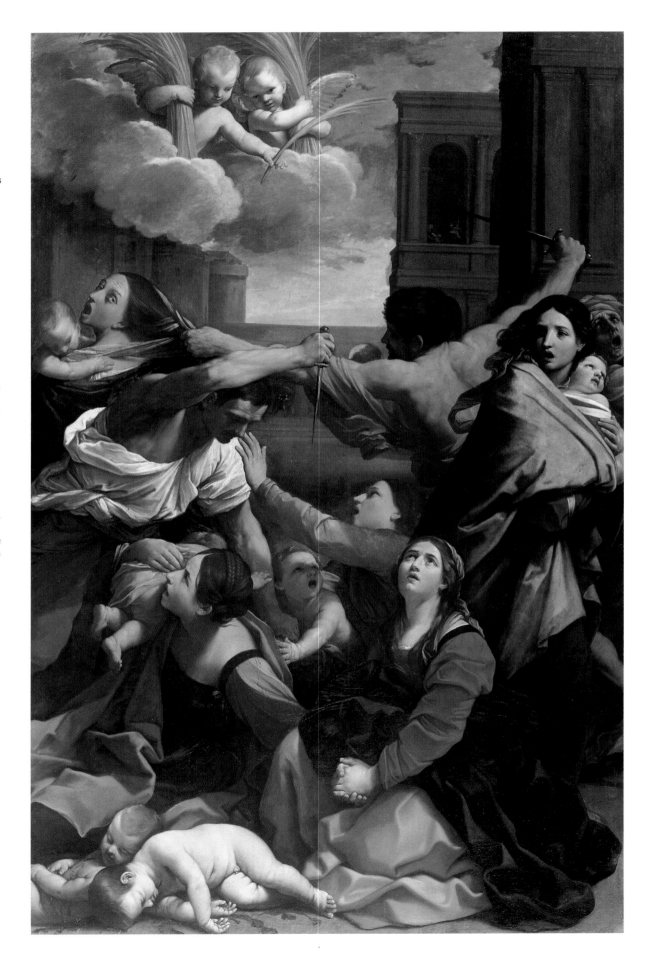

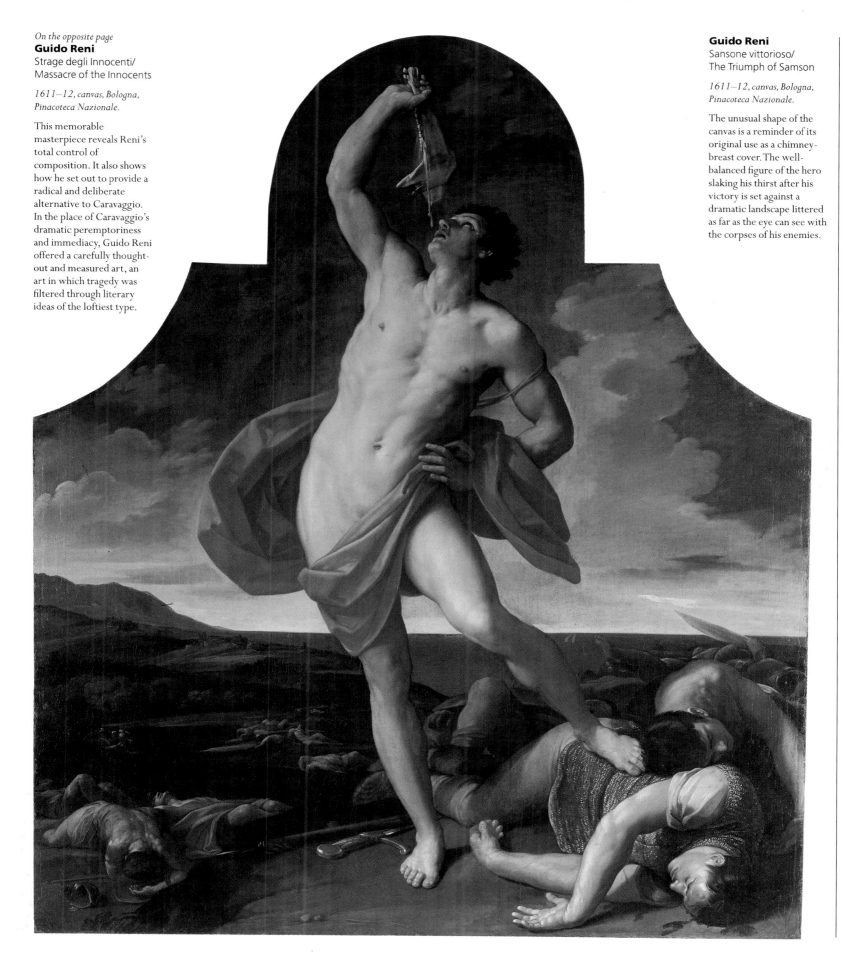

On the opposite page
Guido Reni
Strage degli Innocenti/
Massacre of the Innocents

*1611–12, canvas, Bologna,
Pinacoteca Nazionale.*

This memorable
masterpiece reveals Reni's
total control of
composition. It also shows
how he set out to provide a
radical and deliberate
alternative to Caravaggio.
In the place of Caravaggio's
dramatic peremptoriness
and immediacy, Guido Reni
offered a carefully thought-
out and measured art, an
art in which tragedy was
filtered through literary
ideas of the loftiest type.

Guido Reni
Sansone vittorioso/
The Triumph of Samson

*1611–12, canvas, Bologna,
Pinacoteca Nazionale.*

The unusual shape of the
canvas is a reminder of its
original use as a chimney-
breast cover. The well-
balanced figure of the hero
slaking his thirst after his
victory is set against a
dramatic landscape littered
as far as the eye can see with
the corpses of his enemies.

265

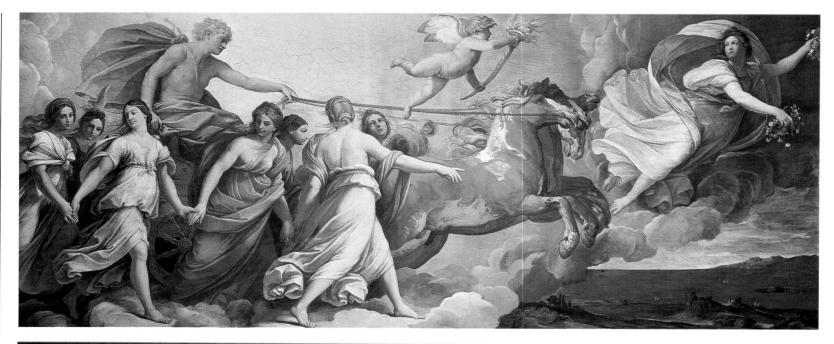

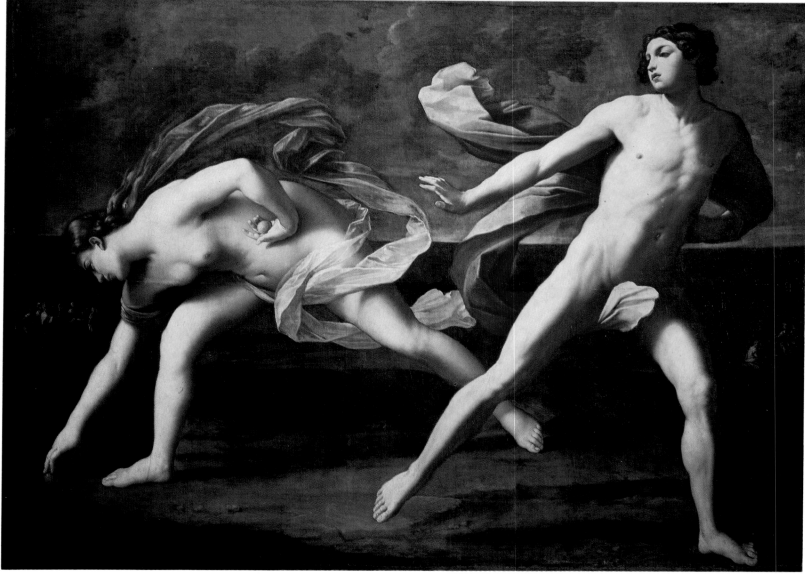

Opposite page, top
Guido Reni
L'Aurora/
Aurora (Dawn)

*1612–14, fresco, Rome,
Palazzo Parravicini
Rospigliosi.*

During Guido Reni's
second stay in Rome he
directly tackled themes
from classical Antiquity.
While this composition
was openly derived from
classical art, it was meant in
the spirit of purest love and
has a genuine if rather
insipid beauty.

Opposite page, bottom
Guido Reni
Atalanta e Ippomene/
Atalanta and Hippomenes

*1622–25, canvas, Naples,
Capodimonte Gallery.*

This composition is
calculated and refined.
It highlights the
contradictory gestures of
the unbeatable athlete
Atalanta bending down to
pick up the golden apple
dropped by Hippomenes.
Thanks to his stratagem,
the youth is about to win
the contest. The idea of
movement is rendered
almost exclusively by the
billowing cloaks. The ivory
smooth bodies of the two
contestants clearly stand
out remarkably against the
gray-brown background.

Guido Reni
Ratto di Elena/
The Abduction of Helen

1631, canvas, Paris, Louvre.

A supremely elegant
treatment of the famous
story.

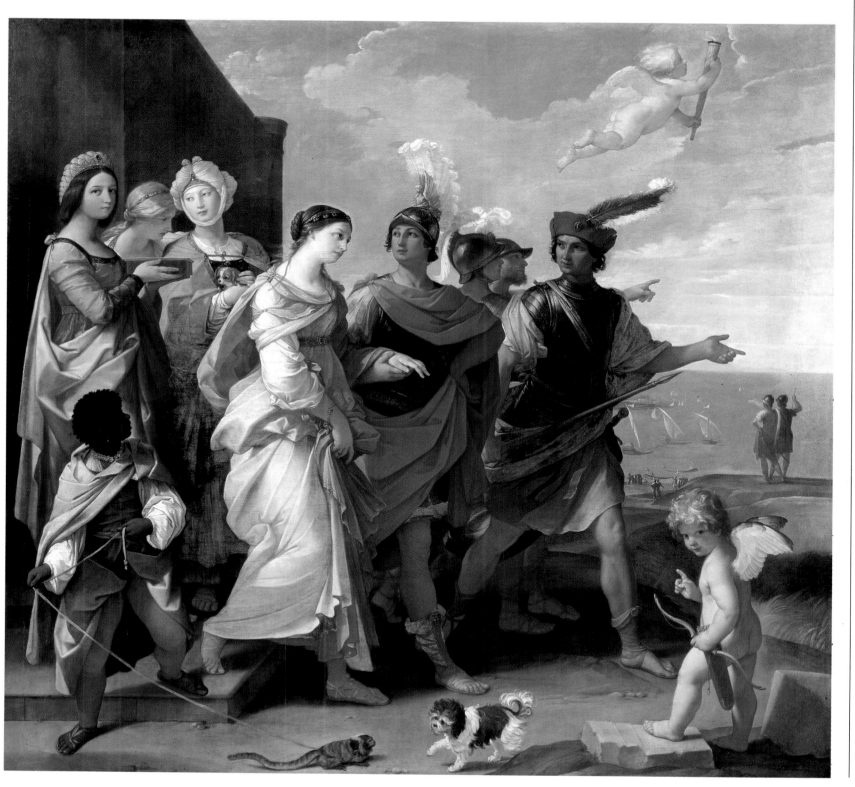

Domenichino
Diana the Huntress

1614, canvas, Rome, Galleria Borghese.

The story of how this festive picture came to be painted is very unusual. Cardinal Aldobrandini commissioned it as a sequel to Titian's *Bacchanals* which he had recently added to his collection. The comparison with such an illustrious model brought out the best in Domenichino, especially his ability to handle light, and spurred him to take a fresh approach. Unlike Titian, the Emilian painter was willing to avoid explosive use of color and movement. Instead he seemed content to concentrate on a serene contemplation of the beauty of girls, animals, and the countryside.

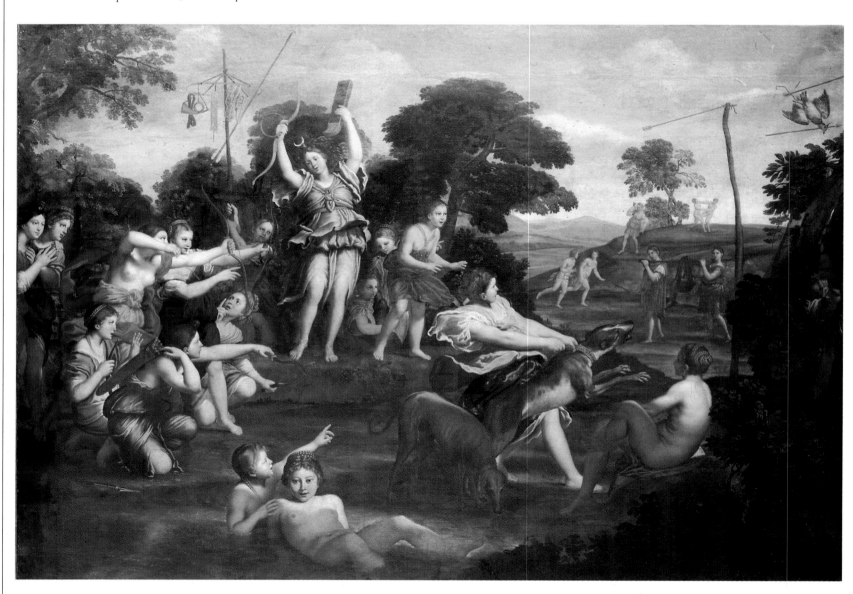

Domenichino

Domenico Zampieri, Bologna, 1581–Naples, 1641

Domenichino was perhaps the most sophisticated painter of the seventeenth century, so much so, in fact, that at times his work can seem rarefied. He also played an important cultural role with regard to the theory of art. He studied under the Carracci cousins, first in Bologna and then in Rome (where at the beginning of the century he assisted Annibale who was then working in the Farnese Gallery and on the large lunettes in Palazzo Doria-Pamphili). Domenichino was completely bowled over by the simple, classical, and elegant beauty of Raphael's art, having a deep admiration for all the great masters of the early sixteenth century. His career was mainly spent trying to revive that wonderful era of the High Renaissance, but he did this with a completely up-to-date critical and intellectual approach. His output typically included altarpieces such as *The Communion of St. Jerome* painted in response to Agostino Carracci, Rome, Vatican Gallery, and countless secular and religious fresco cycles, such as those painted for Villa Aldobrandini at Frascati, for the S. Nilo Chapel in the abbey at Grottaferrata (1610) or the beautiful murals he painted in the S. Cecilia Chapel of S. Luigi dei Francesi in Rome (1611–14). These are located almost opposite Caravaggio's St. Matthew canvases painted in such a different style a dozen years earlier. Domenichino's career stalled slightly after the failure of his frescos in S. Andrea della Valle (1624–28). Embittered by their poor reception, he moved to Naples where he painted the Chapel of the Tesoro in the cathedral.

Domenichino

La sibilla Cumana/
The Cumaean Sibyl

*c. 1610, canvas, Rome,
Pinacoteca Capitolina.*

The girl's idealized but
highly sensual beauty seems
to be reflected in all the
luxurious trappings that
surround her. Every last
detail of the picture is
handled with impeccable
care which was, indeed,
typical of Domenichino.
The Emilian painter was
openly inspired by
Raphael's work, and in
particular his *Ecstasy of St.
Catherine* in Bologna, but
rephrased in a manner
suitable for a pagan
prophetess rather than a
Christian saint, with gold-
decorated turban, splendid
wrap, and gilded chair.

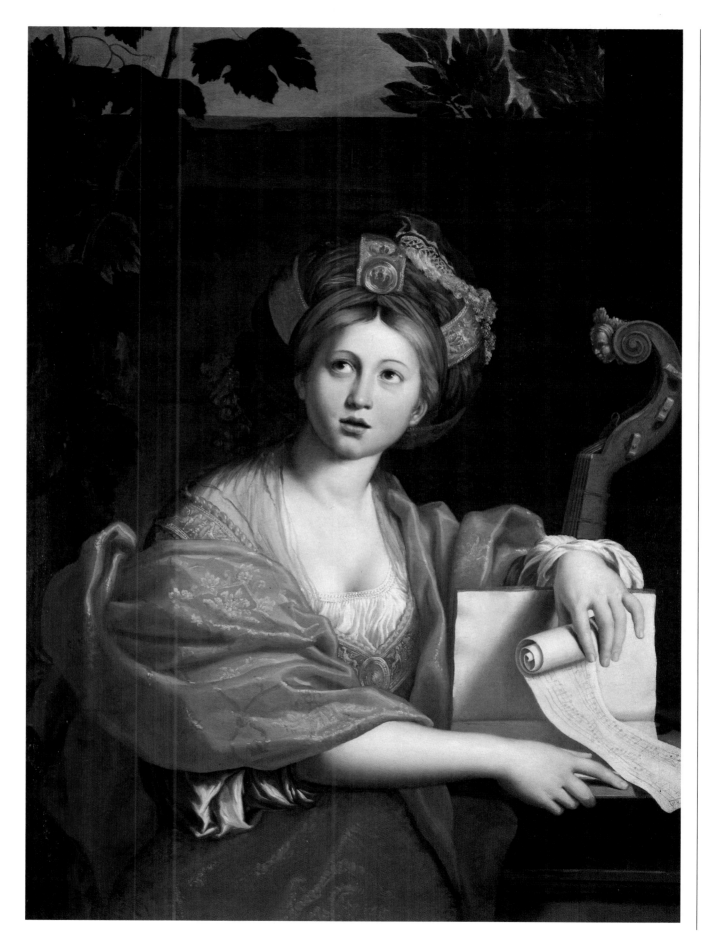

Francesco Albani
L'acconciatura di Venere/
Venus at her Toilet

*1618—22, canvas, Rome,
Galleria Borghese.*

This is one of a group of
four tondi on mythological
subjects.

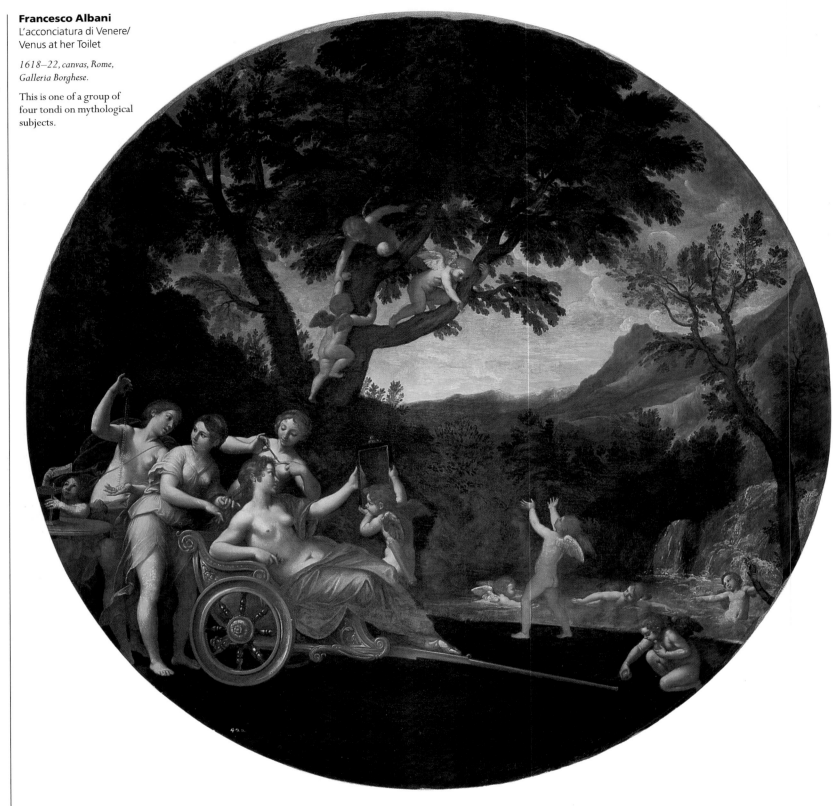

Francesco Albani

Bologna, 1578–1660

Albani studied in Bologna with the
Mannerist Denijs Calvaert before
joining the Carracci Academy where he
was an enthusiastic pupil. Like so many
other artists from Bologna, he moved to
Rome to study classical art which he
then applied with zeal to his own work.
Albani's classicism can be seen in the
altarpieces he painted after returning to
Bologna. Among them is *The Baptism of
Christ* now in the Bologna Pinacoteca
Nazionale. His love of classical antiquity
is still more evident in the cycles he
painted on mythological subjects,
a genre of painting he practically
established. He used mythology in
Dance of the Amorini or the allegorical
tradition (elements, seasons) as the
pretext to paint smiling idylls to which
he added nymphs, goddesses, and happy
little putti all set against luminous ideal
landscapes. In this way he created an
appetite for light-hearted, pleasant
works which lasted throughout the
seventeenth century. It did, however,
tend at times to decline into insipidity.
His favorite format for this type of
composition was the tondo or oval.

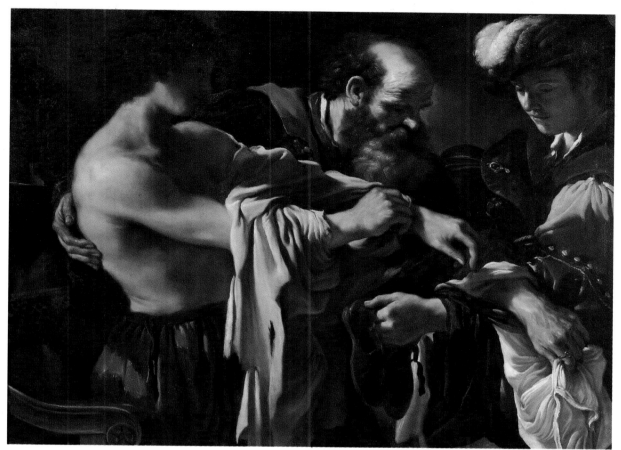

Guercino

Giovan Francesco Barbieri, Cento, 1591–Bologna, 1666

Guercino (a nickname meaning "the squinter") was self-taught but developed precociously. Despite the fact that he spent much of his life in Cento, a small provincial town between Bologna and Ferrara, he managed to become one of the major artists of his day. He was early inspired by the classical reforms of Ludovico Carracci but his pictures were full of movement and intense feeling. In 1621 Pope Gregory XV summoned him to Rome where he stayed until 1623, trying to balance his own dynamic temperament with the rarefied manner of the classical school. The works he produced in Rome such as *Aurora*, in the Ludovisi's country house were perhaps his most original paintings. After he went back to Emilia, his energy gradually seemed to dissipate and his painting became more controlled. On the death of Guido Reni (1642) he moved to Bologna where the dominant climate was coldly classical. Altering his art to suit this atmosphere, Guercino became the leader of its academic art world.

Guercino

Il ritorno del figliol prodigo/The Prodigal Son's Return

1619, canvas, Vienna, Kunsthistorisches Museum.

This wonderful piece of youthful painting was done for Cardinal Serra. It is full of energy and feeling. The way Guercino handled his characters' hands and the fabric of their clothes in itself conveyed the emotion of the scene. Guercino also revealed the contrasting and violent emotions of the three men.

Guercino

Sansone catturato dai filistei/Samson Captured by the Philistines

1619, canvas, New York, Metropolitan Museum of Art.

As shown here, Guercino's early masterpiece demonstrates far better than most other paintings that it is possible to achieve dramatically theatrical effects without abandoning real naturalism.

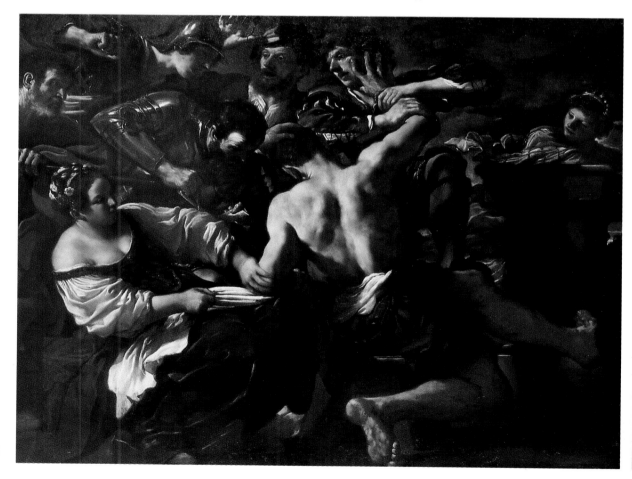

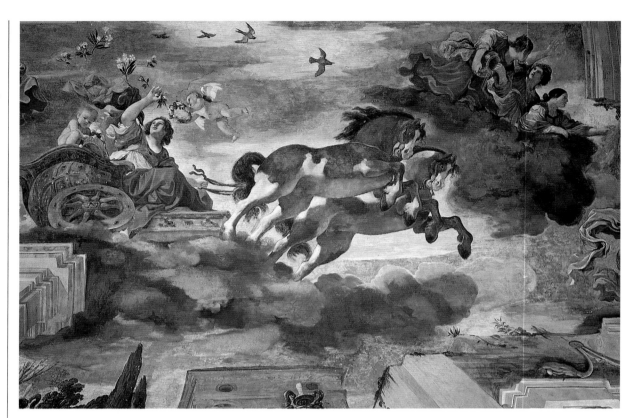

Guercino
Aurora

1621, fresco, Rome, casino Ludovisi.

When he became pope under the name of Gregory XV, Alessandro Ludovisi invited Guercino to Rome, where he lived until 1623. His first job in Rome was to decorate the Ludovisi country house. The fresco of *Aurora* was set in frames painted by Agostino Tassi. The thirty-year-old Guercino unleashed all his flair and fantasy on this composition which has an extraordinarily lively feel to it. This was a direct challenge to Guido Reni. Only a few years earlier Reni had painted the same subject for the Rospigliosi country house, only in his case the result was an elegant, coldly classical, if typically graceful piece.

Guercino
Et in Arcadia ego

1618, canvas, Rome, Galleria Nazionale d'Arte Antica.

This is one of Guercino's best-known paintings. It shows two young shepherds who have discovered a skull. The title could be interpreted as a sentence uttered by Death ("I too am in Arcadia"). But any moral significance to the work is lost in a moment of pure contemplation. Quotations from Correggio and Venetian art are completely in tune with the depth and sensitivity of feeling typical of Guercino.

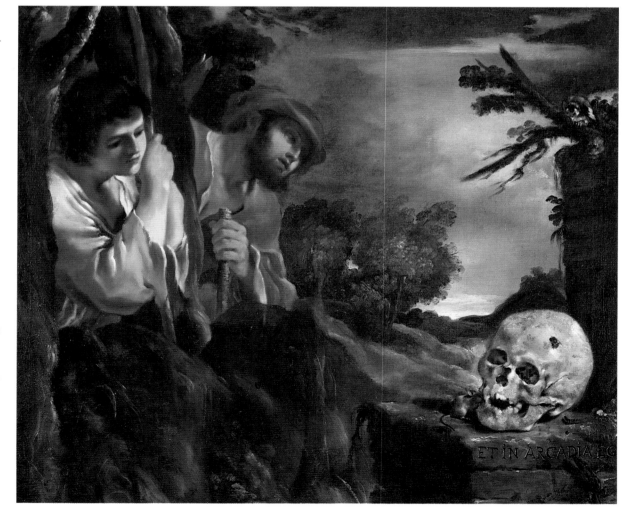

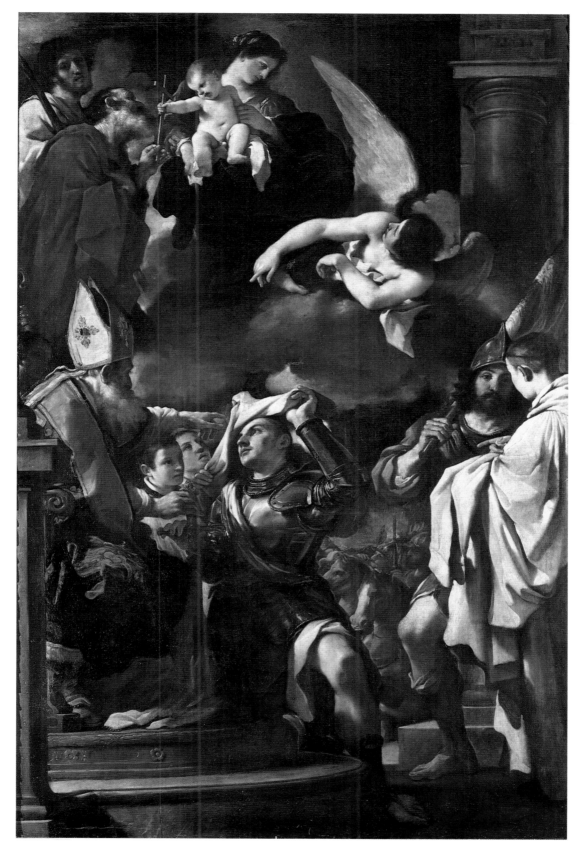

Guercino
Vestizione di san Guglielmo d'Aquitania/ St. William of Aquitaine Receiving the Cowl

1620, canvas, Bologna, Pinacoteca Nazionale.

This canvas originated from the church of S. Gregorio in Bologna and according to contemporaries it was a "large splash" of light and color that completely overshadowed all the other paintings around it, including Ludovico Carracci's altarpiece. There is no doubt that this was the most important painting Guercino produced in his early years. He took great trouble preparing it and worked from careful studies and pencil sketches. The structure of the composition was highly original. The figures are arranged along the sides of an invisible lozenge, leaving the center of the painting empty. The use of light and shade emphasized both the very delicate colors (right through to the candid white robes of the brother on the right) and the deeply dark areas. Thanks to this painting, Guercino became the favorite painter of Cardinal Ludovisi and leader of the Bologna school.

Bartolomeo Schedoni

Modena, 1578–Parma, 1615

Schedoni's untimely death (perhaps suicide owing to gambling debts) brought an abrupt end to the career of one of the most attractive painters of the seventeenth century and an eccentric exponent of the Emilian school. He was connected to the Farnese courts in Parma and Modena where he both assimilated and reworked a variety of different influences. Among them we can see both a direct line to Correggio, the finely detailed way of working used by the Carracci cousins, and all of the latest trends from Rome. Ranuccio Farnese sent Schedoni to Rome at the close of the sixteenth century, but he soon returned to Emilia and settled in Parma. It was there that he painted a small but fascinating group of masterpieces in a severe and noble style. At the same time his works were warmed by a light that softened fabrics and added delicacy to expressions. Although the dates and places were different, Schedoni's personal story ran along similar lines to Caravaggio's. His violence and trouble-making got him into endless scrapes with the law, while his passion for tennis was so great that he almost lost the use of his right hand.

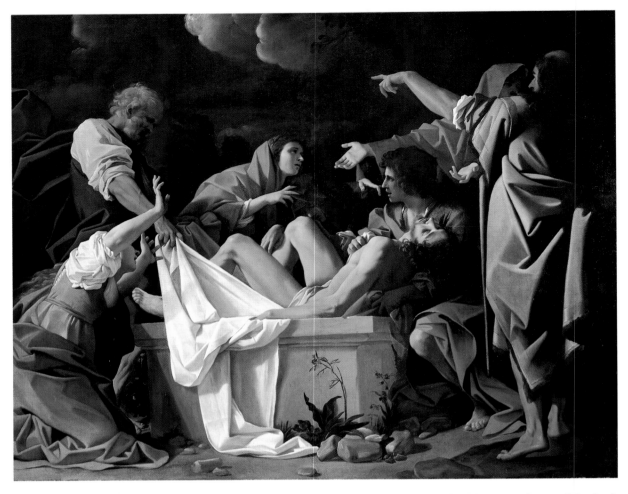

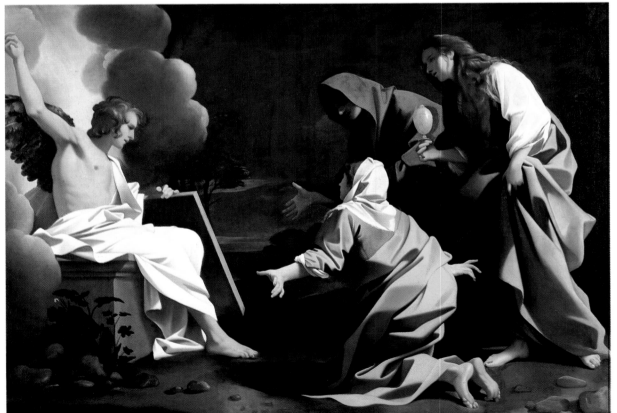

Bartolomeo Schedoni
Cristo deposto nel sepolcro/Deposition; Le Marie al sepolcro/The Two Marys at the Tomb

1613, canvas, Parma, Galleria Nazionale.

These two memorable masterpieces (originally in the Capuchin church at Fontevivo, near Parma) give us cause to regret the brevity of Bartolomeo Schedoni's tormented artistic life. They show that he really would have been able to point Baroque painting in an original and intense direction. The way he blocked out gestures, used violent light and dazzling whites, combined with perfect clarity of detail to produce an almost metaphysical effect.

Bartolomeo Schedoni
La carità/Charity

1611, canvas, Naples, Gallerie di Capodimonte.

This painting holds a historic place in the Farnese collection. It is also one of Schedoni's best-known works. The rather generic title is not really sufficient as the canvas appears to be describing a real episode. Schedoni gave his characters an amazing degree of consistency and peremptoriness. The blind boy staring out at us with empty eyes is one of the strongest images ever produced in the seventeenth century. As always, Schedoni also drew on Correggio's legacy for touches of moving lyricism, such as the little boy on the right. But the real magic of the painting lies yet again in the highly personal way that Schedoni used light, both penetrating and delicate at the same time. His light brings out the colored fabrics while casting long shadows over parts of the faces.

Guido Cagnacci

Santarcangelo di Romagna, 1601–Vienna, 1663

Cagnacci was an interesting Emilian painter of the mid-seventeenth century. Like many others from his region, he was actively involved in rediscovering classical Antiquity. He also holds a special place in the history of art because he moved to Vienna and so exported the latest classical style to the German-speaking world. Cagnacci had been Guido Reni's pupil and tended to combine references to classical models and to Raphael's work with his own lively interest in the type of daring perspectives and brilliant compositions that the new Baroque style favored. We can see this phase of his work in the huge canvases in Forlì cathedral painted early in his career. In 1650, a journey to Venice added more color to his palette and opened up the range of the subjects he handled to include sensual scenes with seductive half-naked young girls. This type of composition was much sought-after by collectors and opened up international avenues. Cagnaccio's move to Vienna in 1658 put the seal of success on his painting.

Guido Cagnacci
La morte di Cleopatra/
The Death of Cleopatra

*1658, canvas, Vienna,
Kunsthistorisches Museum.*

This work from the end of his Viennese period is a broader reworking of the theme of the female nude that Cagnacci had so sensually explored on several occasions. Such works were unsurprisingly popular.

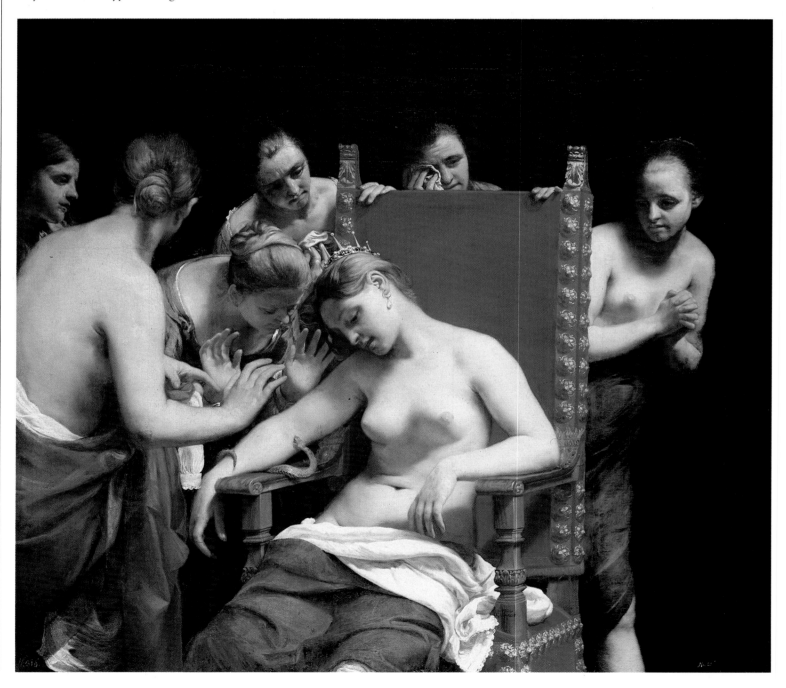

Guido Cagnacci
Fiori in una fiasca/
Flowers in a Flask

c. 1645, canvas, Forlì,
Pinacoteca Comunale.

This is one of the most
fascinating masterpieces of
Italian still life. The Forlì
painting is of pivotal
importance in gaining
an understanding of
Cagnacci's genre work. It is
clear that the canvas reveals
true lyrical inspiration and
is not merely a piece of
clever painting. Our
admiration for the
impressive virtuoso skill in
capturing the subject is
soon replaced by a poetic
feel for a fairly cheap bunch
of flowers that is straining
toward the light. The
flowers seem to be
stretching upwards, as if
trying to escape the
humiliation of being
trapped in the tacky straw-
covered flask.

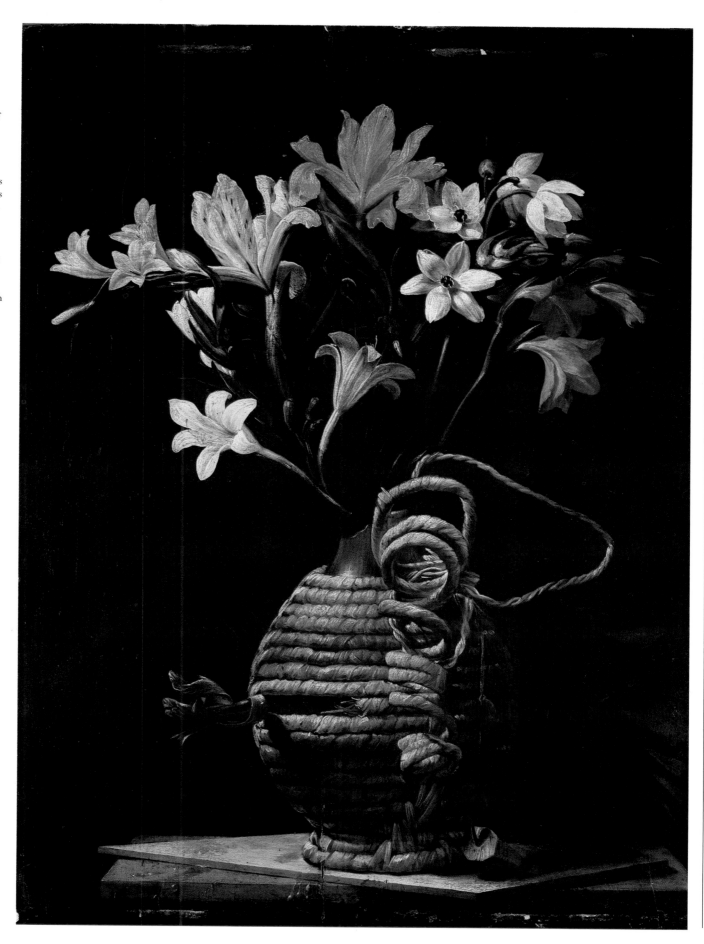

Orazio Gentileschi

Pisa, 1563–London, 1639

Coming from a family of artists, whose tradition was continued by his brilliant daughter Artemesia, Orazio Gentileschi trained in one of his uncles' studios in Rome. His own career, however, was slow in starting and he was almost 40 before it really got underway. Then in the first decade of the seventeenth century friendship with Caravaggio brought about a sudden change. Still retaining his Tuscan tradition of superb elegance and draughtsmanship, Orazio added Caravaggio's chiaroscuro and realism. The resultant paintings were both accomplished and powerfully expressive. After a decade working in Rome, in about 1612 Gentileschi settled in the Marches where he painted a number of altarpieces and frescos for Fabriano cathedral. In 1621 a nobleman called Sauli invited him to Genoa. This was the start of the extraordinary international success he enjoyed with several aristocratic patrons. They commissioned canvases for their collections and Gentileschi often produced the same composition in more than one version. After meeting the Savoy ducal family, in 1624 Orazio Gentileschi left for Paris where he worked until 1626 for Marie de' Medici. He then moved to London where he remained until he died. He was much admired by the English court and private collectors for the now much lighter-toned and very enjoyable quality of his canvases, and he painted the ceilings for the Queen's House at Greenwich, now in Marlborough House, London.

Orazio Gentileschi
Visione di santa Francesca Romana/The Vision of St. Francesca Romana

1615–19, canvas, Urbino, Galleria Nazionale delle Marche.

Orazio Gentileschi possessed a very personal talent for creating a double effect in his altarpieces. On the one hand, he captured the silent nobility and courtliness of a solemn scene. On the other, he evoked deep and humble feelings of great inner delicacy.

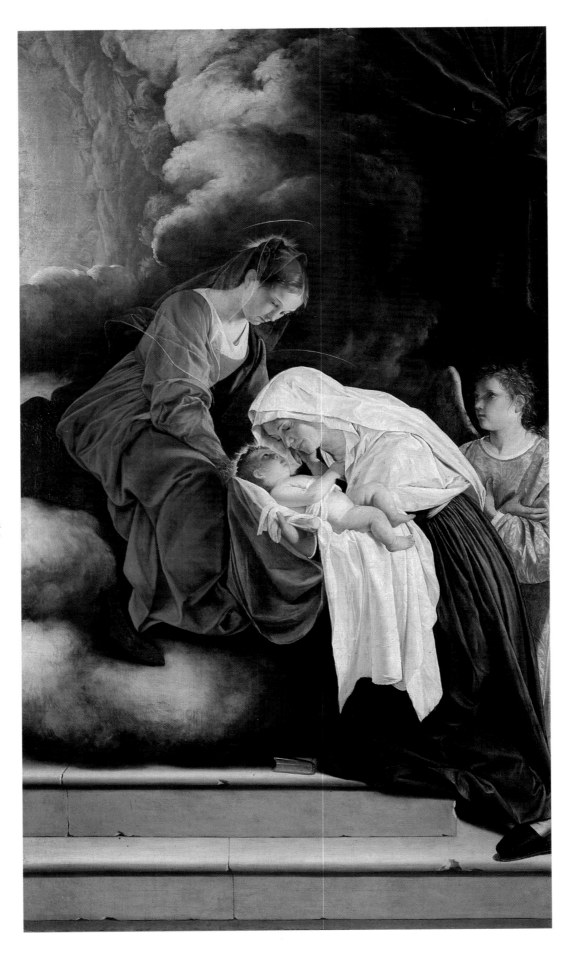

Orazio Gentileschi
Annunciazione/
Annunciation

1623, canvas, Turin, Savoy Gallery.

This painting dates from Gentileschi's time in Genoa (an earlier version of the same subject is in the church of S. Siro in Genoa) and is probably his most celebrated work, often considered his masterpiece. The huge red drape hanging behind the Madonna's pure white bed is an overt homage to Caravaggio. Indeed it is to him that the canvas owes its overall sense of vibrant reality, its light and its feeling. Nevertheless, Gentileschi reworked the basic style of Caravaggio's expressive art in an unusually rich fashion. He freely applied color in a manner akin to the great Flemish painters of the day, such as Rubens or Van Dyck, who were either working in Genoa or whose canvases could be viewed there. In addition, his impeccable draughtsmanship, derived from his Tuscan background, emphasized the refined and noble qualities of the picture.

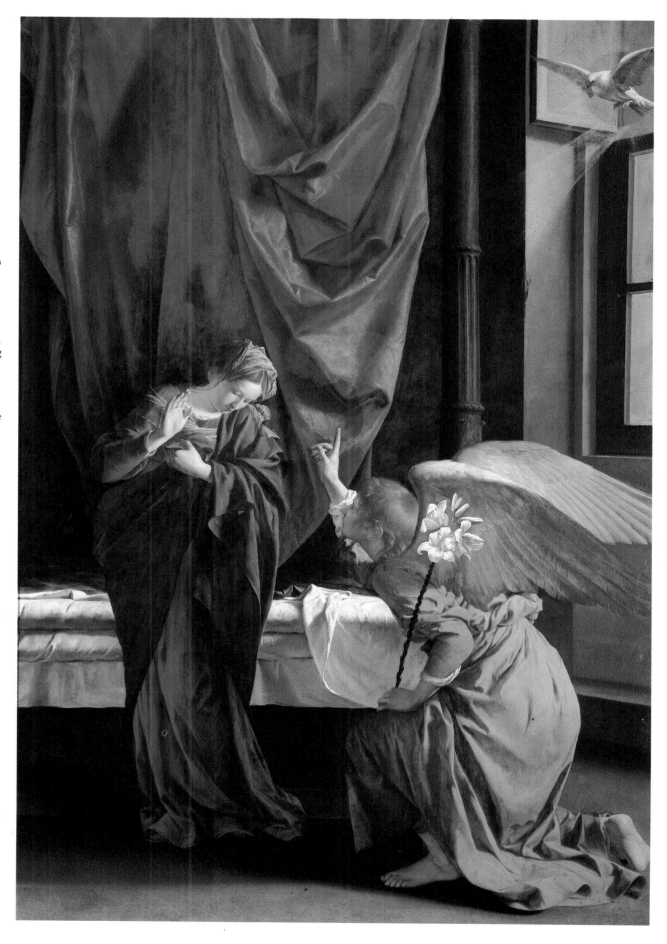

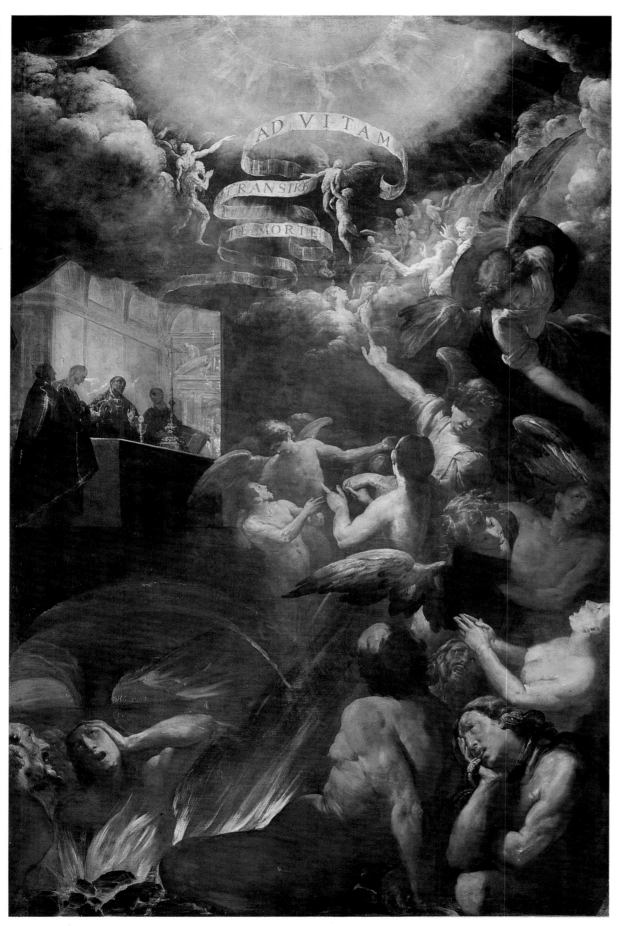

AD VITAM TRANSIRE DE MORTE

Cerano

Giovanni Battista Crespi, (probably) Cerano (Novara), c. 1575–Milan, 1632

Cerano was a painter, sculptor, architect, intellectual, and, by the appointment of Cardinal Federico Borromeo, his friend and patron, the director of the Ambrosian Academy of Art in Milan. He was the most influential cultural figure in Milan at the start of the seventeenth century. He worked on important Church commissions influenced by the Council of Trent's edicts and were aimed at reforming Lombard art. Crespi was at ease with colossal undertakings (such as the cycle of paintings dedicated to St. Charles). He had a strongly dramatic temperament which produced pictures of overwhelming energy and moving intensity, such as *The Baptism of St. Augustine*, 1618, Milan, S. Marco, or his contribution to the *Altarpiece*, Milan, Brera, which he painted together with Morazzone and Giulio Cesare Procaccini. This altarpiece was nothing less than a manifesto for the movement in painting known as the Seicento Lombardo.

Cerano
Messa di san Gregorio/
The Mass of St. Gregory

1617, canvas, Varese, S. Vittore.

The visionary and dramatic violence of the leading painter in the group known as the Seicento Lombardo places the episode connected with the mass into the background. Instead, all eyes are on the turbulent vision that links Purgatory in a spiral leading upward to the light of highest Heaven.

On the opposite page
Cerano
San Carlo erige le croci alle porte di Milano/
St. Charles Borromeo Erecting Crosses at the Gates of Milan

detail, 1602, canvas, Milan, cathedral.

This was part of the cycle of large-scale of pictures commissioned by Cardinal Federico Borromeo when his uncle, Charles, was made a saint.

Giovanni Serodine

Ascona (Switzerland), c. 1594–Rome, 1630

Serodine was a solitary and eccentric figure on the post-Caravaggio scene. Like so many from his part of the world, he left the Lombard valleys to find work in Rome where he arrived in about 1615. Rather than following in the footsteps of his father and brother, both famous plaster-decorators, Serodine tried instead to make a name for himself as a painter. His temperament was diametrically opposed to the classical school and it was not long before he found himself marginalized. He only obtained a handful of commissions (including *The Charity of St. Lawrence* in the abbey at Casamari). These all illustrate his harsh, dramatic style, which was even more direct and brutal than Caravaggio's. He worked with rapid brushstrokes, as if wielding a saber, far removed from the polished grace of the Emilian school. Serodine died young and only produced a few works in his short career. Among them, three canvases on religious subjects that he sent back to the parish church in Ascona were outstanding, as was his *Portrait of the Father* (Lugano, Museo Civico).

Giovanni Serodine
Incoronazione della Vergine e santi/
Coronation of the Virgin with Saints

c. 1625, canvas, Ascona, parish church.

This is one of the greatest, most unusual and uncomfortably intense masterpieces produced in Italy during the seventeenth century. The altarpiece is one of only a handful of certain attributions from which we can reconstruct the unhappy career of Serodine. In the canvas for his parish church he structured the scene into two layers. At the top of the picture, there is a blurred vision of the coronation of the Virgin. Below, we see the motionless face of Christ on a cloth around which cluster six ragged saints, whom Serodine treats with even greater harshness and directness than ever seen in Caravaggio.

Evaristo Baschenis

Bergamo, 1617–77

Because he was in holy orders, Baschenis is sometimes referred to as Father Evaristo. The Bergamese Baschenis was, more than anything else, the perfect example of a "specialist" painter. In fact nearly all his œuvre was dedicated to painting musical instruments, sometimes his pictures being finished by other painters who added figures (as in the case of two paintings that have recently been found in the Brera in Milan). From this specific point of view, Baschenis is one of the most fascinating and focused painters of the whole of the seventeenth century. His use of realism and light is reminiscent of Caravaggio. His canvases had an intense quality which was dominated by his exceptional technical ability (one thing that stands out is the way in which he depicted dust on the back of stringed instruments). But Baschenis' work never degenerated into a mere display of virtuoso talent. It was rather directed to convey a sense of almost severe moral purpose. Baschenis' success with still life gave rise, especially in Bergamo itself, to a real fashion for the genre, with other painters following his example.

Evaristo Baschenis
Natura morta con strumenti musicali e statuetta classica/Still Life with Musical Instruments and a Small Classical Statue

c. 1645, canvas, Bergamo, Accademia Carrara.

Evaristo Baschenis
Natura morta con strumenti a corda/Still Life with Stringed Instruments

c. 1650, canvas, Bergamo, Accademia Carrara.

This is a more sober version of Baschenis' favorite theme of musical instruments. Here he conveyed a mood of silent solitude that is full of lyricism and poetry. Compared to the previous canvas, the setting has been simplified, the brocade hanging and the classically-inspired statue has been eliminated. The result is a much clearer image with an almost spiritual feel to it.

283

Palma the Younger

Jacopo Negretti, Venice, c.1544–1628

Palma the Younger, great-nephew of Palma the Elder was almost the sole heir to the great legacy of the Venetian Renaissance. He kept its ideals going into the seventeenth century, becoming the leading artist in the city. His apprenticeship included a spell in Titian's studio followed by a long stay in Rome (1567–74). It was Palma the Younger who completed the *Pietà* after Titian's death. He also worked alongside Veronese and Tintoretto on the decorations in the Doge's Palace where he came to know fully the Venetian tradition. From 1580–90 he painted cycles of large canvases either for Venetian Schools or sacred buildings (the sacristies of S. Giacomo in Orio and of the Jesuit church, the Scuola di San Giovanni Evangelista, and the Ospedaletto dei Crociferi). Thanks to the intelligent way they quoted from Tintoretto and their own narrative drive, these are Palma the Younger's best works. After this he went back to official commissions at the Doge's Palace. He organized his own, large studio which he used to produce a repetitive series of religious and allegorical pictures that can be found throughout the territory of the Venetian Republic.

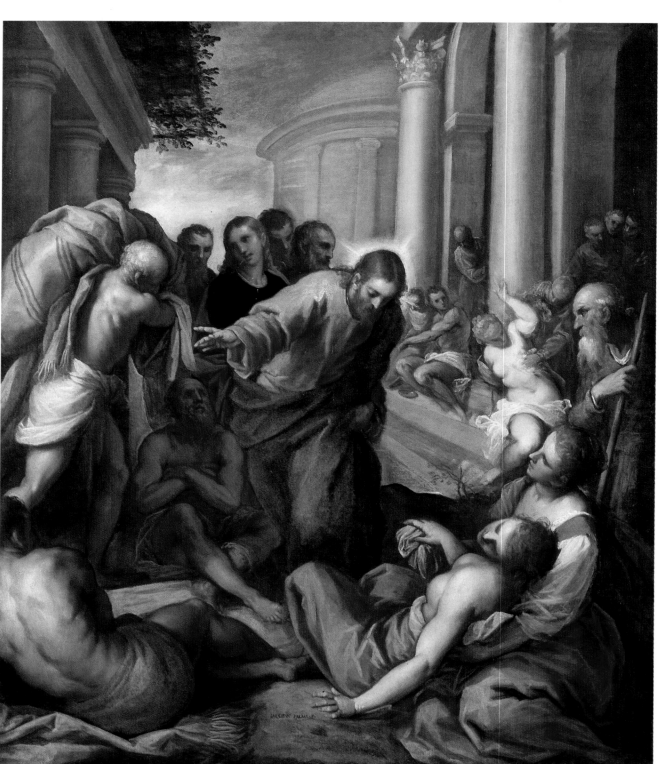

Palma the Younger
La piscina probatica/
The Pool

1592, canvas, Marano di Castenaso (Reggio Emilia), Collezione Molinari Pradelli.

This was clearly inspired by the great examples of sixteenth-century Venetian art and in particular by the works of Tintoretto. The composition is typical of Palma the Younger's mature style. Compositional flair, the employment of diagonal perspectives and rich colors almost obliterated by heavy shadow as well as the theatrical eloquence of the gestures and use of foreshortening are all typical characteristics of Palma the Younger's style of painting. When he managed to control all of them, as in this splendid example, he took post-Renaissance Venetian painting, generally considered a dismal period in art, to its highest degree of effectiveness and expression. When, on the other hand, the effects he used degenerated into repetitive formulas, seventeenth-century Venetian art very quickly became monotonous. This painting is a part of the Collezione Molinari Pradelli, the most extensive private collection of seventeenth- and eighteenth-century art in Italy.

Domenico Fetti

Rome, 1589–Venice, 1623

Fetti is a highly interesting painter although in certain ways he remains enigmatic. The bulk of his brief career was spent in Mantua where he was court painter to the Gonzagas. This out-of-the-way location allowed him to develop a highly original style of painting where a variety of different influences blended together. He trained during the last days of Mannerism, but he was influenced decisively by Rubens' arrival in Italy. His dialogue with Rubens and more generally his interest in Flemish and Dutch painting gave rise to a rich and luminous way with his brushstrokes. Most of his canvases tended to be fairly small and these are perhaps more interesting than the larger works he produced, such as the frescos in Mantua cathedral or the large lunette showing *The Miracle of the Loaves and Fishes* in the Pallazzo Ducale in Mantua. He painted a splendid cycle on the Gospel parables for the same princely residence. Unfortunately the pictures have since been split between various museums – Dresden, Vienna, Prague, and Florence. Fetti was so successful that he produced numerous versions of many of his paintings, such as his famous *Melancholy*.

Domenico Fetti
La Malinconia/Melancholy

c. 1622, canvas, Venice, Gallerie dell'Accademia.

This complex allegory based on the figure of a girl meditating on a skull was inspired by a print by Dürer. Fetti, however, completely reworked the subject in a Baroque manner. The objects, the dog, and the foliage that we see all appear to add fleshy fullness to the picture. In doing so, Fetti was doubtless recalling the examples of sixteenth-century Venetian art.

Bernardo Strozzi

Genoa, 1581–Venice, 1644

Strozzi was a Capuchin friar who led a tumultuous life. He was also the most important exponent of the rich vein of Genoese art in the seventeenth century. The Ligurian school was molded through its contacts first with the great Flemish master Rubens, which led to him using rich, thick colors applied with wide brushstrokes, and later with Van Dyck, whose refined elegance added its own influence. Strozzi's interpretation of these trends was highly original and combined with his thorough knowledge of other currents in art, from the Lombard school to the diffusion of Caravaggio's style. After producing a splendid series of frescos, altarpieces, and paintings for private collectors in Genoa, Strozzi moved to Venice in 1630 after a serious disagreement with his Capuchin order. His paintings were an immediate success in Venice, partly because Palma the Younger had recently died and there was a lack of native painters. From then on, Strozzi could be considered one of the most important painters in seventeenth-century Venice. Apart from religious paintings, he was also much admired for the fleshy but lively portraits he painted.

Bernardo Strozzi
La cuoca/The Cook

c. 1620, canvas, Genoa, Palazzo Rossi Galleria.

The scene as a whole can be considered a masterpiece of Italian genre painting. We should not overlook the lively and sharp presence of the cook herself.

Bernardo Strozzi
L'elemosina di san
Lorenzo/The Charity of
St. Lawrence

*1639–40, canvas, Venice,
S. Nicolò dei Tolentini.*

After moving to Venice,
Strozzi was also successful
in his later career when he
produced large-scale
paintings and altarpieces.
This filled a gap that had
opened in the local school.
Strozzi's early fleshy and
thick style was still present
in his Venetian canvases
with their clear references
to Rubens. By this time,
however, the opportunity
of seeing the work of Titian
and other great sixteenth-
century Venetian masters
had made Strozzi's work
more spectacular.

Battistello Caracciolo

Giovanni Battista Caracciolo, Naples, 1578–1635

Caracciolo was Caravaggio's most important follower. He only appeared on the Neapolitan art scene when he was 30, in the first decade of the seventeenth century when Caravaggio was working in the city. A group of paintings commissioned for Neapolitan churches reveals that he could interpret intelligently Caravaggio's realism. He used strong chiaroscuro backgrounds against which sculpturally defined figures stood out. His painting became more polished after a trip to Rome in 1614. By then Battistello had become the leader of the Neapolitan school and divided his time between religious subjects (altarpieces and, unusually for a Caravaggist, frescos) and paintings for private patrons. In 1618 he left for Genoa but spent some time in both Rome and Florence. During these stays he learnt of the Carraccis' revived classicism and met with like-minded painters wishing to reform Caravaggio's legacy. Back in Naples, he translated this experience into grandiose, wide-ranging scenes. An example is his masterpiece *Washing of the Feet* of 1622, painted for the charter house of San Martino in Naples.

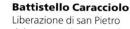

Battistello Caracciolo
Liberazione di san Pietro dal carcere/Liberation of St. Peter

1615, canvas, Naples, church of Pio Monte della Misericordia (in storage at the Gallerie di Capodimonte).

This picture was painted just after Caracciolo came back from Rome and is his definite masterpiece. It is also one of the most fascinating and original interpretations of Caravaggio's style. Of particular note is the splendidly classical figure of the angel who is about to take the hand of the frightened St. Peter. Caracciolo understood Caravaggio's art probably better than any other Caravaggist painter.

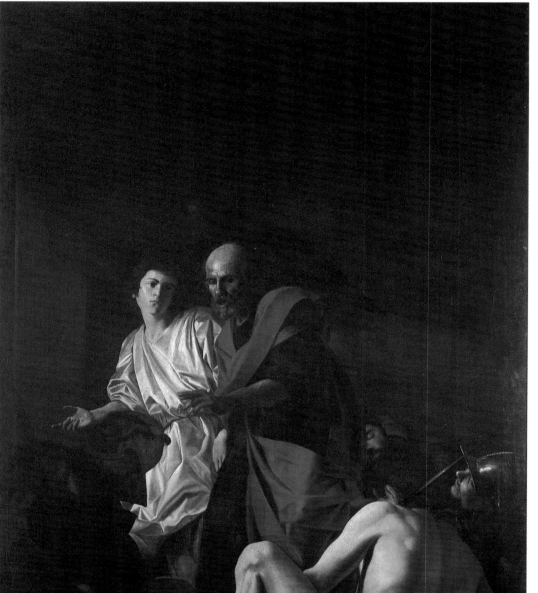

Bernardo Cavallino

Naples, 1616–56

Cavallino was an elegant painter of the second generation of the Neapolitan school in the seventeenth century. Almost everything he produced was for private collectors and, with only a few exceptions, his canvases were not very large. He studied under Massimo Stanzione and showed keen artistic intelligence in the way he interpreted the developments that took place in Naples and Rome after Caravaggio's death. Cavallino's lively and nervous brushwork was shot through by flickering light. In him, Caravaggio's naturalism blended together with an almost classical interest in pose and compositional structure. His gestures tended to be rather theatrical, his expressions inspired. He brought to his work a quality of dramatic movement that gave it an unmistakable, pathetic feel.

Bernardo Cavallino
Estasi di santa Cecilia/
The Ecstasy of St. Cecilia

1645, canvas, Naples,
Museo di Capodimonte.

This is the beautiful cartoon
that Cavallino painted when
he was blocking out the
most important
commission of his career,
The St. Cecilia Altarpiece now
in the Palazzo Vecchio in
Florence. The final version,
however, does not possess
the same freshness and
immediacy as the cartoon.
As this is one of his few
works that we can date
accurately, it forms an
important watershed in his
œuvre. Cavallino's work
was terminated abruptly
when he died at just 40
years of age during an
outbreak of the plague.

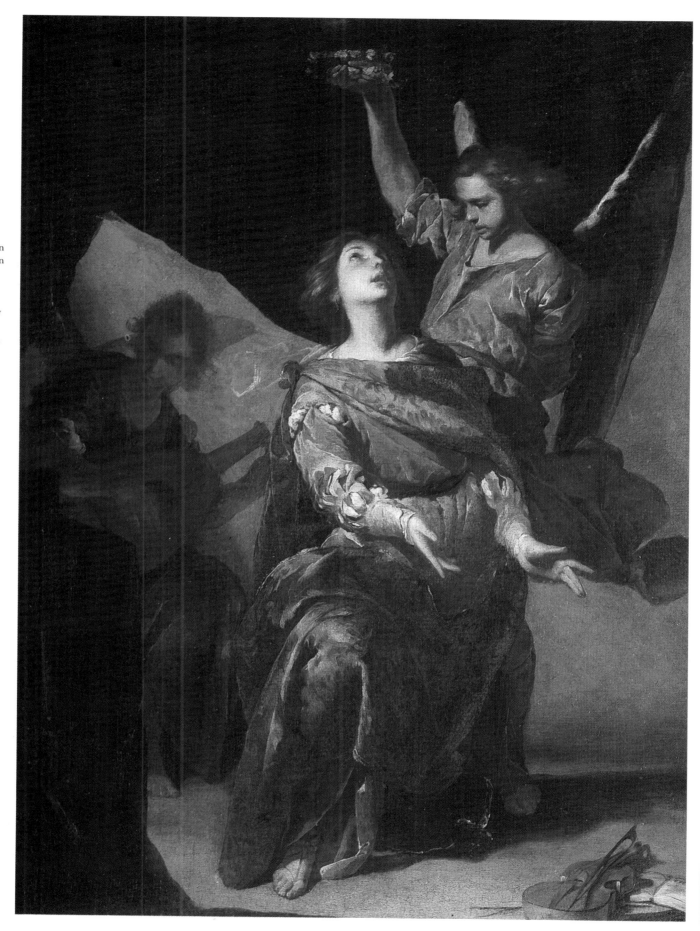

Mattia Preti
San Sebastiano/
St. Sebastian

c. 1660, canvas, Naples, Museo di Capodimonte.

This canvas is the creative legacy of Mattia Preti's stay in Naples. The picture clearly takes off Caravaggio's light as its point of departure. The refined way in which it is painted, however, as well as the use of elegant details and the classically-inspired pose of the saint's statuesque body bathed in a ray of light are all extremely revealing about the painter's extensive and important travels. In fact, Preti amalgamated the most disparate influences with great originality.

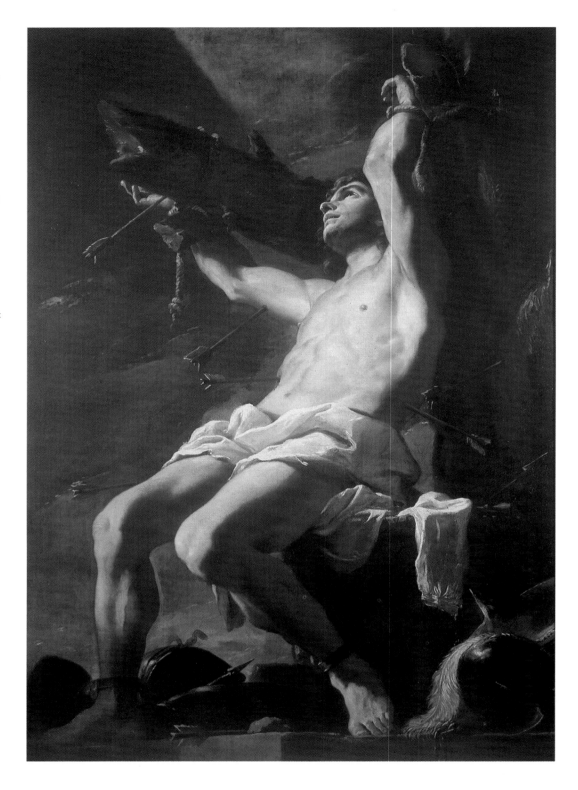

Mattia Preti

Taverna (Catanzaro), 1613–Valletta, 1699

Mattia Preti left Calabria to join his brother Gregorio, also a painter, in Rome. He met with such outstanding success that within a short time he had become one of the most authoritative southern painters of the second half of the seventeenth century. Suffice it to mention that at just 29 Preti was made a Knight of Malta. He is usually included in the Neapolitan school, but the early part of his career was spent in Rome where, among other things, he painted the grandiloquent frescos of *The Life of St. Andrew* in the church of S. Andrea della Valle. He was interested in a wide range of styles, from Caravaggio's naturalism to the way the great Venetian masters had used color. In 1653 he moved to Modena where he painted the frescos in the apse and dome of S. Biagio. The time he spent in northern Italy broadened his artistic culture further. He reached his fullest maturity and originality during the brief but very important period he spent in Naples (1656–60). During this period he turned out several of his masterpieces at a breathtaking rate. Some of them still remain in Naples (Capodimonte, Palazzo Reale), but others have gone abroad, in particular to the United States. In 1661 he went to Malta where he stayed until his death. He alternated between painting altarpieces and frescos for the island's churches. From time to time he paid visits to his home town which, over the years, became almost a gallery of his work.

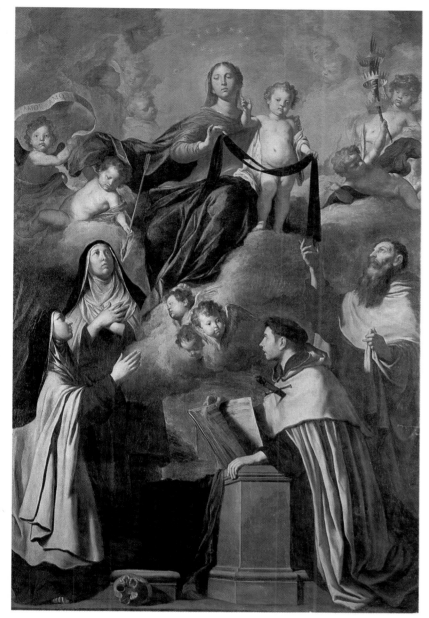

Pietro Novelli
Madonna del Carmelo/
Our Lady of Mount
Carmel

*1641, canvas, Palermo, Museo
Diocesano.*

The clarity of composition
and elegant way each figure
can be identified make this
noble altarpiece a truly
fundamental work in
Baroque religious painting
in Sicily. It was originally
commissioned for the
church of S. Maria Valverde
in Palermo.

Pietro Novelli
Monreale (Palermo), 1603–Palermo, 1647

Although he only started painting quite
late, Novelli went on to become the
most important Sicilian painter of the
seventeenth century. One of his seminal
influences came from studying the
works Caravaggio had left on the island.
Another was the arrival in Palermo of
Van Dyck in 1624. After working for a
while in Palermo, just after 1630 Pietro
Novelli set off for Naples and Rome.
He took on board the example of
strong chiaroscuro from Ribera and
incorporated it into his own style which
became self-assured and very personal.
This can be seen from the two canvases
about St. Benedict in the abbey of S.
Martino alle Scale in Mondovi. By now
he was the best-known artist in Sicily
and certainly the most in demand. He
traveled the island incessantly,
alternating paintings with plans for
fortifications, architecture, jewelry
designs, and stage scenery. Among his
most important work, we should
mention the decoration of the
presbytery and apse in the cathedral at
Piana degli Albanesi which was
commissioned by the Greek
community.

Pietro Novelli
Sposalizio della Vergine/
The Virgin's Wedding

*1647, canvas, Palermo,
S. Matteo.*

This is Novelli's last known
work and is suffused with a
subtle but undeniable sense
of melancholy, a feeling of
misgiving which makes us
feel each character is in
solitude and unable to
communicate with the
others. Here Pietro Novelli
has captured the lyrical
intuition to be found in
Caravaggio's Sicilian work
and made it his own.

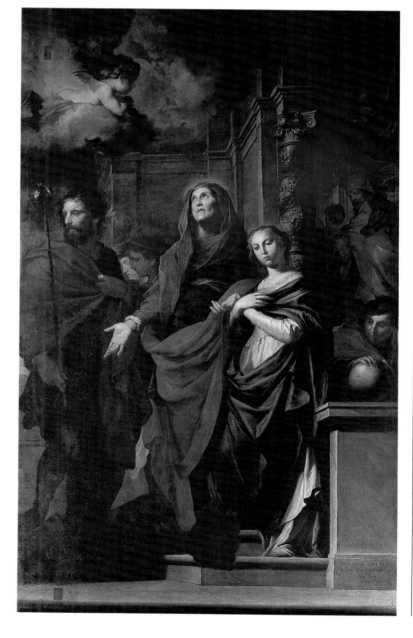

Luca Giordano

Naples, 1634–1705

Luca Giordano was a true chameleon of art. Giordano was a pupil of Ribera, influenced by his almost brutal manner. In 1652, he visited Rome, Florence, and Venice. He absorbed something of the Venetian tradition, especially Veronese, which he mixed with the Baroque theatricality of Pietro da Cortona and abandoned Caravaggio-style chiaroscuro. He produced many pieces for Neapolitan churches; shimmering reflections of his prodigiously rapid technique. His nickname was "Luca Fa Presto" (Luca works quickly) because of his amazing speed of painting. During a second trip to Florence and Venice (1665–67) Giordano's style became the reference point for late Baroque painting in Italy. After five years back in Naples, Giordano went to Florence again where he produced one of his most important works, the gallery frescos in the Palazzo Medici-Riccardi (1682). These airy, luminous frescos provide a foretaste of eighteenth century art. In 1692 he went to Spain for ten years, painting frescos and canvases with his usual rapidity. He was old by the time he returned to Naples and, in 1704, painted his last masterpiece, the fresco in the Tesoro sacristy of the charter house of S. Martino.

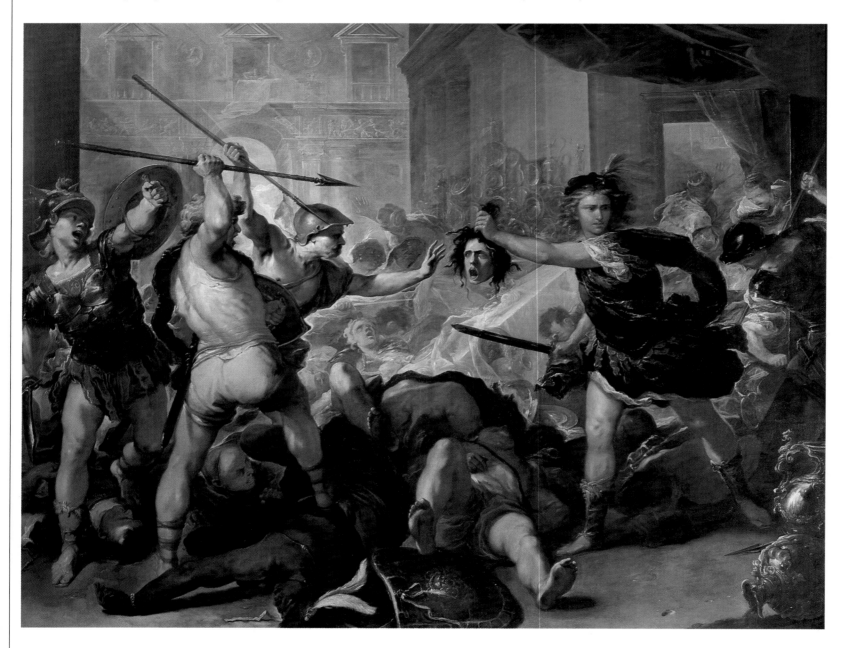

Luca Giordano
Perseo combatte contro Fineo e i suoi compagni/ Perseus Fighting Phineus and his Companions

c. 1670, canvas, London, National Gallery.

Gian Lorenzo Bernini

Naples, 1598–Rome, 1680

Bernini was by far the most important Baroque sculptor and architect of seventeenth-century Europe and one of the key creators of the whole Baroque era. But he worked initially as a painter. There is no doubt that this was only a sideline which he did mainly in his youth and even then almost as a dilettante. Despite this — indeed precisely because of this — his work reveals a sure and brilliant hand, free from any trace of pedantry. He studied in Rome under his own father, Pietro, and soon proved one of the most precocious infant prodigies in the history of art. His work was immediately sought after by the major collectors. He was little more than an adolescent when Cardinal Scipione Borghese commissioned him to sculpt a monumental cycle of four large marble groups (among which was his defining masterpiece *Apollo and Daphne* which can still be seen in the Borghese Gallery in Rome. When Pope Urban VIII was elected (1623), Bernini became the focus of a colossal Baroque-style modernization program in the Vatican. Using his talents as a sculptor, architect, and town planner, Bernini reshaped St. Peter's and the huge square outside it, starting with the installation of the bronze canopy over the high altar. Then with extraordinary vigor and passion Bernini embarked on a series of sculptures and buildings that literally changed the face of Rome. We need only mention his stupendous fountains (like the River Fountain in Piazza Navona), his huge marble group *The Ecstasy of St. Theresa* that is installed like a theatrical set in the transept of S. Maria della Vittoria, or his lifelike portrait-busts. It is these busts that we can compare to his rare and precious paintings. In this context, however, there is still much study to be done.

Gian Lorenzo Bernini
Self-Portrait as a Young Man

c. 1620, canvas, Rome, Galleria Borghese.

This particular painting is of paramount importance to any attempt to reconstruct the young Bernini's œuvre of paintings. The nervous rapidity of the brushstrokes and quick flash of his eyes reveal his desire to capture expression in an instant. He did this systematically in his sculpted portraits.

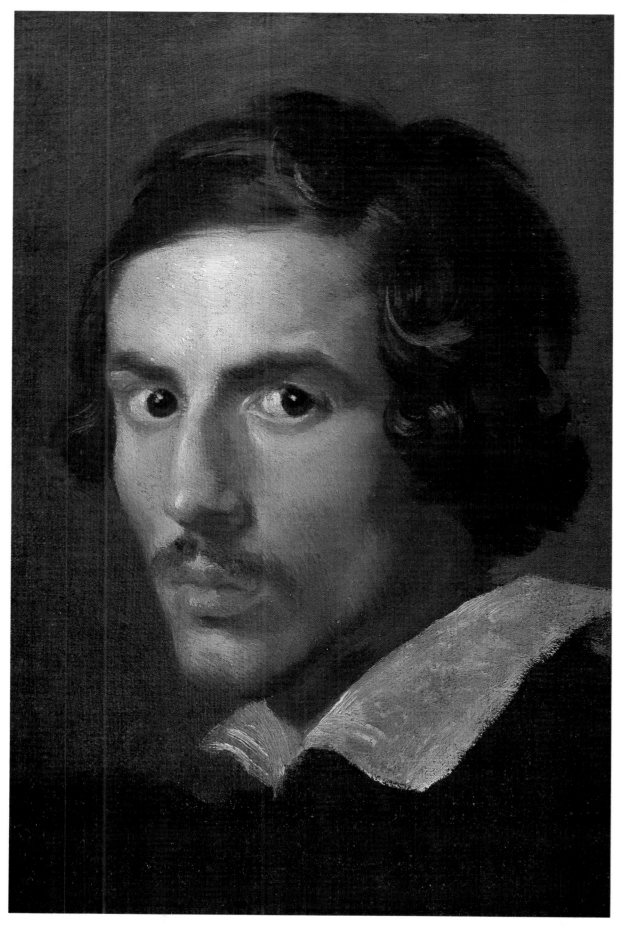

Pietro da Cortona
Ratto delle Sabine/ The Rape of the Sabine Women

1627–29, canvas, Rome, Pinacoteca Capitolina.

The Sacchetti family commissioned this painting in the 1620s when Pietro da Cortona was just making his name in Roman circles. They thus became his first patrons and introduced him to the world of aristocratic commissions. During the first two decades of the century, Caravaggio's naturalistic style had been rivaled by the Carracci cousins' academic style of classicism. Each school had its own followers and some attempts had been made to bring the two together. The arrival of Pietro da Cortona, at the same time as Bernini erupted onto the scene as the preferred sculptor and architect of the Barberini pope Urban VIII, were together sufficient to transform art in Rome and to create a true Baroque style. Pietro da Cortona's painting stands out for its open theatricality, lively gestures, richness of color, and brushwork, as well as its diffused light. The Sabine women being lifted into the air deliberately derive from Bernini's works, such as *Apollo and Daphne*, as if to underline the bond between the two artists. There is little real violence in his treatment of this scene from Roman legend, merely a splendidly theatrical display of half-clothed bodies.

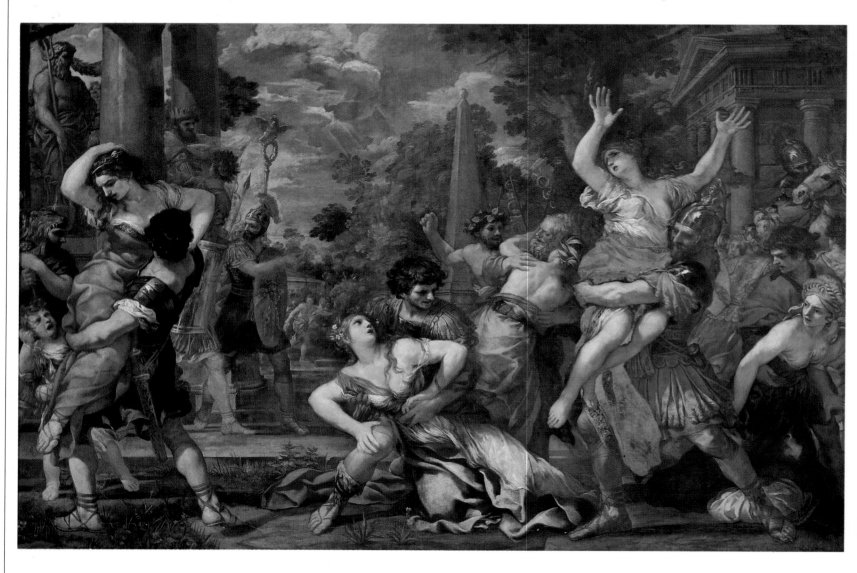

Pietro da Cortona

Pietro Berrettini, Cortona (Arezzo), 1596–Rome, 1669

Architect, designer, and decorator as well as painter, a decisive figure in the development of European art at in the mid seventeenth century, Pietro da Cortona was the greatest Tuscan painter of the entire century. He is also the acknowledged master of all that is most fanciful and rich in Baroque art. Much of his career was spent in Rome, where he went when he was just 16. There he made contact with Bernini, who was about the same age and was immediately caught up in artistic debate. His first success came with the frescos he painted for Palazzo Mattei (1624). After that his name was established and he received official commissions, especially from the Barberini pope Urban VIII. Pietro da Cortona kept his distance both from naturalism in Caravaggio's style and from Emilian classicism. His painting was rich, frothy, and above all else decorative. He could transform stately subjects into compositions of quite breathtaking exuberance. After finishing frescos in S. Bibiana and paintings for the Sacchetti family in 1626, Pietro painted his outstanding masterpiece when he completed the ceiling in a drawing room of Palazzo Barberini (1633–39). It was this work that earned him the title of "Prince of the Accademia di San Luca," in other words the most esteemed artist in Rome. When he later moved to Florence, his stay culminated in the spectacular sequence of frescos in Palazzo Pitti that generations of future artists would flock to study. By the time he went back to Rome he was extremely famous and accompanied by a troop of pupils. He painted frescos in Palazzo Pamphili and the Chiesa Nuova but alternated his painting with ever more frequent architectural commissions. Among the most important buildings he designed, we should mention S. Maria della Pace because he did not merely design the church's architecture but actually reshaped the whole of the surrounding area as well.

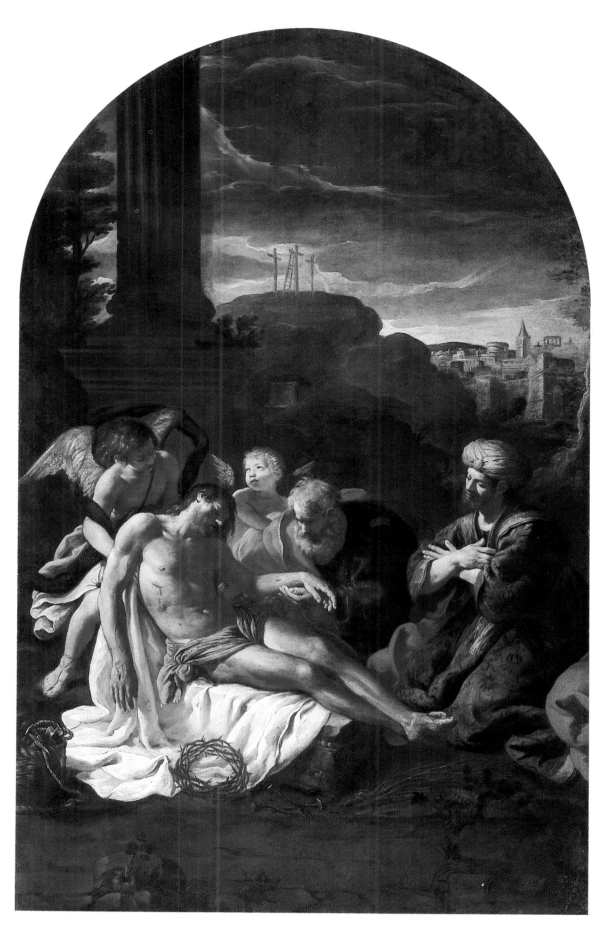

Pietro da Cortona
Pietà

1620–25, canvas, Cortona (Arezzo), S. Chiara.

This early painting was rediscovered almost by chance in 1983. It had been inexplicably lost for over three and a half centuries in the painter's home town and provides remarkable proof of Pietro da Cortona's early and versatile talent. It also reveals his Tuscan heritage as well as his taste for embellishing his paintings with billowing drapes and glimpses of landscape.

Pietro da Cortona
Madonna e santi/
Madonna and Saints

*1626–28, canvas, Cortona
(Arezzo), Museo
dell'Accademia Etrusca.*

Pietro da Cortona's œuvre
contains splendid examples
of rich altarpieces which
are a triumph of his proud
and exultant style. Some
also provide memorable
examples of Baroque taste.
This painting was
commissioned by the
Passerini family for the
church of S. Agostino in
the painter's home town.
In a civilized fashion, it
trumpets the fact that some
of the Passerini family were
members of chivalrous
orders. So we see the
Knights of St. Stephen
(notice the cross on the
cope of the pope, St.
Stephen), the Knights of
Malta (represented by the
figure of John the Baptist
and the cloak in the center)
and the Order of Calatrava
(St. James the Great can be
seen behind John the
Baptist). Even in this quiet
scene, there is an air of
great energy and vigor,
almost as if the saints were
about to burst into song.
The colors are also
marvelously fresh and
vivid.

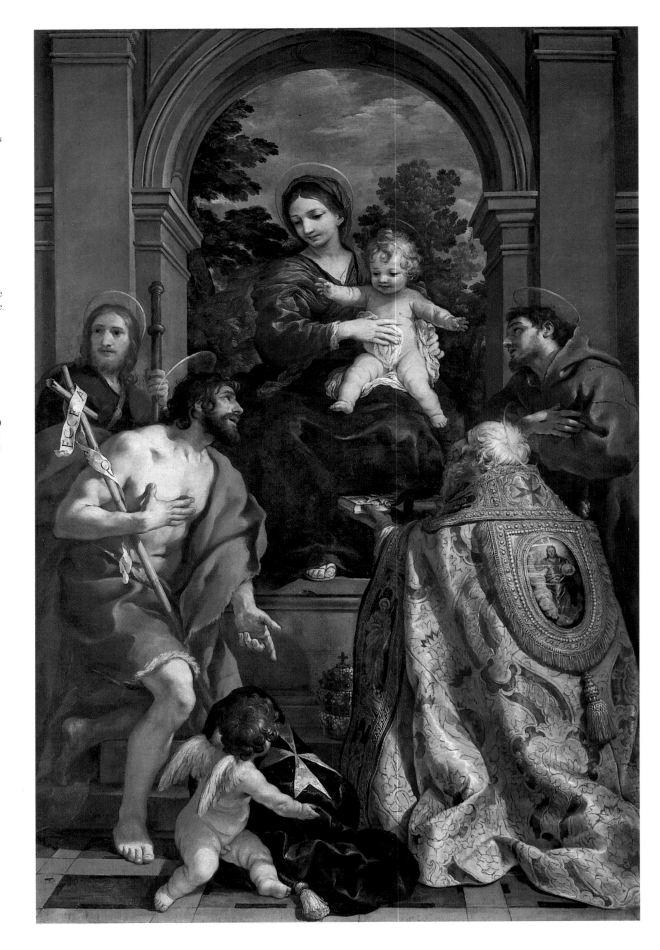

Pietro da Cortona
Trionfo della Divina Providenza/Triumph of Divine Providence

1633–39, fresco, Rome, Palazzo Barberini.

This ceiling in the reception room at Palazzo Barberini (which now houses the National Antique Art Gallery), was the most important single work that helped to make the Baroque the dominant style in Rome, and so over much of Europe, during the seventeenth century. The orderly clarity of Annibale Carracci's frescos in Palazzo Farnese was replaced by a turbulent composition that was full of spiraling movement. Everything combines to underline the vibrant dynamism of the work. The large scudding clouds and the perspective viewpoints looking up from below were probably inspired by Correggio's examples. But the brand new ingredient was Pietro da Cortona's desire to turn the fresco into a total work of art. The spectator was intended to lose his perception of space when he looked at it and become caught up in a spiritual and esthetic ecstasy. Another hallmark of Baroque was the happy way it mixed different subjects. In this scene, officially on a religious theme, the triumphs of the Barberini dynasty are nearly as apparent as those of Divine Providence as can be seen from the way their heraldic device of flying bees dominates the scene.

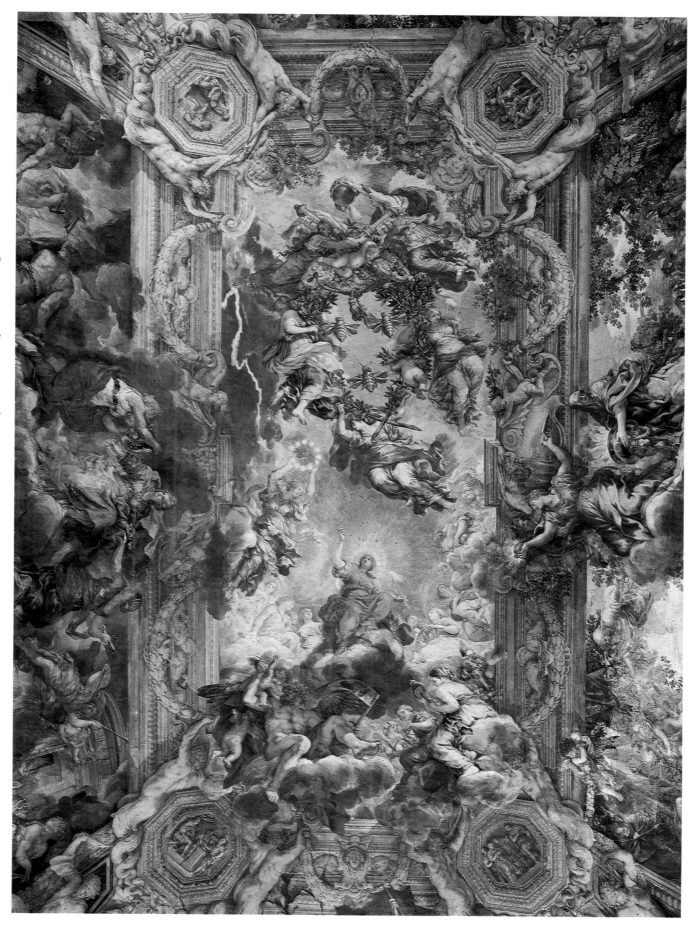

Carlo Maratta

Camerano (Ancona), 1625–Rome, 1713

A leading figure in Rome's cultural world in the second half of the seventeenth century, Carlo Maratta is a good example of both the strengths and weaknesses of the Baroque. His technical ability was unsurpassed as was his knowledge of formal models. At the same time he seemed to struggle to be creative in a truly innovative fashion. He grew up in the classically-inspired atmosphere of Nicolas Poussin's circle and had close contacts with Bellori, a man of letters. Maratta studied sixteenth-century painting admiringly (especially Raphael and Correggio) and joined the group of Emilian artists who had succeeded the Carracci. Most of his career was spent in Rome where he painted numerous large altarpieces, excellent portraits and fresco cycles, such as the one in Villa Falconieri at Frascati. He was praised as "Raphael reincarnate" and became leader of the Roman school after the deaths of Pietro da Cortona and Bernini. His painting was typically polished and flawlessly stylish. He attracted imitators and admirers all over Italy. Under Maratta, however, the Accademia di S. Luca ceased to be an exponent of new ideas, no longer stimulating new styles as the Carracci had intended. It became instead a place where paintings were collected and tradition studied.

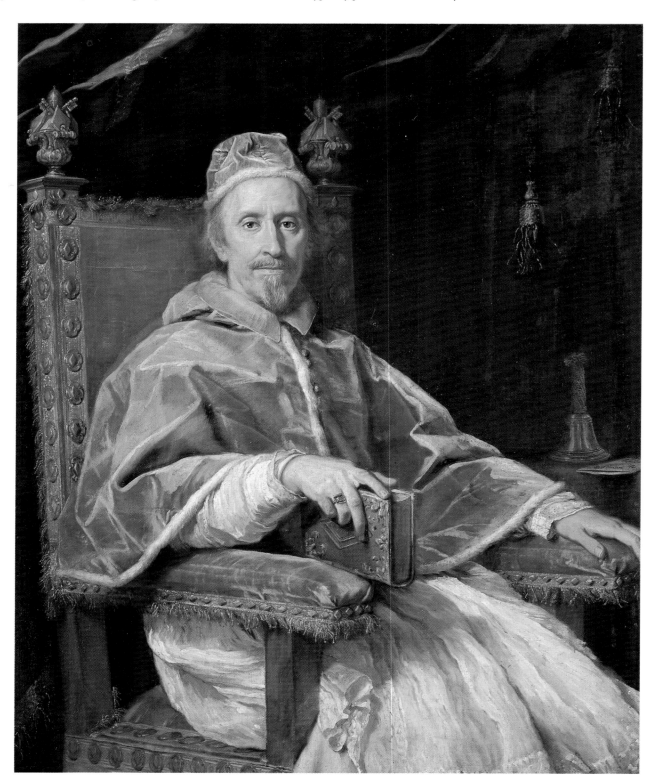

Carlo Maratta
Ritratto di papa
Clemente IX/Portrait of
Pope Clement IX

1669, canvas, Rome, Vatican Gallery.

Apart from demonstrating the favors granted by important Roman patrons, Maratta's portraits are also perhaps the most lively and penetrating part of his work. He took pains to capture the exact physiognomy of his sitters in whom he sometimes seemed to uncover an incurable feeling of melancholy hiding just below the surface. Here his admiration for Raphael's portraits is evident, but he has added a more stylish air to suit the tastes of the high Baroque.

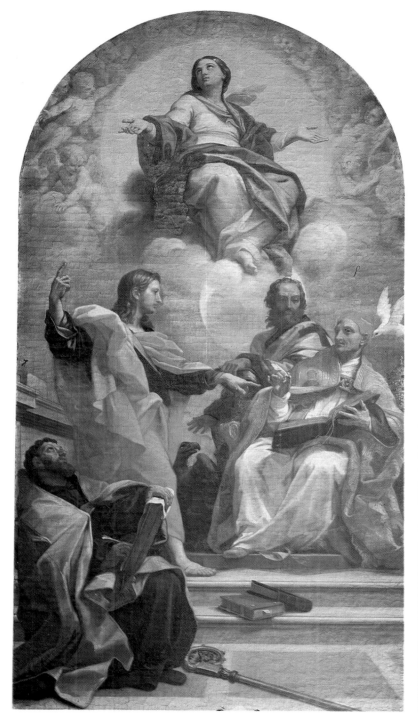

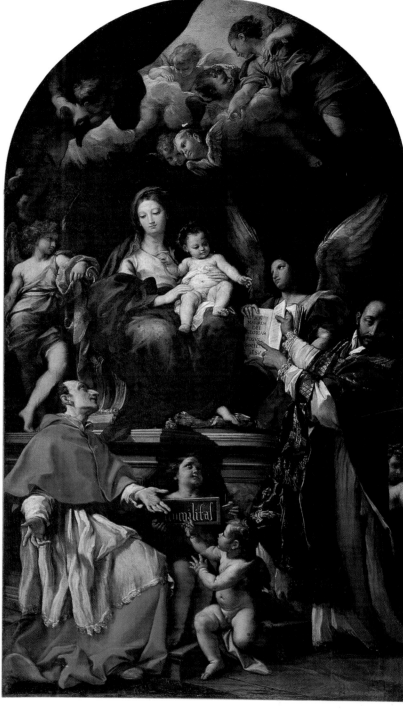

Carlo Maratta
Assunzione e Dottori della Chiesa/Assumption and the Doctors of the Church

1689, canvas, Rome, S. Maria del Popolo.

The tranquil calm of this scene was derived from cleverly following Raphael's model. It sums up the way that Maratta managed serenely to dominate the image he

painted. Pietro da Cortona's exuberance had by now subsided. From this we can deduce that Roman art was losing its impetus after the death of Bernini (1680) and was about to enter a phase of soporific academicism.

Carlo Maratta
Madonna in trono col Bambino, angeli e santi/Madonna and Child Enthroned with Angels and Saints

1680/1690, canvas, Rome, S. Maria in Vallicella.

Far more convincing than the previous canvas, this altarpiece possesses a richness of color that is unusual for Maratta. He

was, in fact, influenced by looking at Venetian painting, which can also be seen from the way the composition is laid out as well as the expressions and gestures of the characters. Maratta had an eclectic ability to quote from others but always toned it down in a sober and controlled fashion. Indeed, this might be seen as his main claim to fame. Otherwise he was an

isolated figure trying to handle the difficult passage between one style and another, between one generation and the next.

Andrea Pozzo

Trento, 1642–Vienna, 1709

Andrea Pozzo first trained as a painter in his home town but then became a lay brother with the Jesuits, so earning the courtesy title of "Padre Pozzo," Father Pozzo. His work as a painter, architect, and set designer was always linked to the Jesuits' presence in various cities. Before long Father Pozzo was seen as the person best able to interpret the Jesuit esthetic. This was based on harmoniously involving the congregation of the faithful in divine glory and the imitation of the lives of the saints. After stays in Milan, Genoa, and Venice, Father Pozzo settled for some time in Turin. During this Piedmontese period he painted frescos and altarpieces in the Savoy capital and various provincial towns, including the perspective cycle in S. Francesco Saverio at Mondovì (1679). His connection with the Jesuit bases in Piedmont was to continue even after he had left for Rome. His ability to conjure up illusionistic architectural effects reached its peak in the fresco on the ceiling of S. Ignazio (1691–94). This was accompanied by an important and well-documented scientific treatise on perspective both in painting and architecture. Also in Rome, Andrea Pozzo designed the spectacular altar dedicated to St. Ignatius Loyola in the church of Gesù and painted the frescos in the refectory of the monastery at Trinità dei Monti. The last link in his artistic career was forged when he moved to Vienna in 1703. There he painted frescos in the Jesuit College, in the palace of the Counts of Liechtenstein and in the ancient university. These works made a deep impression on eighteenth-century artistic taste across the German-speaking states.

Andrea Pozzo
Gloria di sant'Ignazio di Loyola/The Glory of St. Ignatius Loyola

1691–94, fresco, Rome, S. Ignazio.

This spectacular composition is almost an inventory of Baroque architectural ceilings and their final triumph. According to Jesuit ideas, the space within a church was a single area in which the faithful congregated. In S. Ignazio space is stretched (Pozzo was clever at the illusion of "doubling" the perspective of the real architecture) before exploding into light and glory. Saints, angels, allegories, and floating clouds accentuate the virtuoso effect. The impression is one of exuberance and freedom. In reality, it was worked out using scientific criteria.

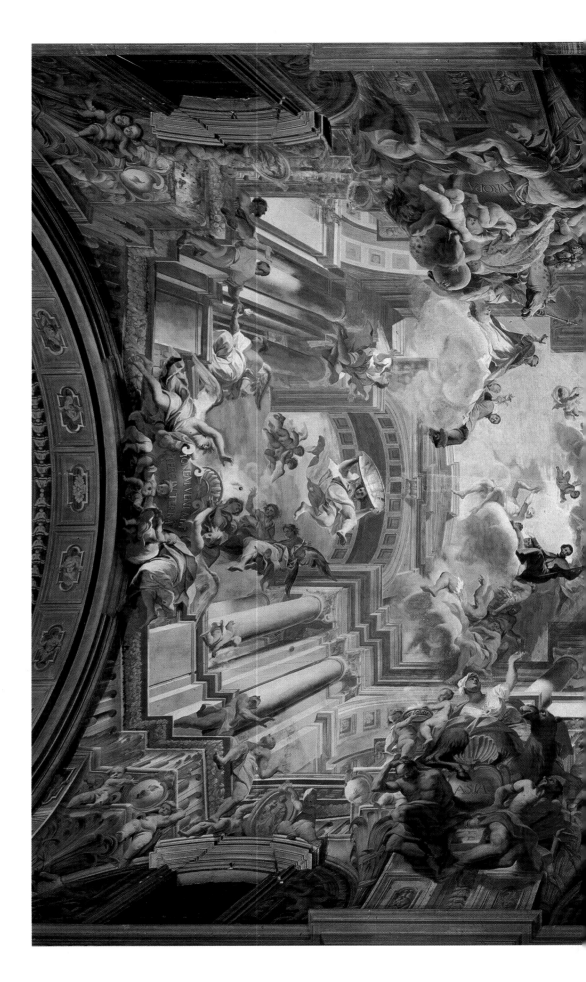

The 18th Century

Canaletto
*Il Bucintoro di ritorno al molo
il giorno dell'Ascensione
/The Return of the Bucentaur to
the Molo on Ascension Day*

1730–35
Windsor Castle, Royal Collection.

In the opening decades of the eighteenth century, after a long period marked by endless wars, religious fanaticism, and the pompous grandeur of Baroque courts, Europe relaxed. Its new, carefree attitude found perfect expression in Rococo art, one of the most light-hearted and pleasure-loving of all styles. A climate of gently festive gaiety spread through every court in Europe, epitomized by the art of Tiepolo in Italy and Watteau in France. In fact, the style of one country differed surprisingly little from that of the next. Gradually, however, after 1750, this hedonism, this sunlit voyage to a happy, trouble-free island, the Cythera of dreams, began to falter and by the 1780s it had given way to a new seriousness and heroism, typified by Diderot and d'Alembert's *Encyclopédie*. This, intended as a monument to Enlightenment ideals, used clear logic and reason to organize all knowledge and make it easily available without any restrictions, aiming to raise people's moral as well as intellectual standards and to overthrow superstition and prejudice.

The concepts of high-minded liberty and justice, derived partly from English writers such as Locke and popularized by Rousseau and Voltaire, became commonplace even in the great autocratic monarchies of Austria, Prussia, and Russia. These principles were also adopted by the Italian states of Savoy, Florence, and Naples (in other words, almost everywhere, except paradoxically France, where the Enlightenment had originated, and Britain and the United States, where it was already well-established). Inevitably, the arts also changed with the times. Rococo frivolity was replaced by rigorous adherence to a revived and austere classicism, which looked back to the most heroic aspects of ancient Rome.

Italy in the early eighteenth century had provided Europe with the best large-scale Rococo decorative artists and also *vedutisti* (view-painters), as demonstrated by the travels of Tiepolo, Sebastiano Ricci, Canaletto, Bellotto, and a host of other minor painters who followed in their footsteps. Italy long remained the favorite destination of artists and travelers of all nations in Europe searching for culture. But, unlike in previous centuries, gentlemen embarking on the Grand Tour, art collectors, and intellectuals became less attracted by contemporary Italian art as the century progressed. As they headed for Rome, Naples, and Florence (it is not coincidence that these three cities appear in Stendhal's famous travelogue), they were drawn more by the ghosts of the Renaissance, by the fascinating light of the country, the clemency of its climate, the abundance of Greek and Roman ruins and archeological remains. From 1770 onwards, the discovery and excavation of the buried Roman cities near Vesuvius was one of the cultural marvels of the century. Rome itself became one of the cradles of the new Neo-Classical style, but Italy as a whole was increasingly sidelined in cultural developments. This fact was offset only in part by the appeal of its history and art.

In other words, the common view of Italy held by foreigners became more nostalgic than realistic. This in itself was a sign of the nation's increasing economic and political backwardness, aggravated by the long-term shifts in trade patterns from the Mediterranean to the Atlantic. Only in a few Italian cities (especially Milan, which had passed from Spanish domination to the more enlightened Austrian government of Maria-Theresa, and in Venice in the last splendid days of its thousand-year independence) was there any intellectual development worth mentioning. These cities produced jurists (Beccaria), men of letters (Gozzi, Verri), and playwrights (Goldoni) who were indeed to figures on the European level. Italy could undoubtedly still claim musical supremacy, at least in opera, but socially and economically it was depressed and often provincial. With this in mind, it becomes easier to understand how ancient and Renaissance mas-

Sebastiano Ricci
Susanna e i vecchioni/
Susanna and the Elders,
1713, canvas, Chatsworth
(Derbyshire), Duke of
Devonshire's Collection.

Canaletto, *Campo San Giacometto*, 1729–30, canvas, Dresden, Gemäldegalerie.

Canaletto, *Processione dei cavalieri dell'Ordine del Bagno davanti a Westminster/ Westminster Abbey with the Procession of the Knights of the Order of Bath*, 1747–55, canvas, London, National Gallery.

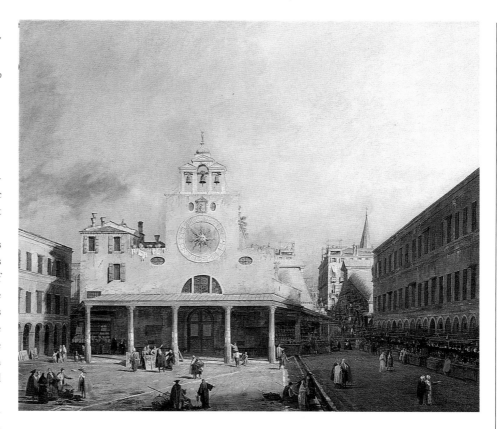

terpieces were allowed to stream out of Italy during the eight-eenth century. They filled many of the great royal and aristocratic collections which in turn form the cores of some of the greatest museums in Europe.

Europe was now the one significant continent on the globe, as the old Asiatic monarchies sank into terminal decadence, and its own horizons grew steadily wider. The "new" continent of Australia was discovered, along with the "primitive savages" of the islands of Oceania. Great Britain's North American colonies rebelled, declared independence in 1776, and gave birth to the United States of America. This new power in the west was more than balanced, for Europeans, by the awakening of the Russian giant in the east. Under its Tsar, Peter the Great, Russia had pushed towards the west, building a majestic new capital of St. Petersburg on the Baltic which soon attracted painters and mus-icians from the West. Finally, in 1789 the French Revolution com-pletely overthrew the old social and political order. With it, the middle classes emerged as the class of the future. It was not only crowned heads that fell under the guillotine, but a whole epoch.

Art began to change very rapidly towards the end of the cen-tury. Neo-Classicism replaced the Rococo before being chal-lenged and partly superseded in turn by Romanticism early in the next century. In the course of the eighteenth century Europe pro-duced extraordinary philosophers, writers, musicians, and art-ists. All became interpreters, if not apostles, of change in its last decades. Goethe and Kant, Foscolo, Canova, David, Turner, Wordsworth, Beethoven, and Goya were emotionally involved in the revolutionary tumult that swept the whole of Europe, when Napoleon's blazing star was rising. It was Napoleon who inflicted the final blows to the political and cultural map of old Italy. Under the Treaty of Campoformio (1797) he ceded Venice to Austria and thus ended the Venetian Republic's thousand years of proud independence. When Napoleon then entered Rome, he humiliated the Papacy more thoroughly than any previous ruler had ever done. He also organized the looting of artistic and arche-ological masterpieces on an unprecedented scale, the best works being taken to Paris to glorify his own regime. This theft was only partly compensated after the Congress of Vienna and the Restoration of the French monarchy in 1815.

During the first half of the eighteenth century Italian painting was highly influential across Europe: Giambattista Tiepolo pro-duced his greatest work for a German ruler at Würzburg before going to work in Spain and Canaletto painted chiefly, and very profitably, for rich English clients. Indeed, the prevailing style of the first half of the century was set by the enormous success of

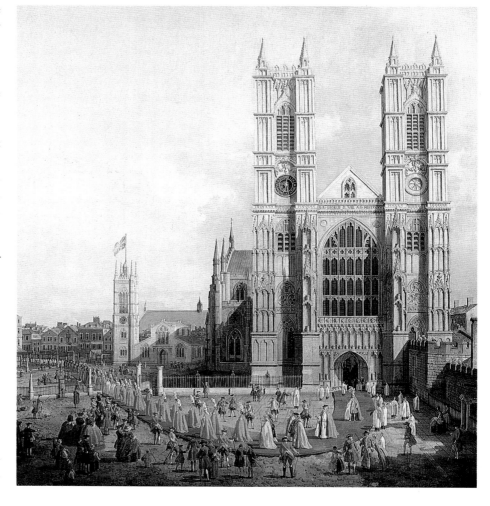

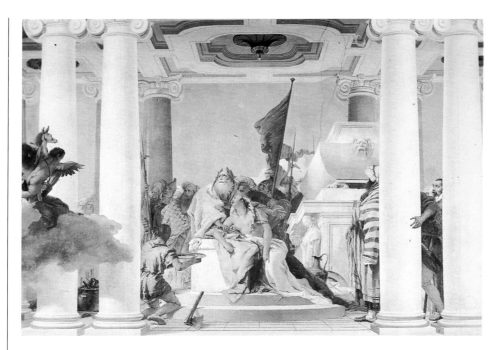

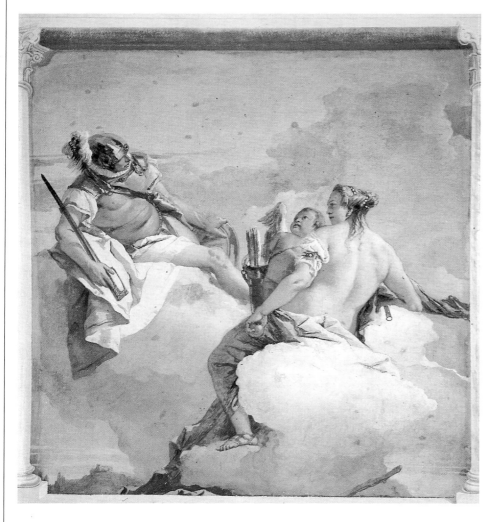

Giambattista Tiepolo
Sacrificio di Ifigenia/The Sacrifice of Iphigeneia, 1757, fresco, Vicenza, Villa Valmarana, small palace.

Giambattista Tiepolo
Marte e Venere/Mars and Venus, 1757, fresco, Vicenza, Villa Valmarana, guest house.

Giandomenico Tiepolo
Il riposo dei contadini Peasants at Rest, 1757, fresco, Vicenza, Villa Valmarana, guest house.

often flamboyant Venetian painters. They imposed their artistic tastes across the whole of Europe, especially as far as large-scale decorative art was concerned. Sebastiano Ricci, Piazzetta, and above all, Tiepolo were masters of an exuberant style of painting that acknowledged no limits. They tackled any subject, displaying fantastic inventiveness in astounding allegories. No project seemed too large for them.

But there were other currents as well. The Lombard painters Ceruti and Fra Galgario, the Genoese artist Magnasco, Crespi from Bologna and Traversi from Naples (in addition of course to Giandomenico Tiepolo in Venice) all adopted different but equally lively approaches. These artists paid close attention to themes and people taken from everyday life, which later led to the strand of "social" painting of the second half of the nineteenth century. If the *vedute* "view paintings" produced by Canaletto, Bellotto, and Guardi can be interpreted as part of a more sober and realistic strand in Italian art, it is less easy to explain why Neo-Classicism made so little impact in Italy in the later decades of the century. Although the movement was based on studies of Roman remains in Italy, and developed first in Rome, north European artists soon made it their own. The contrast between the explosive fantasy of late Baroque and Rococo and the "return to classical order" can be seen by comparing the the great Baroque architect of Turin, Filippo Juvarra, with the relative austerity of John Soane in England or Benjamin Latrobe in the United States. In painting, this rigor emerged as the spirit behind the relaunch of the Academies. The century's end was, however, a significant period in the history of Italian art, if not of art itself. Although the age did not directly produce many paintings of note (the most interesting painter of the day was Pompeo Batoni, who simply emulated earlier artists), it led to the founding of great museums in Milan, Bologna, and Venice.

Italian art at the end of the century, with its greatest artists all dead and without heirs, with Venice under Austrian rule and the rest of the peninsula dominated and looted by the French, was depressingly like the ruins of a downtrodden Italy in turmoil that the poet Ugo Foscolo was so fond of lamenting. Nevertheless, in this desperate situation an ideal of eternal beauty survived which proved stronger than any political catastrophe or teachings of an academy. This ideal was captured and given form by the greatest of all Neo-Classical sculptors, Antonio Canova, who thus acted as a link between the old Italy and the new. He was able to interpret the new world which increasingly turned to the secret passions and agonized emotions of the individual human heart, so anticipating Romanticism.

Alessandro Magnasco

Genoa, 1667–1749

Son of a minor Genoese painter, Alessandro Magnasco trained in his home town before moving to Milan when he was still young. There he worked for many years in Filippo Abbiati's studio. His meeting with Sebastiano Ricci marked a turning-point in his art. Their acquaintance was renewed during a stay in Florence (1703–09) at the court of Grand Duke Ferdinand of Tuscany. Soon afterwards, Magnasco gave up painting large figures (he only produced a handful of these in his later years) and instead concentrated on his unmistakable canvases with fantastic landscapes or interiors peopled with weird characters. At the start he stuck to windswept countryside and ruins with beggars. But during his second and longer stay in Milan (1709–35), he applied his typically vivid style to scenes set in monasteries, torture chambers, seascapes, masques, and bacchanals. His output was extremely well received in Milanese scholarly circles. The critical jury is still out as to any deeper meaning of these canvases, which mingle the macabre with the burlesque, simple description with powerful melodrama. Magnasco went back to Genoa in old age and it is there that we find his last, visionary and transfigured works. His art later influenced Marco Ricci and Francesco Guardi.

Alessandro Magnasco

Furto sacrilego/ Sacrilegious Robbery

1731, canvas, Milan, Quadreria arcivescovile.

The painting illustrates a crime committed on January 6, 1731. Thieves were trying to force an entry into the church of S. Maria in Campomorto at Siziano (Pavia) to steal the holy vessels used for mass. They were seen off by skeletons which issued from the graves in the surrounding cemetery. The macabre scene is a large votive piece. The events are watched by the Virgin who we see in the top right-hand corner organizing the skeletons' sortie and decreeing the punishment for the thieves, who were subsequently hanged. The canvas belongs to the church where the attempted sacrilegious robbery took place but for safety reasons it is kept in the Diocesan Museum in Milan.

On the opposite page
Alessandro Magnasco

Refettorio dei frati osservanti/The Observant Friars in the Refectory

1736–37, canvas, Bassano del Grappa, Museo Civico.

The number of people depicted and the richness of the decorations lead us to think that this may have been the General Chapter of the Franciscan Order.

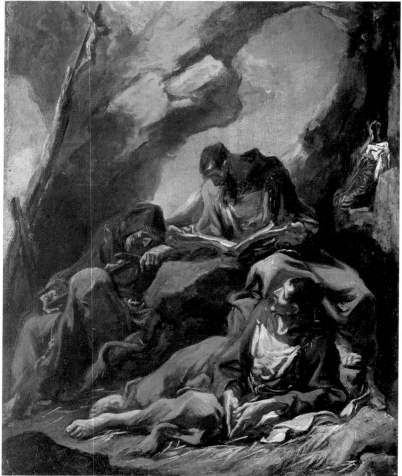

Giuseppe Maria Crespi

Bologna, 1665–1747

Crespi studied in Bologna under teachers who still favored the academic style of the Carracci. His early work was traditional in subject but already unconventional in style, as he painted frescos, mythological scenes, and altarpieces. But none of these could satisfy the rebellious, curious spirit of an artist whom the scholar Rudolf Wittkower has praised as "the only real genius of the late Bolognese school." After his early frescos in Bologna, Crespi spent a fruitful time in Florence in the opening years of the eighteenth century. Here he was able to rival Magnasco and Flemish genre painters, painting scenes of market places, kitchens, farm houses, and domestic interiors. His masterpieces are the canvases from the cycle dedicated to the *Seven Sacraments* (now in Dresden). In them, various scenes are interpreted in a humble and popular vein, but at the same time they retain an intimately mystical quality. Crespi was also an outstanding portrait-painter, as is demonstrated by the very witty sketch he made for a portrait of Cardinal Lambertini (Bologna, Pinacoteca Nazionale). This was modified before the final version was painted (Rome, Vatican Gallery), as the cardinal had been elected pope, under the name of Benedict XIV. He was a fine teacher too, numbering Piazetta and Pietro Longhi among his students, and a great influence on Venetian art.

On the opposite page, top

Alessandro Magnasco

Tre monaci camaldolesi in preghieri/Three Camaldolite Monks at Prayer;

Tre frati cappuccini in meditazione nell'eremo/ Three Capuchin Friars Meditating in their Hermitage

c. 1713–14, canvases, Amsterdam, Rijksmuseum.

Bottom

Alessandro Magnasco

Interrogatorio in carcere/ Interrogations in Jail

c. 1710, canvas, Vienna, Kunsthistorisches Museum.

This is one of a group of three paintings inspired by the disasters of war. Looting, the wounded, and torture are all depicted in a lucid, almost documentary style, which could almost be regarded as a form of protest, uncommon though that was at the time.

Giuseppe Maria Crespi

La Sguattera/ The Scullery Maid

1710–15, canvas, Florence, Uffizi.

Giuseppe Maria Crespi's genre painting often touched on intimate domestic moments. This painting is from his Florentine period. Thanks to Duke Ferdinand de' Medici's patronage he had been able to make direct contact with Magnasco and to get to know Flemish painting. But he went beyond these influences in the delicate way he defined the light which reveals the objects in the kitchen to the viewer one by one.

On the opposite page
Giuseppe Maria Crespi
Librerie/Bookshelves

*c. 1725, canvas, Bologna,
Conservatorio Martini, Civico
Museo Bibliografico Musicale.*

This is one of the finest
achievements in Italian still-
life painting of the
eighteenth century. The two
false bookcases are full of
dusty tomes on music and
scores that have been hastily
consulted and shoved back.
The work was probably
commissioned by Giovan
Battista Martini, a famous
Bolognese musicologist
who was respected and
feared across Europe as a
music critic.

**Giuseppe Maria
Crespi**
Donna che si spulcia/
Searcher for Fleas

*c. 1730, canvas, Pisa, Museo
Nazionale e Civico di San
Matteo.*

It is possible that this canvas
(of which Crespi produced
various versions) was
commissioned by Owen
McSwiney, director of the
Opera House in London
and Canaletto's first agent.
The humble, direct reality
of the piece is explored
through the minute details
of everyday life. It bears
comparison to Hogarth but
lacks the caustic irreligious
caricature that makes the
English painter's work so
unmistakable.

Vero Ritratto
Di un Rinoceronte
Condotto in Venezia
l'anno 1751
Fato per mano di
Pietro Longhi
per Commissione
Del N.O. Giovanni Grimani
dei Servi. Patrizio Veneto

Pietro Longhi

Venice, 1701–85

The son of a goldsmith (his real surname was Falca), Pietro Longhi tried without much success to become one of the group of eighteenth-century Venetian painters so much in demand for large-scale decorations. His youthful work included frescos in the Palazzo Sagredo which reveal his lack of talent in this field. But at about the age of 40, Longhi managed to find his own creative voice which soon made him a specialist in a highly successful new genre. Drawing on his memories of youthful studies with Giuseppe Maria Crespi (an important precursor to Longhi's brand of genre painting), he began painting small canvases on everyday subjects, showing real places and people. Unlike most view-painters at the same time, normally forced to seek foreign patrons, Longhi mainly worked for local patrons and collectors, including the noble families of Grimani, Barbarigo, and Manin. Longhi prepared his work by making careful preparatory sketches. He concentrated almost exclusively on small-scale canvases depicting the modest day-to-day activities of aristocratic Venetian families. The wonderful amiability of these episodes of no earth-shaking importance is marked by an observant, often gently satirical touch. The playwright Goldoni called Longhi a "man seeking the truth," but his was not a very harrassing quest. In later life Longhi also produced two interesting cycles of paintings. One was a series showing the *Seven Sacraments* while the other depicted *Hunters in the Valley*. Both are now in the Pinacoteca Querini-Stampalia in Venice.

On the opposite page
Pietro Longhi
Il rinoceronte/
The Rhinoceros

*c. 1751, canvas, Venice,
Ca' Rezzonico, Museo del
Settecento Veneziano.*

The painting contains a notice that accurately dates the episode in question. In fact, when the exotic animal went on show it became an instant attraction that was talked about across Europe. Longhi's image not only captures the size of the rhinoceros, but also recreates the atmosphere of excitement among the public whose curiosity had drawn them to this fairground attraction.

Pietro Longhi
Il pittore nello studio/
The Painter in his Studio

*1740–45, canvas, Venice,
Ca' Rezzonico, Museo del
Settecento Veneziano.*

We are given a shadowy self-portrait of the artist's profile against the light. At the same time mute dialogue between the lady who is sitting for him and the artist himself seems to be deliberately interrupted by the presence of the man who appears to be rather worried about the painter's work.

Pietro Longhi
Il Sarto/The Tailor

*1741, canvas, Venice,
Gallerie dell'Accademia.*

The picture belongs to the Contarini Collection. Once again, Longhi proved his perfect taste in the way he blends the color harmonies. The painting centers around the contrast between the professionally smooth gestures of the tailor who is showing off the costly fabric and the lady who almost seems bewildered.

Pietro Longhi
Caccia dell'anitra in
laguna/Duck Hunters
on the Lagoon

*c. 1760, canvas, Venice,
Pinacoteca Querini Stampalia.*

The canvas is very
concentrated and intense in
the way it shows the
nobleman's sport. In the
prow of a boat rowed by
four rugged oarsmen, the
powdered gentleman bends
his bow to shoot terracotta
pellets contained in the
basket at his feet (a suitably
quiet form of shooting for
the Lagoon). The diffused
light and infinite horizon of
the lagoon are unique in
Longhi's œuvre.

Pietro Longhi
Il cavadenti/The Tooth
Puller

c. 1746, canvas, Milan, Brera.

This, one of Longhi's most
popular paintings, is set in
front of the portico to the
Doge's Palace. The tooth
puller is proudly showing
off the tooth he has just
pulled for the boy holding a
handkerchief to his mouth.
The people passing by are
wearing the traditional
Venetian domino: hooded
cloak and mask. The
children are feeding bread
to a monkey. Even the
dwarf plays her part by
making the "sign of the evil
eye," raising two fingers to
ward off ill luck.

Giacomo Ceruti

(Il Pitocchetto), Milan, 1698–1767

Ceruti was Milanese by birth but chose to live in Brescia. He was one of the most interesting Lombard painters of the eighteenth century but his output is very varied and patchy. In his altarpieces and religious paintings he seems unsure of himself, but in his portraits he could be penetratingly intense. In his works about the poor, he sometimes bordered on genius and gave rise to a new genre in painting. No one before him, not even Caravaggio, had ever portrayed with such moving grandeur the rejected of this earth, those whom the Italians call the "pitocchi" (hence Ceruti's nickname Pitocchetto, the Little Miser). The tradition of "painting from reality" spanned several centuries and was an authentic and deep aspect of Lombard art, where Ceruti's place is crucial both for its stylistic and moral importance. In the middle of a century too often written off as frivolous and superficial, Ceruti painted little seamstresses, washerwomen, errand boys and idiots, stragglers and the destitute. In doing so, he sounded a note of humanity that is still heart-touching. The characters in these street ballads are portrayed nobly. Ceruti's brush explores their souls and melds them with the dull and dark colors of their clothes. It is thanks to Ceruti that we have a different, disenchanted but moving image of the eighteenth century.

Giacomo Ceruti
Lavandaia/The Laundress

c. 1736, canvas, Brescia, Pinacoteca Tosio-Martinengo.

Unforgettable and touching miniature masterpiece of human and social truth, this painting is filled with an emotional involvement that balances between resignation, dignity, and accusation.

Giacomo Ceruti
Natura morta con gallina, cipolla e recipiente di terracotta/Still Life with a Hen, an Onion, and a Terracotta Pot

1750–60, canvas, private collection.

This is a striking example of Ceruti's still lifes.

Giacomo Ceruti
Natura morta con piatto di peltro, coltello, forma di pane, salame, noci, bicchiere e brocca con vino rosso/Still Life with a Pewter Plate, a Knife, a Loaf of Bread, Salami, Walnuts, a Glass, and Jug of Red Wine

1750–60, canvas, private collection.

Ceruti is not well-known for his excellent still lifes. In these paintings we encounter the same world made up of humble things, of everyday items and stark truth which are the hallmark of his "pitocchi" paintings.

Fra Galgario

Vittore Ghislandi, Bergamo, 1655–1743

Vittore Ghislandi was the son of a quadraturista and as a young man often helped his father paint the illusionistic perspective decorations in which he specialized. Ghislandi took vows as first as a lay-brother and then as a friar in the Order of St. Francis of Paola. After some time in the Paolotti Monastery in Venice he moved back home to the Galgario Monastery, whose name he adopted. We know little about his work as a painter before the beginning of the eighteenth century. By then he was over 40 years old and it may have been Salomon Alder who suggested that he start to concentrate on portraits. In any case he ended up specializing in them exclusively. Although he was abreast of what was going on in the creative worlds of Milan, Bologna, and Venice, he preferred to look for his inspiration to the local tradition in Bergamo, in particular to the work of Gian Battista Moroni. Thus started an abundant number of portraits of noblemen and ladies from the local aristocracy. Fra Galgario showed no mercy in the way he starkly depicted their physical and moral reality. Fra Galgario's portraits (some of which are in museums in Bergamo and Milan but most still in private collections) are extremely varied. This is thanks also to the richness of his palette and loaded brush. It was precisely this vivacity, combined with his sureness of composition and peremptory way of capturing the sitter's psychological make-up, that makes the Bergamo portraits a faithful mirror of provincial life in the eighteenth century.

Fra Galgario
Ritratto di Giovanni Secco Suardo col servitore/
Portrait of Giovanni Secco Suardo and his Servant

1720–30, canvas, Bergamo, Carrara.

Richness of color and unfailing mastery of brushstrokes, combined with psychological intensity in capturing character, are the hallmarks of Fra Galgario's portraits. In this case the painting also carries moral undertones. Even when relaxing, which can be deduced from the way his clothes are loosened and the fact that he is not wearing a wig, the nobleman maintains his formal, pompously impressive poise. The wise-looking old man may well only be a servant, but his presence provides an alternative type of dignity to that of the count. He counter-balances the social and intellectual claims of the nobleman with a reminder of the common human virtues which need no titles.

Sebastiano Ricci
Punizione di Amoroe/
The Punishment of Cupid

1706–07, canvas, Florence,
Palazzo Marucelli-Fenzi.

This is a splendid example
of the work Ricci produced
during his Florentine
period. It incorporated
references to Luca
Giordano but brought to
them a completely new
richness and innovation.

Sebastiano Ricci

Belluno, 1659 – Venice, 1734

Ricci was an exuberant personality,
internationally renowned and an
archetypal "traveling" painter. After
training in the Veneto, Ricci spent some
time in Emilia (Bologna, Parma and
Piacenza). This proved crucial to his

development as his style was influenced
by the local classicism, deepened when
Ricci made a trip to Rome, where
Annibale Carraci's frescos in Palazzo
Farnese deeply moved him. After a brief
trip to Vienna, Ricci went back to Venice
in 1708, where his art changed. His
Altarpiece of St. George the Great was a
deliberate homage to Paolo Veronese
and inaugurated a totally new era in

eighteenth-century Venetian painting,
trying to revive the glories of its
Renaissance. Compared to his earlier
works, his art was now remarkably free
in composition and brushwork. This
new style of painting was an immediate
success. By 1711 Sebastiano had joined
his nephew Marco Ricci in London
where he remained for five years,
working for many great noblemen.

After a brief stop-over in Paris (enough
to gain him admittance to the
prestigious Académie Royale), he went
back to work in Venice where he
produced canvases for collectors as well
as altarpieces. At the end of his career
he painted the *Assumption* in the
Karlskirche in Vienna for the Emperor
Charles VI.

Sebastiano Ricci
Caduta di Fetonte/
Fall of Phaeton

*1703–04, canvas, Belluno,
Museo Civico.*

Undoubtedly Sebastiano
Ricci's dashing virtuoso
technique had its roots in
the Baroque. In his hands,
however, it was translated
into an explosive, light-
hearted energy.

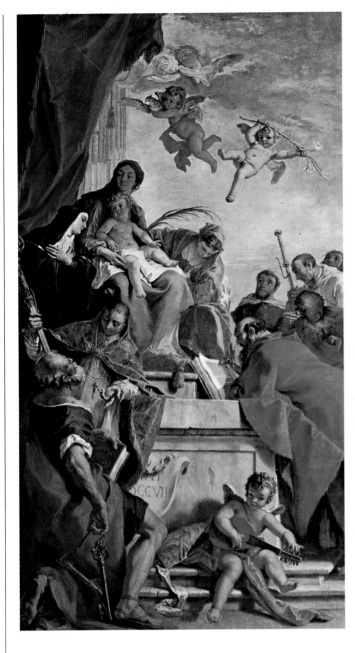

Sebastiano Ricci
Madonna col Bambino in trono e santi/The Madonna and Child Enthroned with Saints

1708, canvas, Venice, S. Giorgio Maggiore.

This has to be one of the most cheerful altarpieces of the whole eighteenth century. It was directly inspired by Veronese's *Sacra Conversazione* but the subject is reinvented with a freshness and exquisite coloration that are spectacularly effective. It was commissioned for a side altar in the church designed by Palladio. It is carefully composed using rising diagonal lines that shift the viewer's attention toward the left of the picture, that is to say toward the Madonna and Child. This geometrical rigor (which is disguised by the apparent immediacy of an action-packed scene) also helps to overcome the tricky problem of having so many figures packed into a fairly small space.

Sebastiano Ricci
San Pietro liberato dal carcere/The Liberation of St. Peter

1722, canvas, Venice, S. Stae.

This sweeping, dynamic composition was part of the most important cycle of canvases commissioned in Venice in the first part of the eighteenth century. The cycle consisted of twelve pictures destined for the presbytery of the church of S. Stae (its full name is Sant'Eustachio and it overlooks the first section of the Grand Canal). Each picture was commissioned from a different artist, thus bringing them together at the same time as provoking comparisons between their various styles. Apart from Ricci, the group comprised among other major geniuses of Venetian painting in the eighteenth century, Piazzetta, Pittoni, and Giambattista Tiepolo. Thanks to these commissions S. Stae became the most important experimental setting for Venetian art in the early part of the century.

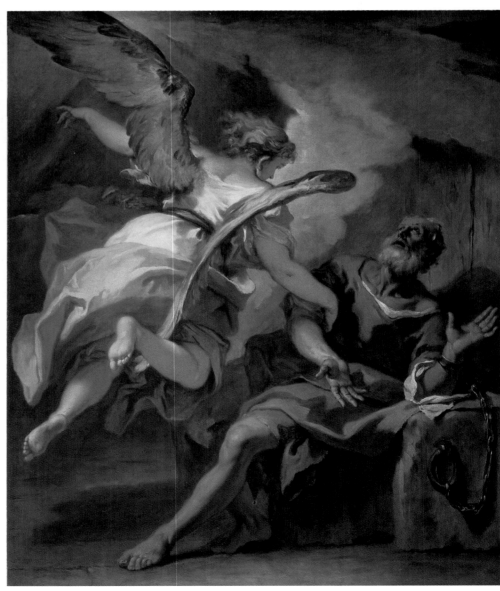

Giambattista Piazzetta

Venice, 1683–1754

Piazzetta was the son of a wood carver from whom he inherited his taste for sculpturally solid figures and a wonderful gift for engraving. His career included an unusual episode for a Venetian painter. From 1703–05, in fact, he studied in Bologna with Giuseppe Maria Crespi, being inspired by Crespi's dramatic use of chiaroscuro. Piazzetta was also excited by Guercino's altarpieces with their "big splashes" of color. The immediate effect of these influences was that he developed a dramatic pictorial style with tremendous emotional power. He tended to use strong chiaroscuro, contrasting brilliantly-lit areas and others plunged into shade. His palette contained a lot of muted browns, partly due to which his pictures convey a strong religious feeling. However, thanks to his contacts with Tiepolo (with whom he worked in the church of the Gesuati and who had been at first influenced by him) Piazzetta's work gradually became lighter and more luminous, although he never painted frescos. Even when decorating the ceiling of a chapel (in the church of S. Zanipolo) he painted on canvas. Piazzetta produced many fine secular compositions for collectors. Among these we should mention his famous *Fortune Teller* in the Accademia in Venice or his *Rebecca at the Well* in the Brera in Milan. He was also an excellent illustrator and engraver. Finally, Piazzetta played a key role in teaching and was one of the founders of the Venetian Academy of Fine Art.

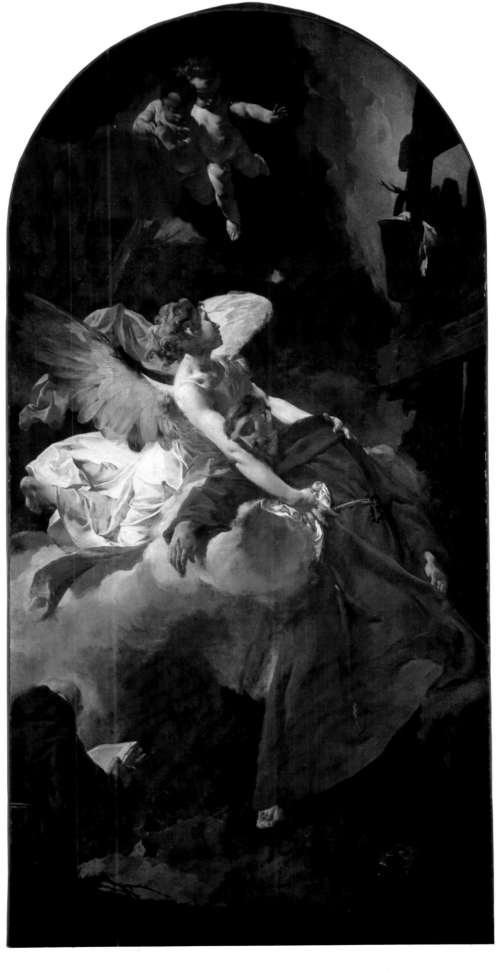

Giambattista Piazzetta

Estasi di san Francesco/ The Ecstasy of St. Francis

1729, canvas, Vicenza, Palazzo Chiericati, Pinacoteca Civica.

This is among Piazzetta's finest paintings and is also a masterpiece of eighteenth-century sacred art. The altarpiece (which was originally in the church of S. Maria d'Aracoeli in Vicenza) is composed along three parallel diagonals that cut across the composition from left to right. The most important section is in the center where Piazzetta contrasts the luminous and robust figure of the wonderful angel with the lifeless, dark, and heavy figure of the fainting saint. The descriptive detail (such as the scruffy wooden structure or the figure of Brother Leo with his back to us) accentuate the feeling of isolation and intense mysticism.

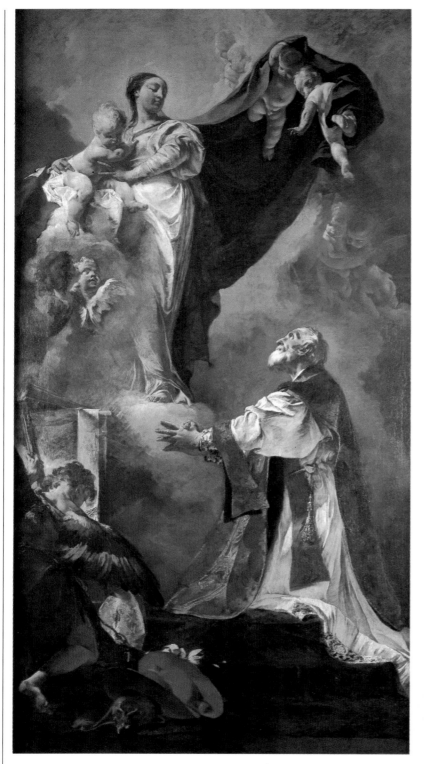

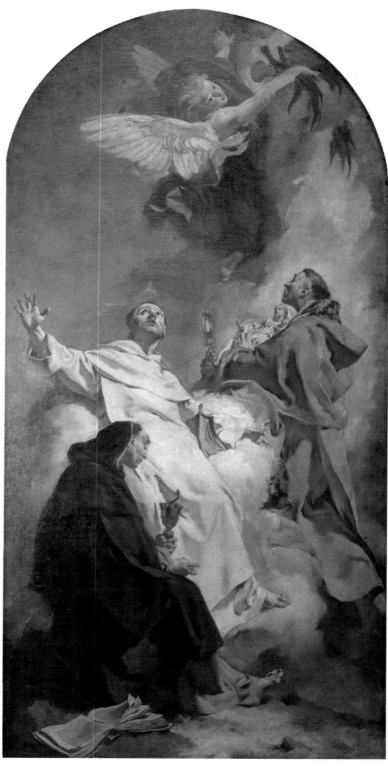

Giambattista Piazzetta
Apparizione della Vergine a san Filippo Neri/ The Virgin Appearing to St. Philip Neri

1725, canvas, Venice, S. Maria della Fava.

Starting from a triangular compositional layout which derives from Titian, Piazzetta packs the picture with vibrant emotion thanks to the creative tension between the characters and the still-life inserts.

On the opposite page
Giambattista Piazzetta
Sant'Jacopo condotto al martirio/St. James Led to Martyrdom

1722, canvas, Venice, S. Stae.

Giambattista Piazzetta
Tre santi domenicani: Lodovico, Bertrando, Vincenzo Ferreri e Giacinto/ Three Dominican Saints: Laurence Bertrand, Vincent Ferreri, and Hyacinth

1738, canvas, Venice, S. Maria dei Gesuati.

The beautiful church of the Gesuati stands on the banks of the Zattere and is a shrine to eighteenth-century Venetian painting. It contains no less than three stupendous altarpieces by Sebastiano Ricci, Giambattista Tiepolo (who also painted the frescos on the ceiling), and Piazzetta himself. In this work he touched on a source of enormous energy when he created the angel flying upside-down and in the way he plays with the three colors of the saints' habits (white, black, and brown) and their rapt expressions.

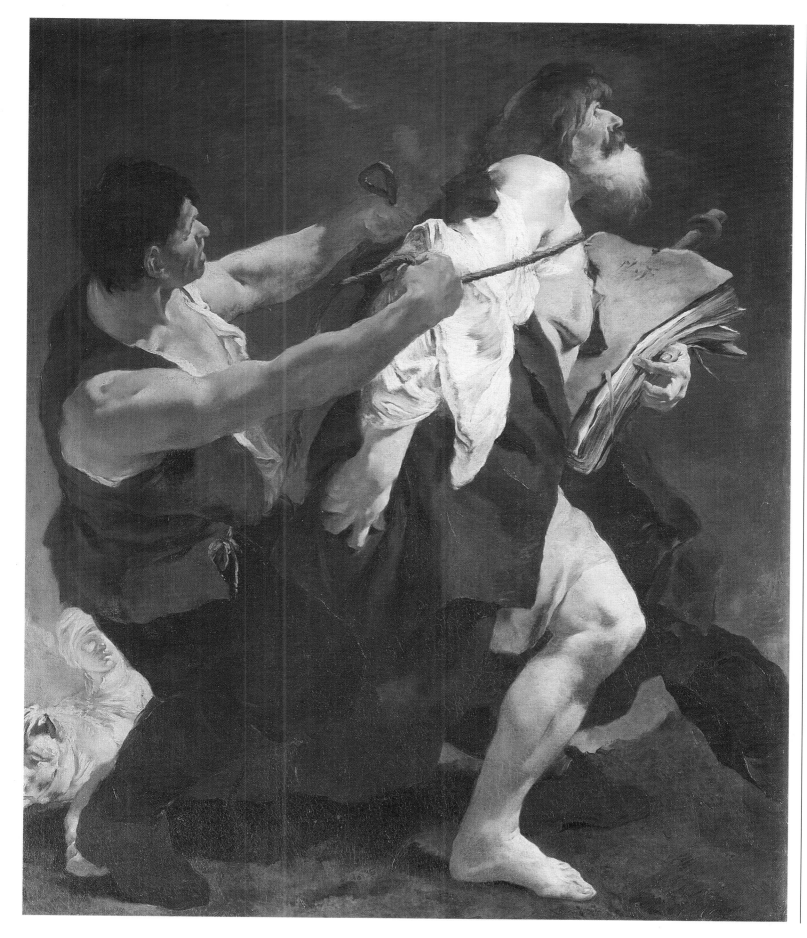

Giambattista Tiepolo

Venice, 1696–Madrid, 1770

Tiepolo was the most exuberant and influential, and arguably the greatest, painter in eighteenth-century Europe before the rise of Neo-Classicism. He revived the full glories of the Venetian Renaissance enriched with references to Rubens, Rembrandt, and the Roman Baroque. Tiepolo helped create the style of large-scale decorative programs embarked on by courts across the continent. His fame rests chiefly on his huge frescos but he should also be remembered as an extremely versatile painter, able to move freely from one art form to another and to adapt to the most disparate subjects. He was a pupil of Gregorio Lazzarini but soon surpassed him, being just 21 when he became a member of the Venetian Painters' Guild. In 1719 he married Cecilia Guardi, sister of the two painters Francesco and Giannantonio. He was attracted by the experimental work being done by Piazzetta and Sebastiano Ricci (working alongside them on the paintings in S. Stae in 1722). After this he turned his own attention to getting rid of all Baroque heaviness. Increasingly he opened up sunny, vividly colorful scenes inspired by the grand traditions of the cinquecento. After early fresco cycles in Venice, Tiepolo had his first big success with the stupendous decorations he painted for the gallery in the Bishop's Palace in Udine (1726). This is an explosion of playful luminosity. From then on he received an evergrowing number of commissions from both private and religious patrons. For all of them, Tiepolo painted canvases and frescos full of light-hearted fantasy. Their stylistic source was Paolo Veronese with a deliberately accentuated sense of theater. For this reason Tiepolo almost always worked with his trusted colleague Girolamo Mengozzi Colonna, a quadraturista who painted the counterfeit architecture into which the narrative scenes slotted. During the 1730s Tiepolo worked throughout the Veneto and Lombardy. Among his major works in this period are the frescos in the Colleoni Chapel in Bergamo, the ceiling of the church of Gesuati and a number of altarpieces in Venice, and the decorative program for a number of major Milanese palaces (Archinto, Dugnami, Clerici). By now at the height of his fame, Tiepolo poured even more invention and surprises into his work. He unleashed his unbridled fantasy and love of allegory on huge commissions in Venice in the Scuola del Carmine and especially the Palazzo Labia, his finest surviving work in the city. (As Venice's damp sea air does not encourage fresco-painting, the city's last truly great painter paradoxically painted very little in the city itself.) He also produced many paintings for foreigners but, unlike many Venetians (such as Sebastiano Ricci, Canaletto, and Bellotto), he was reluctant to work abroad. He was finally persuaded to do so by Prince-Archbishop Karl Philipp von Greiffenklau and in 1750 he took an army of assistants to Würzburg. The frescos he produced for the Residenz in this small town in Franconia (north Bavaria) are the masterpieces of Rococo painting in Europe. They mark the style's unsurpassable zenith and inevitably the start of its decline. Back in the Veneto, Tiepolo did more fine paintings in aristocratic villas (Valmarana in Vicenza, Pisani at Stra), as well as commissions for altarpieces, such as that in the Cathedral at Este. In 1762, again with a group of assistants from his studio including his sons Giandomenico and Gianlorenzo, Tiepolo set off for Spain. In Madrid he painted frescos in a number of rooms in the Royal Palace, including the Throne Room. However, while he was in Spain, Neo-Classicism first appeared in the form of Anton Mengs' insipid art. Soon Tiepolo's fantastic and transfiguring style of decoration seemed out of fashion and the great painter died in Madrid almost neglected. The young Goya was later influenced by him.

Giambattista Tiepolo
Rachele nasconde gli idoli/
Rachel Hiding the Idols

c. 1726, fresco, Udine, gallery in the Archbishop's Palace.

In Udine the main stairway and gallery in the palace of the Patriarch Dionisio Dolfin, later to become the Archbishop's Palace, contains the first major fresco cycle painted by Giambattista Tiepolo. The frescos have recently been cleaned and we can now fully enjoy them once more. The Biblical scenes are set in curved Rococo frames which give the narrative a fantastic rhythm. This is enriched by countless realistic details including allusions to popular folklore. Among the characters he included portraits of himself at about the age of 30 and of his wife Cecilia Guardi.

Giambattista Tiepolo
Educazione della
Vergine/Education of the
Virgin

*1732, canvas, Venice, S. Maria
della Fava.*

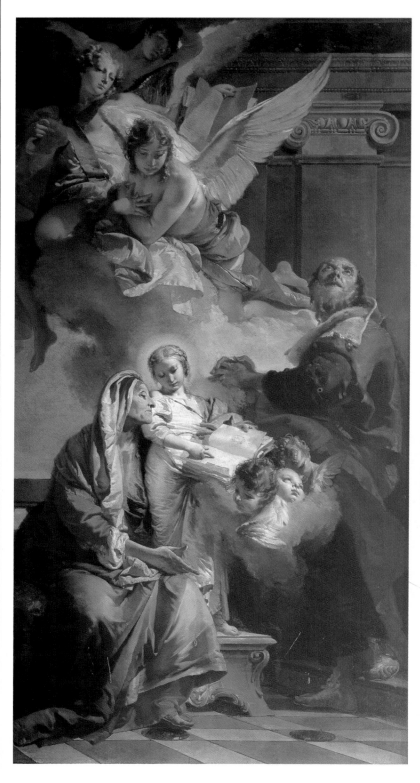

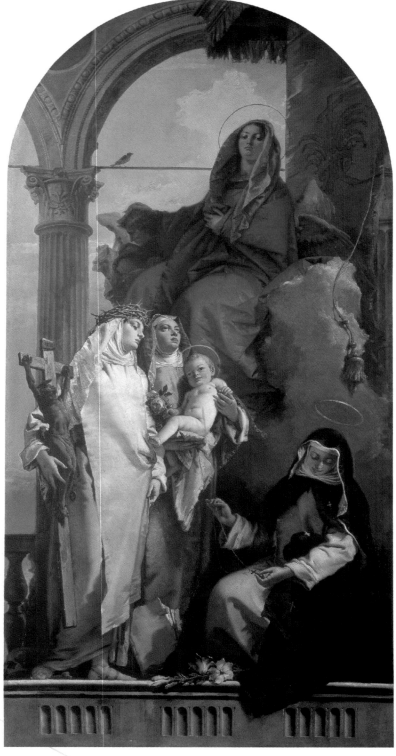

Giambattista Tiepolo
Apparizione della Vergine
alle sante domenicane
Rosa da Lima, Caterina da
Siena e Agnese da
Montepulciano/The Virgin
Appearing to Dominican
SS. Rose of Lima,
Catherine of Siena, and
Agnes of Montepulciano

*1740, canvas, S. Maria dei
Gesuati.*

The figures in these two
altarpieces are portrayed
more as the heroines of
noble dramas than as saints.
They combine true pathos
with elegant sensuality, as if
they were creatures of

some higher human
species. At the same time,
however, they are firmly
linked to our sense of
everyday life through the
descriptive details which
are so naturalistic as to
border on trompe-l'œil.

Giambattista Tiepolo
Giove appare a Danae/
Jupiter Appearing to Danae

*1733, canvas, Stockholm,
University Collection.*

Bought in 1736 by Count
Carl Gustaf Tessin, this
painting shows the rapid
spread of Tiepolo's fame
outside Italy. The Queen of
Sweden had, in fact, heard
about him. The scene delights
in the splendid seduction
but above all it hinges on
contrast. Just compare the
grand, classically-depicted
figures of the main characters
with the liveliness of the
minor episodes and
characters. Once again
Tiepolo has given free rein
to his own irreverent sense
of humor (for example, the
little scene at the bottom
where the tiny dog is barking
at the god's eagle). Nothing
remains of the terror felt by
Danae before the god as
depicted once by Titian.

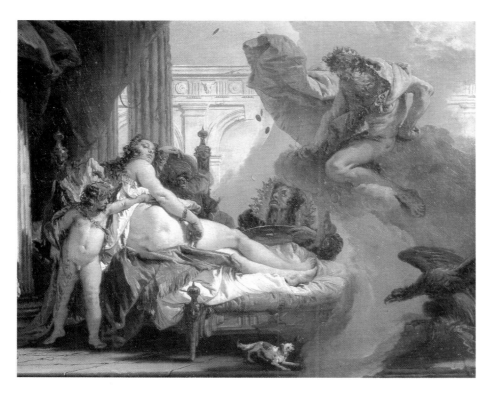

Giambattista Tiepolo
Volo della Santa Casa
verso Loreto/Flight of the
Holy House to Loreto

*1743, canvas, Venice, Gallerie
dell'Accademia.*

This oval sketch is all we
have left of Tiepolo's daring
creation for the ceiling of
the church of the Scalzi in
Venice. Unfortunately the
resultant fresco was
destroyed by bombing
during the First World War.
The canvas itself only
conveys a little of the
impressive effect produced
by the Holy House, held
aloft by angels, hurtling
across the church ceiling
and breaking loose from its
structural base.

Giambattista Tiepolo
Trionfo di Flora/
Triumph of Flora

*1743–44, canvas, San
Francisco, M.H. de Young
Memorial Museum.*

The work was
commissioned by the
connoisseur Francesco
Algarotti for Count Brühl,
a prominent member of the
Court of Saxony. In order
to increase the general
luminosity of his colors,
Tiepolo concentrated
unashamedly on three
primary colors (yellow, red,
and blue). He alternated
billowing cloaks with
elegant architectural
features and the silent
shapes of the trees. In
addition, everything is
scattered with enchanting
flowery garlands that are
finely painted with
meticulous delicacy.

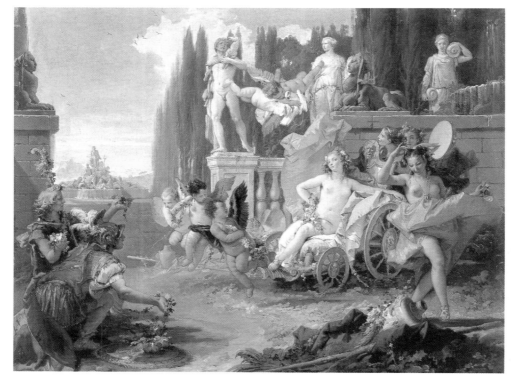

Giambattista Tiepolo
Adorazione dei Magi/
The Adoration of the Magi

1753, canvas, Munich, Alte Pinakothek.

Tiepolo painted this altarpiece during his stay in Germany. Because of the damp climate, he could only work on the frescos in the Würzburg Residenz in the spring and summer. So in the fall and winter he had

to concentrate on painting in oil on canvas. He produced some fantastic and exotically beautiful works in which the religious subject seems merely a pretext for eye-catching, showy images, but he himself was genuinely religious. The style of the age, however, meant that even religious topics often became theatrical.

Giambattista Tiepolo
Investitura del vescovo Aroldo/Investiture of Bishop Harold;
Le nozze del Barbarossa/ The Marriage of Frederick Barbarossa

1751–53, frescos, Würzburg, Residenz, Kaisersaal.

Tiepolo's long and extremely fruitful stay at the court of the Prince-Archbishop of Würzburg

opened with an explosion of joy and light in the frescos of the Imperial Salon. The abstruse iconographic program (which mixed Greek mythology, the German Middle Ages, and the history of the local bishopric) was transformed into a brilliant decorative scheme, thanks to the white and gold plaster work which creates the illusion of raised curtains. This was done by

Solari, a stucco artist from Ticino. Tiepolo himself was assisted by his sons Giandomenico and Lorenzo. He created rigorously accurate architectural backdrops against which he set crowds of people in extravagant costumes. His compositions always appear quite spontaneous but were, in reality, worked out to the smallest detail beforehand.

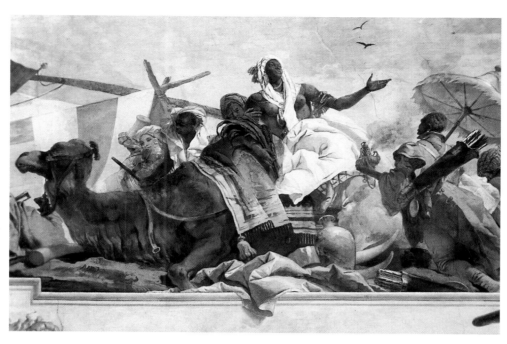

Giambattista Tiepolo
Allegoria dell'Africa/
Allegory of Africa

*1753, fresco, Würzburg,
Residenz, Kaisersaal.*

The main staircase of the
Residence is without
question the greatest
achievement of Rococo
architecture in Europe.
It was also the most daring
design ever produced by
the architect Balthasar
Neumann. All around the
cornice and across the
boundless ceiling of the vast
room, Tiepolo painted an
impressive tribute to his
patron, drawing on a
happily jumbled summary
of current knowledge of
geography and the natural
world. Tiepolo's borders
are brimming with a
countless variety of people,
animals, and plants of all
sorts. He portrays four
splendid women, allegories
for Europe, Africa, Asia,
and America. Each of the
beauties (whose looks and
clothes were meant to
reflect the distinctive
features and customs of the
different parts of the
world) is surrounded by the
typical produce of her
continent. Here we see
black Africa riding a camel.

Giambattista Tiepolo
Donna con un pappagallo/
Woman with a Parrot

*1760–61, canvas, Oxford,
Ashmolean Museum.*

Although Tiepolo did from
time to time produce
excellent portraits, this
luminous painting may not
be a portrait at all. It is,
however, almost a symbol
of eighteenth-century
grace. The rosy bust of the
extremely pretty young girl
can without disadvantage
be compared to the sensual
female half busts that Titian
had painted two centuries
earlier.

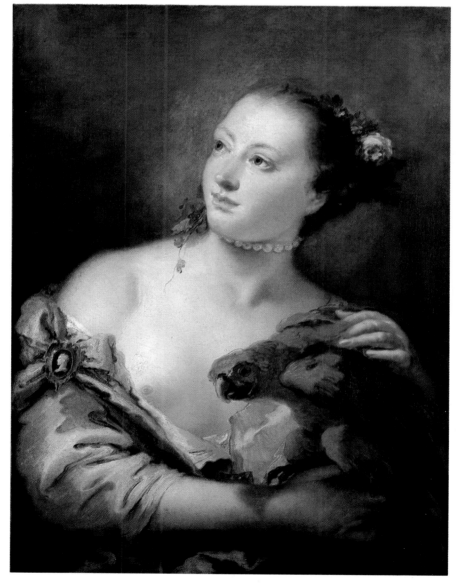

331

Giambattista Tiepolo
Ultima communione di santa Lucia/Last Communion of St. Lucy

1748–50, canvas, Venice, SS. Apostoli.

Still further proof of Tiepolo's extraordinarily eclectic talents comes from the fact that at the same period that he was working on the breathtakingly secular spectacle of the frescos in Palazzo Labia, he also painted his most religiously intense Venetian altarpiece. In no sense did he compromise the clear sobriety of the architecture nor the brilliance of his palette. Indeed they seem to underline the sadness of the scene.

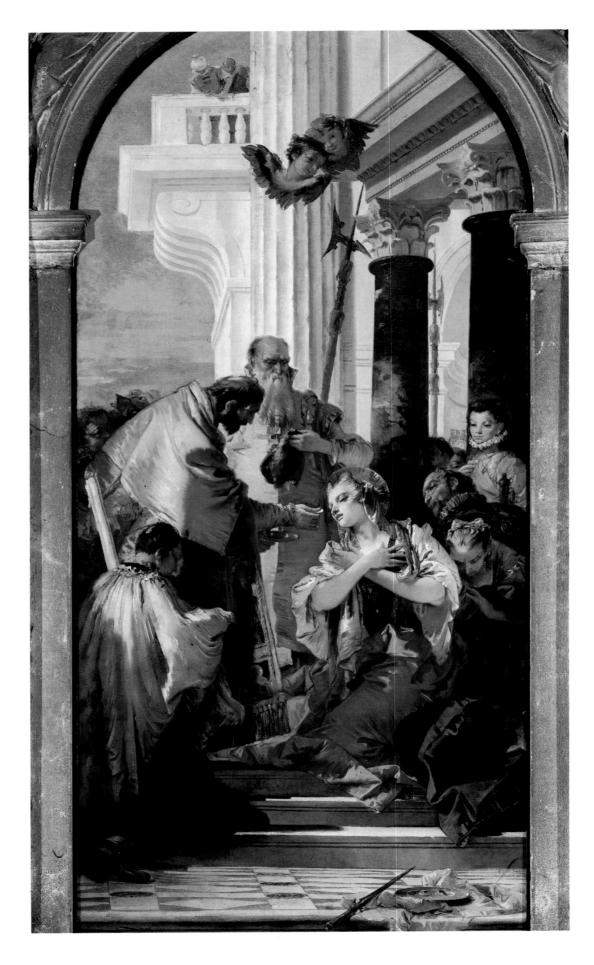

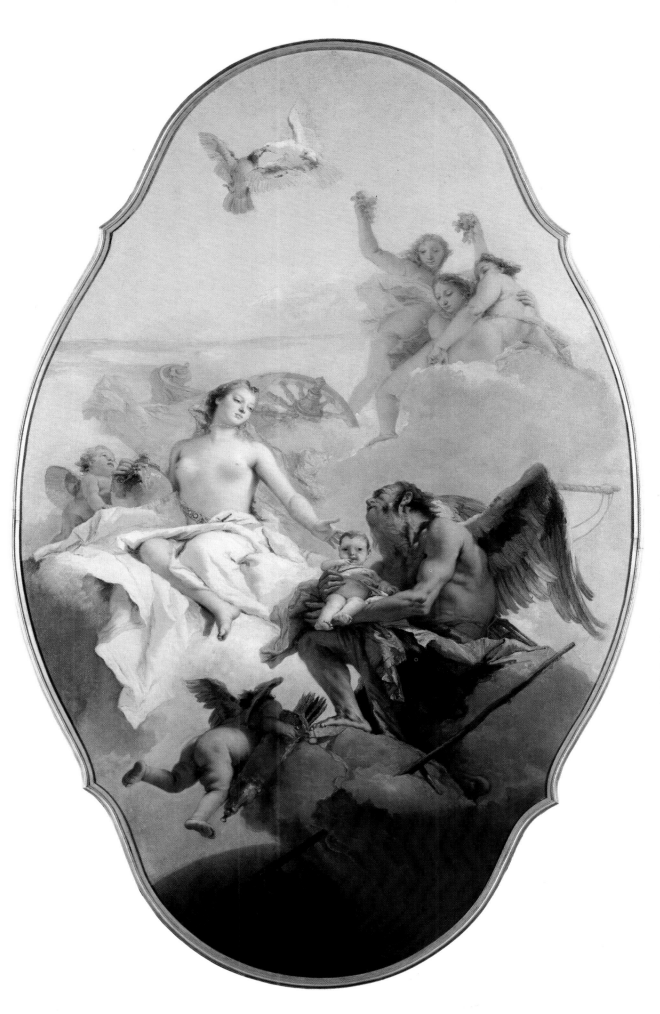

Giambattista Tiepolo
Allegoria con Venere e il
Tempo/Allegory with
Venus and Time

*1754–57, canvas, London,
National Gallery.*

This is a typical ceiling
backcloth. The canvas
would have been attached
to the ceiling and was
therefore intended to be
viewed from below. Yet
again the Venetian master
demonstrated his supreme
ability to create stunning
illusions of light-filled
pearly-blue space. He
alternated areas of intense
luminosity with areas in
shade. Besides the
delightful allegorical
allusions, he sought images
with very concrete
qualities. He also added
beautiful details, such as the
two doves in flight. The
model he used for Venus is
probably the same as the
one used for the *Woman with
a Parrot* (see p. 331). Her
young beauty contrasts
startlingly with the
mournfully decrepit figure
of Time. Some critics have
seen in such an aged figure
a hidden allegory of the
Venetian Republic's own
terminal decay.

Giandomenico Tiepolo

Venice, 1727–1804

The gifted and clever son of a great artist, Giandomenico Tiepolo spent many years learning by working alongside his father. Giambattista was so convinced of his son's talent that he involved him in the major commissions he undertook at the height of his own powers, and Giandomenico went with him to Würzburg, Vicenza, Stra, and Madrid. It becomes progressively easier to pick out Giandomenico's contributions to the works completed in these years, as during this time he was gradually acquiring his own personal style. This was substantially different (at least in the choice of subject matter) from his father's. Giandomenico's temperament emerged most effectively in the frescoes he painted for the guest lodge at Villa Valmarana near Vicenza (1757). They are imbued with a strong sense of realism, if still elegant and playful. Giandomenico had a marked preference for scenes from contemporary life. He viewed life always from a somewhat ironic perspective (although this was usually quite gentle, he could on occasion become savage). This was true of him both as a painter and as an engraver. At the same time he never broke away fully from his father's style. In particular, Giandomenico worked very closely with his aged father during their stay in Spain (1762–70). The paintings he and his father produced in Madrid were to be a fundamental influence on Goya at the start of his own career. After his return to Italy, Giandomenico pursued important decorative programs in Venice, Brescia, and Genoa. His painting gradually became tinged with the feeling that it was the end of an epoch. This translated as a lightness of touch and a latent melancholy in the frescoes he painted in his family's own villa. These were painted during the last decade of the eighteenth century and are now in the Ca' Rezzonico.

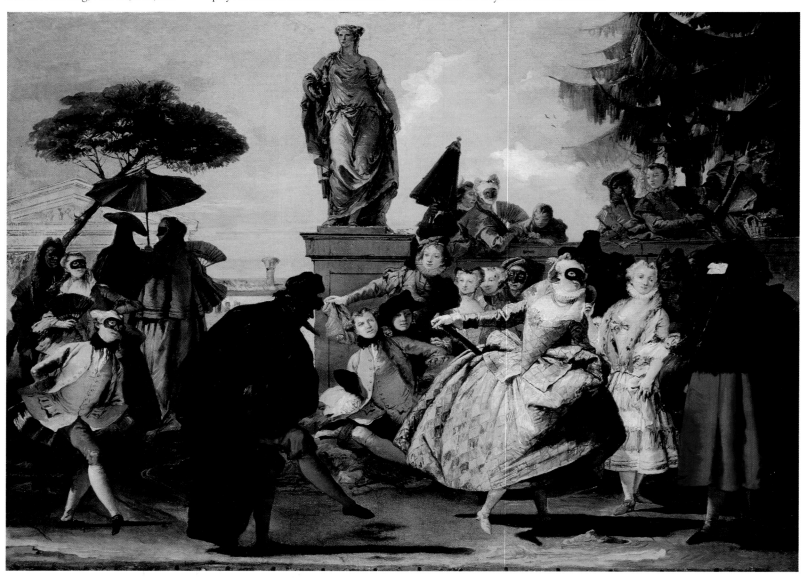

Giandomenico Tiepolo

Il minuetto/Minuet

1756, canvas, Barcelona, Museo d'Art de Catalunya.

This is an extremely interesting early piece which borrows its compositional layout from scenes painted by his father (for instance, *Triumph of Flora*, on p. 329). The difference is that Giandomenico chose not to paint mythological or allegorical scenes. The minuet is being danced by people wearing traditional masks and having a good time. Its proper classification is therefore a genre painting. It was works like this that made such a deep impression on the young Goya.

On the opposite page

Giandomenico Tiepolo

Passeggiata estiva/ Summer Stroll

1757, fresco, Vicenza, Villa Valmarana, Nani, guest house.

While Giambattista was busy in the main house painting famous episodes taken from heroic poems, his son Giandomenico decorated the rooms in the guest house with enjoyable if somewhat enigmatic scenes like this. The subject of the seasons, which Giambattista would probably have portrayed in wonderful allegories, provided Giandomenico with the occasion to depict scenes set in the countryside with romantically distant vistas but utterly real people.

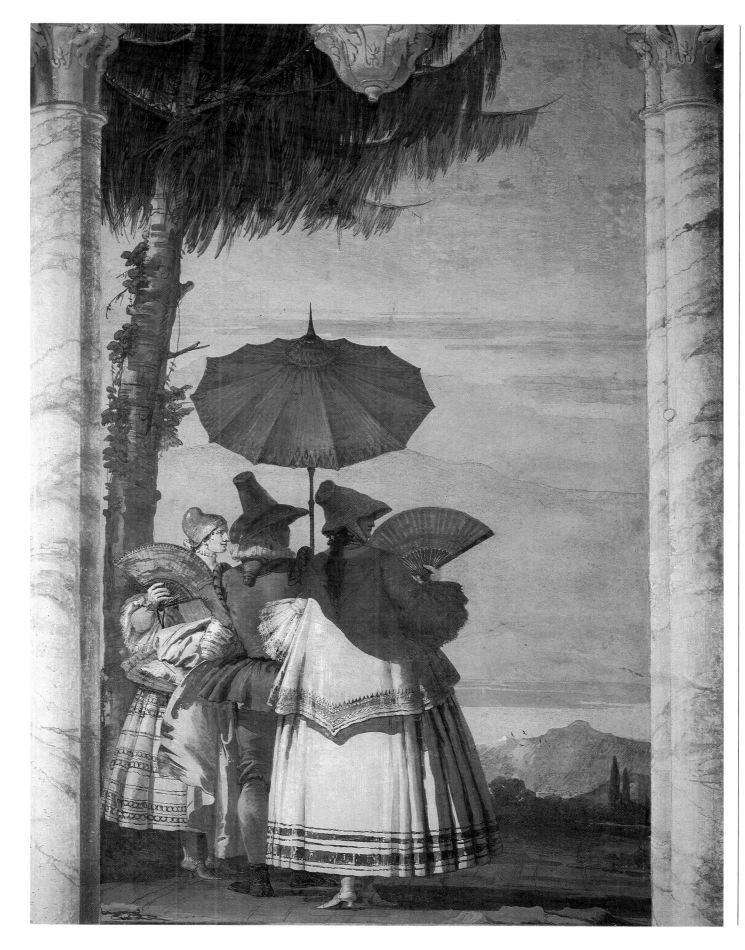

Gaspare Traversi
Lezione di disegno/
The Drawing Lesson

c. 1750, canvas, Kansas City,
Nelson-Atkins Museum.

To use the term coined in the eighteenth century, this is an excellent example of a domestic scene or "conversation piece." It contains the full range of types, people, and feelings usually found in Traversi's work which uniquely captured Naples under Bourbon rule with a full range of ordinary people, aristocrats, and common folk. Traversi was always ready to turn his well-developed sense of humor laced with sarcastic bitterness on himself. Nevertheless the immediate, brilliant liveliness of the subjects should not make us forget the stylistic aspect of Traversi's work. He raised genre painting to a nearly monumental level, just as Giacomo Ceruti did in Lombardy. It is fairly difficult to pinpoint the date of these group portraits but it is likely that they were done around the middle of the century.

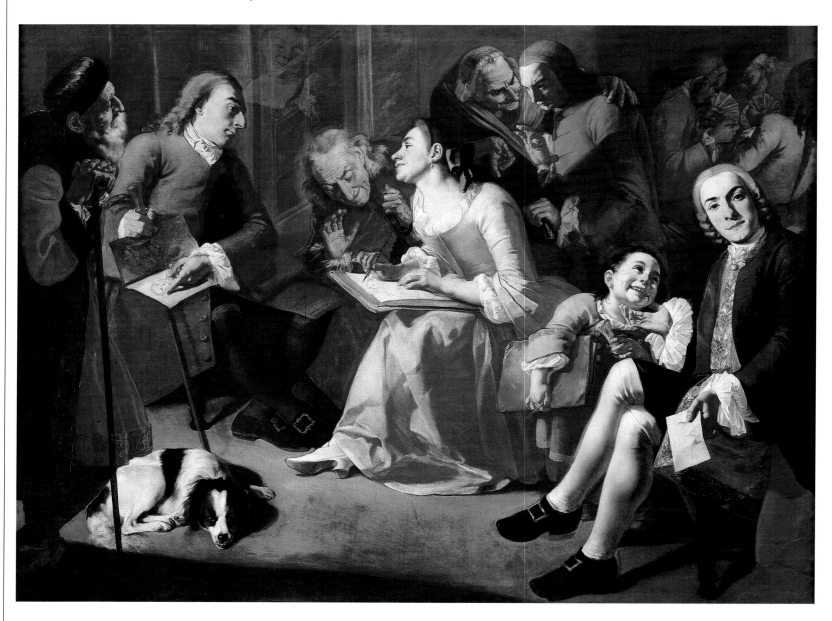

Gaspare Traversi

Naples, c. 1722–Rome, 1770

At the end of its splendidly rich Baroque era, eighteenth-century Neapolitan art produced a whole batch of interesting artists, of whom one stands out above the crowd: Gaspare Traversi. For a long time he has remained unknown, or at least very little known and then mainly for his religious paintings. (Although they were certainly better than average, especially the Parma altarpieces the Bourbons commissioned from him, they are not very original.) Traversi has been rediscovered recently as one of the freest and most fearless eighteenth-century artists in Naples. His œuvre has been pieced together by recent studies. What is remarkable about it is a large number of large genre scenes showing people, places, and situations from real life. In Traversi's hands squires and villagers, street urchins and singers, supposed connoisseurs and idlers act out a pictorial version of Neapolitan comedy. It should be underlined, however, that Traversi's style was far from sloppy or popular. Quite the contrary, his art was extremely accomplished and broad-ranging. The aspects of caricature that it contained never degenerated into vulgarity or slovenliness. Taken as a whole, Traversi's painting can be considered to be an interesting, markedly independent if minor contribution to European art during the eighteenth century. This is due to the almost Voltairian spirit of amusement, skepticism, and irony with which he viewed everyday life.

Pompeo Gerolamo Batoni

Lucca, 1708–Rome, 1787

Pompeo Batoni was a very cultured man who gained international fame at an early age. He was the first Italian artist consciously to work out a formal alternative to Rococo art and Venetian painting, which he felt to be outdated. He was born in Tuscany but trained in Rome where he studied Raphael and classic Renaissance art. He quickly came up with a "reform" program for painting along controlled academic lines. This was not unlike the similar project pushed through a century earlier by Annibale Carracci. From his *Sacra Conversazione* in the church of S. Gregorio al Celio in Rome (1732) to his large *Sacra Famiglia* in the Brera in Milan, Batoni set out to provide a series of paintings that could be used as a model for religious art. In his paintings each figure is posed in a composed fashion. Thanks to his draughtsmanship, the quality of definition is clear. In turn the figures fit within an extremely clear and simple plan of composition. With the work of his rival Anton Raphel Mengs, Batoni's art marked the first beginnings of Neo-Classicism, in an urbane, highly polished, if very derivative manner. This was not seen at the time as the mere imitation of Classical Antiquity, but rather as stimulating research into ideal beauty, and proved very popular at the time. Batoni also produced excellent portraits in his clear and steady hand.

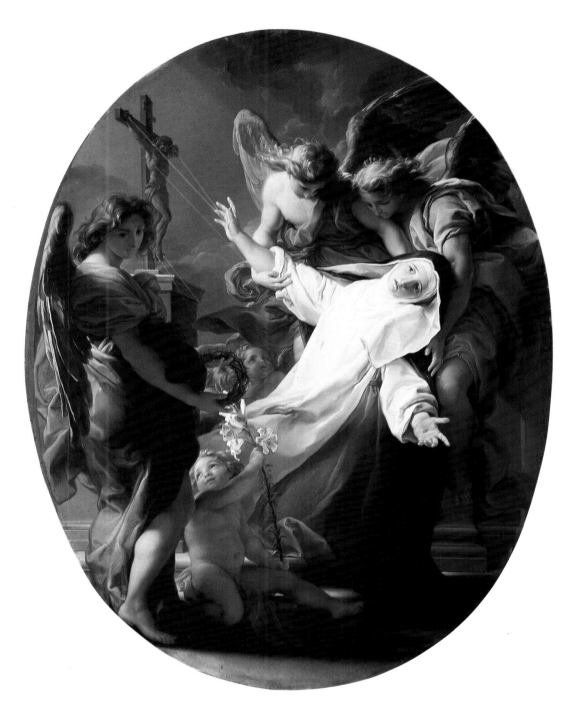

Pompeo Gerolamo Batoni

Estasi di santa Caterina da Siena/The Ecstasy of St. Catherine of Siena

1743, canvas, Lucca, Museo di Villa Guinigi.

If we compare works on similar subjects (for example *The Ecstasy of St. Francis* by Piazzetta shown on p. 323), we can measure the cultural change that Batoni was proposing. The great sense of movement contained in compositions by artists in the first half of the century could also be seen in the speed with which they painted. This was now subjected to a rigorous check. Everything was controlled and expressed in impeccable form at the cost of losing much emotional intensity. After the middle of the century, this academic way became the main influence on painting in central Italy.

Giovan Paolo Panini

Piacenza, 1691–Rome, 1765

Panini was one of the most accomplished *vedutisti* (view-painters) of the eighteenth century. He came from a long tradition of Emilian view-painters and scenery-painters. In 1715 he moved to Rome where he first worked as a decorator painting counterfeit architecture in various palaces. He then found a fuller creative voice by painting scenes of holidays or special events. The spectacular backdrops he used for these works were the squares and buildings of Rome. The beauty of these monumental backgrounds, bathed in a clear light that seemed to exalt the very notion of the Eternal City, was so powerful that he had no need of a narrative pretext for them. Many of Panini's paintings are simply views animated by lively little figures. He had a considerable influence on Canaletto and the great Venetian view-painters of the eighteenth century.

Giovan Paolo Panini
La piazza e la basilica di
S. Maria Maggiore/
The Piazza and Church of
S. Maria Maggiore

*1744, canvas, Rome, Palazzo
Quirinale, Coffeehouse.*

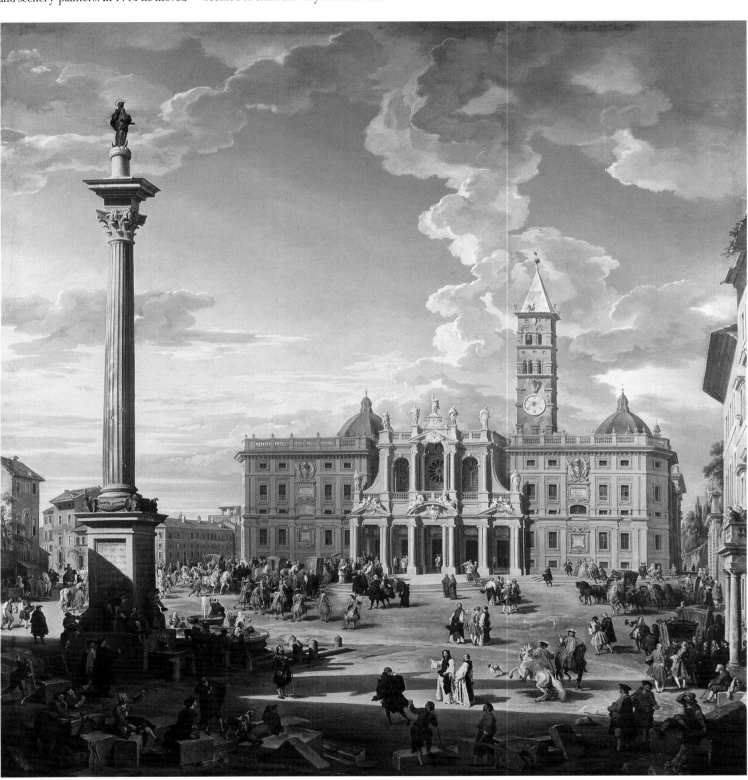

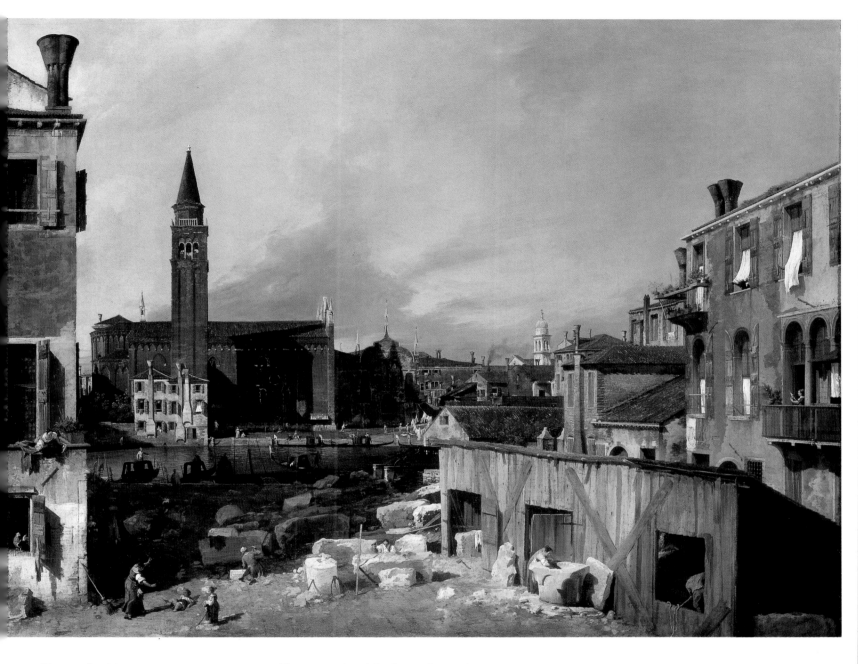

Canaletto

Giovanni Antonio Canal…
Venice, 1697–1768

Together with his fellow Venetian Tiepolo, who was the same age, Canaletto played a crucial role in spreading the glories of late Venetian art across Europe in the eighteenth century. All of his cityscapes were painted for export (it is no coincidence that there are very few works by Canaletto in Venice itself) where they quickly became extremely valuable commodities in the art market. Two centuries later, there appears to be no slackening of this interest. Canaletto came from a family of artists and made his own start assisting his father, who was a scenery-painter. They prepared work for theatrical productions in Venice and Rome. Although he did not stick at it for long, this early experience left a formative mark on Canaletto. In fact, he always paid great attention to conjuring up evocative, theatrical views that used deep perspective. During those early years he made contact with the London theater impresario Owen McSwiney who was the first person to value his work. In about 1728 Canaletto started painting views of Venice for English tourists. He tended to choose monumental vistas seen on a clear day. His success was overwhelming. Over the years the British Consul in Venice, Joseph Smith, commissioned dozens of paintings (later bought from him by King George III) and whole series of etchings. Smith promoted the painter to English collectors and tourists, so boosting his fame. Canaletto's views were at least in part done with the help of the camera obscura, an optical device which preceded the introduction of the photographic camera. Thanks to these devices, but above all because of his own ability as a perfect draughtsman who was able to capture luminosity in a thrilling fashion, Canaletto was for a while one of the most successful artists in Europe. In 1746 he moved to London where he remained for some years. During his time here he alternated views of Venice (painted from his highly-detailed sketchbook) with vistas of the English capital and country houses, but his fortunes gradually declined.

Canaletto
Il laboratorio dei marmi di San Vidal/The Stonemason's Yard at San Vidal

c. 1727, canvas, London, National Gallery.

Although this view was precise in detail it could scarcely be recognized today. The church in the background is S. Maria della Carità (now the Accademia) dominated by the campanile which fell down in 1741. It has a breathtaking vividness absent from most of Canaletto's later more finished work.

Canaletto
Corteo dogale alla chiesa di San Rocco/ The Doge Visiting the Church of S. Rocco

detail, 1735, canvas, London, National Gallery.

The picture shows a ceremony that took place each year at the beginning of August. The Doge used to visit an open-air exhibition of paintings outside the Scuola di San Rocco. The pictures were hung from the façades of the buildings and a canopy protected visitors from the sun.

On the opposite page
Canaletto
Il Bucintoro di ritorno al molo il giorno dell' Ascensione/The Return of the Bucentaur to the Molo on Ascension Day;

Regata sul Canal Grande/ Regatta on the Grand Canal

1730–35, Windsor Castle, Royal Collection.

The two pictures showing traditional Venetian ceremonies are from a series of 14 views of the Grand Canal painted by Canaletto and engraved by Antonio Visentini (*Prospectus Magni Canalis Venetiarum*, published in 1735). They found their way into the British Royal Collection via Consul Smith's collection. He was one of the foremost collectors of Venetian painting and a passionate supporter of the view-painters.

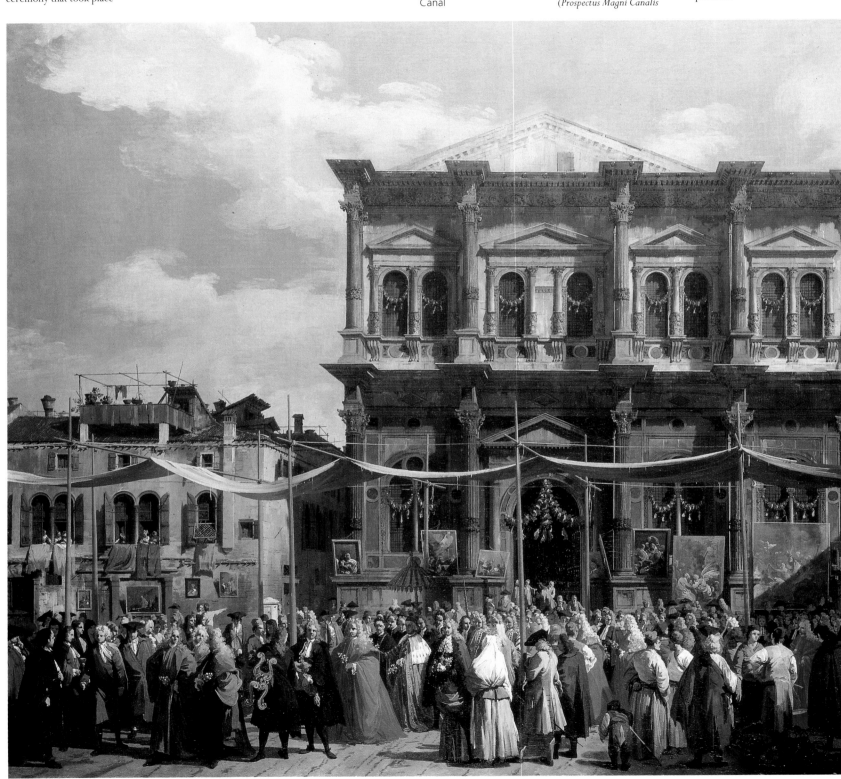

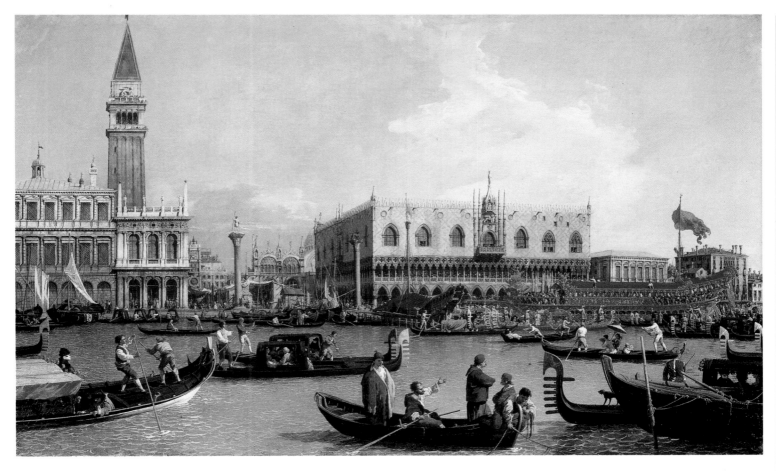

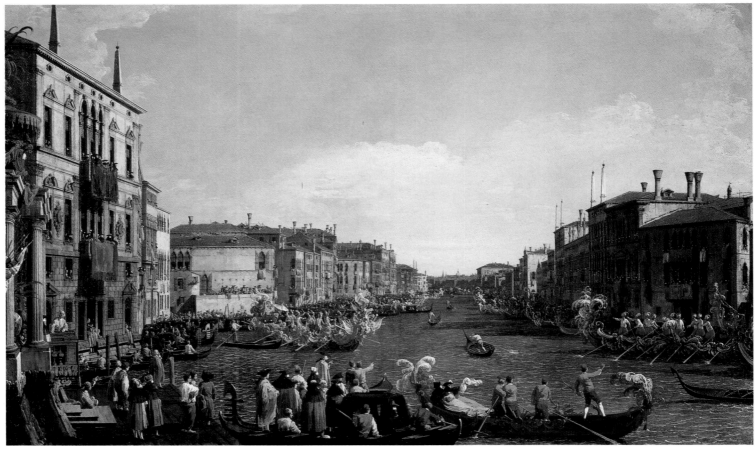

Canaletto
Il Tamigi verso la City/
The Thames and the City

*1746—47, canvas, Prague,
Národní Muzeum.*

Canaletto
Bacino di San Marco/
The Basin of St. Mark

*1738—40, canvas, Boston,
Museum of Fine Arts.*

This is one of Canaletto's most famous works and would be considered a masterpiece for its complexity and dimensions alone. Here Canaletto started to "dilate" space as if he were viewing it through a wide-angled lens. He obtained the panoramic effect by lowering the line of the horizon, something he was to repeat during his stay in England. Over half the canvas is taken up by the sky. This helps to increase the sense of solemn spectacle that the painting engenders.

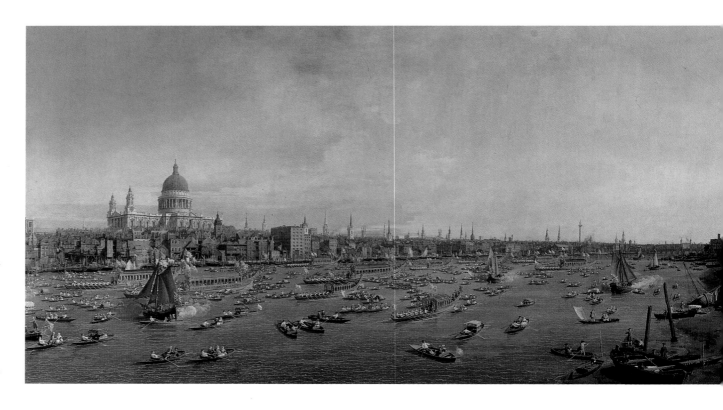

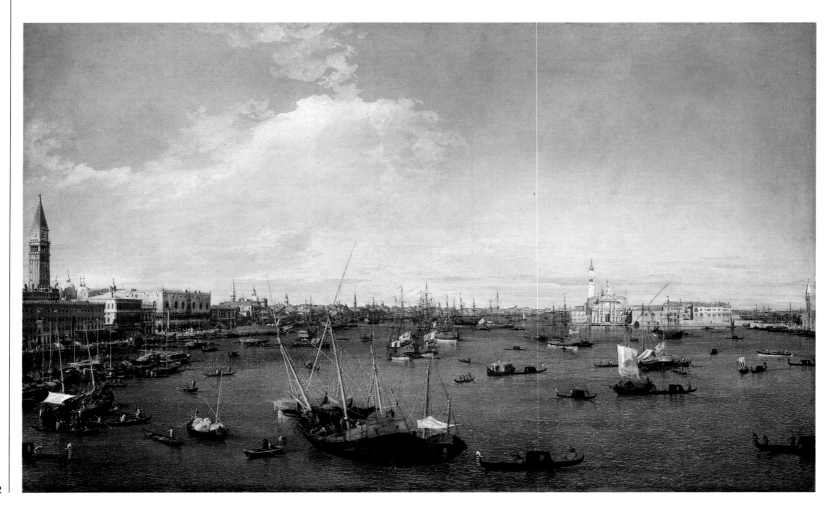

Canaletto
Le chiuse di Dolo, sul Brenta/The Lock at Dolo, on the Brenta

c. 1728–29, canvas, Oxford, Ashmolean Museum.

This is a very fine and atmospheric view of a lesser-known subject.

Canaletto
Veduta di un fiume, forse a Padova/View of a River, Perhaps in Padua

1745, canvas, United States, private collection.

343

Bernardo Bellotto

Venice, 1721–Warsaw, 1780

Bernardo Bellotto had a highly successful international career. He left Venice and Italy when he was just 26 and went on to make a brilliant career for himself in the courts of Central Europe in the age between the fading of Rococo and the triumph of Neo-Classicism. Canaletto (whose name he sometimes illicitly adopted, especially during his stay in Poland) was his uncle on his mother's side and trained the young artist, but Bellotto had a vividness and sensitivity to massed clouds and weather effects which recall Dutch art. By 1738 he was already a member of the Venetian Painters' Guild. Still under Canaletto's guidance, the young Bellotto traveled extensively in Italy. He first toured the Veneto region and then went to Rome, Florence, Turin, Milan, and Verona. In each city he left memorable images, giving a precocious demonstration of his ability to capture not only the architectural or natural features, but also the specific quality of the light in each place he visited. After returning briefly to Venice, in the summer of 1747 he accepted an invitation from Augustus III, the Elector of Saxony, and moved to Dresden. The ten years he spent in "the Florence of the Elbe" produced a noteworthy series of wonderful vistas of the city and its surrounds. He repeated these paintings for the Prime Minister, Count Brühl. He had enormous success and his reputation spread throughout the whole of Central Europe. In 1758 the Empress Maria-Theresa summoned him to Vienna where he painted clear pictures of the capital's Gothic and Baroque monuments. His next stop was Munich where, from 1761, he worked for the Elector of Bavaria. After five years there, Bellotto returned to Dresden and then went on to Warsaw where he spent the closing years of his life working for the King of Poland, Stanislav Poniatowski. His views of Warsaw are nearly all collected in the city's Royal Castle. Because their poetic quality was combined with faultless accuracy, they were used as a blueprint for rebuilding Warsaw after its near-total destruction in the Second World War.

Bernardo Bellotto
Rovine della Kreuzkirche a Dresda/The Ruins of the Old Kreuzkirche in Dresden

1765, canvas, Dresden, Gemäldegalerie.

This is one of Bellotto's later works, painted during his second stay in Saxony. It demonstrates his quite extraordinary, perhaps unique, capacity to capture the spirit of an event. In this case it was the demolition of the Gothic church of the Holy Cross in Dresden's New Market Square. The church had been damaged during a war and was rebuilt in Rococo style a few years later. This image of ruin, bordering on an anatomical dissection of the mortally wounded church, was to reappear two centuries after Bellotto's day with the devastating bombing of Dresden during the Second World War.

Bernardo Bellotto
Veduta con la villa Melzi d'Eril/View with the Villa Melzi d'Eril

1744, canvas, Milan, Brera.

In the background we can see the waters of Lake Maggiore and the massif of Monte Rosa.

Bernardo Bellotto
Veduta della Gazzada/ View of the Gazzada

1744, canvas, Milan, Brera.

The two views on this page have recently been restored and we can once again see the crystal transparency of the light. The splendid early masterpieces were painted while the young artist was traveling in Lombardy. They manage to combine poetry with faithful realism in the way they capture the feel of the climate and season. He succeeded in catching the movement of the early fall wind which was pushing the clouds along and drying the washing on the line. He painstakingly and lovingly portrayed the simple colors of the stones, the roof tiles, the clothes people wore, and the way the leaves are just beginning to turn color. All this makes these paintings perhaps the most heartfelt portraits ever painted of the region.

Bernardo Bellotto
Capriccio con il Colosseo/
Capriccio with the
Colosseum;

Capriccio con il
Campidoglio/
Capriccio of the Capitol

*1743—44, canvases, Parma,
Galleria Nazionale.*

These are part of a cycle of
four canvases which are
similar in shape and subject
matter. The young Bellotto
painted them during a
seminal visit to Rome.
Gradually, he was to move
away from the faithful view
of glimpses of Roman
monuments. Instead he
favored the freer *capriccio* or
imaginary view. This still
included real buildings
(which were truthfully
reproduced) but they were
set in an eclectic
combination of invented
architecture which in turn
was given an evocative
setting. Such *capricci* were
very popular at the time.

At the bottom of the opposite page

Bernardo Bellotto
Veduta di Verona col fiume Adige dal ponte Nuovo/View of Verona and the River Adige from the Ponte Nuovo

1747–48, canvas, Dresden, Gemäldegalerie.

The campanile of S. Anastasia and the ancient Scaliger castle seem to protect the quiet flow of the river. For once, Bellotto opted to capture the ordinary life of the people and the everyday look of the city. He included the small houses built along the shores of the river which were to be demolished at the end of the nineteenth century to make way for flood protection embankments.

Bernardo Bellotto
Piazza del Mercato Nuovo a Dresda/New Market Square in Dresden;
Il fossato dello Zwinger/ Zwinger Waterway

1750, canvases, Dresden, Gemäldegalerie.

The two canvases are part of an exceptional series of views of Dresden commissioned by the Elector of Saxony. A number of things are of interest: the large size of the paintings; the unfailingly splendid light; the clarity of the views; and finally the variety of different angles from which Bellotto framed the city. They supply fascinating views of a great Baroque city in its prime.

Francesco Guardi

Venice, 1712–93

Francesco Guardi came from a long line of painters, and he worked for years with his older brother Giannantonio, whose style deeply influenced his early work. After his brother's death, Francesco's art changed and he became the most mysterious and moving of all the artists at work during Venice's last decline. Unlike other view-painters, Guardi never left his native city, but his work too was aimed at international travelers. Guardi's views are often of plain, dirty, and poor quarters, which may explain his comparative lack of success. He did not set up his own studio until he was over 40 and he died in poverty. His pictures offer an image of the city – insubstantial, melancholic, decaying – which is quite the opposite to Canaletto's luminously solid and splendid views, but their vividness shows a poetic feeling which many now prefer. It is difficult to date Guardi's work, although we know that most of the views were painted in his middle or even old age.

Francesco Guardi
Gondola sulla laguna (La laguna grigia)/
Gondola on the Lagoon (The Gray Lagoon)

c. 1760–70, canvas, Milan, Museo Poldi Pezzoli.

Francesco Guardi
Il ponte dei tre archi a Cannaregio/ The Three-arched Bridge at Cannaregio

1765–70, canvas, Washington, National Gallery.

Guardi did not always choose the most famous spots or buildings in Venice. Indeed, he often opted for less fashionable views depicting the houses that ordinary people lived in. This canvas has made an otherwise anonymous bridge famous. There is not a single important public building in sight in this impoverished quarter.

Francesco Guardi
La festa della Sensa/The
Feast of the Ascension

*c. 1775, Lisbon, Fundação
Gulbenkian.*

Guardi's art displays
moments of genius in the
way he was able to capture
specific moments in
Venetian life. This odd view
shows the pavilions that
were erected for the
famous Feast of the
Ascension (known simply
as the Sensa in Venetian
dialect). It was always one
of the most popular
highlights in the calendar.
Guardi uses a wonderful
range of color, mainly of
light tones.

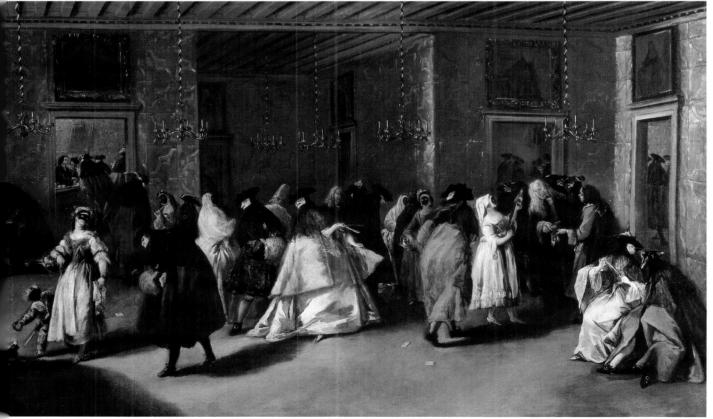

Francesco Guardi
Il ridotto/The Foyer

*1755, canvas, Venice,
Ca' Rezzonico, Museo del
Settecento Veneziano.*

Guardi shows us the foyer
of one of the many theaters
in Venice, which were great
social centers. People came
here to meet and to enjoy
themselves pretty much
regardless of what was
being performed on stage.

Francesco Guardi
La chiesa e il campo dei Santi Giovanni e Paolo/ The Campo and Church of SS. John and Paul

1760–65, canvas, Paris, Louvre.

The great Gothic church almost overpowers the scene and seems to be trying to fill the surrounding quarter. Guardi depicted famous monuments without resorting to Canaletto's insistent clarity. On the contrary, a continuous vibration seems to run through the air, blurring the outlines.

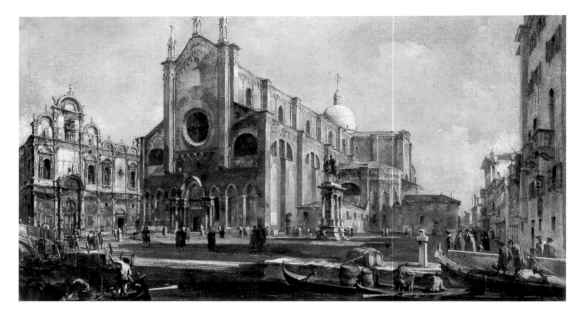

Francesco Guardi
Concerto di dame al casino dei Filarmonici/ Ladies' Concert at the Philharmonic Hall

1782, canvas, Munich, Alte Pinakothek.

This is one of Guardi's masterpieces. Because it depicts an event that actually took place we can date it with accuracy. It therefore also provides an essential reference point for the whole of Guardi's œuvre. The scene was, in fact, one of a number from a cycle that has since been scattered. It shows the celebrations organized in honor of the Russian "Counts of the North" who visited Venice in 1782. This canvas shows the famous chorus of orphan girls assembled from the Conservatorio della Pietà, one of the most famous vocal and instrumental ensembles in the whole of Europe. During the first half of the century the Pietà's all-female orchestra had been conducted by Antonio Vivaldi and had reached a pinnacle of excellence in its performances, impressing the philosopher Jean-Jacques Rousseau among other foreign visitors.

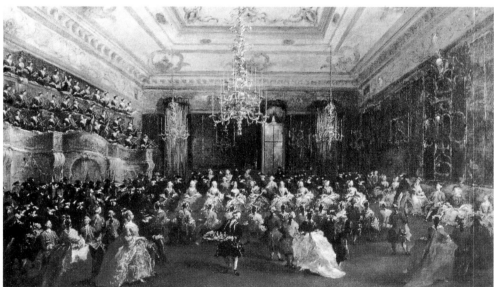

Francesco Guardi
Incendio del deposito degli oli a San Marcuola/ Fire in the San Marcuola Oil Depot

1789, canvas, Venice, Gallerie dell'Accademia.

This is one of Guardi's last masterpieces, based on a real event which occurred during the evening of December 28, 1789. The glow of the fire has inspired an extraordinary, almost spectral night scene with the orange flames forming a barrier between the people and the houses, all painted with vivid, light brush strokes.

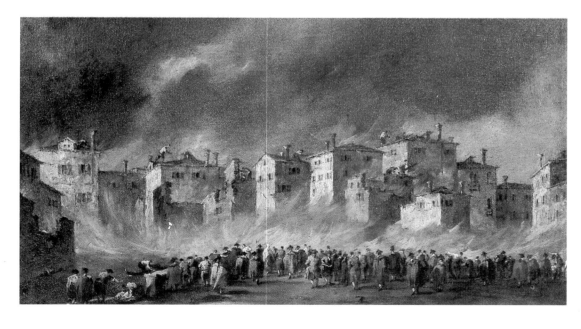

Giannantonio Guardi

Vienna, 1699–Venice, 1761

Giannantonio Guardi was the more famous Francesco's older brother and teacher but was, in his own right, one of the most interesting painters in eighteenth-century Venice. For almost a century and a half, however, his name was practically forgotten, being rediscovered by art historians only in our own century. He may have trained in Vienna (the Guardi family was originally from the Trentino and had many links to artistic circles in Austria), but began his own career in Venice copying famous Renaissance paintings. His copies were in great demand and most went to foreign collectors, including Marshal Schulemburg. It was by mastering such a specific job that Giannantonio learned how the great masters painted. He was then able to translate this into his own, highly personal style. Guardi's studio turned out many mythological and literary works, floral compositions and odd little Turkish scenes. In 1738, Giannantonio sent some paintings to the church of Vigo d'Anaunia in the Trentino. They provide interesting samples of his bravura style of painting, rapid and flowing brushstrokes. Francesco gradually emerged through the ranks in Giannantonio's studio but it is not always easy to tell the work of the two brothers apart. Even today this still causes many problems for the critics. The most typical work that the two brothers produced together dates from around 1750. This was *The Story of Tobit* in the organ loft of the Venetian church of S. Raffaele. Giambattista Tiepolo married the sister of the Guardi brothers.

Giannantonio Guardi
Madonna e santi/
Madonna and Saints

1746–48, canvas, Belvedere di Aquileia (Udine), parish church (stored in the Patriarch's Palace in Gorizia).

Giannantonio Guardi's most important religious painting was also a work of astounding novelty. The scene seems to be accelerating at a vertiginous pace. The speed is conveyed above all through the nervous brushstrokes which get continually shorter or are interrupted. The effect is brilliantly successful.

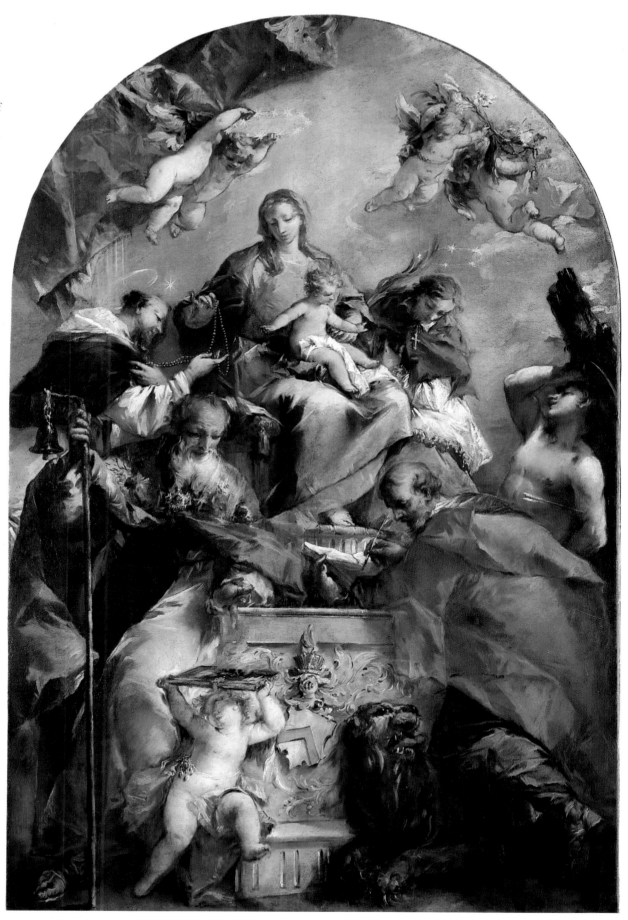

The 19th Century

Telemaco Signorini
Ponte Vecchio a Firenze/
The Ponte Vecchio in Florence

Detail, 1879, Milan, private collection.

The process of change set in motion by the French Revolution continued to dominate Europe in the early years of the nineteenth century. Italy was almost a passive spectator of Napoleon's tremendous rise and dramatic fall. This was so much the case that during the Congress of Vienna, assembled in 1815 to establish a new balance of power in Europe after Napoleon's defeat at Waterloo, the Austrian ambassador Metternich uttered the famous phrase: "Italy is only a geographical expression." Italy was again carved up into many petty states, with Austria ruling much of the north directly and the rest of Italy indirectly, through little Duchies and the Kingdom of the two Sicilies.

Despite this gloomy situation, Italy still managed to produce figures of great nobility, such as the poets Giacomo Leopardi and Ugo Foscolo and the sculptor Antonio Canova, as well as brilliant opera composers from Rossini to Verdi. But, apart from in opera, they were isolated personalities who did not leave schools or movements behind them. Neo-Classicism and the Empire style dominated the opening decades of the century. Italian artists were well placed in this respect because they lived in the midst of wonderful examples of work of the past, from archeological remains to the masters of the Quattrocento and Cinquecento. Perhaps the most interesting element in Italian art at the start of the nineteenth century was in fact a dawning awareness of its huge cultural heritage. This heritage had been threatened and to some extent broken up during the Napoleonic campaigns. In 1795 Luigi Lanzi published his *Storia pittorica dell'Italia* (*History of*

Italian Painting). This was the first systematic attempt to classify Italian painting, dividing it up into regional schools. Lanzi's study made a fundamental contribution to the creation of some of the great national museums around the country. It was also the impetus needed to reorganize some of the major princely collections. Laws were then passed protecting the national artistic heritage. Canova also did a lot of work aimed at bringing back works that had been taken to France.

Francesco Hayez is the most representative and was the longest lived of the first wave of Romantic artists. The starting point of his style was in fact the rediscovery and study of art from previous centuries. While there was a dramatic reduction in demand for paintings on religious subjects, there was an equally rapid growth in the number of canvases showing scenes or people from the Middle Ages or the Renaissance. This Romantic desire to reclaim history was not limited to the figurative arts. Plays, novels, and operas (such as the most famous works by Manzoni or Verdi) were inspired by people, places, and episodes from the past. To some extent it was a means of bypassing the rigors of censorship which were extremely harsh, especially in regions such as Milan or Venice under Austrian occupation. At the same time it pointed to a need to rediscover themes and stimuli that everyone could identify with and which generated a sense of national pride. For this reason, paintings on historical subjects played a role in the long run-up to the Risorgimento. The political success of the Risorgimento enabled Italy to reclaim its independence from foreign powers and to be united as a nation under the Piedmontese Kings of Savoy.

It was not until the middle of the century, however, that current affairs were reflected in painting. A handful of artists, nearly all from Lombardy or Tuscany, actually took part in the wars or joined Garibaldi's band of volunteers (known as the Mille, or Thousand). The illustrations they produced about events in contemporary life from 1855 replaced attempts to resurrect episodes from long ago. It was this attempt to "reclaim reality" that led to the birth and growth of the Macchiaioli, by far the most important group of Italian painters to emerge in the nineteenth century. Based around Florence, they revolted against academic conventions, stressing freshness and spontaneity by the use of patches ("macchie") of color to paint scenes from real life. They included painters such as Boldini, Lega, Fattori, and Signorini.

Different members of the group had very individual temperaments and different sources of inspiration, producing very diverse results. Lega tried to capture the poetry of private or intimate moments. Signorini (who very early on took an interest in

Giovanni Segantini
Pascoli di primavera/
Grazing in Springtime
1896, canvas, Milan, Brera.

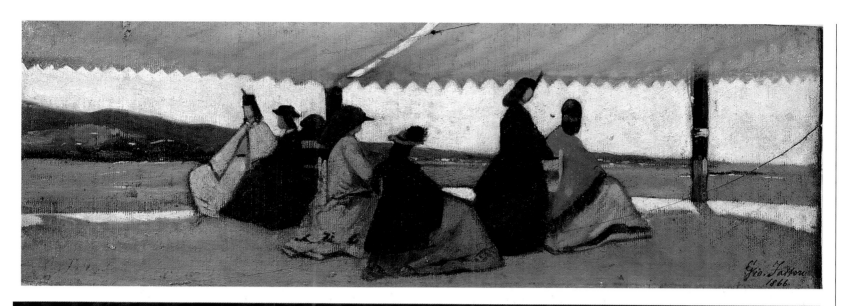

photography as well) managed to fix fleeting movements in a crowd or city scene. Fattori turned his attention to solitude, or to the weariness of soldiers on guard duty in the sun-drenched countryside, or peasants fatigued by heavy labor. Such an interest in social themes was the chief subject matter for the closing years of the century. After the final unification of Italy (1870) the ardor of the Risorgimento died out. People began to realize just how behind the times much of the country was. The privations of the poor, the need to develop an industrial economy, the emergence of a new working class all gave artists both opportunities and the need to develop a new style of painting. This often produced a

sense of social outrage as can best be seen from *Quarto Stato* (the Fourth Estate or Proletariat), a movement started by Pellizza da Volpedo. From the point of view of style, at the end of the century the anti-academic technique of "Divisionism" spread. This meant that tiny dots of individual color were separately applied directly onto the canvas. Although it can be linked to French "Pointillism," Divisionism was a movement in Italian painting that was used across a range of subject matters, from landscapes to the fantasies produced by Symbolism which echoed Gabriele d'Annunzio's dreamy verse.

Giovanni Fattori
*La rotonda dei Bagni Palmieri/
The Rotonda di Palmieri*
1866, wood panel, Florence, Pitti Palace, Galleria d'Arte Moderna.

Giuseppe Pellizza da Volpedo
Il Quarto Stato/The Fourth Estate or *Proletariat*
1898–1901, canvas, Milan, Villa Reale, Galleria d'Arte Moderna.

Felice Giani

San Sebastiano Curone (Alessandria), 1758–Rome, 1823

Felice Giani played an interesting role in the development of the Neo-Classical style and was in touch with many prominent people on the international cultural scene. He moved to Rome when he was 20 where he immediately found work in the last phase of decorating Palazzo Doria (1780). Although he was already interested in the classical ornamental repertory, the young Giani flirted with visionary Romanticism. In the work that he produced subsequently in Rome and Faenza (Palazzo Zarchia Laderchi and Palazzo Milzetti, his masterpiece), the dynamic flair that had characterized his style before 1800 did not disappear. It seemed rather to be redirected toward re-reading classical antiquity in an eclectic key. The combination of a stay in Paris and the Napoleonic years gave his style one final thrust. He made a second journey to Paris where he painted frescos in the villa of the Secretary of State of the Kingdom of Italy. This commission brought him international renown and put him in touch with the various currents in French painting at the start of the nineteenth century. Giani's work belongs to the historicist phase that straddled the end of the eighteenth and the start of the nineteenth centuries. His fantasy and ornamental taste took him beyond definitions of Neo-Classical or Romantic.

Felice Giani
Nozze di Poseidone e Anfitrite/The Marriage of Poseidon and Amphitrite

1802–05, tempera mural, Faenza (Ravenna), Palazzo Milzetti, ante-chamber to a bathroom "along the lines of the Baths of Titus."

Felice Giani had studied Raphael and Albani as well as the newly-discovered frescos at Pompeii. He represented the most fresh and attractive aspect of Neo-Classicism, a style often thought to be cold or monotonous. Despite being tucked away in a provincial town, the Palazzo Milzetti frescos are continually full of surprises. They make light-hearted use of refined and always well-chosen colors. At the same time, the themes from classical mythology are not treated with pedantic erudition but with imaginative narrative freedom. It is only recently that critics rescued Giani from years of neglect. Today he is considered one of the most interesting figures on the official art scene during the Napoleonic era. Thanks to his never-failing good taste, he managed to cope with even the most difficult subjects. Nor did he limit himself to imitating classical art. On the contrary, he came up with new solutions which were definitely daring.

Antonio Canova

Possagno (Treviso), 1757–Venice, 1822

Canova was an exceptionally gifted sculptor and an intellectual of the highest order. He had a decisive influence on European art in the decades around the late eighteenth and early nineteenth centuries, becoming the greatest of all Neo-Classical sculptors. He only painted occasionally and then almost as a pastime but the results are most interesting. He began his career in Venice in the great eighteenth-century tradition. In 1779 he moved to Rome where he immediately took on large-scale commissions (such as the tombs of the popes in SS. Apostoli and St. Peter's). These revealed him firmly as the heir to grand sculpture in the tradition of Michelangelo and Bernini. Canova was fired by a boundless love of classical art but brought its ideal concepts of beauty back to life without resorting to imitation or sinking into sterility. His supreme sensitivity seemed to make even cold marble malleable. The smooth surfaces of his sculptures, and in particular his female figures, have a remarkably delicate, sensual grace. Canova used drawings and, to some extent, paintings to test out and develop the compositions he would later sculpt. The paintings he did which were not connected to other works, *Hercules Killing his Children*, Bassano, Museo Civico and *Deposition*, Possagno, Tempio Canoviano, hint at an almost Romantic vision.

Antonio Canova
Le tre Grazie danzanti/
The Three Graces Dancing

c. 1799, detail from a frieze in tempera on paper, Possagno, Canova's house.

Canova mentioned "various ideas on dances, the play between nymphs and cupids, muses, philosophers, etc., sketched exclusively for the artist's own study and enjoyment." There is little doubt he was referring to the tempera cycle at Possagno and similar sketches now in Bassano. Picking up the themes and techniques discovered in Herculaneum, Canova created brightly colored mythological figures that stand out against the black background. These sketches are the forerunners of themes and figures he would later sculpt.

Francesco Hayez

Venice, 1791–Milan, 1882

Hayez trained in Venice at a time when eighteenth-century graciousness was still predominant. After some time in Rome as a young man, where he fell under Canova's and Ingres' classical influences, most of his long artistic career was spent in Milan. He first moved there in 1820 and later became director of the Brera Academy. By following phases in his painting over seven decades, we can trace the most important turning points in the development of Italian art in the nineteenth century. Hayez learnt a perfect drawing technique, as can clearly be seen from his penetrating portraits, which stand comparison to those painted by Ingres. He used his technique mainly to create huge historical canvases. His tone was unashamedly Romantic, something that particularly appealed to the Viennese court, although his style remained mainly classical. He painted the Emperor's portrait and frescoed the ceiling in the Caryatid Room of the Palazzo Reale in Milan (destroyed during bombing in 1943). Hayez became one of an intellectual set in Milan that included Rosmini, Manzoni, and Rossini. Through his work he at times conveyed moral and civil feelings that must be read in the light of the Risorgimento. His school influenced generations of Lombard painters from the Neo-Classical period right through to late nineteenth-century Verism.

Francesco Hayez
Il bacio/The Kiss

1859, canvas, Milan, Brera.

This canvas has quite rightly become one of the symbols of Italian Romanticism. It sprang from the sentimental and melodramatic strand of medieval costume drama that Verdi so beautifully captured in his operas.

On the opposite page
Francesco Hayez
Rinaldo and Armida

1812–13, canvas, Venice, Gallerie dell'Accademia.

This youthful work was to some extent still rooted in Venetian art of the late eighteenth century but also reveals Canova's influence. Hayez created a splendid effect in the way the light filters through the green of the garden of the seductive enchantress. He also showed virtuoso talent in the way the light reflects in the circular shield that glitters in the foreground.

Francesco Hayez
La sete dei crociati sotto Gerusalemme/Crusaders Thirsting near Jerusalem

1836–50, canvas, Turin, Palazzo Reale.

This is a fine example of the type of grandiose painting that Hayez produced on historical and literary subjects. He was often inspired by themes taken from the Middle Ages. Hidden under historical symbolism, they were really about the Italian Risorgimento. Similarly, classical subjects were chosen to evade censorship.

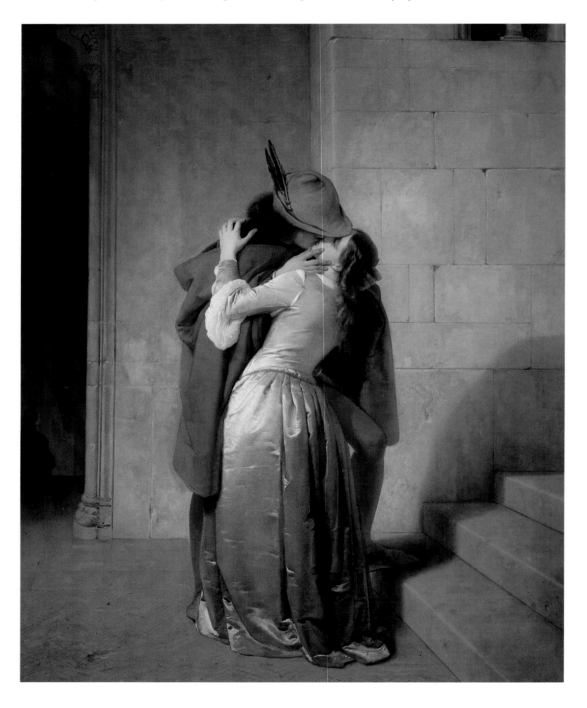

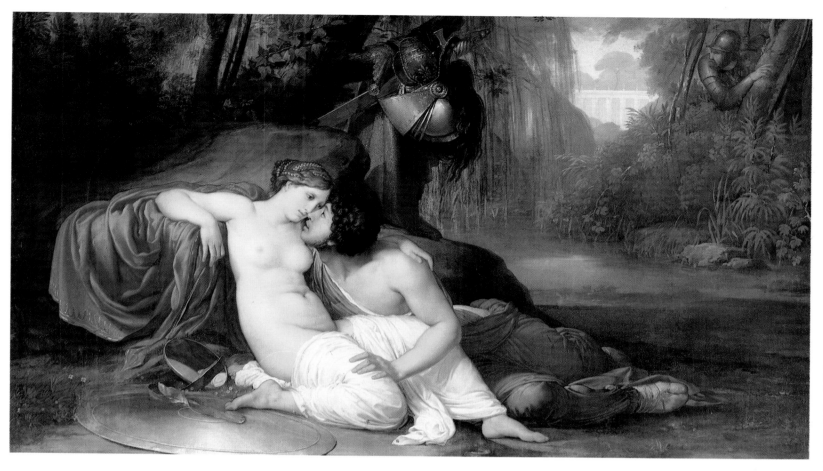

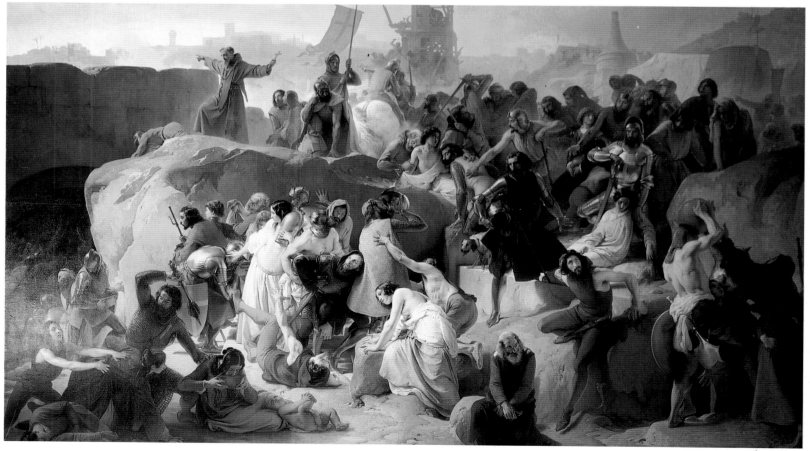

Silvestro Lega

Modigliana (Forlà), 1826–Florence, 1895

Lega was originally from Emilia but the fact that he spent his youth in Florence left an indelible mark on him. This was not merely from an artistic standpoint either. He was still studying at the Academy of Fine Arts, learning the rigorous formal rules of Romantic and purist art, when he became involved in republican political circles and the Risorgimento. He was just 22 in 1848 when he took part in the ill-fated conspiracy of the Tuscan students at Curatone. Upon his return to Florence, he used his training as a traditional painter to produce canvases about contemporary history. Although he was among those who met in the Caffè Michelangelo, the birthplace of the Macchiaioli movement, for a long time Lega remained committed to a Romantic style of painting. He did, however, change to new subjects, such as minor episodes from the wars of independence that were increasingly popular. In 1861 he set up his own studio in the hills at Pergentina on the outskirts of Florence. His studio became the laboratory of the central and most important phase in the development of the Macchiaioli movement, to which Lega by now was unreservedly committed. Landscapes painted *en plein air* (in the open) and a poetic interpretation of everyday scenes were Lega's preferred way of painting. His style always retained overtones of the tradition of classical painting. In particular the light colors of his palette, his clear draughtsmanship, monumental figures, and tranquil gestures all bring fifteenth-century painting to mind. In the 1860s Lega produced his freshest and most lovely works. They centered around his search to capture intimate feelings, country settings and interiors always with a simple and serene feel to them. Later on, perhaps also because the Macchiaioli group began to disintegrate, his color became much brighter and he seemed to be looking for stronger effects.

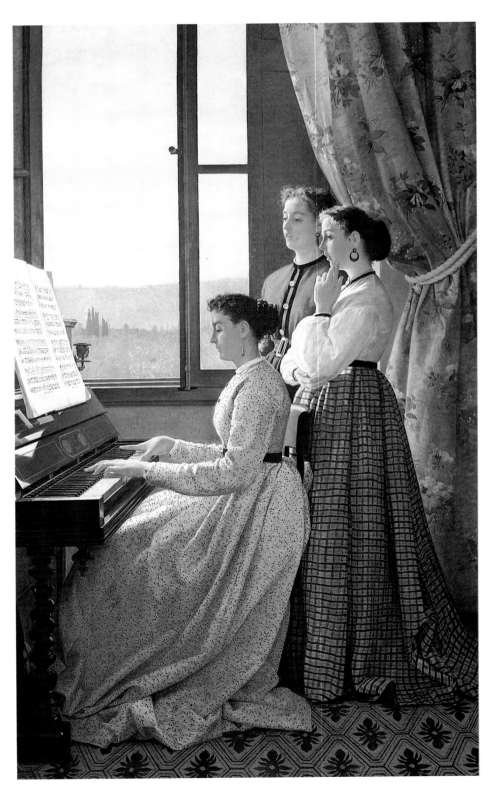

Silvestro Lega
Canto dello stornello/
The Folk Song

1867, canvas, Florence, Pitti Palace, Galleria d'Arte Moderna.

This is a good example of Silvestro Lega's lyrical and attractive intimate quality. As tranquil day-to-day life rolled by, he seemed on the look out for small moments whose emotion he could capture. The unaffected but charming manner in which he depicted the three young women was typical of his honesty as a painter.

Silvestro Lega
I promessi sposi/
The Betrothed

*1869, canvas, Milan, Museo
della Scienza e della Tecnica.*

The title of this painting is
quite deliberately, and with
a touch of light-hearted
punning, taken from that of
the most important Italian
novel written in the
nineteenth century, *I
Promessi*. Unlike Manzoni
(who set the tale of Renzo
and Lucia in the seventeenth
century), Lega depicts an
evening stroll taken by a
young engaged couple of
his own day.

Silvestro Lega
Il pergolato/The Pergola

1868, canvas, Milan, Brera.

The underlying concept of
Macchiaioli painting was
the application of "macchie"
or splodges of light and
color. This enchanting
canvas provides an
excellent demonstration of
how it worked. A thickly-
growing pergola protects a
group of women from the
slightly stifling heat of a
summer's afternoon. It is
masterly in the way it
blends the colors together,
even though it cannot stand
any comparison to what
was happening in Paris as
the same time.

Giovanni Fattori
In vedetta/The Patrol

1872, wood panel, Rome, private collection.

Fattori was extremely good at depicting battle-scenes and soldiers. But over and above the stirring moments of the struggle of the Risorgimento, he liked to capture soldiers on patrol or on watch in the scorching loneliness of the summer fields. The light cavalrymen seem to have been scattered and left to fend for themselves or are engaged on duties that seem pointless.

Giovanni Fattori

Leghorn, 1825–Florence, 1908

Fattori painted with enormous energy and feeling. He was also an excellent graphic artist and engraver. He was, in short, one of the best Italian artists of the nineteenth century. Although he scarcely ever left Tuscany, thanks to Diego Martelli he kept abreast of what was going on internationally. Indeed, he consciously drew parallels between the research of the Macchiaioli (and he was the most enthusiastic and long-lived member of the group) and the work being done by the Impressionists – a comparison seldom accepted by outsiders, however. After early training in Leghorn, in 1848 he started his studies at the Florence Academy where he acquired the style of monumental painting applied to historical subjects. His youthful works include a number of huge canvases on medieval subjects as well as his first attempts at portraiture, a genre that he would develop throughout his life to consistently good effect. In the course of the meetings at the Caffè Michelangelo with Signorini, Lega, and many other artists, he was persuaded to abandon his Romantic chiaroscuro painting in favor of a more immediate style based on a new relationship between light and color taken directly from reality. In other words, he started painting in "macchie," blotches or spots. In about 1860 Fattori started to apply the new technique to paintings of contemporary battles. This gave the scenes a moving, but anti-rhetorical, sense of involvement. Fattori followed these canvases with countless scenes about work in the fields. In them, his love of nature in the Maremma (and the coast near Leghorn) combined with his human and social interest in the toil of peasants. Fattori's realism was also expressed through his choice of colors bursting with light and his drawing technique which never forgot the historical lesson of Tuscan art. If his technique of painting *en plein air* and the wonderful luminosity of his canvases to some extent recall the results the Paris Impressionists were achieving in the same period, his robust brushwork with its use of concise "macchie" of color was quite original. From the 1870s the Macchiaioli group began to break up and Fattori spent more and more time on portraits and engravings.

Giovanni Fattori
Le macchiaole/
The Gleaners

1865, canvas, Milan, private collection.

Throughout his career Fattori was often inspired by work in the fields. He seemed to harbor feelings that brought him close to the work and toil of peasants in the Maremma, a not very prosperous agricultural area along the Tuscan coast. This is typical of the work that he produced in early adulthood. This may have some connection to his early photographic experiments. Later on, Fattori's work was more concise and evocative even though it often dealt with the same kind of socially committed subjects here, of course, making a pun on his own artistic group.

Giovanni Fattori
Carro rosso (Il riposo)/
The Red Cart at Rest

1887, canvas, Milan, Brera.

This painting represents a very important stage in Fattori's later career. It describes a moment of rest from the toil of labor. The monumental profiles of the oxen and the heavy frame of the peasant stand out clearly against the background of a shoreline scorched by sunlight and bordered by a calm sea.

Telemaco Signorini

Florence, 1835–1901

One of the outstanding artists in the Macchiaioli movement, Signorini was definitely the one painter in the Tuscan group who had a real interest in getting his work known internationally. He studied at the Florence Academy and from 1855 was one of the main movers behind the meetings at the Caffè Michelangelo where he promoted the idea of a thorough reform of painting. He had a lively personality and took part in the Risorgimento in 1859 which in turn inspired him to paint realistic images of battle fields. In about 1860 he spent a lot of time on the Riviera around La Spezia and in the Cinque Terre district. It was then that he converted to the "macchia," using strong contrasts of light and shade. In 1861 he went to Paris for the first time where he had a seminal meeting with Gustave Courbet. On his return to Italy he settled at Lega's house at Pergentina and was in the vanguard of the Macchiaioli movement. Apart from landscapes and scenes from everyday life, Signorini also tackled themes with a strong social commitment. He traveled quite a lot to London and Paris which meant that he had constantly to compare the splendid colors in his palette with the more muted light of elsewhere.

Giuseppe De Nittis

Barletta (Bari), 1846–Saint Germain-en-Laye (Paris), 1884

After studying at the Naples Academy, in the 1860s De Nittis moved to Florence where he became an enthusiastic member of the Macchiaioli group. His picturesque rural scenes became lively landscapes which rapidly made him famous. When he was still very young, Apulia-born De Nittis proved that his

graphic talent had an exceptionally swift evocative power. In 1867 he visited Paris for the first time and was thunderstruck. It was only then that his real career began. His Mediterranean light and the verve of his ever-fluid brushwork were tempered with subjects, light, and influences from Impressionism. Paris became his main home although he did visit London on several occasions and also returned to Italy for stays of varying length. De Nittis' French œuvre can be divided into two main strands. On the

one hand, he produced extremely successful commercial works featuring melodramatic costume scenes. These were sold by the prominent gallery owner Goupil. On the other hand he came up with a series of Parisian landscapes and bourgeois scenes that he painted with photographic lifelikeness. The fact that De Nittis adhered to the ideals of Impressionism was confirmed when his works were exhibited at the various Impressionist Salons, and in particular at the historic 1874

exhibition held in the photographer Nadar's studio. For many decades the painter's career was split along two parallel paths. Successful *feuilleton* paintings in the late nineteenth-century style were on one side. On the other he freely interpreted the most avant-garde ideas of painting *en plein air*. The second category included a number of portraits.

On the opposite page
Telemaco Signorini
Sala delle agitate al manicomio/A Ward of Disturbed Women in a Mental Hospital

1865, canvas, Venice, Ca' Pesaro, Galleria d'Arte Moderna.

The powerful graphic content of this almost monochrome painting brings to mind paintings by Daumier.

Giuseppe De Nittis
Alle corse al Bois de Boulogne/Horse Races in the Bois de Boulogne

1881, pastel, Rome, Galleria Nazionale d'Arte Moderna.

This excellent picture was painted during his French period and both for technique and subject matter it stands comparison with the Impressionists. It is also an excellent example of how up to date De Nittis was, indeed playing a leading role among the avant-garde. The relationship with photography, which is confirmed by comparing the painting to a photograph that De Nittis owned, gives the painting a sense of trembling reality. His verve for portraiture was another pleasing note found throughout his work.

Angelo Morbelli
Alessandria, 1853–Milan, 1919

Recent critical and commercial reassessments have finally done justice to one of the most important and powerful Italian artists at work at the end of the nineteenth and the start of the twentieth centuries. Without ever having recourse to Symbolism or sentimentality, Morbelli managed to catch the growing awareness of social and human matters in Italy in the years after unification. He trained in the late-Romantic realist school at the Brera Academy (where he produced paintings on topical subjects, such as the *Milan Station* now in the Milan Galleria d'Arte Moderna). In about 1890, however, Morbelli joined up with the Divisionists, adapting their technique to subjects where social action was called for, in particular work in the fields and the dire conditions in which old people lived. His paintings showing loneliness and squalor in a Milanese old people's home, the Pio Albergo (commonly called the Baggina), were particularly powerful. Morbelli mainly stuck to landscape painting in his later years.

Angelo Morbelli
Per 80 centesimi?/
For 80 cents?

1893–95, canvas, Vercelli, Borgogna Civico.

The title underlines, with a deliberate note of accusation, the pitifully low daily wage paid to the women who weeded the rice paddies. They worked for hours on end with their feet in the soggy Piedmontese and Lombard soil. Morbelli was one of the first painters to use Divisionism in depictions of socially committed subjects.

Angelo Morbelli
Alba domenicale/
Sunday Dawn

1890, canvas, private collection.

Morbelli's social realism was at its most forthright in scenes dealing with the themes of labor and exploitation. But it can also be seen in paintings portraying old people. Here we see a group of elderly country folk trying to hurry to Mass. At the same time the morning light is beginning to unfold its brightness.

Giovanni Segantini

Arco (Trento), 1858–Sankt Moritz (Switzerland), 1899

The human and artistic parable of Segantini was one of the most intense in the history of nineteenth-century Italy. The artist's troubled character (he was sent to reform school when he was

young) first emerged during the years he studied at the Brera Academy where he learned the style of Naturalism that was current in Lombardy during the second half of the century. Unable to put up with city life, thanks to the patronage of Vittore Grubicy in 1881 he was able to go and live in Brianza where he painted scenes of life in the fields and landscapes. His first excursions

to the Swiss mountains in Graubunden encouraged him to adopt the technique of Divisionism which gave his paintings their unusual luminosity. In about 1890 views of the Alps or peasant scenes became the pretext for allegories with moral or symbolic meanings and were increasingly full of religious mysticism. While Segantini's style, with its fluid figures and elegance of line, was a

forerunner of Art Nouveau, he himself tended increasingly to withdraw into meditations of a mystic nature. These led him to seek out the purity and limpid horizons of the mountain summits. His quest culminated in the unfinished *Triptych of the Alps: Life, Nature, and Death* that Segantini was working on in the year he died in Sankt Moritz.

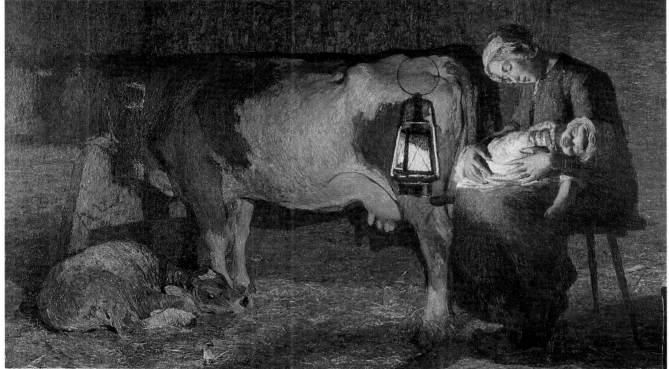

Giovanni Segantini
L'ora mesta/
The Sad Hour

1892, canvas, private collection.

Evening is falling over the fields. Segantini's brush managed to capture almost the very last flicker of the light which he painted with an unmistakable, vibrant intensity.

Giovanni Segantini
Le due madri/
The Two Mothers

1889, canvas, Milan, Civica Galleria d'Arte Moderna.

Segantini's affectionate and direct involvement in rural life allowed him to see the common maternal bond between the young peasant breast-feeding her baby and the cow with its calf.

Giuseppe Pellizza da Volpedo

Volpedo (Alessandria), 1868–1907

After long travels round the various academies of Italy (Milan, Florence, Rome, Bergamo) and a trip to Paris in 1889, the Piedmontese painter settled in Milan where he joined the Divisionist group of which Segantini, Morbelli, and Previati were also members. Pellizza's technique was excellent in the way he could capture vibrations in the light. He tackled a diverse range of themes and genres (including still life and portraits) and was sometimes seduced into an evocative Symbolist use of atmosphere. However, he seemed to find his fullest and most personal creative vein in Social Realism. Inspired by reading Marx and Engels, Pellizza spent many years studying and making progressively more evolved versions of his masterpiece *The Fourth Estate or Proletariat* which he finished in 1901. The painting was badly received at the Venice Biennale which embittered Pellizza's last years. He moved to Rome where, in the opening decade of the twentieth century, he proved an important influence on Giacomo Balla and younger painters in general. It was they who would absorb the techniques of Divisionism and move on to Futurism.

Giuseppe Pellizza da Volpedo
Statua a villa Borghese/
Statue at the Villa Borghese

1906, canvas, Venice, Ca' Pesaro, Galleria d'Arte Moderna.

This was one of Pellizza's last works. It marks the furthest development reached by Divisionism, a technique that was being acquired by young painters who, within a few years, would give birth to Futurism.

Giu...
Vol...
Idilli...
Spri...

189...
colle...

The...
mov...
play...
tree...
degr...
with...
Pell...
effec...
play...

Any discussion of art, and more specifically of painting, in our century means that at least in part we must set aside the rigid distinctions between national schools that were previously applicable. The presence of "world art capitals" such as Paris and, more recently, New York obliges us to look at all cultural expression in a far broader context. Since the Second World War, national cultural frontiers have tended to collapse, a process speeded up by the appearance of transnational groups of artists. But even in the first half of the twentieth century such internationalism was not uncommon. For instance, we should not forget that Picasso was Spanish in origin, Chagall Russian and Modigliani Italian. But all three were working and living in Paris at the same time, during the heroic age of Modernism just before the First World War.

Despite this, however, we can still distinguish a very specific character to Italian art. The century started mostly as a continuation of late nineteenth-century styles, with Italian painters using Divisionist techniques and Symbolist themes often derived from foreign influences. They were also open to influences from Art Nouveau, colored by a general late-Romantic esthetic, often highly emotional in tone. We need only think of the passionate grief that surfaced at the death of Giuseppe Verdi, who had remained the musician adored by everyone in Italy. By the end of the first decade of the century, however, such close links to the past were being broken. The radicalism of the writer and poet Filippo Tommaso Marinetti paved the way for Futurism, a truly revolutionary movement. Bored by traditional art and fascinated by technological progress and the emerging industrial cities, Marinetti brought about an extraordinary vital period in Italian culture that attracted people in all of the creative arts. Thanks to the brilliance of Umberto Boccioni, painting was also able to discover in Futurism new, perhaps disturbing, but always exciting images.

Futurist painting was based on a number of fundamental concepts. First, it wanted to get away from static pictures to capture the essence of speed while simultaneously using a number of different perspectives. It celebrated the "rise of the city," unreservedly making use of unexpected materials and juxtaposing different moods, objects, and figures. Although its exponents were conscious of being engaged in a long-distance dialogue with the Cubists in Paris and with some currents of Abstract Art, Futurism remained a specifically Italian and figurative movement. At various times, some of the major painters of the century became part of the movement. Among them were Carlo Carrà, Mario Sironi, and Giorgio Morandi. The outbreak of the First World War, a

catastrophe for the whole of Europe, also marked the end of Futurism, and not only because of what happened to some of its leading figures (Boccioni volunteered and was killed in 1916; the architect Sant'Elia died in the trenches). By 1917 a new movement in art was beginning to take shape – Metaphysical painting. Its birth can be pinpointed to the time that Giorgio de Chirico and his brother Savinio spent in a hospital in Ferrara where they met Carlo Carrà and Filippo de Pisis.

In contrast to the generous but often disorganized verve of Futurism, Metaphysical painting used solid, silent images that were frequently disturbing and full of references to dreams, the imagination, and visions, all generally painted in a Neo-Classical style. The archetypal character used in Metaphysical painting was the tailor's dummy, a human shape without a face, frozen into immobility on the edge of deserted squares or in rooms with

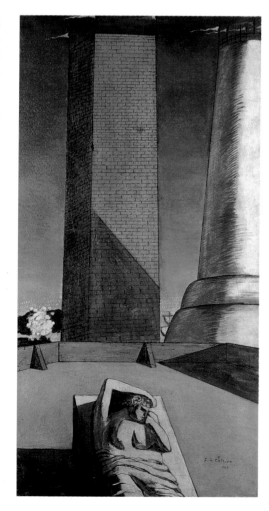

Giorgio de Chirico
*Ilrisreglio di Arianna/
The Awakening of
Ariadne*, 1913, canvas,
private collection.

unreal perspectives. Because he had been born in Greece, de Chirico frequently used evocative ancient myths which he recreated with enormous passion and feeling. Like Futurism, Metaphysical painting was an immediate artistic success, molding public taste and converting intellectuals and painters alike. In just a decade, Italian art had produced two movements whose international importance is undeniable. After almost 150 years of provincialism, both succeeded in focusing world attention on what was happening in modern Italian art. But Amedeo Modigliani and Giorgio Morandi, two of Italy's greatest painters who, for different reasons were both isolated in some ways from their international contemporaries.

Although Italy was among the victors, the end of the First World War left the country with serious social, economic, and political problems. Sironi's somber *Urban Landscapes* conveyed a bitter and almost inhuman image of the industrial suburbs. For the umpteenth time, Italian art discovered that the imaginative energy and stimulus it needed to create new work lay in its own past. Carlo Carrà rediscovered *valori plastici* (plastic values) in the painting of Giotto, Masaccio, and Piero della Francesca. He proposed that painters revert to unambiguously figurative and naturalistic painting where figures and objects were defined by volume, the use of shading, and perspective.

During the 1920s Carrà started an artistic movement known as the *Novecento Italiano* (Italian 20th century), which became the official school of Italian art. It tried to reintroduce genres from the classical Italian tradition of painting, such as still lifes, domestic scenes, and landscapes. Among those in the group (which was united by exhibiting collectively), Sironi stood out. He tried to give concrete life to the concept of "Constructivism" in art by getting involved in the design and decoration of large-scale building projects.

The painting produced by the *Novecento* effectively suited the esthetics of the Fascist regime which in turn supported it through commissions for its major public works. But Italian painting was hampered in its development by the deliberate cultural and social autarchy of the Fascist state, which led to widespread indifference to what was happening on the international scene. De Chirico moved to Paris partly so as not to lose touch with the international avant-garde. Morandi shut himself up in his Bologna studio and got on with his patient research. The rest of Italian art, meanwhile, was soon at risk of becoming completely introspective and provincial.

At the end of the 1930s anti-Fascist sentiment led to the formation of the *Corrente* group. The movement had links with inter-

Mario Sironi
Il camion/The Truck
1920, canvas, Milan, Brera.

national Expressionism and its common denominator was the liberal and strong use of color. The Sicilian-born painter Renato Guttuso stood out among the other young anti-Fascist artists. His art reveals huge and varied historical and artistic debts but he chose Picasso and Cubism as his main points of reference. All his works are strongly committed socially. At the end of the Second World War, Italy was in physical and moral ruins, torn apart by defeat and bombing. It was then that Guttuso founded the *Fronte Nuovo delle Arti* (New Art Front). Thanks to the enormous creative energy he poured into his graphic work and canvases, Guttuso managed to free himself from a form of art that at times tended to be too declamatory in style. He also pushed very hard for what he considered to be a necessary international dialogue with other art movements.

Guttuso brings us almost up to our own times and the start of a whole range of artistic movements in the last decades of this century. The facts and people involved in them are still in the making. They have advanced complex concepts, and they are influenced by market forces, public taste, and institutional decisions alike. They include an enormous variety of subjects, materials, solutions. They interact with other creative and artistic media. For all these reasons they deserve to be treated separately and so fall outside the scope of this publication.

Amedeo Modigliani
Nudo rosso/Red Nude,
also known as Nude on a
Cushion

*1917, canvas, private
collection.*

For a long time Modigliani's
large female nudes were
simplistically (and in a
vulgar sense dismissively)
considered "pornographic."
They are in fact among the
rare images in western art
that can unequivocally be
defined as "erotic" and on a
par with the great
masterpieces of oriental
art. Modigliani's
draughtsmanship captured
the contours of the female
body with an unmatchable
delicacy that has its
historical roots in
Quattrocento art. This
allows a real and pulsating
sensuality to emerge of its
own accord. It is as far
removed from Egon
Schiele's morbidity (the
well-known Viennese
painter produced a series of
scandalous female nudes) as
it is from the weary
allegories produced by
followers of Decadent Art.

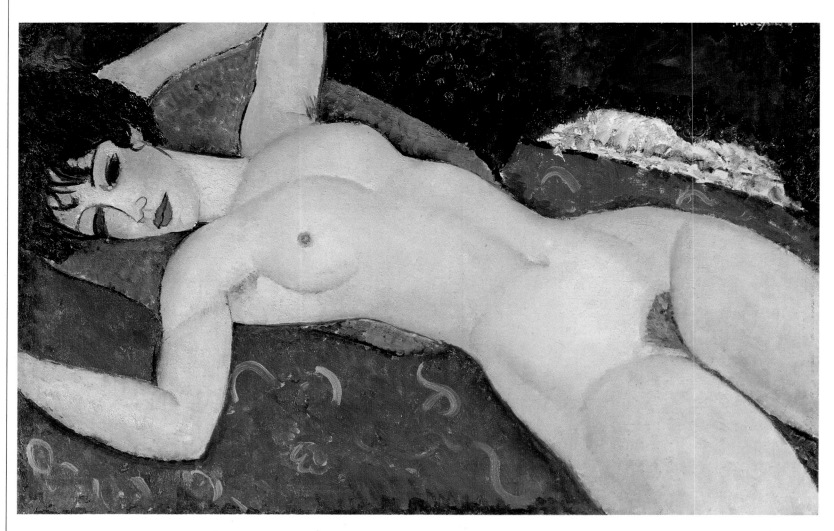

Amedeo Modigliani

Leghorn, 1884–Paris, 1920

Modigliani's father was from Tuscany
and his mother was French. He studied
in Italian academies (Florence and then
Venice), but the whole of his brief
career as a painter was spent in Paris.
He started visiting it in 1905 but did
not settle there for good until 1909.
Even the phonetic sound of his French
nickname "Modi" singled Modigliani
out as an archetypally damned genius:
"maudit" (damned). He strove in his art
to reach a probably unattainable
creative intensity, which finally
exhausted him. His setting was Paris,
but Paris in a minor key among the
crumbling buildings of Montparnasse
or in rooms filled with the fumes of
drugs and alcohol. Modigliani was
unquestionably one of the greatest and
most poetic European artists of the first
half of the twentieth century. He was
conscious of coming from a very long
artistic tradition, especially the Tuscan
Quattrocento. This allowed him to
translate his own violent feelings into
lucid line and volume. Such qualities
place Modigliani at the heart of Italian
painting. His Italian training emerges in
the absolutely pure rigor of his
draughtsmanship and his devotion to
the human figure. Although he was
perfectly well aware of the Cubists,
Modigliani was never particularly
attracted by their austerely intellectual
approach to art. If anything, he was
more fascinated by the potent
simplicity of Negro sculpture,
Toulouse-Lautrec's vivid touch, and
especially the sculpture of the
Romanian Constantin Brancusi. For a
number of years Modigliani
deliberately painted very little in order
to concentrate on sculpture. But his
relationship with sculpture was not an
easy one. Between 1915 and 1920
(when he died at just 36, followed a few
days later by his pregnant wife Jeanne
Hébuterne, so affected by his death that
she committed suicide) Modigliani
went back to painting. He had been urged
to do so by the art dealer Zborowski
and he produced approximately 30 oils,
nearly all portraits. The unmistakable
way Modigliani lengthened his figures
(his swan-like necks have become
legendary) increased the solitary
elegance and lightness of the subjects.
At the same time, their expressions are
conveyed with penetrating simplicity.
By nature Modigliani was not inclined
to join or follow any avant-garde. He
remained aloof and founded no school
to carry on his style. His art does,
however, bear similarities to works
produced in the same period by other
artists from various countries who had
all settled in Paris.

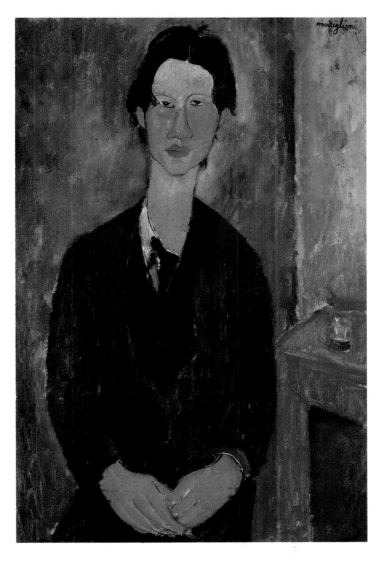

Amedeo Modigliani
Ritratto di Soutine seduto
a tavola/Portrait of
Soutine Sitting at a Table

*1916, canvas, Washington,
National Gallery.*

The Jewish-Lithuanian
painter Chaim Soutine was
one of the few real friends
Modigliani had in Paris.
Between 1913 and 1920

Modigliani, Soutine, and
Chagall (who like them was
of Jewish origin and was
finding it difficult to settle
in a new city) often spent
time together, drinking,
talking, and working. They
worked side by side in the
"ruche" or hive of
Montparnasse turning out
works for the art collector
Zborowski. Like Soutine,

though for different reasons
(Modigliani's middle-class
Italian background was far
more sophisticated than
Soutine's peasant origins),
Modigliani kept his distance
from both Fauvism and
Cubism, the main currents
in Parisian art at the time
but he was keenly aware of
Cezanne's still lifes.

Amedeo Modigliani
Autoritratto/
Self-portrait

*1919, canvas, São Paolo
(Brazil), Museu de Arte
Contemporânea da
Universidade.*

This is one of the last
images that we have of the
artist. He had aged
prematurely, his health
wrecked by excessive

alcohol and drugs. The
lyrical poetic strain that
permeates Modigliani's
œuvre here seems to be
concentrated in the sad
sweetness of his face and
posture. Even the cheap
furniture and clothes give
clues to the undeniable
daily difficulties of the
artist who seemed to
contemporaries to be
cursed.

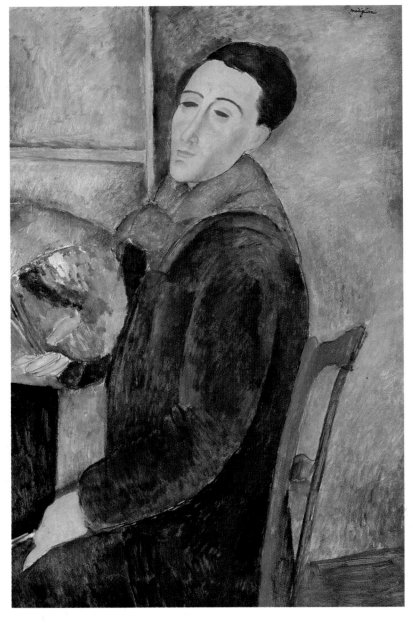

Amedeo Modigliani
Ritratto di Paul Guillaume/
Portrait of Paul Guillaume

1916, canvas, Milan, Civico Museo d'Arte Contemporanea.

This inspired work was painted during a particularly fruitful period in the history of Modigliani's art. It is one of four portraits that Modigliani painted of Paul Guillaume, an intellectual and art dealer who was both his patron and supporter. Guillaume was particularly close to Modigliani during the disorganized but creative years when he lived in Montparnasse. Guillaume's pose seems friendly and relaxed. From his expression he seems absorbed in what he is doing. Modigliani's elegant technique allowed him to create a subtle balance between extremely pure, almost abstract, line and the physical and psychological reality of the sitter. This is why the portrait provides a perfect example of how Modigliani managed to meld his draughtsmanship, derived from his classical Tuscan background, with an awareness of what was happening among the international avant-garde.

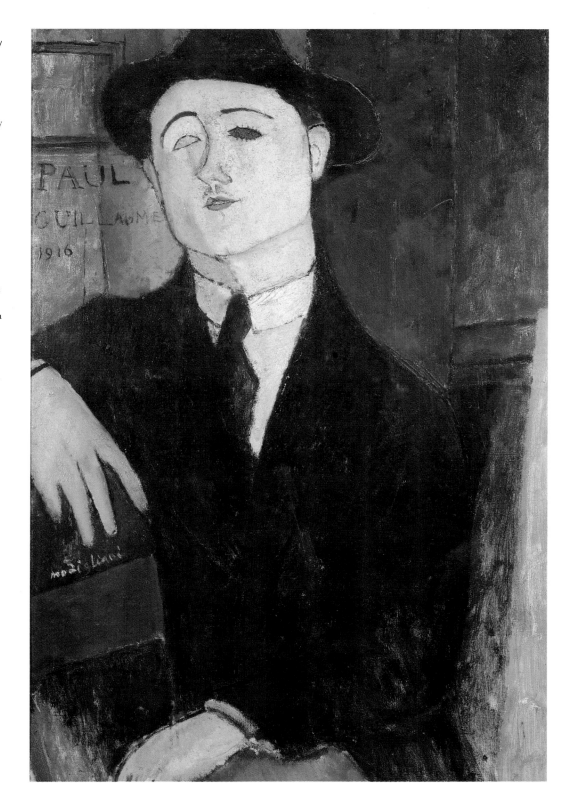

Umberto Boccioni
La città che sale/
The City Rises

*1910–11, canvas, New York,
Museum of Modern Art.*

This is the masterpiece that encapsulates the spirit of Futurism. It has the overwhelming power of a true "manifesto" of a new art movement. Boccioni spent a lot of time making studies and sketches for the canvas (one of these sketches is in the Brera in Milan). The grandiose painting combines realism and symbolism in the way it depicts the construction of industrial suburbs. The foreground is dominated by the gigantic colored waves of two horses that are very frisky. Many people are trying to rein them back but they seem to have been almost thrown into the air by an uncontainable explosion of energy. The horses (which recur almost obsessively in Boccioni's art) stand for the dynamic and positive way industrial suburbs were growing up around the major cities. Boccioni welcomed with open arms this urban growth and the economic process that went with it. (Within a few years, however, the same setting would become the scene for Sironi's somber evocations of solitude.) In the background of the canvas, Boccioni clearly depicted the scaffolding erected for the building work. Farther off still, we can see the smoking chimneys of the factories. Starting with the techniques of Divisionism, Boccioni developed a new way of painting. He used "detached" brushstrokes, sometimes long and sometimes dotted, but always full of tremendous rhythmical power.

Umberto Boccioni
Reggio Calabria, 1882–Verona, 1916

Indisputably, the Futurist movement was one of the most important contributions that Italy has made to world art in the twentieth century. Boccioni was the founder of Futurism as well as being its most convinced and important exponent. For a short while (he died prematurely after falling from a horse during the First World War) Boccioni and Marinetti guided a group of painters, writers, and musicians through one of the most intense and interesting periods of the whole European avant-garde. In the opening decade of the century Boccioni studied art in Rome under Giacomo Balla, a sculptor and painter who later became a Futurist, before setting off on lengthy travels (to Venice, Russia, and Paris). While he was abroad, he was able to compare his own Divisionist technique with other contemporary forms of figurative expression. In 1907 he settled in Milan where he was attracted to the social themes that Lombard painters were then exploring. Their subjects were often the explosive growth of new working class districts in the industrial cities of the north. Boccioni's meeting with the poet and writer Marinetti marked a crucial turning point in Italian culture. Together they launched Futurism which aimed at expressing the vitality and energy of the contemporary world. It turned its back on the art of the past and embraced everything to do with modernity: movement, action, noise, and speed. Boccioni not only produced some of Futurism's most seminal works but also wrote on the theories underlying its avant-garde motives and aspirations, which contrasted with Cubism emerging in France at the same period. Boccioni sought a way to convey his visions through both his paintings and his rare but highly interesting sculptures. His canvases were filled with vivid colors applied with quivering brushstrokes and he chose subjects that had a deeply symbolic meaning to him. They encapsulated his attitude of embracing enthusiastically the newest technology, sports, and progress. Boccioni volunteered for the army when Italy entered the First World War in 1915. This period marked a turning point in his own painting which now became more contemplative and less frenetic as he turned back to Post-Impressionism for new ideas.

Umberto Boccioni
Ritratto della sorella/
Portrait of his Sister

*1907, canvas, Venice,
Ca' Pesaro, Galleria d'Arte
Moderna.*

All of Boccioni's work is
dominated by a number of
symbolic presences, such as
horses, scaffolding for
buildings, and female figures.
Boccioni showed particular
intensity in the way he
observed and repeatedly
portrayed the women in his
family, including his sister
and, even more, his mother.
We can follow the various
stages in the development
of the painter's style from
the gradual way that his
images of women lose shape
as he moved from late-
nineteenth century Realism
to the "anti-grace" of
Futurism, which echoes the
deliberate "ugliness" of
Cubism.

Umberto Boccioni
Officine a Porta Romana/
Factories at Porta Romana

*1908, canvas, Milan, collection
of the Banca Commerciale
Italiana.*

This is one of the most
important and decisive
works that Boccioni
produced in his pre-
Futurist period. It was
painted using the "divided
color" technique that had
been most fully developed
in Milan. The urban scene
and the growth of a new
working-class area was
viewed from an unusual
perspective. Above all,
however, the painter's
insight added a historical
and social commitment to
the work. Boccioni seemed
to be acutely aware that a
new epoch was beginning.

Umberto Boccioni
Tre donne/Three Women

*1910–11, canvas, Milan,
collection of the Banca
Commerciale Italiana.*

This fascinating canvas was
painted at a decisive
moment in Boccioni's
career which also
represents a turning point
in the development of
Italian painting in this
century. From the purely
technical point of view the
canvas (which is very large)
should still be classified as
Divisionist as it is clearly a
continuation of the work of
Pellizza da Volpedo.
However, the way Boccioni
has fragmented the color
gives the portrait of the
three women a strongly
dynamic feel. This is
continued in the way dust
moves and vibrates in the
filtered light. The subject
matter can to some extent
be considered typically late
nineteenth century. It is a
variation on the theme of
the "three ages of woman"
so dear to the Symbolists
and familiar to Gustav Klimt
as well.

Umberto Boccioni
Rissa in galleria/
Riot at the Gallery

1911, canvas, Milan, Brera.

Only a few years after the placid late nineteenth-century middle-class views of city life so frequently produced in both Italy and France, Boccioni set out to be deliberately polemical in this typical Futurist painting. Brilliantly illuminated by electric lamps, two women are grabbing each other by the hair just outside a café. Their brawl sparks off a ferment of curiosity among the onlookers. The scene fragments and multiplies into luminous dust, creating the impression of furious speed. On Boccioni's part, the painting was also the excuse for a satirical comment on social manners. The staid bourgeoisie tended to view the deliberately clamorous goings-on of the Futurists with irritation and disapproval. Boccioni turned the tables on them by making them the protagonists of this farce, a kind of crazy ballet that the painter observed with amused detachment.

Carlo Carrà

Quargnento (Alessandria), 1881–Milan, 1966

Carrà's artistic career stretched over many stages of Italian art during the twentieth century. He moved to Milan when he was 14 and was still only adolescent when he undertook long periods of study in Paris and London. Thanks to this, his artistic horizons were broadened early. His studies at the Brera Academy gave him a perfect understanding of the techniques of painting. He thus had a wide knowledge of classical and modern art, including Divisionism and even Cubism, about which he probably knew more than other Italian artists of the time. With this strong and well-informed background in 1910 he joined the Futurist movement, soon becoming one of the leading painters in the group. Carrà managed to attain a perfect balance between a sense of volume and the illusion of movement. He was also committed to Futurist theory and wrote numerous articles. Furthermore, he experimented with new techniques such as *collage*. All of these factors combined to make Carrà a major figure in Italian art at the start of this century. After his memorable encounter with de Chirico and de Pisis in Ferrara's military hospital in 1916, Carrà became one of the founding members of the Metaphysical group. This set out to reintroduce more defined shapes and simplified volumes. After the First World War had ended, Carrà worked enthusiastically to restore appreciation of early Renaissance painters from Giotto to Piero della Francesca. In the 1920s Carrà founded a movement called the *Novecento Italiano* into which he poured his theories and ideas on form. These included clarity of composition with a grandiose yet poetic simplicity of gesture. The only exception he allowed to these principles was for his landscapes, especially those of the Tyrrhenian coast. In these he expressed the lyricism of nature and the quality of the light through a much thicker palette that was rich in *sfumato*.

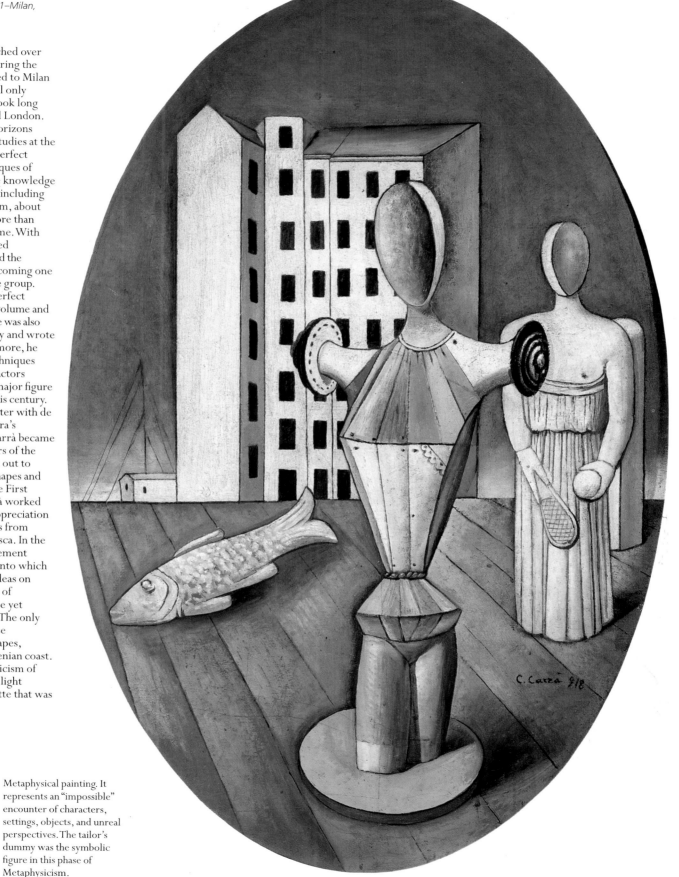

Carlo Carrà
L'ovale delle apparizioni/
The Oval of the Apparitions

1918, canvas, Rome, Galleria Nazionale d'Arte Moderna.

This canvas effectively summarizes Carrà's role in Metaphysical painting. It represents an "impossible" encounter of characters, settings, objects, and unreal perspectives. The tailor's dummy was the symbolic figure in this phase of Metaphysicism.

Carlo Carrà
I funerali dell'anarchico
Galli/The Funeral of the
Anarchist Galli

*1910–11, canvas, New York,
Museum of Modern Art.*

This large painting seems to
reveal Futurism's political
stance, but the truth is that,
initially at least, it had no
specific political views.
Later on, in the 1920s and
1930s, what remained of it
was absorbed into the
Fascist esthetic.
Nonetheless it is a highly
interesting early work in
which Carrà's great talent
clearly emerges. From his
early Divisionist technique
he has here moved on to a
painting that captures the
masses in motion.

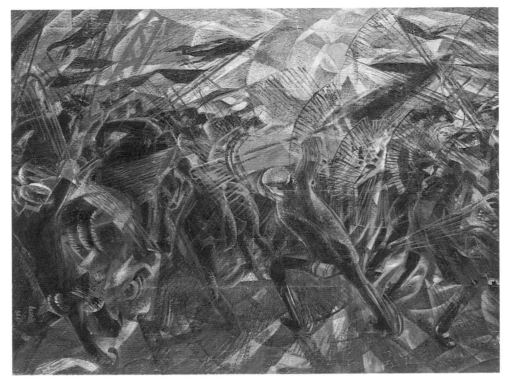

Carlo Carrà
Il cavaliere rosso/
Horse and Rider, *also
known as* Red Rider

*1913, tempera and ink on
woven paper, Milan, Civico
Museo d'Arte Contemporanea.*

This picture provides a
paradigm of Futurism. A
red horse galloping away
furiously, a blue jockey, and
rays of yellow light form a
brilliant chromatic setting
for the explosive speed of
the horse. The way that
details are multiplied (the
charger's hooves, the rider's
back) suggests the idea of
movement.

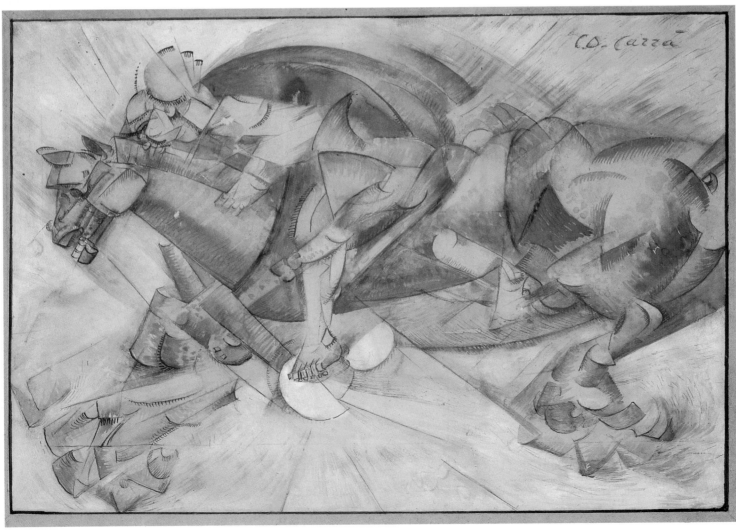

Carlo Carrà
L'amante dell'ingegnere/
The Engineer's Mistress

1921, canvas, Milan, private collection.

After the tumultuous demonstrations of the Futurists, Metaphysical painting seemed to be the art of silence, of the unconscious and mystery. This canvas was painted at the end of the period when Carrà was part of the Metaphysical group. By now, his outlines are less distinct, his colors less brilliant, and contrasts less sharp than in the work he was producing between 1917–20. Under Sironi's influence, Carrà tended to darken his palette and return to the Valori Plastici (Plastic Values) upon which was to be based the notion of a "return to order" in Italian painting (and politics) during the 1920s. But compared to Sironi's somber quality, Carrà's work always retained a far more lyrical and ethereal vein. His powers of evocation remained light and fascinating. While in the Metaphysical period perspective in his work had tended to be thrust forward, now horizons were receding toward a distant line. The thin strip of light is reminiscent of a sunset and underlines the dreamlike quality of the scene.

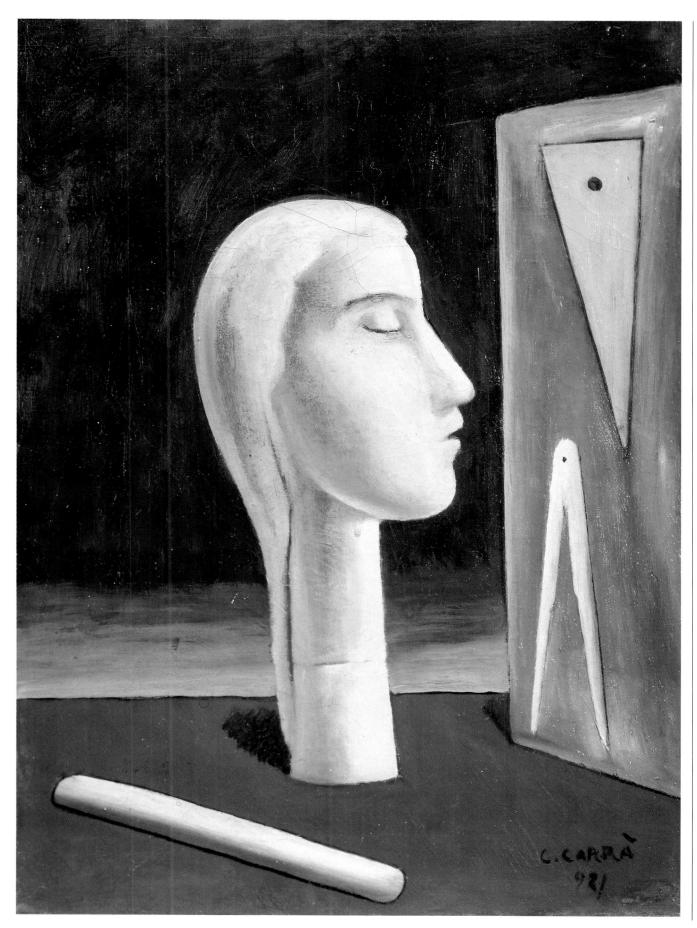

Giorgio de Chirico

Volos (Greece), 1888–Rome, 1978

The son of an engineer who built many of the railroads in Greece, de Chirico always took it as a sign of destiny that he was born in the land of ancient myths and gods. Like his brother Alberto Savinio, throughout his life he always felt that he had a deep affinity with the classical world. This was the constant spirit behind his work, the one thing that remained true even when his style altered dramatically and when, as so often happened, he was molded by foreign influences. There is no doubt that he stood outside the sometimes rather provincial climate of Italian art. De Chirico's main relationship, in fact, was with the various currents of European culture. He studied in Munich where he was much influenced by Nietzsche's philosophy and Arnold Böcklin's Symbolist art. Both men, in fact, shared his acute longing for the ancient classical world. In 1910 de Chirico moved to Paris where he became a friend of Guillaume Apollinaire and he watched the development of Cubism with detached interest. It was there that de Chirico's creative spirit first emerged. This took the form of strongly evocative images blocked out in settings with disturbingly allusive perspectives that seemed to belong to the world of dreams. His famous encounter with Carrà in 1917 in Ferrara military hospital, where he was recovering from a nervous breakdown, proved of fundamental importance. It was then that Metaphysical painting was officially born. This became perhaps the most original and influential movement in Italian art in the twentieth century. Typically its subjects were tailor's dummies, statues, silent and deserted Italian squares, clear-cut shadows, buildings used as empty backdrops, and objects from everyday life shifted to totally alien settings. In 1918 de Chirico and Carrà contributed to the periodical *Valori Plastici* which gave a literary dimension to Metaphysical painting. Dissatisfied with the way Italian painting was heading in the 1920s, de Chirico went back to Paris. Here he became a tremendous influence on the emerging Surrealists – although he personally tended to dismiss them – while his own interest in archeological themes and motifs increased. In the 1930s, this passion for the past took the form of Neo-Baroque paintings full of horses, still-lifes, and portraits. Later in the course of his long career, de Chirico returned tediously to the same themes over and over again. In particular he revisited his Metaphysical phase.

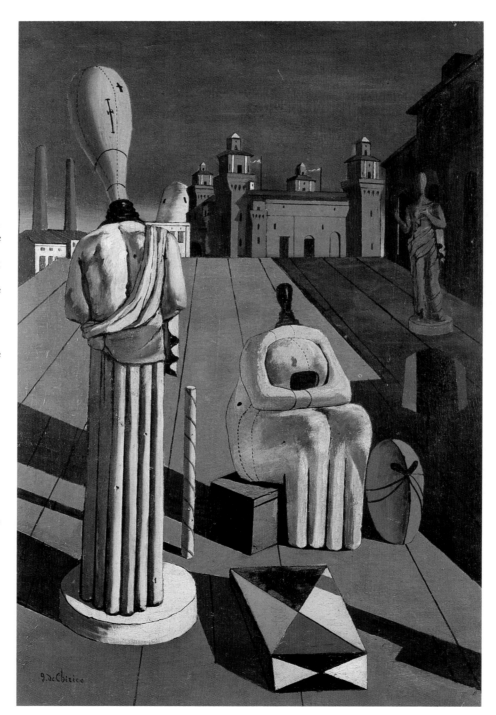

Giorgio de Chirico
Le muse inquietanti/
The Disquieting Muses

1918, canvas, Milan, private collection.

This is one of the emblematic works of twentieth-century Italian art. There is no doubt that it made an utterly original contribution to international art, being in effect Metaphysical painting's manifesto. With precise clarity it depicts an "impossible" situation in which elements of reality combine in a totally incongruous fashion. The steep perspective and enameled colors make each component look like a lacquered toy. In the background we see the Este Castle in Ferrara, the town where de Chirico, Savinio, Carrà, and de Pisis met in 1917 and started the Metaphysical movement. The *Silent City* is obviously Ferrara, an ancient princely city whose court has long vanished and which has been reduced to a city of memories. For de Chirico it became the ideal setting for the oneiric and mysterious presence of the "disquieting muses."

Giorgio de Chirico
Le chant d'amour/
Love Song

1914, oil, New York, Museum of Modern Art.

Inspired by the title of a poem by Guillaume Apollinaire, de Chirico composed an unexpected encounter between a plaster cast of the head of the Apollo Belvedere, a floppy rubber glove, and a ball. In the background a locomotive is puffing past (possibly a professional tribute to his father, who was a railroad engineer).

Giorgio de Chirico
L'enigma dell'ora/
The Enigma of the Hour

1911, canvas, Milan, private collection.

While Italian art was being speeded up by the dynamism of the Futurists, de Chirico started to produce his immobile and mysterious paintings. His absolutely clear draughtsmanship and the rhythmic pattern of the shadows give an even greater magical quality to the mysterious way that voices, time and life itself are forever suspended.

Giorgio de Chirico
La nostalgie de l'infini/
Nostalgia of the Infinite

1913, canvas, New York, Museum of Modern Art.

Another typically silent, deserted urban enigma.

Giorgio de Chirico
Il figliol prodigo/
The Prodigal Son

*1922, canvas, Milan, Civico
Museo d'Arte Contemporanea.*

Historically this painting is
still part of de Chirico's era
of Metaphysical painting.
Here we see the immobile
embrace of a dummy and a
plaster statue (once again
resembling his father's
"ghost" which appeared
recurrently in both de
Chirico's and Savinio's
work). The encounter takes
place in an architectural
setting which is defined
with a clear perspective
recalling that of the great
fifteenth-century masters.
The clear decisiveness of
the draughtsmanship and
the exact fall of light are
signs of the imminent
advent of a phase in which
de Chirico would
reinterpret the history of
art. This phase would obsess
de Chirico for years to
come.

On the following page
Giorgio de Chirico
Ettore e Andromaca/
Hector and Andromache

*1917, Rome, Galleria
Nazionale d'Arte Moderna.*

The immobile and silent
presence of dummies was
one of the unmistakable
characteristics of de
Chirico's painting between
1910–20. More generally
they are typical of Italian
Metaphysical painting. We
should remember that de
Chirico's brother Alberto
Savinio had included the
strange and anguished
figure of a tailor's dummy in
his first literary work, *Songs
of the half-dead*. This work
was part poetry, part prose,
written in French and was
published in 1914.
References to the classical
world and Homeric heroes
occur frequently in de
Chirico's art and may be
traced back to the fact that
he was born in Greece.

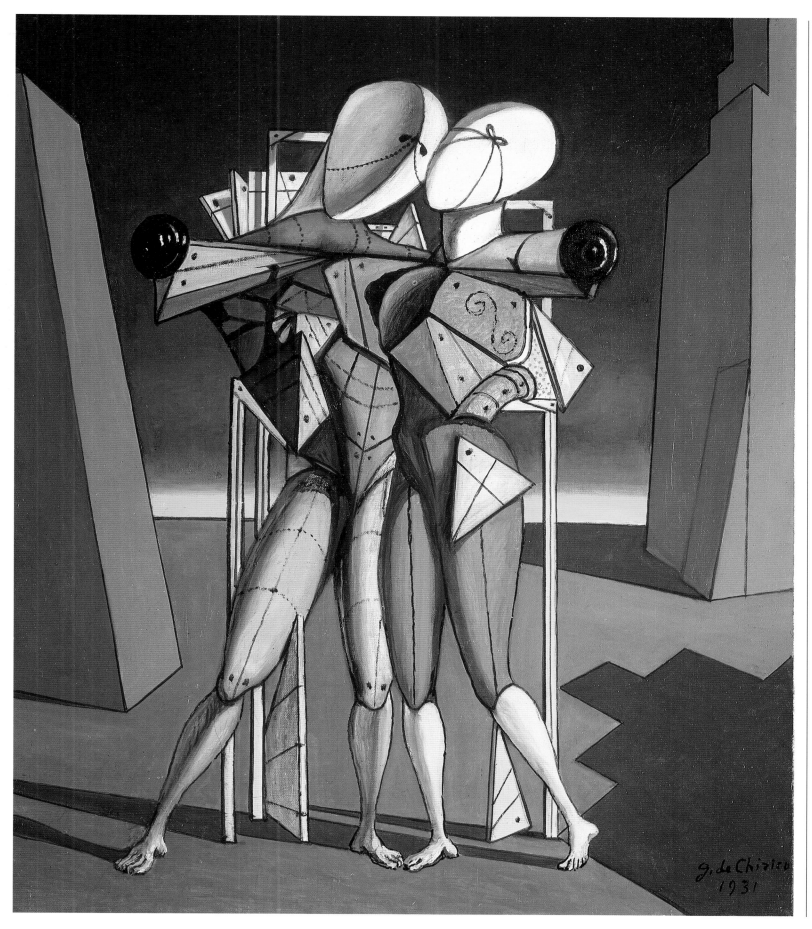

Giorgio Morandi

Bologna, 1890–1964

One of the great figures in Italian painting in the twentieth century, Giorgio Morandi was a truly exceptional figure. He was a solitary painter, remote from any movement, who had little contact with any other artist. Morandi scarcely ever went anywhere other than Bologna and Grizzana, the tiny town in the Apennines where he spent his summers. Nevertheless, in his early work it is possible to pick out a thread that runs from his awareness of Cézanne's work through contacts with the Futurists and on to his approval of the Metaphysical painters. But from 1920 onwards his research centered on a handful of everyday subjects (by preference still lives with bottles or landscapes) which he continuously reworked as he went deeper and deeper into his themes. In essence, Morandi's creative process did not need new subject matter. His was a completely inner intellectual journey which used patient contemplation to analyze the consistency, rhythm, surroundings, reflections, and delicate chromatic tones of objects. From the point of view of style, we should note how he moved on from his paintings of the Metaphysical period, typified by geometrical draughtsmanship and layers of shadow, to a progressive accumulation of forms. In his later works his brushwork was broader and thicker.

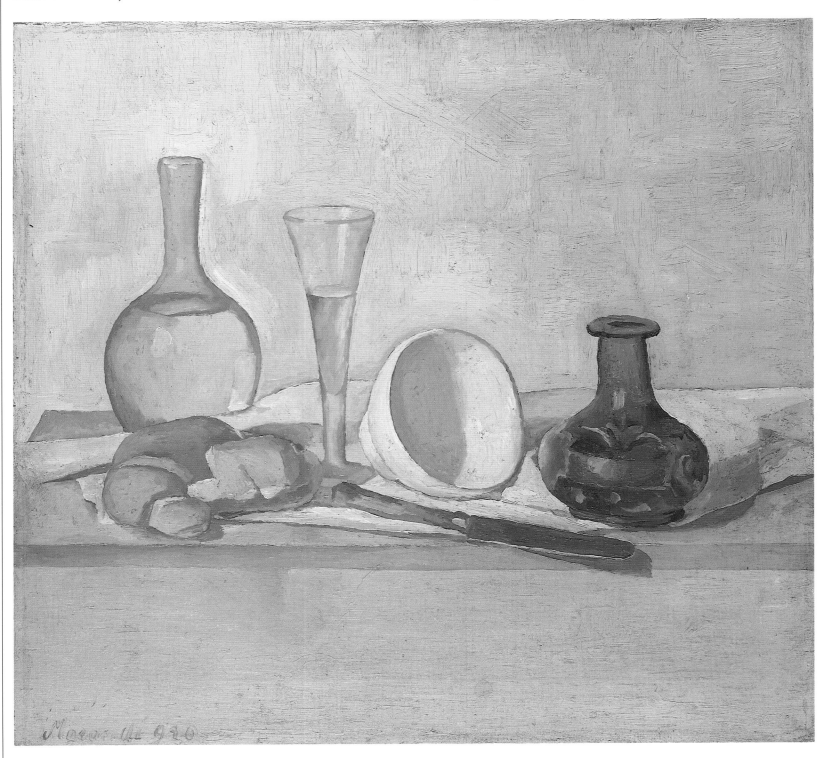

On the opposite page
Giorgio Morandi
Natura morta con la brioche/Still Life with a Brioche

1920, canvas, Düsseldorf, Kunstsammlung Nordrhein-Westfalen.

Giorgio Morandi
Natura morta con la palla/Still Life with a Ball

1918, canvas, Milan, Civico Museo d'Arte Contemporanea.

This is a famous canvas that Morandi painted in his early years. With startling clarity it captured the concepts of stasis, void, and of silence which dominated (in the early years at least) the entire group of Metaphysical painters. Morandi's patient and solitary labor began here. It already reveals the results of austere control yet is imbued with a note of touching lyricism and melancholy.

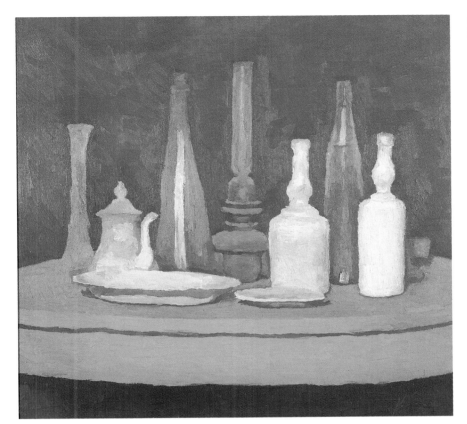

Giorgio Morandi
Natura morta/Still Life

1929, canvas, Milan, Brera.

Giorgio Morandi
Natura morta con manichino/Still Life with a Dummy

1918, canvas, St. Petersburg, Hermitage.

This is one of the Metaphysical canvases Morandi painted during the First World War or immediately after it. In many of the paintings of this period, objects were isolated from their surrounding space by means of boxes. Inside the boxes, objects could float as if they were in a vacuum.

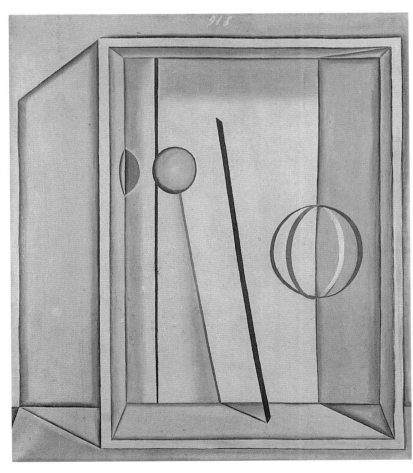

Mario Sironi

Sassari, 1885–Milan, 1961

Sironi's long career straddled a number of decades and covered many of the important moments in Italian twentieth-century art. The fact that Sironi went along with certain facets of Fascist-approved art has in the past made art critics question his worth. Today, however, it is generally agreed that Sironi was one of the most interesting figures of our century. The painter's beginnings were stormy. After studying engineering at Rome University, in 1910 Sironi made his first, rather unhappy, attempts at painting in Giacomo Balla's studio. He became both Balla's pupil and his friend. Despite this, Sironi became dissatisfied and anxious with what he was doing, so he gave up art and moved to Milan. It was there that in 1914 he made contact with the Futurists and started painting again. Compared to Boccioni's brilliant and lively vein, Sironi's colors were always somber and dark. He tended to underline the heavy volumes of the objects he painted. Nevertheless, his participation in the Futurist movement was a strongly personal statement which was an indicator of things to come. During the First World War Sironi also used *collage* to block out forms in rigorously succinct blocks which brought him very close to Metaphysical painting. From 1919 onwards he concentrated on subjects connected with the urban landscape, becoming the artistic spokesman for human and social unrest after the end of the First World War. The industrial suburbs, which were perhaps Sironi's best known and most original subject, were dominated by gloomy buildings that loomed disproportionately large. This gave a sense of drama about to unfold in places where the human figure seemed irrelevant. For Sironi existential anguish could be resolved by recourse to the Valori Plastici (Plastic Values) he shared with Carrà. Sironi was naturally attracted toward order and reason. He did not limit himself to transmitting this through his painting but also worked on construction projects and alongside architects, set designers, and decorators. Sironi made his name through traditional genres such as frescos, mosaics, or monumental low reliefs. His painting was dominated by studies of nudes, mountainous landscapes, and cityscapes. They were all marked, however, by his dark colors and the sense of monumentality that inspired all of his work. As he grew older, his painting tended to contain more fragments, memories, archeological quotations, and recollections of classical antiquity, sometimes placed in sequence, sometimes just a random collection. This type of subject dominated Sironi's later output.

Mario Sironi
La lampada/The Lamp

1919, oil, Milan, Brera.

This is an extremely interesting work from Sironi's Metaphysical period. It draws on the theme of the tailor's dummy so dear to de Chirico. The scene seems set in an immobile fantasy world where Sironi remains chained to the shadows of reality and becomes the disturbing subject of his own picture.

Mario Sironi
Periferia/The Suburbs

1920, oil, Venice, private collection.

The silent, ghostly city suburbs that Sironi painted in the years after the First World War provide a tense and obsessive image of a victorious nation going through serious economic and social difficulties. The high, somber walls have no exits. The square blocks of the industrial buildings and the total absence of life create an inhuman environment.

Renato Guttuso

Baghiera (Palermo), 1912–Rome, 1987

Guttuso was a great, if controversial, painter. He doggedly defended the value of figurative art (against abstract art) both from the point of view of style and for historical and social reasons. Guttuso marked the radical passage that Italian painting underwent during the Second World War. He was spurred on by his anti-Fascist beliefs and during the 1930s worked first in Rome and then in Milan. He was a very cultured man with extraordinary technical ability. This allowed him to rework influences from Expressionism, popular Sicilian art and, above all, from Picasso. In 1947 he founded the *Fronte Nuovo dell'Arte* [New Art Front]. It was in the artistic avant-garde, was connected to the Communist Party, and unashamedly embraced social commitment. Nevertheless Guttuso never went in for rabble-rousing nor was he merely an illustrator used by politicians or ideologues. His art always contained a great deal of moral tension and often employed a powerful sense of portraiture.

Renato Guttuso
Crocifissione/Crucifixion

c. 1940–41, canvas, Rome, National Modern Art Gallery.

This was the manifesto of neo-Cubist Realism of which Guttuso was the main exponent.

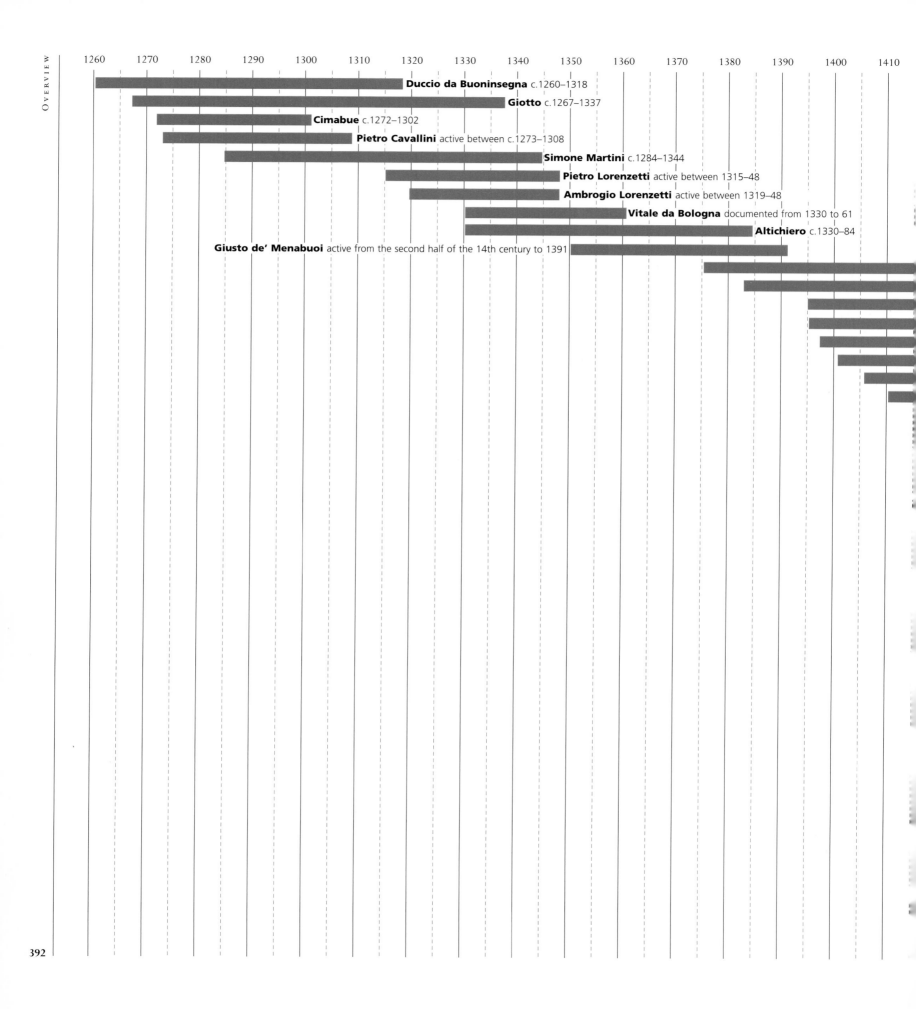

Duccio da Buoninsegna c.1260–1318

Giotto c.1267–1337

Cimabue c.1272–1302

Pietro Cavallini active between c.1273–1308

Simone Martini c.1284–1344

Pietro Lorenzetti active between 1315–48

Ambrogio Lorenzetti active between 1319–48

Vitale da Bologna documented from 1330 to 61

Altichiero c.1330–84

Giusto de' Menabuoi active from the second half of the 14th century to 1391

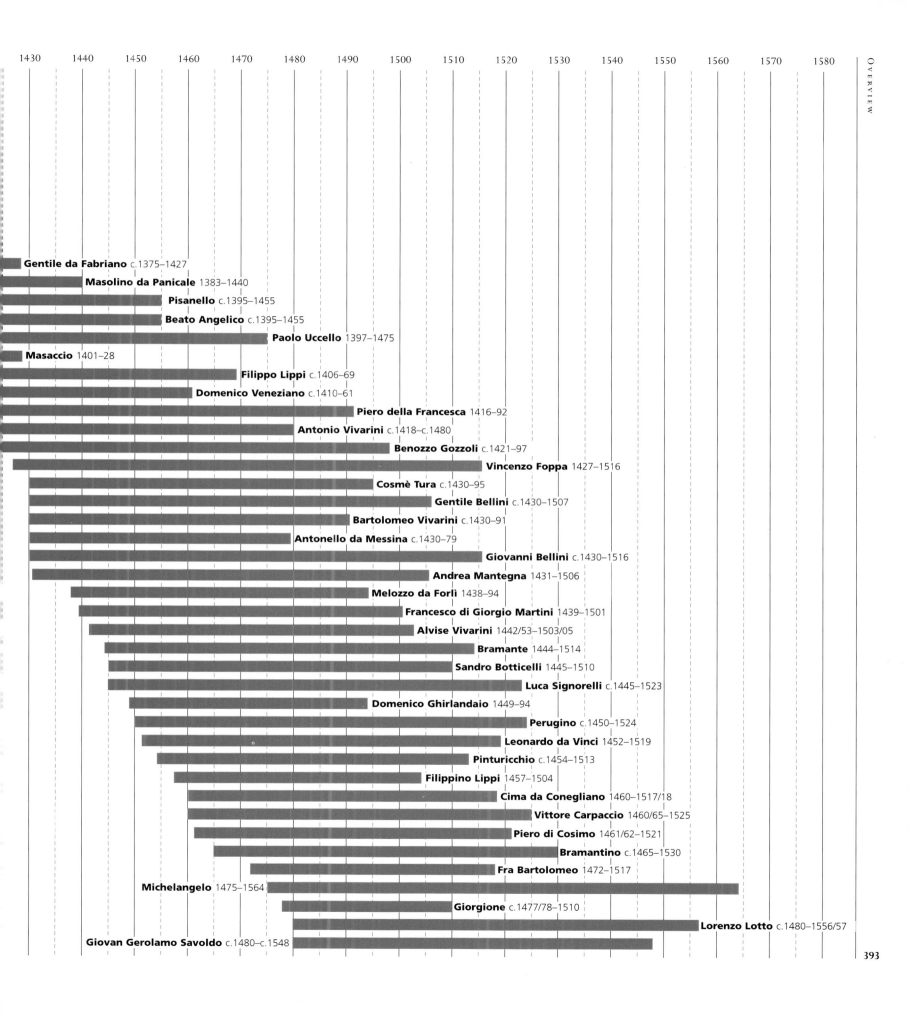

1430	1440	1450	1460	1470	1480	1490	1500	1510	1520	1530	1540	1550	1560	1570	1580	

Gentile da Fabriano c.1375–1427

Masolino da Panicale 1383–1440

Pisanello c.1395–1455

Beato Angelico c.1395–1455

Paolo Uccello 1397–1475

Masaccio 1401–28

Filippo Lippi c.1406–69

Domenico Veneziano c.1410–61

Piero della Francesca 1416–92

Antonio Vivarini c.1418–c.1480

Benozzo Gozzoli c.1421–97

Vincenzo Foppa 1427–1516

Cosmè Tura c.1430–95

Gentile Bellini c.1430–1507

Bartolomeo Vivarini c.1430–91

Antonello da Messina c.1430–79

Giovanni Bellini c.1430–1516

Andrea Mantegna 1431–1506

Melozzo da Forlì 1438–94

Francesco di Giorgio Martini 1439–1501

Alvise Vivarini 1442/53–1503/05

Bramante 1444–1514

Sandro Botticelli 1445–1510

Luca Signorelli c.1445–1523

Domenico Ghirlandaio 1449–94

Perugino c.1450–1524

Leonardo da Vinci 1452–1519

Pinturicchio c.1454–1513

Filippino Lippi 1457–1504

Cima da Conegliano 1460–1517/18

Vittore Carpaccio 1460/65–1525

Piero di Cosimo 1461/62–1521

Bramantino c.1465–1530

Fra Bartolomeo 1472–1517

Michelangelo 1475–1564

Giorgione c.1477/78–1510

Lorenzo Lotto c.1480–1556/57

Giovan Gerolamo Savoldo c.1480–c.1548

393

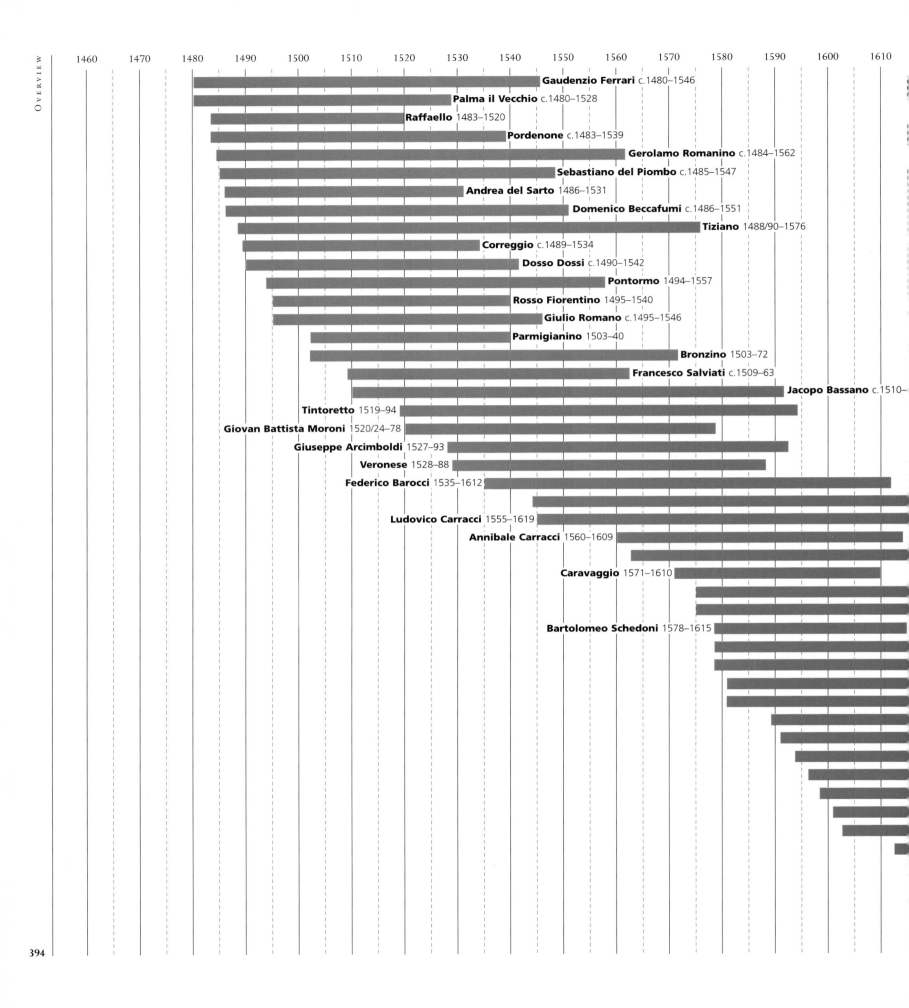

| 1460 | 1470 | 1480 | 1490 | 1500 | 1510 | 1520 | 1530 | 1540 | 1550 | 1560 | 1570 | 1580 | 1590 | 1600 | 1610 |

Gaudenzio Ferrari c.1480–1546

Palma il Vecchio c.1480–1528

Raffaello 1483–1520

Pordenone c.1483–1539

Gerolamo Romanino c.1484–1562

Sebastiano del Piombo c.1485–1547

Andrea del Sarto 1486–1531

Domenico Beccafumi c.1486–1551

Tiziano 1488/90–1576

Correggio c.1489–1534

Dosso Dossi c.1490–1542

Pontormo 1494–1557

Rosso Fiorentino 1495–1540

Giulio Romano c.1495–1546

Parmigianino 1503–40

Bronzino 1503–72

Francesco Salviati c.1509–63

Jacopo Bassano c.1510–

Tintoretto 1519–94

Giovan Battista Moroni 1520/24–78

Giuseppe Arcimboldi 1527–93

Veronese 1528–88

Federico Barocci 1535–1612

Ludovico Carracci 1555–1619

Annibale Carracci 1560–1609

Caravaggio 1571–1610

Bartolomeo Schedoni 1578–1615

| 1630 | 1640 | 1650 | 1660 | 1670 | 1680 | 1690 | 1700 | 1710 | 1720 | 1730 | 1740 | 1750 | 1760 | 1770 | 1780 |

Palma il Giovane 1544–1628

Orazio Gentileschi 1563–1639

Cerano c.1575–1632

Guido Reni 1575–1642

Battistello Caracciolo 1578–1635

Francesco Albani 1578–1660

Bernardo Strozzi 1581–1644

Domenichino 1581–1641

Domenico Fetti 1589–1623

Guercino 1591–1666

Giovanni Serodine c.1594–1630

Pietro da Cortona 1596–1669

Gian Lorenzo Bernini 1598–1680

Guido Cagnacci 1601–63

Pietro Novelli 1603–47

Mattia Preti 1613–99

Bernardo Cavallino 1616–56

Evaristo Baschenis 1617–77

Carlo Maratta 1625–1713

Luca Giordano 1634–1705

Andrea Pozzo 1642–1709

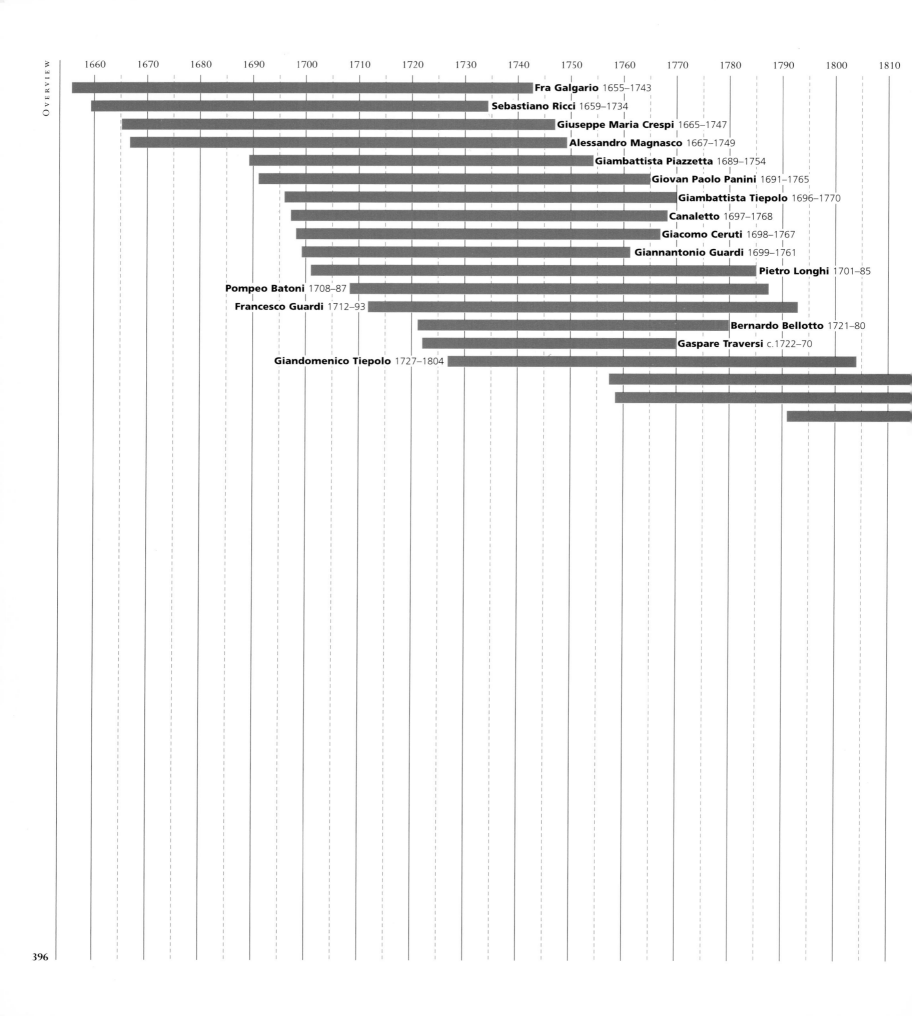

1660 1670 1680 1690 1700 1710 1720 1730 1740 1750 1760 1770 1780 1790 1800 1810

Fra Galgario 1655–1743

Sebastiano Ricci 1659–1734

Giuseppe Maria Crespi 1665–1747

Alessandro Magnasco 1667–1749

Giambattista Piazzetta 1689–1754

Giovan Paolo Panini 1691–1765

Giambattista Tiepolo 1696–1770

Canaletto 1697–1768

Giacomo Ceruti 1698–1767

Giannantonio Guardi 1699–1761

Pietro Longhi 1701–85

Pompeo Batoni 1708–87

Francesco Guardi 1712–93

Bernardo Bellotto 1721–80

Gaspare Traversi c.1722–70

Giandomenico Tiepolo 1727–1804

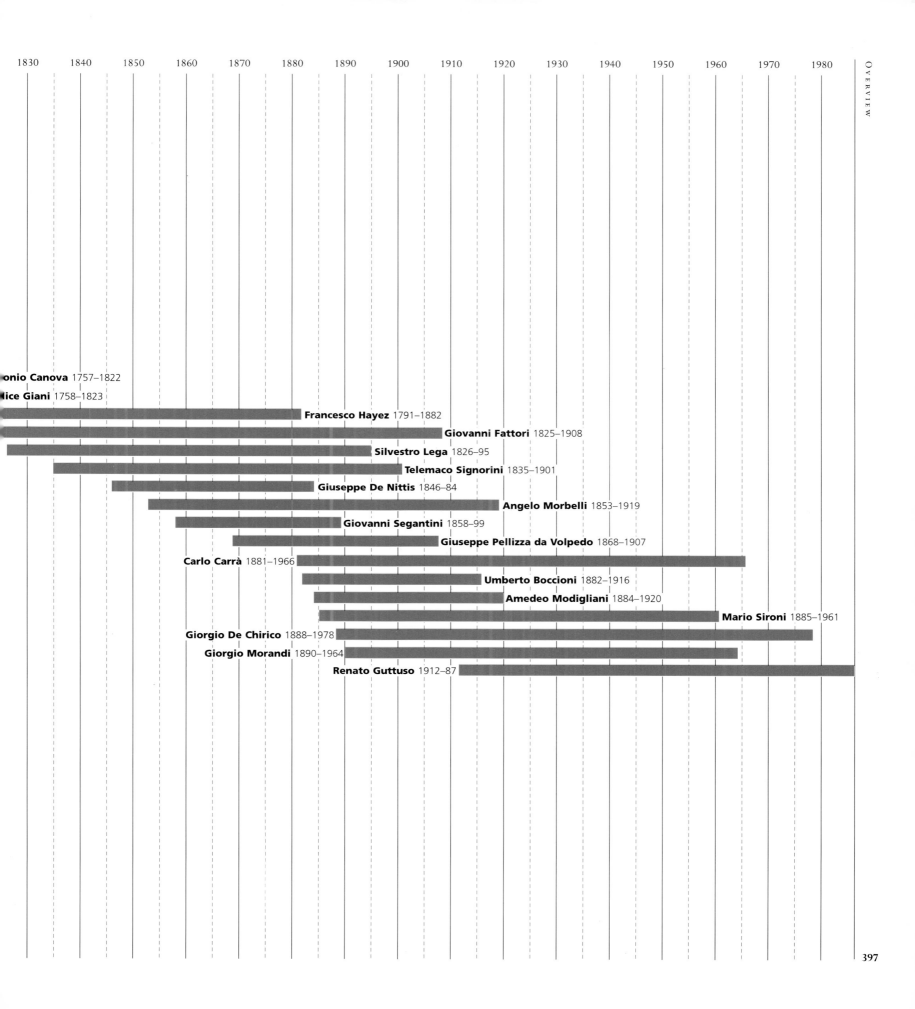

onio Canova 1757–1822

lice Giani 1758–1823

Francesco Hayez 1791–1882

Giovanni Fattori 1825–1908

Silvestro Lega 1826–95

Telemaco Signorini 1835–1901

Giuseppe De Nittis 1846–84

Angelo Morbelli 1853–1919

Giovanni Segantini 1858–99

Giuseppe Pellizza da Volpedo 1868–1907

Carlo Carrà 1881–1966

Umberto Boccioni 1882–1916

Amedeo Modigliani 1884–1920

Mario Sironi 1885–1961

Giorgio De Chirico 1888–1978

Giorgio Morandi 1890–1964

Renato Guttuso 1912–87

Index of Artists

Index of Paintings

Bold numbers indicate illustrations

Text and picture research by Stefano Zuffi
Additional picture research by Francesca Castria

Photographic references
Electa Archive, Milan
Mondadori Archive, Milan
In addition we would like to thank the photographic
archives of the museums and organizations which have
provided material for the illustrations.
The publisher remains available to those with legitimate
title over any source of illustration that may not have been
mentioned.

Original title: La pittura italiana
© 1998 English-language edition
Könemann Verlagsgesellschaft mbH
Bonner Str. 126, D-50968 Cologne

Translation from the Italian: Elizabeth Clegg
Editor: Nigel Rodgers
Typesetting: Goodfellow & Egan
Printing and binding: Elmond SpA
Printed in Martellago, Italy

ISBN 3-8290-0490-7